P9-DEU-410

ART SINCE 1940
STRATEGIES OF BEING

Second Edition

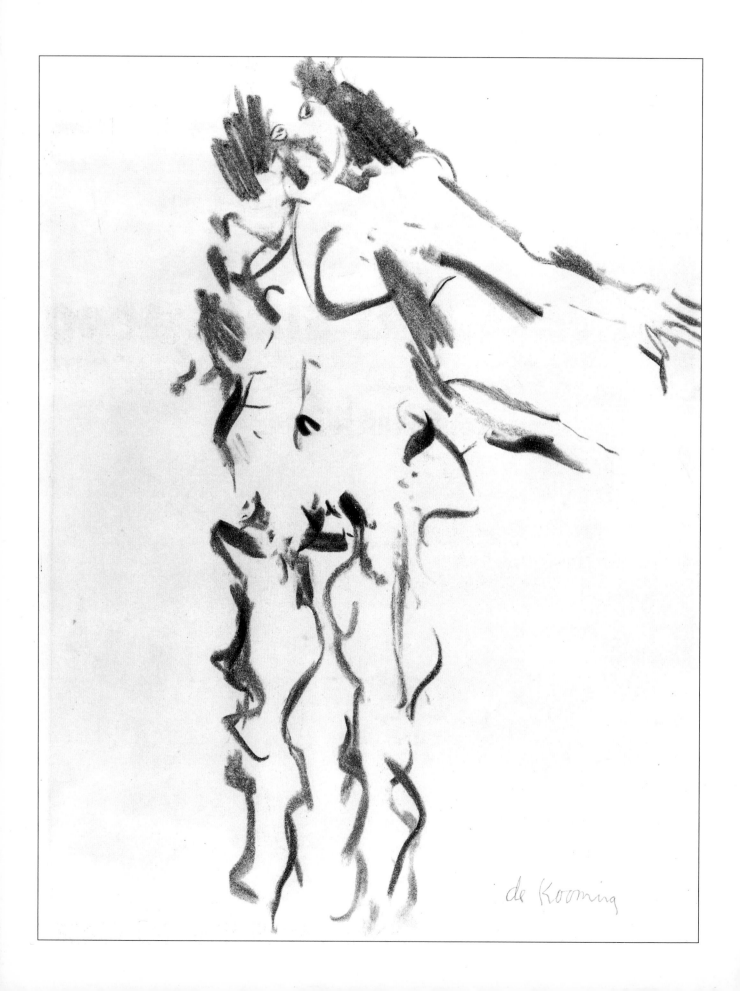

de Kooning

ART SINCE 1940
STRATEGIES OF BEING
Second Edition

JONATHAN FINEBERG
University of Illinois

Prentice Hall, Upper Saddle River, N.J. 07458

2000 North and South American educational editions
published by Prentice Hall
A Pearson Education Company
Upper Saddle River, New Jersey 07458

10 9 8 7 6 5 4

2000 British edition published by Laurence King Publishing

Copyright © 2000 Prentice Hall

All rights reserved. No part of this book may be reproduced, in any
form or by any means, without permission in writing from the
publisher.

ISBN 0-13-085843-9

Passages from William S. Burroughs, *Naked Lunch* (New York,
1959) are reprinted by permission of Grove/Atlantic, Inc.

The lines from "Cape Hatteras" are reprinted from THE POEMS
OF HART CRANE, edited by Marc Simon, by permission of
Liveright Publishing Corporation. Copyright © 1986 by Marc
Simon.

Passages from "Dog," in Lawrence Ferlinghetti, *A Coney Island of the
Mind*. Copyright © 1958 by Lawrence Ferlinghetti. Reprinted by
permission of New Directions Publishing Corp.

Excerpt from "Howl" from *Collected Poems 1947–1980*. Copyright ©
1955 by Allen Ginsberg. Used by permission of Harper Collins
Publishers, Inc.

Passages from Ernest Hemingway, *A Farewell to Arms* reprinted with
permission of Charles Scribner's Sons, an imprint of Macmillan
Publishing Company, from A FAREWELL TO ARMS by Ernest
Hemingway. Copyright © 1929 by Charles Scribner's Sons.
Copyright renewed 1957 by Ernest Hemingway.

"The Red Wheelbarrow," William Carlos Williams, *The Collected
Poems of William Carlos Williams, 1909–1939, Vol.1*. Copyright ©
1938 by New Directions Publishing Corp. Reprinted by permission
of New Directions Publishing Corp.

This book was designed and produced by
CALMANN & KING, LTD.
71 Great Russell Street, London WC1B 3BN

Senior Managing Editor: Richard Mason
Design: Richard Foenander; The Design Revolution
Cover design: Richard Foenander
Typesetter: Fakenham Phototypesetting
Printed and bound in China

FRONT COVER Clockwise from upper left: **Jackson Pollock**, 1950,
© Estate of Hans Namuth/VAGA, New York, 1994; **Bruce
Nauman**, *Self-portrait as a Fountain*, 1966–67, 19¾ × 23¾ ins
(50.2 × 60.3 cm) (from eleven color photographs of 1970, edition of
eight). Courtesy of Sperone Westwater, New York. ©1994 Bruce
Nauman/Artists Rights Society (ARS), New York; **Mariko Mori**,
Subway, 1994. Fuji super gloss (duraflex) print, wood, pewter frame,
27 × 40 × 2 ins (68.5 × 101.6 × 5.08 cm). Courtesy American Fine
Arts, New York; **Christo**, 1983, © United Press International; **Anne
Hamilton**, *Mantle*, 1998. Photo by Thibault Jeanson (*and onto back
cover*).

BACK COVER Clockwise from upper left: **Yves Klein**, *Leap into the
Void*, near Paris, October 23, 1960. Photo ©Harry Shunk. ©1994
Artists Rights Society (ARS), New York/ADAGP, Paris; **Jörg
Immendorff** in his studio, 1998. Photograph © Jonathan Fineberg
1998; **Josef Beuys**, 1974, © Estate of Peter Moore/VAGA, New
York; **Cai Guo-Qiang**, *The Century with Mushroom Clouds*. Event at
Nevada Nuclear Test Site, 1996. Photo by Hiro Ihara (*and onto
spine*); **Alice Aycock** drawing *Circling 'Round the Ka'Ba: The Glass
Bead Game*, 1985 (photographer unknown); **Robert Arneson** in his
studio in Benicia, California, 1978. Photo © Estate of Robert
Arneson/VAGA, New York, 1994.

FRONTISPIECE Willem de Kooning, *Woman*, 1961. Pencil on paper,
11 × 8½ in (27.9 × 21.6 cm).
Private collection, Illinois. © 2000 Willem de Kooning Revocable
Trust/Artist Rights Society (ARS), New York.

To Marianne

"Painting is a state of being . . . self-discovery. Every good artist paints what he is."

– JACKSON POLLOCK

CONTENTS

8

Contents

FOREWORD TO THE SECOND EDITION

I would like to point out—especially to students—that this is a personal account. It is predominantly an American perspective and it is *my* perspective on art since 1940. There are many other possible and equally valid points of view from which this book could have been written. What matters here is not the list of art objects and artists (my choices continue to change), but rather my sincere engagement with the works of my lifetime that have most enlarged or challenged the way I see the world. What I hope to have communicated through my encounter with these works is the seriousness of these artists and their endeavors, and the way in which their art can give one a fresh perspective on reality.

I was born in the months before Pollock's first drip picture, so this is very much an account of issues that came to the fore in my own lifetime. Moreover, I have had the privilege of meeting (and often coming to know quite well) many of the artists in this book. That, along with the work they produced, helped me to experience both their work and our times on a deeper level. I want to acknowledge once again my gratitude to the artists discussed in this volume.

I also want to thank several individuals by name, along with still more unnamed persons, for generously taking the time to help me make this a better book: Mary Coffey, Jeffrey Deitch, David O'Brien, Jeannene M. Przyblyski, Margit Rowell, Martica Sawin, Vicente Todolí, and Angela Westwater. All of them made identifiable contributions to improving this second edition.

I am also very grateful to the staff at Calmann & King, London, who worked on this book with great forbearance and skill to rescue this very tardy author—in particular my editor Richard Mason, the designer Richard Foenander, and Bud Therien at Prentice Hall who has the steadiest hand in publishing of anyone that I know. I also want to thank warmly five friends from whom I have learned so much in conversation over the last five years about issues that touch directly on this book: Manuel Borja-Villel, John Carlin, Josef Helfenstein, Hubert Neumann, and Buzz Spector.

Jonathan Fineberg
Urbana, Illinois
August 1999

ACKNOWLEDGMENTS

Until I wrote this book I never understood those (as it once seemed to me) melodramatic expressions of gratitude to the author's husband or wife "without whom this couldn't have been written." I now realize that either those authors found their books easier to write than I have mine, or they discovered, as I have, that there is no way adequately to express the contribution my wife, Marianne, has made to this book, intellectually and spiritually. I am also deeply grateful for the patience of my children—Maya, Naomi, Henry—who gave up a lot of my time that was rightfully theirs over the decade when I sat buried in my library researching and writing this book. That Maya—the eldest—could tell me she wanted to be an art historian after watching this process touches me more deeply than I can say (though I secretly hoped for law school).

I also want to acknowledge the three greatest teachers of my life: Harold Rosenberg, Christo, and my father, Henry H. Fineberg, M.D. The influence of Harold's uncompromising commitment to intellectual values will never leave me: fifteen years after his death I can still hear his voice over my shoulder, needling me and scrutinizing my argument as I write. Christo's ideas about change and time, in particular, were too radical for me even to acknowledge at first, because they revolutionized my thinking so fundamentally: I still find the effects of his ideas continuing to unfold in my life in new ways. Finally, my father's psychoanalytic perspective on the influence of social interaction as the key to understanding the mechanisms of art shaped my perspective on the world and is at the very heart of this book's premise.

An ongoing conversation of now fifteen years' duration with my friend John Carlin has greatly enriched my life and I want to thank him warmly for that. Likewise, I am enormously grateful to many friends who have generously given their time and shared their ideas with me. Some of them even suffered through extensive parts of this text in draft (for which I am especially indebted): in particular, I want to acknowledge Katherine Manthorne, the late Robert Motherwell, Richard Shiff, and Larry Silver. I am also very grateful to Stephen Fineberg, Lois Fineberg, Philip Graham, and Bob Holman for being there when I most needed them.

Important contributions to my understanding of various issues came from discussions with Manuel Borja-Villel, Mary Schmidt Campbell, Jeanne-Claude Christo, Rene Conforte, Caroline Cox, William J.R. Curtis, Gabriella de Ferrari, Ebon Fisher, Henry Louis Gates, Jr., Alma Gottlieb, Anne Coffin Hanson, Michael Heizer, Grace Mansion, Elizabeth Murray, John Neff, Charles Slichter, Tim Spelios, Robert Farris Thompson, Vicente Todolí, David Weinstein, and Jessica Weiss: I thank them all. I have also been blessed with a succession of remarkably talented current and former graduate students at the University of Illinois who helped in numerous ways (and also graciously accommodated my preoccupation

Acknowledgments

with this project during its various phases): I especially want to thank Candace Bott, Mary Coffey, Charng-Jiunn Lee, Lorraine Menar, Rene Meyer-Grimberg, Mysoon Rizk, Peggy Schrock, Zan Schuweiler-Daab, and Lisa Wainwright.

This entire enterprise rests in part on the outstanding work of other writers on postwar art whose books and essays I have read and admired: in particular I want to mention Dore Ashton, Robert Hughes, and Irving Sandler, although there are many others, too numerous to list individually, whose works have helped teach me this subject.

I want to thank Jane Block, Christopher Quinn, and the staff of the Ricker Library at the University of Illinois, who have come to the rescue repeatedly. There are also a number of people on the staffs of museums and galleries who went out of their way to help: I am grateful to them all, especially Anita Duquette of the Whitney Museum, Bob Panzer at VAGA, and Katia Stieglitz of ARS whose help was particularly appreciated.

Everybody ought to have a friend like Carl Brandt, my agent: I want to thank him for many hours of listening patiently and then leading me out of my conundrums with unfailingly sound judgment. Bud Therien at Prentice Hall was wonderful to work with and I am enormously grateful that he had enough faith in me to keep an open mind about my radical transformation of this project as it went along. I could not have been more pleased with the work of everyone at Calmann & King, where the production of this book was undertaken: I especially want to thank my editor Richard Mason and the designer Richard Foenander.

I owe a profound debt to the Research Board of the University of Illinois; I do not know another institution that does the job of supporting serious research so well. I am most grateful to the Dean of the College of Fine and Applied Arts, Dr. Kathryn Martin. Finally, I want to say how much Ted Zernich's friendship and support have meant to me over the years since he assumed the directorship of the School of Art and Design at the University of Illinois. Ted always comes through for me somehow, and deserves a good deal of credit for helping me make my time at the University of Illinois the most productive years of my career.

Jonathan Fineberg
Urbana, Illinois
August 1994
(revised 1999)

PREFACE

It is my view that great works of art arise from the effort of exceptional individuals to come to terms with the facts of their existence—within themselves and in the world. Insofar as the artist's experience touches on the experience of others, his or her work offers a fresh perspective on events for someone else too, though that is not its purpose. In the sense that artists explore their ideals and speculate on the meaning of matters of defining importance to them in their art, it is a spiritual endeavor. That is the aspect of art most worth understanding, remembering, discussing.

Some may criticize this book for presenting "heroic narratives" when the collective aspect of history is being emphasized in contemporary criticism. So much the better. Artists stand against the corporate experience of culture; the models of "heroism" described here consist of great feats of imagination and thought. A culture without such "heroic narratives" to inspire us is a gloomy prospect indeed.

This book attempts to survey art from 1940 to the present as an accumulation of unique contributions by individual artists, interspersed with a few chapters that concern the broader context of the six decades treated here. These broader chapters include a number of other wonderful, if less historically central, artists whom space does not permit me to discuss in greater depth. I have tried to take a long view about this subject and have made a judgment about which artists seem to me to have shaped their cultural moment in the most significant ways; in particular I have tried to be a careful field worker in listening to what artists have told me about the work that has influenced them. Nevertheless, this process of selection has also been painful for me since, by these criteria, I have said little about—or even left out—many artists whom I deeply admire.

I should add that the number of illustrations included by individual artists is not strictly proportional to my estimation of their influence; sometimes it merely happened that more pictures were needed to explain an idea. Also I have introduced the detailed coverage of important artists in the chronological context in which they had their most significant impact. Thus artists like Guston and Bearden, for example, come up in relation to their defining roles in the art of the seventies even though both were already important artists in the late forties. Finally, I want to point out what should be obvious—that this is intended as a survey of European and American art and that I chose the opening date of 1940 because it was then that a large part of the Paris art scene moved *en masse* to New York, definitively transforming it into the art capital of the world.

It will become clear to the reader that on the whole I do not believe in movements. They seem to me an effort to simplify what needs to remain complicated. Whereas in science one aspires to the simplest explanation of the phenomenon under scrutiny, the whole point of art and the humanities is to open our minds to more alternatives and ambiguities in the way we see the world.

1
INTRODUCTION

Approaching Art as a Mode of Thought

Anyone who is moved by Vincent van Gogh's *Three Pairs of Shoes* [fig. 1.1] can never again look at a pair of old work boots [fig. 1.2] without a rich resonance from van Gogh's worldview. In the painting, one sees the shoes through the artist's eyes and in so doing begins to know the artist. In this way the artist speaks to us through our empathic response to his account of experience. He is, as Wordsworth described the poet, "singing a song in which all human beings join with him."[1]

Making art is a form of thinking that we access through empathy. The thinking in a work of art is not necessarily verbal, though that may enter in too, but *visual thinking*, which can be equally rigorous. Even in an abstract work, which may seem to concern only issues of color, form, and the like, the structure that the artist conceives for those pictorial elements provides a model for organizing experience. That model constitutes the artist's "style" and resembles a personality in the sense that its traits are clearly consistent. Each individual work constitutes a particular application of that system. As Willem de Kooning put it: "You've developed a little culture for yourself. Like yoghurt, as long as you keep something of the original microbes, the original thing in it will grow out. So I had—like most artists—this original little sensation, so I don't have to worry about getting stuck."[2]

The implicit underlying subject matter of modern art is always the personality of the artist in its encounter with the world—the alternately painful and exhilarating intersection of psychological forces, intellect, society, and events. Brushwork, line, composition, even representational matter constitute metaphors for the artist's experience of events (internal and external), and in giving form to these subjective experiences the artist arrives at what A. N. Whitehead, the Oxford philosopher, called "symbolic truth."[3] The definitively individual nature of this activity makes the common oversimplification of modern art into "movements" implausible. At most one can say that all artists necessarily embark from common elements of the visual language and experience of their time (inflected by their *personal* experience which may coincide with that of other artists or general viewers). This connects them to other artists in ways that often lead to the commonalities of style or subject that, in turn, have given rise to the idea of movements.

In Western art from ancient times well into the nineteenth century even the most innovative artists depended upon patrons and a public that measured quality in relation to well-known standards of subject matter, technique, and style. In the twentieth century we have come increasingly to value an artist's work most of all for its success in changing those standards by the force of its originality. But the more original an artist's vision the more his or her frame of reference will vary from what the rest of us think and see. Thus the individuality that we prize so

1.1 (opposite, top) **Vincent van Gogh,** *Three Pairs of Shoes,* 1886–7. Oil on canvas, 19⅜ × 28½in (49.2 × 72.4cm). Collection, Harvard University Art museums, Cambridge, Mass. Bequest—collection of Maurice Wertheim, class of 1906.

1.2 (opposite) Snapshot of a pair of work shoes, Les Baux, France, 1968 Photograph by Jonathan Fineberg.

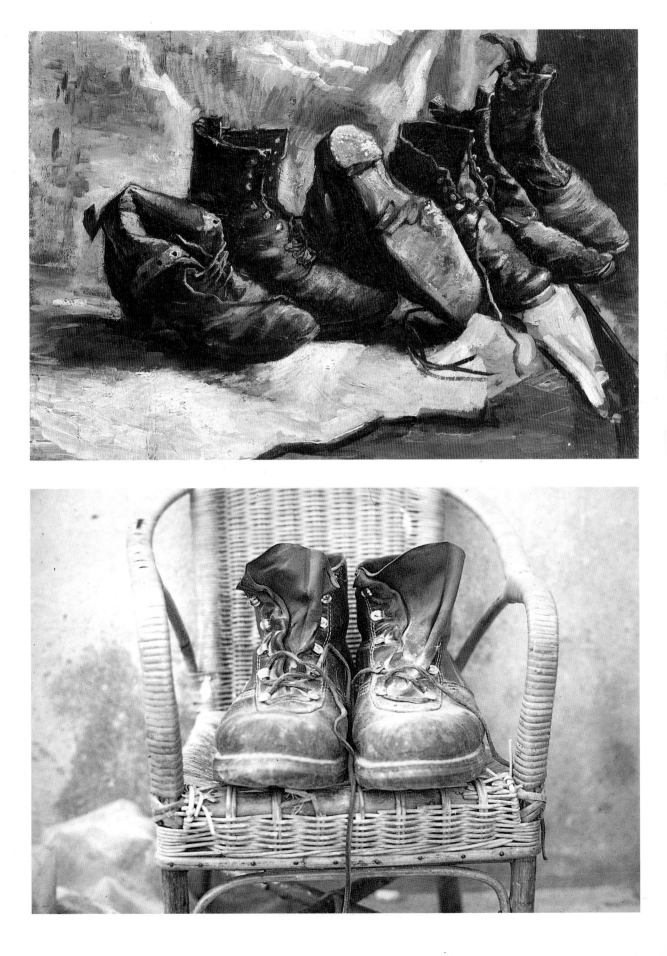

highly in an artist's work makes understanding the work a much more complex interpretive task; the meaning of art today is far less accessible to us than new art was to the audiences of earlier eras.

The Concept of the Avant-Garde

The paradigm of the modern artist as a thinker of unexpected thoughts, expounded upon in the metaphors of visual form, has its origin in the mid nineteenth century. In 1855, the official Exposition Universelle in Paris rejected two large works by the painter Gustave Courbet. In defiance (though not without leaving the accepted works in the official exhibition too!) he had a small temporary building constructed on a lot nearby, and set up his own one-person "exposition" with a catalog proclaiming his new style of "realism" as an expression of democratic values.[4]

Courbet militantly advocated democracy at a time when an emperor (Louis Napoleon) ruled France and the artist intentionally embodied his radical politics in his paintings. "Through my affirmation of the negation of the ideal and all that springs from the ideal I have arrived at the emancipation of the individual and finally at democracy," he wrote in 1861. "Realism is essentially the democratic art."[5]

In relation to subject matter, Courbet's political stance meant depicting ordinary laborers and other unidealized aspects of peasant life, as he did in his *Stonebreakers* [fig. 1.3]. But it was as much Courbet's style of painting that carried his political message. By *Salon* standards his technique looked markedly crude in texture and therefore hasty in application. Courbet deliberately created the impression of haste to imply spontaneity; he wanted to stress that he had responded to nature just as he found it, that he had looked with an open mind rather than trying to perfect nature according to the customary canons of ideal beauty.

So Courbet used style as a visual metaphor, parallel to his subject matter, for the way in which he regarded the world. In both respects his transcription of nature onto canvas struck most of his contemporaries as too direct and consequently as inartistic. When typical *Salon* artists chose peasant subjects they idealized the setting, modeled the figures to look like the Greek and Roman statues in the Louvre, and finished the surface with many layers of heavy varnish. It would never have occurred to such an artist to imbue his (or, rarely, her) work with a dissident political philosophy.

No one (at least no one in conventional circles) wanted to hear about Courbet's political ideas. Furthermore his style

1.3 Gustave Courbet, *Stonebreakers*, 1849. Oil on canvas, 5ft 2½in × 8ft 6in (1.59 × 2.59m).

Destroyed 1945, former collection Dresden Gemäldegalerie, Neue Meister. Photograph courtesy Deutsche Fototek Dresden, Sächsische Landesbibliothek.

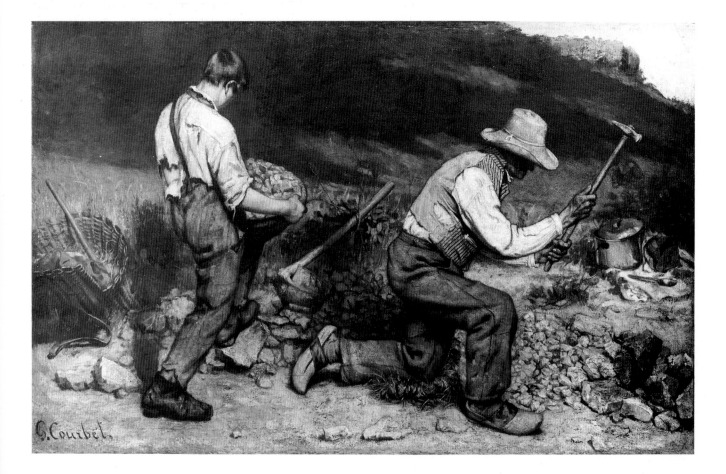

did not look the way most people thought it was supposed to. Indeed, to many of Courbet's viewers, his work did not look like art at all, and by contemporary standards it wasn't! But Courbet painted with so much conviction that over time his way of seeing won over more and more artists and observers to his point of view. In this fashion he effectively changed the definition of art to include himself. In addition the difference between his work and what the public generally recognized as art paralleled the difference between his view of the world and the prevailing one. In this act of redefinition, Courbet provided a paradigm of the modern artist as someone whose aesthetic runs counter to the normalizing force of tradition. This model for the relation of the visual artist to society came to be known as the concept of the "avant-garde."

"Avant-garde" originated as a French military term, referring to the small group of soldiers that went out ahead of the main forces to scout for the enemy. In art "avant-garde" (or "vanguard" in English) describes the situation in which an artist thinks that (1) his or her art expresses ideas and that (2) those ideas not only differ from what the rest of society believes, but that they come closer to "the truth." In addition the concept implies that (3) art has a bearing on understanding the present and perhaps even an influence on the future. Vanguardism places great emphasis on the newness and the profundity of insight in an artist's thinking.

The concept of the avant-garde evolved from the movements for democratic revolution that dominated Europe and America beginning in the third quarter of the eighteenth century. Building on the ideas of the Enlightenment *philosophes*, the French statesman Baron Turgot outlined a doctrine of progress at the Sorbonne in 1750. Indeed a growing belief in the idea of progress had already begun to replace the static assumptions behind the hierarchy of hereditary power and social class. Between the mid seventeenth century and the mid eighteenth the philosophers Thomas Hobbes, John Locke, and then Jean-Jacques Rousseau discussed the "natural rights" of man and the "social contract" that underlie the idea of democracy. Increasingly people looked to the introduction of new ideas in open debate—the mechanism of democracy—as the vehicle of progress. Not only public opinion, but also the ideas of the individual, started to matter more, and the emergence of an artistic avant-garde echoed this new political model.

One important implication of this stress on innovation is the idea that if a work of art redefines standards, it must be measured against its success at fulfilling the standards it sets for itself. This dream of an autonomous work of art—an abstract idea that responds only to its own internal criteria rather than to an external referent in what is commonly called "nature"—has often been understood as the signature of modernism. "I should like to write a book about nothing," the French writer Gustave Flaubert confided in 1852; "a book dependent on nothing external."[6]

Writers of the 1920s and 1930s such as the British critics Clive Bell and Roger Fry celebrated art that deemphasized any reference to nature as "dehumanized," which they saw as a positive virtue. For them the form was the content; they rejected as inessential not only the representation of nature but the psychology of the artist.[7] Clement Greenberg, the American heir to Fry and Bell, took this to an extreme in portraying the avant-garde as being chiefly engaged with the purification of art as an autonomous abstraction. He defined this as "high art," which attempts to expunge all references to the world, as opposed to "kitsch," or popular culture.[8]

So many critics since 1970, especially in the United States, grew up on Greenberg's narrow definition that this drive towards purification is now assumed to be a defining trait of modernism in much contemporary theory. So, too, is the notion that the major twentieth-century artists subscribed to the separation of "high art" from life and from popular culture, as Greenberg did. But this is by no means the case; indeed the eclecticism of modern artists, their radical openness to disparate sources of content, is one of the most constant—though not always the most explicit—features of modernism. In fact much of the "historical avant-garde" (futurism, dada, constructivism, and early surrealism) sought specifically to disrupt boundaries between art and life and between "high" and "low" art as a means of undermining the institution of art and broadening the critique of values.[9]

Such critical theorists as Jean Baudrillard and Fredric Jameson, instead of looking carefully enough at the work and statements of artists, accepted Greenberg's separation of "high" and "low" art as the main determining trait of modernism and then mistakenly defined "postmodernism" as an attack against it.[10] Hal Foster went so far as to label the work of Robert Rauschenberg, who he noted, attempts " 'to reconnect art and life'... as farce."[11] But Greenberg (and Foster) notwithstanding, the wish to revolutionize mainstream values is the defining role of the avant-garde, which is, by most accounts, inseparable from modernism.

Vanguardism has, to a great extent, emanated from and been paid for by the bourgeoisie. Yet the avant-garde has consistently aimed its most vehement attacks at the bourgeoisie, making vanguardism a form of self-criticism. Self-criticism, in turn, is central to the aspirations for objective analysis and innovation that modernism (and democracy) reveres. In the art of the late twentieth century, however, the vanguard attack on tradition has become such an acknowledged aspect of the artistic process that the avant-garde and even innovation have ironically become traditions in themselves, as Harold Rosenberg pointed out in his famous essay, "The Tradition of the New."[12] Rosenberg observed that the very expectation of novel ideas in art today has undermined the ability of art to shock people any more. This observation is what underlies the most intriguing new element in the discussion of the avant-garde, namely the widespread sense of its demise.

The Critical Point of View of this Book

The logical conundrum in which many contemporary critics find themselves with respect to the avant-garde results from the tendency to transform art into an academic discourse (often the most pernicious enemy of art). Whereas, broadly speaking, the leading critics of the forties and fifties responded in a literary style to the expressive content of specific works and focused on the mind of the individual artist, art writers from the 1960s through the 1990s have increasingly shifted to "critical theory" and "cultural studies," using works of art as illustrations of cultural constructs and sociopolitical forces. Critical theory derives from philosophy and theoretically oriented sociology. Cultural studies resembles traditional history with an emphasis on broad social factors, such as race and gender, and with an infusion of language from critical theory.

This transformation in critical thinking began with the shift in the early sixties to an art criticism founded on philosophy and linguistics—especially on the writings of Ludwig Wittgenstein and the linguistically based structural anthropology of Claude Lévi-Strauss. These writers concerned themselves with philosophical questions of meaning and knowing in contrast to the emphasis on existence by the critics of the forties and fifties. The focus of critics in the sixties then expanded to take in what came to be called French "poststructuralist" theory. This began to make its mark in the mid sixties, notably in the work of Jacques Lacan, the later Roland Barthes (his early work was structuralist), Michel Foucault, and Jacques Derrida (who pioneered "deconstruction"). These poststructuralists either elaborated on or reacted against the structuralist redefinition of human experience as a decipherable construct of language.

In general the transition in art from abstract expressionism to pop art, paralleled in theory by a switch from existentialism to structuralism at the beginning of the sixties, expressed a broad cultural shift from a concern with alienation and other spiritual matters to consumerism and a material reading of art. Around 1960 pop art remade consumerist myths into icons—and from this process evolved a new kind of iconographic painting, as in the work of Andy Warhol. Roland Barthes did something similar in *Mythologies* (1957, translated into English in 1972), which examines some familiar phenomena of popular culture as elements in a landscape of "sign" systems.

This split between the spiritual and the formal embodies a perennial philosophical polarity, as central to the ten-year battle in the journals between Jean-Paul Sartre and Claude Lévi-Strauss as it was to the contrasting approaches of Harold Rosenberg and Clement Greenberg. However, Greenberg's retreat from the existential focus of abstract expressionism in establishing a critical foundation for the so-called "color field painting" of the late fifties (see Chapter 6) also involved a denial of the social and historical construction of meaning in painting. In this sense Greenberg's formalism

distinguished itself from French structuralism, which more closely parallels the collage aesthetic of pop art (like Lévi-Strauss's *bricolage*[13]) in its stress on the social integration of the object. But both structuralism and American formalist criticism centered on the material object, unlike existentialism, which concentrated on the nature and response of the subject (the artist).

I admire Derrida's imaginative and deliberate use of style in deconstructionism to frustrate attempts at finding summary meaning, though I regard it more as a literary manifesto than as philosophy. His formulation of syntax as a network of movement to undermine a dominant ideology opened intriguing perspectives on immediate experience, but they were not altogether new. De Kooning's monumental "Women" of the fifties launched an analogous visual—and to me more powerful—attack on the same kind of closure in a destabilizing exploration of reality with paint.

Built into the origins of modernism is the idea, explained more than a hundred years ago by Baudelaire, that imagination "decomposes all creation, and with the raw materials accumulated and disposed in accordance with rules whose origins one cannot find save in the furthest depths of the soul, it creates a new world."[14] All interpretation is in some measure relative and contingent. In the course of the pages that follow, one of the intriguing, overarching narratives that emerges concerns the growing impact of this realization in culture globally. As the influence of American culture spread in the twentieth century, its fundamental hybridity and mutability also increasingly influenced world culture, and thus the agenda of artists worldwide. More so than Europe, the United States has a multicultural identity implied in its founding self-conception; indeed as a culture it is committed to a destabilizing fluidity in its forms—politically, economically, and socially. From Emerson, Thoreau, and Whitman, through O'Keeffe, Hemingway, and William Carlos Williams, to the present, the greatest American artists and writers have always been engaged with a myth of self-reliance, grounded in common experience. Whereas European modernism and the European avant-garde have occupied themselves with breaking down inherited hierarchies in thinking, American culture has always seen itself as starting "from scratch"—which is how the painter Barnett Newman put it in 1967.[15]

In everything from free-market capitalism to the myth of "pioneer" individualism, Americans have always taken a broadly ahistorical approach to things, as though we can begin with a *tabula rasa* and then move forward from there. That attitude has given America in the twentieth century a Protean adaptability in economics and technology and art. It also means that the European innovations of the avant-garde and modernism have never precisely fit the American situation. The American contribution to the twentieth century is post-modernism, with its journalistic vulgarity in accepting all aspects of popular culture and respecting no canon of style or technique. American

postmodernism is not an attack on history or aesthetics but a brash disregard for their very premises in favor of a fundamental uprootedness and a definitive instability.

In *The Ego and the Id* Freud described a persevering pressure from the unconscious mind to gratify its wishes directly in the world. The resistance to the attainment of such immediate gratification from others or from the material conditions of the world necessitates the creation of a mental mechanism—which Freud called the "ego"—that assesses what is possible and integrates the unconscious wishes into the reality. He expanded the political dimension of this idea in *Civilization and its Discontents*. This tension between the inner self and the world is what, in my view, provides the foundation for that "happening of truth" in art which Martin Heidegger described in 1935.[16] For him a work of art needed to be discussed in terms of the process of its creation, precisely because creating is a form of seeing or knowing. The writings of both Derrida and Sartre grew out of this same basic principle from Heidegger and Edmund Husserl (another German philosopher and the one on whom Derrida wrote his first book). But from there, depending on what line of reasoning one follows, one can end up at Sartre, at the poststructuralism of Michel Foucault, at Derrida, or at the position underlying this book—namely, a formally based mode of analysis that looks to the spiritual concerns of the individual as the origin and defining rule for the forms. Moreover, this approach assumes that through the form—together with other expressions of intention by the artist—one can make a meaningful and verifiable (though not a complete or final) interpretation.

I began my introduction to this book with van Gogh's painting of shoes as a homage to Heidegger, who opened his seminal lectures of 1935/6 on the "Origin of the Work of Art" with the same example. These lectures affirm the foundations of modern art in the expression of being rather than in pure form. My persistent focus in this book is on the work of extraordinary individuals. I have subordinated the role of "movements" and collective cultural constructs. This approach expresses my belief that the innovations of individuals, in response to what they themselves encounter in the world, play the most significant role in driving the narrative of art history (though I do not wish to discount the impact of vernaculars, tradition, social, political, or economic factors in defining "what the artist encounters"). Moreover, this narrative is being continually revised to include previously neglected points of view that later acquire historical significance through the responses of subsequent audiences.

A "mainstream," for better and worse, undeniably exists: better, because mutuality and reciprocity, which form the foundation of all civilized interaction, require agreed-upon norms;[17] and worse, because a mainstream can become a tyranny of majority values.[18] Alternative narratives continually take on new importance by redefining the mainstream to include themselves (as Courbet did). Artists' creative struggles to reconcile their individual imaginative life with their social existence can—through the empathic reading of viewers—affect the level on which others experience events. The structural strategies in a work of art (motivated by what I wish to call "strategies of being") can put the viewer in a certain frame of mind that he or she can then bring to bear, as a posture for questioning, on real events. One of the hazards of our educational system's concern with technical mastery has been to foreground "history" in the history of art at the cost of the more immediate but always baffling and inconclusive experience of the art itself. I hope this book will help us revert to a healthier state of ignorance.

2

NEW YORK IN THE FORTIES

2.1 (opposite) **Adolph Gottlieb,** *Romanesque Façade,* 1949. Oil on canvas, 48 × 36in (121.9 × 91.4cm).

Collection, Krannert Art Museum and Kinkead Pavilion, University of Illinois, Urbana-Champaign. Purchased out of the "Illinois Biennial" exhibition of 1951. © Adolph and Esther Gottlieb Foundation/VAGA, New York.

New York Becomes the Center

With the French and British entrance into World War II in September 1939, artists and intellectuals began fleeing Paris, which had been the world's art capital for more than a century. The surrealists had dominated the thriving interwar art scene in Paris, but by 1942 the critical mass of the movement's key figures—André Breton, Salvador Dali, Max Ernst [fig. 2.2], André Masson, Matta, Kurt Seligmann, and Yves Tanguy [fig. 2.3]—had all gone to New York. In addition great cubists, abstract artists, and others from the School of Paris had come over, too, among them Fernand Léger, Piet Mondrian, Marc Chagall, Jacques Lipchitz, and Amedée Ozenfant. Of the major artists only Pablo Picasso and the seventy-three-year-old Wassily Kandinsky remained in Paris for the duration of the war. This book begins at the turning-point of 1940, when the center of the art world shifted to New York, preparing the ground on which the nascent New York School would almost immediately seize the leadership of the avant-garde.

Surrealism

Surrealism evolved from the shock tactics of dada around 1924, under the direction of the poet André Breton. Influenced by Freudian psychoanalysis, the surrealists looked to the unconscious mind as the source of artistic subject matter. In the first *Surrealist Manifesto* of 1924 Breton defined surrealism as "pure psychic automatism by which one intends to express verbally, in writing or by other method, the real functioning of the mind. Dictation by thought, in the absence of any control exercised by reason, and beyond any aesthetic or moral preoccupation."[1]

The French surrealist André Masson created his *Battle of Fishes* [fig. 2.4] by spilling glue on the canvas and then pouring on sand; the sand stuck where the glue fell and he used the forms produced in this random fashion as a springboard for free association. He then modified these chance shapes with paint to accentuate the subject matter of his associations. The finished painting "reads" like a poem rather than a narrative; instead of interacting in logical ways, each image moves off into seemingly different trains of thought. The underlying coherence of meaning in the work relies on metonymy, as in the symbolism of a dream where ideas are represented, often cryptically, by associated ideas. This is a classically surrealist application of "psychic automatism." As a device for generating form, automatism would become central to the artists of the New York School.

After 1930 many surrealists undertook a more literal, illusionistic rendering of dream images. In a work like René Magritte's *The Voice of Space* [fig. 2.5], for example, the free-associative element resides in the selection of the imagery rather than in the technique or style (which, in this case, is academic illusionism). Despite its conservative style illusionistic surrealism continued the movement's radical

2.2 (above) **Max Ernst,** *Totem and Taboo,* 1941–2. Oil on canvas, 28⅜ × 36¼in (72.1 × 92.1cm).

Collection, Staatsgalerie Moderner Kunst, Munich. Lent by Theo Wormland-Stiftung. © 2000 Artists Rights Society (ARS), New York/ADAGP, Paris.

2.3 Yves Tanguy, *Through Birds, Through Fire, But Not Through Glass,* 1943. Oil on canvas, 40 × 35in (101.6 × 88.9cm).

Collection, Minneapolis Institute of Arts. Gift of Mr. and Mrs. Donald Winston in tribute to Richard S. Davis. © 2000 Estate of Yves Tanguy/Artists Rights Society (ARS), New York.

2.4 (above) **André Masson,** *Battle of Fishes,* 1926. Sand, gesso, oil, pencil, and charcoal on canvas, 14¼ × 28¾in (36.2 × 73cm).

The Museum of Modern Art, New York. Purchase. © 2000 Artists Rights Society (ARS), New York/ADAGP, Paris.

2.5 René Magritte, *The Voice of Space,* 1931. Oil on canvas (unvarnished), 28⅝ × 21⅜in (72.6 × 54.1cm).

Solomon R. Guggenheim Foundation, New York, Peggy Guggenheim Collection, Venice. Photograph by Myles Aronowitz © The Solomon R. Guggenheim Foundation, New York. © 2000 Charly Herscovici, Brussels/Artists Rights Society (ARS), New York.

exploration of the content and mechanisms of the unconscious mind; but it was finally of less consequence to American artists of the forties than abstract surrealism.

American Pragmatism and Social Relevance

The surrealists' preoccupation with the hidden content of the mind and the formal vocabulary of European modernism (especially twenties cubism and Picasso's surrealist-influenced expressionism of the thirties [figs. 2.10, 3.25, and 5.20]) provided the intellectual and aesthetic ingredients for the New York School. But the ingrained values of interwar American culture constituted the other half of the mix. Reinforced by the experience of the great Depression, the Federal Art Project of the thirties, and by the war itself, America's pervasive Protestant ethic had instilled in these young New Yorkers a sense of obligation to make their art socially relevant or "useful."

In American art of the thirties "relevance" meant either the easily recognizable treatment of political themes or the promotion of "American values." Ben Shahn's *The Passion of Sacco and Vanzetti* [fig. 2.6], an example of the former, concerned the famous 1927 trial and conviction of two Italian-American laborers in Boston for a hold-up and shooting. The jurors reached their verdict entirely on the basis of circumstantial evidence, and many people at the time believed that the jury's attitude toward the defendants' radical leftist politics and their ethnicity played a decisive role. Shahn portrayed the two as martyrs to the cause of social justice. Thomas Hart Benton's celebration of hairy-chested American masculinity in his painting *The Arts of the West* [fig. 2.7] and Grant Wood's well-known *American Gothic* exemplify the alternative to Shahn in their affirmation of the American national myths of the wild West, country religion, and "the heartland." This kind of painting was referred to as "regionalism."

Meanwhile Mexico (like Germany and Russia) had had a leftist revolution during the period 1911–20, and the Utopian aspirations associated with it engendered a brilliant efflorescence of fresco painting beginning in 1921. News of a "Mexican mural renaissance" spread through the New York art press in the late twenties, and the leading artists—Diego Rivera, David Siqueiros, and José Clemente Orozco—began receiving important public commissions around the United States as well. Rivera executed major frescoes in Detroit, San Francisco, and in Rockefeller Center in New York; Orozco painted cycles at Dartmouth and Pomona Colleges and at the New School for Social Research in New York; Siqueiros made his best-known fresco at the New School.

In addition Siqueiros set up a workshop in New York by Union Square, in which he introduced his apprentices (among them Jackson Pollock) to experimental techniques, including paint splattering and the use of industrial "Duco" paints. On account of the latter, and as a pun on Siqueiros's radical politics, some of the younger painters at the time jokingly referred to him as "Il Duco:"[2]—a *double entendre* on

2.6 (above) **Ben Shahn,** *The Passion of Sacco and Vanzetti,* 1931–2. Tempera on canvas, 7ft ½in × 4ft (2.15 × 1.22m).
Collection, Whitney Museum of American Art, New York. Gift of Edith and Milton Lowenthal in memory of Juliana Force. Photography by Geoffrey Clements, New York. © Estate of Ben Shahn/VAGA, New York, 1994.

2.7 (opposite, top) **Thomas Hart Benton,** *The Arts of the West,* 1932. Egg tempera and oil on linen mounted on panel, 8 × 13ft (2.44 × 3.96m).
Collection, New Britain Museum of American Art, Connecticut. Harriet Russell Stanley Fund. Photograph by E. Irving Blomstrann. © The Estate of Thomas Hart Benton/VAGA, New York, 1994.

2.8 (opposite) **Diego Rivera,** *Detroit Industry,* 1932–3. South wall, fresco, 43 × 67ft (13.11 × 20.42m).
© Detroit Institute of Arts. Founders Society Purchase, Edsel B. Ford Fund and Gift of Edsel B. Ford.

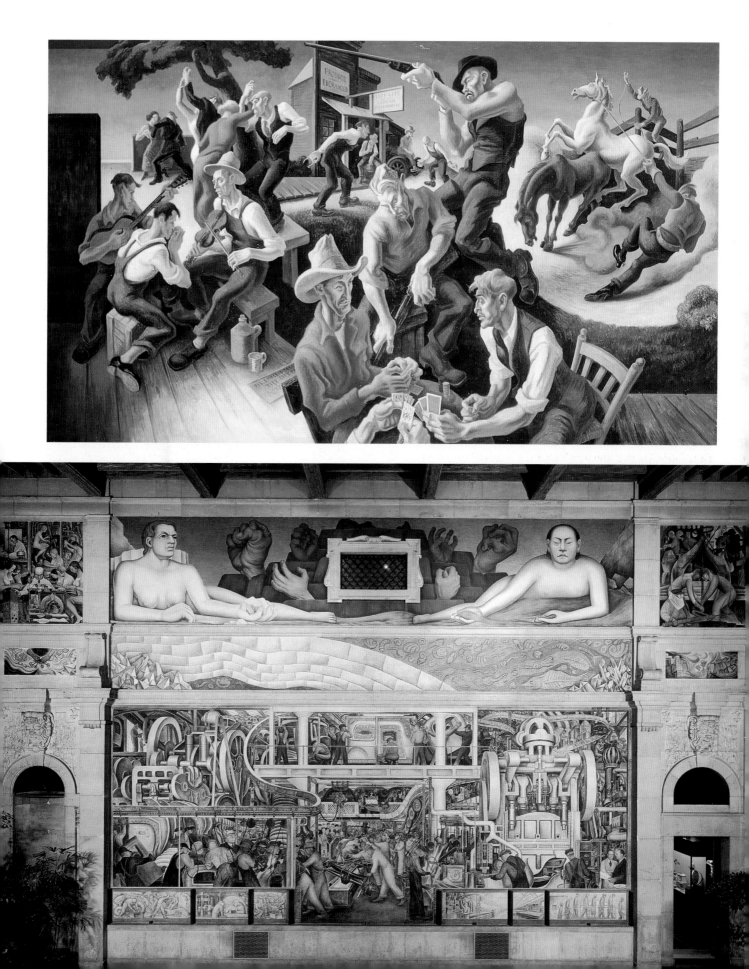

Duco paint and "Il Duce" (the popular epithet of the Italian Fascist, Mussolini). Politics was very much in the air, and Union Square, which took its name from the many labor union headquarters located around it, provided the perfect location for a leftist artist. During the thirties the area was electric with labor organizing and political rallies.

Of all the Mexican muralists, Rivera had the most powerful impact on the younger generation. In his *Detroit Industry* frescoes [fig. 2.8] he transformed the Ford Motor Company's Rouge River industrial complex into a symphony of the industrial future. Although he denied any connection to socialist realism, Rivera deliberately chose to work in a simplified, monumental style so as to educate the masses in the ideals of the leftist Utopia, and his mastery of figural composition on this public scale is unequalled in modern art.

Ben Shahn, in particular, knew and admired Rivera's work and actually worked as an assistant on Rivera's murals for Rockefeller Center. But Rivera's scale and his multi-layered content also profoundly influenced Pollock and other younger artists. Rivera's style brings together a rich matrix of historical and conceptual references: the spirituality of Renaissance frescoes, the idealism of classical proportions, a sense of the origins of his art in pre-Columbian civilization, shallow cubist space with its overtones of European modernism, constructivist compositional dynamism, and a Utopian enthusiasm for the machine age.

Nevertheless Rivera sought an indigenously "American" art (by which he meant Mexican) that was at the same time not provincial. In his autobiography he described himself as undergoing a kind of rebirth through native culture when he returned to Mexico from Paris in 1921.[3] In his *Detroit Industry* frescoes, and even more obviously in the City College of San Francisco fresco of 1939, Rivera conceived the great machines as modern transformations of ancient Indian gods; indeed one can find direct sources in Aztec statuary for some of Rivera's industrial images.[4] This transformation implies a sense of continuous and inevitable cultural evolution, which Rivera modelled on the Marxist view of history. It also suggests Rivera's sense of the rich and mysterious presence of ancient forces lingering behind the forms of the modern world.

Benton and his fellow regionalists, the Mexicans, and the social realists (like Ben Shahn) all sought idealistic transformations of society by programmatic appeals to the masses on an expansive public scale, using an easily legible style. They agreed on very little else than the imperative for social relevance and on their opposition to European modernism, whose rarefied language seemed to them elitist (though earlier in their careers all of them had immersed themselves in it). The denial of sensibility and retreat from cultivation (which was synonymous with Europe in the minds of most Americans) was also evident in such American writers of the period as Ernest Hemingway. His straightforward, journalistic style addressed "the common man," emphasizing fact and action over contemplation and sensitivity. He never coaxes the reader with adjectives and rejects sentimentality. Lieutenant Henry, his "hero" in *A Farewell to Arms*, says bluntly: " 'Yes,' I lied. 'I love you.' ... I knew I did not love Catherine Barkley nor had any idea of loving her. This was a game, like bridge, in which you said things instead of playing cards." And later: "I was made to eat. My God, yes. Eat and drink and sleep with Catherine."[5]

Similarly the painter Georgia O'Keeffe and the contemporary imagist poets Wallace Stevens and William Carlos Williams sought a kind of matter-of-fact objectivity in their work. Yet they also seem to have experienced a sense of romantic transport in the closely observed detail of nature and, unlike Benton, felt torn between their "Americanness" and their reverence for the subtlety and depth of European modernism. In 1923 Williams wrote a poem called "The Red Wheelbarrow," which exemplifies this attitude.

The Red Wheelbarrow
so much depends
upon
a red wheel
barrow
glazed with rain
water
beside the white
chickens[6]

The subject matter of the poem is reality. It simply tells you something, in a style that seems like prose. There is no rarefied language, no metaphor. Williams's poem is serious, involved with fact; it reports information from daily life. Neither the paintings of O'Keeffe nor this kind of poetry were anti-intellectual, they merely sought an indigenous American character in their simple facticity. Williams rejected ideology as antithetical to individuality; he admired originality, independent thought, and direct contact with the pulse of the United States. But he also recognized that it was the Europeans who had cast off tradition and brought art up to date with contemporary sensibilities.

The Depression and the Works Progress Administration (W.P.A.)

The stock-market crash of 1929 and the ensuing great Depression intensified the pressure for social relevance in art. George Biddle, who came from a patrician Philadelphia family, studied painting in Paris, and went through Groton and Harvard with F.D.R., wrote to Roosevelt on May 9, 1933:

The Mexican artists have produced the greatest national school of mural painting since the Italian Renaissance. Diego Rivera tells me that it was only possible because Obregon [president of Mexico, 1920–4] allowed Mexican artists to work at plumbers' wages in order to express on the walls of the government

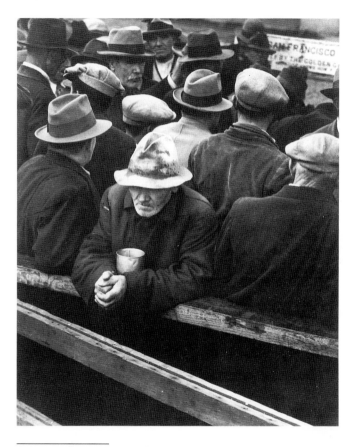

2.9 Dorothea Lange, *White Angel Breadline, San Francisco,* 1933.
Photograph.

Courtesy of the Dorothea Lange Collection, Oakland Museum. Gift of Paul S. Taylor.

2.10 Pablo Picasso, *Guernica,* May 1–June 4, 1937. Oil on canvas, 11ft 6in × 25ft 8in (3.5 × 7.82m).

Collection, Prado, Madrid. © 2000 Estate of Pablo Picasso/Artists Rights Society (ARS), New York.

buildings the social ideals of the Mexican Revolution. The younger artists of America are conscious as they have never been of the social revolution that our country and civilization are going through, and they would be eager to express these ideas in a permanent art form …[7]

This appeal was not viewed unsympathetically; F.D.R. had already had artists on the payroll while governor of New York. As the Depression deepened, the government stepped in with the Public Works of Art Project in 1934, commissioning murals (and distributing a booklet on Rivera's fresco technique to recipients of commissions). The Works Progress Administration (W.P.A.) began the Federal Art Project under Holger Cahill in 1935, expanding the types of commissions to easel painting, sculpture, and other media. In addition the Farm Security Administration commissioned an extensive photographic project, documenting the country's rural areas and workers as well as the plight of the urban poor [fig. 2.9].

The project produced hundreds of thousands of works, and by 1936 it employed around 6,000 artists, half to three-quarters of them living in New York. Although the stipend provided only enough to get by on (around $23 a week), government patronage offered artists dignity, a sense of value, and a place in American society. It also formed a real community of artists for the first time, especially in Greenwich Village in New York. Stuart Davis, Jackson Pollock, Willem de Kooning, Arshile Gorky, Lee Krasner, David Smith, and Mark Rothko—most of the key artists of the New York School—all worked on the project. Those whose income or employment status disqualified them felt like outcasts. Barnett Newman, who had a teaching job in the Depression, said, "I paid a severe price for not being on the Project with the other guys; in their eyes I wasn't a painter; I didn't have the label."[8]

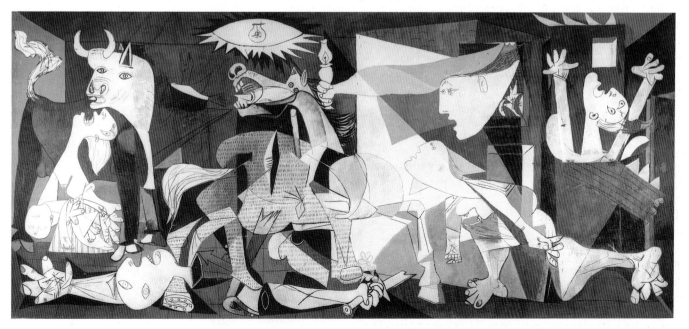

The Availability of European Modernism

Despite the wish among so many prominent figures on the interwar New York art scene to throw off the weight of European modernism, the opposite was also true and its presence grew dramatically in the thirties in New York. The founding of the Museum of Modern Art in 1929 made available magnificent works by Cézanne, Seurat, van Gogh, Gauguin, Toulouse-Lautrec, Picasso, Matisse, and Léger as well as special exhibitions of cubists, surrealists, abstract artists, and Bauhaus art and design. The Valentine Gallery, which had held particularly notable shows of Matisse and Brancusi in the twenties, exhibited Picasso's enormously influential painting *Guernica* [fig. 2.10] in 1939, after which the Museum of Modern Art kept it on display continuously for nearly forty years.

The New Art Circle gallery, founded by J. B. Neumann in 1923, was among the earliest but by no means the only place where young artists might see German expressionism—including works by Beckmann, Klee, and Kirchner. In addition the Gallatin Collection—with works by Cézanne, Seurat, the cubists, Mondrian, and such artists of the Russian avant-garde as Naum Gabo and El Lissitzky—went on loan to New York University in Washington Square; and although the Museum of Non-Objective Painting (later to become the Solomon R. Guggenheim Museum) did not open until 1939, Guggenheim regularly opened his definitive collection of Kandinsky's abstractions to young artists in his New York apartment from 1936 on.[9]

Picasso's *Guernica* had particular importance to younger painters because it combined a powerful political statement with the best European formal sophistication. The title refers to the little Basque town of Guernica, which the German *Luftwaffe*, under directions from the Spanish Nationalist General Franco, leveled in 1937, wiping out most of the defenseless civilian population. When the Republican Government of Spain (in the midst of civil war with Franco) commissioned Picasso to paint a work for its pavilion at the Paris *Exposition Universelle* of 1937, the artist responded with *Guernica*. The monumental scale and powerful expressionism of the work, and the use of a cubist vocabulary for a tragic theme, set an important precedent for American artists. Its influence can be seen in the use of a grand scale with a shallow cubist depth in the great drip paintings of Pollock, for example [figs. 4.1 and 4.5–4.10]; it underlies de Kooning's black paintings of the mid forties [fig. 3.43] and Motherwell's "Elegies" [figs. 3.33 and 3.34].

Meanwhile, European surrealism had already affected younger artists even before the arrival of the surrealists themselves. Some of it had been imported secondhand into America in the thirties by such painters as Peter Blume and

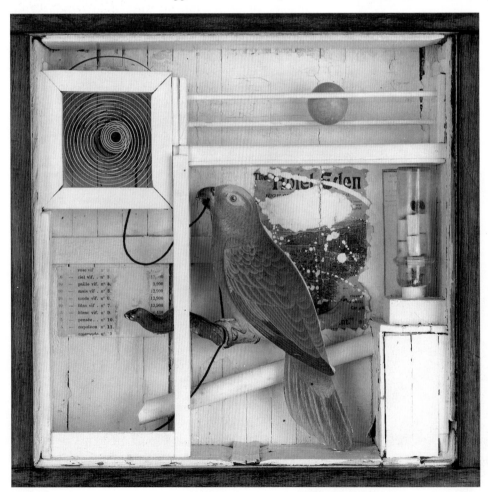

2.11 (left) **Joseph Cornell,** *Untitled (The Hotel Eden)*, 1945. Assemblage with music box, 15 × 15⅝ × 4¾in (38.1 × 39.7 × 12.1cm).
National Gallery of Canada, Ottawa. © The Joseph and Robert Cornell Memorial Foundation.

2.12 (opposite) **Jackson Pollock,** *Male and Female*, c. 1942. Oil on canvas, 6ft 1in × 4ft 1in (1.85 × 1.25m).
Collection, Philadelphia Museum of Art. Gift of Mr. and Mrs. H. Gates Lloyd. © 2000 Pollock-Krasner Foundation/Artists Rights Society (ARS), New York.

Louis Guglielmi, who had studied in Europe. The Julien Levy Gallery began exhibiting the European surrealists' work and publishing translations of their writings at the end of 1931, the Pierre Matisse Gallery showed Miró and Masson from 1935, and the Museum of Modern Art's important "Dada, Surrealism, and Fantastic Art" exhibition of 1936 made available a stunning array of their paintings, objects, and writings. In 1942 the "Artists in Exile" show at Pierre Matisse and Duchamp's "First Papers of Surrealism" show, staged in a former mansion in New York, celebrated the arrival of the artists themselves in New York.

The Americans Joseph Cornell and Arshile Gorky (to whom we will return in Chapter 3) both began showing at Julien Levy's gallery with the surrealists, and from his first collages of 1931 Cornell demonstrates the influence of surrealism—although, as he wrote in 1936 to Alfred Barr (the Director of the Museum of Modern Art who organized "Dada, Surrealism, and Fantastic Art"), "I do not share in the subconscious and dream theories of the surrealists."[10] Cornell told complex, mesmerizing stories with found objects and images, assembled in the self-contained magical worlds of his boxes. He found inspiration not only in the fantastic collages of Max Ernst, which he saw at the Julien Levy Gallery when it opened in 1931, but also in the souvenirs and old cards he saw in the shops around Times Square, in the constellations painted on the ceiling of Grand Central Station, and in any number of other common things that a less imaginative mind might overlook as ordinary.

In Cornell's *Untitled (The Hotel Eden)* [fig. 2.11], for example, the "Hotel Eden" seems to be a stopping place in a magical dream voyage, filled with exotic birds and strange scientific devices. He seems deliberately to suggest a tattered Paradise after the Fall, linking the work to other boxes which refer to punished lovers—Adam and Eve, Paul and Virginia (from the eponymous French novel, popular in the nineteenth century), Paolo and Francesca (from Dante). The swirling spiral in the upper left may refer to the *Rotary Demisphere* of Marcel Duchamp, whom Cornell befriended after Duchamp's return to New York in 1942. Cornell read widely, especially in French literature, and had a fascination with Hollywood stars. But externally he led an utterly simple life. He lived on Utopia Parkway in Queens with an invalid brother, his mother, and his grandfather. He largely supported all of them, taking routine jobs in the garment industry.

The Europeans in New York

When the Europeans finally arrived in person in New York, Marcel Duchamp and the surrealists held the limelight. They were self-confident and lived bohemian lifestyles, as if money never worried them (though many of them were exceedingly poor). They communicated a sense of conviction about the importance of art and of New York as the center; indeed *they* made it seem that wherever *they* were was *ipso facto* the center. Moreover, Breton and the other surrealists had a strong sense of belonging to a unified avant-garde that comprised artists outside surrealism as well. When Breton edited the first catalog for Peggy Guggenheim's Art of This Century gallery in 1942, he included texts and manifestoes by futurists, by Gabo and Pevsner, by Ben Nicholson, and Mondrian, in addition to those by surrealists (Ernst, Arp, and himself).

Breton was also the champion of a young Afro-Cuban painter named Wifredo Lam, who had come to Paris via Spain in 1937 at the age of 25. Picasso was taken with Lam and introduced him into artistic circles in Paris in the late thirties. This is where Lam befriended Breton, and after 1941, when Lam returned to Cuba, he remained in close touch with Breton. In Cuba in the forties, Lam fashioned a highly original, hybrid surrealism that melded traditions from his Afro-Carribean ancestry with both stylistic and theoretical aspects of French surrealism.

In *The Eternal Present* of 1945 [fig 2.13], for example, the *femme cheval* (woman-horse), of which there are three in this painting, is constituted through a partial metamorphosis from a woman into a horse, evident here especially in the heads. This transformation is quite surrealist in its genesis through unconscious association and dream-like mutation. But it also has a dynamic black spirituality with clear connections to the Afro-Cuban voodoo practices in which a woman, in a state of spiritual possession by the *orisha* (or saint), is said to be ridden by the *orisha* like a horse; the surrealist film maker Maya Deren actually documented a Haitian voodoo rite of this kind in *The Divine Horsemen* (1947–51). Breton's continuing links to Lam not only stand for the internationalist perspective that Breton and the other Europeans brought to the New York art scene in the early forties, but Lam's work and even the person of the artist himself (whose father was Chinese) also exemplify the rich mix of cultures in the New World that increasingly shaped the second half of the twentieth century and its art.

So, having the Europeans personally on the scene in New York was very different from just looking at works by them in a show or collection. The European moderns not only connected New York in a very vital way to a more international world, but they also provided a compelling new model of what an artist was. To the Europeans art and life were inseparable and they lived this heightened existence for twenty-four hours a day. In conversation with the younger Americans they also imparted their insight into the more subtle formal concerns of painting, thereby implicitly encouraging them to come up to the aesthetic level of European modernism. Associating with artists is a time-honored way for the young to learn not just the craft, but what it means to be an artist. The presence of the Parisian vanguard in New York finally gave young Americans an opportunity to see this firsthand, creating the fertile soil out of which the new American avant-garde grew.

The Europeans found life in New York quite different from that to which they were accustomed. Paris is a city of neighborhoods and the vitality of each neighborhood radiates from its cafés. Conversation over a two-hour cup of

2.13 Wilfredo Lam, *The Eternal Present,* 1945. Mixed media on jute, 85 × 77½ in (215.9 × 196.9 cm).
Museum of Art, Rhode Island School of Design. Nancy Day Fund. © 2000 ARS, NY/ADAGP.

2.14 William Baziotes, *Green Form,* 1945–6. Oil on canvas, 3ft 4in × 4ft (1.02 × 1.22m).
Collection, Whitney Museum of American Art, New York. Gift of Mr. and Mrs. Samuel M. Kootz and exchange. Photograph by Geoffrey Clements, New York.

coffee was an indispensable ingredient of Parisian intellectual life. The members of Parisian art movements had always frequented particular haunts in Paris; and for the surrealists it was above all the Café Cyrano near Pigalle, at which they would run into one another almost daily and engage in protracted discussions. Any young artist interested in surrealism could simply drop by and attach her- or himself to the group. New York had no such tradition: the pace of life was too fast and the city too populous to make a café society possible. In addition the artists had to scatter to find housing quickly when they arrived, which effectively meant that no one neighborhood could be identified with a particular movement, although Greenwich Village would become a focus for the New York School.

The young Museum of Modern Art opened its doors to the surrealists, and to some extent the Julien Levy and Pierre Matisse galleries helped compensate for the loss

of the established Paris meeting places. But the most important gathering spot was the private gallery of Peggy Guggenheim, called Art of This Century. In 1942 alone she showed work by Arp, Ernst, Miró, Masson, Tanguy, Magritte, Dali, Brauner, and Giacometti. But the Art of This Century also gave one-man exhibitions to the Americans Jackson Pollock [fig. 2.12], Hans Hofmann, Mark Rothko, Clyfford Still, William Baziotes [fig. 2.14], and Robert Motherwell [fig. 2.15]. In addition there was by then a tradition of American "little magazines" that were actively publishing vanguard art, and the surrealists started up some of their own. *View* and *VVV* were particularly significant. The first issue of *View* came out in September 1942 under the editorship of Charles Henri Ford. At first it was mostly literary in character, but by 1944 it provided an important forum for visual artists. *VVV*—though it only lasted for three issues—first appeared in June 1942 and was edited by a young American sculptor named David Hare. The editorial staff of *VVV* included André Breton, Max Ernst, Marcel Duchamp, Claude Lévi-Strauss, André Breton, and the Americans Robert Motherwell, Harold Rosenberg, Lionel Abel, and William Carlos Williams. Through such collaborations in the galleries and journals, the presence of the European moderns soon flowered into a close liaison with the Americans.

The Sense of a New Movement in New York

By 1943 talk of the emergence of a new movement had already begun to spread in the New York art world. In the spring of 1945 the Art of This Century gallery mounted a show called "A Problem for Critics," challenging the art press to identify this new "movement." The show included works

by the abstract surrealists Hans Arp, André Masson, and Joan Miró, as well as by the Americans Hans Hofmann, Jackson Pollock, Arshile Gorky, Adolph Gottlieb [fig. 2.1], and Mark Rothko. Between 1942 and 1950, the Americans in that show—together with others, of whom the most important

2.15 Robert Motherwell, *Pancho Villa, Dead and Alive,* 1943.
Gouache and oil with cut-and-pasted paper on cardboard,
28 × 35⅞in (71.1 × 91.1cm).
The Museum of Modern Art, New York. Purchase. © Estate of Robert Motherwell/VAGA, New York, 1994.

were Willem de Kooning, Robert Motherwell, Barnett Newman, Clyfford Still, and David Smith—produced a body of work which placed American art at the forefront of the international avant-garde for the first time. As a group (which they never were in any systematic sense) these American artists came to be known as "abstract expressionists" or, as the artists themselves preferred, "the New York School."

Commonalities and Differences Among the Artists of the New York School

Art historians had begun using the term "abstract expressionism" at the end of World War I to refer to

Kandinsky and other Europeans who painted abstractly with expressionist brushwork. In a 1946 review for the *New Yorker*, Robert Coates applied the term for the first time to the work of an American artist of the forties when he described the paintings of Hans Hofmann as "abstract Expressionist."[11] He capitalized the E to indicate that he regarded Hofmann's work as a type of "Expressionism" in the tradition of Kandinsky, which is precisely how Hofmann had been describing himself for some time. Ironically Hofmann, of the major New York School artists, had the least in common with the rest. In addition to the difference in age and background, he continued to be preoccupied with the formal principles of European modernism over and above any conscious concern with an introspective subject matter.

Except for Hofmann, who was fifty when he left Germany and sixty-five by the mid forties, the artists of the New York School faced many of the same formative cultural, philosophical, and aesthetic issues. These included: the imperative of social relevance; existentialism; the surrealists'

ROMANTICISM resists rigorous definition but deserves an attempt here since it will come up again. It is a personality trait that transcends culture and time, although the paradigmatic examples are artists and writers of the late eighteenth and early nineteenth centuries, such as the English painter Turner and the poets Coleridge and Wordsworth. The romantic disposition favors the dynamic, the disordered, the continuous, the soft-focused, the inner, the sensate world. The concept generally involves a faith in progress and change, the subversion of institutions, and an emphasis on the inspired individual in some special contact with nature. The romantic is "too much of words and sensations to be a mystic yet he yearns for the transcendental and universal."[12]

interest in the unconscious mind leavened by an American matter-of-factness; the Mexican influence; and the formal vocabulary of European modernism—especially Kandinsky's abstract expressionism of 1910 to 1914, Mondrian, Picasso's *Guernica*, interwar cubism, and abstract surrealism. From cubism they took the shallow picture space and the concern with the picture plane. The biomorphic forms and automatist elements came from surrealism and Picasso's work of the thirties. Early Kandinsky [fig. 3.19] inspired some of the freedom of brushwork and the painterliness, and his moral tone fueled the ethical seriousness of purpose. To these American artists of the forties Kandinsky represented romantic emotionalism and spontaneity, as opposed to Mondrian, who stood for strict planning, the denial of personality, and intellect.

Although each of the New York School artists responded differently to these sources, they were at roughly the same stage of personal development in a particular time (the forties) and place (New York). Except for Hofmann, they were all students in their twenties and early thirties when Benton and the Mexicans were prominent in New York. As young men and women, many of them worked on the W.P.A.—Gorky, Pollock, Lee Krasner [fig. 2.16], Willem de Kooning, Rothko, Gottlieb, Guston, and David Smith all did; but Motherwell, Hofmann, Kline, Still, and Newman did not. Moreover, between 1942 and 1949 all the major artists of the New York School except Hofmann transcended their early influences to achieve a distinctive personal style,

and all placed paramount emphasis on content or meaningful subject matter in their art, which was predominantly abstract (except for that of de Kooning and Gorky). They took this stance in opposition to the widespread practice of what they regarded as a banal formalist abstraction dominated by the American followers of Mondrian such as Ilya Bolotowsky and Burgoyne Diller [fig. 2.17]. In addition they all believed in the absolute individuality of the artist, for which reason they unanimously denied the idea that they coalesced into a movement. Indeed all but Hofmann objected to the term "abstract expressionism," which, they felt, linked them to the expressionist and abstract artists of preceding generations; by contrast they saw their work as arising out of unique acts of individual introspection.

The artists in this circle also had a general interest in myth as a source for the universals of the human psyche. They looked to ancient Greek literature as well as to "primitive" cultures for a more authentic connection with the underlying forces of nature, especially human nature, than contemporary Western society seemed to provide. Around 1940 Pollock and Rothko in particular had begun reading the theories of the psychoanalyst Carl Jung, who postulated "archetypes" in the individual unconscious which belonged to a "collective unconscious," connecting all of humankind. These archetypes, he thought, manifested themselves in myth. Pollock had undergone some Jungian therapy, and in general the writings of both Jung and Freud were a major topic of discussion among educated people in the forties and fifties. Myths of

2.16 Lee Krasner, *White Squares*, c.1948. Oil on canvas, 24 × 30in (61 × 76.2cm).

Collection, Whitney Museum of American Art, New York. Gift of Mr. and Mrs. B. H. Friedman. Photograph by Geoffrey Clements, New York. © 2000 Pollock-Krasner Foundation/Artists Rights Society (ARS), New York.

rebirth and renewal had a particularly keen attraction for the artists of the New York School as a metaphor for their increasingly spontaneous methods of painting.

Yet for all that they had in common, the central figures of the New York School had important philosophical differences too. Hofmann, for example, disliked surrealism and shunned the psychological orientation of most of the others. Gorky centered his aesthetic on a hidden but predefined subject matter (in the manner of Kandinsky), which he transformed through psychic metamorphosis (using surrealist automatism). This procedure was directly at odds with the premises of his friends de Kooning and Pollock, who used painting as an act of discovery rather than representation (which such predetermination implies). Motherwell's persistent sense of formal continuity with French modernism, especially Matisse, set him apart from the others, and only de Kooning centered his attention for most of his career on the human figure. Smith's formal relation to surrealist style remained close through the forties, but like Hofmann he concerned himself less with psychological introspection than the others. And Newman's automatist doodles in the early forties rapidly grew so involved with metaphysics that exploring the individual unconscious seemed at best tangential, especially after 1946.

Harold Rosenberg (who was as much a part of the group as any of the artists) once remarked that the only thing on which these artists could all agree was that there was nothing on which they could agree,[13] and in hindsight the differences in their styles and theories of art seem as pronounced as the similarities. In a broad sense their radical individuality stood in opposition to the emergence of mass culture, which Rosenberg discussed in a 1948 essay entitled "The Herd of Independent Minds." He wrote:

> … *exactly in so far as he touches the common situation of man in the twentieth century, Kafka goes against the common experience; he undermines the self-confidence of official high culture, which rests on a system of assumptions which are as "false to reality" as the formulas of behavior in a best seller; and for this reassuring common experience he substitutes only the tension of an individual struggling for self-knowledge, a cloudy and painful seeing and not-seeing. Along this rocky road to the actual it is only possible to go Indian file, one at a time, so that "art" means "breaking up the crowd"—not "reflecting" its experience.*[14]

Automatism and Action in the Art of the New York School

Automatism seemed to be the ideal device for artists so concerned with radical individualism. The artists of the New York School viewed it as a technique for generating form that did not impose style. In the beginning Pollock, Motherwell, Rothko, and Gottlieb used automatism to create forms which they would develop through free association as the abstract surrealists Matta, Miró, and Masson had done. Then in the mid forties Pollock, and increasingly Motherwell

too, departed from the surrealist concept by using automatism as a device for objectifying an intense *conscious* experience as it was unfolding, rather than as a means of bringing forth unconscious material for association or of using unconscious thought processes to modify imagery.

Rothko abandoned automatism entirely as he entered his mature style in the late forties; and it remained only in a more limited role in Gottlieb's work. In Gorky's mature work (from 1944) he was selecting his subject matter in a deliberate classical fashion, using automatism only to camouflage and enrich the images. Hofmann, Kline, and de Kooning had never picked up on the surrealist technique, although the spontaneity of their improvisations resembled the gestural freedom which Pollock and Motherwell gleaned from automatism in the later forties. In the mid forties the artists of the New York School gradually stopped evoking classical myths (to which both surrealist artists and the existentialist writers made frequent recourse) and they looked beyond surrealism toward a subject matter of even more immediate and personal introspection. To the extent that the artists of the New York School reached universals of the human psyche they did so as a by-product of the search for self.

Where the surrealists attempted to disorient the viewer and provoke unconscious revelations, for which they sought parallels in the myths of antiquity, the artists of the New York School turned away from the viewer altogether and wiped out the surrealists' theatrical distance. Increasingly Pollock, Motherwell, and by the end of the forties Smith viewed automatism simply as a more direct means of conveying the subjective experience itself. For them content was intrinsic to the act of painting (or welding steel forms together, in the case of Smith) in that the process unearthed a vein of intensely felt experience on which the artist deliberated in paint. The encounter was never oriented either to past sources (psychological or art historical) nor to an anticipated future; the artist lived the painting entirely in the present, and the object was left over as an artifact of that event.

In this sense a painting by Pollock, de Kooning, or Kline embodied a spontaneous act of origination that aspired to an ideal state of defining the style of the painting, the identity of the artist, and even art itself, in the process of painting. These artists turned the conceptual enactment into an object. They sought an embodiment of the individual's act of making order out of chaos, but not the order itself, as Mondrian had. They conceived each work as an uncompleted thought, still in process, and their canvases engaged the immediacy of the present with such directness and spontaneity that today, half a century later, they look as if the paint is still wet.

In 1952 Harold Rosenberg coined the term "action painting," modelled on his intimate knowledge of de Kooning's working process. His essay, "The American Action Painters,"[15] brought into focus the paramount concern of de Kooning, Pollock, and Kline in particular (though Rosenberg did not single them out by name), with the act of painting. Lee Krasner [fig. 2.16], Elaine de Kooning, and other

2.17 Burgoyne Diller,
Third Theme, 1946–8. Oil on canvas,
3ft 6in × 3ft 6in (1.07 × 1.07m).

Collection, Whitney Museum of American Art, New York. Gift of May Walter. Photograph by Geoffrey Clements, New York. © Estate of Burgoyne Diller/VAGA, New York. Represented by the Michael Rosenfeld Gallery.

remarkable women at the time also shared these aspirations in their work but, as Ann Gibson has pointed out, "they were not *seen.*"[16] The social hierarchy of the forties and fifties, even in the art world, simply wasn't open to the full participation of women or ethnic minorities. This began to change only at the end of the sixties. Nevertheless, for some of these women of the New York School, as for the action painters, the canvas was not a representation but an extension of the mind itself, in which the artist thought by changing the surface with his or her brush. Rosenberg saw the artist's task as a heroic exploration of the most profound issues of personal identity and experience in relation to the large questions of the human condition.

The model of Greek tragedy was often raised as a metaphor for this heroic feat of introspection, although it was important as a conscious prototype only for Newman, Motherwell, and the early Rothko among the major artists of the New York School. Like the tragedy of Oedipus, which unfolds as the protagonist lives through each episode, what the painter's actions reveal about him or herself takes

the artist by surprise. Rather than dominating events with a preordained scheme, the action painter throws him or herself in with them and the art theory emerges only in hindsight. In 1939 Breton wrote a widely discussed article for the last issue of the French surrealist magazine *Minotaure* called "The Prestige of André Masson." In it he discussed "risk" and portrayed art as an "event," the significance of which derives not from its quality as a finished object but from its power of revelation. He too had in mind the model of classical tragedy as well as contemporary existentialism, and this essay no doubt influenced Rosenberg's idea of action painting.

Action and Existentialism

The Depression and the W.P.A., the Spanish Civil War, and World War II gave rise to political activism and a mentality of action. Pollock, de Kooning, and others in their circle sought to express this with a style in which the artist defined art in the act of making it. No part of the process in an

action painting is purely technical; everything is a meaningful gesture inseparable from the artist's biography, according to Rosenberg. Likewise, in the writings of Jean-Paul Sartre, action was the means of knowing oneself in relation to the world.

In an essay of 1944 Sartre (the leading postwar existentialist) explained: "In a word, man must create his own essence; it is in throwing himself into the world, in suffering it, in struggling with it, that—little by little—he defines himself."[17] In his fiction Sartre wrote about situations rather than characters, as in *The Wall* (a classic short story of 1939) where a confrontation with death causes the characters to reexperience everything as if new. The dull terror of the absurd in the novels and short stories of Franz Kafka also created an existential dilemma for his characters that demanded a fundamental rethinking of experience. This sense of starting from scratch with only immediate experience parallels the commitment of the New York School artists to the unpremeditated act of painting.

Like abstract expressionism, existentialism was also a non-movement. The major exponents of existentialism—Søren Kierkegaard, Fyodor Dostoyevsky, Friedrich Nietzsche, Rainer Maria Rilke, Franz Kafka, Martin Heidegger, Karl Jaspers, and Jean-Paul Sartre—were so concerned with individuality and the uniqueness of subjective experience that all of them (except Sartre) rejected the term as well as the idea that they belonged to any school of thought. Kierkegaard, who deliberately avoided systematic argument in his writings, asserted that

"the individual" is the category through which, in a religious respect, this age, all history, the human race as a whole must pass. And he who stood at Thermopylae was not so secure in his position as I who stood in defence of this narrow defile, "the individual," … through which, however, no one can pass except by becoming the individual.[18]

In *Notes from the Underground* Dostoyevsky put forward individuality, no matter how perverse or tormented, as the highest good; Nietzsche wrote: "No one can construct for you the bridge upon which precisely you must cross the stream of life, no one but you yourself alone."[19]

The existentialists rejected systems of belief and they shared a dissatisfaction with traditional philosophy as being shallow, academic, and, worst of all, remote from the immediacy of life. Jaspers, who disliked all doctrines, thought that genuine philosophy must well up from inside a man's individual existence. He regarded reason as subphilosophic and declared that philosophy begins only where reason fails. Heidegger insisted on going back to the pre-Socratics[20] because he personally believed that Latin mistranslations of Greek thinkers had vitiated all subsequent philosophy. This was an expression of Heidegger's sense of urgency about starting over from one's own immediate experience, for an authenticity in philosophical thought that parallels the new world consciousness of the artists of the New York School.

From the point of view of postwar American art,

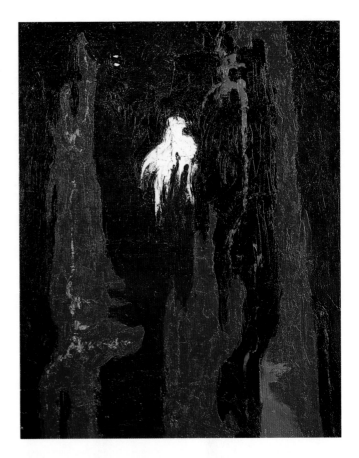

2.18 (above) **Clyfford Still,** *Untitled,* 1945. Oil on canvas, 42⅜ × 33⅝in (108 × 85.7cm).
Collection, Whitney Museum of American Art, New York. Gift of Mr. and Mrs. B. H. Friedman. 69.3. Photograph by Geoffrey Clements, New York.

2.19 (opposite) **Franz Kline,** *Untitled,* 1948. Oil and collage on paperboard mounted on wood, 28⅛ × 22¼in (71.4 × 56.5cm).
Collection, Hirshhorn Museum and Sculpture Garden, Smithsonian Institution, Washington, D.C. Gift of the Joseph H. Hirshhorn Foundation, 1966. Photograph by Lee Stalsworth. © 2000 The Franz Kline Estate/Artists Rights Society (ARS), New York.

existentialism had its most significant influence from 1945 and 1946, when the works of Kafka, Sartre, and then Heidegger began to appear in English. Kierkegaard, Dostoyevsky, and Nietzsche were all available in translation earlier and had already had an enormous effect on modern art and thought. Sartre's preoccupation with dread, failure, and death, his focus on anxiety and ambiguity, and most of all his search for a direct and spontaneous encounter with oneself characterized all the existentialist writers. A person first exists, in Sartre's view, then one encounters oneself, and only then does one define oneself. As if embarking from precisely this position on behalf of the action painters, Harold Rosenberg asserted in 1947 that each artist "is fatally aware that only what he constructs himself will ever be real to him."[21] Similarly Motherwell described the abstract expressionist's "response to modern life" in 1951 as "… rebellious, individualistic, unconventional, sensitive,

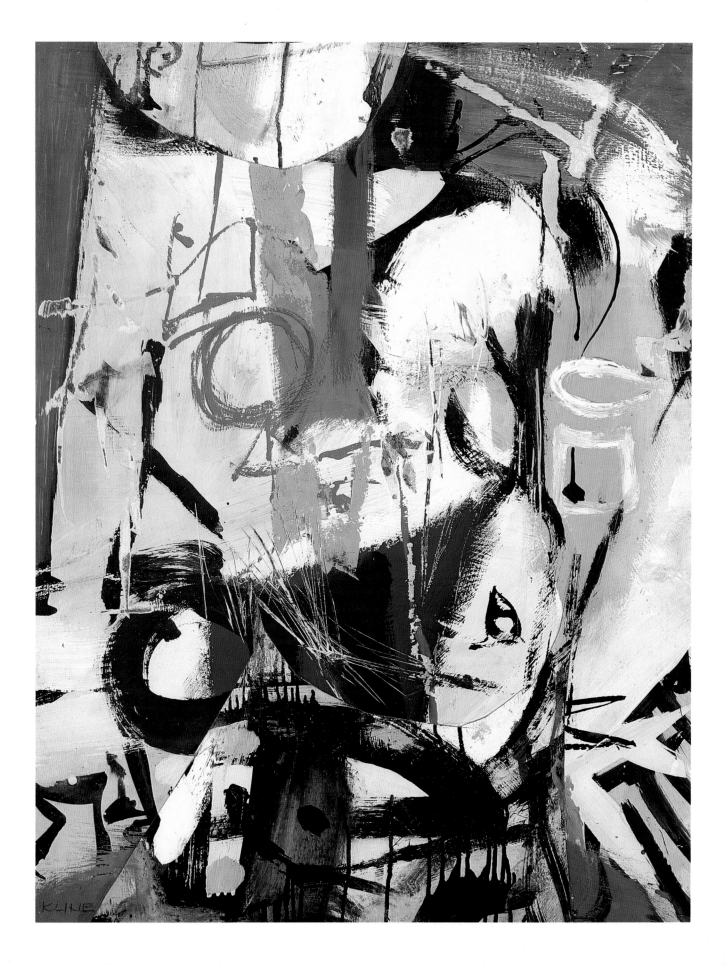

irritable … this attitude arose from a feeling of being ill at ease in the universe … The need is for felt experience."[22]

Clyfford Still

No artist embodied Motherwell's characterization more dramatically than Clyfford Still. Still was a testy, paranoid character, who believed that he would change the world with his paintings; if someone made one false step in confirming this, the relationship with Still was precipitously and irrevocably over. Blunt pronouncements like painting is "a matter of conscience," and "any fool can put color on canvas,"[23] conveyed the impression that he saw himself as the anointed prophet of painting and that his model was John Brown, not Christ. "He used terror tactics," Motherwell recalled. For example, "in his Jaguar (he had a passion for cars) Still had driven out from California; he wanted a painting back from Ossorio [a minor New York School painter and patron] and Ossorio had said no. Still drove out to East Hampton when Ossorio wasn't home; a servant let him in. He went into the house and cut a big piece out of the center of the picture with a razor, rolled it up and left."[24]

By 1945, when he came back to New York, Still was painting what seemed like cross-sections of geological strata with jagged peaks cracking through stratifications of color above them on a vertical plane [fig. 2.18]. These forms derived from Still's expressionistic figures of the thirties and retain an obscure sense of human presence without, however, being representational in even the most indirect sense. The compositions defy symmetry and even seem to deny the limits of the canvas, thus evoking a sense of boundlessness and primary force. In 1951 Rothko said, "Still expresses the tragic-religious drama which is generic to all myths at all times, no matter where they occur … For me, Still's pictorial dramas are all an extension of the Greek *Persephone* myth. As he himself has expressed it, his paintings are 'of the Earth, the Damned, and of the Recreated.'"[25]

In describing the experience of painting, Still portrayed himself as if possessed and spiritually transported: "A great free joy surges through me when I work," he wrote. "And as the blues or reds or blacks leap and quiver in their tenuous ambience or rise in austere thrusts to carry their power infinitely beyond the bounds of the limiting field, I move with them and find a resurrection from the moribund oppressions that held me only hours ago."[26] In Still's mature painting the complete absorption of the figurative elements provides a metaphor for the fusion of self and nature. This fusion amplifies the image of the artist as a microcosm of nature through which cosmic forces surge and it is doubtless influenced by the shamanism of the Indians from Still's native region, the Pacific northwest.

Adolph Gottlieb

Adolph Gottlieb began painting his pictographs [fig. 2.1] around 1941. In stressing the importance of content, he set himself apart from the pervasive formalist abstraction of the time. In 1943 Gottlieb and Rothko collaborated on a letter

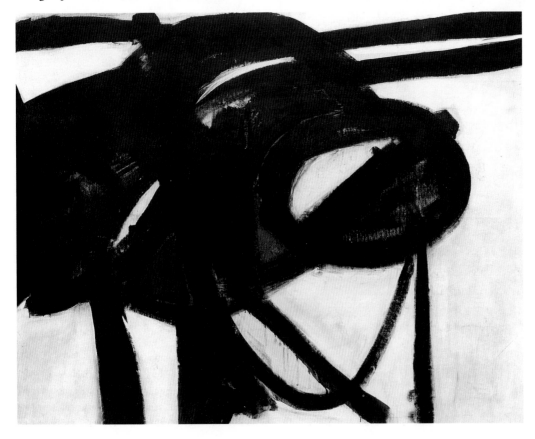

2.20 Franz Kline, *Chief,* 1950. Oil on canvas, 4ft 10¾in × 6ft 1½in (1.48 × 1.86m). The Museum of Modern Art, New York. Gift of Mr. and Mrs. David M. Solinger. © 2000 The Franz Kline Estate/Artists Rights Society (ARS), New York..

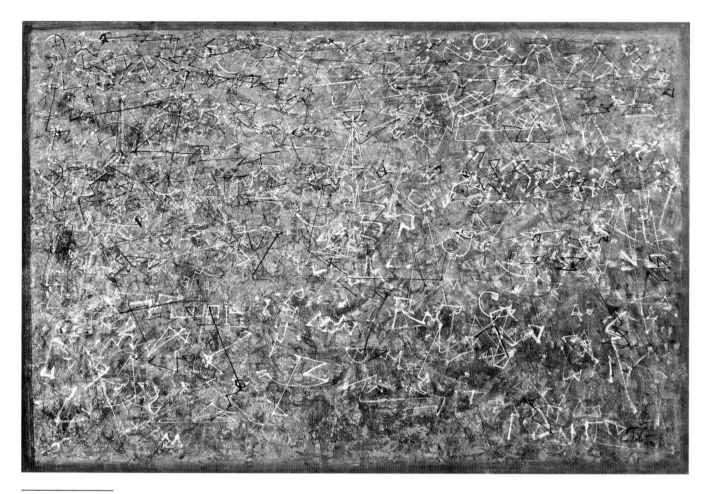

2.21 Mark Tobey, *Universal Field,* 1949. Tempera and pastel on cardboard, 28 × 44in (71.1 × 111cm).

Collection, Whitney Museum of American Art, New York. Purchase. © 2000 Artists Rights Society (ARS), New York/Pro Litteris, Zürich.

to the *New York Times* in which they proclaimed: "There's no such thing as good painting about nothing."[27] The idea of creating free-associative episodes in boxes came from the sequential narrative frames in early Italian Renaissance paintings. From a compositional point of view this allowed an isolation and simultaneity of symbols that paralleled the multiplicity of levels in the unconscious mind, and as a formal device made it possible to use automatism freely while at the same time maintaining control over the pictorial structure.

Franz Kline

Franz Kline [figs. 2.19 and 2.20] came to action painting in 1948 from an expressionist style of figure painting, without working through the cubist and surrealist stages from which so many of the other New York School artists evolved. Kline grew up in northeastern Pennsylvania and his stepfather was a railroad foreman. Particular trains—like the "Chief"—as well as locations that Kline loved in the landscape of the Lehigh Valley recur persistently in the titles of many of his later paintings. As a boy he enjoyed watching

the trains speeding by, and he later captured that sense of velocity and mass in motion in the brushwork of his paintings. Typically Kline started his paintings by first setting down the movement with fast gestural strokes in black and then cutting back the black with white, modifying and clarifying the idea. The paintings concern weight and movement rather than contours or forms.

Elaine de Kooning (a friend since 1943) recalled that around 1948 Kline enlarged some of his quick brush sketches in an opaque projector and "a four by five inch brush drawing of the rocking chair ... loomed in gigantic black strokes which eradicated any image, the strokes expanding as entities in themselves, unrelated to any reality but that of their own existence ... From that day, Franz Kline's style of painting changed completely."[28] Kline's powerful gestures, characteristically black on white and huge in scale, are a kind of grand manifesto of the New York School's emphasis on the direct expression of personality.

Friends In and Around the New York School

The artists of the New York School met informally, but frequently, in certain bars (like the Cedar Tavern just above Washington Square), in automats and cafeterias, or in studios around Greenwich Village. The critics Clement Greenberg, Harold Rosenberg, and Thomas Hess, as well as

2.22 Isamu Noguchi, *Kouros*, 1944–5. Pink Georgia marble, on slate base, 117 × 34⅛ × 42in (297.2 × 86.6 × 106.7cm).

Collection, Metropolitan Museum of Art, New York, Fletcher Fund.

the art historian Meyer Schapiro, were an integral part of this crowd. Greenberg—writing chiefly for the *Nation* and *Partisan Review*—liked Hofmann's "laws" and attacked surrealism for reversing the anti-pictorial trend of cubism and abstract art. He criticized Mondrian's *Broadway Boogie Woogie* as wavering and awkward and denounced Kandinsky for his non-cubist picture space. Writing in the *Nation* in 1944, he admonished: "The extreme eclecticism now prevailing in art is unhealthy and it should be counteracted, even at the risk of dogmatism and intolerance."[29] Though he seemed to want everyone to march in step, he often demonstrated a keen eye for formal quality.

Rosenberg came from a literary background and loved to defend intellectual values deep into the night. Like the existentialists he championed individuality and the unexpected and he felt genuine sympathy with the creative struggle of artists. Instead of laying down the law to artists, as Greenberg increasingly tried to do, Rosenberg, more than any other writer, entered into a dialog with them. By identifying closely with their work, Rosenberg successfully extended the issues they raised pictorially into the realm of words and at times caustically took them to task when he found their ideas ethically questionable or intellectually shallow.

Both Rosenberg and Greenberg had their own creative agendas as writers, and neither can be taken as a spokesman for the artists' intentions. Hess provided a more objective account of the artists but probably influenced them and the scene less as a result. Schapiro's great contribution was as a teacher and friend whose eye the artists respected. Schapiro's lectures at Columbia, as Motherwell had pointed out,[30] made art seem important and worthy of serious thought; as a friend, he talked with artists in their studios about their work and often introduced them to new ideas as well as to one another.

There was also much abstraction on the New York scene in the thirties and forties that had nothing to do with the motives behind the New York School, even though many artists had personal ties which crossed these boundaries. Burgoyne Diller [fig. 2.17], for example, took his inspiration from a formalistic reading of Mondrian and of the Parisian *Abstraction–Création* group; yet in the early forties he was an important friend to Jackson Pollock. The classes of Hans Hofmann also turned out many formalistic abstract painters—indeed the hard core of geometric abstraction was a group founded in 1936 and called "The American Abstract Artists," more than half of whose organizers were former pupils of Hofmann's. Ad Reinhardt [fig. 6.13], who became a prophet of the sixties minimalists, was perhaps the most articulate and interesting member of this group.

Mark Tobey [fig. 2.21], who founded his abstract style on Zen Buddhism, had lived primarily in Seattle and Europe rather than New York. He was nevertheless a contemporary of the artists of the New York School and showed at the Willard Gallery alongside David Smith. Like them he reacted against the materialism of the burgeoning

2.23 Isamu Noguchi,
Water Garden, 1963. Black
river stone, granite paving.
Chase Manhattan Bank Plaza, New
York. Photograph courtesy Chase
Archives, New York.

mass culture of the late forties. "We have occupied ourselves too much with the outer, the objective," he said, "at the expense of the inner world."[30] Born in 1890 Tobey traveled to the Far East in the thirties where he studied Zen calligraphy in a Japanese monastery. During the forties he developed his so-called "white writing" and acquired a major international reputation.

The contemplative sculpture of Isamu Noguchi [fig. 2.22] also owes more to Zen than to psychological introspection, but the style has an evident debt to the biomorphism of Arp. Noguchi went to Paris for two years on a Guggenheim Fellowship in 1927, worked briefly as a studio assistant to Brancusi, and befriended Alexander Calder. Noguchi was born in Los Angeles in 1904, but spent much of his childhood in Japan. His aesthetic reflects a Japanese feeling for natural materials and spaces, which Brancusi also fostered. One of Noguchi's greatest gifts was in the design of spaces, particularly the dance stage and small sculpturally landscaped gardens [fig. 2.23] and playgrounds, where his sensitivity to subtle changes of form and material plays an important role. He did his first dance sets for the Martha Graham dance company in 1935; his ideas for outdoor parks began in the mid thirties and reflected the influence of Japanese garden design.

By the fifties the New York School was widely recognized as the leading edge of the international avant-garde and many younger artists adopted its stylistic grammar. But the starting-point of these second-generation artists tended to be an appreciation of the painterly quality of the abstract-expressionist brushstroke rather than existential motives of the sort that prompted the work of the artists of the New York School. In this sense the true heirs of the New York School were not the gestural painters of the fifties but the writers of the "beat" generation and the funk assemblagists (see Chapter 7), who metamorphosed the New York School's romantic imagery of the alienated genius into the militant social pariah, as exemplified by Allen Ginsberg, Jack Kerouac, and Norman Mailer. By 1960 other movements with their own radical ideas had emerged, and the New York School had turned into a disparate handful of old masters. Nevertheless David Smith made some of his most innovative work between 1960 and 1965, and the late styles of Guston, de Kooning, and Motherwell went on to break important new ground in the sixties and seventies.

3

A DIALOG WITH EUROPE

Alexander Calder

Alexander Calder showed none of the introspective focus of such artists as Pollock or Motherwell; but like them he successfully assimilated the momentum and subtlety of the interwar European vanguard into an American style. Calder had a playful openness, at once naive and self-confident, curious and filled with a lively sense of wonder about the world. His work is optimistic, gregarious, witty, irreverent, sometimes even bawdy. Indeed a wry, Yankee sense of humor, in the tradition of Mark Twain, characterized both Calder's personality and his work. In his *Autobiography*, for example, Calder told the story of a birthday party organized by his dealer Curt Valentin, for which,

I think Alfred Barr of the Museum of Modern Art was to supply the cake and I was requested to design a candle for it. I took two plumber's candles for the legs and one for the torso; the shoulders and arms were made by a fourth candle, and the head was the butt end of a burnt plumber's candle. The penis I made with a stump of an ordinary red candle. All the wicks were carved clean so they could be lit, and when we proceeded to do this the revelation was disastrous. Apparently, red wax burns the quickest.[1]

Calder's Early Life and Themes

Alexander Stirling Calder was born outside Philadelphia in 1898. His grandfather (Alexander Milne Calder) and his father (also named Alexander Stirling Calder) were successful sculptors of public monuments and his mother was a painter. Calder's parents had relatively little money but they seem to have managed well with what they had. At the age of six, however, the young Calder and his eight-year-old sister had to be left with friends for a year when his father was diagnosed with tuberculosis and went, along with Calder's mother, to a health ranch in Arizona. The family reunited on the ranch in the summer of 1906, and in the fall they all moved to Pasadena, California, where the climate seemed better for his father's health. In his *Autobiography* Calder dated his earliest interest in the planets and stars—which became especially important to the iconography of his mobiles—from evenings spent gazing up at the night sky with his parents on that ranch in Arizona at the time of the family's reunion.

Childhood memories set many themes for Calder's later art. Vivid recollections of trains, the San Francisco cable cars, and toys have echoes in his later sculpture [fig. 3.2]. Pasadena's Tournament of Roses, which he attended frequently between the ages of six and twelve, climaxed with a chariot race, just like the *Circus* he later created in Paris [fig. 3.3]. Even the wire jewelry which Calder made throughout his career began in his youth as a collaboration with his sister to adorn her dolls.

From the age of seven, Calder already displayed the unusual inventiveness with tools and found materials that

3.1 (opposite) **Alexander Calder,** *Performing Seal,* 1950. Painted sheet metal and steel wire, 33 × 23 × 36in (83.8 × 58.4 × 91.4cm).

Museum of Contemporary Art, Chicago. Promised gift of the Ruth and Leonard J. Horwich Family, PG92.6 © 2000 Estate of Alexander Calder/Artists Rights Society (ARS), New York.

3.2 Alexander Calder, *Only, Only Bird,* 1952. Tin cans and wire, 11 × 17 × 39in (27.9 × 43.2 × 99cm).
Phillips Collection, Washington, D.C. © 2000 Estate of Alexander Calder/Artists Rights Society (ARS), New York.

3.3 (below) **Alexander Calder,** performing his *Circus* in Paris, c. 1926–30. Photograph by André Kertész.
© 1994 Estate of André Kertész.

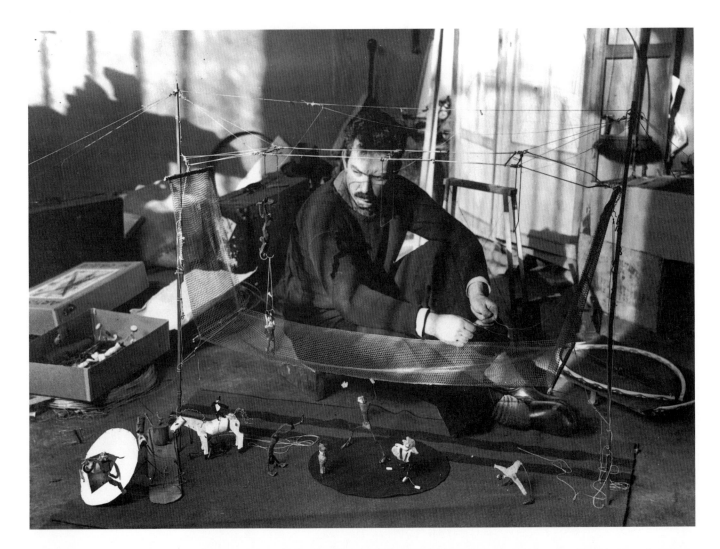

characterized his artistic career and adult life. As an adult, he still tinkered incessantly with rudimentary inventions, made with the simple tools and materials he had to hand. At one point, for example, he rigged up an arrangement of pulleys by his bed to turn on the stove for coffee in the morning. If it didn't work he would get up, repair it, and then get back into bed rather than just turn on the burner in the normal way.

This mechanical aptitude attracted Calder to an engineering college, from which he graduated in 1919; but after a sequence of unsatisfying jobs he gave up on engineering in 1922. Feeling undecided about what to do, he took work as a common seaman on a ship sailing from New York to San Francisco via the Panama Canal, and in the course of the voyage, Calder had an experience that significantly reinforced his childhood interest in the stars and planets. "It was early one morning," he recalled, "on a calm sea, off Guatemala, when over my couch—a coil of rope—I saw the beginning of a fiery red sunrise on one side and the moon looking like a silver coin on the other. Of the whole trip this impressed me most of all; it left me with a lasting sensation of the solar system."[2] This cosmic imagery figured importantly in the artist's first stabiles and in the genesis of the mobile, around 1930.

Calder studied at the Art Students League in New York from 1923 to 1926 and then worked his passage across the Atlantic to Paris (still the undisputed art center of the world). Calder had made a number of drawings of the circus in 1925, on commission from the *National Police Gazette*, and by the end of 1926 he had begun his great project of the 1920s, the wire *Circus*. At the end of the twenties Calder had a few one-man shows in New York of his wire portraits and animals (including some carved in wood); in one exhibition his work appeared side by side with a display of eighteenth-century mechanical birds in cages that may have inspired the gear-driven sculptures like the *Fishbowl with Crank* [fig. 3.4], although they also grew naturally out of the aesthetic of the *Circus*.

Calder in Paris

Calder opened the performances of his *Circus* with a scratchy recording on the gramophone. As the voice of the ringmaster, "Monsieur Loyal," Calder would announce: "Mesdames et Messieurs je vous présente …" and then ceremoniously march in each of the animals and performers in his thick, paw-like hands. He performed the *Circus* on his hands and knees, making the sounds of the different animals as they entered the ring. The event included sword swallowers, acrobats, clowns, lion tamers, and a variety of other acts. Many of the performers actually moved, through some clever mechanical invention: Rigoulot, the weight lifter, bent over, hooked his wire hands on the barbell and lifted it into the air; the seals tossed a ball back and forth; and the acrobats (using a simple catapult device) sprang, hilariously, from one place to another. People were fascinated

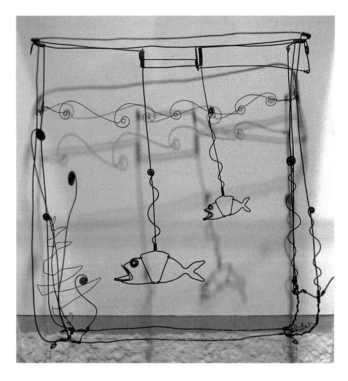

3.4 Alexander Calder, *Fishbowl with Crank,* 1929. Wire, 15⅞in (40.3cm) high.
Private collection, New York. © 2000 Estate of Alexander Calder/Artists Rights Society (ARS), New York/ADAGP, Paris.

by Calder's meticulous attention to detail: he put safety netting below the high-wire act, and using an air bulb and wooden blocks for legs, he figured out how to make the elephant move with the animal's typically awkward lumber.

The *Circus* grew from two suitcases full of performers and props in 1927 to five by 1930. Then Calder more or less stopped working on it, although he continued to put on performances to the end of his career and frequently returned to circus themes in his sculpture, as in the magnificent *Performing Seal* of 1950 [fig. 3.1]. In the early days Calder occasionally charged admission to these performances to make his rent, but he generally presented the *Circus* free to his friends and their friends, and in this way he met most of the advanced artists in Paris in the late twenties. In the fall of 1928 Calder met the artists Man Ray, Jules Pascin, and most importantly Miró, with whom he maintained a life-long friendship. In March of 1930 the painter Fernand Léger, Frederick Kiesler (a Viennese architect who developed close ties to Peggy Guggenheim and to the painters of the New York School), the de Stijl artist Theo van Doesburg, Le Corbusier, and Mondrian all came to see the *Circus*. The *Circus* even made an appearance in Thomas Wolfe's 1934 novel *You Can't Go Home Again*[3] after a 1929 performance in a New York apartment.

In Paris Calder shared Léger's interest in machine culture and they established a fast friendship. But it was Calder's encounter with Mondrian that played the most important part in transforming Calder into a serious

abstract artist. After Mondrian came to see the *Circus* Calder repaid the visit and later described the Dutchman's studio this way:

It was a very exciting room. Light came in from the left and from the right, and on the solid wall between the windows there were experimental stunts with colored rectangles of cardboard tacked on. Even the victrola [the record player] which had been some muddy color, was painted red. I suggested to Mondrian that perhaps it would be fun to make these rectangles oscillate. And he, with a very serious countenance, said: "No, it is not necessary, my painting is already very fast." ... This one visit gave me a shock that started things. Though I had often heard the word "modern" before, I did not consciously know or feel the term "abstract." So now at thirty-two, I wanted to paint and work in the abstract.[4]

Calder swiftly assimilated the correlation between Mondrian's metaphysics and the formal simplification of his style. This revelation in turn shifted Calder's concept of his own art on to a new level of profundity. Formally Mondrian inspired in Calder a new use of flat planes, primary colors—especially red—in opposition to black and white, a concern

for the equilibrium of space and surface, and the idea of non-symmetrical balance. He also made Calder more aware of the relation of style to the definition of a worldview. Calder understood that Mondrian saw the harmonies in his paintings as abstract blueprints for harmonizing the underlying structure of nature with social Utopia. In Mondrian's view, painting permitted the contemplation of the cosmic order and society in their purest forms. Although Calder's wire sculpture of the 1920s already embodied a fully elaborated character, the correlation of form and metaphysics that Mondrian's work brought home gave Calder's work a new depth. It began to take on a tone of formal concentration and sophistication that the more directly exuberant *Circus* lacked, for all its youthful brilliance.

In 1930, shortly after this visit to Mondrian's studio, Calder began his first abstract sculptures and soon the *Abstraction–Création* group in Paris (which included Mondrian and Arp) invited Calder to join. Such classic Calder sculptures as *Little Ball with Counterweight*, *The Pistil*, and *A Universe* [fig. 3.5] evolved out of the wire sculptures in the service of this more philosophical content. In April 1931 the Galerie Percier in Paris gave Calder a show of his wire portraits and abstractions. In the course of the exhibition Calder met Duchamp, who suggested the name "mobiles" for the works with moving parts; Jean Arp asked Calder if the wire abstractions were "stabiles" (the term Calder adopted for works that do not move).[5]

Cosmic Imagery and the Mobiles

All of Calder's new abstractions of 1930 and 1931 made use of cosmic imagery. Indeed it became a central theme in Calder's work, particularly in the movement of the mobiles. His friend Miró was using images of the sun, moon, and stars in the twenties and painted a series of "constellations" around 1940; Jean Arp constructed a series of wood reliefs entitled "constellations" in the early thirties. But cosmic imagery was particularly present in Calder's mind at the time because of the discovery on March 14, 1930 of Pluto (the ninth planet) by scientists at Lowell Observatory in Arizona. This widely publicized event captured the public imagination in the same way as the moon landings of the sixties and must have reawakened Calder's longstanding interest, dating back to his childhood "star-gazing." As he remarked: "The underlying sense of form in my work has been the system of the Universe, or part thereof. For that is a rather huge model to work from."[6]

The formal vocabulary of these abstractions of the early thirties appears to have been inspired by orreries (mechanized models of the universe) and tellurians (mechanical earth, moon, and sun systems) from the seventeenth and eighteenth centuries. In the first half of the thirties Calder motorized several of these pieces. In so doing, however, he regularized the relations into repetitious patterns that he found less interesting than the myriad

3.5 Alexander Calder, *A Universe*, 1934. Motor-driven mobile: painted iron pipe, wire, and wood with string, 40½in (102.9cm) high. The Museum of Modern Art, New York. © 2000 Estate of Alexander Calder/Artists Rights Society (ARS), New York.

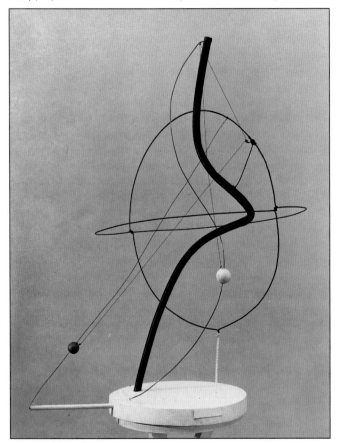

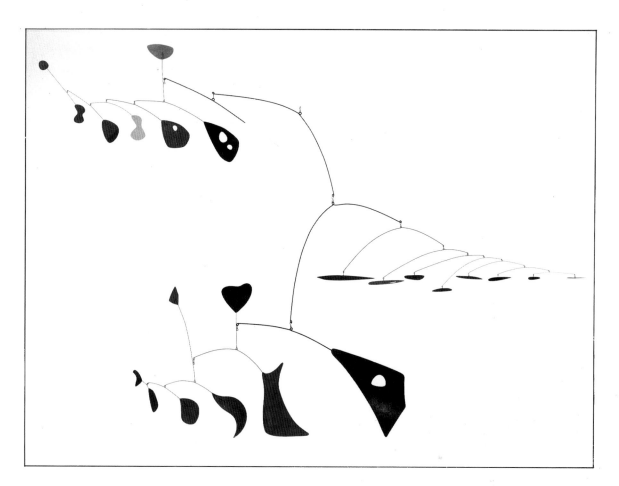

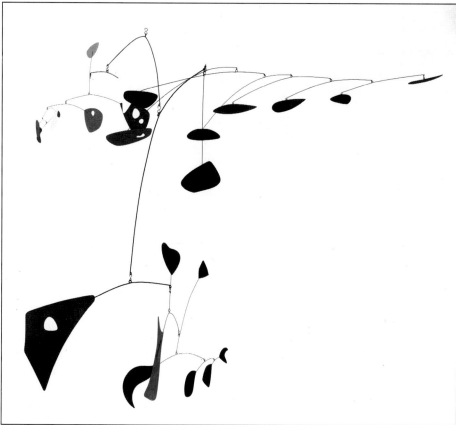

3.6 (above) **Alexander Calder,** *Object in Y,* 1955. Painted metal, 7ft 9in × 11ft 6in (2.36 × 3.51m) (variable).

Photograph by Ellen Page Wilson, courtesy PaceWildenstein Gallery, New York. © 2000 Estate of Alexander Calder/Artists Rights Society (ARS), New York.

3.7 Alexander Calder, *Object in Y,* 1955. View 2.

Photograph by Ellen Page Wilson, courtesy PaceWildenstein Gallery, New York. © 2000 Estate of Alexander Calder Artists Rights Society (ARS), New York.

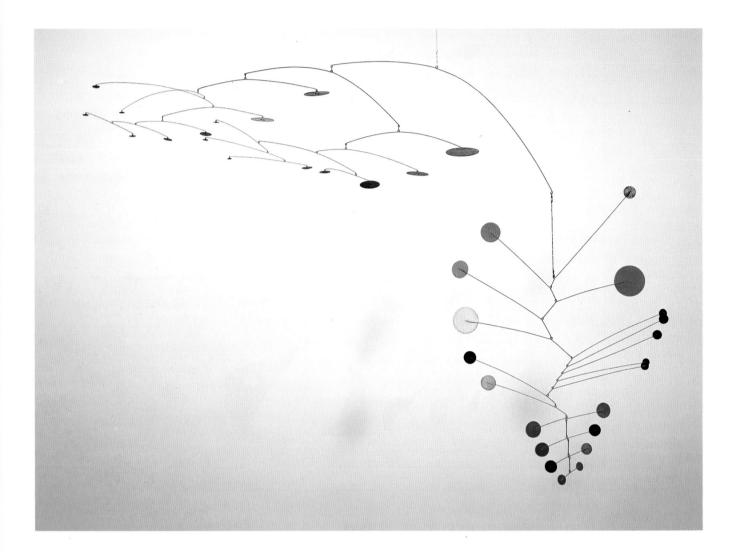

3.8 Alexander Calder, *Non-Objective,* 1947. Painted metal,
58 × 84 × 36in (147.3 × 213.4 × 91.4cm).

Photograph courtesy PaceWildenstein Gallery, New York. © 2000 Estate of Alexander
Calder/Artists Rights Society (ARS), New York.

arrangements created by chance in the actions of the unmotorized mobiles, as seen here in two configurations of the same piece [figs. 3.6–3.7].

As an aside, Albert Einstein found the repetition in the motorized works interesting enough. He went to the Museum of Modern Art in 1943 to see Calder's *A Universe* [fig 3.5], and after standing in front of it for forty-five minutes and waving away everyone who approached, he reportedly muttered, "I wish I had thought of that." Calder speculated that Einstein was "waiting to see the same combinations come up again so that he could work out the ratios of the different parts. I had set the movements in a ratio, I think, of nine to ten, so that the whole machine had to do ninety cycles before it repeated itself."[7] As Albert Elsen has pointed out, Calder's ability to visualize a work that involved such complex permutations among the parts, in cycles lasting as long as forty minutes, was a quite

extraordinary feat of conceptualization.[8]

Nevertheless it seems that Calder was more interested in events he could not predict and sought to make a work that would spontaneously respond to unpredictable interventions with an infinitely varied, adaptive equilibrium; the mobiles provided that. Calder talked about his mobiles as "abstractions which resemble nothing in life except their manner of reacting."[9] Calder's invention of the mobile in 1930 was a radical innovation; it literally incorporated into sculpture time (the fourth dimension), movement, and relative variations in speed and distance. The time–space–matter continuum—a central concern of advanced science since 1905—tied in with Calder's cosmological interests. Movement undermined the seemingly fixed nature of the object: "I went to movement for its contrapuntal value," Calder explained.[10] Calder also created a number of abstract drawings on cosmological themes around 1931–2, which, along with the *Circus* drawings from the same time [fig. 3.9], are Calder's greatest works on paper.

Calder's mobiles asserted an utterly different definition of sculpture than that which had existed since antiquity. Where a work like Henry Moore's *Reclining Figure* [fig.

4.44] is a fixed form sitting on a pedestal (that separates it from the real space of the viewer like the frame on a picture), Calder's *Non-Objective* [fig 3.8] seems to float freely in the same space inhabited by the viewer. This idea of incorporating the real space around the sculpture into the work (called "open-form" sculpture) was pioneered by the prewar cubists and futurists and by the Russian avant-garde, especially Vladimir Tatlin, who insisted on "real materials in real space."[11]

In their precise outlines and sophisticated mechanics, the mobiles reflected Calder's engineering training at Stevens Institute. In particular he remembered a wave machine from a kinetics course as a forebear of his fascination with mechanical action. As a genre Calder's mobiles all have a celestial metaphor inherent in their structure, since they suggest the absence of a fixed frame of reference—an analog to objects in space. The parts of *Non-Objective* or *Object In Y* move effortlessly, creating a seemingly infinite variety of form. Like the planets they continually redefine their relations around the different centers of equilibrium and gravity that the artist has cunningly composed. The perpetually changing relations within the mobiles give them a metaphysical identity that relies on temporal memory to assemble the sequence of partial definitions comprising the more complex identity of the whole. This gives the mobile a kind of physical transparency, revealing all its internal processes in a manner that greatly extends the static transparency of prewar cubism and futurism.

The mastery of continuous, unpredictable change is a central theme in Calder's art. Its roots go back to the frequent dislocations of his unsettled childhood and the strain caused by his father's illness. This background seems to have produced in the adult artist a surface resilience and an ability to keep emotional ups and downs out of sight by way of a dry wit and a disinclination to look inward. A *Life* magazine reporter once asked if he ever felt sad and Calder replied: "No, I don't have the time. When I think I might start to, I fall asleep. I conserve energy that way."[12]

In Calder's strikingly cool account of the year-long separation from his parents in 1905 and 1906, he described one of his mother's letters to him about the train trip to Arizona. With a typical Calder pun that belies deeper feelings he recounted: "She also wrote about the Harvey Company—it held the place of the diner in those days—

3.9 Alexander Calder, *The Circus,* 1932. Ink on paper, 20¼ × 29¼in (51.4 × 74.3cm).
Courtesy Perls Galleries, New York. © 2000 Estate of Alexander Calder/Artists Rights Society (ARS), New York.

which gave them a tray of food at one station and took it out at the next. We seemed to be living on trays in those days— tray *bien*!"[13] The experience must have caused considerable stress for the child, and yet he uses humor in his *Autobiography* to negate the subject's emotional charge. This mirrors the central metaphor for the mobiles: the regaining of equilibrium from the chaos of the unexpected.

In January 1931 Calder married Louisa James (the grand-niece of William and Henry James), whom he had met on a passenger ship for New York in June 1929. Two years later they moved back to New York and later bought a house in rural Roxbury, Connecticut, where Calder worked from 1938 to 1953. The Calders' first daughter, Sandra, was born in 1935 and Mary, their second, came four years later.

Both Calder's family life and his career settled into a good stride by the mid thirties. The Pierre Matisse Gallery began showing his work on a regular basis, the Museum of Modern Art acquired one of his sculptures, he designed sets for Martha Graham's dance troupe, and was generally very much on the New York scene in the thirties and forties. In addition Calder had established close ties with the European moderns—indeed the Spanish architect José Luis Sert asked him to create the *Mercury Fountain* for the

3.10 Alexander Calder, *Constellation,* 1941. Painted wood and wire, 51 × 46½ × 10in (132.1 × 118.1 × 25.4cm).

Private Collection. Photograph courtesy Whitney Museum of American Art, New York. © 2000 Estate of Alexander Calder/Artists Rights Society (ARS), New York.

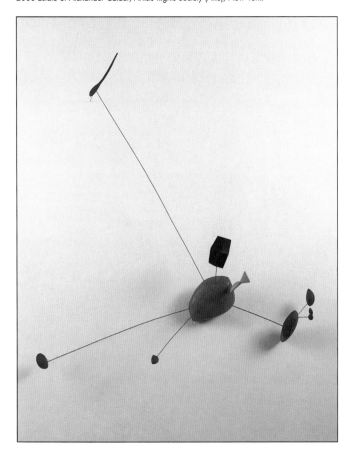

Spanish Republican Pavilion at the 1937 Paris World's Fair (to accompany Picasso's *Guernica* and Miró's *The Reaper*)— his dealer, Pierre Matisse, provided the primary showcase for the European surrealists in New York, and more and more of the artists Calder knew from Paris began emigrating to New York in person. The Calders had especially close relations with the surrealist painters André Masson, Kay Sage, and Yves Tanguy (who was married to Sage), all of whom lived in Connecticut.

Calder's personal tie to surrealism and dada was important. His biomorphic abstraction was adapted from surrealism and Calder credited Miró with encouraging his brilliant colors and preference for simple oval and circular forms.[14] Calder's work has none of the surrealists' concern with unconscious, psychological dynamics nor any of the soul-searching emotionalism that surrealism inspired in the painters of the New York School.

In 1943 when aluminum grew scarce because of the war, Calder made a series of wooden "constellations" [fig. 3.10] which he said were particularly inspired by the 1940–1 "constellations," in gouache by his friend Miró.[15] They also have a formal affinity with the shapes in the paintings of Tanguy [fig. 2.3] and with Giacometti's *The Palace at 4 a.m.* [fig. 5.14], which had been on display at the Museum of Modern Art in New York since the mid thirties. But whereas the surrealist Giacometti used the frame of the platform and the cage in *The Palace at 4 a.m.* as the setting for a dream and juxtaposed its images in psychic free association, Calder's *Constellation* [fig. 3.10] coheres around an experimental curiosity about structure in the universe. Calder treats the platform or wall matter-of-factly as a frame of spatial reference, and his work recalls a range of associations from Tinkertoys (developed in 1914) to the solar system, but not the unconscious mind.

Some of Calder's works come directly from natural subjects, such as the plant forms in his *Bougainvillea* [fig. 3.11]; others are derived not from the appearance of nature but from an abstract idea, visualized in the mind with sufficient particularity to seem real, as in *Non-Objective* or the "constellations."

"Léger once called you a realist," Katherine Kuh reminded him. "How do you feel about this?"

"Yes, I think I am a realist … Because I make what I see. It's only the problem of seeing it. If you can imagine a thing, conjure it up in space—then you can make it, and *toute de suite* you're a realist. The universe is real but you can't see it. You have to imagine it. Once you imagine it, you can be realistic about reproducing it."[16]

By the forties Calder had become an established artist. The Museum of Modern Art gave him a one-man exhibition in 1943/4 and no less a figure than Jean-Paul Sartre wrote the catalog introduction for his 1946 gallery show in Paris. By the end of the forties he was receiving increasingly important commissions from around the world. In 1953 the Calders bought a second house in Saché, France, and began spending more and more time in Europe

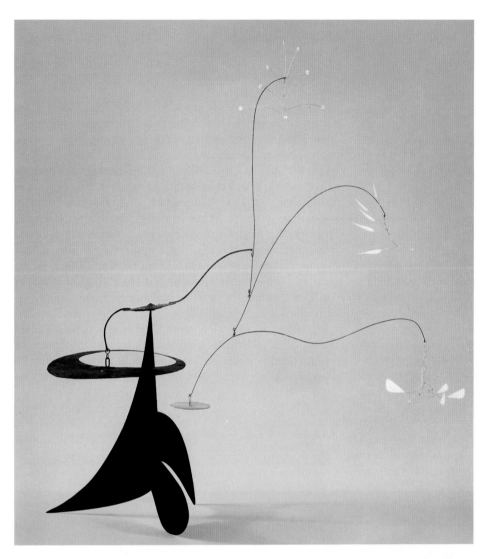

3.11 Alexander Calder,
Bougainvillea, 1947. Painted sheet metal,
wire and weights,
6ft 4in × 6ft 11in (1.93 × 2.11m).
Private collection. Photograph courtesy of Christie's,
New York. © 2000 Estate of Alexander Calder/Artists
Rights Society (ARS), New York.

3.12 (below) **Alexander Calder,**
Flamingo, 1974. Painted steel plate,
40ft (13.5m) high.
Federal Center Plaza, Chicago. Photograph by Jonathan
Fineberg. © 2000 Estate of Alexander Calder/Artists
Rights Society (ARS), New York.

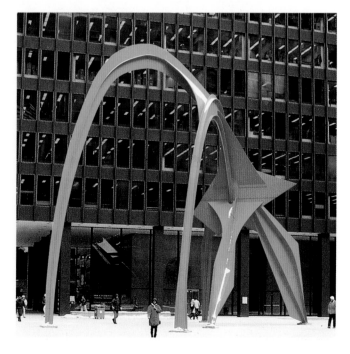

again. Although Calder died in 1976 at nearly eighty years
of age, his development never tapered off. Around 1940 he
took the mobiles off their supporting armatures and started
hanging them from the rafters. Then he began to
experiment with scale.

The stabiles, which also originated in that first body of
abstract work of 1930 and 1931, started to take a different
form around 1936. Calder defined the new stabiles with
large flat planes of metal, fabricated in an industrial style.
These grew in size during the forties too, and when the
commissions for both mobiles and stabiles on an
architectural scale started coming his way in the late fifties,
Calder began collaborating with industrial fabricators in
their construction. Calder's magnificent 1974 *Flamingo* [fig.
3.12] in the Federal Plaza in Chicago—like the other large
stabiles—not only appears to be constructed like the hull of
a great ship, it is. Yet this work also maintains a supple, avian
grace on a scale and in a style that holds its own brilliantly
against the steel and glass skyscrapers around it.

Hans Hofmann

Stylistic Lessons from Europe

Like Calder, Hans Hofmann provided an important bridge between European modernism and the new American avant-garde, although Hofmann retained a European sensibility that neither Calder nor the American-born artists of the New York School ever developed. This "European sensibility" is difficult to define precisely, but it has to do with a conception of the artist as a vehicle for the forces of nature and indeed as inseparable from nature in the artist's definition of him or herself. The idea goes back to the romantics of the late eighteenth century and contrasts with the more pragmatic, matter-of-fact attitude that artists of the interwar period singled out as a characteristically American trait.

Hofmann was a German who emigrated to America, and from the mid thirties through the late fifties taught young American painters the formal subtleties of European modernism: nuances of handling paint and color (based on his firsthand experience with fauvism and Kandinsky); an analytical approach to pictorial structure (from his study of Cézanne and cubism); and a spirituality (as he found it in Kandinsky's romantic abstraction). Hofmann's seriousness of purpose and his intensity toward the formal issues of painting set an example that the young Americans emulated. As a charismatic teacher on the scene, Hofmann helped bring the emerging American vanguard up to a level of formal sophistication hitherto the sole province of the European moderns.

In Stuart Davis's *House and Street* [fig. 3.13], one can see the limited extent to which interwar American painting had assimilated European styles. Davis was an important painter of the period. He had studied with Robert Henri and gone to Paris in the twenties. But like other advanced American artists between the wars he sought to remodel European modernism into a "description" of America with a sociopolitical agenda. While he recognized that no American artist had "created a style which was ... completely divorced from European models," he nevertheless wanted to distinguish himself from his influences: "I am an American, born in Philadelphia of American stock. I studied art in America. I painted what I see in America, in other words, I paint the American scene."[17]

Despite his radical simplification of the subject matter in *House and Street*, Davis still emphasizes the *description* (of an American city scene). The strength of the work lies in its presentation of "facts" in a disengaged style that is at the

3.13 Stuart Davis, *House and Street*, 1931. Oil on canvas, 26 × 42¼in (66 × 107.3cm).
Collection, Whitney Museum of American Art, New York. Purchase. Photograph by Geoffrey Clements, New York. © Estate of Stuart Davis/VAGA, New York, 1994.

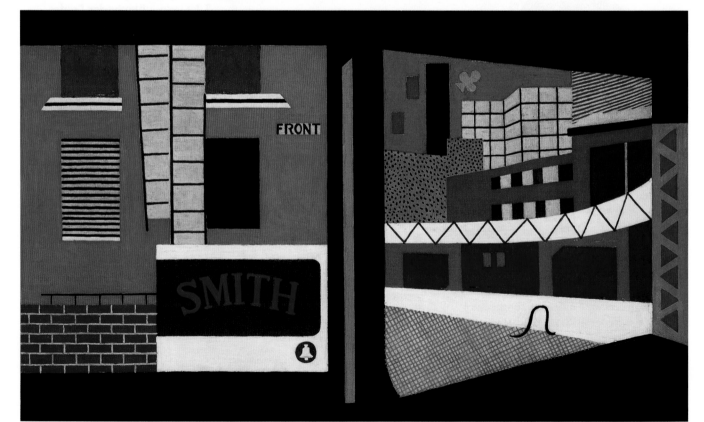

same time distinctly "modern" (in its shallow space and its flat planes of bright color, as in French cubism of the twenties) and also American in the formal execution. By contrast Picasso, even in those phases where his painting is very flat (as in *Guernica* or *The Studio* [figs. 2.10 and 3.25]), always has a formal elegance, a richly worked surface that is interesting to look at entirely on the level of paint surface.

Hofmann helped the younger Americans to understand this aspect of European modernism—what the French call *belle peinture* (the beautiful handling of paint). On the whole, the best American painters never adopted this painterly refinement; indeed, dispensing with it implied a rejection of hierarchies that was at the heart of American art. The best work of Pollock, for example, always had a kind of awkwardness in paint handling that set off the freshness of the conception; De Kooning retained a mastery of brushwork from his European training, but his was a commercial art rather than a fine art training and what his formal eloquence allowed him to do was to push bravura brushwork over the edge of refinement; Motherwell took pains to master this aspect of European modernism, and yet everything he painted also included a simultaneous cancelling out of this classical elegance with an expression of what he saw as his "raw" Americanness. What makes Davis so interesting and important is precisely that he pushed "belle peinture" aside (perhaps unwittingly) for a distinctly American populism (even vulgarity) that prefigures American pop art and was seminal for late twentieth-century advertising.

Hofmann was born in Bavaria in 1880 and spent his

youth in Munich during the symbolist period. He was trained as an engineer and had some commercial inventions to his credit. From 1904 to 1914 he painted in Paris and frequented the Café du Dôme, where he met many of the leading Parisian artists, including Picasso, Braque, Pascin, Rouault, Picabia, Matisse, and Léger. Although he had no personal contact with the German expressionists until after World War I, Hofmann stored some of Kandinsky's great prewar paintings in his Munich studio from 1914 to 1918 and later received two of them in thanks for his kindness.

A weak lung got Hofmann excused from military service and enabled him in 1915 to open the Hans Hofmann School for Modern Art in Schwabing (the artists' quarter of Munich). The best known of the many American pupils he attracted was the sculptress Louise Nevelson, who attended Hofmann's last session there in the spring of 1931. In the summers of 1930 and 1931 he taught at the University of California in Berkeley, and in the fall of 1931 he moved to New York City. There Hofmann taught at the Art Students League for two years and then opened his own school. In 1935 he also started up a summer school in Provincetown, on the tip of Cape Cod, where Robert Motherwell, Jack Tworkov, and other artists of the New York School would regularly spend their summers in the forties.

Hofmann taught an aesthetic approach; to him art had nothing to do with politics or social consciousness. He stressed drawing and lectured on pictorial structure, paint handling, and on intuitive expression through materials. Although Hofmann's interpretation of fauvism, prewar

3.14 Cézanne, *Mont Sainte-Victoire,* 1902–4. Oil on canvas, 27½ × 35¼in (69.9 × 89.5cm).
Collection, Philadelphia Museum of Art, George W. Elkins Collection.

cubism, Cézanne, and Kandinsky was formalistic and twenty years behind the developments on the European scene, it nevertheless carried much authority for his young American students. Hofmann had a heavy German accent and a hearing problem, which made communication difficult; but instead of interfering with his teaching, this seems to have given an Olympian distance to his charismatic personality.

Hofmann's Art Theory

Hofmann also wrote essays on art theory, pervaded by the spirituality of Kandinsky and Mondrian. "The artist's technical problem," Hofmann wrote, "is how to transform the material with which he works back into the sphere of the spirit."[18] But Hofmann detached the spirituality of Kandinsky and Mondrian from their radical social aims and thus essentially missed the point of their work. What he understood well about their painting was its visual structure, and to this he intuitively attached an emotional dimension, which he identified as "spirituality." The main part of Hofmann's theories, however, concerns spatial dynamics and visual tensions. For example, he reasoned that "painting possesses fundamental laws. These laws are dictated by fundamental perceptions. One of these perceptions is: the essence of the picture is the picture plane. The essence of the picture is its two-dimensionality. The first law is then derived: the picture plane must be preserved in its two-dimensionality."[19]

This idea derives from Hofmann's study of the works of Paul Cézanne [fig. 3.14] in terms of turn-of-the-century French theory, as in Maurice Denis' famous statement of 1890: "A picture—before being a battle horse, a nude woman, or some anecdote—is essentially a plane surface covered with colors assembled in a certain order."[20] Cézanne's prominent brushwork, and such compositional devices as his tipped-up perspective and regularized system of simplifying forms, flattened out the pictorial space and emphasized the surface of the canvas. The work of the prewar cubists carried still further this accentuation of the picture plane, the shallow space, and the systematic application of paint. Hofmann hypothesized from these influences: "Depth, in a pictorial, plastic sense, is not created by the arrangement of objects one after another toward a vanishing point, in the sense of Renaissance perspective, but on the contrary (and in absolute denial of this doctrine), by the creation of forces in the sense of *push and pull*."[21]

Hofmann's concept of "push and pull" asserts that all movement within a painting necessarily implies a reciprocal movement in the opposing direction; movement into pictorial space demanded a balancing advance toward the viewer. One can see the direct influence of this idea in Louise

3.15 Hans Hofmann,
Landscape, 1941. Oil on plywood, 30 × 35in (76.2 × 88.9cm).
Private collection. © Estate of Hans Hofmann, VAGA, New York.

3.16 Henri Matisse, *Promenade Among the Olive Trees,* 1905. Oil on canvas, 17½ × 21¾in (44.5 × 55.2cm).
Metropolitan Museum of Art, New York. Robert Lehman Collection, 1975. © 2000 Succession H. Matisse, Paris/Artists Rights Society (ARS), New York.

From the mid thirties into the early forties Hofmann painted numerous summer landscapes of Cape Cod [fig. 3.15]. Although they are dated by their stylistic affinity with prewar Paris, the paintings' unique fusion of fauvist color and cubist space makes them powerful nonetheless. Throughout this period Hofmann remained committed to nature; whether in the studio or out of doors in the landscape, Hofmann constantly tested reality while simultaneously asserting the autonomy of these paintings as paintings. The translation of three-dimensional space onto the picture plane acknowledges the flatness of the canvas; the ecstatic palette of brilliant and energetically applied color agitates the entire surface with uniform intensity, further emphasizing the surface, as in the fauvist works of Matisse [fig. 3.16]. Hofmann's landscapes are raw; they brim over with excess energy, and so did he.

Under the pressure of the new formal devices of surrealism in the early forties, the visible link to nature in Hofmann's painting gave way to a more experimental mode. In particular in the drip pictures of 1942 to 1944 (like

3.17 Hans Hofmann, *Fantasia,* c. 1943. Oil on plywood, 51½ × 36⅝in (130.8 × 93cm).
Collection, University Art Museum, University of California at Berkeley. Gift of the artist. © Estate of Hans Hofmann/VAGA, New York.

Nevelson's works [fig. 7.20], which simultaneously move forward and back from a hypothetical picture plane. Yet this and other aspects of Hofmann's teaching may have had their most profound influence through the interpretations of the formalist critic Clement Greenberg, who stated in 1945 that he owed "more to the illumination received from Hofmann's lectures than from any other source."[22]

Hofmann's Painting

On the whole, Hofmann did little painting between 1915 and 1938. His energies went mostly into teaching. Lee Krasner studied with Hofmann around 1940, and through her he met Jackson Pollock and other artists in their circle. Yet Pollock's concentration on existential introspection was too psychological for Hofmann. When Krasner brought Pollock to Hofmann's studio for the first time in 1942, Hofmann said to Pollock: "You don't work from nature. You work by heart. This is no good. You will repeat yourself." Knowing that Hofmann was at this stage more of a teacher than a practicing painter and hadn't even shown his work in New York yet, Pollock responded defiantly to this patronizing advice: "I *am* nature … Put up or shut up. Your theories don't interest me."[23]

As a painter, Hofmann did all of his important work in America, carrying fauvist color and handling into a free abstract expressionism. Though the painterly handling resembled Kandinsky's canvases of 1912 to 1914, Hofmann's work lacked Kandinsky's depth of subject matter. The strength of Hofmann's work derives from a passionate engagement with the mastery of paint application and composition in themselves. In addition Hofmann's work always maintained a shallow, orderly space, meticulously derived from Cézanne and cubism.

A Dialog with Europe

Fantasia [fig. 3.17]), Hofmann stresses spontaneity by splattering the paint rather than applying it with a brush. This automatist technique frees the gesture of the hand. But Hofmann had no interest in using an automatist gesture as a means of probing or expressing his unconscious mind. Indeed Hofmann pointedly explained: "My work is not accidental and not planned. The first red spot on a white canvas may at once suggest to me the meaning of 'morning redness' and from there on I dream further with my color."[24] As distinct from surrealist free association, Hofmann insisted that his work proceeded from an "inner necessity" that was psychic rather than psychological; its claim to truth centers upon a revelation of the content to the artist (as it did for Kandinsky, from whom Hofmann borrowed the term "inner necessity"). "The spirit in a work," Hofmann asserted, "is synonymous with its quality. The *Real* in art never dies, because its nature is predominantly spiritual."[25]

The rich, heavily applied palette of Hofmann's painting *The Third Hand* [fig. 3.18] takes off from the romantic clouds of color in the early Kandinsky [fig. 3.19]. The individuality of Kandinsky's spatial vision and the secretive character of his iconography cast the artist as the medium for cosmic truths. Hofmann's vision remained somewhat more secular, focused as it was on a systematic exploration of technique and structure. Yet his declaration of presence in his own handprint provides the same kind of romantic counterpoint to his mysterious color actions. In addition Hofmann (like Kandinsky and other symbolist-influenced painters) had a mystic's fascination with synaesthetic correlations between color and sound; he invoked music in some of his titles and in

3.18 (opposite) **Hans Hofmann,** *The Third Hand,* 1947. Oil on canvas, 5ft⅛in × 3ft 4in (1.53 × 1.02m).
Collection, University Art Museum, University of California at Berkeley. Gift of the artist.
© Estate of Hans Hofmann/VAGA, New York.

3.19 Wassily Kandinsky, *Sketch 1 for Composition VII,* 1913. Oil on canvas, 30¾ × 39⅜in (78.1 × 100cm).
Private collection, Germany. © 2000 Artists Rights Society (ARS), New York/ADAGP, Paris.

the subjectivist "orchestration" of colors.

Hofmann had his first one-man show at the age of sixty-four; it took place in 1944 at Peggy Guggenheim's Art of This Century gallery. Writers frequently blame this late start on the energy that Hofmann's teaching siphoned off. But Hofmann was not a man in a hurry: he lived with his prospective wife Miz for twenty-eight years before making up his mind to marry her; he painted for forty-four years before his first one-man show; and he did not commit himself stylistically until he was seventy-eight years old (in 1958). He may not have felt confident enough about his work in the forties to commit himself to a single direction, and perhaps that held him back from showing his work. Not even his students saw his work in the thirties; he permitted only a small number of close friends into his studio. Samuel Kootz began showing Hofmann's paintings at the end of 1947, after which time his work became better known. In 1948 this brought him an American museum show with an accompanying monograph and a major exhibition in Paris. But even as he gained visibility as a painter he continued to pursue a wide range of styles.

Art generated on a predominantly formal basis, rather than out of a long-term philosophical commitment, runs the risk of lacking stylistic continuity. Hofmann himself was evidently concerned about this when he took pains to construct a philosophy that deliberately rejected the adoption of a particular style; he insisted that he viewed painting as a dedication to individual, spontaneous expression, and took as his model the stylistic diversity of Paul Klee. "If I ever find a style," he told Kootz, "I'll stop painting."[26] Yet in 1958 Hofmann gave up teaching—he closed both the New York and Provincetown schools and turned to painting full time—and for the last eight years of his life focused on a unified stylistic development that resulted in some of the best paintings of his career.

Hofmann's late painting (from 1958 to 1966) centered on a defined opposition between hard geometry and painterliness, as in *The Golden Wall* [fig. 3.20]. Some late works include only loose gestures or precise, geometric forms. Most, however, involve a new synthesis of, on one hand, the fauvist palette and the Cézanne-inspired structural rationality of the late-thirties landscapes with, on the other hand, Kandinsky's free brushwork and his romantic spatial organization. These paintings reflect the precision of Hofmann's analysis of color relationships and their structural implications, as set out in his essay "The Color Problem in Pure Painting—Its Creative Origin":

Since every color can be shaded with any other color, an unlimited variation of shading, within every color scale is possible. Although a red can be, in itself, bluish, greenish, yellowish, brownish, etc., its actual color-emanation in the pictorial totality will be the conditioned result of its relationship to all the other colors. Any color shade within one color scale can become, at any moment, the bridge to any other color scale. This leads to an interwoven communion of color scales over the entire picture surface …[27]

3.20 Hans Hofmann, *The Golden Wall,* 1961. Oil on canvas,
4ft 11½in × 5ft 11¾in (1.51 × 1.82m).
Collection, Art Institute of Chicago. Mr. and Mrs. Frank G. Logan Prize Fund, 1962.775.
© Estate of Hans Hofmann/VAGA, New York.

With the rectangles, which dominate Hofmann's compositions by 1958, the artist leads the viewer around the space in a processional way, as in a plan for a classical building. The viewer discovers the spaces through these defining forms. Mondrian's writings on the contrast of rectangles to other forms helped Hofmann refine one aspect of this language, and the picturesque complexity of Kandinsky's spatial systems informed another. Hofmann's distinction between shifting and overlapping rectangles—both retreating and advancing in space—is a subtlety that grew out of his concept of "push and pull."

The large areas of intensely saturated color in Hofmann's paintings influenced the so-called "color field" painters of the late fifties and sixties [figs. 6.10–6.12]. In that period, in which much abstract painting was dominated by the formal questions discussed by Clement Greenberg, many artists and critics looked to Hofmann as a heroic

pioneer. Meanwhile Hofmann himself sounded like something straight out of Clement Greenberg. Writing in 1962, Hofmann explained:

I am often asked how I approach my work. Let me confess: I hold my mind and my work free from any association foreign to the act of painting. I am thoroughly inspired and agitated by the actions themselves which the development of the painting continuously requires.[28]

In 1937, when the American Abstract Artists group was founded in New York, half the founding members had studied with Hofmann. The stylistic premise of the group was abstraction, purified of external reference. Hofmann was

a master at assimilating stylistic ideas without regard to the content from which they originated; even his sensual landscapes of 1936 to 1941 and the great last works of 1958 to 1966 have an almost polite reserve in the way that the artist segregates the language of intuitive expression from an overtly personal content. In this respect, Hofmann had a profound effect on such painters of the sixties as Frank Stella and Robert Ryman [figs. 10.2, 10.4, 10.5, and 10.23] but it set him apart from the likes of de Kooning and Pollock.

Arshile Gorky

Arshile Gorky was a self-educated intellectual, and thus all the more earnest in his reading of literature and in his dedication to art. He carried small books on artists around in his pockets and talked about art incessantly—on park benches in Washington Square, in bars, or at parties. He would stand in front of a Vermeer or a great Titian in the Metropolitan Museum and scrutinize it, sometimes expostulating aloud to himself as he examined each detail. Afterwards he and de Kooning or other friends would go out for coffee and discuss the painting for hours. For Gorky art was the vehicle through which he experienced everything and a matter of the utmost importance.

Gorky's Life (Real and Imagined)

Gorky was born Vosdanik Adoian on April 15, 1904 in Turkish Armenia. His mother descended from a noble line of priests from the fifth-century Armenian Apostolic Church, and she imbued him with a love of the ancient culture and language. The rich manuscripts, architecture, sculpture, and wall carvings in the 3,000-year-old city of Van inspired an early interest in art and blended in his memory with his deep emotional attachment to his mother and to the majestic scenery of his native region. The central theme of his later life and art was a vivid, animistic recreation of his family and childhood surroundings in the village of Khorkom and on the shores of Lake Van in far eastern Turkey.

Long victims of religious persecution by the Islamic Turks, the Armenians suffered a systematic campaign of genocide during World War I. When Gorky was four, his father fled to the United States to avoid conscription into the Turkish army. Two years later the young Gorky had to evacuate to the stronghold of Van with his mother and sisters, and in 1915 they set out on foot for Caucasian Armenia in the infamous "death march." The Turks slaughtered stragglers and by year's end they had exterminated a million-and-a-half Armenians. Gorky's family arrived in July, and in the fall Gorky's elder sister and half-sister emigrated to the United States, leaving him with his mother and youngest sister Vartoosh. Conditions for the refugees were appalling and in March 1919 Gorky's mother literally died of starvation in his arms. He and Vartoosh then began a circuitous, year-long journey to reach the United States.

On February 26, 1920—sixteen years old and destitute—Gorky arrived at Ellis Island in New York with Vartoosh. Three days later the husband of their half-sister, Akabi, picked them up and brought them home to Watertown, Massachusetts. After some odd jobs and a couple of years in a Boston art school, Gorky moved in late 1924 to Sullivan Street, near Washington Square in New York. He took more art courses in New York and then joined the teaching staff at the Grand Central School of Art where, according to Harold Rosenberg, Gorky stressed the idea of getting emotion into drawing, once even hiring a Hungarian violinist to play during the class![29]

Gorky systematically constructed an artistic image for himself, beginning by a change of name just prior to leaving Boston. "Arshile" is a cognate of Achilles, the heroic warrior of the *Iliad*, who flew into battle out of rage at the death of his beloved friend Patroclus; and "Gorky" means "bitter" in Russian. Thus Gorky, in effect, named himself "the bitter Achilles," no doubt in reference to his rage and sorrow at the death of his mother and his enforced exile. He also deliberately chose a Russian name, which seemed not only glamorous, but also registered his admiration for Chekhov and Dostoyevsky. He even claimed to be related to the Soviet writer Maxim Gorky in order to enhance his intellectual pedigree. Of course "Maxim Gorky" was also a pen name, prompting Rosenberg's crack that: "In making someone else's alias his own name, Arshile involved himself in the higher mathematics of pseudonymity."[30]

Almost everyone who knew him recollected Gorky's character as humorous in its melodramatic expressions and

3.21 Arshile Gorky dancing at a party, c. 1945. Photograph by V. V. Rankine

in his fabrication of biographical details. In the summer of 1936 he had a brief affair with the female painter Michael West and sent her love letters plagiarized from the French artist Gaudier-Brzeska with sections from Paul Eluard.[31] They were quite torrid too; he even signed one of them "In flames, Arshile."[32] In addition, Gorky's friends joked about how he enjoyed playing the exotic Armenian peasant at parties, complete with shepherd dances and folk songs [fig. 3.21]. Even Stuart Davis, a close friend in the early thirties, described Gorky and his studio as if the artist had staged everything; it was an "artistic-type studio … equipped with the paraphernalia popularly believed to be the appropriate sign of the true artist [including] … a few plaster casts around, and a stringed musical instrument of some kind to complete the setting."[33]

At six feet three, the lean, dark-complexioned, handsome artist with large, "pleading war-orphan eyes," as Rosenberg described them, and a strong foreign accent made an unforgettable impression. Gorky accentuated the effect by pulling a black velour hat down low over his forehead and wearing, buttoned up tight under the chin, a long, black overcoat that flowed like a monk's cassock down to the ankles.

Gorky did stage everything in the sense that he carefully selected and systematically emulated certain famous artists and intellectuals as a means of incorporating what he admired. He did this at the easel and in shaping his artistic persona. In essence, he felt he had to invent the autobiography that would lead to the intellectual and artistic position he had taken. To the sophisticated New Yorker it seemed like a put-on, but even his friends may have underestimated the naive directness with which Gorky pieced together a self-image and a style. He came from a world that had disappeared and was in any case so foreign in every respect to New York that he had to redefine himself as though *ex nihilo*. In effect he was a natural embodiment of the existentialist hero, who creates his identity in the process of encountering himself, and experiences everything as if new.

3.22 Arshile Gorky, *Nighttime, Enigma, and Nostalgia*, 1931–2. Ink on paper, 24 × 31in (61 × 78.7cm).

Collection, Whitney Museum of American Art, New York. 50th Anniversary Gift of Mr. and Mrs. Edwin A. Bergman. Photograph by Geoffrey Clements, New York. © 2000 Estate of Arshile Gorky/Artists Rights Society (ARS), New York.

What Rosenberg learned from Kafka about starting from scratch in one's assessment of events, Gorky discovered in life.

Everyone who knew Gorky has remarked on the acuity and freshness of his visual insight. This rightly baffled them because it had the effect of substantiating the artist's otherwise unbelievable act. To Gorky, the false pretense of a blood relation to Maxim Gorky, the impossible claim of having studied with Kandinsky for three months in 1920,[34] and the sequence of stylistic charades of Cézanne, Picasso, and Miró in his painting—all had an intellectual vividness that made them "real" to him. Certainly nothing could be less credible than the actual facts of his early life. It is not that Gorky was out of touch with reality; rather, he believed that true intellectuals must construct their own reality and intellectual genealogy. The clarity and conviction with which he presented this notion was an important contribution to the development of several of his fellow artists in the New York School.

Gorky taught them a new perspective on facts that was also an existential exercise. His particular "history" was a completely authentic facet of his artistic statement. The intellectual position set out in his art was in turn his strategy for survival. Gorky lived his art with absolute dedication at all times and in doing so provided an example of the seriousness of the endeavor; his complete surrender of himself, both in his life and his art, to the demands of his aesthetic helped to pave the way for a deeper understanding of the modern movements of Europe.

The Development of Gorky's Style

In the mid twenties Gorky painted in an impressionist style, then he began making pictures heavily influenced by Cézanne. He came to develop a portrait style based closely on the early work of Picasso, and for a time he imitated the Spaniard's clean-edged cubist pictures of the twenties. Between 1925 and the late thirties Gorky painstakingly aped the styles of one major modern master after another. He also learned about the European moderns through his contacts with other artists. In 1928 Gorky met John Graham, a Russian-born artist who began making annual trips to Paris in 1930, establishing friendships with Picasso and Breton and keeping abreast of the French art scene generally. Throughout the thirties Graham played a critical role for Stuart Davis, Willem de Kooning, and David Smith (all of whom Gorky met in 1929 and 1930) as well as for Pollock and Gorky in keeping them up to date with current events in Paris. In 1929 Gorky also met David Burliuk, an old friend of Kandinsky's from the Blue Rider period, and Gorky must have heard firsthand about Kandinsky's abstraction.

Gorky's drawing *Nighttime, Enigma, and Nostalgia* [fig. 3.22] belongs to a closely related group of pen-and-ink compositions done in 1931 and 1932. Gorky used the vocabulary of biomorphic abstraction to create the Arp-like three-dimensional forms that he set in a shallow and subdivided perspectival space. While *Nighttime* seems to derive its geometry, cross-hatching, sharp contours and

contrasts, and perhaps even its ambiguous depth from cubist pictures of the twenties, the compartmentalization of the composition and the dramatic juxtapositions suggest the influence of Paolo Uccello's *Miracle of the Host*, the Renaissance painting of which Gorky had a life-sized reproduction on his studio wall.[35] The enigmatic objects and situations in Giorgio di Chirico's paintings seem to have inspired these drawings; Gorky knew de Chirico's work from the Gallatin Collection and probably also from the 1928 de Chirico exhibition at Valentine Gallery.[36]

Yet despite Gorky's obvious debts to other artists in *Nighttime* his fusion of the biomorphs with the highly structured space is for the first time in his career a style recognizably his own; it is self-confident and evocative. In addition the improvisation on human muscles and bones (in the figure on the right) and the shapes of the volumetric abstract forms (left of center) evolved over the next decade into the fundamental elements of his great paintings of the forties. The solid patterns of the anatomical parts and clothing in Gorky's portraits of the thirties [fig. 3.23] and the colorful planar shapes in such abstractions of the mid thirties as *Organization* [fig. 3.24], the *Khorkom* paintings, and still later the three paintings entitled "Garden in Sochi" [fig. 3.26] derive from a flattening out of the organic, sculptural forms in these drawings of 1931 to 1932. In addition the anatomical variations later provided a basis for handling the figurative elements in works of the final phase of Gorky's style, such as *The Liver is the Cock's Comb* and *The Calendars* [figs. 3.28 and 3.29].

Gorky's career began to have some modest success in the thirties, highlighted by the inclusion of three works in a 1930 exhibition at the Museum of Modern Art and a one-man show in 1934 in a Philadelphia gallery. In 1935 the W.P.A. commissioned Gorky, at roughly $100 a month, to work on a mural for Newark Airport. The mural showed the systematic transformation of airplane parts using a combination of biomorphic abstraction and cubist flatness, heavily influenced by the color and compositional rhythms of Fernand Léger. But this elegant mural did not have the studied derivativeness of Gorky's work of the twenties, and it received considerable attention.

During the Depression, radical politics took over from vanguard art in many quarters. Painting was widely viewed as a tool of agitation, best exemplified by the Mexican muralists. Gorky took quite the opposite view—that the genesis of a true work of art is in the history of art, not as a product of the wider socioeconomic milieu. Although he attended some of the recurring meetings that sought a Marxist approach to painting, it seems that he went to speak only on behalf of artistic values.

Around 1930 Gorky moved into a grimy commercial loft building in Union Square. But friends reported that he scrubbed the floor so thoroughly and so frequently that it came to have the washed-out look of driftwood. He wanted to create a beautiful refuge not only from the pressures for "social relevance" in art but from the desperation of his own

poverty. He lived off occasional teaching and help from friends, but in his world of painting he made no concessions; despite the Depression he stockpiled supplies (only the best ones) with an air of aristocratic *noblesse oblige*. Stuart Davis remarked: "outside of an art store, I had never seen anything like this."[37]

Gorky had the same uncompromising idealism in his image of family life. Marny George, whom Gorky married in 1935, later remarked that Gorky had tried to mold her into what he imagined to be the ideal wife for him, but took little notice of who she actually was. This led to the break-up of their marriage in under a year.[38] A series of portraits of himself, his mother, and his sister Vartoosh (to whom he remained close throughout his life) provided the first deeply felt subject matter of Gorky's career. Although Gorky himself signed and dated many of these paintings as if they had been completed in the twenties, they probably date from the later thirties.

Gorky's painting of *The Artist and His Mother* [fig. 3.23] is the most moving of the portrait series. He worked from a 1912 photograph of himself with his mother, taken in the city of Van, three years before her tragic death. Making careful drawings from the photograph, he painted two full-sized

3.23 Arshile Gorky, *The Artist and His Mother* 1926–36. Oil on canvas, 5ft × 4ft 2in (1.52 × 1.27m).

Collection, Whitney Museum of American Art, New York. Gift of Julien Levy for Maro and Natasha Gorky in memory of their father. Photograph by Geoffrey Clements, New York. © 2000 Estate of Arshile Gorky/Artists Rights Society (ARS), New York.

versions, eliminating detail and refining his mother's face into a beautiful system of perfect ovals and arcs. Furthermore he composed the picture like an icon, with a tripartite division that suggests the throne of the Virgin. In one version the enlarged black pupils of the eyes and the transparent immateriality of the shoulder seems to transform the mother into a non-corporeal vision of pure spirit.

Gorky attained the shiny, glass-like surface by repeatedly scraping it down with a razor blade and repainting. This technique became a stock procedure for de Kooning too, who no doubt learned it from Gorky. Gorky may in turn have devised it from looking at the magnificent Ingres portrait of *Madame de Haussonville*, which had recently been acquired by the Frick Collection. The anatomical segmentation in Gorky's portrait, which resembles his planar biomorphic abstractions of the late thirties, also influenced the early figurative paintings of his good friend de Kooning. In 1949 de Kooning wrote that "when, about fifteen years ago, I walked into Arshile's studio for the first time, the atmosphere was so beautiful that I got a little dizzy and when I came to, I was bright enough to take the hint immediately … it is about impossible to get away from his powerful influence."[39]

In the mid thirties Gorky began obsessively painting abstractions, like *Organization* [fig. 3.24], that derived from Picasso's work of the late twenties [fig. 3.25]. According to Rosenberg, Gorky came to be known as "the Picasso of Washington Square."[40] When Julien Levy went to Gorky's studio for the first time in 1932, he sensed Gorky's talent but couldn't reconcile himself to the artist's peculiar, almost superstitiously faithful, apprenticeship to Cézanne, Picasso, and then Miró. "I was *with* Cézanne for a long time, and now naturally I am *with* Picasso," he told Levy; Levy promised him a show some day, "when you are *with* Gorky."[41]

The series of paintings in homage to Khorkom (the village of Gorky's childhood) dominate the strikingly original abstractions of the late thirties. In these compositions Gorky expanded upon the vocabulary of free abstract forms announced in *Organization* and anticipated in the drawings of 1931 and 1932. The rich, sensuous surfaces were so heavily painted that the pictures weighed as much as sculptures. It became a regular joke in his studio to ask some unsuspecting visitor to go over and pick one up.

Between roughly 1940 and 1943 Gorky also painted a series of paintings called "Garden in Sochi." Stylistically the sequence shows a transition from the strong influence of

3.24 (opposite, top) **Arshile Gorky,** *Organization*, 1934–6. Oil on canvas, 4ft 1¾in × 5ft (1.26 × 1.52m).

Collection, National Gallery of Art, Washington, D.C. Alisa Mellon Bruce Fund, 1979. © 2000 Estate of Arshile Gorky/Artists Rights Society (ARS), New York.

3.25 (opposite) **Pablo Picasso,** *The Studio*, Paris (winter 1927–8; dated 1928). Oil on canvas, 4ft 11in × 7ft 7in (1.49 × 2.31m).

The Museum of Modern Art, New York. Gift of Walter P. Chrysler, Jr. © 2000 Estate of Pablo Picasso/Artists Rights Society (ARS), New York.

A Dialog with Europe

3.26 Arshile Gorky
(Vosdanik Manoog Adoian), *Garden in Sochi*, no. 3 c. 1943. Oil on canvas, 31 × 39in (78.7 × 99cm).

The Museum of Modern Art, New York. Acquired through the Lillie P. Bliss Bequest. © 2000 Estate of Arshile Gorky/Artists Rights Society (ARS), New York.

3.27 (below) **Joan Miró,** *Flame in Space and Nude Woman*, 1932. Oil on cardboard, 16⅛ × 12⅝in (40.9 × 32.1cm).

Collection, Fundació Joan Miró, Barcelona. © 2000 Artists Rights Society (ARS), New York/ADAGP, Paris.

Miró's flat, brilliant colors, relatively thinly but opaquely painted, to an even denser impasto than the Khorkom paintings, and ending with a feathery and transparently brushed canvas set off by drawing with a fine black line [fig. 3.26]. Sochi probably comes from the Armenian "sos" or "sosi" meaning a "poplar tree." Gorky's sister recalled, "it was the custom in our family at the birth of a son to plant a poplar tree which would later have the birth date and name carved on it. Gorky as a child loved his tree and took great pride in caring for it."[42]

In 1942 the Museum of Modern Art bought the 1941 version of *Garden in Sochi* and asked Gorky to write a statement about the series. His text indicated that his father's garden was the underlying theme of these works. He called it "the Garden of Wish Fulfillment" and recounted:

often I had seen my mother and other village women opening their bosoms and taking their soft and dependent breasts in their hands to rub them on the rock. Above all this stood an enormous tree all bleached under the sun, the rain, the cold, and deprived of leaves. This was the Holy Tree ... people ... would tear voluntarily a strip of their clothes and attach this to the tree. Thus through many years of the same act, like a veritable parade of banners under the pressure of wind all these personal inscriptions of signatures, very softly to my innocent ear used to give echo to the sh-h-h-h-sh-h of the silver leaves of the poplars.[43]

In the first version, the bare-breasted figure is still legible along the left edge, with a butterfly overhead, the trunk of a tree in the upper center, and perhaps the pennants of cloth in the upper right. The out-of-scale shoe in the center may refer to a pair of slippers given to Gorky by his father before leaving for America, and consequently of great symbolic significance to the artist. But the shoe probably also relates to Miró's *Still Life with an Old Shoe* of 1937, which was at the Pierre Matisse Gallery in New York and featured a shoe filling a large area of the foreground. Gorky's use of automatist form control to transform natural subjects, especially figures, is heavily indebted to the metamorphic figures of Miró [fig. 3.27] and Picasso [fig. 5.20]. The precise edges, thin planes, silhouettes, and flat grounds in the first "Garden in Sochi" painting also reveal the influence of Miró.

Gorky's Late Works

In 1942 everything came together in Gorky's painting; he clarified for himself what he wanted to paint and more or less how he had to do it. With this aesthetic self-assurance, the last six years of his life not only proved the most productive of his career but yielded work of uniformly brilliant quality, focused on a subject matter with highly specific referents in nature. André Breton was on the right track when he said Gorky "maintains a direct contact with nature—sits down to paint before her."[44]

Scholars have pointed out that the seemingly abstract works which Gorky made in the forties contained figures, often family members before a fireplace, or details of plants or landscape.[45] Where the "Garden in Sochi" pictures still have a predominantly emblematic character, the new compositions begun after 1942 successfully embody the deep resonances of Gorky's Armenian past in the describable present of his family in Connecticut. In an April 1944 letter to Vartoosh about *The Liver is the Cock's Comb* [fig. 3.28] Gorky wrote, "… it is as if some ancient Armenian spirit within me moves my hand to create so far from our homeland the shapes of nature we loved in the gardens, wheatfields and orchards of our Adoian family in

3.28 Arshile Gorky, *The Liver is the Cock's Comb*, 1944. Oil on canvas, 6ft 1¼in × 8ft 2in (1.86 × 2.49m).

Collection, Albright-Knox Art Gallery, Buffalo, New York. Gift of Seymour H. Knox, 1956.
© 2000 Estate of Arshile Gorky/Artists Rights Society (ARS), New York.

Khorkom. Our beautiful Armenia which we lost and which I will repossess in my art."[46]

The Liver seems to be populated with figures, one standing at the right edge, others on either side of the center, and there is perhaps a dog lying at the bottom, right of center. Gorky's metamorphic figures seem to condense multiple images into one form, as in a dream. Drawings make such guesswork easier, though one is always uncertain about the precise identity of the images. Those who knew Gorky well have confirmed that the images derive from natural forms—so, too, does Gorky himself, as in the letter to Vartoosh. Even the deliberate working-out of the forms in preliminary studies on paper makes it clear that Gorky had something specific in mind.

Gorky also conceived the picture titles of the forties to link up closely with their subject, providing multiple meanings and references. Many ancient and medieval texts refer to the liver (not the heart) as the center of passion. The "cock's comb," at once the headdress and the elaborately feathered genitalia of the figure along the right side of the canvas, as well as the brown phallus in the center of the left half of the painting, have to do with vanity and virility. On one level this invites the interpretation that the source of passion is physical lust, on another level that living itself is vanity (the "liver" meaning "one who lives").[47]

At the beginning of 1942 the young surrealist Matta (whom Gorky had recently befriended) encouraged Gorky to add more turpentine to his pigment;[48] this immediately gave Gorky's painting a looser, more spontaneous effect. But Matta conceived of the technique as a way of fostering free association, which he used for generating new forms, whereas Gorky already knew precisely what he wanted to paint. In a letter of 1939 Gorky rejected such surrealist devices for their lack of control: "I do not believe in anarchy in art. There must be some structure … For me, art must be a facet of the thinking mind … unrelenting spontaneity is chaos."[49] By 1947 when he described the surrealists as "drunk with psychiatric spontaneity and inexplicable dreams,"[50] his own concept of painting was firmly established as anything but automatist. For Gorky this looser technique of Matta's helped him to systematically disguise a consciously generated subject.

Gorky's debt to the Kandinsky of 1913 to 1914 [fig. 3.19] in his painting of the forties could be seen in the voluptuous pleasure of the surface application of paint, but also in the independence of color, form, and line from one another; in the flowing, often semi-transparent, brilliant color; in the romanticism of brushwork and palette; and above all in the handling of the subject matter. Kandinsky's early abstract paintings contain many "disguised" objects which any careful viewer can see, but, as in Gorky's work, not necessarily identify with certainty. In 1943 Gorky wrote to Vartoosh that his father's garden in Khorkom was "a secret treasure to which I have been entrusted the key,"[51] and Gorky

3.29 Arshile Gorky, *The Calendars,* 1946–7. Oil on canvas, 4ft 2in × 5ft (1.27 × 1.52m). Destroyed, former collection N. Rockefeller. © 2000 Estate of Arshile Gorky/Artists Rights Society (ARS), New York.

maintained the secrecy of this treasure by disguising the subjects of his paintings. Thus Gorky's claim to have studied with Kandinsky in 1920, although untrue in the literal sense, nevertheless reflects a real intellectual and aesthetic link.

When Gorky married Agnes Magruder ("Mougouch") in 1941 and started his own family, she and the children joined the gallery of "loved ones" or "loveds" that included himself, Vartoosh, his mother, his paintings, and the landscape of his childhood, which he personified in his imagination. These "loved ones" are the "secret" subject matter of Gorky's paintings. For Gorky the security of a family, which he lost in childhood, took on the most profound importance. After marriage and the births of his daughters Maro (1943) and Natasha (1945), portrayals of the family became his obsessive subject.

The Calendars [fig. 3.29] shows just such a family scene, with Gorky standing at the right reading a magazine behind his seated wife Agnes (with black hair) rocking a cradle. The older child sits (at left) in a large gray chair looking out of the window at an orange sunset. A log is engulfed in flames in the fireplace (center) and in front of the fireplace is what may be a pram. A large dog sits in the center foreground looking out. Two types of calendar are on the wall above this scene: a pink bathing beauty on a white beach with explicitly exposed genitals and a nature calendar with a fluffy bird. Perhaps the "cheesecake" calendar and the nature scene reflect two sides of his sexuality, a theme that resembles that of *The Liver is the Cock's Comb*.

Gorky re-created the composition of *The Calendars* in a series culminating in a nearly monochrome painting called *The Opaque*. Gorky had endured such immense loss and deprivation in his childhood that he may have developed these disguises to protect himself. This trait was evident in the personal dissimulations of his earlier career and it was also present, symbolically, in his decision to organize a class on camouflage painting at the Grand Central School of Art in 1942. As he stated in the brochure he wrote to advertise the class: "An epidemic of destruction sweeps through the world today. The mind of civilized man is set to stop it. What the enemy would destroy, however, he must first see. To confuse and paralyze this vision is the role of camouflage."[52] And in a short essay about his murals for the Newark Airport he discussed "the marvel of making from the common—the uncommon."[53]

Tragedy pursued Gorky relentlessly. On January 26, 1946 he had a studio fire and lost about thirty canvases. After watching them burn, he produced two pictures called *Charred Beloved*, whose titles refer directly to the lost paintings. Late in February 1946 he underwent a cancer operation. He bounced back with an extraordinarily productive year in 1947, making nearly 300 drawings and twenty paintings. Then in December 1947 his father died.

Gorky's last works are filled with the sense of imminent death. Gorky's last painting was so titled—*Last Painting*—and the subtitle, *The Black Monk*, is a revealing allusion to a Chekhov play of the same name. In the play an apparition of a black monk tells Kavrin (the hero) that his frail frame cannot bear the weight of his genius, and then he dies. Gorky had suffered severe depression, which led in turn to marital problems, and during the winter of 1947/8 he tried killing himself several times. On one occasion his wife recalled seeing him take a rope and march up the hill; she sent the children out after him, telling them "Look, Daddy is going to build a swing," so that they would unwittingly divert him long enough for the mood to pass.[54] But on June 26, 1948 Julien Levy and his wife were driving with Gorky in Connecticut and had an accident in which the latter broke his neck. He temporarily lost the use of his right arm and became despondent and difficult; he thought he would never paint again. Agnes began to fear the effect of this depression on the children, so she took them to her parents' house. Three weeks later Gorky hanged himself in the woodshed, leaving a note on the wall that said, "Goodbye, my loveds."[55]

Gorky, more than anyone, gave vanguard painting in the forties a tragic image. Yet he also symbolized the triumph of aesthetic experience over the vagaries of (even a potentially tragic) life. His work brought the individual's experience of the past (real and imagined) into the immediate present as an ineluctable element of one's ongoing definition of self (in the existentialist sense) and demonstrated that art, if not life, is an act of intellectual will.

Robert Motherwell

Jackson Pollock came from a poor family and never finished high school, Gorky barely escaped with his life from the Armenian refugee camps, de Kooning stowed away on a ship from Holland and arrived in New York with nothing but the clothes he was wearing. In addition most of the outstanding artists of the New York School educated themselves by reading and debating with other artists in cafeterias and bars near Washington Square and began painting in less than modest circumstances during the late twenties or early thirties. By contrast Robert Motherwell attended prep school, toured Europe in the Depression, received a bachelor's degree in philosophy from Stanford, and was well on his way to a Ph.D. at Harvard, funded by his father, when in 1939 he decided to become a painter. He too kept company with the others and lived meagerly in the forties. Yet he never suffered the same poverty as they did or went through the lengthy trial-and-error process of bad student works. Before Motherwell ever picked up the brush he knew precisely where he stood in terms of modernist styles and ideas; as a painter he sprang, so to speak, fully grown from the head of Zeus.

Motherwell's splendid education made him the most literate and articulate of the major New York School artists. But nowhere in his upper-class background or education did he

have any exposure to the bohemian existence or commitment of genuine painters. Motherwell grew up in San Francisco amid affluent surroundings. The family summered by the sea in Aberdeen, Washington, and his father, a conservative bank chairman, fully expected his only son to head straight from college into business or law. De Kooning once quipped that all the best painters were lawyers and doctors;[56] the pressure on Motherwell not to be an artist was formidable. But Motherwell's decision to become a painter was only postponed by his education and pressure from his father.

Intellectual Affinities with the European Moderns

Instead of going back to Harvard in the fall of 1940, Motherwell went to Columbia to study art history. There he met Meyer Schapiro, a young instructor in the department, who encouraged Motherwell to drop out and start painting. Schapiro introduced him to some of the European surrealists who had come to New York, including Kurt Seligmann, with whom Motherwell studied engraving. Soon Motherwell had befriended Matta, Duchamp, Ernst, Lam, Masson, Tanguy, and Breton. With an interest in psychoanalysis and a strong intellectual background he fitted in well with the cerebral surrealists. They shared an appreciation of the romantic and symbolist traditions, especially in poetry, and Motherwell became fascinated with their technique of automatism.

The problem for the artists of his generation, as Motherwell saw it, was "to bring American art up to the level of European modernism without being derivative."[57] Automatism seemed to him a viable means of accomplishing that, because it offered "a creative principle that did not impose a style."[58] Instead it brought out only what was native to the individual, and the aesthetic of the New York School came to center on precisely that point.

Whereas the surrealists used automatism to explore the workings of the unconscious mind and then turned to more conventional means to describe what they found, Motherwell and the other artists of the New York School saw automatism as a means for generating a form that would directly embody their existential struggle for self-definition. "Every artist's problem is to invent himself," Motherwell wrote in 1949.[59] Automatism provided the ideal tool for the painter in search of self who wanted to retain the vitality of each moment of discovery as it unfolded. Because of his fine education, Motherwell probably understood the implications of automatism for his contemporaries' aspirations sooner and in greater depth than anyone and played an important role in communicating its possibilities to Pollock and others.

Shortly after Motherwell met Krasner, Pollock, and Baziotes in 1942, he experimented writing automatist poems with them. The following year Peggy Guggenheim told him that she would be having a show of collages by various European moderns; she suggested that if he and Pollock wanted to try making some, and if they were good, she would include them. So in 1943 Motherwell and Pollock made their first collages [fig. 2.15] side by side in Pollock's studio and showed them at Peggy Guggenheim's gallery the same year.

Motherwell took to collage so naturally that for him it provided the expressive freedom that the automatist gesture gave Pollock. Yet the difference in their approach to modernism is also characterized by the contrast between Motherwell's affinity for, in effect, revolutionizing an established vocabulary with the introduction of an American sensibility and Pollock's wish simply to disregard that vocabulary (although he always struggled with the impossibility of doing so) [figs. 2.12 and 2.15]. Motherwell's admiration for the analytical and formal traditions of French art—embodied in cubist collage and in the painting of Picasso and Matisse—stood for him in perpetual counterpoint to the immediacy of emotional experience and this opposition provided a central theme in his art.

Motherwell's fluency in the language of collage derived from his ongoing dialog with the European moderns. In 1951 he explained: "Every intelligent painter carries the

3.30 Robert Motherwell, *Tobacco Roth-Händle,* 1974. Four-color lithograph and screenprint on HMP handmade paper, 40½ × 30⅝in (102.9 × 77.8cm).

Published by Tyler Graphics Ltd. Collection, Walker Art Center, Minneapolis, Tyler Graphics Archive. © Dedalus Foundation Inc./VAGA, New York, 1994.

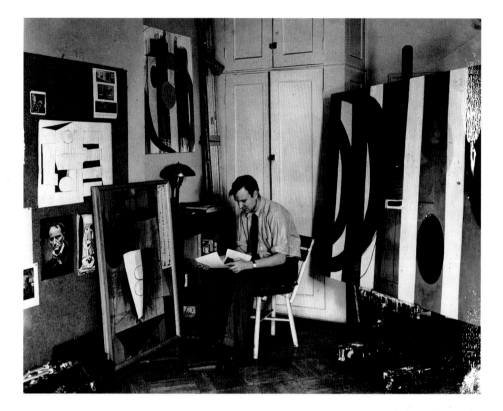

3.31 Robert Motherwell in his Greenwich Village studio, 1943.
Photograph by Peter A. Juley.

whole culture of modern painting in his head. It is his real subject, of which everything he paints is both an homage and a critique, and everything he says a gloss."[60] This speaks to only one side of Motherwell's aesthetic and yet the formal traditions of European modernism had a degree of importance for Motherwell that differentiates him from the other major artists of the New York School. It also accounts for his success as the outstanding printmaker of his generation [fig. 3.30],[61] although it was only after his retrospective at the Museum of Modern Art in 1965 that he became deeply involved in printmaking.

Recurring Themes in Motherwell's Work

Unlike printmaking, collage was a mainstay of Motherwell's development from the outset. *Pancho Villa, Dead and Alive* [fig. 2.15], one of his first collages, was purchased for the Museum of Modern Art out of Peggy Guggenheim's 1943 show. He later talked about the immediate inspiration for the work, a trip to Mexico with Matta in the summer of 1941, and he noted: "I was fascinated … with Anita Brenner's fabulous book of photographs of the Mexican Revolution, called *The Wind Swept Over Mexico*. One picture showed Pancho Villa after he was shot, spread out—sprawled out, really—in a Model T, covered with blood."[62] The dead man in this collage is bullet-ridden and wholly bereft of the sexual attributes evident in the vital figure on the active backdrop to the right.

In this early collage Motherwell had already set out the most important and prevalent themes of his career: life and death, violence, and revolution. He also instigated a formal

opposition between the intensely felt emotional elements (in the eccentrically drawn ovals, the painterly areas, and the brilliant touches of color—both pigment and collage) and the schematic, controlled structure of verticals and horizontals in a shallow cubist space (holding the emotions in check). The formal opposition of ovals and vertical stripes anticipates Motherwell's most famous series, the "Elegies," which he began in 1948. In some form, this opposition between the formal and the emotional defined virtually all Motherwell's future work. Finally the implicit reference to the refinement of European art and culture—here symbolized in the collage technique itself, with its allusions to Picasso and Matisse—would also be a recurrent preoccupation with Motherwell.

Teaching, Writing, and Editing in Motherwell's Early Career

However much Motherwell felt intellectually at home amongst the surrealists, he did not identify with their paintings. Instead his sensibility gravitated toward abstraction. A look at the interior of his studio in 1945 [fig. 3.31], complete with a photograph of Baudelaire pinned to the wall, shows the depth of his roots in a broader European tradition. He admired Mondrian as the painter of pure intelligence; he was drawn to Arp, Klee, and of course Picasso, Miró, and Matisse, who were in the mainstream of classical French modernism. Thus in 1941 he not only sought out the surrealists in New York but he met Mondrian, Chagall, Léger, Lipchitz, Calder, Ozenfant, Zadkine, and Noguchi as well.

Peggy Guggenheim gave Motherwell his first one-man show in 1944 at the Art of This Century gallery, and in 1945 he signed a contract with the dealer Sam Kootz, which gave him some steady income. He also taught. In the summers of 1945 and again in 1951 Motherwell gave classes at Black Mountain College, the progressive school in North Carolina through which Willem de Kooning, Josef Albers, Merce Cunningham, John Cage, Robert Rauschenberg, and so many other interesting artistic and literary personalities passed in the decade after World War II. Motherwell collaborated with David Hare, William Baziotes, Mark Rothko, and initially Clyfford Still in 1948 and 1949 to organize a school in Greenwich Village called "Subjects of the Artist," so named to stress their concern with content, despite their commitment to abstraction.

The public meetings and discussions held at the Subjects of the Artist school provided a focus for some of the vitality of the Greenwich Village art scene. Immediately after the school opened Still quit and Barnett Newman took his place on the staff. The next year Tony Smith took over the organization, closing the school but keeping up the program of lectures and meetings. "Subjects of the Artist" transformed into "Studio 35" (the address was 35 East 8th Street) and then merged into "The Club," which continued to host interesting meetings; but by this time Motherwell

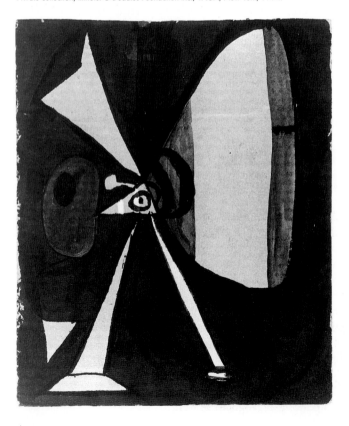

3.32 Robert Motherwell, *Untitled,* 1945. Gouache and ink on cardboard, 9¾ × 8¼in (24.8 × 21cm).
Private collection, Illinois. © Dedalus Foundation Inc./VAGA, New York, 1994.

and his contemporaries had only an occasional involvement.

In addition to teaching, Motherwell's intellectual inclinations led him into an active schedule of lecturing, writing, and editing in the forties. In 1942 he wrote for the first issue of the surrealist journal *VVV* and then in 1944 took on the editorship of the Documents of Modern Art series for the publisher and book dealer George Wittenborn. The Documents series provided translations of major primary texts of modern art and had a crucial role in making the art theory of European modernism available to young American artists. Motherwell also wrote a few critical essays for the *Partisan Review*, and in 1948 he edited the journal *Possibilities* with Harold Rosenberg.

Motherwell's Painting

Motherwell spent the summers of 1945 and 1946 in East Hampton, which had become the summer outpost of the New York School. There he painted a number of metamorphic birds [fig. 3.32] and figures influenced by Picasso [fig. 5.20] and Miró [fig. 3.27]. In 1947 Motherwell built a house in East Hampton, and in 1948 he began the "Elegy to the Spanish Republic" series with a little pen-and-ink drawing that he made to go with a poem by Harold Rosenberg called "A Bird for Every Bird" (for the planned second issue of *Possibilities*). The issue never materialized and Motherwell stuck the sheet in a drawer, forgetting about it for the better part of a year. In 1949 he rediscovered the sketch and reinterpreted it in a small painting which he called *At Five in the Afternoon* [fig. 3.33], after the refrain in García Lorca's poem "Lament for Ignacio Sánchez Mejías."

In this painting the austerity of the monochrome palette and the regimentation of the composition into regular bars and ovals provide a dramatic foil for the spontaneous emotive elements, such as the loose gestural brushwork, the paint drips, and the free irregularity of the artist's rebellion against the self-imposed compositional order of alternating bars and ovals. The resistance to order embodied in the personal eccentricities of the work stands for resistance to order on wider fronts—psychologically, politically, and culturally. It has a complex layering of metaphorical meaning that is specific in its associations on several levels, despite its abstract vocabulary.[63]

The specificity of the subject matter in the abstractions of Motherwell and of the other New York School artists has been stressed by all of them. When Motherwell recalled painting this enlarged version of the drawing, he spoke about metaphors of "abandonment, desperation, and helplessness."[64] In the act of painting he transformed these emotions into a poetic vision on a tragic and universal scale. As he recalled it, "when I painted the larger version—*At Five in the Afternoon*—it was as if I discovered it was a temple, where Harold's [the small version he had made for *Possibilities*] was a gazebo, so to speak. And when I recognized this, I looked around for … what the temple should be consecrated to, and that was represented in the work of Lorca."[65]

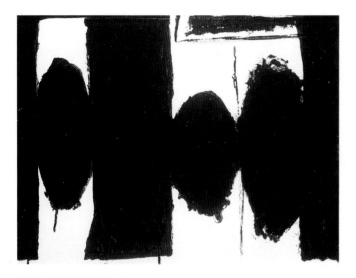

3.33 Robert Motherwell, *At Five in the Afternoon*, 1949. Casein on composition board, 15 × 20in (38.1 × 50.8cm).
Collection, Helen Frankenthaler, New York. Photograph by Peter A. Juley & Son, New York. © Dedalus Foundation Inc./VAGA, New York, 1994.

The execution of the Spanish poet, García Lorca, by the Fascists in the Spanish Civil War of the thirties became a symbol of injustice. For many artists and intellectuals it embodied the modernist confrontation with established cultural values. As Motherwell once remarked, the theme of all the "Elegies," is the "insistence that a terrible death happened that should not be forgot."[66] The term "elegy" itself means a funeral dirge or lament. Lorca's poem concerns a heroic bullfighter who is gored in the ring, and three symbolic colors create auras around the key images of

the poem—the red blood, the bleaching white light of the sun, and the blackness of death and shadows.

After painting *At Five in the Afternoon* Motherwell did a number of other works on the same compositional principle of black alternating bars and ovals over a white ground, and named them after various Spanish cities. He then went back and entitled the whole series "Elegy to the Spanish Republic" and began numbering them; this theme persisted for the remaining forty years of the artist's career [fig. 3.34]. Generally Motherwell painted the "Elegies" on a large, mural scale and worked by composing the major forms and then, later, filling them in. The contours and drips were modulated at the end of the painting process, and it is these areas that carry the most intense expressive content in the compositions.[67]

The "Elegies" constituted the first of several major thematic structures in Motherwell's work. The second to emerge was the "Je t'aime" series [fig. 3.35], most of which he painted between 1953 and 1957 during the latter half of his second marriage (1950–7). Motherwell's two daughters were born in these years; his friendship with David Smith also dates from this time (1950); as did his shift from summering in the Hamptons to summering in Provincetown (as of 1956). The "Je t'aime" series are characterized by the French phrase (meaning "I love you") written across the canvas. The inscription is redolent of the elegance of mediterranean culture and is usually surrounded by tempestuous color and raw brushwork.

3.34 Robert Motherwell, *Elegy to the Spanish Republic, No. 78*, 1962. Oil and plastic on canvas, 5ft 11in × 11ft¼in (1.8 × 3.36m).
Collection, Yale University Art Gallery, New Haven, Conn. Gift of the artist. © Dedalus Foundation Inc./VAGA, New York, 1994.

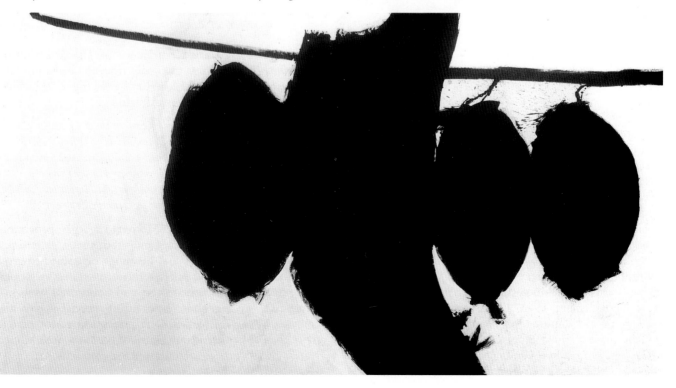

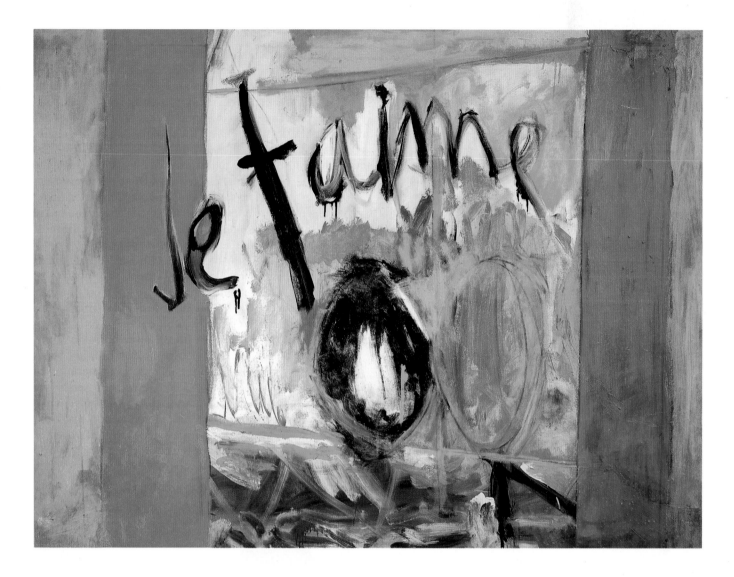

3.35 Robert Motherwell, *Je t'aime No. 2*, 1955. Oil on canvas, 4ft 6in × 6ft (1.37 × 1.83m).
Collection, Mr. and Mrs. Gilbert Harrison, New York. © Dedalus Foundation Inc./VAGA, New York, 1994.

Motherwell based the third major series, the "Opens," on a compositional device. He began them in 1967/8, just after his marriage to the painter Helen Frankenthaler ended. These works involve a geometric division, usually a three-sided window or box motif coming down from the top of the canvas. The austere clarity of their structural architecture seems to equate to the emphasis on analysis promoted by formalist critics of the sixties (notably by Greenberg, who was close to Frankenthaler). Nevertheless the proportion and often even the drawing of the "Opens" rely on an instantaneous gesture which is as spontaneous as the gestural elements in an "Elegy."

Despite the limiting parameters of the format, the "Opens" have a broad expressive range. *The Blue Painting Lesson* [fig. 3.36], a five painting sequence, has a rich, warm blue that evokes the refreshing sensuality of the seaside.

The emphasis on direct experience in *The Blue Painting Lesson number one* differs markedly from the brooding tone of a metaphysical work like *In Plato's Cave* [fig. 3.37], which, as the artist explained, refers to Plato's

famous image of art as the shadow cast on the dark cave's wall by persons passing by the fire. For Plato, art is an inferior third order of reality (like a shadow), just as an individual person is an inferior second order of reality, as compared to the primary reality of an archetypal, metaphysical person. "In Plato's Cave" is also the name of a superb poem by ... Delmore Schwartz.[68]

In the seventies and eighties Motherwell began generating more and more distinct series and subthemes within series. The subtlety of his work and his range continued to grow with increasing formal self-assurance. It seems as though every new work generated fresh and unresolved issues for him, while at the same time fitting precisely into the complex totality of his aesthetic project. For Motherwell, more than any other major figure of the New York school, painting was a process of philosophical elaboration.

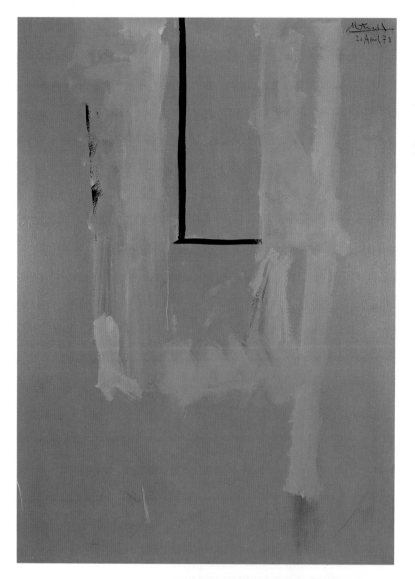

3.36 Robert Motherwell, *The Blue Painting Lesson: A Study in Painterly Logic, number one of five,* April 20, 1973. Acrylic on canvas, 5ft 1in × 3ft 8in (1.55 × 1.12m).

Collection, Dedalus Foundation Inc. © Dedalus Foundation Inc./VAGA, New York 1994.

3.37 Robert Motherwell,
In Plato's Cave No. 1, August
19, 1972. Acrylic on sized
canvas, 6 × 8ft
(1.83 × 2.44m).

Collection, Dedalus Foundation Inc.
Photograph by Steven Sloman, New
York. © Dedalus Foundation Inc./VAGA,
New York, 1994.

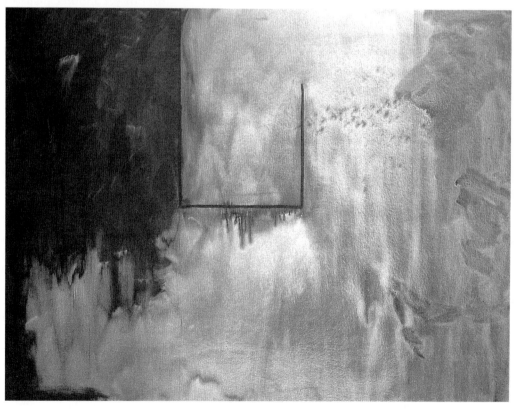

Willem de Kooning

Willem de Kooning's *Woman and Bicycle* [figs. 3.38 and 3.39] is a dozen different paintings superimposed on one another. Patches of raw canvas lie at the bottom edge of the composition adjacent to geometric forms in flat green, resembling the backgrounds to his seated women of the early forties [fig. 3.41]. As the viewer looks up from the lower edge of *Woman and Bicycle*, the anatomy of the feet and calves disintegrates into the turbulent cross-layering of brushwork. Strokes of many colors and speeds erupt in all directions, the intensity of each one cancelling out the one below it. Light wisps dance over thickly applied masses of pigment; forceful vectors of contrasting colors collide in skirmishes of the brush that appear and then disappear again under the quick smear of a palette knife.

Here and there a sense of the figure comes into focus and quickly out again. "Content is a glimpse of something, an encounter like a flash,"[69] the artist explained. The enormous fleshy breasts bulge forward, then at second glance they seem flat, like a cutout that clings to the surface of the picture plane. A second grinning mouth hangs around the neck like a glittering necklace; it remains from a previous position of the head, an earlier composition, now largely crossed out. This is a painting in a perpetual state of redefinition. No passage is more than a temporary point *en route* to a new approximation. The inherently "unfinished," always "in process" character of de Kooning's work makes this canvas seem as freshly painted today as it did when the artist made it half a century ago.

De Kooning's inability to "finish" a canvas was already legendary in the early forties.[70] Sometime in 1950 Rosenberg recounted seeing *Woman I* and thinking that the painting looked finished. But as he and de Kooning started talking about it, the artist slipped back into the train of thought that had led up to it; then he picked up a loaded brush and slapped it across the center;[71] it was two more years before the artist let the picture go. Yet the characteristic "unfinished" quality of de Kooning's work expresses his underlying aesthetic. He once described one of the large "Woman" pictures by saying: "It's not finished but it's a very good painting."[72] If it were finished, one imagines, it surely would not look so good.

De Kooning cultivated the inherent ambiguities in every situation. In *Woman and Bicycle* he created extreme spatial oppositions: the breasts read alternately as a flat pattern and as fully rounded forms; the energetic brushwork creates an expansive surface plane that provides a background for the figure while at the same time absorbing it; this active surface in turn seems to hover in front of yet another plane of flat background implied at the bottom edge. De Kooning heightened the disconcerting effect of the figure–ground relationships by constantly dissolving and reformulating contours and forms. All these expressive oppositions serve to create a figure that is simultaneously menacing and sensuous. Even the bold and authoritative handling is undercut by a frenetic, nervous, and tentative flipside.

Woman and Bicycle belongs to de Kooning's famous series of slightly over-life-sized women, painted in the early fifties. The style itself is an attack on closed systems, finality, and any fixed way of looking at things. "There is no plot in painting," de Kooning told Harold Rosenberg. "It's an occurrence which I discover by, and it has no message."[73] So de Kooning used the act of painting to examine things around him, keeping all possibilities open and maintaining an atmosphere of uncertainty. He had "slipping glimpses,"[74] as he called them, of things as they glanced in and out of apprehension. In pursuing a thought, he might obliterate the preceding idea or direction completely. This open-ended working process embodied Rosenberg's idea of the action painter, and it is a fundamental assertion of existence, of being alive, of resisting dissolution in the chaos of modern life.

De Kooning read widely in philosophy and literature, and he particularly liked Kierkegaard's idea that everything necessarily contains its opposite. "That's what fascinates

3.38 (opposite) **Willem de Kooning,** *Woman and Bicycle,* 1952–3. Oil on canvas, 6ft 4½in × 4ft 1in (1.94 × 1.24m).

Collection, Whitney Museum of American Art, New York. Purchase. Photograph by Geoffrey Clements, New York. © 2000 Willem de Kooning Revocable Trust/Artists Rights Society (ARS), New York.

3.39 Willem de Kooning, *Woman and Bicycle,* detail.
© 2000 Willem de Kooning Revocable Trust/Artists Rights Society (ARS), New York.

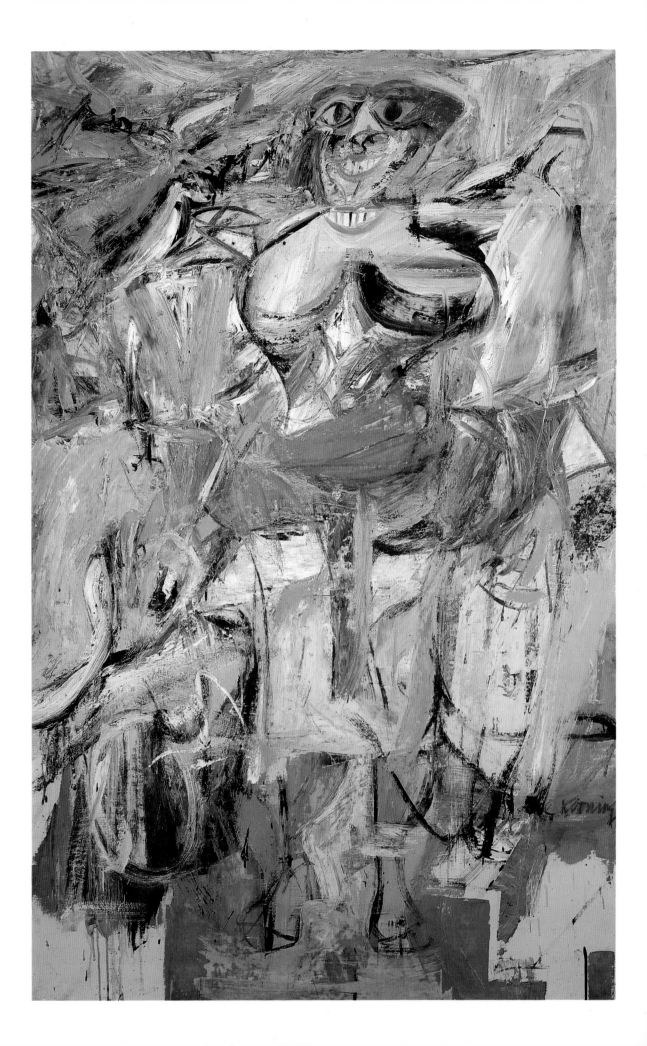

me," he told Rosenberg; "to make something that you will never be sure of, and no one else will … That's the way art is."[75] Yet de Kooning did not have the same distinctively American consciousness of Pollock or Newman, for example, who promoted the idea that they started from scratch each time they began to paint. De Kooning referred to that notion as "making art out of John Brown's body … standing all alone in the wilderness."[76] Instead de Kooning celebrated his deep engagement with the painting of the old masters, and felt more akin to Titian and Rembrandt than to Mondrian, Kandinsky, or the surrealists.

Nevertheless de Kooning lived entirely in the present; he did not look back to a golden age or forward to a more perfect future. In this respect he and his fellow painters of the New York School differed from such modernist precursors as Mondrian or Kandinsky, who had sought to lead the way to Utopia through their art. "Art never seems to make me peaceful or pure," de Kooning observed. "I always seem to be wrapped in the melodrama of vulgarity."[77]

De Kooning's Training and Early Career

De Kooning was born in Rotterdam, the Netherlands, on April 24, 1904. His early training at the Rotterdam Academy of Fine Arts and Techniques stressed craftsmanship, and there he studied foreshortening, modeling, and the rendering of light and shadow. His *Still Life: Bowl, Pitcher, and Jug* [fig. 3.40], drawn at the age of seventeen, demonstrates his prodigious skill at rendering. Made with little dots of conté crayon (a type of compressed charcoal stick), it rivals a photograph in its realism.

Thanks in large part to this training, de Kooning had many technical tricks up his sleeve for which he was to

3.40 Willem de Kooning, *Still Life: Bowl, Pitcher, and Jug,* c. 1921. Conte crayon and charcoal on paper, 18½ × 24¼in (47 × 61.6cm).

Collection, Metropolitan Museum of Art, New York. Van Day Truex Fund, 1983. © 2000 Willem de Kooning Revocable Trust/Artists Rights Society (ARS), New York.

become well-known among Greenwich Village artists by the mid thirties. For example, when Gorky was struggling in vain to achieve some of Miró's effects, he turned to de Kooning, who showed him how to use a liner's brush (a special long-haired brush used in painting precise decorative lines on the sides of automobiles). According to Rosenberg, Gorky was so fascinated that he sat down and did arabesques with the liner's brush for days afterwards.[78]

De Kooning arrived in the United States in 1926 at the age of twenty-two, moved into a Dutch seaman's home, and took work as a house painter in Hoboken, New Jersey, for $9 a day. He came to New York aspiring to a career as a commercial artist, but when he finally found a job in the field, he discovered that it paid no more than house painting. At this point de Kooning decided to start thinking of himself as a fine artist,[79] and in 1927 he moved into a loft on Manhattan's 42nd Street, still supporting himself with odd jobs, including commercial art, department store displays, sign painting, and carpentry.

In 1935 de Kooning signed on to the Federal Art Project. But the government barred aliens at the end of 1936, so he had only one year on the F.A.P. Like everyone else on the project he earned the now famous $23.86 a week, and by de Kooning's unique style of reasoning, the fact that this salary was what the government paid an artist led him to conclude that it therefore cost only $23.86 a week to be an artist full time and that seemed like a bargain! Curiously the Depression was a good time for many young artists and writers. While older people lost businesses or their life's savings, young people had a special opportunity through the Works Progress Administration (W.P.A.). There was an excitement about social and intellectual ideas, people had time to talk, and money didn't matter; it could not get in the way since no one had any. There were no picture sales, no exhibitions, no careers to worry about. Although de Kooning had a great underground reputation among artists, he exhibited very little before the end of the forties and sold virtually nothing.

De Kooning met Arshile Gorky and Edwin Denby around 1927, and they became his closest friends. He also spent time with John Graham and Stuart Davis, from around 1929. By 1936 his circle included David Smith, Clement Greenberg, Fairfield Porter, Rudi Burckhardt, and Harold Rosenberg. John Graham enlisted de Kooning's participation in a 1942 exhibition, through which he met Pollock. But when Peggy Guggenheim invited de Kooning to show at the Art of This Century gallery, he refused. Not only was he reluctant to show his work when he had only just begun to find his own stylistic voice, but he also disliked the surrealists in Peggy Guggenheim's circle,[80] as did his friend John Graham. It was not until after his first one-man show at the Egan Gallery in 1948 that de Kooning began exhibiting actively.

The dominant influence on de Kooning's work of the thirties was that of his friend Gorky, through whose eyes he saw Miró, cubism, and abstract surrealism. De Kooning and Gorky associated with a circle of chiefly abstract artists even though they were both painting the figure; as a consequence, the

3.41 Willem de Kooning, *Seated Woman,* c. 1940. Oil on charcoal on masonite, 54¼ × 36in (137.8 × 91.4cm).
Collection, Philadelphia Museum of Art. Albert M. Greenfield and Elizabeth M. Greenfield Collection. © 2000 Willem de Kooning Revocable Trust/Artists Rights Society (ARS), New York.

public still regards them both as abstract artists, even though neither ever abandoned figurative imagery. De Kooning, in particular, nearly always worked in both abstract and figurative modes simultaneously and in relation to one another.

The permanent trademarks of de Kooning's style emerged around 1939 or 1940 in such works as *Seated Woman* [fig. 3.41]. In particular, the painting nakedly shows the artist's method of working, a process which gives the canvas its characteristic unfinished look. Here the artist stopped at a point where one still senses the ongoing struggle for resolution. In addition he intensified the color and radically fragmented the figure. De Kooning talked of how a "frozen glimpse" would come to him[81] in the process of painting, and one can see that here, in the independent identity of the anatomical parts as abstract forms.

The various altered positions of the crossed leg in *Seated Woman* have more affinity with the *pentimenti* (visible changes of mind) in Picasso's drawings for *Guernica* than with the automatic drawing of the surrealists. However, in

de Kooning's painting, this appearance of work-in-progress lacks the elegance of the Picassos. In general, painters of the New York School in the forties rejected the refinement in composition and touch of the School of Paris. Moreover, *Seated Woman* shows de Kooning's discomfort with foreshortening, which he largely avoided, and despite some indication of a space behind the figure, the whole composition seems to be flattened against the picture plane, as in cubism [fig. 3.25].

The Dissolution of Anatomy into Abstraction

In 1944 and 1945 the anatomical fragments, with their multiplicity of drawn and redrawn lines, began taking over de Kooning's abstraction like a speculative commentary on the concurrent paintings of women. The compositions of 1944 began to convey the tension of de Kooning's investigative process much more vividly than his preceding works had done. The drawing in *Pink Angels* [fig. 3.42], for example, reveals a continuing trial and error process in the plethora of transparent overlappings. Meanwhile the forms in the picture hint at a figurative reference.

3.42 Willem de Kooning, *Pink Angels,* 1945. Oil on canvas, 4ft 4in × 3ft 4in (1.32 × 1.02m).

Collection, Frederick Weisman Company, Los Angeles. © 2000 Willem de Kooning Revocable Trust/Artists Rights Society (ARS), New York.

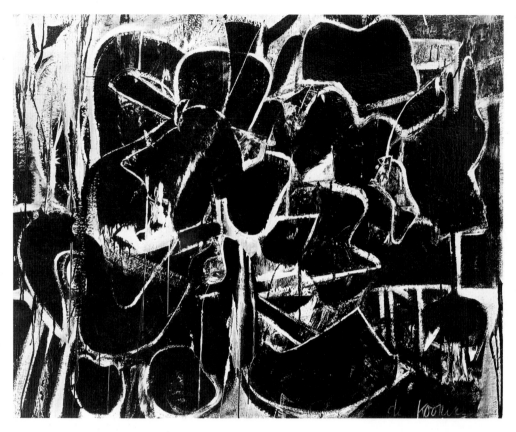

3.43 Willem de Kooning,
Painting, 1948. Enamel and oil on
canvas, 3ft 6⅝in × 4ft 8⅛in
(1.08 × 1.42m).
The Museum of Modern Art, New York.
Purchase. © 2000 Willem de Kooning
Revocable Trust/Artists Rights Society (ARS),
New York.

Most of the shapes in de Kooning's abstractions of the forties seem to have evolved from human anatomical parts. De Kooning pointed out that "even abstract shapes must have a likeness,"[82] a kind of meaningful familiarity that their derivation in the figure provides. At about this time de Kooning also seems to have begun tracing forms and reusing them in other compositions, thereby further heightening their familiarity by linking them to other pictures as well as to objects and events. In the abstractions of 1946 the anatomical fragments woven together by the abundant linear *pentimenti* began to disperse themselves into an allover composition, as in the contemporaneous works of Pollock, and they created a curtain of flat forms that asserts the surface of the picture plane.

At this point de Kooning embarked on a powerful series of predominantly white on black paintings that climaxed in 1948 and 1949 with such works as the large *Painting* [fig. 3.43]. This composition relies on the same vocabulary of flat-patterned anatomical parts as de Kooning's other abstractions around this time. But because of its limited palette it creates an even greater ambiguity of space and volume than his more colorful compositions by establishing a more continuous surface of interpenetrating planes. De Kooning included some of the black paintings in his first one-man show at the Egan Gallery in 1948—the same year that Pollock first showed his ground-breaking drip pictures.

In 1948 de Kooning and several of his friends organized what came to be known as "The Club." De Kooning said he wanted a social club like the store front parlors in the working-class Italian and Greek neighborhoods nearby. "We didn't want to have anything to do with art; we just wanted to get a loft, instead of sitting in those god-damned cafeterias."[83] So they pitched in and rented a loft on 8th Street, where the artists could just relax together. In the summer of 1948 de Kooning taught at Black Mountain College in North Carolina with Josef Albers, John Cage, and Buckminster Fuller. He also visited East Hampton for the first time in April 1948 when he and his wife Elaine went out with Charles Egan to see the Pollocks.

During 1947 and 1948 de Kooning continued to paint the seated women alongside the great abstractions. In some pictures he also added yet another syntactical level by painting in letters and numbers. *Attic* and *Excavation* [fig. 3.44] come the closest of de Kooning's major compositions to the "allover" style of Pollock's contemporary drip paintings [figs. 4.1 and 4.5–4.8]. De Kooning achieved this effect by building up such a density of forms that the overabundance of images fills every available space within the confining edges of the frame. This results in an even dispersal of the anatomically suggestive elements across the entire surface. The allover compositions of both Pollock and de Kooning brim over with energy, but where Pollock is assertive, de Kooning is quizzical. Another difference is that de Kooning packed his compositions so tightly that they seem to collapse in on themselves like black holes, whereas the Pollocks seem to expand outward.

A close look at *Excavation* and any number of other de Kooning pictures from the late forties onward reveals what

look to be fragments of newsprint buried under the surface. De Kooning frequently used sheets of newspaper to slow up the drying of the paint, and if he did not rework an area it retained a ghost of the photographs or columns of type. He liked this effect for its added complexity, but he did not construct a systematic iconography around such elements in the way Picasso did in his collages of 1912 to 1914. For de Kooning the complexity of the individual's experience, especially in the urban environment, was central. The ubiquitous impressions of newsprint enhance the effect of the random overload of sensory information and anticipate the arbitrary accumulations of Robert Rauschenberg's "combine paintings" of the mid fifties.

3.44 Willem de Kooning, *Excavation,* 1950. Oil on canvas, 6ft 8in × 8ft 4⅛in (2.03 × 2.54m).

Collection, Art Institute of Chicago. Gift of Mr. and Mrs. Noah Goldowsky and Edgar Kaufmann, Jr.; Mr. and Mrs. Frank G. Logan Prize Fund, 1952.1. © 2000 Willem de Kooning Revocable Trust/Artists Rights Society (ARS), New York.

In *Excavation* de Kooning fragmented anatomy into abstract parts and distributed them within a decentralized composition. But he seems also to have been conscious of developing a greater richness of symbolic meaning within each form. For this reason the work is more intellectually sophisticated than anything de Kooning had done before it. Like *Woman and Bicycle, Excavation* betrays its simpler thematic origins at the bottom edge. As the viewer moves upward, the superimposed associations grow more subjective and complicated.

Excavation appears to originate with impressions of a city's excavation site, with a backhoe and steamshovel represented in geometric forms at the lower right. Architectural supports (perhaps beams or piers) stand in a cadence of verticals across the bottom, and midway up on the left one can see a small block of older buildings, including a yellow-roofed tower. But the scale of these buildings does not match that of the earthmoving equipment; despite the unity of theme, then, there is a continuing transformation of the mental context as we move up the composition.

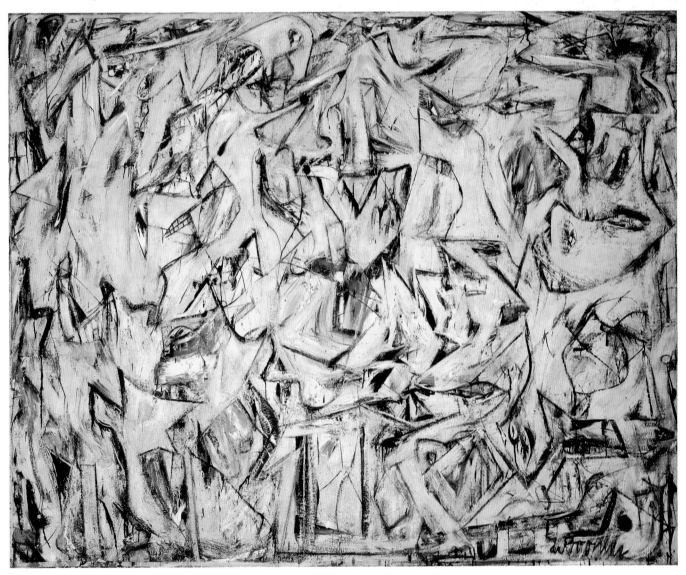

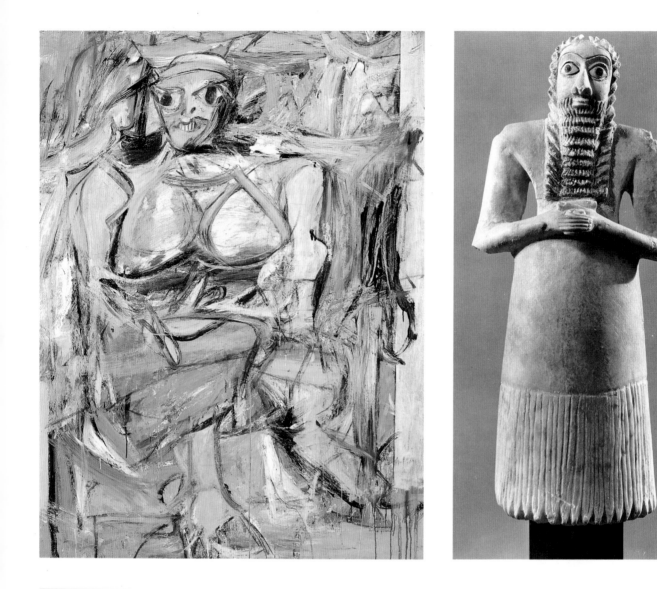

3.45 (above) **Willem de Kooning,** *Woman I*, 1950–2. Oil on canvas, 6ft 7⅞ × 4ft 10in (1.92 × 1.47m).
The Museum of Modern Art, New York, Purchase. © 2000 Willem de Kooning Revocable Trust/Artists Rights Society (ARS), New York.

3.46 (above right), Ancient Sumerian standing male figure, Tell Asmar, c. 3000 B.C.
Collection, Metropolitan Museum of Art, Fletcher Fund, 1940.

The metamorphosis of scale and forms in *Excavation* occurred through the complex and arbitrary layering of impressions in the busy "no environment," as de Kooning called it,[84] of New York City. He filled the upper three quarters of this painting with an ongoing sequence of forms, each suggesting the next in an increasingly abstract train of thought. Here nothing remains legible except in a fragmentary way. The clearly delineated nipple on a breast mutates into an eye, as in the metamorphic expressionism of Picasso [fig. 5.20]. And to whom do the grinning teeth belong? The nude, the painter, or the Cheshire Cat?

Excavation is not a perspective space but a mental map of an interlocking chain of experiences over time. It is a large canvas—roughly 6½ by 8½ feet—but it remains an easel picture made up of emotionally charged details rather than a mural to be read at a distance. "The squarish aspect," de Kooning explained, "gives me the feeling of an ordinary size. I like a big painting to get so involved that it becomes intimate ... looks smaller."[85] Some of this intimacy also derives from de Kooning's brushwork, which started to take on a life of its own in *Excavation*.

The Anatomical Forms Dissolve into Brushstrokes

Immediately after the completion of *Excavation* in the late spring of 1950 de Kooning embarked on a series of monumental paintings of women [figs. 3.38, 3.39, and 3.45]—the most celebrated works of his career. "It's really

**3.47 Willem and Elaine
de Kooning,** 1953.
Photograph by Hans Namuth. © 1991
Hans Namuth Estate. Courtesy Center for
Creative Photography, the University of
Arizona.

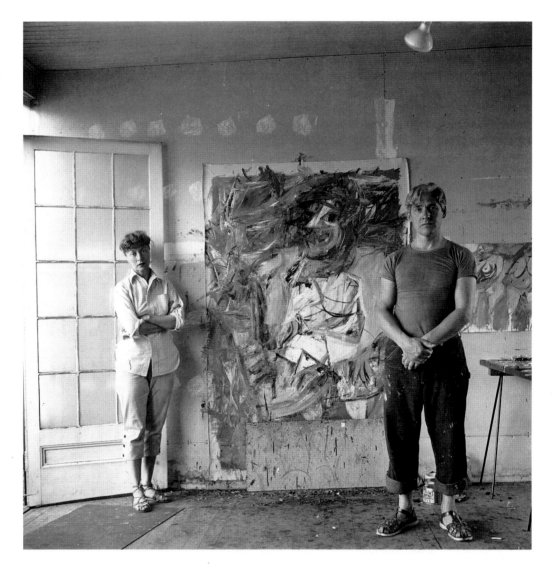

absurd to make an image, like a human image, with paint, today, when you think about it," he told David Sylvester in 1960. "… But then all of a sudden it was even more absurd not to do it."[86] Unlike the planar seated women of the early forties, these women are sensuous, full-figured Aphrodites of vulgar warmth, like the paleolithic *Venus of Willendorf*, which he cited as an inspiration for the series.[87]

De Kooning not only looked at Stone Age Venuses in books but also went to study Cycladic and Sumerian figures [fig. 3.46] in the Metropolitan Museum. The huge-eyed expressions of the Sumerian idols made them seem to de Kooning "like they were just astonished about the forces of nature."[88] Likewise, the 1948 exhibition of Giacometti's new figural sculpture [figs. 5.15–5.17] at Pierre Matisse[89] conveyed a sense of the fragile and fleeting existence of the individual in relation to "the forces of nature." Like *Woman I*, Giacometti's figures have a heavily gestural surface and hover on the edge of abstraction, exploring their own tentative presence and scale in relation to the world around them. According to Elaine the show "knocked him out—it

was crucial; it looked like the work of a civilization—not one man."[90] The primitive sexuality and raw textural handling of Dubuffet's monumental frontal nudes [fig. 5.8] (shown at Pierre Matisse in January 1951) also have a strong resonance with de Kooning's monumental women.

The explicit subject of de Kooning's "Woman" paintings is obvious, but there has been much speculation as to their specific inspiration. Thomas Hess thought that de Kooning's mother, who had been a tough bartender in a Rotterdam sailors' bar, provided the prototype for the "monstrous" females;[91] others suggested that Elaine was the subject, an assertion that she found so preposterous that on August 23, 1953 she asked Hans Namuth to photograph her in front of one of them [fig. 3.47] to "establish once and for all that I did not pose for these ferocious women. I was taken aback to discover in Hans' photograph that I and the painted lady seemed like … mother and daughter. We're even smiling the same way."[92]

If intimations of Elaine provided a starting point for these paintings, then feelings about the artist's mother,

about the comical variety of costume and mannerism among the ladies shopping on 14th Street, and the pretty pin-ups on his studio wall all entered into the complex sequence of thoughts that led gradually to the final compositions. "The *Women*," de Kooning mused, "had to do with the female painted through all the ages … I look at them now [in 1960] and they seem vociferous and ferocious. I think it had to do with the idea of the idol, the oracle, and above all the hilariousness of it."[93] "I *like* beautiful women. In the flesh, even the models in magazines," he told one interviewer.[94]

In a conversation with Rosenberg, de Kooning noted that *Woman I* also reminded him of water—of his childhood in the Netherlands near the sea, of working on the porch at Leo Castelli's house in East Hampton where he painted the first "Woman" paintings; subsequently, even when he painted a "Woman" picture in the city, he would "get a feeling" again of the ocean.[95] Like *Woman and Bicycle*,

Woman I has a small portion of flat, geometric background along the edge of the canvas (in this case along the right edge). This allusion to the flat backgrounds of de Kooning's earlier paintings of women implies a continuity in the development of the "Women" of the fifties that parallels their physical gestation. As one association built upon another, so the paint was put down layer by layer, as de Kooning explored the subject on the canvas.

But ultimately these "Women" of the fifties, like all of de Kooning's paintings, had to do with testing and mastering his immediate personal experience. They represent the subjective "reality" of the artist. Harold

3.48 Willem de Kooning, *Gotham News*, 1955–6. Oil on canvas, 5ft 9in × 6ft 7in (1.75 × 2.01m).

Collection, Albright-Knox Art Gallery, Buffalo, New York. Gift of Seymour H. Knox, 1955.
© 2000 Willem de Kooning Revocable Trust/Artists Rights Society (ARS), New York.

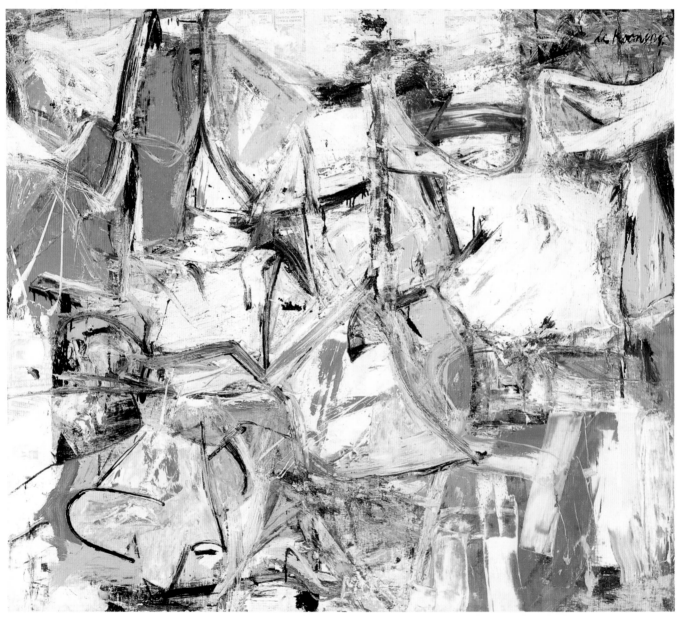

3.49 Willem de Kooning, *Two Figures,* 1967.
Oil on paper, mounted on canvas, 35¾ × 23¾in
(90.8 × 60.3cm).

Collection, Toyota City Museum of Art, Nagoya, Japan.
Photograph courtesy Grete Meilman Fine Art, New York. © 2000
Willem de Kooning Revocable Trust /Artists Rights Society (ARS),
New York.

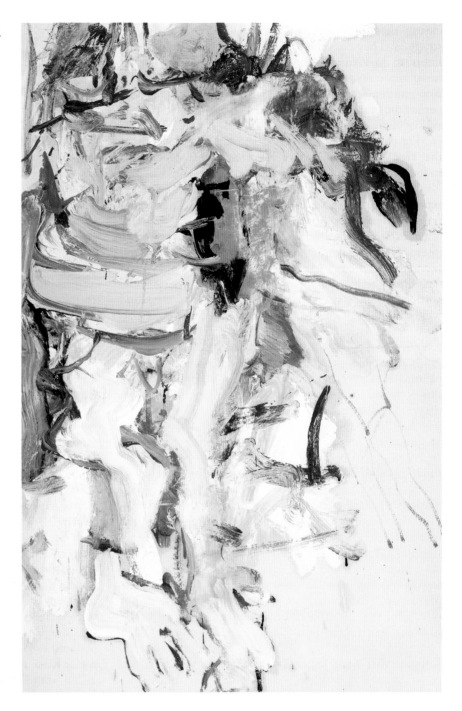

Rosenberg challenged de Kooning on this point:

R: *The way you see something doesn't mean necessarily that that's the way it is. Putting a stick in water so that it looks as if it's broken …*

de K: *Well it is. That's the way you see it.*

R: *What do you mean, it is broken? If you pull it out of the water it's not broken.*

de K: *I know. But it's broken while it's in the water.*

R: *The break is an illusion …*

de K: *That's what I am saying. All painting is an illusion.*[96]

The painter must, in de Kooning's view, entertain any hypothesis: "In art one idea is as good as another";[97] at issue is what the artist does with an idea. Since all art is a matter of ideas to begin with, it made no sense to de Kooning even to distinguish abstract from representational painting.[98]

During the fifties de Kooning increasingly emphasized painterly gestures, muscular brushwork, and rich color. The central image of the figure, as an organizing principle for the composition, permitted greater freedom in the process of painting than did the anatomical segments, which needed a separate structural scheme. The "Women" also showed more

clearly than previous paintings all the artist's creative struggles. They convey the sense not of a finished painting but of an arrested moment in the defining of a problem. "I never was interested in how to make a good painting," de Kooning remarked. "... I didn't work on it with the idea of perfection, but to see how far one could go—but not with the idea of really doing it."[99]

For the academic year of 1950/1, de Kooning taught at the Yale Art School, where his friend Josef Albers had become the dean after leaving Black Mountain College. Teaching was a draining experience that de Kooning never repeated after this, but he still was not selling much and remained very poor. Thomas Hess recalled that "he ate in dingy cafeterias; he ducked landlords; once he received a message to telephone the Museum of Modern Art and found that he did not have the nickel."[100] De Kooning joked with Rosenberg: "[Sidney] Janis wants me to paint some abstractions and says he can sell any number of black and whites. But he can't move the women. I need the money. So if I were an *honest* man, I'd paint abstractions. But I have no integrity! So I keep painting the women."[101]

Nevertheless in January 1950 de Kooning had a painting in the prestigious Whitney Annual; in June he had one of the six one-person shows in the American section of the Venice Biennale; in 1951 the Museum of Modern Art put him into their important "Abstract Painting and Sculpture in America" exhibition; and in April of the same year Egan gave him his second one-man gallery show. The Egan show consisted of abstractions, confirming the art world's impression of de Kooning as an abstract artist. Sidney Janis signed up de Kooning for the artist's third one-man show in March 1953, in which he presented the monumental "Women" (five of them) for the first time.

The "Women" scandalized many people, even some of de Kooning's friends who found it hard to accept the unavoidable fact that the paintings were not abstract. The Museum of Modern Art bought *Woman I* from the show but in general the collectors did not respond to the work—de Kooning had to continue living on a shoestring. When Greenberg delivered the Olympian pronouncement to de Kooning that "it is impossible today to paint a face," de Kooning came back with: "That's right, and it's impossible not to."[102] In the sixties Greenberg had begun openly attacking de Kooning.

By 1954 deliciously sensuous figures in the Marilyn Monroe mold had begun to supplant the more grotesque and ferocious *Woman I* and her sisters. De Kooning even titled one of these new works *Marilyn Monroe*, and when Selden Rodman asked him why he painted her he said: "I don't know. I was painting a picture, and one day—there she was." "Subconscious desire?" Rodman asked. "Subconscious hell!" the artist laughed.[103] The "Women" of the early fifties all inhabit the "no-environment" of the city, where one cannot tell what is indoors or outdoors; an architectural detail could be in the lobby of Rockefeller Center or outside on the façade of a building. This setting extends the simultaneously disturbing and enticing ambiguity of the figures themselves.

De Kooning's Abstractions of the Fifties

Around 1955 de Kooning turned away from the figure toward complex, urban abstractions, filled with the bustle of 10th Street; in works such as *Gotham News* [fig. 3.48] de Kooning portrayed the "no-environment" in itself. As mentioned earlier, de Kooning put sheets of newspaper on the surface of his pictures to keep the paint workable, and the traces of type, the pinups and advertisements are especially prevalent in this group of abstractions. Newsprint artifacts of commercial America belong to the complexity of the city. At one point early in the genesis of the large "Women," de Kooning cut out numerous mouths from pictures of women in magazines and glued them on to his compositions;[104] thus advertising and the media already figured as an underlying theme of the series.

Where the abstractions of the late forties and early fifties are centripetal, the abstractions of the late fifties and early sixties are more expansive compositions, featuring broader strokes and flatter, more lyrical color. A feeling of countryside pervades these paintings. They are impressionistic in comparison to *Excavation* or even *Gotham News*, which require detailed and lengthy scrutiny. According to de Kooning, "they're emotions, most of them ... landscapes and highways and sensations of that [i.e. of landscapes and highways], outside the city."[105]

De Kooning's 1956 show of abstractions at the Sidney Janis Gallery sold well, and he started to make some money. He moved in with Joan Ward when she gave birth to his daughter Lisa in 1956, although Elaine remained very much part of his daily life. In 1958 and again in 1959/60 he visited Italy, and after his highly successful 1959 exhibition of large abstractions at Janis he retreated from the scene, spending less and less time in the city, rarely attending parties, and never answering his telephone. De Kooning's growing numbers of imitators were a real psychological burden to him. In order to discourage people from bothering him, he even stopped his landlord at 831 Broadway from installing an elevator. In 1954 the de Koonings had rented a house in Bridgehampton, Long Island, with Franz Kline, Ludwig Sander, and Nancy Ward. Then in 1955 Elaine successfully encouraged her brother Peter to buy a house next to the Rosenbergs on Acabonic Road in East Hampton. In 1963 de Kooning built a new studio in The Springs (part of East Hampton), vacated his Manhattan loft, and moved out to Long Island permanently.

The "Women" of the Sixties and the Late Works

The paintings of women that de Kooning began in 1961 have the same loose, sensuous handling as the abstractions of the same period, though he saturated the figures with richer color and a greater buildup of smaller

brushstrokes. Even the simplest of pencil drawings from this time [frontispiece] have a fleshy voluptuousness. The "Women" of the sixties are more relaxed and more frankly sexual; increasingly, too, the contours of the figure open out with a lateral sweep into expansive surrounding landscapes. These nudes belong to the tradition of Rubens, although their bodily functions and appetites are more explicitly revealed.

Two Figures [fig. 3.49] portrays women on the beach, with the sea in the background, in a landscape bathed in brilliant sunlight. Typically de Kooning used the colors suggested by the environment—a natural palette, in contrast to Léger or Mondrian, whose primary colors indicated the prevalence of theory and system over nature. From the beginning de Kooning's "Women" have always in some way originated in nature. Each figure had a specific and individual—if imaginary—character that seemed entirely real. On the 1966 *Woman Acabonic*, for example, he speculated: "I think she maybe is a woman who makes hats. She's kind of funny-looking; she's here for the weekend ... well, she's turning into her forties, I guess ... She's sweet and friendly. Don't you think so? People say I make such monsters. I don't think so at all."[106]

The loose, authoritative brushwork of de Kooning's figure paintings of the late sixties has a self-assurance that announces a late style as boldly distinctive as the late styles of Rembrandt or Matisse. *Two Figures* lacks the probative anxiety of the monumental "Women" of the fifties or the density of major abstract compositions like *Excavation*. Here the artist seems to enjoy the certainty of his hand as he savors the soft flesh, the rich light, and the fresh smells of the sea air. These late sixties

women express a joy of life in their tactile pleasure and in their appreciative portrayal of the human comedy.

On a trip to Rome in 1969 de Kooning modeled his first sculptures and over the next five years he made roughly twenty-five bronze figures, all employing the same gestural technique and style as his paintings of the late sixties. In 1970 he enlarged the scale and hired an assistant to handle such technical aspects as constructing armatures, but his improvisational manner of working often necessitated unconventional methods. In one case de Kooning used a coke bottle in a last-minute adjustment to the armature and left it exposed in the cast. In *Seated Woman on a Bench* [fig. 3.50] he stuck part of a modeled arm and hand on top of the head, along with the glove he wore to work on the piece.

In the early seventies the figures in de Kooning's paintings grew looser and more disembodied. In works of the mid seventies they disappeared completely into a new kind of "allover" abstraction made up of saturated strokes of color as highly defined as the anatomical segments of the forties. These compositions are diffused with a disconcertingly unanchored energy, like an electric forcefield. Then around 1980 the color thinned out into paler washes shot through with powerful wide strokes of black. Even at the age of eighty, painting continued to provide de Kooning with a means of exploring his relation to the perpetually changing conditions of existence. He could not avoid it. "Your individuality," he said, "is like having a rat in the room always walking around. You can't escape it," and yet, "at the end you take a walk in your *own* landscape. It's simple, feels good."[107]

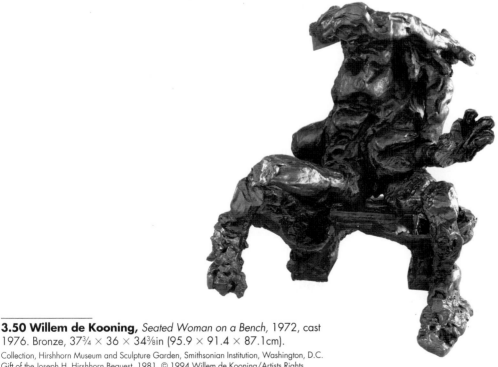

3.50 Willem de Kooning, *Seated Woman on a Bench,* 1972, cast 1976. Bronze, 37¾ × 36 × 34⅜in (95.9 × 91.4 × 87.1cm).

Collection, Hirshhorn Museum and Sculpture Garden, Smithsonian Institution, Washington, D.C. Gift of the Joseph H. Hirshhorn Bequest, 1981. © 1994 Willem de Kooning/Artists Rights Society (ARS), New York.

Jackson Pollock

In 1956 Willem de Kooning pointed out that "every so often, a painter has to destroy painting. Cézanne did it, Picasso did it with cubism. Then Pollock did it. He busted our idea of a picture all to hell. Then there could be new paintings again."[1] As early as 1942 Jackson Pollock was working at the defining edge of new painting. The painter Lee Krasner, with whom he lived from 1942 until the end of his life, reported that "in front of a very good painting … he asked, me 'Is this a painting?' Not is this a good painting, or a bad one, but *a painting!* The degree of doubt was unbelievable at times. And then, again, at other times, he knew the painter he was."[2]

Pollock's *Male and Female* [fig. 2.12] relied on the surrealist device of automatism to yield the irrationally juxtaposed and associated anatomical fragments, numbers, and geometric shapes as well as the loose autographic brushwork. The frontality and the shallowness of the space in the work reveal the influence of cubism and of Picasso's interwar expressionism, particularly *Guernica* [fig. 2.10]. For the totemic figures, Pollock drew inspiration from African and Native American art and from the work of the Mexican muralists.

Yet whatever Pollock's indebtedness to preceding styles, the directness with which he permitted his unconscious to determine the form of this painting had no art historical precedent. The picture's "reality" lies not in any reference to the phenomenal world but in the truth of the unconscious mind. Beginning in 1947 Pollock further refined the language of this radical content with the technical innovation of pouring or dripping his paint (figs. 4.1 and 4.5–4.10]. In addition he dissolved the customary compositional focus on a central image and broke down the illusion of objects in space, arriving at an "allover" composition in which the seemingly limitless intricacy of surface texture creates a vast, pulsating environment of intense energy, completely engulfing the viewer.

Although many of the writings on Pollock have overplayed the myth of tragic heroism, the artist did affect a tough exterior: he was isolated and independent, and he gradually self-destructed in a downward spiral of emotional turmoil during his early forties, after a dozen prolific years of majestic painting. Pollock lived and worked with relentless drive, As Lee Krasner explained: "Whatever Jackson felt, he felt more intensely than anyone I've known. When he was angry, he was angrier; when he was happy, he was happier; when he was quiet, he was quieter …"[3]

Pollock's Early Life and Influences

Paul Jackson Pollock, born in Cody, Wyoming, on January 28, 1912, was the youngest of five sons in a working-class family. His mother had artistic aspirations and conveyed this sufficiently to her children that all five sons wanted to become painters. Pollock's father failed in one

4

EXISTENTIALISM COMES TO THE FORE

4.1 (opposite) **Jackson Pollock,** *Cathedral,* 1947. Enamel and aluminum paint on canvas, 71½ × 35¹⁄₁₆in (181.6 × 89.1cm).

Collection, Dallas Museum of Art. Gift of Mr. and Mrs. Bernard J. Reis. © 2000 Pollock-Krasner Foundation/Artists Rights Society (ARS), New York.

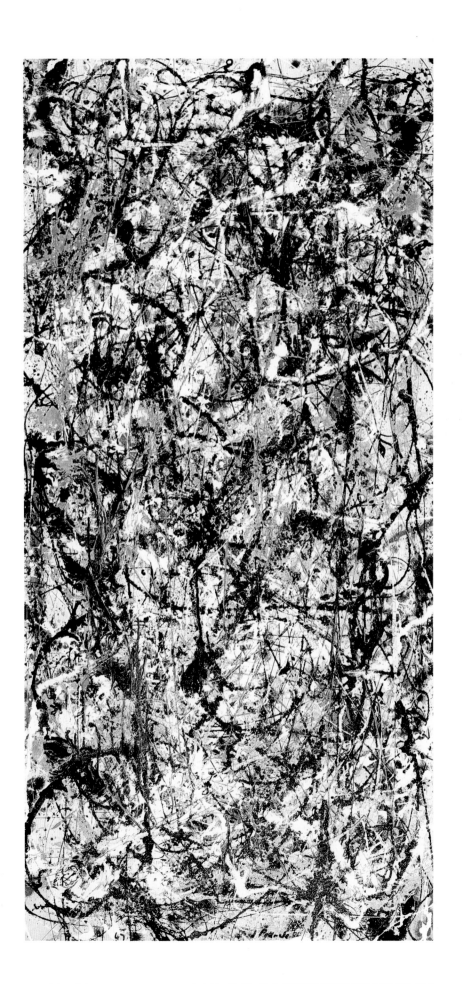

truck farm after another, causing an economic instability that forced the family to relocate seven times in Jackson's first twelve years. In the summer of 1927 Jackson and his eighteen-year-old brother, Sanford, worked on a survey team, roughing it on the North Rim of the Grand Canyon. Pollock discovered alcohol at this time and also dropped the name "Paul," which he thought less manly than "Jackson."

Pollock went to high school in Los Angeles with Philip Guston, who also became a major painter of the New York School. They were both rebellious and intellectual. After being expelled twice in two years for writing broadsides against the school's emphasis on athletics, Pollock gave up in 1930 and headed to New York, where he joined his eldest brother Charles in the classes of Thomas Hart Benton at the Art Students League. Pollock met Stuart Davis, who taught there, and Arshile Gorky, who was often to be found in the school cafeteria. Pollock stayed on at the League until Benton left in January 1933 but Benton's influence continued to dominate both the younger artist's subject matter and style until around 1938.

Inspired by mannerist and baroque art, the dramatic spatial composition of Benton's *The Arts of the West* [fig. 2.7] spills headlong toward the viewer from deep in space. Benton taught and used in his own work a rhythmic system of interlocking curves and countercurves—often disposed around imaginary vertical axes—as the underlying principle for his compositions.[4] This dynamic unfolding of the pictorial space provided an abstract metaphor for the idea of an inevitable unfolding in the evolution of history (an idea inspired by Marxist historical theories). Benton's choice of subject matter also echoed this in the sense that he attempted to show a continuity between present-day America and its ancient past. Long after his flirtation with Marxism and modernism in the early twenties, Benton retained this compositional characteristic.

Benton attempted to formulate a uniquely "American" style through the exploration of the country's historical subject matter and its contemporary life. His adulation of "American" frontier masculinity must have appealed to Pollock. Benton's work, reinforced by the example of the Mexican muralists [fig. 2.8], sowed the seeds for the emergence of a grand scale and an epic quality in Pollock's painting of the forties. But large size also suited Pollock's grand subject matter, which concerned universals in the human psyche, and the powerful instinctual forces that acted on his consciousness.

Like so many others at the time, the Mexicans held a Marxist view of historical evolution, and they hoped to incite their countrymen to social change by educating them about their heritage and about the relentless progress of history. The visit of David Siqueiros to Los Angeles in 1928 and reproductions of Mexican murals had already captured Pollock's interest before he left California. As a high-school student he had encountered Rivera's work through some communist meetings he attended. In 1936 Pollock took a job in Siqueiros's Union Square workshop,

where he experimented with unorthodox materials and novel techniques of application, including the spraying, splattering, and dripping of paint.

As Pollock moved away from Benton's influence and from representation as a whole, he focused increasingly on inner content. He found encouragement for this approach in an article by John Graham in 1937 called "Primitive Art and Picasso." In it Graham wrote that primitives,

satisfied their particular totemism and exteriorized their prohibitions (taboos) in order to understand them better and consequently to deal with them successfully. Therefore the art of the primitive races has a highly evocative quality which allows it to bring to our consciousness the clarities of the unconscious mind, stored with all the individual and collective wisdom of past generations and forms. In other words, an evocative art is the means and the result of getting in touch with the powers of our unconscious.[5]

Graham's belief that the unconscious mind provided essential knowledge and creative powers for the artist and that primitive art offered more direct access to this material impressed Pollock so profoundly that he wrote to Graham asking to meet him. The ensuing friendship greatly emboldened Pollock in his search for universal mythic images in his own unconscious, while at the same time enlarging his understanding of recent European art (especially cubism and surrealism).

The Europeans who arrived in New York around 1940 further sharpened Pollock's focus on unconscious imagery. "I accept the fact that the important painting of the last hundred years was done in France," he acknowledged in 1944. "... The fact that good European moderns are now here is very important, for they bring with them an understanding of the problems of modern painting. I am particularly impressed with their concept of the source of art being the unconscious."[6]

But Pollock was quick to add that the most important Europeans were Picasso and Miró, who did not come to the United States. It was to Picasso above all that Pollock returned again and again in his art. *Guernica* [fig. 2.10], which arrived in New York in 1939, was especially significant. This period of Picasso's work inspired the fragmentation of expressionist images in the shallow space of Pollock's drawings of the late thirties, and it also provided Pollock and his contemporaries with a profoundly moving example of painting with a social conscience that was at the same time at the forefront of formal innovation. The social imperative—already inherent in American art and greatly heightened by the two world wars and by the Depression—weighed heavily on Pollock and his contemporaries.

In 1935 Pollock went on to the easel-painting division of the Federal Art Project, which provided him with a modicum of financial stability. Burgoyne Diller [fig. 2.17] was his supervisor and covered for him when he could not supply his quota of paintings. In addition to its economic benefits the Works Progress Administration (W.P.A.) put

Pollock into a community of painters, including the nascent New York School, who were all trying to digest the same disparate influences of the Mexican muralists, abstract cubism, abstract surrealism, and Picasso's expressionist painting of the thirties, especially *Guernica*.

Pollock's Breakthrough of the Early Forties

Pollock struggled with acute depression and alcoholism in the late thirties and in 1939 he entered into Jungian psychoanalysis. In addition to whatever the treatment did for his emotional crises, it profoundly affected his art by encouraging his search for totemic images with universal, unconscious meaning. Between 1942 and 1948 Pollock gave many of his compositions (including some of the early drip pictures) mythic titles with overtones of primitive forces: *Guardians of the Secret, Male and Female, Moon Woman, Totem Lesson, Night Ceremony, The She-Wolf,* and *Enchanted Forest.* Many of the early action paintings, such as *Galaxy* and *Cathedral* [fig. 4.1], were given titles that evoked a sense of spirituality or the sublime in nature. From 1948 through 1952 Pollock mostly numbered, rather than titled, his paintings, but totemic associations still lingered on. Indeed by not naming his pictures, Pollock sought to make their spiritual content more universal. Nevertheless in 1951 Pollock reintroduced legible totemic figures and in 1953 he resumed the mythic titles.

In November 1941 John Graham put together works by both Krasner and Pollock for a joint show. From this, Krasner discovered that Pollock lived around the corner from her, so she looked him up. The following fall they moved in together, and through Krasner Pollock greatly widened his circle of artistic friends; in particular she introduced him to de Kooning, Hofmann, Harold Rosenberg, and Clement Greenberg. Krasner also appears to have been more successful than the psychotherapists in stabilizing Pollock, who entered the most innovative and productive decade of his life.

In *Male and Female* [fig. 2.12], one of Pollock's first great pictures, the totemic quality and the stabilizing symmetry remained from the works of the previous two years, but the images poured forth in a freer, more disconnnected way. The eyes at top left, the numbers, the impulsive gestures and spills come together, as if randomly, out of a dense chaos of active elements. The totemic figures superimposed on the two black vertical strips reinforce the geometry and stabilize the otherwise free play of gestures and small images.

In the works of the early forties. Pollock transformed the influence of Benton's dramatic compositions and of the Mexicans' Marxist faith in the relentless evolution of history into the idea of a dynamic and inevitable unfolding of the content of the unconscious mind. Over the next four years this idea increasingly dominated not only the content of Pollock's work but the evolution of his style; as the gestures grew more genuinely automatic, it became necessary to devise some new means of balancing the composition. In

Male and Female the geometry serves that purpose; later, Pollock developed the "allover" composition to solve this structural problem.

Although the surrealists helped to legitimize the unconscious as a subject for Pollock, as early as 1942 he already seems to have begun using psychic automatism in a wholly different way. The surrealist maintained an experimental distance, analyzing his or her automatist expressions, discovering their content through free association, and then going back into the picture to enhance these discoveries. Pollock worked impulsively and directly on the canvas to capture the unconscious images as they tumbled out. In *Male and Female* the occasional areas of dripped and splattered paint were not springboards for free association, as in surrealism, but an effort to record the spontaneity of his unconscious thought processes. As such this technique proved the ideological precursor for Pollock's great stylistic breakthrough in the "allover" drip pictures of 1947, such as *Cathedral*.

In addition, the paramount concern with immediacy among Pollock and his friends led them to conclude that if you used sketches you were not "modern." This differentiated them from their mentors Picasso and Miró and from their friend Gorky. Since they believed that important painting, by definition, addressed the issues of its time, you had to be "modern" and therefore to work spontaneously on the canvas. In a radio interview of 1950 Pollock explained: "My opinion is that new needs need new techniques ... the modern painter cannot express his age, the airplane, the atom bomb, the radio in the old forms of the Renaissance ... the modern artist is living in a mechanical age ... working and expressing an inner world—in other words, expressing the energy, the motion, and other inner forces."[7]

In 1942 Motherwell and Baziotes introduced Pollock to Peggy Guggenheim, who asked him to participate in a group show of collages at her new Art of This Century gallery. Pollock, Motherwell, and Baziotes all made their first collages in preparation for that show and wrote automatist poetry together. Then in November 1943 Pollock had a one-man show at the Art of This Century, for which James Johnson Sweeney (an important curator at the Museum of Modern Art) wrote the catalog. Alfred Barr bought *The She-Wolf* for the Museum of Modern Art out of the exhibition, and the San Francisco Museum bought *Guardians of the Secret*. In a review of the show, Clement Greenberg championed Pollock as the greatest painter of his time, and shortly after that Peggy Guggenheim put Pollock on a retainer. This provided Pollock with a regular income, just as the Federal Art Project was shutting down. Guggenheim not only gave him a $300 monthly stipend but a link to the recently arrived surrealists who showed in her gallery.

In the early forties Pollock balanced the scattered automatist doodles in his work against a persistent totemic imagery. The totemic figures carried over from Pollock's expressionistic work, which had been heavily influenced by Orozco and Picasso. The looser automatist brushwork and

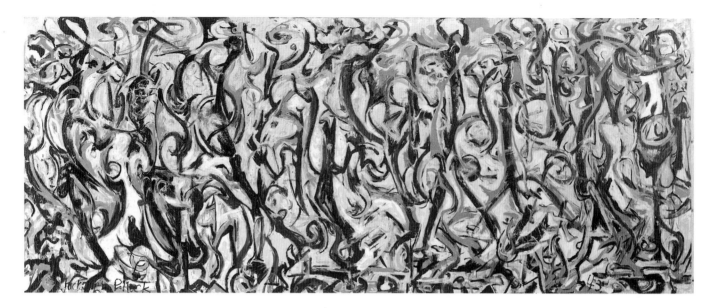

4.2 Jackson Pollock, *Mural,* 1943. Oil on canvas,
8ft 1¼in × 19ft 10in (2.47 × 6.05m).
Collection, University of Iowa Museum of Art. Gift of Peggy Guggenheim. © 2000 Pollock-Krasner Foundation/Artists Rights Society (ARS), New York.

the freer issuing forth of small spontaneous forms and symbols represented the newer influence of surrealism. In these works Pollock began to reconcile the two, using automatism to break down the formal isolation of the totemic images. The dissolution of these images as discrete entities enabled them to interact more fluidly with the free associations in a style of painting that was becoming increasingly oriented toward process. In this carefully thought-out orchestration between the two elements, Pollock's new painting of the early forties seemed to emulate John Graham's description of Picasso's painting, as combining an " … ease of access to the unconscious" with "conscious intelligence."[8]

Some critics have argued that a programmatic Jungian symbolism underlies the images, but no one has succeeded in providing a consistent reading of any such iconography in any paintings by Pollock.[9] Pollock did believe in the collective unconscious and in the course of free association he may have called up and used individual images from material he read or heard about during his Jungian analysis. In the same way Pollock occasionally referred to specific myths in his titles, as in *Pasiphaë* of 1943, but they were never more than a means of enriching or deepening the associations. Pollock created out of his own unconscious, using automatism to transform his psychic experience into gestures and forms. In some instances he then found affirming similarities in known legends, but he avoided systematic referents from external sources.

Pollock's Transition to a Pure Gestural Style

In *Mural* [fig. 4.2] the gesture itself carried the expressive content. But even in this work certain specific associations can be traced. In particular, it has been convincingly argued that on one level the dark curving verticals in *Mural* had a figural reference, influenced by Native American pictographs.[10] Demonstrations of Indian sand painting, which

the artist saw in 1941 at the Natural History Museum in New York, also seem to have later encouraged the free gestural pouring technique that Pollock developed at the beginning of 1947. In February 1944 an interviewer for *Art and Architecture* asked Pollock if he made reference to actual images from Native American art in his paintings and he responded: "That wasn't intentional."[11] He explained that in working intuitively images inevitably emerged from the unconscious, through free association rather than as a deliberate iconography. Similarly, the shamanistic intentions of the sand painters, who regarded such work as a healing act, may have figured obliquely in Pollock's thinking, even though he does not seem to have explicitly set out to emulate them. [12]

Peggy Guggenheim had commissioned Pollock to paint the 8-by-20-foot *Mural* for her home in July 1943. The grand scale of the picture, like the large works of Benton and the Mexicans, transforms the canvas into an engulfing environment, a whole wall of paint rather than a small object that one can both visually and physically dominate. In this way it set a precedent for the scale of Pollock's celebrated drip paintings. It also forced the artist to work on the floor (like the Navajo sand painters he saw in New York) so that he could move around all sides of the picture and reach every part of it.

If the abstract, rhythmic gestures which supplanted the totemic images in *Mural* (and in several other paintings of 1943 and 1944) grew out of figural signs, the final effect was nevertheless one of a gestural style. In this respect Pollock not only anticipated his work of 1947 to 1950, but in some canvases or parts of canvases during 1942 and 1943 he also tentatively explored dripping and pouring, as we have seen

in *Male and Female*. Despite this, these works remain conceptually linked to the imagistic works in that they were self-consciously "composed"; in the case of *Mural* Pollock deliberately organized the composition around Benton's system of curves and countercurves.[13]

The even distribution of compositional interest across the entire surface of *Mural* was its most revolutionary feature. This anticipated the idea of the "allover" composition as a solution to the problem of how to organize a picture generated by automatist gesturing. As each of Pollock's painterly brushstrokes grew increasingly unique and individually formed, they became more and more adequate as replacements for the totemic images. In 1946 and 1947 Pollock finally abandoned imagery and structural systems for an "allover" composition and a completely gestural style. In this respect he went even further than Mondrian or Miró, who always maintained an underlying compositional structure though both had painted evenly dispersed compositions.

Pollock and Krasner spent the summer of 1944 in Provincetown and in 1945 they went to The Springs in East Hampton, Long Island, where they bought a farmhouse and 5 acres. As unceremoniously as possible Pollock and Krasner married in late October and moved out to The Springs permanently (albeit with frequent trips to New York). "It was hell on Long Island" in the beginning, Krasner later recalled.[14] Pollock's studio had no heat or electric light, they had no hot water at first, and they couldn't afford heating fuel for the house, much less an automobile. Yet Pollock did begin having annual exhibitions at this time—at Art of This Century, then at the Betty Parsons Gallery—and finally by 1949 he began selling enough to afford some modest comforts.

In 1946, Pollock's first full year on Long Island, his work underwent another dramatic change. During the first half of the year a mixture of gestural and totemic images dominated his painting, as in *The Key* [fig. 4.3]. In the latter part of the year he abandoned the overt images entirely and embarked on the "Sounds of the Grass" series, which culminated in such extraordinary canvases as *Shimmering Substance* [fig. 4.4]. In these works the artist handled the entire surface as an even field of gestural strokes—sensuously applied, rich in color, and devoid of any overt imagery.

4.3 Jackson Pollock, *The Key,* 1946. Oil on canvas, 4ft 9¾in × 7ft 1in (1.47 × 2.16m).

Collection, Art Institute of Chicago, through prior gift of Mr. and Mrs. Edward Morris, 1987.216. © 2000 Pollock-Krasner Foundation/Artists Rights Society (ARS), New York.

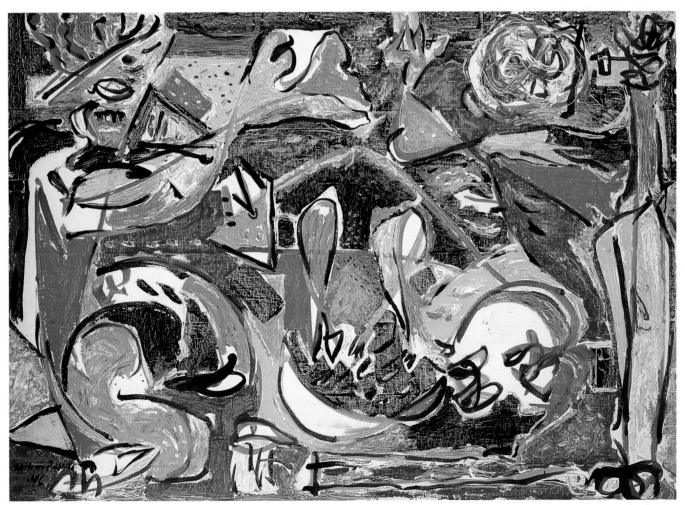

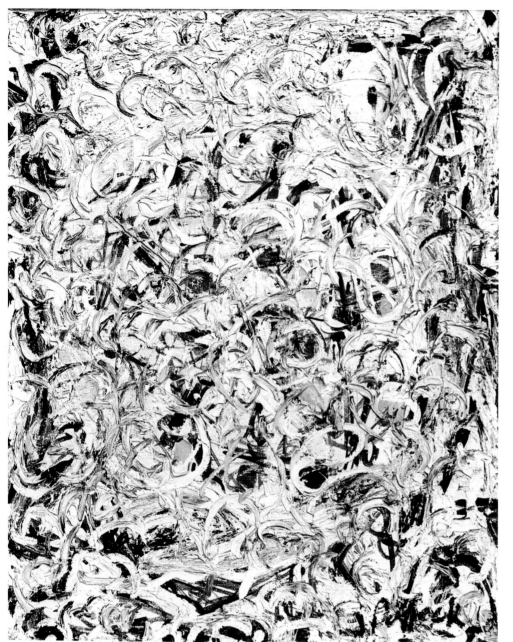

4.4 Jackson Pollock,
Shimmering Substance from the
"Sounds in the Grass" series,
1946. Oil on canvas, 30⅛ ×
24¼in (76.5 × 61.6cm).
The Museum of Modern Art, New York. Mr.
and Mrs. Albert Lewin and Mrs. Sam A.
Lewisohn Funds. © 2000 Pollock-Krasner
Foundation/Artists Rights Society (ARS), New
York.

In *The Key*, even in the 1943 *Mural*, one may read some elements as figures or objects in space. *Shimmering Substance* has only the actual depth of the heavily sculptured paint surface and a subtle illusion of shallow space behind the woven plane of surface texture. The freedom of the gesturing in *Shimmering Substance* is made possible by the evenness of the distribution of visual activity (Pollock's "allover" structure), which avoids compositional anarchy. The stress on the physical quality of the action on the surface shows Pollock using automatist gesturing in an even more direct way than in such works as *Mural*.

The Dripped and Poured Canvases

Pollock's drip paintings, which followed immediately after the "Sounds in the Grass" series at the end of 1946 or early 1947, have still more gestural freedom than *Shimmering Substance*. In creating works like *Cathedral* [fig. 4.1] and *Number 1* [fig. 4.6], Pollock laid his canvas on the floor and used his brushes like sticks, hovering just above the surface but never touching it. This permitted an easier, more spontaneous movement of the arm and body than he could achieve while still having to press the paint on to the canvas with a brush or knife, as in *Shimmering Substance*. Pollock also generally made his drip paintings bigger. Thus by working

directly on the floor he was not only able to use gravity to facilitate his method of application but he was also able to walk around the compositions, reaching every part by literally stepping into them [fig. 4.5].

In the dripped and poured canvases Pollock eliminated all symbols and signs; only the gesture itself remained as a mythic metaphor. This summed up what was radically new about Pollock's application of automatism: he used the technique to express rather than to excavate; he translated the act of painting itself into an adventure of self-realization. When Pollock told Hofmann in 1942 "I *am* nature,"[15] he meant that to him the central subject matter of

painting derived from this direct, introspective exploration instead of from the external world.

Intuitively the viewer can feel the process by which Pollock made the drip compositions and imagine the sensation of moving freely across the canvas along with the gestures of paint. Indeed, the viewer must re-create the feeling of this process in order to experience the deeper meaning of the work, because the painting is "about" the introspective content recorded in those gestures. Pollock's drip paintings demand that the viewer surrender intellectual control while freely empathizing with the energetic color and movement. One "should not look *for*," Pollock

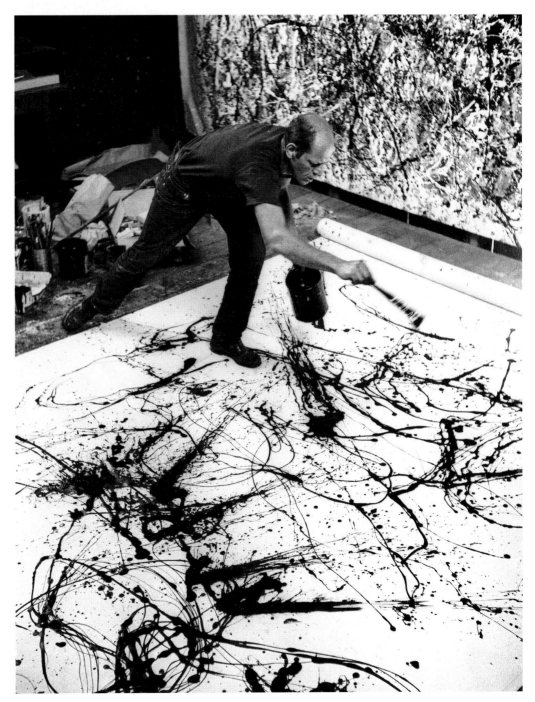

4.5 Jackson Pollock at work, 1950.

Photograph by Hans Namuth. © 1991 Hans Namuth Estate. Courtesy Center for Creative Photography, the University of Arizona.

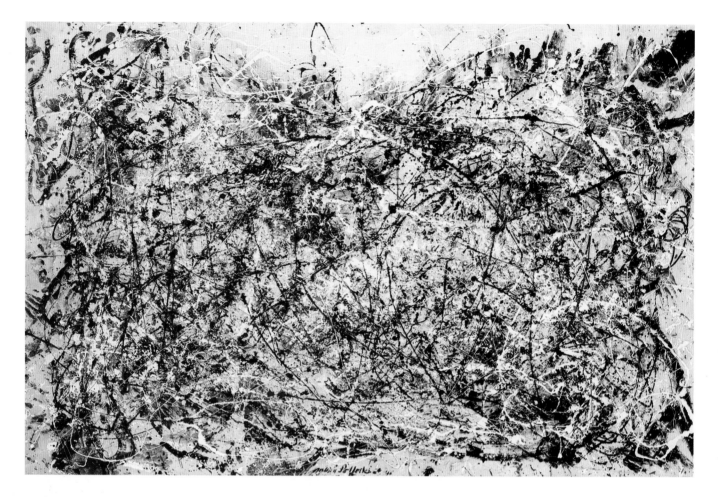

4.6 Jackson Pollock, *Number 1, 1948,* 1948. Oil and enamel on unprimed canvas, 5ft 8in × 8ft 8in (1.73 × 2.64m).

The Museum of Modern Art, New York. Purchase. © 2000 Pollock-Krasner Foundation/Artists Rights Society (ARS), New York.

explained, "but look passively—and try to receive what the painting has to offer."[16] This state of willing suspension of control is the only possible point of embarkation to the awe-inspiring emotions which the painter was recording.

As compositions, each of Pollock's drip pictures simultaneously dissolves into a chaotic jumble of individual lines while also coming together as a structurally uniform, whole field. They have no "correct" viewing position as do Renaissance paintings; indeed the viewer must move across them. They draw their audience in to inspect the details closely, passage by passage, and at the same time overwhelm the viewer with their huge size [figs. 4.7 and 4.8]. Their coloristic and textural richness emphasizes the expansive surface, yet the elaborate and totally visible overlay of multiple layers of paint (and sand, cigarette butts, glass, and other materials) creates a very real depth and space.

The transparency of the process—the way in which the viewer can so readily reconstruct the act of creation—gives the drip paintings an extraordinary immediacy. This highlights the present as the fixed reference point in the painting, and that emphasis is one of the hallmarks of modernism. The brilliance of its fulfillment in these pictures accounts in part for why so many of Pollock's contemporaries saw the drip paintings as an art historical watershed.

The painters of the New York School were exceptionally conscious of wanting to carry on the legacy of modernism.

The collapse of time into the present is a central issue in modernism; the past exists only in its real bearing on the present. Thus for many of Pollock's contemporaries the writings of James Joyce provided a paradigm in the way Joyce subverted sequential or historical time. Looking back, the New York School painter James Brooks remarked that Joyce " ... influenced me more than any painter ... Joyce had a non-narrative style. What you were reading was right there. You're not waiting for something to come."[17] Ibram Lassaw, a sculptor of the New York School, added: "It occurs to me about James Joyce, there is this overall feeling in Joyce's work,"[18] as there is in Pollock's painting. Pollock himself confirmed the deliberateness of this characteristic in 1950 when he commented on "a reviewer a while back who wrote that my pictures didn't have any beginning or any end. He didn't mean it as a compliment, but it was."[19]

In painting, Kandinsky pioneered the disintegration of narrative time, and his work must have encouraged Pollock to paint in a manner that seems to swallow up the viewer, physically and temporally. To Pollock's generation,

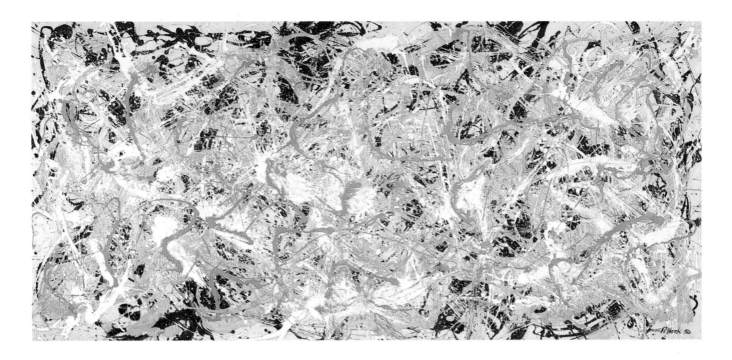

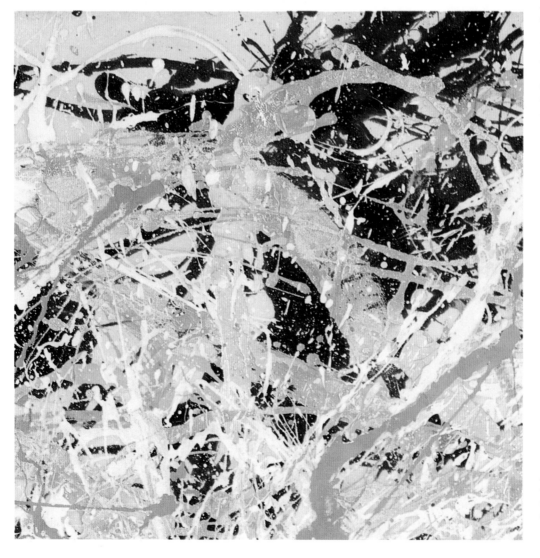

4.7 (above) **Jackson Pollock,** *Number 27*, 1950. Oil on canvas, 4ft 1in × 8ft 10in (1.24 × 2.69m).

Collection, Whitney Museum of American Art, New York. Purchase. Photograph by Geoffrey Clements, New York. © 2000 Pollock-Krasner Foundation/Artists Rights Society (ARS), New York.

4.8 Jackson Pollock, detail of *Number 27*, 1950.

© 2000 Pollock-Krasner Foundation/Artists Rights Society (ARS), New York.

Existentialism Comes to the Fore

Kandinsky's work stood for spontaneity and spiritual content in abstract art. In May 1943 Pollock worked as a janitor in the Museum of Non-Objective Painting, which had the world's greatest collection of Kandinsky paintings, and he undoubtedly saw the museum's 1945 Kandinsky memorial exhibition. In addition to displaying some 200 Kandinskys in the show, the museum published translations of his important writings, including the *Text Artista* (which Pollock owned) and his theoretical treatise, *Concerning the Spiritual in Art*.

In one passage of the *Text Artista* Kandinsky wrote about learning, "not to look at a picture only from the outside, but to 'enter' it, to move around in it, and mingle with its very life."[20] Pollock may have had this passage in the back of his mind—along with the Native American sand painters—when he talked about his new painting process, in 1947:

On the floor I am more at ease. I feel nearer, more a part of the painting, since this way I can walk around it, work from all four sides and literally be in *the painting. This is akin to the Indian sand painters of the West. I continue to get further away from the usual painter's tools such as easel, palette, brushes, etc. I prefer sticks, trowels, knives, and dripping fluid paint or a heavy impasto with sand, broken glass and other foreign matter added. When I am* in *my painting, I'm not aware of what I'm doing. It is only after a sort of "get acquainted" period that I see what I have been about ... the painting has a life of its own. I try to let it come through.*[21]

The genius of Pollock's drip style is not of course a technical discovery, nor is it reducible to its sources; Siqueiros, Hofmann, and even Pollock himself had experimented with the technique in the early forties or before. The loose, continuous drawing techniques of the surrealists often yielded networks of lines that resembled the complexity of Pollock's poured and dripped paint surfaces too. As early as the middle twenties the surrealists experimented with pouring and spattering paint, and Pollock certainly knew these works. But Pollock only started using the technique regularly when it became relevant for exploring the implications of *Mural* and certain other works of the middle forties.

One of the remarkable aspects of the drip pictures is the unerring control that Pollock maintained over the gestural marks, the color, and the overall visual evenness of the field using this freer technique of application. It seems that having physically to apply the paint to the canvas in Pollock's earlier work actually obstructed the continuity of the gestures; by contrast, dripping and pouring gave the artist more control, not less. In this sense the new technique offered a greater accuracy of rendering.

Despite the initially anarchic appearance of the drip pictures, Pollock built up the lush, colored surfaces gradually, giving every line and spot a unique character, full of expression. As early as 1943 each of Pollock's paintings is remarkably complete in itself and distinct from the others. In view of the technique, particularly after 1946, it is striking how unique and unrepetitive each of these compositions is.

In his essay "The American Action Painters," written in 1952, Harold Rosenberg provided the definitive description of Pollock's position:

At a certain moment the canvas began to appear to one American painter after another as an arena in which to act— rather than a space in which to reproduce, redesign, analyze, or "express" an object, actual or imagined. What was to go on the canvas was not a picture but an event ... What matters always is the revelation contained in the act ... A painting that is an act is inseparable from the biography of the artist.[22]

Just as this account is heavily influenced by existentialism, Pollock's emphasis on the unpremeditated act of painting derives at least in part from the existentialist idea of affirming being through action (to "realize" one's condition, as Sartre phrased it in *Being and Nothingness*[23]). The "action painter" examines him or herself in the language of paint. When an interviewer asked Pollock in 1950, "Then, you don't actually have a preconceived image of a canvas in your mind?" he answered, "Well, not exactly—no—because it hasn't been created, you see ... I do have a general notion of what I'm about and what the results will be."[24]

Pollock's work exposes directly, in the process of painting, the changing facts of his creative experience. He transformed the obligation for social relevance, a pervasive current between the wars, into an unrelenting moral commitment to

4.9 Jackson Pollock, *Echo (Number 25, 1951)*, 1951. Enamel on unprimed canvas, 7ft 7⅞in × 7ft 2in (2.33 × 2.18m).

The Museum of Modern Art, New York. Acquired through the Lillie P. Bliss Bequest and the Mr. and Mrs. David Rockefeller Fund. © 2000 Pollock-Krasner Foundation/Artists Rights Society (ARS), New York.

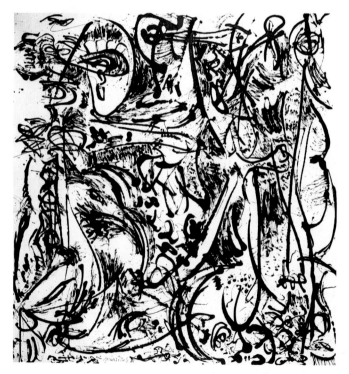

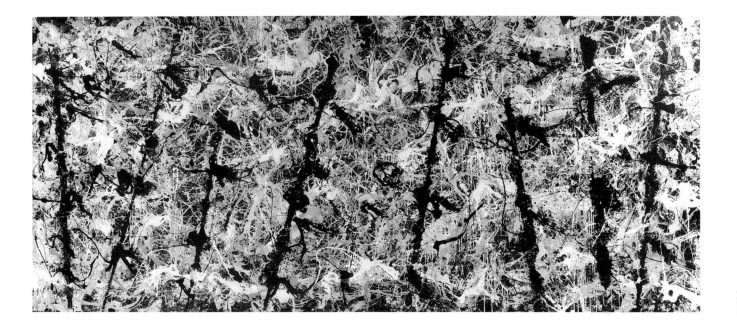

4.10 Jackson Pollock, *Blue Poles, Number 11,* 1952. Oil, enamel and aluminum paint, glass on canvas, 6ft 10⅞in × 15ft 11⅝in (2.11 × 4.87m).
Collection, National Gallery of Australia, Canberra. © 2000 Pollock-Krasner Foundation/Artists Rights Society (ARS), New York.

a search for the "self." The multiple impressions of the artist's own hand in the upper right corner of *Number 1* stress the visceral immediacy of the artist's personal presence and, by contrast, emphasize the vastness of the canvas as measured against them. A number of painters of the New York School used handprints in this way [fig. 3.18].

Perhaps Pollock took some cues from jazz. According to Lee Krasner he thought jazz "was the only other really creative thing happening in this country."[25] Like the be-bop improvisations of Dizzy Gillespie or Charlie Parker, the style of each of Pollock's drip pictures was invented in the process of painting. What he was trying to convey preceded the ability to do so. By visibly recording the history of their own making, the drip paintings render form and content inseparable.

In 1947 Peggy Guggenheim closed her gallery and returned to Europe. Betty Parsons agreed to take on Pollock in her gallery, although she could not afford the monthly stipend that Guggenheim had been paying. The latter continued that herself for a short time until Pollock's sales became sufficiently buoyant to make him a meager living. He premiered his drip pictures in his first Betty Parsons exhibition of January 1948. They were widely ridiculed and continued to be until his death, even though the recognition of his genius within the art world grew rapidly.

Pollock in the Fifties

With the help of a local physician, Pollock stayed completely away from alcohol between 1948 and 1950, and the work of these years is calmer and freer. He got national attention in the press after 1948, even if it was often unsympathetic; in 1949 *Life* even ran an article entitled, "Is Jackson Pollock the Greatest Living Painter in the United States?"[26] and in 1950 the photographer Hans Namuth made a short film of Pollock working.

Pollock's drip pictures of 1950, like *Number 27* [figs. 4.7 and 4.8], are less probative, larger, and more elegiac. They tend to have a more open weave of lines and seem more contained within themselves as they reach the outer edges of the canvas. By contrast, the denser works of 1949 continue at the same level of intensity edge to edge. The most monumental works of 1950 also have a soft, diffuse light, like the late paintings of Monet. These large compositions represent at once a summation of this phase of Pollock's development and a creative dead end.

In late 1950 Pollock started drinking again, and his creativity took a sharp turn toward purely black-and-white pictures, many with figures or totemic images, as in *Echo (Number 25, 1951)* [fig. 4.9]. He did a few drip pictures, too, but his productivity trailed off and he seemed to have lost confidence in the direction of his development. Several of the paintings from 1951 to 1953 are still of a high quality, such as *Echo* and *Blue Poles, Number 11* [fig. 4.10], but they also have a more anxious and groping feel; some works of these years seem faltering.

In *Blue Poles* Pollock introduced the cadence of strong blue diagonals (painted against the edge of a two-by-four) as if he were seeking some stability. It may also imply a yearning to return to the security of his roots, since the idea of the poles resembles the compositional device that Benton taught Pollock in the early 1930s and that Pollock used in 1943 for *Mural* (though Benton meant for such poles to be hypothetical, not visible).

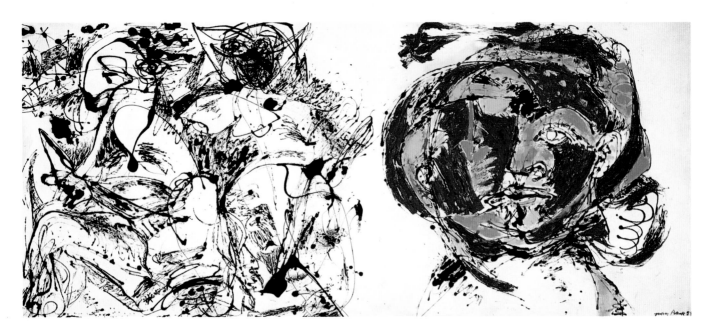

4.11 Jackson Pollock, *Portrait and a Dream,* 1953.
Oil on canvas, 4ft 10½in × 11ft 2in (148.6 × 342.2cm).
Dallas Museum of Art. Gift of Mr. and Mrs. Algur H. Meadows and the Meadows Foundation,
Inc. © 2000 Pollock-Krasner Foundation/Artists Rights Society (ARS), New York.

Soon after *Blue Poles* Pollock made the extremely different *Portrait and a Dream* [fig. 4.11], which returned in spirit to his point of departure in the early forties—himself (the "portrait," painted in color) and images from the unconscious (the "dream," in black and white). But rather than having the space brimming over with a myriad of unconscious images, the head is a solitary form and the freer automatist forms at the left seem as though contained within a frame. Next Pollock did a few dense, intricately tangled paintings like *Scent, Grayed Rainbow,* and *White Light,* which relate more closely to his style of 1946, although they have a brooding darkness that is new.

In 1954 and 1955 Pollock's painting nearly ground to a halt as his drinking got heavier and his depression deeper. The public still joked about his work: In 1956 *Time* magazine called him "Jack the Dripper."[27] By this time he had stopped painting entirely and, on the night of August 10th, he drove his car off the road near his home in The Springs, killing himself and one of the two young women he had with him.

Pollock's legacy to subsequent artists is profound but often not readily visible. His drip style did not inspire imitators precisely because it was so strikingly unique; whereas the gestural painters of the fifties could try out the autographic brushwork of de Kooning, Kline, and Guston without necessarily producing a baldly derivative work, no one could paint a drip composition that did not look like a weak Pollock. Yet Pollock's radical reorientation of time in painting—his concentration on the instant at which the paint hit the canvas, purging references to past time or previous painting—was the central inspiration for the immediacy in the gestural painting of the fifties as well as in the "happenings" that began at the end of the decade. The directness with which the materials are expressed in the minimal and process art of the sixties is also indebted to Pollock, as is the detachment from historical time and experience in the work of Jasper Johns and of the pop artists, even though they rejected Pollock's vehement assertion of romantic individuality.

Barnett Newman

Style, in modern art, is the result of an artist's effort to find a successful, visual embodiment of his or her thinking. Whereas de Kooning and Pollock worked out their ideas on the canvas surface, Barnett Newman thought everything through in advance. His painting confronts us with such an uncompromisingly metaphysical idea that his work still leaves many seasoned art viewers bewildered.

Newman was a highly articulate intellectual, who fought against any kind of artistic subject matter that was tied down to an object. Yet, as Richard Shiff has pointed out, his art is by no means non-objective in the usual sense; rather it is an attempt to distill and universalize individual experience of the most profound and personal kind.[28] In particular Newman's painting has to do with the notion of the sublime, which he contrasted with what he called "the Greek, plastic achievement,"[29] namely the concept of the beautiful. The sublime comes through the direct intuition of universal experience; it consists of pure spirituality. Newman viewed

the Greek aesthetic as expressing the personal and depending on the physical beauty of the object.

Caspar David Friedrich's painting of 1809–10, *Monk by the Seashore* [fig. 4.12], is an early formulation of what is meant by a sublime subject in painting. In Friedrich's picture a man, seen from the back, looks out at the incomprehensible vastness of the sea and sky at night. The small scale of the man (or one may imagine oneself) against the endless space of the heavens and the sea evokes a breathtaking apprehension of the infinite, a sense of cosmic boundlessness, and by contrast a profound realization of one's own insignificance and mortality.

Newman sought a more direct embodiment of the experience of the sublime, appropriate to the middle of the twentieth century, and this quest preoccupied him throughout the forties. He expressed this concern first in writings such as his essay for the catalog of "The Ideographic Picture" exhibition (1947) which he organized at the Betty Parsons Gallery; in the show he included works by Hans Hofmann, Clyfford Still, Theodoros Stamos, Ad Reinhardt, Mark Rothko, and himself. An ideograph is a written symbol that communicates an idea directly, rather than through language or through the mediation of any symbolic form.

In his essay Newman wrote of seeking a modern equivalent to "primitive" art, in which the abstract shape itself is

a living thing, a vehicle for an abstract thought-complex, a carrier of the awesome feelings that he [the Kwakiutl Indian] felt before the terror of the unknowable. The abstract shape was, therefore, real rather than a formal "abstraction" of a visual fact with its overtone of an already known nature. Nor was it a purist illusion with its overload of pseudo-scientific truths.[30]

Newman wanted to distinguish himself and his friends from the other types of abstraction then prevalent: on the one hand from that which was predominantly formal rather than emanating from content (this seemed to him a form of trivial decoration); and on the other hand from abstraction like Mondrian's, which, although steeped in metaphysics, seemed to Newman too impersonal and Utopian.

Newman saw the artist as a revolutionary in search of universal truths, discovered by way of the personal and immediate. In addition he regarded the search as heroic in the manner of Greek tragedy, even though he did not want to produce works that had anything to do with classical form or beauty. He wrote:

The question that now arises is how, if we are living in a time without a legend or a mythos that can be called sublime, if we refuse to admit any exaltation in pure relations, if we refuse to live in the abstract, how can we be creating a sublime art? We are reasserting man's natural desire for the exalted, for a concern with our relationships to the absolute emotions. We do not need the obsolete props of an outmoded and antiquated legend … We are freeing ourselves of the impediments of memory, association, nostalgia, legend, myth, or what have you, that have been the devices of Western European painting. Instead of making cathedrals out of Christ, man, or "life," we are making them out of ourselves, out of our own feelings. The image we produce is the self-evident one of revelation, real and concrete, that can be understood by anyone who will look at it without the nostalgic glasses of history.[31]

Newman was born in 1905 in New York City, where he attended public school and Hebrew school; at home he received a substantial education in religious philosophy from a steady stream of Jewish immigrants that his father

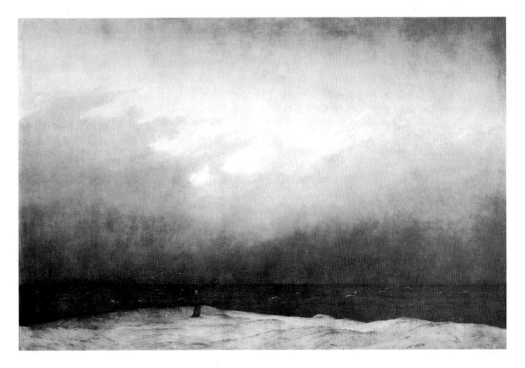

4.12 Caspar David Friedrich,
Monk by the Seashore, 1809–10.
Oil on canvas,
3ft 7¼in × 5ft 7½in
(1.1 × 1.72m).
Collection, Staatliche Museum zu Berlin, Preussischer Kulturbesitz, Nationalgalerie.
Photograph by Jörg P. Anders, Berlin.

housed on arrival from Europe. Newman always wanted to be an artist. He discovered the Metropolitan Museum as a teenager and took classes at the Art Students League in his last year of high school and while attending City College, from which he graduated in 1927. He then agreed to work for two years in his father's men's wear manufacturing business in the hope of saving some money to help him through a career as a painter.

The 1929 stock-market crash derailed this plan, and the thirties were bleak for Newman. He taught art in high school, while continuing to work for his father until 1937. Unlike most of his fellow artists Newman was not on the Federal Art Project; he could not have produced the requisite amount of work at that time, and in addition he earned enough income as a teacher to make him ineligible. As a result Newman felt left out, particularly years later when so many people looked back at having worked on the Project as a mark of serious participation in the artistic developments of that era. In 1936 Newman married a young teacher named Annalee Greenhouse, who stuck by him devotedly, defending his art and encouraging him to persevere.

Although deeply reflective, Newman was also colorful and affable. The battles in which he fervently engaged, in "letters to the editor" or verbally with fellow artists, like his decision to run for mayor of New York in 1933, sometimes went to comic extremes for their vehemence and sincerity. In his mayoral platform, for example, he insisted: "We must spread culture through society. Only a society entirely composed of artists would be really worth living in. That is our aim, which is not dictated by expediency."[32]

Newman made little progress as a painter in the thirties and from the end of the decade until the mid forties he stopped painting altogether. He could not find a satisfactory place to begin in existing styles of painting. Newman and his friends generally admired the spirit of surrealism, but they felt that one could not deal with an unconscious content and universal subjects in an antiquated illusionist style. Dada objects, although more radical in style, seemed to Newman to be too quickly consumed as precious objects of *petit bourgeois* taste. He did not want to make something that a collector could acquire as an object without engaging its content. So he wrote about art and encouraged his friends in their endeavors until he could figure out how to proceed with his own painting.

Between 1939 and 1941 Newman pursued a long-standing interest in science, studying botany and ornithology. In particular, he wanted to know about the beginnings of life—how it emerged and how its orders developed. He was always looking for an analog to the genesis of thought and the evolution of the human mind. In some ways this provided the philosophical basis for his successful resumption of painting. In the mid forties Newman recommended painting with works that derived from surrealist automatism and free association, like the contemporary works of his friend Rothko (fig. 4.24]. But unlike the surrealists, Newman did not focus on psychological introspection; rather he looked to cosmic themes, as his titles indicate. In 1946, for example, he used such titles as *Pagan Void*, *The Beginning*, *The Command*, *The Euclidian Abyss*, *The Slaying of Osiris*, and *The Blessing*, evoking themes of rebirth from the chaos, Genesis, and evolution. In an essay of the period (1943–5) called "The Plasmic Image" Newman explained:

All artists, whether primitive or sophisticated, have been involved in the handling of chaos. The painter of the new movement [i.e. Gottlieb, Rothko, Pollock and himself] … is therefore not concerned with geometric forms per se but in creating forms which by their abstract nature carry some abstract intellectual content. There is an attempt being made to assign a Surrealist explanation to the use these painters make of abstract forms … [but] Surrealism is interested in a dream world that will penetrate the human psyche. To that extent it is a mundane expression … The present painter is concerned, not with his own feelings or with the mystery of his own personality, but with the penetration into the world mystery. His imagination is therefore attempting to dig into metaphysical secrets. To that extent his art is concerned with the sublime. It is a religious art which through symbols will catch the basic truth of life which is its sense of tragedy … the artist tries to wrest truth from the void.[33]

The Revelation of Newman's *Onement I*

In a little painting he called *Onement I* [fig. 4.13], Newman finally found a visual expression for these ideas that "looked right" to him, and this painting established the direction for the rest of Newman's career. He reported that he had begun the canvas as a background for another painting, but that it sat unfinished in his studio for about three quarters of a year—through the fall of 1948. He kept finding himself looking at it, wondering why it moved him so deeply and felt so resonant with his state of mind. But he puzzled over this picture for months, trying to assess its significance. Newman referred to the line straight down the middle of *Onement I* as the "zip." The structural symmetry of the zip in *Onement I* wipes out the problem of composition. By thus reducing the composition to zero Newman killed the preciousness of the painting as an art object and forced the viewer to apprehend the work more strictly in terms of ideas. Thus *Onement I* provided a brilliant visual analog for certain of Newman's key ideas, and he employed the zip (though most often not in the middle) in almost all his subsequent paintings.

The title word "Onement" has a number of important meanings. It is a component of "atonement," an important concept for Jews, which they mark during Yom Kippur. The Cabbalists regard this holy day as a time to reflect on the mystery of creation. Spinoza, the philosopher whose writings Newman studied along with the texts of the Cabbala, ranked knowledge into three levels: (1) data and rules learned without any reference to the intellect; (2)

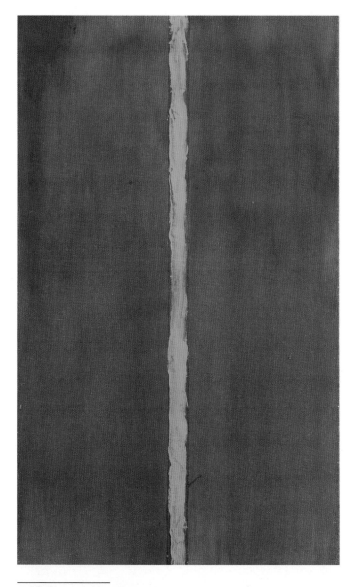

4.13 Barnett Newman, *Onement I,* 1948. Oil on canvas, 27¼ × 16¼in (69.2 × 41.3cm).
The Museum of Modern Art, New York. Gift of Annalee Newman. © 2000 Barnett Newman Foundation/Artists Rights Society (ARS), New York.

things learned by deduction or logic; and (3) (the highest order of knowledge) immediate knowledge, using reason, but obtained through a direct intuition to the essence of things, an insight that went beyond reason. This last level resembled what Newman called "the sublime."

Newman was after an epiphany, a simultaneously terrifying and exalting moment of total reality. For him, as for Spinoza, this came from a oneness with God. Spinoza looked at man as an extension of the "all" of God, who is omnipresent. But he saw God as always growing and the layers of meaning as infinite. Newman tried to paint the fullness of this experience, not the void. The solid color fields, in *Onement I* and subsequent pictures, are this pervasive fullness. Newman's interest in Jewish mysticism might seem at odds with his scientific and intellectual side, but Newman used the science—as he used philosophy— to open another point of access into the mysteries of creation.

Once Newman began thinking in these terms, the existing styles of painting seemed anachronistic. Surrealism's illusionistic rendering was preimpressionist, and its content was more of an imaginary fiction than the over-powering reality for which Newman searched. Cubism seemed to him a stylization of people and things in the modern world; this did not offer the possibility of such content either. He was left with only one option: to undertake an act of origination, starting from scratch, like Genesis itself.

Onement I symbolizes Genesis. It is an act of creation and of division. Newman's zip down the middle evokes God's separation of light and darkness, a line drawn in the void. Like the Old Testament God, the artist starts with chaos, with the void; Newman begins with blank color—no texture, no form, no details. The zip is a primal act.

The colors in *Onement I* also symbolize Genesis. The red-brown field of the background is the color of earth, Adam is the man created by God, and the Hebrew word for earth is *adamah*. So Adam is made from the earth, from clay. In addition humans are the only animals that walk upright; the vertical gesture down the middle of the canvas stands for humankind, whose first incarnation is Adam. The sensuous edges of the painter's gesture give it an individual and human character in contrast to the impersonal and limitless field of color. The zip resembles Giacometti's figures, which despite their heavily modelled surfaces are so thin as to be fragile, fleeting moments in existence [figs. 5.15—5.17], and Giacometti was exhibiting his postwar figural work in New York for the first time in February 1948, just when Newman was painting *Onement I*.

"Onement" also carries a reference to Eve. The Talmud says: "It is only when he is complete that man is called 'one,' … When he is male together with female, as is highly sanctified, and zealous for sanctification."[34] So "onement" has its roots in the Cabbala and in Talmudic literature, which belong to Newman's background. "Onement" is the Genetic moment; it is Adam and Eve conjoined; it celebrates human creativity, especially that of the artist.

In October 1948 Newman painted a second version of the painting. In *Onement I* he painted the zip over a strip of tape; this time he painted over tape then peeled it off to leave a clean-edged, unmodelled zip down the middle. This switch from the soft zip to the hard, unmodulated one recurs for the next two or three years in many pairs of paintings and has a female–male complementarity. Newman painted seven "Onement" pictures over half a decade. The fact that the zip is centered is their crucial trademark. This symmetry stands for perfection in man's oneness with the all of God. Yet every depiction of it is unique. Even where the zip does not bisect the picture plane, it is placed in some modular relation to the perfection of the center, thereby enhancing the visual tension of the zip as well as its meaning.

The Paintings of the Late Forties

After *Onement II* Newman started painting prolifically again, making works like *Galaxy* [fig. 4.14], which has two asymmetric zips, playing on the deviation from the middle as an expressive gesture in relation to centeredness. Although Newman used a mathematical ratio in placing the zip, these works have an important affinity with action painting in that they aspire to an experience of immediacy and presence, despite their carefully premeditated structures. The increasing scale of Newman's paintings from 1949 also echoes the ambition of the content in his work. *Be I*, for example, is 8 feet tall.

All of the painters of the New York School were moving toward a larger scale at this time. As Robert Motherwell said,

the large format, at one blow, destroyed the century long tendency of the French to domesticize modern painting, to make it intimate. We replaced the nude girl and the French door with a modern Stonehenge, with a sense of the sublime and the tragic … One of the great images [of New York School painting] should be the house-painter's brush, in the employ of a grand vision dominated by an ethical sensibility that makes the usual painter's brush indeed picayune.[35]

4.14 Barnett Newman, *Galaxy,* 1949. Oil on canvas, 24 × 20in (61 × 51cm).

Collection, Estee Lauder, Inc., New York. © 2000 Barnett Newman Foundation/Artists Rights Society (ARS), New York.

4.15 (above) **Barnett Newman,** *Abraham,* 1949. Oil on canvas, 82¾ × 34½in (210.2 × 87.6cm).

The Museum of Modern Art, New York. Philip Johnson Fund. © 2000 Barnett Newman Foundation/Artists Rights Society (ARS), New York.

Looking back to the late forties across the distance of twenty years, Newman spoke of the ethical motives underlying the radical innovations of the painters in his circle:

Twenty years ago we felt the moral crisis of a world in shambles, a world devastated by a great depression and a fierce World War, and it was impossible at that time to paint the kind of painting that we were doing—flowers, reclining nudes, and people playing the cello [the subjects of such modern painters as Cézanne, Picasso, and Matisse]. *At the same time we could not move into the situation of a pure world of unorganized shapes and forms, or color relations, a world of sensation. And I would say that, for some of us, this was our moral crisis in relation to what to paint. So that we actually began, so to speak, from scratch, as if painting were not only dead but had never existed.*[36]

Newman had his first one-man show at the Betty Parsons Gallery in early 1950. *Be I*, the largest picture in the show, had barely fit into Newman's studio on 19th Street; he had had to carry it out on to the sidewalk and back in order to turn the picture around.[37] This is important in understanding the proximity at which he worked on the painting; Newman meant the viewer to see it very close up, just as he saw it in the studio. He even tacked a statement to the gallery wall, instructing visitors to stand close in order to fee the expansiveness of the color field.[38]

Newman painted *Abraham* [fig. 4.15] on a large scale, too, but instead of the fine metaphysical white zip and the earthbound cadmium red background in *Be I*, he conceived this picture in a somber mood, using a dark palette and a heavy stripe. The existential despair evident in this black-on-black painting has partly to do with the death in 1947 of the artist's father, who was named Abraham, though it also refers to the biblical Abraham. The relation of the stripe to the center still persists in *Abraham*—he encoded a secret symmetry, placing the right edge of the stripe on the centerline of the canvas. He divided the whole composition mathematically so that the width of the stripe was half the width of the left-hand section, in a 2:1:3 proportion. Newman's sketch for such a painting would have been a scrap of paper with calculations for the numerical proportions of the divisions. Newman made a few drawings that seem to relate to *Onement I* and one drawing of 1949 related to *Achilles*, which he painted three years later. Otherwise he did no drawings for paintings between 1947 and 1959.

Vir Heroicus Sublimis and Other Works of the Fifties

In 1950 Newman moved to a larger studio on Wall Street and began to paint even bigger pictures. But the move as well as his 1950 show briefly interrupted his work and seems to have precipitated a shift in his painting. Newman's monumental *Vir Heroicus Sublimis* [fig. 4.16] projects a metaphysical absoluteness; it is the antithesis of the precious object. The Latin title means "man, heroic and sublime."[39] The hidden square in the middle—described by the two zips—emphasizes the perfection of the center, around which he ordered the canvas. The color field evokes the universe, the infinite, and completely lacks any texture or sense of human intervention. The zips, on the other hand, convey the painter's presence and spatially establish the relation of the individual to the wider order of things.

The extraordinary scale of the eighteen-foot-long *Vir Heroicus* and other pictures of this time made it practically impossible for all but a few collectors or galleries to hang them, much less buy them. As such they proclaim Newman's

4.16 Barnett Newman, *Vir Heroicus Sublimis,* 1950–1. Oil on canvas, 7ft 11⅜in × 17ft 9¼in (2.42 × 5.41m). The Museum of Modern Art, New York. Gift of Mr. and Mrs. Ben Heller. © 2000 Barnett Newman Foundation/Artists Rights Society (ARS), New York.

Existentialism Comes to the Fore

4.17 (left) **Barnett Newman,** *Untitled (Number 4),* 1950. Oil on canvas, 74 × 6in (188 × 15.2cm).

Collection, Mr. and Mrs. I. M. Pei, New York. © 2000 Barnett Newman Foundation/Artists Rights Society (ARS), New York.

4.18 (right) **Barnett Newman,** *Here I,* 1950 (cast: sculpture 1962, base 1971). Bronze, 107¼ × 28¼ × 27¼in (272.4 × 71.8 × 69.2cm).

Collection, Moderna Museet, Stockholm, Sweden. Photograph by Malcolm Varon, New York. © 2000 Barnett Newman Foundation/Artists Rights Society (ARS), New York.

freedom to attempt the impossible—though Pollock's first sixteen-foot canvas, *Number 1* of 1949, must also have encouraged Newman to experiment with this huge scale.

Newman wanted to rid the painting of its physicality as an object in order to emphasize its meaning. But many have misread his work as a formalist statement, because of his concern with measurement and placement. Tony Smith recounted an incident in which a curator came to see the *Vir Heroicus Sublimis* and told Newman that he "'finally understood it; it was just a relationship of shapes— Bauhaus!' Newman growled that the only things in the picture that 'count' are the stripes,"[40] and to prove it he went on to make a whole series of paintings consisting only of the zips, such as *Untitled (Number 4)* [fig. 4.17]. In these Newman concerned himself with the placement of the zips in a total space, rather than merely within the space defined by a color field. In addition, these paintings have so much sculptural physicality in real space that the leap from them to sculpture was not great.

In *Here I* [fig. 4.18] Newman turned a pair of zips—a textured one and a precise metaphysical one—into three-dimensional forms, in which one can sense a human presence. In August 1949 the Newmans visited Annalee's family in Akron, Ohio, and went to see the nearby Miamisburg Indian mounds. Newman later described that experience to Thomas Hess as "a sense of place, a holy place. Looking at the site, you feel 'here I am, *here*' … and out beyond there [that is, beyond the limits of the site] there is chaos, nature, rivers, landscape … but here you get a sense of your own presence … I became involved with the idea of making the viewer present: the idea that 'man is present.'"[41] Newman built the sculpture *Here I* on a mound. It does not convey a sense of *space*, but of *place*. It has to do with a place in which one can "be," in a primal sense. Newman meant to epitomize a revelatory experience, like that of Joseph Smith selecting the Mormon Zion in a vision or of the Jewish Zionists' spiritual longing for Palestine as the Jewish homeland.

The biblical subjects and the concern with the absolute persist in the works of 1951 and 1952. In *The Day One* the zips hover at the edges and in *The Day Before One* they do not exist at all. Neither of these works show any paint texture: the canvas has absorbed the paint, in a way that heightens its immateriality. As here, Newman often made canvases in pairs of identically measured stretches, though he sometimes painted them as much as a year apart. The *Vir Heroicus Sublimis* has a dark mate called *Cathedral*, which could not be more different in character. But they undoubtedly have an iconographic connection, as in the case of *The Day Before One* and *The Day One*, which deal with the moment of the beginning in Genesis.

Befitting the grandeur of the theme, *The Day Before One* and *The Day One* each stand eleven feet tall. When Betty Parsons gave Newman his second exhibition in 1951, she could not include them because they would not fit into the gallery. One can only assume that Newman knew perfectly well that they could not be shown and chose this course of

action as a gesture of confrontation with the restraints of the known and the possible.

In the early fifties Newman painted a number of pictures titled for Greek mythological heroes. He was not intending to invoke Freud in an exploration of individual psychology, as in surrealism, but rather to continue his heroic quest for art. Such works as *Achilles*, *Ulysses*, and *L'Errance* (meaning "The Odyssey") use the metaphor of the epic hero to portray Newman's own odyssey in the thirties and forties, his search for a means of artistic expression. But on the whole Newman's journey was not understood, even by his friends. Pollock encouraged him, Kline and some of the others expressed sympathy for him, but some, even among his fellow artists, thought Newman was a phony; the Museum of Modern Art left him out of their "15 Americans" show of 1952 (that included so many of his colleagues). At one point, Ad Reinhardt drew a chart in the *Art Journal* representing Newman as a leaf falling off the tree of abstract expressionism, provoking Newman to sue the journal and nearly run its publisher (the College Art Association) out of business.

4.19 Barnett Newman, *Stations of the Cross: Lema Sabachthani, the First Station*, 1958. Magna on canvas, 6ft 6in × 5ft (1.98 × 1.52m).

Robert and Jane Meyerhoff Collection, © 1995 Board of Trustees, National Gallery of Art, Washington, D.C. © 2000 Barnett Newman Foundation/Artists Rights Society (ARS), New York.

The "Stations of the Cross"

Newman suffered feelings of failure in the mid to late fifties, and in 1957 he did no painting at all. Then he had a heart attack, which seemed to work like instant psychoanalysis.[42] He immediately went back to painting in 1958 and completed a series of stunning compositions, based on the Stations of the Cross. As in the earlier works that deal with God or biblical subjects, Newman did not seek to represent the subject. He was not a religious zealot. He intended to deal with the abstract and universal experience which each of these subjects evoked:

Lema Sabachthani—Why? Why did you forsake me? Why forsake me? To what purpose? Why? This is the passion, this is the outcry of Jesus. Not the terrible walk up the Via Dolorosa, but the question that has no answer ... Lema? to what purpose— is the unanswerable question of human suffering.[43]

In the biblical text, the first station concerns the condemnation of Christ. The hard black stripe at the left in *Stations of the Cross: Lema Sabachthani, The First Station* [fig. 4.19] has an absolute ring of spirituality coming through the blackness and across the white field toward the right edge, where the more clouded human doubts about death and the condemnation seem to reside. In most

of "The Stations of the Cross," one may speculate that the left edge seems to address the eternal question: "why?"; whereas the right edge of the canvas suggests earthbound associations, human concerns—and there is a constant dialog between right and left.

This moving series of paintings—which ended with *The Fourteenth Station* (the entombment) in 1966—seems also to have been an autobiographical exploration,[44] confronting the artist's brush with death in his heart attack, his relation to his colleagues, and his rejection by the art world. But Newman always generalizes such specific experiences, giving a transcendental value to his philosophical and spiritual searchings. As he wrote in 1947, "The basis of an aesthetic act is the pure idea ... that makes contact with the mystery—of life, of men, of nature, of the hard black chaos that is death, or the grayer softer chaos that is tragedy. For it is only the pure idea that has meaning."[45]

Mark Rothko

In 1949 Mark Rothko developed a pictorial format of softly defined, rectangular clouds of color, which he stacked symmetrically on top of one another [fig. 4.20]. These rectangles of uniform width fill the canvas almost edge to edge; at the top and bottom the forms also press close to the perimeter. This is a rudimentary visual language conceived to evoke elemental emotions with maximum poignancy. Rothko regarded this format as an inexhaustible structure for, in his words, "dealing with human emotion, with the human drama as much as I can possibly experience it,"[46] and except for his three late mural cycles, he worked exclusively in this format until his death in 1970.

The monumentality and static simplicity of these compositions express the workings of a complex, subtle, and turbulent mind, plagued by depression but also by an overwhelming sense of urgent responsibility for the exploration of profound human content in painting. The critic Dore Ashton, who met Rothko in the fifties, portrayed him as a man disposed to causes—always ready to storm the barricades whether in the name of his leftist politics, his radical views on art education for children, or his concept of the mission of abstract art.[47] He was a nervous man, who would get up and walk around with a cigarette between courses at a dinner party.[48] Robert Motherwell described him as a cauldron of "seething anger [that] would sometimes blow up, completely irrationally."[49]

Underneath the meditative reserve of his paintings and their deliberate reduction of vocabulary lies a passionate ethical and psychological fundamentalism. The very simplicity of the structure sets a moral tone that places

4.20 Mark Rothko, *Green and Tangerine on Red,* 1956. Oil on canvas, 7ft 9½in × 5ft 9⅛in (2.37 × 1.75m).
Phillips Collection, Washington, D.C. © 1998 Kate Rothko Prizel & Christopher Rothko/Artists Rights Society (ARS), New York.

4.21 Mark Rothko,
Subway Scene, 1938. Oil on canvas, 35 × 47½in (89 × 120.7cm).

Collection, the Rothko Estate. Photograph courtesy National Gallery of Art, Washington, D.C. © 1998 Kate Rothko Prizel & Christopher Rothko/Artists Rights Society (ARS), New York.

4.22 (below) **Milton Avery,**
Interior with Figure, 1938. Oil on canvas, 32⅛in × 40in (81.4 × 101.6cm).

Collection, Hirshhorn Museum and Sculpture Garden, Smithsonian Institution, Washington, D.C. Gift of The Joseph H. Hirshhorn Foundation, 1966. © 2000 Milton Avery Trust/Artists Rights Society (ARS), New York.

matters of value in high relief. Rothko's work has a frightening sense of the absolute that resembles the primitive force of Old Testament justice. As William Rubin (a curator at the Museum of Modern Art) remarked, Rothko's "pictures sometimes rumbled and threatened like a live volcano."[50] Sometime around 1956, the artist told Dore Ashton that he was making the most violent paintings in America.[51] For Dominique de Menil, the patron of his last murals, Rothko's paintings evoked "the tragic mystery of our perishable condition. The silence of God, the unbearable silence of God."[52]

Rothko's Formative Years

Marcus Rothkowitz (he simplified the name to "Mark Rothko" around 1940) was born in 1903 in the Lithuanian town of Dvinsk. His childhood was marked by the worst period of mob violence against Jews in Russia in a generation, and for the rest of his life he harbored memories of that threatening environment. In August 1913, the ten-year-old Marcus, his older sister, and his mother left to join his father and two brothers in Portland, Oregon. Seven months later his father died.

The young Rothko had learned self-discipline memorizing the Talmud in the Jewish school of Dvinsk and he excelled academically in Portland. In 1921 he won a full scholarship to Yale. Although he studied drawing in high school, he gave the larger share of his energy to radical politics. At Yale Rothko explored music, drama, literature,

philosophy, and mathematics (at which he was particularly brilliant), but his radicalism still remained the focus of his intellectual life. In his second year at Yale the scholarship evaporated and after struggling along for the year he dropped out and headed for New York,

Rothko started taking courses at the Art Students League and briefly did some acting. Studying under Max Weber at the League, Rothko learned about cubism, Cézanne, the color harmonies of Matisse, and the primitivism of the German expressionists. The recently opened New Art Circle gallery of J. B. Neumann introduced Rothko to a good

variety of German expressionist works and he began his career painting uninspired figure compositions of an expressionistic character.

The 1938 *Subway Scene* [fig. 4.21] is the last and most accomplished work in a series that grew out of Rothko's expressionist style. The painterly handling, the generality of the forms, the symmetry and planar frontality of the composition, and the subject itself—the somber atmosphere of the New York subway—anticipated aspects of Rothko's mature work.[53] This painting also shows the influence of Milton Avery's quiet lyricism [fig. 4.22] in the staid composition, the hints of rich but subdued color harmonies, and the large flat color areas, although the mood of frozen anxiety that hangs over the Rothko contrasts markedly with the calm sensuality of Avery's painting.

Rothko met Avery in 1928 and they established a warm, lifelong friendship. In 1929 or early in 1930 he also met Adolph Gottlieb and developed an intimate relationship with him that recalls the serendipitous meeting of minds between de Kooning and Gorky in the late thirties. This camaraderie peaked in the early forties, when Gottlieb and Rothko collaborated on some important joint statements on art.

Rothko's history in the thirties resembled that of other painters of his generation. He was struggling simultaneously with his basic ability to survive, his social conscience, and the stylistic influences of the European moderns. He was aided by the support of an artists' group called "The Ten," which he and Gottlieb helped to organize in 1935, and by close relationships with Gottlieb, Edith Sachar (a goldsmith whom he married in 1932), and Milton and Sally Avery. It was around the Averys' vacation house near Gloucester, Massachusetts, that the Gottliebs and Rothkos spent their summers in the mid thirties. Rothko also met David Smith and Barnett Newman at that time, and in 1936 to 1937 he worked in the easel painting division of the Federal Art Project.

Political activism and a concern for social justice characterized the intellectual climate of New York in the late thirties. When John D. Rockefeller had Diego Rivera forcibly removed from the scaffold at Rockefeller Center in 1934 (and then destroyed the mural) for including a portrait of Lenin in his painting, the outcry from artists created a focus for political organizing. The event catalyzed the founding of the Artists' Union in 1934 with a journal called *Art Front*, edited by Stuart Davis.[54]

Rothko participated in the Artists' Union, in the American Artists' Congress, and in the Federation of American Painters and Sculptors. He was always drawn to leftist politics, characterizing himself as "still an anarchist,"[55] as late as 1970. But in the interwar period the climate of ethical concern arising from the Depression, the looming specter of fascism in Europe, and then the war gave Rothko's social and political agenda particular urgency. For Rothko, Gottlieb, Newman, and many of their contemporaries this made conventional painting seem irrelevant and consequently immoral; they sought subjects that addressed the timeless ethical and ontological questions of the human condition.

Turning to Classical Myth

In 1938 Rothko and Gottlieb turned to classical myth to find themes on an elevated order of magnitude and universality. A few years later Rothko explained:

the known myths of antiquity ... are the eternal symbols upon which we must fall back to express basic psychological ideas ... And modern psychology finds them persisting still in our dreams, our vernacular, and our art, for all the changes in the outward conditions of life ... The myth holds us, therefore, not thru [sic] the possibilities of fantasy, but because it expresses to us something real and existing in ourselves.[56]

Rothko and Gottlieb explored not only Greek tragedy but also the writings of Nietzsche and Jung, and the mechanisms of the unconscious mind.

A general interest in myth prevailed from the mid thirties through the war among the surrealists, Picasso, John Graham, and most of the nascent New York School. Sir James Frazer's classic book of mythology *The Golden Bough*, the works of Plato, Aeschylus, and Shakespeare, all became central texts for an examination of universal human questions. The tragic hero provided a model of key interest and for Rothko so too did works of classical music, especially Mozart's operas.

Rothko's first mythic painting, *Antigone* [fig. 4.23], has an overall gray tone, like an archaic stone frieze. The layering of the forms in registers of shallow relief reinforces this association to antiquity, while the frontality of the composition gives it an emblematic character, stressing its distance from representation. The classical profiles and curly hair of the heads, as well as the part-animal, part-human feet in the lower stratum, refer in a general way to sources in Greek sculpture and painting.

Rothko infused this and other mythical pictures with quotations from architectural ornament on the buildings of New York (linking his work to the material reality of the present). He also included crucifixion imagery such as the outspread arms that separate the top two layers of forms in *Antigone* (extending the mythic content beyond the Greek pantheon). In some of his drawings Rothko even showed the hands of these outstretched arms pierced with nails. The Passion of Christ represented for Rothko, as it did for Newman, an embodiment of the eternal tragedy of the human condition and not a uniquely Christian subject—any more than *Antigone* was a uniquely Greek one. This mixture of iconographic elements broadened the base of Rothko's subject matter into a foundation for universal tragedy.

The stratification, which characterizes Rothko's mythic works from roughly 1938 through 1942, echoes the implicit collapse of time by which the artist brought the ancient past into the relevant present. The archaeological metaphor, centered on the idea of a cumulative memory of the past acting upon the present, permeates the theories of Freud as well as the writings of such literary modernists as T. S. Eliot and James Joyce, with whose works Rothko was conversant.

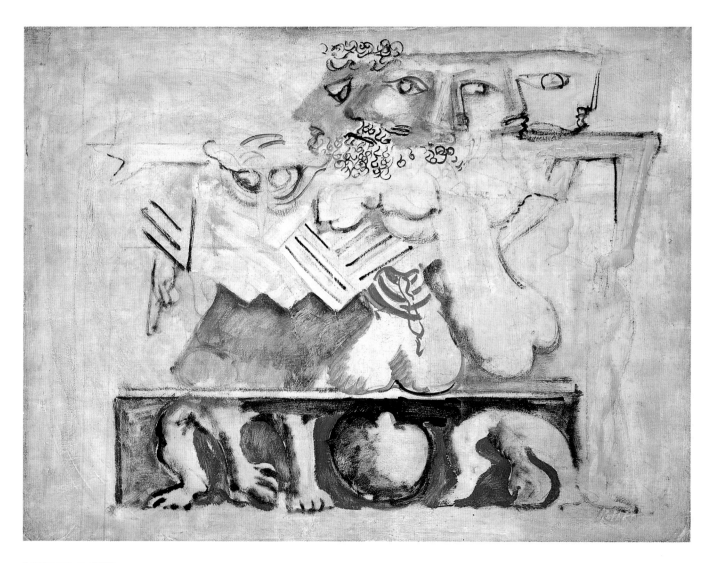

4.23 Mark Rothko, *Antigone,* c. 1941. Oil on canvas
34 × 45¾in (86.4 × 116.2cm).
Collection, National Gallery of Art, Washington, D.C. Gift of the Mark Rothko Foundation.
© 1998 Kate Rothko Prizel & Christopher Rothko/Artists Rights Society (ARS), New York.

For Rothko, history verified the universality of ancient themes. In a commentary to his 1942 painting *Omen of the Eagle* he explained: "The theme here is derived from the Agamemnon Trilogy of Aeschylus. The picture deals not with the particular anecdote, but rather with the Spirit of Myth, which is generic to all myths at all times. It involves a pantheism in which man, bird, beast and tree—the known as well as the knowable—merge into a single tragic idea."[57]

Stylistically the works of 1942 and 1943 owe a certain amount to the formal vocabulary of surrealism, particularly the frottage techniques, birdlike forms, and dreamscapes of Max Ernst; to Masson's metamorphic vocabulary of man and animal; to the poetic structure of Miró's work; and to the transformative vocabulary of biomorphic abstraction, as in Rothko's *The Entombment* [fig. 4.26]. But Rothko and Gottlieb concerned themselves above all else with content

as they took pains to assert in a now famous letter to the *New York Times*: "It is a widely accepted notion among painters," they wrote, "that it does not matter what one paints as long as it is well painted. This is the essence of academicism. There is no such thing as good painting about nothing."[58]

Surrealism, Psychoanalysis, and "the Spirit of Myth"

In retrospect the letter to the *New York Times* also anticipated the development of Rothko's mature style: "We favor the simple expression of the complex thought," they proclaimed. "We are for the large shape because it has the impact of the unequivocal. We wish to reassert the picture plane. We are for flat forms because they destroy illusion and reveal truth."[59] If this proclamation sounds like Barnett Newman's art theory of the forties, that is not accidental. Newman worked closely with Gottlieb and Rothko on it, and in thanks for his publicly unacknowledged, but obviously substantial help, each artist gave Newman a painting in 1943.

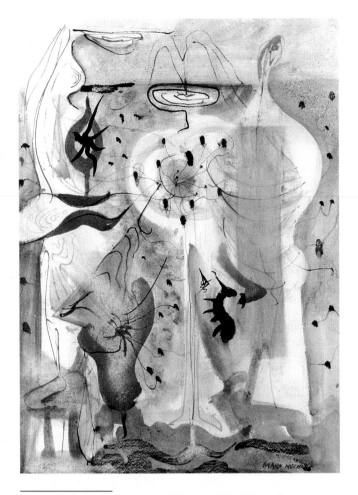

4.24 Mark Rothko, *Baptismal Scene*, 1945. Watercolor on paper, 19⅞ × 14 in (50.4 × 35.6cm).

Collection, Whitney Museum of American Art, New York. Purchase. Photograph by Geoffrey Clements, New York. © 1998 Kate Rothko Prizel & Christopher Rothko/Artists Rights Society (ARS), New York.

In the theory of surrealism Rothko saw a passage through the specific anecdote toward the mechanisms of the unconscious mind. He had experimented with automatic drawing as early as 1938[60] and taken an interest in the Oedipus myth. The careful preparatory drawings for his mythic pictures clearly indicate that he did not conceive them in an automatist manner, but from 1944 through 1946 Rothko did experiment with automatism to produce loose, linear doodles that dominate the foregrounds of his compositions. He painted the backgrounds of these works in luminous, "allover" washes of color, often dividing them into wide horizontal bands. In several canvases of 1945 he also began to increase the scale. The paintings of this three-year period are uneven in quality, despite notable successes like *Baptismal Scene* [fig. 4.24], but they provided a crucial transition to Rothko's "multiforms" of 1947 to 1949 [fig. 4.25], where the doodles melted into soft color forms and then gradually coalesced, in 1949, into the hazily defined color blocks of Rothko's mature style [fig. 4.27].

Freud's theories provided the surrealists with a link

between the world of dreams (the unconscious mind) and the everyday world. Rothko's search for the "Spirit of Myth," encouraged by Jung's interest in universal myths, followed this path one step further. In 1945 Rothko described it this way:

I adhere to the material reality of the world and the substance of things. I merely enlarge the extent of this reality ... I insist upon the equal existence of the world engendered in the mind and the

4.25 Mark Rothko, *Untitled*, 1949. Oil on canvas, 54½ × 27½in (138.4 × 69.9cm).

Photograph courtesy PaceWildenstein Gallery, New York. © 1998 Kate Rothko Prizel & Christopher Rothko/Artists Rights Society (ARS), New York.

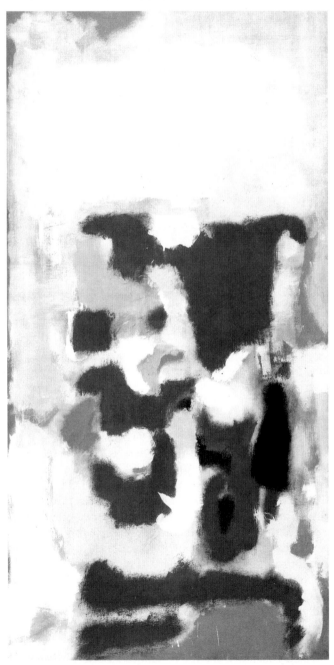

world engendered by God outside of it ... The surrealist has uncovered the glossary of the myth and has established a congruity between the phantasmagoria of the unconscious and the objects of everyday life. The congruity constitutes the exhilarated tragic experience which for me is the only source book for art.[61]

The reviewers of Rothko's January 1945 show at the Art of This Century immediately saw the connection to surrealism, but also noted that Rothko's work was at the same time rather different. While the meaning, according to *Art News*, for example, "derived from the unconscious ... he does not use orthodox surrealist symbols."[62] During the early forties Rothko and a number of other New York painters had shifted their focus past that continuum stressed by Freud and the surrealists toward the universal orders of myth discussed by Jung. The deliberate planning of structure in Rothko's "automatist" works of 1944 to 1946, as testified to by the numerous studies on paper for them, underscores this difference in emphasis.

Clyfford Still, whom Rothko greatly admired,[63] referred disparagingly to the automatists as "scribblers";[64] he rejected surrealism's link to the particularities of the individual psyche and the historical moment. Instead Still sought to embody the sublime and the absolute independence of the individual by rejecting all the conventions of painting; his crusty application, tenebrous palette, and his flat, anti-illusionistic forms [fig. 2.17] deliberately oppose traditions of sophisticated paint handling, coloristic harmony, and compositional structure.

Rothko met Still on a trip to California in 1943. Two years later Still began to show up occasionally in New York and East Hampton, and in the summer of 1947 he taught with Rothko at the California School of the Arts in San Francisco. During 1946—the high point of their relationship—Rothko's work started to exhibit the impact of Still's compositional ideas. Rothko's automatist drawing dissolved into indistinctly defined color forms, moving among one another at a glacial pace over a flat plane. This shift in style to a more purified color abstraction [fig. 4.25] gave way between 1947 and 1949 to larger shapes, frequently more geometric in character, and then an increasingly regular, horizontal layering of forms in 1949.

Between 1947 and 1950 Rothko made few sketches. He worked out his ideas directly on the canvas, in thin washes of color that seem to dematerialize into the weave of the fabric. This identity of the paint with the surface, as well as the increasingly simplified order of the compositions, creates a meditative mood, stressing immateriality and universality while playing down the artist's presence, as expressed in the autographic gesture.

Rothko's own watercolors of the mid forties informed the thin handling of his oils after 1945, as did the work of Miró, who thinned his paint into washes to heighten their ethereal, poetic quality. Matisse's *The Red Studio*, which went on permanent display in February 1949 at the Museum of Modern Art in New York, also influenced Rothko's approach. *The Red Studio* consists of a delicately traced map of insubstantial objects and architecture drawn over a large, flat, evenly washed expanse of red canvas. Rothko spent many hours in front of this painting.[65]

"Heroifying" the Ineffable

During 1949 Rothko finally arrived at a style that seemed to promise "the elimination of all obstacles between the painter and the idea, and between the idea and the observer," as he explained in an article for the journal *The Tiger's Eye* of that year. "As examples of such obstacles, I give (among others) memory, history, or geometry, which are swamps of generalization."[66] Rothko rejected memory in so far as it concerned forms that evoke an already known content, thus narrowing the experience and trivializing the universality of his painting. History, including identifiable myths like that of Antigone, also deflects the viewer's attention from a confrontation with the unknown, which was central to Rothko's vision by the late forties. "Geometry" refers to the ubiquitous geometric abstraction and other styles that derived from formal notions rather than from a compelling content.

In order to achieve "the simple expression of the complex thought ... the impact of the unequivocal,"[67] as Rothko had expressed it in his 1943 letter to the *New York Times*, he relied on the large scale of the color blocks in the works of 1949 and after to create an overpowering material presence; yet it was the presence of something undefinable. Children's art may have been instrumental in Rothko's formulation. He taught art to children at the Center Academy of the Brooklyn Jewish Center from 1929 until 1952 and took a keen interest in their formal ideas. In a notebook from the late thirties Rothko observed that "the scale conception involves the relationships of objects to their surroundings—the emphasis of things *or* space. It definitely involves a *space* emotion. A child may limit space arbitrarily and then heroify his objects. Or he may infinitize space, dwarfing the importance of objects."[68]

Beginning in his paintings of 1949, Rothko "heroified" the central color forms in the same manner as he described children doing it. Yet the lack of particularizing features in Rothko's forms creates an immediacy that is free from the secondary influence of narrative and overt cultural interpretation. He thus achieved a vivid sense of an ineffable presence. In the writings of Sartre existence precedes essence; in Rothko's work the subjective experience of the viewer's encounter with the indescribable painted object provides a foundation for the defining of object and self, and how they relate. The infinite variations of color, distribution, proportion, and handling—from canvas to canvas and even within a single work—manifest the artist's range of speculation on this unresolvable question.

De Kooning's large women of the early fifties also fill the composition and create a powerful presence like Rothko's massive rectangular color clouds. However, the fact that de Kooning's work is figurative and his brushwork prominent

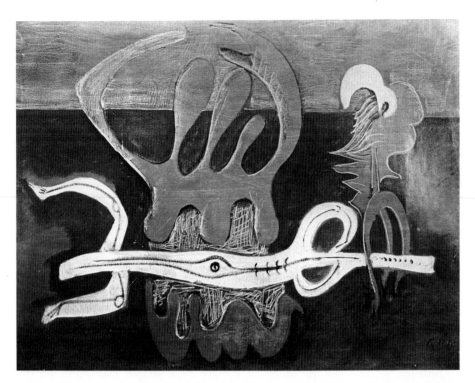

4.26 Mark Rothko, *The Entombment,*
c.1946. Oil on canvas,
23 × 40in (58.4 × 101.6cm).

Collection, Edith Ferber. © 1998 Kate Rothko Prizel &
Christopher Rothko/Artists Rights Society (ARS), New York.

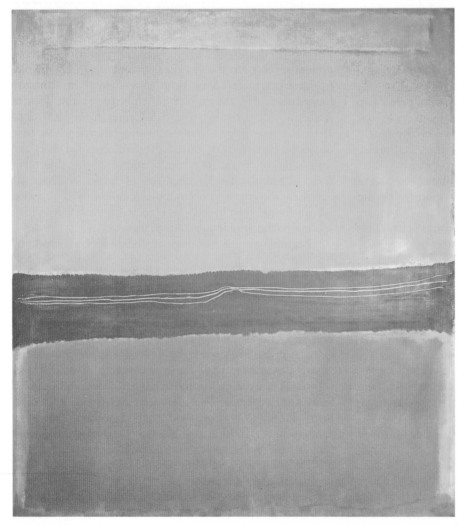

4.27 Mark Rothko, *Number 22,* 1949.
Oil on canvas, 9ft 9in × 8ft 11⅛in
(2.97 × 2.72m).

The Museum of Modern Art, New York. Gift of the artist. ©
1998 Kate Rothko Prizel & Christopher Rothko/Artists Rights
Society (ARS), New York.

gives his paintings a more earthbound focus. It is interesting that in 1951 Pollock also reintroduced figurative elements, derived from the mythic images of his work of the early forties [figs. 2.12 and 4.9]; and David Smith built several works of the fifties and sixties using geometric parts, arranged around a figurative structure [figs. 4.38 and 4.43]. For Newman no remnant of the figure is conceivable, because his work originated in a metaphysical thought, a pure abstract idea attained through the eidetic image (the ideograph) and concepts of placement in space. But Rothko reached for the universal content of human experience through an individual exploration of grand themes, and this allows for the theoretical possibility of a lingering figurative content.

The stratification in Rothko's paintings of the late thirties and early forties into bands of symbols [fig. 4.23] prefigures the compositional order of the rectangular color blocks. This suggests not only a formal predisposition for such shapes but that, through association, the mythic content may still persevere indirectly in the abstract work. Rothko's interest in the entombment and other aspects of the Passion of Christ also lingers in these later works. The art historian Anna Chave has suggested that the horizontal band of red with incised lines across the center of *Number 22* [fig. 4.27] is literally derived from earlier depictions of horizontal dead figures lying across the laps of maternal figures—as in the many medieval and Renaissance paintings of scenes from the Passion of Christ, first reinterpreted by Rothko in works such as his *Entombment* [fig. 4.26] of around 1946.[69]

Yet "it was with the utmost reluctance," Rothko explained in 1958, that "I found the figure could not serve my purposes."[70] Rothko may well have struggled with the figure as late as 1949, although there is neither visual evidence nor any room in Rothko's art theory to demonstrate the perseverance of conscious imagery in more than a few works in 1948 and 1949. On the contrary, the presence of disguised figures would directly contradict the artist's statement that the "shapes ... have no direct association with any particular visible experience, but in them one recognizes the principle and passion of organisms."[71] Such specific underlying subject matter would also run in opposition to his intention "to destroy the finite associations with which our society increasingly enshrouds every aspect of our environment."[72]

On the other hand, to the extent that a "clear preoccupation with death," as he phrased it, permeated his work and that he believed that "all art deals with intimations of mortality,"[73] Rothko's abstract painting continues to carry a spiritual link to entombment and *pietà* themes as well as to Greek tragedy. Such subjects persist as metaphysical content, associated to figural works from earlier periods but not literally derived from them.

Formally Rothko's luminous color structures are something genuinely new in the history of art; they have no antecedent, even though they draw on many sources. Rothko admired Mondrian for the way his forms hold the picture plane. Medieval religious pictures share the iconic symmetry that conveys an elemental religious feeling in Rothko's work. The mysteriously hidden source of his glowing light heightens this feeling; the same effect exists in the works of Rembrandt and Fra Angelico, whose handling of light he greatly admired. Like Pollock, Rothko also saw how the richness of color and surface in impressionism, especially in the late works of Monet, was more important than the subject matter being represented.

Rothko looked shrewdly at work in museums and books to glean visual ideas, he read philosophy and literature, and he may even have taken formal inspiration from music. For example, the composer Edgard Varèse (whose work Rothko knew) would separate a single timbre or tone in his most celebrated compositions, playing it off against various orchestrations and rhythms to bring out the nuances of its individuality. This has a parallel in Rothko's isolated clouds of individual hues. Rothko's painting is an art of perpetual and meticulous refinement. It is directly sensual and relies on great subtlety and variety in the color, application, and even the structure of the forms. Within his limited format, Rothko developed a remarkably wide emotional range, from exuberance to contemplation and foreboding.

The Murals and Other Late Work

By the late fifties the public had begun to appreciate the originality and subtlety of Rothko's work, and his reputation grew considerably. In 1958 Philip Johnson commissioned him to paint a monumental mural for the Four Seasons Restaurant in the new Seagram Building. This was Rothko's first mural commission and his first series. The idea of painting a permanent cycle of murals for a specific space appealed enormously to Rothko because it meant that he could finally have control over the way a group of canvases were viewed.

In the spring of 1959 Rothko set up a studio on the Bowery to paint the commission, and over the next two years he made three sets of murals. The first group—which he immediately either dispersed or destroyed—were in his usual format of stacked rectangles. Then he broke away and used open rectangles. He also abandoned this second set of murals; one can only speculate as to the reasons. Rothko completed the third and final sequence in a horizontal format of rectangles with open centers. But instead of delivering the paintings he returned the money and a decade later gave them to the Tate Gallery in London, where they were installed precisely according to his wishes. There may be some truth in the belief, which he evidently encouraged, that he rejected the Seagram commission because he found it distasteful that the restaurant catered to the rich, but the large scale of the room in relation to the murals and the lack of a meditative mood in the busy restaurant seem more likely as the precipitating causes.

Two years later the Nobel Prize-winning economist Wassily Leontief asked Rothko to execute a mural for the private dining-room of Harvard's prestigious Society of

4.28 Mark Rothko, *Murals for Holyoke Center,* Harvard University, west wall, 1962. Glue and oil media on unprimed cotton duck canvas, panel 1: 8ft 8½in × 9ft 9¼in (2.65 × 2.98m); panel 2: 8ft 9¼in × 15ft ½in (2.67 × 4.59m); panel 3: 8ft 9⅛in × 8ft (2.67 × 2.44m).
Collection, President and Fellows of Harvard College, Cambridge, Mass. Gift of Mark Rothko. © 1998 Kate Rothko Prizel & Christopher Rothko/Artists Rights Society (ARS), New York.

Fellows, which Leontief chaired. Rothko began the Harvard murals in December 1961 and completed them within a year. These murals [fig. 4.28] loomed over the relatively small room, and the reddish backgrounds with dark forms over them created an air of somber silence. The orange rectangles in the left panel have a mysterious iridescence. The murals commanded the space quietly, even passively at first, and set a contemplative tone. But below the surface stillness they seem to vibrate with anxiety and elemental force.

The scale of the Harvard murals in relation to the room follows from a development, initiated by Rothko around 1950, toward larger, more monumental pictures.

I realize that historically the function of painting large pictures is painting something very grandiose and pompous. The reason I paint them, however—I think this applies to other painters I know—is precisely because I want to be very intimate and human. To paint a small picture is to place yourself outside your experience, to look upon an experience as a stereopticon view or with a reducing glass ... However you paint the larger picture, you are in it. It isn't something you command.[74]

Like Newman, Rothko wanted his paintings to be seen from close up, to fill the environment and engulf the spectator. Rothko's concern with controlling the viewer's position in relation to the work had long been an issue; indeed he had been generally unwilling to participate in group shows for some time because he could not control the space around his work.

A religious metaphor resurfaces persistently in connection with Rothko's paintings, particular when seen in groups. He himself remarked that "the people who weep before my pictures are having the same religious experience I had when I painted them."[75] The Harvard murals create the atmosphere of a cathedral; and Rothko conceived his last mural commission for a Catholic chapel in Houston. In addition the texts and art of early

Christianity attracted Rothko because they embodied a simplicity of faith. Typically, early religious paintings seem to use the same symmetry, lack of motion, shallow depth, and richness of surface to evoke meditation on a spiritual realm that transcends earthly thoughts. One may find oneself transported by staring into the rich nuances of shadow and hue in the deep ultramarine robes of a medieval Virgin, just as one can in Rothko's subtle oscillating fields of color. But Rothko cleared away all reverberations of objects to create a grand, tragic silence.

In the late spring of 1964 Rothko received the commission from John and Dominique de Menil to paint

4.29 Mark Rothko, *Untitled,* 1969. Acrylic on canvas, 7ft 4in × 6ft 7in (2.34 × 2.01m).
Photograph by Al Mozell, courtesy PaceWildenstein Gallery, New York. © 1998 Kate Rothko Prizel & Christopher Rothko/Artists Rights Society (ARS), New York.

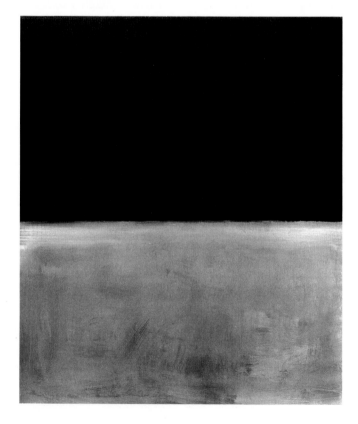

a set of murals for an octagonal chapel in Houston. Here he had even greater control over the setting for the paintings than at Harvard. Inscriptions of the Stations of the Cross were planned for the outside walls of the chapel, and this set the tone for Rothko's concept of the murals. In the winter of 1964 he laid a parachute over the skylight of his studio to create a sacral light. Then he began work on the paintings, using a single, nearly black rectangle on a background of dark maroon. The purplish red of the murals, which deepened by the time he finished them to an almost black on black palette, was, as Dominique de Menil wrote, "the color elected to bring his paintings to their 'maximum poignancy' as he said … as if he were bringing us on the threshold of transcendence."[76] Working incessantly, he completed the mural cycle in 1967, though the installation didn't take place until February 1971, a year after his death.

By the sixties Rothko had achieved financial security and a prodigious reputation. Presidents Kennedy and Johnson invited him to their inauguration festivities and to dinner at the White House; in 1961 the Museum of Modern Art gave him a major retrospective; and in the fall of 1963 the prestigious Marlborough Gallery took him on. Still he felt trapped and restless. In the spring of 1967 he sunk into a deep melancholy and a year later he had an aneurism of the aorta. His mood was black. During his last years he did many brilliantly colored works, though the somber tone of the Houston murals prevailed [fig. 4.29], and after his heart attack in 1968 he started painting predominantly with acrylic on paper. Rothko's marriage and emotional life steadily deteriorated during this period and finally on February 25, 1970 he took his own life.

In *The Birth of Tragedy* (a key work for Rothko[77]) Friedrich Nietzsche noted that the Greeks "developed their mystical doctrines of art through plausible *embodiments*, not through purely conceptual means."[78] Nietzsche chose the Greek deities Apollo and Dionysos to "embody" his postulate of an inherent dualism in the human psyche—on the one side chaos, dissolution, and excess (the "Dionysian") in perpetual tension with the perfection of harmony, individuation, and restraint (the "Apollonian") on the other. Greek tragedy, he argued, merging the two in an eternally conflicted whole.

In Rothko's work from 1949 to 1970 the very simplicity of the radically pared down structure provides an awe-inspiring material embodiment of "a single tragic idea." A Rothko painting "is not a picture of an experience, it is an experience."[79] Rothko's compositional format maintains a tense equilibrium between the forces of disintegration and precise definition. He unified these drives into a single stylistic system, but deliberately avoided reconciling them. The obstinate, immovable presence of Rothko's paintings pushes the viewer out on his or her own, face to face with fundamental, unresolved, ontological questions. Free of "the familiar," he wrote, " … transcendental experiences become possible … Pictures must be miraculous … a revelation, an unexpected and unprecedented resolution of an eternally familiar need."[80]

David Smith and the Sculpture of the New York School

Like the painters of the New York School, the sculptors also shifted their focus in the late forties to the implications of surrealist automatism and to existentialism. Theodore Roszak, for example, abandoned his machine-age constructivism for expressionistically handled abstractions in bronze, stressing subjectivity. Ibram Lassaw began building up nubby accretions of surface texture on intuitively assembled linear structures of welding rods. Seymour Lipton's use of a spatial armature as a stage set for biomorphic abstract forms in such works as *Imprisoned Figure* [fig. 4.30] is indebted to Alberto Giacometti's surrealist cages [fig. 5.14] and the psychologically charged biomorphism of Matta [fig. 5.3]. The dreamlike mutations of figures in the surrealist bronzes of Max Ernst [fig. 4.31] informed the sculpture of the young American David Hare and may linger behind the figural presence of Herbert Ferber's welded, gestural abstractions as well [fig. 4.32].

But David Smith was the outstanding sculptor to emerge from this shift toward existential introspection and automatism among the artists of the New York School at the end of World War II. Indeed in the next two decades he successfully realized the gestural spontaneity of the action painters in an extensive body of welded sculpture [figs. 4.33—4.43]. Through the free association of forms, his work from 1952 until his untimely death in 1965 defined itself in the process of construction. Welding made this technically possible, by permitting the artist to fabricate his pieces quickly and to work in an improvisational manner; he could experiment with forms and remove or alter them at will. "I do not work with a conscious and specific conviction about a piece of sculpture," he explained in 1952. "It is always open to change and new association. It should be a celebration, one of surprise, not one rehearsed."[81]

In addition the directness of fabricated sculpture—unlike bronze casting—retained the dominance of the "artist's hand" in all aspects of the work. Like automatist spontaneity, the personal gesture of the artist had become an important issue to artists of this generation, for whom it signalled authenticity. "The sculpture work is a statement of my identity," Smith said. "It is part of my

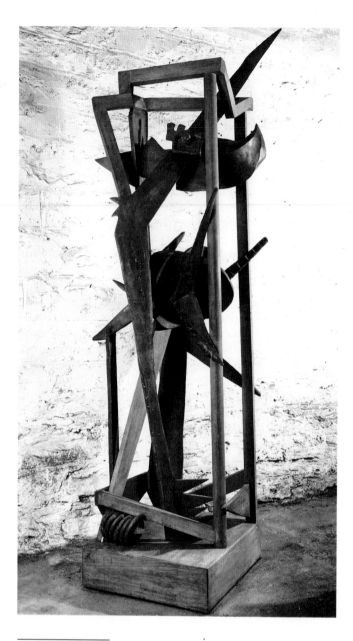

4.30 Seymour Lipton, *Imprisoned Figure,* 1948. Wood and sheet-lead construction, 84¾ × 30⅞ × 23⅝in (215.3 × 78.4 × 60cm), including wood base, 6⅛ × 23⅛ × 20⅛in (15.5 × 58.7 × 51.1cm).
The Museum of Modern Art, New York. Gift of the artist.

emblematic of masculinity and of the machine age—"the metal itself possesses ... associations ... of this century: power, structure, movement, progress, suspension, brutality"[84]—and he felt that art had to engage this language of the machine in order to express an authentic experience of the present.

Smith was characterized by a friend, Herman Cherry, as "a sensual man with vast appetites [who] held to the rigors of a monastic life in his work."[85] Typically Smith would work in isolation on his farm in upstate New York for months at a time and then, according to his friend Robert Motherwell, he would come down to New York City for a few days to have a rousing good time.[86] Smith's farm gave him both the physical and psychic space to work, but the loneliness could also become overpowering. "Aloneness," he once complained, "is the condition of the artist's creative life."[87]

Smith's Initiation into the Art World

David Smith was born in 1906 in Decatur, Indiana. His father managed the local independent telephone company. The artist remembered him as a weekend

4.31 Max Ernst, *The King Playing with the Queen,* 1944. Bronze (cast 1954, from original plaster), 38½in (97.8cm) high, at base 18¾in × 20½in (47.6 × 54cm).
The Museum of Modern Art, New York. Gift of D. and J de Menil. © 1994 Artists Rights Society (ARS), New York/SPADEM/ADAGP, Paris.

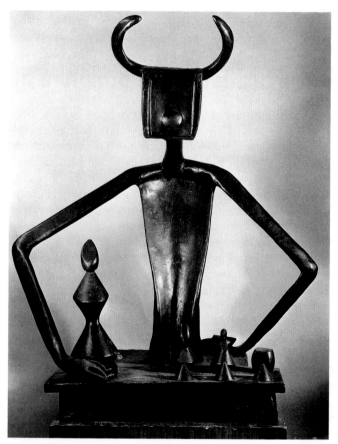

work stream, related to my past works, the three or four in process and the work yet to come. In a sense it is never finished. Only the essence is stated, the key presented to the beholder for further travel."[82]

Like Pollock and others in their circle, Smith sought the particular truth of encountering himself at the most primitive level of his being. He saw it as a pioneering, existentialist odyssey that evoked for him the American frontier myth. "Art," he said, "is the raw stuff which comes from ... aggressiveness by men who got that way fighting for survival."[83] He even saw the materials themselves as

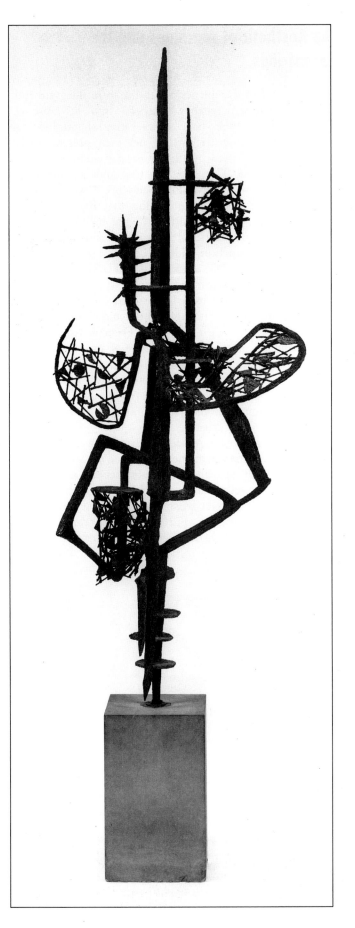

inventor, and indeed Smith had the impression from childhood that everyone in town seemed to be inventing cars and other machines and devices. Smith's mother was an austere Methodist schoolteacher, obsessed with respectability and instilling discipline. In consequence Smith rebelled violently against authority all his life. His grandmother provided a refuge from home and the illustrations in the Bible that she gave him seem to have fostered his wish from an early age to be an artist.

At the age of twenty-one Smith went to New York. He studied at the Art Students League from 1927 to 1932 and on Christmas Eve of that first year married Dorothy Dehner, a fellow student. Smith discovered the works of Picasso, Kandinsky, Mondrian, and the Russian constructivists in classes with Jan Matulka, who had studied with Hofmann. Although Smith was a painting student, not a sculptor, Matulka encouraged him to experiment with textures and relief. Through friends at the League, Smith met John Graham, who in turn introduced him to a wider circle of artists, including Stuart Davis, Arshile Gorky, Willem de Kooning, and Milton Avery. Graham's frequent travels to France, his library of vanguard art journals, and his contacts with European artists provided a conduit of information about advanced art for Smith, as it did for Gorky, de Kooning, and later Pollock.

It was around 1930 that Smith saw reproductions of welded sculpture by Picasso and González in issues of *Cahiers d'Art*, which belonged to John Graham. "I learned that art was being made with steel—the material and machines that had previously meant only labor and earning power,"[88] he recalled. It was the sculpture of Julio González that inspired Smith to buy welding equipment in 1932. But working in a Brooklyn apartment, he kept setting fire to the curtains and to drawings on the walls. Then one day on a walk by the docks he ran across a rundown structure called the Terminal Iron Works, inhabited by two Irish blacksmiths named Blackburn and Buckhorn. Smith arranged to rent space from them and made his first series of welded heads there in 1933. He felt so much at home in this environment that he continued to call his studio the Terminal Iron Works even after he abandoned the dock and moved permanently up to his farm at Bolton Landing.

Like so many of his contemporaries in New York during the thirties, Smith struggled to assimilate the formal languages of cubism and, beginning in 1937, biomorphic surrealism. In *Construction on a Fulcrum* [fig. 4.33] the flat abstract shapes and the manner in which the composition maintains reference to a picture plane—with a fixed viewing position and a deliberate ambiguity between two- and three-

4.32 Herbert Ferber, *The Flame*, 1949. Brass, lead, and soft solder, 16 × 10 × 10in (40.6 × 25.4 × 25.4cm).
Collection, Whitney Museum of American Art, New York. Purchase.

dimensional space—come directly from cubist constructions of 1912 to 1914. *Construction on a Fulcrum* teases the viewer by making the sphere at the apex appear flat in the context of the planar and linear elements—and Smith's sculpture rarely lost this connection to the picture plane.

The Museum of Modern Art's stunning "Fantastic Art, Dada, and Surrealism" exhibition of December 1936 and January 1937 turned the heads of nearly everyone in the New York art world. Smith embarked on a decade-long exploration of surrealism after seeing it. In addition many of the artists with whom Smith associated in the late thirties—not least Pollock, whom he met in 1937—were increasingly involved in psychological introspection and issues of presence and self-discovery. The death of Smith's father in August 1939 may also have heightened the emergence of more inwardly reflective content in Smith's work. Early in 1938 Marian Willard gave Smith his first one-man show at her East River Gallery. This provides a rough benchmark after which Smith entered nearly six years of preoccupation with ideas inspired by the surrealists and the surrealist-influenced work of Picasso [fig. 5.20], González, Giacometti, and Miró, who were all represented in that show at the Museum of Modern Art.

The Aesthetic of Machines and the Unconscious

At the end of the thirties Smith began to integrate real tools—pliers, wrenches, washers—into his abstract sculptures. The tools had an evocative significance as emblems of the industrial world. Yet their presence only exacerbated the critics' hostility toward welding as a new fine-art technique. The critic for *Cue* snidely referred to Smith's 1940 show as "Sewer Pipe Sculpture,"[89] while a writer for *Time* described it as "plumbing that has survived a conflagration" in an article entitled "Screw Ball Art."[90]

In the early forties Smith experimented with metamorphic abstraction, indebted to Picasso's and Miró's figures of 1927 to 1933 [figs. 5.20 and 3.27]. Like them Smith preserved a clear connection to sources in the external world. Yet he used the unconscious as a tool to transform the subject, and the impact of surrealist dream imagery is evident. Smith referred to Freud as "the greatest single influence on the theoretical side of art, providing an analytical system for establishing the reality of the unconscious … from which the artist derives his inspiration."[91] What seemed important was the subject matter of the unconscious, which Smith recognized as part of the identity of the artist.

The imperative for socially relevant, "instructive," or edifying subject matter in the thirties led to a widespread mistrust of both surrealism and abstract art as escapist. Smith spoke out vehemently on behalf of abstraction: "The great majority of abstract artists are anti-fascist and socially conscious,"[92] he insisted. Furthermore he made fifteen antiwar "Medals for Dishonor" at the end of the thirties,

4.33 David Smith, *Construction on a Fulcrum,* 1936. Steel, 14 × 17in (35.6 × 43.2cm).

Collection, Willard Gallery. © Estate of David Smith/VAGA, New York, 1994.

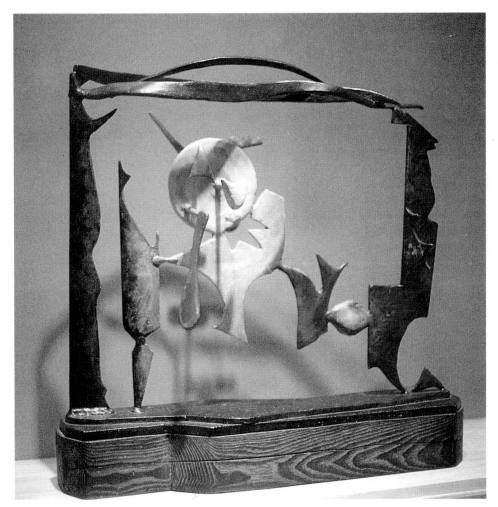

4.34 David Smith, *Helmholtzian Landscape,* 1946. Steel, painted blue, red, yellow, and green, 5⅞ × 17⅝ × 7⅛in (40.3 × 44.8 × 18cm). Kreeger Museum, Washington, D.C. © Estate of David Smith/VAGA, New York, 1994.

with subtitles like *The Cooperation of the Clergy* and *War Exempt Sons of the Rich*, in a style that blended expressionism with illusionistic surrealism.

In the spring of 1940 the Smiths moved permanently to the farm in Bolton Landing, despite its rudimentary amenities. Anxious about being drafted, Smith took a deferrable job in 1942 on the all-night shift at the American Locomotive Company in Schenectady, where he built locomotives and M-7 tanks. This not only isolated Smith from the New York scene, but during his two years at American Locomotive he had almost no time for sculpture. Metal was hard to find anyway, and he did continue to draw. But in 1944 he found he was medically unfit for service and he immediately quit the factory. He had some savings by this time and together with timber sales from the land he had enough money to start work on a new house and studio.

Marian Willard gave Smith regular shows in the forties and his reputation grew, although he sold very little. In a 1943 review for the *Nation*, Clement Greenberg wrote that Smith would become one of America's greatest artists if he kept up the pace of his development.[93] In 1945 Smith moved away from surrealism toward an almost pictorial naturalism with flat forms in a shallow cubist space, inspired by Picasso's sculpture of the late twenties.

Smith titled *Helmholtzian Landscape* [fig. 4.34] for the nineteenth-century German scientist who wrote a pioneering treatise on the physiology of perception. In this work Smith set a string of freely defined abstract forms in a frame, separating them into an illusionistic pictorial space apart from the real space around them. At the same time he defined the border in flat planes and organic contours that give the impression of a drawing on a two-dimensional surface and that connect the frame visually to the imaginary world it surrounds. He further heightened the richness of the reality within the frame by painting the steel free-forms in bright colors.

In *Helmholtzian Landscape* Smith created a deliberate sequence of visual puns: three-dimensional forms in real space create an illusion of flat forms in a pictorial space; the illusion of a pictorial space in turn refers to a picture, which attempts to create the opposite illusion of real space on a two-dimensional canvas. Even the mechanism which separates the worlds of real and depicted space—the frame—is itself ambivalently defined as both a real object (the frame) and part of the imaginary landscape (as a drawing). The complexity of the perceptual ambiguities are what make this a proper homage to Helmholtz. On an entirely different level, the work has to do with a discourse

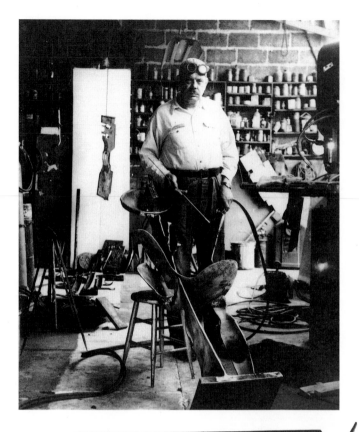

between reason and intuition as symbolized in the study of light by the scientists Helmholtz and Chevreul as compared to the examination of light by the impressionist painters, with whom they were contemporary.[94]

In 1946 and 1947 Smith sold a few sculptures, and in September 1948 he began his first teaching job at Sarah Lawrence College, then an exclusive women's school in the boroughs of New York City. He taught there for two years while also struggling to finish building his house at Bolton Landing. This left little time for sculpture, and he produced only three works in 1948 and seven in 1949. Then two sequential Guggenheim awards in 1950 and 1951 enabled him to work in the studio full time again and to buy the materials he needed [fig. 4.35].

4.35 David Smith in his Bolton Landing studio with *Detroit Queen,* c. 1962.
Photographer unknown.

4.36 (below) **David Smith,** *Hudson River Landscape,* 1951.
Welded steel, 49½ × 75 × 16¾ in (125.7 × 190.5 × 42.5cm).
Collection, Whitney Museum of American Art, New York. Purchase. © Estate of David Smith/VAGA, New York, 1994.

The Pictograms and *Hudson River Landscape*

S mith turned almost exclusively to welding after 1950 and he increased the scale of his work dramatically. His work of 1950 and 1951 is dominated by several large pieces that look like "drawings" in steel lines. *Hudson River Landscape* [fig. 4.36], measuring over six feet across, captures the feeling of a rolling northeastern landscape. It is flat, narrative, and has a weightless lack of sculptural volume; instead it evokes a pictorial illusion in a shallow cubist space.

Seen from the side, *Hudson River Landscape* disappears. Smith conceived the piece with a single viewing position in mind and little actual depth. He persistently played with the idea of three-dimensional forms that demanded to be read in two-dimensional (or "pictorial") terms, thus emphasizing "seeing" over engaging the sculpture physically, either by touching or walking around or into it. This trait characterizes a majority of Smith's works right to the end of his career.

To the extent that *Hudson River Landscape* looks like the contours of a Stuart Davis painting [fig. 3.13], it also reflects Smith's persevering connection to cubism. But instead of changing the picture plane into sculptured relief he inverted the equation and changed the real volume of sculpture into a picture space. By this time Smith knew that precisely this fusion of "American machine techniques [his preoccupation with tools and welding] and European cubist tradition" were not only "accountable for the new freedom in sculpture making," as he put it, but that it constituted the stylistic core of his identity as an artist. "Here I am talking about direct metal constructions," he went on; " … the new method is assemble the whole by adding its unit parts … an industrial concept, the basis of automobile and machine assembly."[95]

Looking out of the train window, Smith made hundreds of drawings of the Hudson Valley while commuting between Bolton Landing and Sarah Lawrence College in 1948 and 1949; *Hudson River Landscape* synthesizes the feeling of that picturesque journey. The vastness and romance of the American landscape, and in particular *this* landscape with its obvious association to the nineteenth-century painters of the Hudson River School, are themes that show Smith to have been part of a classic American tradition. The "sublime"—as evoked in the breathtaking visions of the Hudson River School and earnestly debated by Newman, Rothko, and Gottlieb a hundred years later—was indeed an underlying theme in this sculpture by Smith. As an expression of his willingness to take on the big themes, it is also a measure of his artistic self-confidence.

Around 1950 Smith had begun to look for timeless, grander themes. Gottlieb got him interested in pictograms, with which Smith experimented in various works of 1950 and 1951. Smith's interest in the origins of language and by 1952 in totems came out of the search for a universal content. The notion of pure visibility and of communication through visual forms that precede language may have been connected to the transition in Smith's sculpture from the pictographic letters in

4.37 David Smith, *Tanktotem I,* 1952. Steel, 90 × 39 × 16½in (228.6 × 99 × 41.9cm).
Collection, Art Institute of Chicago. Gift of Mr. and Mrs. Jay Z. Steinberg. © Estate of David Smith/VAGA, New York, 1994.

sculptures of 1950 and 1951, through the pictorialism of *Hudson River Landscape*, to the more direct totemic figures of 1952 like the sculptures of the "Agricola" and "Tanktotem" series [fig. 4.37].

An Existential Encounter with the Materials at Hand

I n the works of 1952 Smith became preoccupied with totemic figures—an interest to which Pollock had then also returned. In realizing these works, Smith employed more found objects and made few preparatory drawings. They involved a huge increase in improvisation with the materials at hand, because they evolved through free

association. Here Smith attempted a kind of sculptural collage in found and contrived machine parts and industrial materials that is indebted to the formal traditions of cubist collage and construction.

In these compositions Smith achieved a total harmony of personal identity and style. Whereas the works of 1951 and earlier made manifest his exploration of influences from cubist relief, surrealism, the expressionist Picasso, and Gottlieb's pictographs, in the works that followed, the force of Smith's personality completely transcended his sources. Each piece centers on an exploration of the artist's identity, as in the contemporary works of de Kooning, Pollock, or Rothko. "My problem is to be able to look every day and to press my limitations beyond their endurance," he told Katherine Kuh in 1960. "What are these limitations?" she asked. "They're me."[96]

The "Tanktotem" and "Agricola" pieces are the first of the more than fifteen different numbered series in which Smith began to work in 1952; nearly all of his sculptures from this point onward have series titles. For Smith a series was not a progressive or systematic exploration of a single theme, but rather a single mood. He nearly always worked on pieces in several series at one time and most often the collective titles relate to the materials: in the "Tanktotem" pieces he used steel tank heads, which he ordered from a standard catalog; "Agricola," which is Latin for "farmer," designates a group of works built with fragments of farm implements; the "Albanys" incorporate heavy steel plate purchased from the Albany Steel and Iron Supply. In a few cases Smith named a series in relation to some general feeling, as in the birdlike "Ravens" or the "Sentinels," which give the impression of an immobile figure at attention.

Career Success and Personal Sacrifices

Smith completed 250 sculptures between 1950 and 1960, two-and-a-half times the number he made over the preceding decade. He drove himself as if he had to live up to Greenberg's prediction of 1943, that he would be the greatest sculptor in the United States. But the personal sacrifices were great. His ambition had made him increasingly difficult to live with, his uncontrollable temper had gotten worse, and he had been having an affair with a student from Sarah Lawrence when Dorothy left, this time for good, on Thanksgiving Day of 1950.

Worries about finances also resurfaced when his two grants ran out; despite his growing international reputation he still sold very little. In a note book of the early fifties he wrote " ... nothing has been as great or as wonderful as I

4.38 David Smith, *Construction with Forged Neck*, 1955. Steel, 76¼ × 13 × 8⅝in (193.7 × 33 × 21.9cm).

Collection, Estate of David Smith. Photograph courtesy M. Knoedler & Co., New York.
© Estate of David Smith/VAGA, New York, 1994.

envisioned … It would be nice to not be so lonesome sometimes—months pass without even the acquaintance of a mind … so much work to be done—it comes too fast to get it down in solids—too little time, too little money … to stay alive longer—I've slipped up on time—it all didn't get in."[97]

Jean Freas, the woman Smith had begun to see at Sarah Lawrence in 1949, was twenty when they met, Smith was forty-three. They married on April 6, 1953 and had two daughters (in 1954 and 1955); in 1958 this marriage too came apart. By this time the momentum of Smith's work and career had accelerated, despite his reputation of being difficult to deal with. In 1957 the Museum of Modern Art gave him a one-man show of thirty-four sculptures, and by the end of the year his income had quadrupled.

The Figural Presence and the Work of the Last Decade

In 1954, while Smith was teaching as a visiting professor at the University of Indiana in Bloomington, he found an iron works called Seward and Company where they let him work on a power forge. The "Forgings," made at this foundry in early 1955, are all anthropomorphic with a wispy verticality reminiscent of the attenuated figures of Giacometti [figs. 5.15–5.17].[98] Some of the "Forgings" have a totemic presence—they are "the savage idols of basic patterns"[99] to use Smith's own words—and they follow from works like the "Tanktotems." Others seem more explicitly lifelike. *Construction with Forged Neck* [fig. 4.38], for example, has the appealing awkwardness of a young girl, perhaps a dancer. After Smith's death in 1965 the executors of his estate found and allegedly destroyed a stack of nude photographs he had taken of girls, probably from nearby Bennington College. Smith's executors leapt to the conclusion that he had taken the pictures for entertainment, but one wonders whether he might instead have been using the photographs as a source for these figurative sculptures of the fifties and sixties.[100] The latter conclusion is also suggested by Smith's *Running Daughter*, a figural piece from the later fifties, for which the source is well known to have been a photograph of his three- or four-year-old daughter.

Construction with Forged Neck is built humorously around the large orifice at the midsection. With its long skinny leg, tall neck, and tiny head, it seems to stand there in self-consciousness and embarrassment. The subject of this work appears to be its youthful sensuality. Smith's remark that he did "girl sculptures"[101] and his involvement with the Bennington girls in the fifties and sixties seem pertinent to the character of such works.

The relation of Smith's sculpture to his life experience is part of what gives his work after 1951 such total conviction. "Art before my time," he remarked, " … is history explaining past behavior, but not necessarily offering

4.39 David Smith,
Voltri XIII, 1962. Steel,
64⅛ × 103¾ × 26in
(162.9 × 236.5 × 66cm).

Collection, University Art Museum,
University of California at Berkeley. Gift
of Mr. and Mrs. Eugene E. Trefethen, Jr.
© Estate of David Smith/VAGA, New
York, 1994.

Existentialism Comes to the Fore

solutions to my problems. Art is not divorced from life. It is dialectic."[102] This sense of continuity between art and life is reflected formally in Smith's increasing effort to eliminate the base from his sculpture or to incorporate it into the composition, as well as fusing "real" tools into the works. In several of the "Tanktotems" Smith set the figures directly on the ground. By placing the piece in the viewer's real space instead of visually creating a space apart by using a base (which serves like a frame in painting), the artist attacked the separation between art and the viewer.

Smith started the "Cubi" series in 1961 [figs. 4.40, 4.41, and 4.43], and despite their geometry many of them also retain a figurative character. He made this series in stainless steel partly to avoid the need to paint and laboriously maintain outdoor work that was otherwise prone to rust. Nevertheless Smith did also paint some sculptures to keep them from rusting, and to some extent the burnishing of the stainless steel in the "Cubis" gave them a brushed-on look which, like painting the pieces, pictorialized them. Although Smith could weld stainless steel, he did not have the equipment to cut it; consequently he had to order the volumes prefabricated and since irregular shapes were not readily available from the commercial suppliers Smith's stainless steel sculptures tend to be geometric.

As early as 1946 Smith had been purchasing leftover scraps from steel-fabricating plants so that he could have stockpiles of random forms on hand to work with. Although Smith's work got larger after 1950, he still did not construct it from sketches. Instead he developed the practice of laying pieces out on the floor or on a white table and collaging them directly. He would weld the components in place and then work on other elements of the composition after he got the structure upright. This technique further reinforced the pictorialism of his sculpture by initially developing it in one view against a two-dimensional backdrop.

In 1958 and 1959 Smith also made a number of paintings by laying out forms on the floor. Using a white surface and spray-painting over the shapes he laid down, he produced a composition of negative overlays and voids that stressed his persistent interest in the line contour of forms and in pictorial space rather than mass and volume. In some instances he used this technique on pieces of cardboard, cut to the regular shapes of his stainless steel volumes, as a way of working out the composition for some of the "Cubis." But he rarely made conventional drawings for sculpture.

In 1962 the composer Gian-Carlo Menotti asked a reluctant Smith to participate in the upcoming summer festival of the arts in Spoleto, Italy, of which Menotti was the director. Once there, he was given an abandoned steel factory in Voltri, near Genoa, with all its contents and a crew of assistants for a month. The place unexpectedly struck a deep chord of nostalgia. Smith later commented that "these factories ... were like Sundays in Brooklyn in 1934 at the Terminal Iron Works, except that here I could use anything

4.40 David Smith, *Cubi XVII* (side view), 1963. Polished stainless steel, 107¾ × 64⅜ × 38⅛in (273.7 × 163.5 × 96.8cm). Collection, Dallas Museum of Art. The Eugene and Margaret McDermott Fund. © Estate of David Smith/VAGA, New York, 1994.

4.41 (opposite) **David Smith,** *Cubi XVII*, 1963. Polished stainless steel, 107¾ × 64⅜ × 38⅛in (273.7 × 163.5 × 96.8cm). Collection, Dallas Museum of Art. The Eugene and Margaret McDermott Fund. © Estate of David Smith/VAGA, New York, 1994.

I found."[103] He had an incredibly productive stay, completing an extraordinary twenty-seven sculptures—among the greatest of his career—in one month.

Smith built *Voltri XIII* [fig. 4.39] around what he called "chopped clouds"[104]—the freeforms that are cut off the end of a sheet of steel to square it off after rolling it out. The space, the limitless material, and the numbers of workers at his disposal in Italy got Smith interested in greater size. The flatcars that trundled among the railroad tracks into the old factory complex spawned the idea for the large pieces on

Existentialism Comes to the Fore

wheels; they must have evoked memories of the train engines that fascinated Smith in his youth. In addition Smith had probably seen the figures on wheels by Giacometti in the Museum of Modern Art or the Pierre Matisse Gallery. Smith was so moved by the Voltri experience that he had a large quantity of the materials from the factory shipped home and he constructed the "Voltri-Bolton" or "Volton" compositions at Bolton Landing using materials from the factory in Italy.

Smith created all but one of the twenty-eight works in the "Cubi" series—the most celebrated series of his career—during the last three years of his life. By and large the "Cubis," like much of Smith's work, imply one viewing position. *Cubi XVII* [fig. 4.41], for example, loses much of its

4.42 David Smith, *Zig VIII,* 1964. Steel, painted red, white, and black, 8ft 4¾in × 7ft 7½in × 6ft 11in (2.55 × 2.32 × 2.1m).
Collection, Museum of Fine Arts, Boston. Centennial Purchase Fund. © Estate of David Smith/VAGA, New York, 1994.

4.43 (below) **David Smith,** *Cubi XXIII,* 1964. Stainless steel, 6ft 4¼in × 14ft 4⅞in (1.94 × 4.39m).
Collection, Los Angeles County Museum of Art. Modern and Contemporary Art Council Fund. © Estate of David Smith/VAGA, New York, 1994.

dynamism when seen from the side [fig. 4.40]. The "Cubis" also toy with the viewer's perception by creating ambiguities that encourage a reading of the actual volumes as two-dimensional depictions. The highly reflective surface exaggerates the contrast between the lighted areas and those in shadow, creating the effect of a two-dimensional rendering of volumes with black shading rather than one involving real objects in space. In addition the shimmering light pattern calls attention to the surface, flattening out the forms still more.

Smith very much liked the way in which stainless steel was able to reflect the light and atmosphere of the surroundings. But the hand-worked quality of the surface also attracted him and relates to the brushwork that can be seen in the painted sculpture of the period, such as *Zig VIII* [fig. 4.42]. Meanwhile, the rough finish of the welds in the "Cubis" conveys a sense of forms coming together quickly, as if with the spontaneity of action painting. However, the necessity for prefabricating the stainless steel components made improvisation more difficult; he was forced to plan them at least enough to be able to order the parts. So, in addition to the spray paintings, Smith devised the procedure of using empty liquor boxes to make three-dimensional studies for the "Cubis" and he also kept a stock of forty to fifty prefabricated cubes on hand to allow for spontaneous modifications.

Smith wrote an intriguing note in a sketchbook of 1952 about "reducing the human form to cubes—exploited by Cambiaso,"[105] referring to Luca Cambiaso, a sixteenth-century Italian mannerist, who made drawings of figures segmented into geometric volumes. Indeed many of the works in the "Cubi" series evoke figural associations. Even the horizontal *Cubi XXIII* [fig. 4.43], for example, seems to portray the same classical subject as in a work such as Henry Moore's *Reclining Figure* [fig. 4.44]. Yet, in others, if the figure provided the initial gesture from which Smith's process of formal association began, he left it buried beyond recognition under the final form.

In the last fifteen years of his life David Smith successfully transformed the automatist principle of the New York School painters into a major body of sculpture

4.44 Henry Moore, *Reclining Figure,* 1935–6. Elmwood, 19 × 36¾ × 17½in (48.3 × 93.4 × 44.5cm).
Collection, Albright-Knox Art Gallery, Buffalo, New York. Room of Contemporary Art Fund, 1939. © The Henry Moore Foundation, 1994.

that has the immediacy of a series of charcoal sketches. The idea was antithetical to the traditional techniques of sculpture. Moreover, Smith's materials and technique were novel in that they came from the world of labor and industry; in this way he integrated his real experience of the world with the fundamental nature of his psyche. He believed that "from the artist's point of view he deals with truths, statements of reality,"[106] and also felt that "since impressionism the realities from which art has come have all been the properties of ordinary men."[107]

Nevertheless "art is poetic," Smith insisted. "It is poetically irrational. The irrational is the major force in man's nature. And as such the artist still deals with nature."[108] Within the terms of the artistic metaphor, each new sculptural synthesis—if only by virtue of its own entrance into the totality of experience—changes the world and is in turn outdated by events as soon as it comes into being. Thus in making sculpture an embodiment of identity, Smith kept his work and his sense of self poised on the edge of the unknown.

5

THE NEW EUROPEAN MASTERS OF THE LATE FORTIES

Jean Dubuffet and Postwar Paris

Although the surviving masters of prewar modernism—particularly Picasso, Matisse, Léger, Ernst, and Miró [fig. 5.2]—continued generating important work after 1945, an entirely different set of issues informed and motivated the generation that emerged in Europe after the war. However much admiration one felt for Matisse or Picasso, they were of an older generation and their subject matter no longer seemed relevant to young artists. Meanwhile, the Depression and the war had also undermined the ideological credibility of abstraction. Painters such as Mondrian and Kandinsky had seen abstract art as a vehicle for bringing about a new spiritual awakening in society at large. But by the end of World War II this social metaphysics no longer seemed believable, and in addition the great theoreticians of abstraction—Kandinsky, Mondrian, Lissitzsky, Malevitch, Delaunay, and Klee—were all gone.

Surrealist automatism, which was essentially amoral, still provided a vital creating tool, yet after 1945 only Matta managed to produce a major new body of surrealist work [fig. 5.3]. Postwar artists felt they had to construct an authentic new foundation for art in response to the pressing social and ethical issues which had come to the fore in the thirties and early forties. Surrealism, with its exploration of the unconscious mind, indicated a possible route, but it was existentialism that provided the ideological context for a more emotionally immediate approach.

The pessimism of European intellectual life after World War I had deepened into despair during the thirties, and postwar existentialism grew out of that despair. If the existence of God still seemed credible, it had to be a harsh, incomprehensible God in a reasonless universe. By reasserting subjective individualism, existentialism responded to the moral failure of the Hegelian emphasis on the ideal, the abstract, the "essence" of things, and to the depersonalization of modern life. However tortured by doubt, the individual could at least experience his or her own existence with integrity. "Read only your own life," Nietzsche had advised, "and from this understand the hieroglyphs of universal life."[1]

Jean-Paul Sartre, an atheist and the oracle of postwar existentialism, believed that the world was irreducibly irrational. He nevertheless imposed a moral imperative, a sober sense of "good faith" in facing the "truth" of one's condition. This underlies both the art of the New York School and the innovative new figurative art that arose in Europe at the end of World War II. In Europe Jean Dubuffet, Alberto Giacometti, and Francis Bacon (like de Kooning, Pollock, Rothko, and Newman in New York) returned to first principles and reinvented art for themselves. They were driven by a need to explore questions about the meaning of their own lives, and they directed their attention to immediate experience as the only knowable truth from which to proceed. Dubuffet in particular looked back to the

5.1 (opposite) **Jean Dubuffet,** *The Squinter,* October 1953. Butterfly wing collage, 9¾ × 7in (24.8 × 17.8cm).

Private collection. Courtesy PaceWildenstein Gallery, New York. © 2000 Artists Rights Society (ARS), New York/ADAGP, Paris.

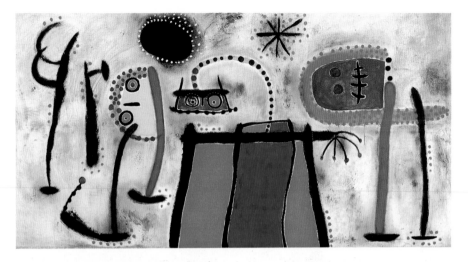

5.2 Joan Miró, *Painting,* 1953. Oil on canvas, 6ft 4¾in × 12ft 4¾in (1.95 × 3.77m).
Collection, Solomon R. Guggenheim Museum, New York. Photograph by David Heald. © 2000 Artists Rights Society (ARS), New York/ADAGP, Paris.

5.3 Matta, *Je m'honte (I Shame Myself/I Ascend),* 1948–9. Oil on canvas, 6ft 4¾in × 4ft 7⅞in (1.95 × 1.42m).
Menil Collection, Houston, Photograph by Hickey-Robertson. ©1994 Artists Rights Society (ARS), New York/ADAGP, Paris.

French writer Georges Bataille, who coined the term "*l'informe*" in 1929 to imply an aesthetic that he hoped would undermine all definitions, all hierarchies in thinking, to "un-form all categories because he found them false to an underlying formlessness in all matter."[2]

Dubuffet's Painting of the Forties

Jean Dubuffet decided to leave his wine business and start painting in 1942, during perhaps the grimmest period of Hitler's occupation of Paris. At first glance his art [figs. 5.4–5.7] seems entirely detached from such worldly events. He depicted the most ordinary views of daily life in an ungainly style that was influenced directly by graffiti and the art of children. But deeply affected by the moral crises of wartime Europe. Dubuffet returned to the rudimentary origins of art at that point in history when the logic of civilized values had been twisted to a horrific conclusion.

The outlines of the figures in *Childbirth* [fig. 5.4] appear to have been scratched into the surface, like graffiti. Slogans and caricatures on walls are a time-honored vehicle of anonymous dissent and Dubuffet intended this allusion. His

5.4 Jean Dubuffet, *Childbirth [L'Accouchement],* from the "Marionettes of the Town and the Country" series, 1944. Oil on canvas, 39⅜ × 31¾in (100 × 80.7cm).

The Museum of Modern Art, New York. Gift of Pierre Matisse in memory of Patricia Kane Matisse. © 2000 Artists Rights Society (ARS), New York/ADAGP, Paris.

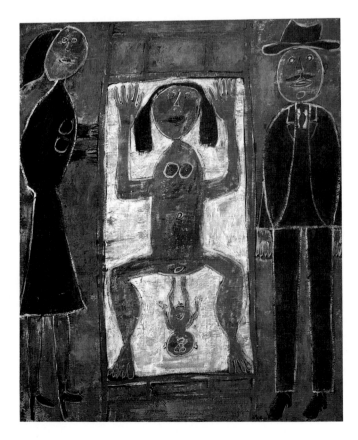

crude and impulsive style invokes the aesthetic of the uncultivated common man and prefigures the shift in art after 1960 from a romantic emphasis on the exceptional to ordinary life and popular culture. In 1946 Dubuffet remarked: "It is the man in the street that I'm after, whom I feel closest to, with whom I want to make friends and enter into confidence and connivance, and *he* is the one I want to please and enchant by means of my work."[3]

Childbirth also lacks perspective; the artist stacked up the bed and the stiff figures parallel to the picture plane and crudely rendered then in the manner of a child. Dubuffet deliberately constructed a style that was primitive by conventional standards of beauty. Like Barnett Newman, he rejected what he regarded as a Greek canon of beauty in order to elude the prejudices of culture; he wanted to make a fresh, unconventional exploration of such grand philosophical themes as the origins of thought and the evanescence of the individual.

"The values celebrated by our culture do not strike me as corresponding to the true dynamics of our mind,"[4] he explained.

What to me seems interesting is to recover in the representation of an object the whole complex set of impressions we receive as we see it normally in everyday life, the manner in which it has touched our sensibility, and the forms it assumes in our memory . . . my persistent curiosity about children's drawings, and those of anyone who has never learned to draw, is due to my hope of finding . . . the affective reactions that link each individual to the things that surround him and happen to catch his eye.[5]

Dubuffet had a complex metaphysics. In his scheme the emotional connection between the individual and the objects around him provided a central clue to the underlying continuity of all things. Although rooted in the ideas of romanticism, Nietzsche, and Freud, Dubuffet went beyond them in speaking of man's primal unity with nature and opened a different perspective on his conflict with the strictures of civilization. For Dubuffet everything around the object became part of its definition, and as a result the definition remained in a state of constant flux. In *Childbirth*, for example, there is a sameness in the general manner of rendering each person or thing that suggests a kind of slippage in which one form could begin to look more and more like another, perhaps to become something else or even dissolve completely. The implicit threat of disintegration into the environment and ultimately into a universe of undifferentiated matter is a pervasive theme in his art and thought.

Dubuffet studied the mental state in which one perceives an object before consciously focusing on it. In assimilating the object, the mind brings forth clusters of feeling and association, transforming the perception in terms of the mind's own unconscious purposes. In attempting to "transcribe all the processes and mechanisms resulting from the sight (or evocation in the mind) of a certain object,"[6] Dubuffet looked to the art of children and others, whose rendering of experience is less dominated by cultural norms;

there the raw evidence of these processes is more visible.

The primitive life of the mind is one of Dubuffet's central subjects. His sophisticated analysis made manifest the erudition of a well-read intellectual, but he systematically shed all traces of this in his artistic style. Instead he sought the revelation of the raw, psychic content of the most ordinary experience, which can "transform our daily life into a marvelous feast . . . I am speaking of celebrations of the mind . . . Art addresses itself to the mind, not the eyes."[7]

In the background of Dubuffet's assertion echoes Marcel Duchamp's aspiration to put "painting once again at the service of the mind"[8] and Breton's admonition that "painting . . . should not have for its end the pleasure of the eyes . . . a picture or sculpture is justifiable only insofar as it is capable of advancing our abstract knowledge."[9] However, Dubuffet concerned himself with the physicality of painting more than either Duchamp or Breton did. He regarded art as "a language, an instrument of cognition and communication,"[10] but he believed that the material itself held an expressive power and constituted, by virtue of its materiality, a closer,

more direct and precise language than words. "Art makes no sense if it is not a means of seeing and knowing through which man forces himself to perceive reality."[11] But "I see no great difference (metaphysically, that is) between the paste I spread and a cat, a trout or a bull. My paste is a being as these are. Less circumscribed, to be sure, and more emulsified . . . foreign to us humans, who are so very circumscribed, so far from the formless (or, at least, think ourselves to be)."[12]

Dubuffet's working method resembled surrealist automatism. In the process of painting he recounted that "a larger part is given to facts that unroll themselves inside the mind of the painter as he works."[13] Margit Rowell, who was curator of an important Dubuffet show in 1973, pointed out that although Dubuffet never aligned himself with the surrealists, they "similarly considered categorical thought an impoverished aspect of the true workings of the mind," and she cited the "Second Surrealist Manifesto" of 1929 in which Breton declared: "There is every reason to believe that there exists a point in the mind where life and death, the real and the imaginary, the past and the future, the communicable and the non-communicable, the above and the below, cease to be perceived as contradictions."[14]

Jean Dubuffet was born in Le Havre on the north coast of France in 1901. After graduating from the *lycée* in 1918 he studied painting to some extent, but he felt ill at ease in his studies. He associated mostly with writers and by the forties Dubuffet's circle included many celebrated literary talents. However, toward the end of the forties the critic Michel Tapié began to associate Dubuffet and Fautrier with the artists Wols and then others (figs 6.2–6.6), whose work was based on a formal principle of free gesture. Although derived from Bataille's concept of *l'informe* (meaning "anti-form" in style), *informal* was nevertheless assertive of identity in a way that Dubuffet and Fautrier abhorred, and they both dissociated themselves from *informal* at this time. Jean Fautrier's *Nude* [fig. 5.5] typifies the heavy, almost sculptured surfaces of their canvases. The densely modeled paint used to depict a representational subject had to do with the existentialists' shift of emphasis on to the individual's subjective experience of external reality. Fautrier's painting conveys the sensual, uncultivated, emotional content of the experience rather than an "objective" report on the subject.

5.5 Jean Fautrier, *Nude*, 1943. Oil on paper, 21½ × 15in (54.6 × 38.1cm).

Collection, Museum of Contemporary Art, Los Angeles. ©1994 Artists Rights Society (ARS), New York/ADAGP, Paris.

Dubuffet's Philosophical Premises

Dubuffet had his first one-man show in October 1944, immediately after the Liberation of France. Those early compositions of 1942 to 1944 have the dark outlines, crude brushwork, and flat, unmodeled color areas of child art. Soon the artist also began mixing the pigment with a variety of unconventional materials to create a dense, mortar-like paste. The technique, the style, and the raw sexuality of the imagery shocked the French public, and in Dubuffet's second show, in 1946, outraged viewers even slashed some of the paintings.

Although the work had an iconoclastic intent, it also had profoundly philosophical origins. As in primitive and

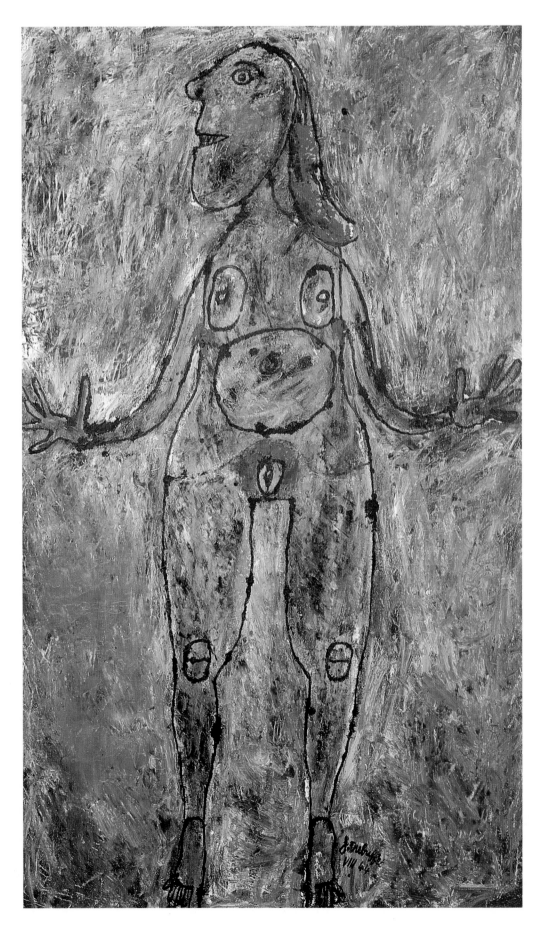

5.6 Jean Dubuffet, *Large Sooty Nude*, August 1944. Oil on canvas, 63¾ × 38¼in (162 × 97.2cm).
Private Collection, New York. Courtesy PaceWildenstein Gallery, New York. ©2000 Artists Rights Society (ARS), New York/ADAGP, Paris.

5.7 Jean Dubuffet,
Landscape with Drunkards,
1949. Oil, sand, and
granular filler on canvas,
35 × 45¾in
(88.9 × 116.2cm).
Menil Collection, Houston. Photograph
by F. W. Seiders. ©2000 Artists Rights
Society (ARS), New
York/ADAGP, Paris.

child art, Dubuffet treated the subjects as a matter of descriptive fact; he did not attempt "psychological" portrayals, which would imply the distance of a detached observer, but instead sought direct extensions of the observing mind itself. The artist's remarks about his *Large Sooty Nude* of 1944 [fig. 5.6] exemplify this state of mind:

I've recently been scrutinizing anthracite. Thinking about anthracite—ecstatically. I almost felt as if I'd changed into anthracite. But as I was painting the ravishing body of a naked woman, my obsession made me paint her in the color and nature of anthracite . . . Was this valid for no reason? There is a continuity from any object to any other object . . . And would you have found it more logical of me, with my obsessive passion for anthracite, to paint an object, any object, in exactly the same mood and with exactly the same hand as someone who had never seen anthracite or who at the moment was obsessed with, say, an egg yolk, or bread, or sand?[15]

Instead of seeing the material as something neutral and inert, Dubuffet regarded it as a reality with which he collaborated. In his mind the preoccupation with the coal dust became inextricably merged with the psychic identity of the nude.

In 1945 Dubuffet began collecting what he called "*art brut*," or "raw art". This consisted of art made by untrained individuals, including psychotics, amateurs, and children, who were thus largely uninfluenced by cultural conventions in making art. The savage purity of *art brut* confirmed Dubuffet's repudiation of cultural values after the war. He

was drawn to the authenticity with which *art brut* communicated the creative mental processes involved in forming a cohesive picture of an individual's reality. "Those who are predisposed toward physiological explanations," Hans Prinzhorn had written in his famous book on the *Artistry of the Mentally Ill*, "always start with the fallacy (one which is hard to overcome) that all well meaning people could agree on one conception of reality, as we might agree on the results of research."[16] But each being has its own version of reality according to Prinzhorn and to Dubuffet, who had discovered the former's book in 1923.

Dubuffet painted several compositionally packed, graffitilike landscapes in 1949. They tend to have a bird's-eye view of the ground while showing figures and buildings in profile, as in his *Landscape with Drunkards* [fig. 5.7]. Dubuffet dug the forms into the thick paste with the back of a brush or some other pointed object. The stony, monochrome surface recalls Brassaï's photographs of graffiti, which Dubuffet had known since the thirties. The two main figures seem to perch on the road, completely out of scale to other elements or figures in the picture. In addition the artist has drawn everything with the stiff, schematic quality of a six-year-old. Even the way in which he had conceived each element in isolation characterizes the art of young children. Dubuffet may have derived this trait from his own observation, but in *Artistry of the Mentally Ill* Prinzhorn specifically discussed the manner in which a child or untrained adult separates an object in a picture from its orientation in space.[17]

A Focus on Matter in the Fifties

In the paintings of 1950 Dubuffet began expanding the figure—and later tables, stones, and beards—to fill the whole composition. *Le Metafisyx* [fig. 5.8] belongs to a series of magnificent, monumental nudes that Dubuffet painted in 1950 and 1951; its vulgar sexuality and the masklike grimace on the face are characteristic. In such works the definition of the figure became marginal as its internal texture was pushed out toward the edges of the canvas. As he explained, these compositions are:

no longer—or almost no longer— descriptive of external sites, but rather . . . the immaterial world which dwells in the mind of man: disorder of images, of beginnings of images, of fading images, where they cross and mingle, in a turmoil, tatters borrowed from memories of the outside world, and facts purely cerebral and internal—visceral perhaps. The transfer of these mental sites on the same plane as that of the real concrete landscapes, and in such a way that an uncomfortable incongruity is the result . . . the discovery that they are perhaps not so foreign [to one another] as one had believed, attracts me very strongly.[18]

5.9 Jean Dubuffet, *Landscape with Two Personages,* January 1954. Assemblage of scraps of newspaper stained with India ink, 39⅜ × 31⅘in (100 × 80.8cm).
Private collection, Paris. ©2000 Artists Rights Society (ARS), New York/ADAGP, Paris.

5.8 Jean Dubuffet, *Le Metafisyx,* August 1950. Oil on canvas, 45⅝ × 35¼in (116 × 89.5cm).
Collection, Musée National d'Art Moderne, Centre Georges Pompidou, Paris. ©2000 Artists Rights Society (ARS), New York/ADAGP, Paris.

In *Le Metafisyx* the unusual texture takes on a life of its own, freely setting off in directions independent of the explicit subject matter. The artist later used unexpected materials, like butterfly wings [fig. 5.1] or leaves, for the same liberating effect. In *Le Metafisyx* Dubuffet encountered the chaos of the unconscious mind in the disorder and detail of a concentrated focus on texture.

In 1951 Dubuffet began literally to cut up canvases and reassemble them on a new surface. He also drew figures on paper or newspaper and then cut them out for collage. Over a decade he assembled images out of a whole range of "inartistic," or at least unconventional, materials, from driftwood to sponge. Dubuffet deliberately made use of novel techniques and materials to create perceptual obstacles to the recognition of subject matter; thus when the figure appears it has the surprising freshness of revelation, as in *The Squinter* [fig 5.1]. Yet despite the newness of the material, the conception of the form and subject remain consistent with his other work: landscapes with high horizons; busy surfaces that merge into a chaotic monotone; stiff, grotesque figures derived from graffiti and child art.

In *Landscape with Two Personages* [fig. 5.9] one can scarcely find the "personages" among the surface patterns.

5.10 Jean Dubuffet, *Place for Awakenings [Site aux éveils]* from the "Matériologies" series, 1960. Pebbles, sand, and plastic paste on composition board, 34⅞ × 45⅜in (88.6 × 115.2cm).
The Museum of Modern Art, New York. Gift of the artist in honor of Mr. and Mrs. Ralph F. Colin. ©2000 Artists Rights Society (ARS), New York/ADAGP, Paris.

The pervasive theme of figures emerging from and dissolving back into amorphous fields of texture embodies an existential sense of the absurdity of the individual's efforts to establish and assert an identity; it also expresses the hopeless resistance against an inevitable reabsorption into the non-being of universal time and matter. The recognition that, with only slight alterations in handling or context, a form in painting can represent a variety of objectively dissimilar things implied to Dubuffet that at some level—revealed to him only in painting—*all* things are reducible to a common denominator.

The most varied things are taken into my net . . . But very often—and it is then that the game takes on its full significance—the facts are more ambiguous, susceptible to belonging to any one of these different registers, explicitly demonstrating, in a very troubling manner, what these registers have in common, how accidental their specificity, how fragile and ready to change. Such an image seems equally eager to transcribe a ravine or a complex, tormenting sky, or a storm, or the reverie of someone

contemplating it . . . a thing with a strongly marked physical character . . . and . . . the course of a dream, or an emotion.[19]

In this existentialist aesthetic what matters most is the artist's conscious and explicit struggle to realize his condition. Sartre believed that the individual attained freedom from convention, became a law unto himself, in confronting death. In Dubuffet's art the implied evanescence of the individual in the perpetual metamorphosis and ambiguity of all things evokes precisely this confrontation.

Place for Awakenings [fig. 5.10] belongs to a series of paintings done around 1960 in which the explicit subject

became the amorphous field itself. It is not an abstract picture in the usual sense but a perpendicular view of a small segment of ground. As such, it celebrates the most prosaic of all things in an attempt to bring what we most take for granted into conscious focus. But on another level this series evokes, more poignantly than anything else in Dubuffet's *oeuvre*, the artist's morbid preoccupation with the idea that man and his perceptual world both emanate from and will momentarily be reabsorbed into the infinite chaos of undifferentiated matter. As was the case with Pollock, the physicality of the material made the existential experience of the painting more real.

A new intensity of color entered Dubuffet's work in 1961 along with a shift in subject to complex urban landscapes. People sit trapped in boxlike cars and buses or line up on crowded walks in *Business Prospers* [fig. 5.11]; in many of the canvases of this time they stand sideways and upside down in a new centrally oriented gravitational scheme. The surface patchwork of satirical shop signs, vehicles, and people conveys the vitality of Paris life. Yet at the same time the identity of each individual element dissolves into the general hum of visual activity, as in the earlier *Landscape with Two Personages*. In the works of 1961

Dubuffet seems to transform the overabundance of stimuli into another kind of undifferentiated energy.

A Grand Style of Entropy

In July 1962, while doodling by the telephone with a ballpoint pen, Dubuffet made a pattern of interlocking forms. The quality of the ballpoint's line eliminated all expressive individuality, and the principle of interlocking forms suggested to Dubuffet an infinitely expandable system of patterning. This became the guiding motif of the "*hourloupe*"[20] series, and he experimented with it for roughly a decade.

At this point the artist's concentration on the elemental matter of nature receded as he turned to the mechanisms of thought. The obsessive cellularity and repetitive patterning of works like *Erre et Aberre* [fig. 5.12] resemble traits in the

5.11 Jean Dubuffet, *Business Prospers* from the "Paris Circus" series, 1961. Oil on canvas, 5ft 5in × 7ft 2⅝in (1.65 × 2.2m). The Museum of Modern Art, New York. Mrs. Simon Guggenheim Fund. ©2000 Artists Rights Society (ARS), New York/ADAGP, Paris.

5.12 Jean Dubuffet,
Erre et Aberre, 1963. Oil
on canvas,
4ft 10⅘in × 6ft 4⅘in
(1.49 × 1.95m).
Private collection. Photograph
courtesy PaceWildenstein Gallery,
New York. ©2000 Artists Rights
Society (ARS), New York/ADAGP,
Paris.

art of psychotics and may have something to do with the return of his collection of *art brut* from years of storage in the United States. Stylistically these works also recast the theme of dissolution. As he explained: "This consistently uniform script indifferently applied to all things . . . will reduce them all to the lowest common denominator and restitute a continuous undifferentiated universe."[21] Dubuffet made up the term *"hourloupe"* for this new style and explained that he "invented [it] just for the sound of it. In French it calls to mind some object or personage of fairytale-like and grotesque state and at the same time also something tragically growling and menacing."[22]

In the mid sixties Dubuffet carved out free-form, volumetric objects and covered their surfaces with the *hourloupe* script in a manner that made recognizable allusions to real objects. He designated these works *"simulacres,"* because they constituted a physical reality which signified an allusion, thus reversing the usual case in art of an illusion

signifying a reality. Like doodles, they are pure figments of the imagination transformed into a physical presence. In the late sixties Dubuffet enlarged this idea on to an architectural scale with the large "trees" and then expanded the *hourloupe* script into whole environments such as the *Cabinet Logo-Logique* and the *Villa Falbala.* "The effect I was after," he said, "was to achieve a feeling of *penetration* into the drawing by causing the matter to develop from a flat piece of household furniture to be looked at on the wall into *a creation of the mind fit to be physically inhabited.*"[23]

In the "Non-Lieux" paintings of 1978 to 1985, his last series, Dubuffet eliminated the concept of a ground altogether. As their name suggests, they offer no sense of place. They extend the idea of penetration into the drawing and further "challenge the objective nature of Being;"[24] this challenge had been the persevering core of his subject matter since the beginning of his career.

The Existentialist Figuration of Alberto Giacometti

Alberto Giacometti [fig. 5.13] was born in 1901 to a family of turn-of-the-century avant-garde artists. His godfather, Cuno Amiet, and his uncle, Augusto Giacometti, were important symbolist painters; his father, Giovanni Giacometti, was a well-known Swiss postimpressionist and a

strong influence in the adolescent Alberto's artistic development. At the age of seventeen, following in his father's footsteps, he attended the School of Arts and Crafts in Geneva, and at nineteen he accompanied the elder Giacometti to the Biennale in Venice where Giovanni's work

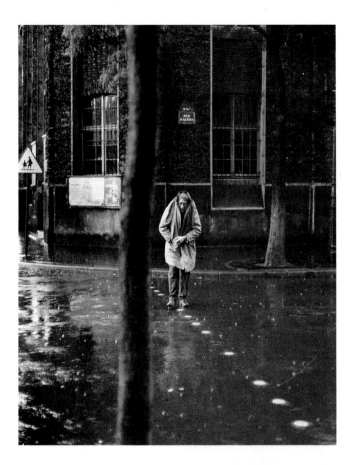

5.13 (above) **Henri Cartier-Bresson,** *Alberto Giacometti,*
1961. Black-and-white photograph.
© Magnum Photos/Henri Cartier-Bresson, 1994.

was on show. In Italy Alberto studied Tintoretto, Giotto, and Cimabue with passionate dedication; the Egyptian and primitive art and the works of Cézanne in the Biennale also profoundly impressed him; then he stayed on for nine months amongst the art treasures of Rome. In January 1922 Giacometti enrolled for three years in the atelier of the highly acclaimed Parisian sculptor Antoine Bourdelle.

Giacometti later recalled that while studying antique sculpture in the galleries of Rome and again before the model in Bourdelle's class, "I was lost, everything escaped me, the head of the model before me became like a cloud, vague and undefined."[25] Thus in the early twenties he already seems to have experienced the existential anxiety that dominated his work after 1940. Giacometti made his first important sculptures in a simplified, cubist style reminiscent of Constantin Brancusi and Alexander Archipenko (whose work he had seen at the Biennale in 1920). He produced a few of these objects in 1926, but he created most of them in the little studio below Montparnasse that he took in 1927 with his younger brother Diego, and in which they both remained until Alberto's death in 1966. By 1928 Giacometti was beginning to receive critical attention, but he sold little. In order to earn a living he and Diego made sculptural furniture and lamps.

Giacometti encountered the surrealists around 1928 and became especially close to Miró, Masson, Calder, and

5.14 Alberto Giacometti,
The Palace at 4 a.m.,
1932–3. Construction in wood, glass, wire, and string, 25 × 28¼ × 15¾in
(63.5 × 71.8 × 40cm).

The Museum of Modern Art, New York. Purchase. ©2000 Artists Rights Society (ARS), New York/ADAGP, Paris.

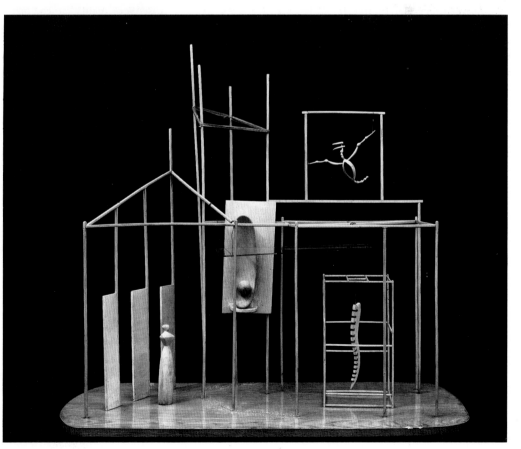

the painter/dealer Michel Leiris. Soon he also met Breton, Aragon, and Dali. He began making surrealist sculpture in 1929. The cages [fig. 5.14] mostly date from the early thirties, although he came back to the idea twenty years later as a setting for some of his postwar figures. Giacometti nearly always maintained a connection to the figure in his work. Nevertheless he saw a conflict between his experience of reality and the inherently abstract character of sculpture, which he sought to resolve in the dreamlike transformations of nature epitomized by his surrealistic experiments of the early thirties.

The Palace at 4 a.m. [fig. 5.14] crystallizes Giacometti's relationship with surrealism. This "fragile palace of matchsticks"[26]—to use the words with which he then characterized his existence—centers on an act of self-definition in the overlapping space of reality and the dream. The armature creates a stage set for a fantasy in which all living things seem to have undergone a metamorphosis into objects. He described the sculpture to Pierre Matisse as:

a palace with a skeleton bird and a spinal column in a cage and a woman at the other end . . . It related without any doubt to a period of my life that had come to an end a year before, when for six whole months hour after hour was passed in the company of a woman who, concentrating all life in herself, magically transformed my every moment. We used to construct a fantastic palace at night . . . [In] the statue of a woman . . . I recognize my mother, just as she appears in my earliest memories. The mystery of her long black dress troubled me; it seemed to me like a part of her body, and aroused in me a feeling of fear and confusion . . . I can't say anything about the red object in front of the board; I identify it with myself.[27]

As early as 1932 Giacometti began some nearly classical figure studies, which suggest that he probably started working from life again. He began to find ordinary reality more fertile to his imagination than dreams, and this precipitated a rift with the surrealists, who officially expelled him from the movement in 1935 when he began working from the model every day. Nevertheless five years of consistent work from life failed to yield any finished sculpture, because he was never satisfied with his ability to portray what he saw in front of him. So from 1940 to 1945 he retreated to working from memory again.

In 1942 Giacometti went for a brief trip to Switzerland but was refused reentry into France and had to remain in Geneva until the end of the war. He finished almost nothing there either. *Woman with Chariot I*, one of the few sculptures from the period, adumbrates his later work in its narrow frozen posture and heavily worked surface. It also has wheels on a block-like base, which the art historian Reinhold Hohl has suggested have to do with the idea of moving the object further from or closer to the viewer to change "its phenomenological size."[28] In this sense it expresses a concern with the role played by the viewer's perception in defining the scale of the work, and by implication asserts subject experience as a basis for defining reality.

From this work Giacometti moved to a series of tiny sculptures (ranging from a mere half-inch in height) on massive bases [fig. 5.15]. The thin insubstantiality of the form in relation to the huge pedestal creates a sense of vast distance, as if the figure was disappearing. "Wanting to create from memory what I have seen," he wrote, "to my terror the sculptures became smaller and smaller, they had a likeness only when they were small, yet their dimensions revolted me, and tirelessly I began again, only to end several months later at the same point. All this changed a little in 1945 through drawing. This led me to want to make larger figures, but then to my surprise, they achieved a likeness only when tall and slender."[29]

Giacometti exhibited the tall, thin figures [fig. 5.16] in 1948 at the Pierre Matisse Gallery in New York, his first one-man show in fourteen years. Jean-Paul Sartre, with whom Giacometti had become friendly in 1940, wrote the introduction to the catalog. Indeed the title of Sartre's famous book, *Being and Nothingness*, could serve as a characterization of the fragile presence of these figures, which first shrunk into near nonexistence and then elongated to a pencil line in space.

Existentialism stresses a radical reduction to the essence or beginning of things. In *Being and Time* Martin Heidegger wanted to start over in order to penetrate being itself. Giacometti's sculpture after 1940, like the work of Pollock and de Kooning, was not driven by the aesthetic objectives of an envisioned, finished composition, but by a need to discover "reality" in the process of working.

Giacometti attempted to cut away all training in order to see what stood in front of him and to portray it. At the same time he repeatedly asserted that this was impossible. So every day he would destroy what he had done the day before and start over again until someone took the work away for a show. According to the accounts of those who sat for him, his efforts to render reality seemed to go inexorably from bad to worse, and he blamed himself for this perceived failure. "This is what I deserve for thirty-five years of dishonesty," he told his friend James Lord. "All these years I've exhibited things that weren't finished and never even should have been started. But on the other hand, if I hadn't exhibited at all, it would have seemed cowardly, as though I didn't dare to show that I'd done."[30] If only once he could represent what he saw, he remarked, he would never have to paint or sculpt again.[31]

The artist underlined the existentialist character of this introspective exploration when he stated that "it's impossible ever really to finish anything."[32] This is because the way in which this artist defines his identity and presence in the world continued to evolve and thus could never achieve a fully satisfactory, objective affirmation. The Giacometti figures express this in their fragility—as if, in a moment, these narrow wraiths could slip through a crack in existence. The sculptures of disembodied anatomical parts, like those of the hand or the head by themselves, express the fragility of this delicately held-together self-image.

5.16 Alberto Giacometti, *Man Pointing,* 1947. Bronze, 70½ ×
4¾ × 16⅜in (179 × 12.06 × 41.58cm),
at base 12 × 13¼in (30.5 × 33.7cm).

The Museum of Modern Art, New York. Gift of Mrs. John D. Rockefeller 3rd. ©2000 Artists
Rights Society (ARS), New York/ADAGP, Paris.

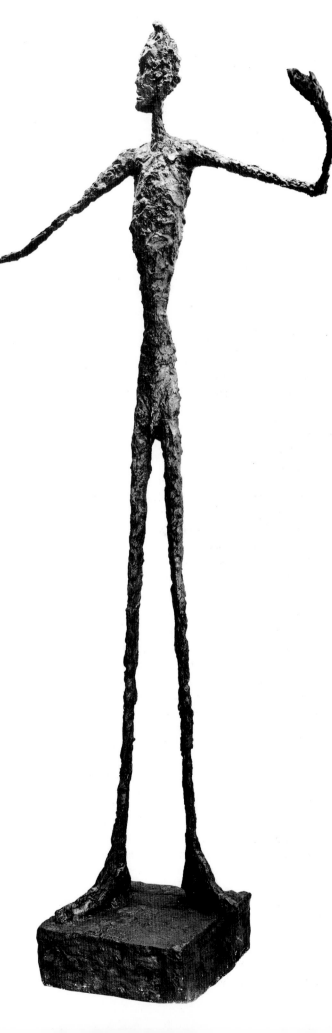

5.15 (below) **Alberto Giacometti,** *Figure I,* c. 1945. Plaster and
metal, 3½in (8.9cm) high, with plaster base 3½ × 2 × 2⅛in
(8.9 × 5.08 × 5.4cm).

The Museum of Modern Art, New York. Gift of Mr. and Mrs. Thomas B. Hess. ©2000 Artists
Rights Society (ARS), New York/ADAGP, Paris.

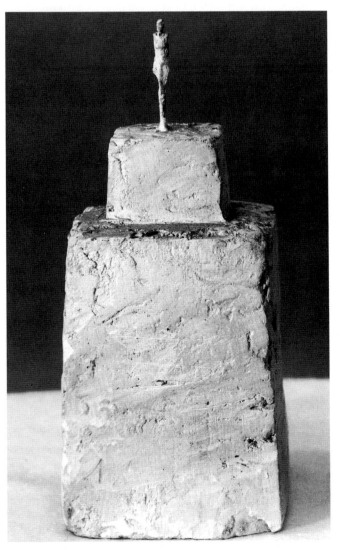

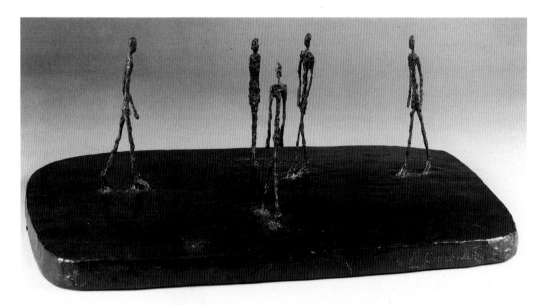

5.17 Alberto Giacometti,
The City Square, 1948—9.
Bronze, 9½ × 25½ × 17⅛in
(24.1 × 64.8 × 43.5cm).
Collection, National Gallery of Art,
Washington, D.C. Gift of Enid A. Haupt.
©2000 Artists Rights Society (ARS), New
York/ADAGP, Paris.

Giacometti's biographers have demonstrated his art historical self-consciousness. The *Man Pointing* [fig. 5.16], for example, makes reference to the ancient Greek *Poseidon of Cape Artemision* and to Auguste Rodin's *St. John the Baptist*.[33] He also drew on the simplified abstractions of Archipenko as well as on Egyptian and ancient Near Eastern figures. Yet this does not contradict Giacometti's approach to the reality of his subject through sudden, transcendental glimpses of the unexpected. Indeed these classical models gave him a place in time and tradition, all the more important for an artist plagued by such a strong sense of estrangement from both nature and society.

As in action painting, the thickly modeled surface of Giacometti's figures asserts the intimate presence of the artist. The cages and platformlike bases of the early thirties [fig. 5.14] reappeared in the late forties as a device for defining the scale of the figures and creating a spatial context in which to explore the issue of the figural presence. The cages, frames, the heavy bases, and the walking figures with their feet mired as though stuck in tar, seem to function as holding devices to keep things from disappearing. In 1958 Giacometti enlarged

the concept created in *The City Square* of a decade earlier [fig. 5.17] into a project for a monumental figure composition for the plaza in front of the Chase Manhattan Bank in New York. In this never-realized artwork the towering figures would have mingled among the pedestrians, creating a disquieting comment on the alienation of city life.

Although Giacometti's circumstances were modest, he never experienced any hardship of the sort that Picasso or, later, Pollock and Franz Kline did. He painted the most familiar people and things around him and lived an uneventful life. Yet this very stability provided him with a silent theater in which the artist struggled to affirm his feeling of existence. James Lord, in his account of Giacometti at work on his portrait, described any number of exchanges that revealed the artist's relentless anxiety: "Presently he started gasping aloud, with his mouth open, and stamping his foot, 'Your head's going away!' he exclaimed. 'It's going away completely.' 'It will come back again,' I said. He shook his head. 'Not necessarily. Maybe the canvas will become completely empty. And then what will become of me?'"[34]

Francis Bacon

The British painter Francis Bacon [fig. 5.18] emerged at the end of World War II painting figures that were frighteningly transformed by the imagery of the unconscious. He would begin with a familiar subject and, like Giacometti, paint it as it actually appeared to him. But the appearance that he sought to portray was a vision that was transformed by the uses and threats perceived in the object by the primitive drives of his uncensored, unconscious mind. "You're not only remaking the look of the image," he told the art critic David Sylvester, "you're remaking all the areas of

feeling which you yourself have apprehensions of."[35]

In the fifties Bacon turned increasingly to ordinary models and, after 1959, to images of his friends. Yet as the overt subject became more unremarkable the visible evidence of the repressed, instinctual perception grew. The nakedness of the expression and the immanent reality of the sitter distinguish these paintings from surrealism. But the artist used an adaptation of surrealist automatism—as de Kooning and Pollock did—to work his way, in the process of painting, closer and closer to the immediate subjective truth. "I don't

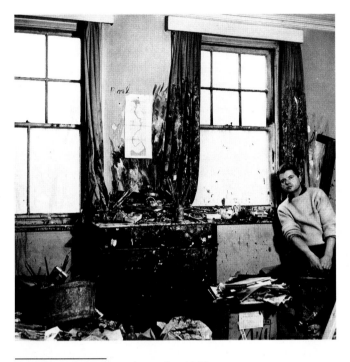

5.18 Francis Bacon in his studio, 1959.
Photograph by Cecil Beaton.

captures a loss of control, a sense of helplessness and terror. In his *Study After Velázquez's Portrait of Pope Innocent X* [fig. 5.22], the claustrophobic space and the pressure of the vertical strokes close in uncomfortably, while the figure blurs into anonymity. Bacon's 1969 *Self Portrait* [fig. 5.23] shows the artist imprisoned behind a twisted, monstrous mask. The eyes look out piteously but make no contact; there is no escape. The portrait at once expresses a terror in what it has revealed, and yet fused with this fear and vulnerability there is an opulent, painterly beauty.

Francis Bacon was born into an aristocratic English family in Ireland in 1909. His father went to work in the War Office in London in 1914, shuttling the family back and forth between London and Ireland about every other year. Bacon also lived intermittently with his grandmother, who had married the Commissioner of Police for County

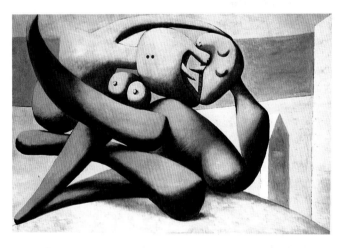

think one can explain it . . . if you could explain your painting, you would be explaining your instincts."[36]

Bacon's shockingly direct revelation of this primal aspect, hidden below the surface of everyday life, evokes the chaotic forces that civilization has repressed in everyone and

5.19 Francis Bacon, *Three Studies for Figures at the Base of a Crucifixion,* 1944. Oil and pastel on canvas, triptych, each pane 37 × 29in (94 × 73.7cm).
Collection, Tate Gallery, London. ©2000 Estate of Francis Bacon/Artists Rights Society (ARS), New York.

5.20 (above) **Pablo Picasso,** *Figures By The Sea,* January 12, 1931. Oil on canvas, 4ft 3⅜in × 6ft 5in (1.31 × 1.96m).
Collection, Musée Picasso, Paris. © 2000 Estate of Pablo Picasso/Artists Rights Society (ARS), New York.

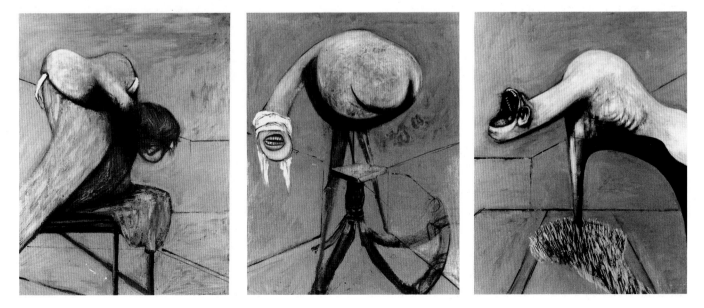

Kildare. With the civil war against British rule then raging, Bacon remembered his grandmother's sandbagged house, snipers' traps in the roads, British military maneuvers on the grounds of his father's home, and a generalized sense of danger permeating his childhood.

In 1929 Bacon was designing furniture and interiors in London, and in August 1930 *Studio Magazine* published an article on his work; years later he incorporated the tubular furniture he had made into his paintings [fig. 5.22]. Bacon began painting at the end of the twenties, constructing a style from a synthesis of illusionistic surrealism and contemporary cubism. He destroyed most of his pre-World War II work, but the pictures which survive foreshadow certain lifelong preoccupations. In *The Crucifixion* of 1933, a fleshy human head—derived from an X-ray of the head of a collector—sits on a table beside a crucified figure. The body is proportioned like a flayed carcass of beef hung in a butcher's shop and the scene seems to take place in a simply divided, sparse interior. In *Wound for a Crucifixion* of the same year a mass of flesh, which Bacon described as "a very beautiful wound,"[37] sits on a sculpture armature; this study was derived from color plates of wounds and rare skin diseases that he had seen in medical books. In 1934 Bacon organized an exhibition for himself, but then did not paint much or show again until the end of the war.

Bacon exhibited his triptych *Three Studies for Figures at the Base of a Crucifixion* [fig. 5.19] at the Lefevre Gallery in London in April 1945. He had conceived these panels as "sketches for the Eumenides which I intended to use as the base of a large crucifixion."[38] In Greek "*eumenides*" literally means "kindly ones," but it euphemistically refers to the furies, because according to myth the truth of their nature was too terrible to utter. "The reek of human blood smiles out at me,"[39] they say in a line from *The Oresteia* of Aeschylus, a line which Bacon particularly admired. For him, the furies embodied repressed forces in the human psyche, and crucifixion was an emblem of sadistic inhumanity. Bacon's inspiration for the shocking vocabulary of *Three Studies (Crucifixion)* came from Picasso's metamorphic figures of the late twenties and early thirties [fig. 5.20].

In *Painting* [fig. 5.21], the figure with slabs of meat angled in toward him on the glass-topped table was inspired through free association in the process of painting by the news photographs of Hitler or Mussolini speaking from a rostrum and hemmed in by microphones. The image of the dictator fascinated Bacon, yet its presence here does not indicate an iconography in the usual sense, as is clear in Bacon's description of the picture's evolution: "I was attempting to make a bird alighting on a field. And . . . suddenly the lines that I'd drawn suggested something totally different, and out of this suggestion arose this picture . . . It was like one continuous accident."[40]

Nevertheless a number of the images in *Painting* recur frequently in Bacon's work: the tubular frame table; the flayed beef hanging as though crucified; closed blinds with dangling cords in a stark and claustrophobic room; an umbrella darkly obliterating the eyes of the suited figure and setting off the row of teeth in his open mouth; slabs of raw meat on the table; and a deep red oriental carpet on the floor. The reemergence of these objects in other paintings by Bacon suggests that their presence is more than "accidental."

I've always been very moved by pictures about slaughterhouses and meat, and to me they belong very much to the whole thing of the Crucifixion. There've been extraordinary photographs which have been done of animals just being taken up before they were slaughtered; and the smell of death. We don't know, of course, but it appears by these photographs that they're so aware of what is going to happen to them, they do everything to attempt to escape. I think these pictures were very much based on that kind of thing, which to me is very, very near this whole thing of the Crucifixion.[41]

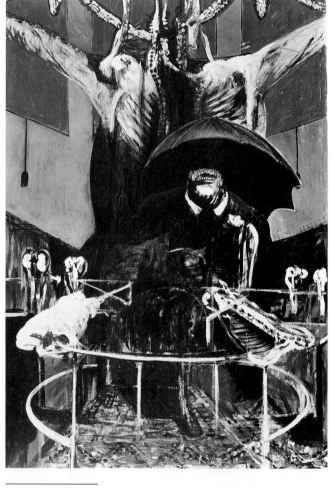

5.21 Francis Bacon, *Painting,* 1946. Oil and pastel on linen, 6ft 5⅞in × 4ft 4in (1.97 × 1.32m).
The Museum of Modern Art, New York. Gift of Philip Johnson. © 2000 Estate of Francis Bacon/Artists Rights Society (ARS), New York.

5.22 (opposite) **Francis Bacon,** *Study After Velázquez's Portrait of Pope Innocent X,* 1953. Oil on canvas, 5ft ¼in × 3ft 10½in (1.53 × 1.18m).
Collection, Des Moines Art Center. Purchased with funds from the Coffin Fine Arts Trust, Nathan Emory Coffin Collection of the Des Moines Art Center, 1980.1. © 2000 Estate of Francis Bacon/Artists Rights Society (ARS), New York.

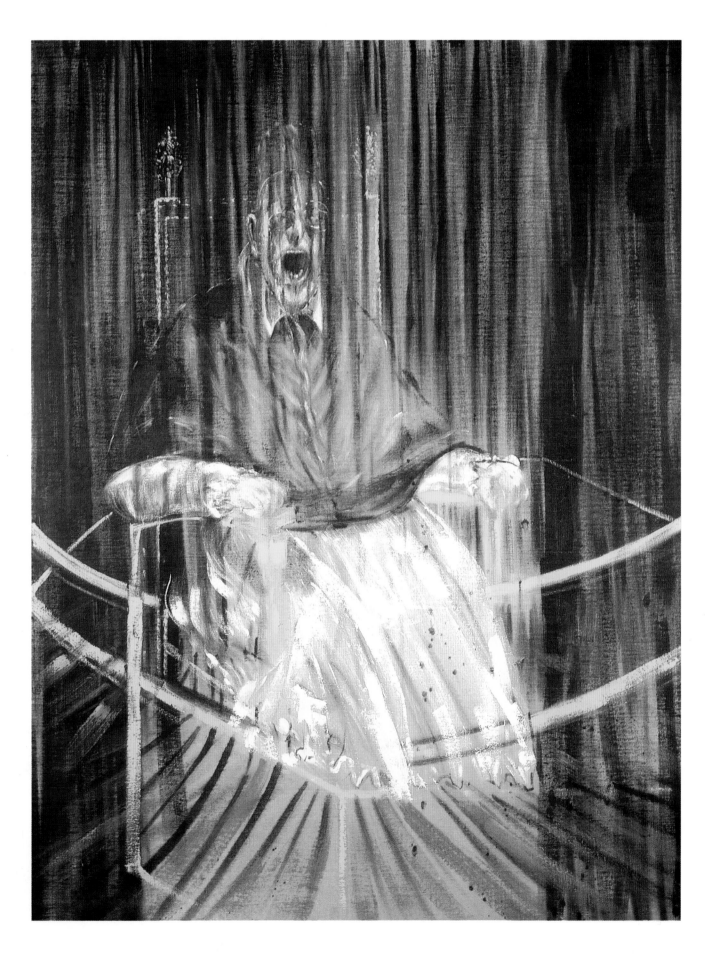

The New European Masters of the Late Forties

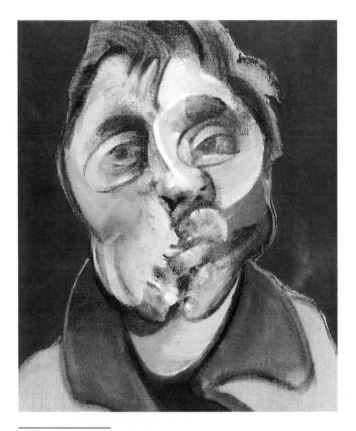

5.23 Francis Bacon, *Self Portrait,* 1969. Oil on canvas,
14 × 12in (35.6 × 30.5cm).
Private collection. © 2000 Estate of Francis Bacon/Artists Rights Society (ARS), New York.

5.24 Francis Bacon, *Three Studies of Figures on Beds,* 1972. Oil
and pastel on canvas, triptych, each panel
6ft 6in × 4ft 10in (1.98 × 1.47m).
Private collection. © 2000 Estate of Francis Bacon/Artists Rights Society (ARS), New York.

The image of the black figure with hidden eyes and menacing teeth, inspired by the wartime news clippings, the raw meat, and the sense of entrapment in these close interiors also have to do with the cruelty of existence, experienced by the artist in the most intimate terms. "When you go into a butcher's shop," he noted, "and see how beautiful meat can be and then you think about it, you can think of the whole horror of life—of one thing living off another."[42]

Although Bacon did not use a preordained symbolism, he began *Painting* with a conscious subject and freely explored his feelings about it by way of free association. Each new pictorial element that was suggested by what was already there revealed another aspect of the subject's emotional meaning—hidden from consciousness until brought forth. By permitting one image to suggest another, the artist gradually discovered the emotional reality of his subject matter. This technique derives from surrealism, which in turn borrowed the method from Freudian psychoanalysis. But Bacon's approach goes beyond surrealism in its adherence to the overt subject matter, and in this respect comes closer to Freud.

In 1949 Bacon inaugurated a series of some two dozen compositions based directly on a reproduction of Velázquez's *Pope Innocent X* in combination with a film still of the screaming nurse on the Odessa steps in Sergei Eisenstein's 1925 film *The Battleship Potemkin.*[43] The film shows a close-up of the nurse's face with her mouth wide open and blood streaming from her eye. In *Study After Velázquez's Pope Innocent X* [fig. 5.22], he also used a contemporary photograph of Pope Pius XII for such details as the glasses.

The shower of vertical brushstrokes and the gold rails (derived from his tubular furniture) trap the figures; in some versions Bacon put the pope in a linear cage. The sense of confinement narrows the focus of the composition to a detailed examination, as if it were a clinical study of a specimen in a jar. The effect is anxious, searching,

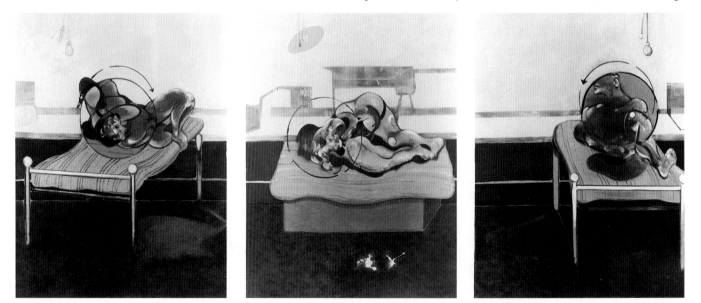

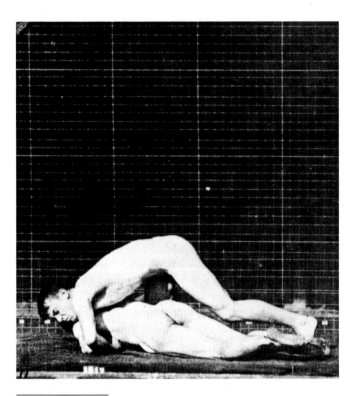

5.25 Eadweard Muybridge, photograph from *The Human Figure in Motion,* 1887.

disquieting, and at the same time sensuous. "I'd bought that very beautiful hand-colored book on diseases of the mouth," he reported, "and, when I made the Pope screaming, I didn't want to do it in the way that I did it—I wanted to make the mouth, with the beauty of its colour and everything, look like one of the sunsets . . . of Monet."[44]

On the surface the reproduction of a seventeenth-century papal portrait seems a relatively low-key subject, unlike a crucifixion or a theme inspired by Greek tragedy. Yet the frightening sense of loss of control evoked in these works far surpasses that of his earlier paintings. Indeed the safe historical neutrality of the subject works as counterpoint to the artist's highly charged transformation. In versions of this theme and in other works painted after 1960, such as *Self Portrait* [fig. 5.23] and *Three Studies of Figures on Beds* [fig. 5.24], the artist introduced cubist overlays of perspective—showing more than one angle at a time on a face or figure. The richly detailed and painterly handling, set off against the starkness of the backgrounds, makes the disturbing deformations uncomfortably close.

From the late forties until his death in 1992 Bacon worked largely from his memory of real motifs and from photographs or reproductions. In addition to snapshots of friends and news photographs, he made extensive use of such books as *The Human Figure in Motion*, a late nineteenth-

century collection of photographic studies by Eadweard Muybridge [fig. 5.25]. Muybridge devised a multiple camera apparatus to capture sequential movement in a succession of still shots, but instead of reading the procedure as cinematic, Bacon interpreted it as a method of rupturing the continuity of action. The figures in the central panel of *Three Studies (Beds)* derive from Muybridge's study of men wrestling. Bacon changed the wrestlers into embracing lovers and blurred them as if the picture were an action still, leaving detail to the imagination. "Shapes are remade or put slightly out of focus," the artist remarked, "to bring in their memory traces."[45]

The arrows encircling portions of the figures in *Three Studies (Beds)* were inspired by a technical book by K. C. Clark entitled *Positioning in Radiography.*[46] As with the Muybridge volumes, Bacon made frequent recourse to this book for images. He also used a short, broader, more typographical style of arrow in a number of paintings, that came, as he told the curator Hugh Davies, from a golfing instruction book; in both cases he wanted the arrows to recreate the neutrality of a textbook.[47]

Devices that promote this kind of clinical detachment seem almost mandatory to counterbalance the highly charged nature of Bacon's subject matter. Indeed the whole enterprise of his style is delicately poised—trying to press on, to search for feelings of the most intimate kind and at the same time maintaining enough distance to paint them. For example, Bacon described achieving a likeness in a portrait, but then when "I tried to take it further and tried to make it more poignant, more near . . . I lost the image completely."[48]

After 1960 Bacon also used chance in a more systematic way to loosen up his associative process as he continued to focus with unyielding discipline on his unconscious vision of his subjects. "I want a very ordered image," he said, "but I want it to come about by chance."[49] Increasingly, one starting-point was literally to throw paint at the canvas. "In the better things," according to Bacon, "that paint has an immediacy, although I don't think it looks like thrown-about paint."[50] He left the white splash at the bottom of the central panel of *Three Studies (Beds)* entirely intact; there is also a modified trace of splattered paint in the face on the left panel and in the midst of the figures in the center.

What distinguishes Bacon from the surrealists in his use of chance is that the surrealist portrays the elaboration of the dream itself or provokes a glimpse of the irrational reality underlying free association. Bacon, by contrast, uses the allusions stimulated by chance to bring out and analyze a feeling underlying the subject matter. Bacon painted his model over and over again, continually refining its appearance to attain a more and more precise psychic likeness. "One wants a thing to be as factual as possible," he explained, "and at the same time as deeply suggestive or deeply unlocking of areas of sensation."[51]

6

SOME INTERNATIONAL TENDENCIES OF THE FIFTIES

Purified Abstraction

Life seemed simpler in the fifties. Communism had replaced Hitler as the arch-danger in the mind of the American public, and although Europeans were less categorical in their views they more or less went along. The 1947 Truman Doctrine disbursed American economic and military aid to anyone who was against communism; the Western democracies founded NATO in 1949 to counter the growing Soviet threat in Europe; and in June 1950 the United States embarked on the Korean War to hold the line against communism in Asia. At home Senator Joseph McCarthy's wild accusations of "red" infiltration stirred Congress to open a "third front" against communism within the nation itself.

The Eisenhower era (1953–60) was a period of unprecedented American prosperity and world dominance. Business was booming and the mainstream middle class were beaming with economic confidence, even though there was widespread paranoia about signing anything or "getting involved" lest one be hauled into McCarthy's House Un-American Activities Committee. In addition there persisted an undercurrent of fear that the Soviets might attack (particularly after the nuclear tests held in Russia in 1949). But after the Depression, World War II, and then the onset of the cold war "the people" had had enough of the nation's worries. "I like Ike!" was the winning slogan in the election of 1952. Americans didn't want to hear what Adlai Stevenson (the other candidate) thought; for that matter, they didn't even care what "Ike" thought; they just "liked" Ike's reliable paternalism. He promised to be the "father," who could lift the world's affairs off everybody's backs so that people could get on with the American dream of the suburban home, complete with two children, a station wagon, and a family dog.

An Encounter with the Physicality of the Materials in Europe

In the fifties Europeans continued to undergo rationing amid a context of major postwar reconstruction. Many envied the prosperity of the United States and somewhat resented the nation's accompanying international influence. At the same time they appreciated American help in financing the European recovery. In fact the Old World's preoccupations were the same as those of the New: achieving middle-class prosperity. Much of the new art of the fifties—in both Europe and America—reflected this, veering away from the introspective focus of the New York School and Dubuffet's existentialism, and concentrating instead on tangible things; figurative subject matter began a revival, and the gestural richness of abstract-expressionist painting was taken up in both representational and abstract art for its sensuality and painterliness, rather than for its underlying metaphysics.

6.1 Lucio Fontana, *Spatial Concept, 60 0 48, 1960,* 1960. Oil
on perforated canvas, 4ft 11in × 4ft 11in (1.5 × 1.5m).
Collection, Kunstsammlung Nordrhein-Westfalen, Düsseldorf.

Some International Tendencies of the Fifties

6.2 (above) **Pierre Soulages,**
9 December 59, 1959. Oil on
canvas, 6ft 7⅜ × 5ft 3¾in
(2.02 × 1.62m).
Collection, Kunstsammlung Nordrhein-
Westfalen, Düsseldorf. © 1994 Artists Rights
Society (ARS), New York/ADAGP, Paris.

In France Hans Hartung and Pierre Soulages [fig. 6.2] painted in gestural styles tied to those very traditions of stylistic elegance that Dubuffet and Fautrier had reacted against. Serge Poliakoff and Nicholas de Staël also revived the prewar School of Paris in their painterly styles of abstraction. Wolfgang Schulze (who called himself Wols) (fig. 6.4) developed a highly original automatist style, founded in existentialism, in 1945–6; but gestural painting emphasized the identity of the artist over the base materialism that concerned Dubuffet and Fautrier. Wols, with Georges Mathieu (fig. 6.3)—also evolved in direct response to American action painting—and, after 1950, the American expatriate Sam Francis, are among the best known of the group of Parisian artists who came to be known as *tâchistes*. "*Tâche*" means a splash or stain, and as this implies, the movement emphasized expressive paint handling. But they too seemed more concerned with the beauty of the surface—or, in the case of Mathieu, the act of painting as a performance—than with the metaphysics of *l'informe*.

The most interesting European painting in the early fifties came out of ideas related to the concept of *l'informe*. Antoni Tàpies [fig. 6.5], a Catalan painter, worked in an abstract style after 1952, influenced (as Dubuffet was) by his concern with the vital—indeed spiritual—physicality of his materials. Tàpies also experimented with chance informed by Zen Buddhism. "I was obsessed with materiality," he later explained; "the pastiness of phenomena which I interpreted using thick material, a mixture of oil paint and whiting, like a kind of inner raw material that reveals the 'noumenal' reality which I did not see as an ideal or

6.3 Georges Mathieu,
Faintness, 1951. Oil on canvas,
4ft 3⅜in × 5ft 2¾in
(1.3 × 1.59m).
Collection, Art Institute of Chicago. Gift of Mr.
and Mrs. Maurice E. Culberg, 1952.998.
© Estate of Georges Mathieu, 1994.

6.4 Wols (Wolfgang Schulze), *Painting,* 1946–7. Oil on canvas, 31½ × 31½in (80 × 80cm).

Collection, Staatliche Museen zu Berlin, Preussischer Kulturbesitz, Nationalgalerie. Photograph by Jörg P. Anders, Berlin. © 2000 Artists Rights Society (ARS), New York/ADAGP, Paris.

6.5 Antoni Tàpies, *Black Form on Gray Square,* 1960. Mixed media on canvas, 5ft 3¾in × 5ft 3¾in (1.62 × 1.62m).

Collection, Fundació Antoni Tàpies, Barcelona. © 1994 Artists Rights Society (ARS), New York/ADAGP, Paris.

6.6 Alberto Burri, *Wheat,* 1956. Oil on burlap and canvas, 4ft 11in × 8ft 2⅜in (1.5 × 2.5m).

Collection, Kunstsammlung Nordrhein-Westfalen, Düsseldorf.

Some International Tendencies of the Fifties

supernatural world apart but rather as the single total and genuine reality of which everything is composed."[1]

The most interesting Italian painting of the decade also came from ideas related to *l'informe*, in which the material itself embodies an encounter with reality. The major figures were Alberto Burri [fig. 6.6] in Rome and Lucio Fontana [fig. 6.1] in Milan. Burri had begun painting during 1943 as a prisoner of war, interned in Texas. He worked with various unconventional materials—even mixing tar, rags, and living molds with his pigments. But his best-known works are the burlap "Sacks" of the fifties. Burri's expressive manipulation of these earthy materials shifted the emphasis in painting from representation to the physical reality of the object itself.

Lucio Fontana sought "an art in which our idea of art cannot intervene,"[2] as he asserted in his 1946 *White Manifesto*. Like Burri he wanted to stress the total reality of the canvas as a material object to be experienced directly and without formal preconceptions. But Fontana sought to transcend the object, entering a metaphysical space; in effect he used the vivid reality of the material object as a foundation for an even more immanently "real," but at the same time abstract, spatial concept.

At the end of the forties, Fontana began puncturing holes in the canvas and in the fifties he slashed through it as a way

of heightening the intensity of his interaction with its physicality. Nearly all of Fontana's paintings of the fifties and sixties are referred to as "spatial concepts" (*concetti spaziali*). In addition he experimented with "spatial environments" (*ambienti spaziali*) in 1949—neon installations in which he attempted to extend his ideas into a specific space. In the fifties Fontana applied colored stones or glass to the surface of some works to create a transcendent sense of spatial transparency. But Fontana's epiphany of space–time had to do with a flash of insight into cosmic order rather than with the existential concerns of *art informel*.

The outstanding Italian gestural painter of the fifties was Emilio Vedova in Venice. Then in 1957 the American Cy Twombly settled in Rome. In 1957 to 1958 Twombly began painting his so-called "writings" [fig. 6.7]—a calligraphic style of marking the canvas (often configuring letters, worlds, or even fleeting images) in a dispersed "anti-compositional" order that has a cunningly random appearance, like a wall of graffiti. The sense of his stylistic origins in writing (especially

6.7 Cy Twombly, *Untitled,* 1960. Oil, crayon, and pencil on canvas, 38¼ × 55⅛in (97.2 × 140cm).
Collection, Ralph and Helyn Goldenberg, Chicago. Photograph courtesy the collectors.

in the anonymity of graffiti), rather than in the directly autographic gesture of the action painters, underscores Twombly's difference from abstract expressionism.

Twombly's line is not assertively focused like a Pollock or a de Kooning. Instead his sensibility more closely resembles that of John Cage and the earlier work of Jasper Johns (see Chapter 7). Twombly's work has a richly layered ambiguity that resists closure. Yet despite its seeming openness to the chance occurrence of future accretions it firmly asserts its place within the grand narrative of the classical tradition; Twombly diminishes rather than enhances the importance of individual identity, subsuming it into the collective and much larger history of Western culture. Twombly used culture—especially literature and myth—rather than a search for existential identity as the touchstone of his style.

A Material Reading of Action Painting in New York

During the Depression and war years the largely self-educated community of vanguard artists in New York lived meagerly, with little hope of making a living by painting. They persevered out of intellectual commitment, and because they were caught up in the insistent social necessities of the period, most of them participated in some form of political activism. The familial sense of a small artistic community, centered on Tenth Street and Broadway in Greenwich Village, survived as late as the mid fifties. The continuing presence of such established figures as Harold Rosenberg, Willem de Kooning, and Philip Guston dominated the neighborhood. Franz Kline and occasionally Jackson Pollock still frequented the Cedar Bar on University Place by Washington Square.

6.8 Joan Mitchell, *Untitled,* 1952. Oil on canvas, 30⅛ × 40⅛in (76.8 × 102.2cm).
© The Estate of Joan Mitchell. Photo courtesy of Robert Miller Gallery, New York.

6.9 Philip Guston, *Oasis,* 1957. Oil on canvas, 5ft 1½in × 5ft 8in (1.56 × 1.73m).
Collection, Hirshhorn Museum and Sculpture Garden, Smithsonian Institution, Washington, D.C. Gift of Joseph H. Hirshhorn Foundation, 1966. Photograph by Lee Stalsworth.

The Club on East 8th Street maintained a weekly program of speeches and discussions, and a number of cooperative galleries opened with the work of younger artists who emulated the first generation of the New York School, and among them were some prominent women, such as Joan Mitchell (fig. 6.8).

The audience for these gallery shows and discussions consisted chiefly of other artists, interspersed with a few dealers, critics, and friends. While the psychological and confessional tenor of the conversation persisted, there was a more narrow focus on style *per se*. The rapidly growing opportunities for teaching jobs and sales increasingly entered into artists' discussions. "Honesty" endured as a criterion in painting, but "relevance" faded away.

By the end of the fifties the art world had vastly expanded, ushering in a new influx of university-educated artists who did not appear to have the "moral crisis in relation to what to paint,"[3] which Barnett Newman described as the challenge facing artists in his generation. Reflecting the mood of the country at large, artists in the fifties were remarkably apolitical. University education, it seems, had actually made them less interested in discussing intellectual, social, and political issues and had instead taught them about careers.

Hofmann, Kline, and de Kooning were the leading models for young painters in the fifties. They admired Pollock, but they could not emulate him without looking "derivative" (another catchword of the decade), and the rejection of "masterful" brushwork by Newman and Rothko was still deemed too radical to inspire imitators. But instead of the existential crisis embodied in the autographic mark,

the new gestural painters of the fifties talked of "polyreferential" marks, sought "lyrical beauty," and stressed the sensuous pleasure of laying on paint for its own sake. In 1955 a large, late *Waterlilies* composition by Monet went on display at the Museum of Modern Art, further heightening these younger painters' interest in surface richness.

Philip Guston's lush, painterly abstraction of the fifties [fig. 6.9] also became a leading influence in what Elaine de Kooning dubbed "abstract impressionism,"[4] Despite Guston's own commitment to an existentially probative subject matter, he unwittingly encouraged a number of younger artists in the mid fifties toward a more superficial, "lyrical" or decorative style. But most preferred what they regarded as the raw honesty of de Kooning, evidenced by his tendency to leave a painting unfinished, without disguising the marks of his creative struggle in the perfection of a "finished" composition.

"Difficult" painting had credibility; elegant painting was seen as merely "decorative." But to select a model at all contradicted the premise of an existential approach and raised the question with which Irving Sandler provoked a two-part series of artists' statements for *Art News* in 1959: "Is There a New Academy?" One of the respondents summed up the feeling by asking: "Why is it that after an evening of openings on Tenth Street, I come away feeling exhausted from the spectacle of boredom?"[5] There was a widespread feeling that gestural painting had become a collection of tired conventions.

Greenberg's Definition of Modernism

The critic Clement Greenberg stepped into the disarray of second-generation gesture painting and decided he could revitalize painting by providing rules from which painters could proceed: It is "a law of modernism," he wrote in 1955, ". . . that applies to almost all art that remains truly alive in our time—that the conventions not essential to the viability of a medium be discarded as soon as they are recognized. The process of self-purification . . ."[6] evolved, in linear progression, from Pollock to Still, Rothko, and Newman—whose flat expanses of color went beyond the shading and illusionistic depth still remaining in cubist-influenced painters such as de Kooning, according to Greenberg. From them the baton of vanguardism passed to the "color field" or "stain" painters Helen Frankenthaler and Morris Louis, and in the sixties to Kenneth Noland and Jules Olitski. The problem, as Barbara Rose pointed out, was that

Clement Greenberg, quoting Matthew Arnold, saw the task of the critic as defining the mainstream tradition . . . But at any given time the mainstream is only part of the total activity . . . [Greenberg's] argument is that since modernist art emancipated itself from the demands of society, the history of forms has been self-referential and has evolved independently of the history of events.[7]

"This argument," she concluded, "is demonstrably false." Nevertheless a number of influential people in the art world enthusiastically embraced the clarity and logic of Greenberg's monolithic "mainstream"; in 1960 William Rubin, for example, remarked that painterly painting was even "a losing proposition for de Kooning himself."[8]

Greenberg felt confident in his ability to spot the "next move." Moreover, he was certain there would be only *one* next move at a time and that it necessarily had to follow in a logical manner from his belief that

the essence of Modernism lies . . . in the use of the characteristic methods of a discipline to criticize the discipline itself . . . The task of self criticism became to eliminate from the effects of each art any and every effect that might conceivably be borrowed from or by the medium of any other art. Thereby each art would be rendered "pure," and in its "purity" find the guarantee of its standards of quality as well as of its independence.[9]

In Greenberg's modernism color, for example, is "optical" and therefore belongs to painting, so is the picture plane. Consequently sculpture that involved color or made reference to the picture plane would not qualify as an "important" next step. Similarly narrative (a literary device), figural representation, and certainly illusionism were strictly proscribed.

The Greenberg School

By 1960 Greenberg had a prodigious network of influence that dominated the public debate on art. The school of young critics surrounding Greenberg included, most notably: Michael Fried, Rosalind Krauss, Kenworth Moffett, and Walter Darby Bannard. There were also a number of young museum curators who took their cues from Greenberg, and for a full decade after the 1964 exhibition in Los Angeles called "Post Painterly Abstraction" (which set the canon of Greenberg's taste) Greenberg's followers also took over *Artforum* magazine.

Greenberg and Fried singled out David Smith and Anthony Caro [fig. 7.17] as the leading innovators in sculpture. But Irving Sandler rightly wondered "if, as Greenberg maintained, each of the arts was turning in on its own medium, why had he opted for welded construction, which he claimed aspired toward the 'pictorial,' rather than sculpture that approached the object [i.e. minimalism], which was the nature of sculpture?"[10] Minimalism, as Sandler implied, focused on precisely these literal qualities of the object (see Chapter 10).

John Cage's book *Silence*—which stood for inclusiveness and was consequently impure by Greenberg's standards—appeared in 1961, at precisely the same time as Greenberg's influential collection of essays, *Art and Culture*. To the followers of Greenberg, Cage and Duchamp, Rauschenberg, Johns, Oldenburg, and all pop artists were the corrupting antichrists of kitsch. As late as 1974 Kenworth Moffett called Oldenburg a "feeble" artist and chided: "The lack of the

slightest formal integrity prevents his droopy painterly objects from being more than archly cute."[11] Michael Fried went even further, saying "if someone likes *that* stuff . . . I simply can't believe his claim that he is *also* moved or convinced or flattened by the work of Noland, say, or Olitski or Caro," and that anyone who sincerely makes such a claim is "in the grip of the wrong experience."[12]

Formalism decreed a narrowly linear progress in modernism toward a relentless purification. Only optical facts (that which was verifiably visible) were significant in the discussion of painting. Subject matter was irrelevant, illusion forbidden, and anything that did not fit Greenberg's logic was dropped from his definition of modernism as if it never existed. Fried described the inevitable march to purity in an equally affectless and narrow manner: "Once a painter who accepts the basic premises of modernism becomes aware of a particular problem thrown up by the art of the recent past, his action is no longer gratuitous but imposed."[13] The artist had to follow a more or less predetermined path.

Rosalind Krauss wrote that art history "was like a series of rooms *en filade* ['one after another']. Within each room the individual artist explored, to the limits of his experience and his formal intelligence, the separate constituents of his medium. The effect of his pictorial act was to open simultaneously the door to the next space and close out access to the one behind him."[14] In Krauss's formalist decathlon of opening and closing doors squeaky hinges were disqualified, which negates the defining premise of an avant-garde.

Fortunately, the best artists do not follow rules made up by critics, but invent their own. Moreover, art does not develop logically or in a linear progression; and if one could predict the next move in art, that art would be unimportant precisely because it is predictable. At the outset Greenberg was reacting against the form of criticism practiced by Harold Rosenberg, whose chief interest was in ideas implicit in the work of the New York School. What Rosenberg liked about art was its unpredictability—the entry of fresh ideas into the conversation; for him art opened the eyes of the participants to new perspectives on important social or political issues. Greenberg, on the other hand, felt that such "expressionistic" criticism lacked rigor. But as the logical positivists have pointed out, the only absolutely provable truths are tautological: what Greenberg, Fried, and the others gained in rigor they lost in significance.

One of the great ironies in this formalist episode is that all of Greenberg's judgments ultimately relied on taste to determine quality, and there were no object criteria given for taste. Sandler justifiably complained about Fried, who "would allow only one *correct* formalist art at any moment. And he did not make clear why any one option should be any more modernist than any other . . . Fried chose to single out a few artists, notably Noland, Olitski, Stella, and Caro, and accept whatever they made as truly modernist, only because they made it."[15]

Increasingly people began taking issue not only with Greenberg's opinions but also with the manner in which he imposed them on others. In one widely discussed case Greenberg appears to have decided, after David Smith's death, how he thought Smith should have finished certain pieces. So, as executor of Smith's estate, he reportedly had the colors which the artist himself had painted removed and replaced with an entirely different type of surface.[16] Morris Louis, unlike Smith, evidently followed directions in the first place. The painter made a note on the edge of a 1958 canvas that he planned to fold out of sight: "1 inch of white on each side as per Clem."[17] By around 1970 the art and theory on which Greenberg and Fried had built their reputations began to look as dated and unconvincing as their claims of historical inevitability. Greenberg more or

6.10 Helen Frankenthaler, *Mountains and Sea,* 1952. Oil on canvas, 7ft 2⅝ in × 9ft 9¼in (2.2 × 2.98m). Collection, the artist, on extended loan to National Gallery of Art, Washington, D.C. © Helen Frankenthaler.

less faded from view along with the chorus around him. Fried retreated into nineteenth-century studies, and Krauss went on to develop a sequence of theoretical constructs which she applied to works of contemporary art and which continues to attract some academic art historians.

Formalist Painting

Greenberg tried to rejuvenate "decorativeness" as an alternative to expressionism, and he singled out the work of Helen Frankenthaler because she achieved an identity of the surface and color—making them inseparable. By literally soaking the color into the canvas, she made it textureless and thus more "optical" than tangible. Frankenthaler worked in an abstract style derived from Hans Hofmann with impetus from the work of Kandinsky and Gorky. Like Hofmann she took inspiration from nature, but unlike him, she and several other "abstract impressionists" of the fifties were attracted to the decorative surface qualities of the late Monet.

In April 1953 Kenneth Noland (who came from Washington, D.C.) brought his friend Morris Louis to New York to meet Greenberg and look at art. They visited Frankenthaler's studio, and her painting *Mountains and Sea* [fig. 6.10] had a galvanizing effect on Louis. Immediately on their return to Washington, Louis and Noland began to experiment together with staining [figs. 6.11 and 6.12]. Louis abandoned the brush completely and began pouring viscous lines of paint that soaked into the surface. By the beginning of 1954, he had devised a new style based on the technique of staining unsized white cotton with a liquid acrylic medium.

Louis succeeded in getting a different effect from staining than Pollock or Rothko had achieved. His colors blended into one another and into the canvas itself, rather than lying above the surface. This process left rich spectral layerings that revealed themselves with particular *élan* at the edges. Greenberg and his followers applauded Louis for his "honesty" in making explicit the real flatness of the canvas. Michael Fried particularly praised the disappearance of "all suggestion of the gestural, manifestly spontaneous hand-writing of abstract expressionism."[18] For them Morris Louis had surpassed Frankenthaler in pure opticality by establishing a uniformly textured "field" and dissipating any sense of depth or color substance. Even if others saw paintings like *Tet* [fig. 6.11] not as flat but diaphanous, conveying an illusion of depth in and behind the washes of color, Greenberg continued to delight in a feeling of "openness" in "pure painting," derived from the "identity of color and surface."

6.11 Morris Louis, *Tet,* 1958. Synthetic polymer on canvas, 7ft 11in × 12ft 9in (2.41 × 3.89m).

Collection, Whitney Museum of American Art, New York. Purchase, with funds from the Friends of Whitney Museum of American Art, New York. Photograph by Geoffrey Clements, New York

6.12 Kenneth Noland, *And Half,* 1959. Acrylic on canvas, 5ft 9in × 5ft 9in (1.75 × 1.75m).

Collection unknown. Photograph by Geoffrey Clements, New York. © Kenneth Noland/VAGA, New York, 1994.

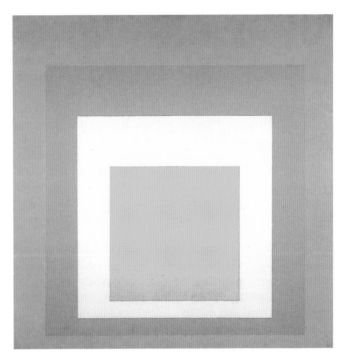

6.13 Josef Albers, *Homage to the Square: "Ascending,"* 1953. Oil on composition board, 3ft 7½in × 3ft 7½in (1.11 × 1.11m).

Collection, Whitney Museum of American Art, New York. Purchase. Photograph by Geoffrey Clements, New York. © 2000 The Josef and Anni Albers Foundation/Artists Rights Society (ARS), New York.

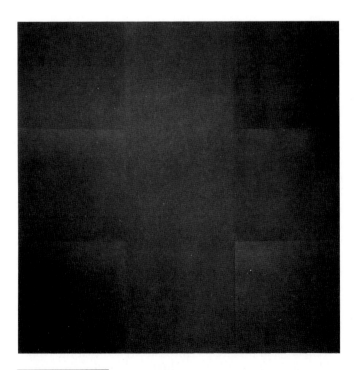

6.14 Ad Reinhardt, *Abstract Painting,* 1960–6. Oil on canvas, 5 × 5ft (1.52 × 1.52m).

Photograph courtesy PaceWildenstein Gallery, New York. © 2000 Estate of Ad Reinhardt/Artists Rights Society (ARS), New York.

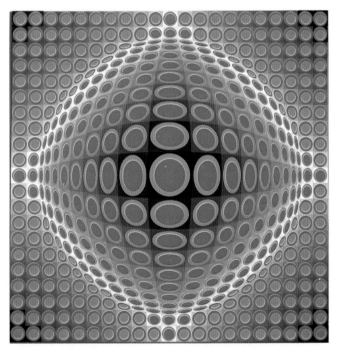

6.15 Victor Vasarely, *VEGA PER,* 1969. Oil on canvas, 5ft 3in × 5ft 3in (1.6 × 1.6m).

Collection, Honolulu Academy of Arts. Gift of the Honorable Clare Boothe Luce, 1984. Photograph by Tibor Franyo. © 2000 Artists Rights Society (ARS), New York/ADAGP, Paris.

Some International Tendencies of the Fifties

Taking off from the targets that Jasper Johns showed at the Leo Castelli Gallery in 1958, Kenneth Noland began a series of target paintings [fig. 6.12] late in 1958. The banality of the format was intentional, for the artist wanted to stress instead the interaction of colors—just as Noland's teacher, Josef Albers, had done in his compositions of nested color squares [fig. 6.13]. According to Fried, Noland sought a "strictly logical relation between the painted image and the framing edge."[19] Fried found precisely the same aspiration in the contemporary works of Frank Stella [figs. 10.2, 10.4, and 10.5]. Noland moved from a Rothko-like softness in the definition of the outer edge to "hard-edged" circles by 1961. From there the stripes developed into chevrons and then into continuous horizontals.

The stain or color-field painting of such artists as Frankenthaler and Louis derived from a formalist analysis of the gesture painting of the New York School. A geometrically based formalist painting had already evolved, in large part out of a literal reading of Mondrian. Ad Reinhardt, its leading exponent, was a contemporary of Pollock and Motherwell but he loathed subjectivity and became increasingly engaged with the more self-negating kind of contemplation in Zen aesthetics. By 1960 his work moved toward a reduction so radical that the typical painting consisted only of a black rectangle inscribed with nearly invisible vertical and horizontal black trisections [fig. 6.14]. He concluded that this was the final solution to painting; and as further progress was therefore impossible, he announced that he intended to repeat this same painting from then on.

Josef Albers, the former Bauhaus master whom Noland had encountered at Black Mountain College, North Carolina, had a great effect on postwar painting through his teaching. Albers taught at Black Mountain from 1933 through the forties and then moved in 1950 to the Yale School of Art. He argued for an experimental attitude concerning materials and a technological rigor in the study of color and design. In his own work he focused narrowly on optical interactions and the expressive dimension is suppressed to a whisper. "Angst is dead," he once wrote on a scrap of paper that he handed to Harold Rosenberg at a party.[20] The fixed compositional format of his series "Homage to the Square" preoccupied him for the last twenty-five years of his life. Albers' painting and writing were equally systematic, orderly, experimental. In 1963 he published a book of color theory called *The Interaction of Color*, and during that decade he enjoyed a considerable following as interest in a more detached and theoretical style of art became more widespread.

In 1965 the Museum of Modern Art opened a widely discussed exhibition called "The Responsive Eye." William Seitz, the curator, wanted to bring together a survey of current artists who manipulated perceptual effects in a formalist—as opposed to an expressionistic—mode. The exhibition brought together "op art" (from "optical"), as in

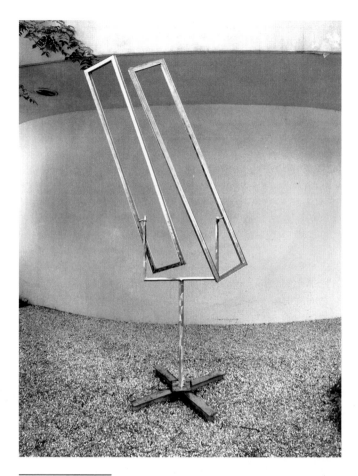

6.16 George Rickey, *Two Open Rectangles Excentric VI, Square Section,* 1976–7. Stainless steel, 144 × 36in (365.8 × 91.4cm).
Collection, Solomon R. Guggenheim Museum, New York. Purchased with the aid of funds from the National Endowment for the Arts in Washington, D.C., a Federal Agency; matching funds donated by Evelyn Sharp and anonymous donors, 1978. Photograph by Robert E. Mates © The Solomon R. Guggenheim Foundation, New York. © George Rickey/VAGA, New York, 1994.

the paintings of Victor Vasarely [fig. 6.15], and kinetic art (having to do with actual motion), as in the delicately engineered works of George Rickey [fig. 6.16], where a light breeze will set all the finely hinged and balanced parts in motion. The popular media loved the show. But the art establishment detested it as a display of vulgar and empty visual gimmicks, and to the chagrin of Greenberg's circle Seitz also included color-field canvases by Morris Louis, Kenneth Noland, and Walter Darby Bannard; as well as works by Frank Stella, Larry Poons, Ellsworth Kelly, Larry Bell, and Agnes Martin (who were associated with minimalism); and by Josef Albers, Ad Reinhardt, and the interwar geometric abstractionist Leon Polk Smith. Greenberg and his circle vigorously argued that the color-field painters practiced a "high" formalist aesthetics, whereas the others, they felt, were only a form of "visual entertainment." In retrospect, however, Seitz's premise for the show seems to hold up pretty well.

"New Images of Man" in Europe and America

The Cobra

The drive toward liberated subjectivity in the figurative styles of Dubuffet, Giacometti, and Bacon led a wider tendency in postwar European and American art. The "Cobra" group—comprising artists from "Co"penhagen, "Br"ussels, and "A"msterdam—is the outstanding example of this broader phenomenon. At the end of 1948 the Belgian poet Christian Dotremont and the Danish painter Asger Jorn gave initial shape to Cobra as a movement. Over the next three years they and their collaborators produced ten issues of a journal entitled *Cobra* and numerous exhibitions. They also instigated artistic exchanges that aimed to give some coherence to this otherwise loose affiliation of northern European artists. Their unifying stylistic bond was a free, organic expressiveness in paint handling and an emphasis on imagery defined in the individual imagination. The major artists of the Cobra group were Asger Jorn from Denmark [fig. 6.18]; Karel Appel [fig. 6.19], Cornelis van Beverloo, known as Corneille, and Constant A. Nieuwenhuys [fig. 6.17] from Amsterdam; and Pierre Alechinsky [fig. 6.20] from Brussels.

Like Dubuffet, Giacometti, Bacon, and the artists of the New York School, the Cobra artists had roots in surrealist automatism, Freudian psychology, and existentialism. With Dubuffet, whom the Cobra knew and admired, they also shared an interest in anonymous, untutored art and in the everyday experience of the common man. Jorn praised popular culture, celebrated inartistic materials, and emulated graffiti. Constant, in a statement that reflected the views of most of the group, remarked that "we consider the

6.17 Constant A. Nieuwenhuys, *The Little Ladder,* 1949. Oil on canvas, 35½ × 29½ (90.2 × 74.9cm).
Collection, Haags Gemeentemuseum, The Hague. © Constant/Artists Rights Society (ARS), New York, 1994.

Some International Tendencies of the Fifties

stimulation of the creative impulse as art's main task" and asserted that "truly living art makes no distinction between the beautiful and the ugly."[21]

The artists associated with Cobra also turned to children's art, as Dubuffet had, for an expression of the unconscious that circumvented the inhibitions of culture. However, as Pierre Alechinsky explained, "Cobra is a form of art which heads toward childhood, tries to recover folk art and child art for itself with the means available to adults, non-naïve means."[22] In this respect they (and other surrealist-inspired artists who emerged after the war) differed from the surrealists. The Cobras' call for "spontaneity" acknowledged the full range of experiences that impinged on the processes of the developed mind, whereas Breton retained idealistic aspirations for a "pure" expression of the unconscious through automatism. In addition Freudian psychology no longer had the same novelty value to the postwar generation, as it had twenty years previously; it had already become a familiar perspective on important aspects of everyday life. Where Breton had hoped to prompt revelations of the unconscious, these artists sought a fuller encounter with reality through the marshalling of unconscious forces.

Consequently, Cobra's style stressed the act of creation and harked back formally to early twentieth-century expressionism. They saw imagination as a mechanism that "unforms" the images supplied by perception—an idea that goes back to Baudelaire and which they took from psychoanalysis and phenomenology via the writings of the French philosopher Gaston Bachelard. Alechinsky's proclamation that "it is through action alone that the thought can intercede in matter"[23] not only suggests a parallel with Dubuffet's notion of "collaborating" with materials but underlines the dialectic between subjective

6.19 (above) **Karel Appel,** *Questioning Children,* 1949. Gouache on wood, 34⅜ × 23½ × 6¼in (87.3 × 59.7 × 15.9cm).
Collection, Trustees of the Tate Gallery, London. © Karel Appel/Artists Rights Society (ARS), New York, 1994.

6.18 Asger Jorn, *A Soul for Sale,* 1958–9. Oil on canvas, 6ft 7in × 8ft 2¾in (2.01 × 2.51m).
Collection, Solomon R. Guggenheim Museum, New York. Purchased with funds contributed by the Evelyn Sharp Foundation, 1983. Photograph by David Heald © The Solomon R. Guggenheim Foundation, New York.

6.20 Pierre Alechinsky, *Death and the Maiden,* 1967. Acrylic on paper mounted on canvas, 4ft 6in × 4ft 6in (1.37 × 1.37m).
Collection, Marion Lefebre, Los Angeles. © 2000 Pierre Alechinsky/Artists Rights Society (ARS), New York/ADAGP, Paris.

intuition and empirical reality. From this point of view, imagination could mitigate man's alienation.

Although Cobra disintegrated as a cohesive movement in the early fifties, its leading artists continued to evolve, developing separately its principles of spontaneity and its existential concerns. For Alechinsky in particular, Cobra

was only the beginning of a major career. Even though his later paintings, like the 1967 *Death and the Maiden* [fig. 6.20], still relate to the ideas of Dotremont and to some Cobra concerns, they also break new ground.

In *Death and the Maiden* the painter transformed the framing edge into a detailed commentary on the center. This black-and-white sequence of notations developed frame by frame in an implicitly ongoing interaction. Like Dotremont's idea of writing in dialog with the physicality of the word as it goes on to the page, this margin unfolds through spontaneous responses, repetitions, and transformations of

suggestions from the center. At this time, Alechinsky painted an extensive series of works on this principle of surrounding the central—and more unified—image with a complex and disparate set of images in the margins that challenge the emphasis on a central set of forms. These works resonate richly with contemporary French poststructuralism, with theoreticians such as Roland Barthes and Jacques Derrida who questioned the authority of the author over the reader in literature and the hegemony of the mainstream (the normative center) in social structures.

The Figurative Revival of the Fifties

Figurative imagery in general underwent a revival in the fifties, both in Europe and America. In sculpture artists ranging from Reg Butler in Britain, Germaine Richier in France, the Italians Marino Marini [fig. 6.21] and Giacomo Manzú, as well as Americans like Leonard Baskin, treated the human figure in an expressionistic manner that is at once contemporary in sensibility and consonant with classical traditions of bronze casting. In Europe perhaps the outstanding traditional figure painter of the period was the Englishman Lucian Freud [figs. 6.22 and 6.23].

6.21 Marino Marini, *Horseman,* 1947. Bronze, 64½ × 61 × 26½in (163.8 × 154.9 × 67.3cm).
Collection, Trustees of the Tate Gallery, London. © Estate of Marino Marini/Artists Rights Society (ARS), New York, 1994.

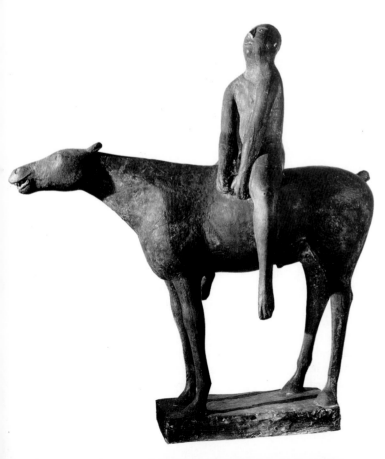

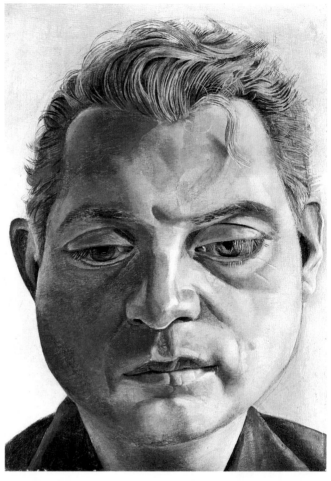

6.22 Lucian Freud, *Francis Bacon,* 1952. Oil on copper, 7 × 5in (17.8 × 12.7cm).
Collection, Trustees of the Tate Gallery, London.

Though directly engaged in the outward appearance of things, Freud wanted his "portraits to be *of* the people, not *like* them. Not having the look of the sitter, *being* them."[24] This powerful sense of the reality beyond the picture creates an uncomfortable intimacy between the viewer and the sitter. On the one hand the viewer feels a formal distance in not being able to divine the enigmatic relations between the figures (where there are more than one) or to know the true identity of the solitary subject. Yet the artist presses the viewer to intrude on an excruciatingly private scene. As the critic Robert Hughes has pointed out, Freud "has seen everything with such evenness, while conveying the utter disjuncture between the artist's gaze and the sitter's lack of response."[25]

In New York the admiration for abstract expressionism produced in the fifties not only a school of second-generation abstract gesture painters but also figurative artists working in a painterly style. These include Grace Hartigan [fig. 6.24], Alex Katz [fig. 6.29], Philip Pearlstein [fig. 6.30], and Fairfield Porter [fig. 6.25]. Jan Müller [fig. 6.26] worked in a gestural manner but his subject matter

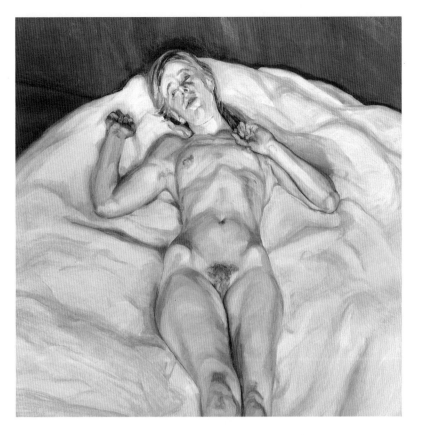

6.23 Lucian Freud, *Naked Girl,* 1966. Oil on canvas, 24 × 24in (61 × 61cm).
Collection, Steve Martin.

6.24 (below) **Grace Hartigan,** *River Bathers,* 1953. Oil on canvas, 5ft 9⅜in × 7ft 4¾in (1.76 × 2.25m).
The Museum of Modern Art, New York. Given anonymously.

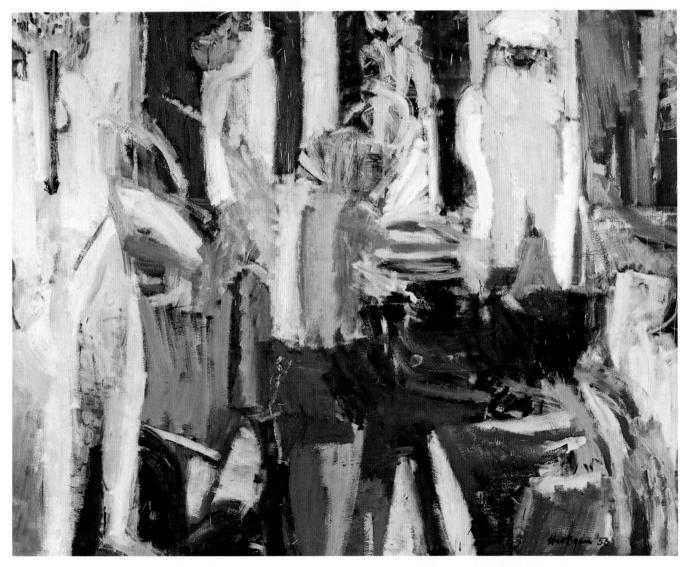

6.25 (opposite) **Fairfield Porter,** *Katie and Anne,*
1955. Oil on canvas, 6ft 8⅛in × 5ft 2⅛in (2.03 × 1.57m).
Collection, Hirshhorn Museum and Sculpture Garden, Smithsonian Institution, Washington,
D.C. Gift of Joseph H. Hirshhorn, 1966. Photograph by Lee Stalsworth.

came from an imagination fueled by medieval religious painting, and his style had more to do with Nolde than with Hans Hofmann (his teacher). Müller did his first serious work in 1952 and immediately achieved a considerable reputation in New York, although his early death in 1956 cut short a promising career.

Yet not even the return of de Kooning and Pollock to the figure in the early fifties convinced some artists of the ongoing viability of figurative art. In particular those under the

influence of Greenberg or Ad Reinhardt felt that "going back" to realist subjects constituted a betrayal of modernism. Greenberg claimed that "any painter today not working abstractedly is working in a minor mode," and Reinhardt quipped "Enter nature, exit art."[26]

Larry Rivers, the outstanding painterly realist to emerge in New York during the fifties, had studied with Baziotes and Hofmann. As his painting *The Studio* [fig. 6.27] shows, Rivers typically distributed precisely rendered details over the surface (like the faces in this work). He interspersed them with roughly sketched or brushed passages and raw areas of unpainted canvas. Rivers treated the canvas as a field of random activity; rather than focusing on a single image, he scattered several centers of interest across the painting. In most cases these

6.26 Jan Müller, *The Temptation of Saint Anthony,* 1957. Oil on canvas, 6ft 7in × 10ft ¾in (2.01 × 3.08m).
Collection, Whitney Museum of American Art, New York. Purchase. Photograph by Geoffrey Clements, New York.

6.27 (below) **Larry Rivers,** *The Studio,* 1956. Oil on canvas, 6ft 10½ in × 16ft 1¼in (2.09 × 4.91m).
Collection, Minneapolis Institute of Arts, John R. Van Derlip Fund. © Larry Rivers/VAGA, New York, 1994.

Some International Tendencies of the Fifties

6.28 Larry Rivers, *Portrait of Frank O'Hara*, 1954. Oil on canvas, 8ft 1in × 4ft 5in (2.46 × 1.35m).
Collection, the artist. © Larry Rivers/VAGA, New York, 1994.

disparate areas cohere around a compositional center, but in some works they approach the "allover" structure of works like de Kooning's *Excavation* [fig. 3.44].

Rivers handled his subject matter with a perverse irony. His frontal, full-length portrait of Frank O'Hara wearing nothing but black military boots [fig. 6.28], for example, snidely stereotypes the poet as a gay pin-up. The many nude depictions of the artist's mother-in-law, Birdie, likewise accentuate her sexuality in a way that makes her appear vulgar and awkward. *The Greatest Homosexual* (1964), after Jacques-

Louis David's 1812 portrait of *Napoleon in his Study*, treats art history with a similarly sarcastic indifference. The detachment with which Rivers presented his subject matter also manifested itself in his self-consciously "virtuoso" technique, calculated to display his fine gestural touch and superb draftsmanship as if they too fell casually from his hand.

Unlike Rivers, who manipulated his subjects to stress the uniqueness of his vision and technique, Fairfield Porter, Alex Katz, and Philip Pearlstein modestly painted what was in front of them; all the details are legible, and there is no pretense of theory. Katz had a sharply simplified subject matter, focusing on individual objects or sitters that are kept isolated in his compositions [fig. 6.29]. This spare treatment of the individual form as a single image, rather than as a participant interacting with other figures inside the frame, made Katz's subjects seem more abstract. The painterly softness of Alex Katz's work from the mid fifties later gave way to a flatter, more hard-edged technique.

Philip Pearlstein [fig. 6.30] concerned himself with executing an indifferently objective representation of his subject, which became almost exclusively nude models posed in the studio. But Pearlstein made none of the

6.29 Alex Katz, *Ada (in Black Sweater)*, 1957. Oil on masonite, 24 × 18in (61 × 45.7cm).
Collection, the artist, on long-term loan to the Colby College Museum of Art, Waterville, Maine. © Alex Katz/VAGA, New York, Marlborough Gallery, New York.

6.30 Philip Pearlstein, *Two Female Models with Drawing Table,*
1973. Oil on canvas, 6 × 5ft (1.83 × 1.52m).

Collection, Philadelphia Museum of Art. Purchased through a grant from the National
Endowment for the Arts and contributions from private donors.

Some International Tendencies of the Fifties

concessions that Katz did to impact and scale. His factual, unidealized style leaves nothing to the imagination and gives no quarter to introspection. It is a visual discipline, unemotionally fixed on the material substance of things. Pearlstein's shift away from gestural painting at the end of the fifties came from a desire to make his rendering more precise. The objectivity of description to which he aspired recalls earlier American painters such as Thomas Eakins and Eastman Johnson. The starkness of the lighting and the banality of the subject matter, however, set Pearlstein's work apart from theirs, and the viewer is impelled to focus more narrowly on the technique.

Figurative Painting in the Bay Area

As in New York, the impetus of abstract-expressionist handling also produced an exceptional group of gestural painters in California. In particular David Park [fig. 6.31] and his students at the California School of Fine Arts in San Francisco, Elmer Bischoff [fig. 6.32] and Richard Diebenkorn [fig. 6.33] turned from painterly abstraction to a gestural style of figuration between 1950 and 1955. Richard Diebenkorn, the outstanding artist of this group, studied with Still and Rothko as well as Park during the mid forties.

6.31 (opposite) **David Park,** *Standing Couple,* 1958. Oil on canvas, 6ft 3in × 4ft 8¾in (1.91 × 1.44m).

Collection, Krannert Art Museum and Kinkead Pavilion, University of Illinois at Urbana-Champaign. Purchased out of the "Illinois Biennial" exhibition of 1961. Artists Rights Society (ARS), New York.

6.32 Elmer Bischoff, *Two Figures at the Seashore,* 1957. Oil on canvas, 4ft 8in × 4ft 8¾in (1.42 × 1.44m).

Collection, Newport Harbor Art Museum. Museum Purchase with a matching grant from the National Endowment for the Arts.

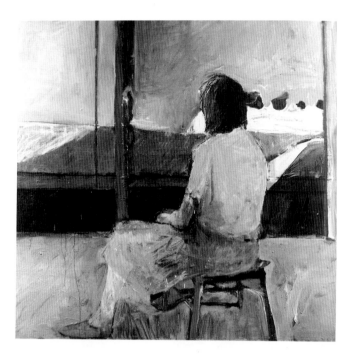

6.33 Richard Diebenkorn, *Girl Looking At Landscape,* 1957. Oil on canvas, 4ft 11in × 5ft⅜in (1.5 × 1.53m).

Collection, Whitney Museum of American Art, New York. Gift of Mr. and Mrs. Alan H. Temple. Photograph by Geoffrey Clements, New York.

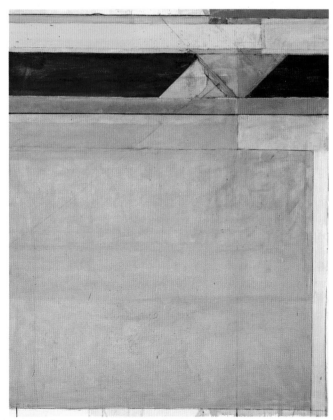

6.34 (above) **Richard Diebenkorn,** *Ocean Park No. 107,* 1978. Oil on canvas, 7ft 9in × 6ft 4in (2.36 × 1.93m).

Collection, Oakland Museum. Gift of the Women's Board, Oakland Museum Association.

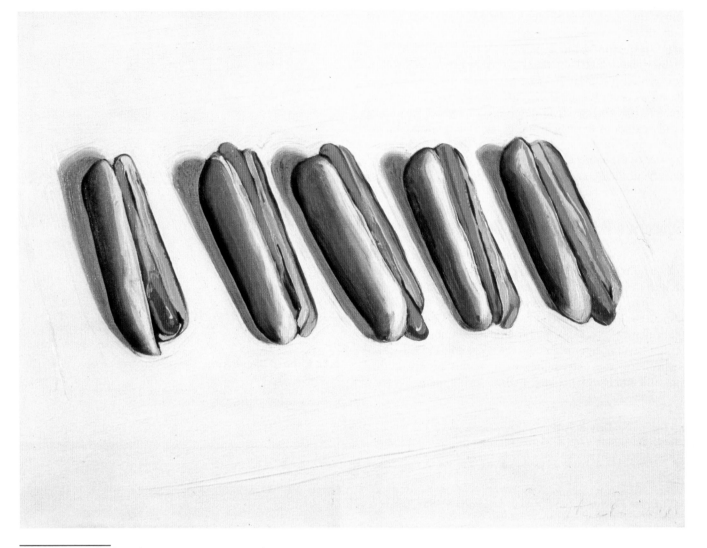

6.35 Wayne Thiebaud, *Five Hot Dogs,* 1961. Oil on canvas,
18 × 24in (45.7 × 61cm).
Private collection, San Francisco.

Attracted to abstract painting by reproductions of
Motherwell's work and that of Baziotes in a 1943 issue of the
vanguard journal *Dyn,* he continued as a non-objective
painter until late 1955.

Diebenkorn spent time painting in New Mexico,
Illinois, and New York, and in 1964 he traveled on a cultural
exchange to Russia, where he was overwhelmed by the great
collections of work by Matisse. After his return he moved to
Santa Monica, on the ocean side of Los Angeles. His
"Ocean Park" series [fig. 6.34], begun in 1967 and followed
through to his death in 1992, derived from the beauty of the
coastal light and announced the artist's return to
abstraction. The sensuality of these paintings and the
tension between the classical elements of drawing and
geometric composition against the lush color and light
demonstrate his debt to Matisse.

Wayne Thiebaud's rich painterly style also derives from
these Bay Area abstract expressionists. Yet unlike them, he
did not subordinate his subject matter to the handling.
Thiebaud is often mistakenly associated with pop art
because of his brilliantly lit and colored images of ordinary
objects. The *Five Hot Dogs* [fig. 6.35]—each isolated in stark
contrast against the white background and rhythmically
repeated to create tense intervals in between—conveys a
detachment toward the subject combined with a strong,
graphic bravado. Yet the real motives behind Thiebaud's
work are the direct pleasures of looking at things, of
analyzing them into patterns, and of handling paint.

Existential Imagist Art in Chicago

Young Chicago artists of the fifties, like their peers in New
York, looked to de Kooning, Hofmann, and Kline as
models. But Chicago also enthusiastically embraced the new
existential figuration from Europe as well as early twentieth-
century German expressionism—a combination of
influences which prompted the emergence of a distinctive
school of existential imagists. When Dubuffet went to New
York for six months (over the winter of 1951/2) he traveled to
Chicago for a major exhibition of his work at the Arts Club

and on December 20, 1951 he delivered a now famous lecture there entitled "Anticultural Positions." Although American art had little impact on Dubuffet's development,[27] a typescript of his talk circulated in Chicago and made an enormous impression on artists and collectors there.

Even before artists like Cosmo Campoli [fig. 6.36] and Leon Golub of the so-called Chicago Monster Roster had read or heard firsthand Dubuffet's 1951 lecture, they were predisposed toward his ideas by their exposure to German expressionism, to psychoanalysis, and to existentialism—all strong influences on the Chicago scene. Paul Tillich, the foremost American existentialist, was then a highly visible professor of theology at the University of Chicago, and the city's Institute for Psychoanalysis (the country's first) was already nearly twenty years old. In 1959 Leon Golub used psychoanalytic terminology in describing his paintings as an "attempt to reinstate a contemporary catharsis, that measure of man which is related to an existential knowledge of the human condition."[28]

If Golub and other artists of the Monster Roster inaugurated a Chicago School of imagists, H. C. Westermann was the artist who defined its most distinctive form. Certainly the most important Chicago artist of the fifties, Westermann [figs. 9.30—9.33] anticipated the eccentric involvement with popular culture and psychotic art that ten years later pushed Chicago artists into international prominence. Yet by the sixties action painting and the existentialist figuration of the previous two decades looked like ideas from the distant past, the swansong of romanticism. By the end of the fifties it had already become clear that Robert Rauschenberg's idea of "collaborating with materials"[29] (so different from Dubuffet's) expressed an entirely new concept of the artist as a mediator between the world and the viewer. In taking the viewer into account, Rauschenberg's idea implied a less overpowering focus on the artist's self-expression and identity. The new works of Jasper Johns also down-played the existential "self," heralding the new definition of individuality that came to prevail in the art of the sixties.

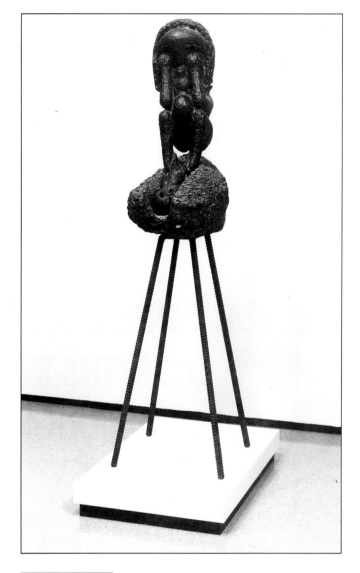

6.36 Cosmo Campoli, *Birth of Death,* 1950. Bronze, rock, wax, and steel, 70 × 18¾ × 24½in (177.8 × 47.6 × 62.2cm). Collection, Museum of Contemporary Art, Chicago. Gift of Joseph and Jory Shapiro, 92.55.

7

THE BEAT GENERATION: THE FIFTIES IN AMERICA

"A Coney Island of the Mind"

"I saw the best minds of my generation destroyed by madness, starving hysterical naked," Allen Ginsberg wrote in *Howl*, his landmark poem of 1955. They "were burned alive in their innocent flannel suits on Madison Avenue . . . or run down by the drunken taxicabs of Absolute Reality."[1] Ginsberg's America in the fifties was a dehumanized prison of mainstream values, in which drug addicts, homosexuals, and the poor were defined out of existence in the common consciousness.

The alienated "beat" counterculture of the period revolved around the writers Allen Ginsberg, Jack Kerouac, and Lawrence Ferlinghetti, but also embraced John Ashbery, William Burroughs, Norman Mailer, Henry Miller, and Kenneth Rexroth. They lived in this limbo of nonexistence, raging against the complacent duplicity of fifties mass culture. The "beats," aided by alcohol, drugs, "cool" jazz, and the inspiration of Zen Buddhism, dropped out of the America celebrated by the *Saturday Evening Post*. In the process they created their own "hip" vocabulary to reappropriate the American experience, *their* experience, of the struggle against conformity, mechanization, and materialism.

"The dog trots freely in the street and sees reality," Ferlinghetti wrote.

> He will not be muzzled . . .
> a real live
> barking
> democratic dog
> engaged in real
> free enterprise
> with something to say
> about ontology
> something to say
> about reality[2]

The gritty self-absorbed alienation of the beats evolved from the distinctive existentialism of the New York School and the New York writers of the forties. No subject was too prosaic for beat poetry, precisely because immediate experience attacked the myths of consumer culture. Similarly, Robert Frank's photographs of the fifties (fig. 7.2) looked at the simple, unglamorized reality of ordinary life in America using a style that deliberately avoided aestheticizing it. Harold Rosenberg adumbrated this view when he wrote in 1948 that "the anonymous human being to whom [the makers of mass culture] bring their messages has at least the metaphysical advantage of being forced to deal daily with material things and real situations—tools, working conditions, personal passions."[3]

For the artists of Rothko's and Pollock's circle the purveyors of mass culture sought, as Marshall McLuhan wrote in 1951 "to get inside the collective public mind . . . in order to manipulate, exploit, control" it; the New York

7.1 (opposite) **Robert Rauschenberg,** *Odalisk*, 1955–8. Oil, watercolor, pencil, fabric, paper, photographs, metal, glass, electric light fixtures, dried grass, steel wool, necktie, on wood structure with four wheels, plus pillow and stuffed rooster, 83 × 25½ × 25⅛in (210.8 × 64.8 × 63.8cm).
Collection, Museum Ludwig Köln. Photograph courtesy Rheinisches Bildarchiv, Köln. © Robert Rauschenberg/VAGA, New York, 1994.

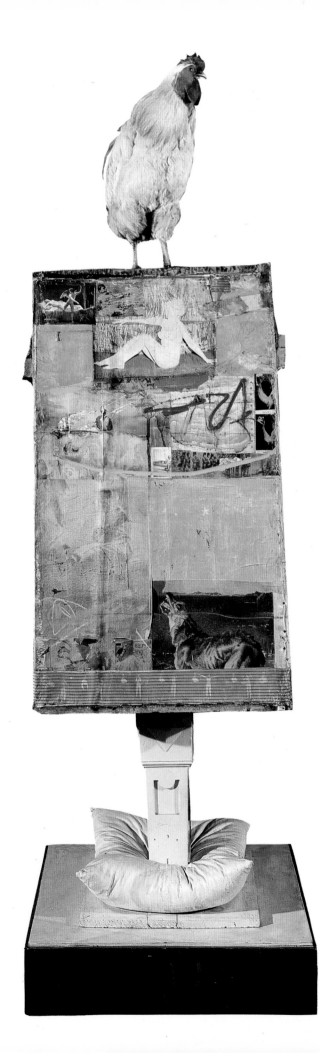

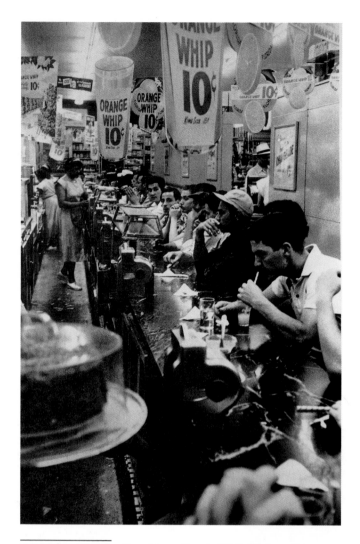

7.2 Robert Frank, *Drug Store—Detroit,* 1955–56, from *The Americans,* New York, 1959.
National Gallery of Art. Gift of Christopher and Alexandra Middendorf in honor of the 50th Anniversary of the National Gallery of Art. © Robert Frank, courtesy PaceWildenstein MacGill, New York.

John Cage

John Cage, born in Los Angeles in 1912, studied with the composer Arnold Schönberg. Schönberg revolutionized modern music by breaking with harmony and with the teleological implications of tonality, in which the composer laid down a key and theme and then fulfilled the direction prescribed. Schönberg went so far as to create charts to ensure that no matter how one inverted or overlaid the systems in his compositions, they would not yield a harmonic melody. He sought to construct a neutral vehicle for musical expression.

John Cage's invention in 1938 of the "prepared piano," together with his early role in the evolution of taped and electronic music, established his vanguard reputation in New York. Yet he realized from reading the reviews of his performances that his compositions failed to communicate the emotions he himself experienced in them. The turning-point came after the performance of *Perilous Night,* written by Cage in 1945 about "the loneliness and terror that comes to one when love becomes unhappy."[7] The utter failure of the critics to understand the feeling in the piece led Cage to completely change direction; he gave up on the idea of communicating in art and instead redirected himself to focus on the idea of opening up the listener's ears to what existed in the environment— unpredetermined experience, detached from artistic

7.3 Marcel Duchamp, *In Advance of the Broken Arm,* 1945. Replica of 1915 "original" readymade, wood and metal, 47¾ × 18in (121.3 × 45.7cm).
Collection, Yale University Art Gallery. Gift of Katherine S. Dreier for the Collection Société Anonyme. © 2000 Artists Rights Society, New York/ADAGP, Paris. Estate of Marcel Duchamp.

School painters expressed their rejection of commercialization by retreating into subjective experience. But McLuhan also suggested that "the very considerable currents and pressures set up around us today by the mechanical agencies of the press, radio, movies, and advertising . . . [are] full, not only of destructiveness but also of promises of rich new developments."[4] He pointed out that "discontinuity is in different ways a basic concept of both quantum and relativity physics. It is the way in which a Toynbee looks at civilizations, or a Margaret Mead at human cultures. Notoriously, it is the visual technique of a Picasso, the literary technique of James Joyce."[5] John Cage and Robert Rauschenberg also preached an aesthetic of inclusiveness, consciously embracing discontinuity, change, the arbitrary and unpredictable. They reveled in the complex reality of what Ferlinghetti called the "Coney Island of the Mind."[6]

intention. By avoiding the imposition of aesthetic hierarchies or systems designed to express order, he hoped to allow each element to present itself on its own.

Cage's discovery of Zen Buddhism in the mid forties seems to have prompted the form of this radical change. Whereas the artists of the New York School turned to psychoanalysis and extracted art from personal introspection, Cage's study of Zen fostered a detachment from emotional crisis and the idea that art originates in the noninterpretive contemplation of nature. "One may give up the desire to control sound, clear his mind of music, and set about discovering means to let sounds be themselves rather than vehicles for manmade theories or expressions of human sentiments," he explained. ". . . Hearing sounds which are just sounds immediately sets the theorizing mind to theorizing, and the emotions of human beings are continually aroused by encounters with nature."[8]

Inspired by Duchamp's readymades (everyday objects which Duchamp presented unaltered as works of art) [fig. 7.3], Cage regarded the everyday world as the source of art. Like Duchamp, whom he befriended in 1941, he attacked the heroic myth of the New York School and opposed psychology as a foundation for art: "There is no room for emotion in a work of art,"[9] he later remarked. Cage looked to the senses as Duchamp had looked to the intellect; both rejected expressionism. In 1950 Cage even began to use chance, which he saw as nature's central operating principle; in other words, he wanted to emulate the underlying process of nature without portraying its actual manifestations.

Rather than using chance to bypass surface consciousness, as in dada and surrealism, Cage hoped to avoid personal determination altogether. This attempt to annihilate the artistic ego as well as the distinction between art and everyday experience was unprecedented and in direct contrast to the posture of his contemporaries in the New York School. Yet Cage resembled them in his emphasis on spontaneity and process.

By 1950 Cage's tenement apartment on the Lower East Side had become a meeting place for a group of friends interested in new music and dance. Christian Wolff (then a high school student) dropped by one day with the *I Ching* or *Book of Changes*, which Pantheon had just published. The book came to Cage at just the right moment, and he used the *I Ching* coins and charts to compose his 1951 *Music of Changes* as a homage to the book. Cage tossed three coins six times, the results of which correlated to a chart, which in turn determined the pitch of each note. Then he went through a similar procedure for timbre and duration. He followed this elaborate process to avoid letting personal choice interfere with the chance procedures. Since the piece lasts for forty-five minutes, Cage had to make an extraordinary number of tosses.

In his theory of a "total soundspace" Cage asserted that music involves all sound, including non-musical sound and the absence of sound. Sound has four essential features: pitch, timbre, loudness, and duration; by contrast, silence, Cage observed, has only duration. In his 1952 silent piece, entitled *4 minutes 33 seconds (4'33")* the performer makes no sound for this exact period of time. Influenced by Rauschenberg's blank "White Paintings" of 1951, Cage eliminated everything from this piece but time (the shared feature of sound and silence) and the chance sounds of the environment.

The chance operations of the *Music of Changes* produced results which, once Cage set them down, remained fixed. But in the silent piece Cage's antipathy to willful patterns took him still further, into indeterminacy, which assumes continual flux. He embraced the true randomness of ambient sounds in the silent piece in order to get the listener to hear in a neutral way. *0'00"* of 1962 took this idea one more step in specifying that it could be performed by anyone in any manner. Although Cage credited Morton Feldman with leading the way into indeterminacy, Cage's chance (or "aleatory") music and ideas of ambient ("concrete") sound certainly influenced Feldman's music as well as that of Earle Brown, Christian Wolff, and La Monte Young.

Merce Cunningham

Cage had a particularly important exchange of ideas with the dancer/choreographer Merce Cunningham. Cage and Cunningham began working together in 1943, the year before Cunningham's first solo recital in New York (while he was still dancing with the Martha Graham Company). Their collaboration broke sharply with choreographic tradition in permitting the individual dancer any movement meaningful to him or her and relieving the performer of any obligation to tell a story, symbolize something, or find equivalents for the music. The music, sets, and the individual dancers functioned independently but simultaneously. Cage and Cunningham created systems, overlaid them, and then watched what happened when they collided. As Cunningham explained: "We have chosen to have the music and the dance act as separate identities . . . one not dependent upon the other, but they coexist, as sight and sound do in our daily lives . . . as an opening out to the complexity we live in, even to the possible enjoyment of it."[10]

Merce Cunningham changed the language of dance. For him any movement, no matter how ordinary—walking, falling, jumping—could constitute dance. Furthermore no action in dance carried any significance beyond what it was in itself, he insisted; like Cage, Cunningham chiefly wanted to engaged the viewer's senses. He also wanted to lay bare the sheer physicality of dance. His choreographic ideas are complex and stress the discipline of technique, frequently demanding that the dancer work barefoot to achieve a more direct and controlled relation to the floor. With all six dancers in Cunningham's troupe cast as soloists, they would cover the whole stage at once; as in a Pollock or de Kooning "allover" painting, such works lacked a compositional focus.

Cunningham's dances are also nonclimactic and rely on chance to enhance the neutrality of the basic approach. As in the art of Rauschenberg and the fifties junk sculptors, Cunningham's works seem to disrupt standard artistic conventions by creating an assemblage of found gestures from real life.

The high point of Cunningham's tours with Cage in the forties was their (unpaid) visit to Black Mountain College in 1948. Cage had been interested in the college since the late thirties.[11] But the 1948 Cage and Cunningham presentation of Erik Satie's *Ruse of the Medusa*, directed by Arthur Penn with performances by, among others, Willem and Elaine de Kooning, Richard Lippold, Buckminster Fuller, and Beaumont Newhall was an electrifying event. Through this performance Cage established a friendship with Josef Albers, the art master of the school; however, when Cage later began working with chance and indeterminacy, Albers declaimed that Cage had "renounced his responsibility as an artist" and broke off relations.[12]

The Cage "Event" of 1952

Nevertheless it was John Cage's *Theater Piece #1* (often simply referred to as "the event"), performed at Black Mountain College in 1952, that became legendary as the first "happening" and the beginning of aleatory music and dance (even though Cage had already written the *Music of Changes* in 1951). M. C. Richards, a member of the Black Mountain faculty, had just finished translating Antonin Artaud's *The Theater and Its Double*—a book which encouraged Cage to think of theater as a time and space filled with coexisting but unrelated events, instead of as a narrative. Artaud's "theater of cruelty" proposed a primitive, ritualistic spectacle stirring a violent exchange with the audience. Cage's theater was more emotionally neutral but no less perplexing and enigmatic to the audience.

In the 1952 "event" M. C. Richards and the poet Charles Olson read poetry from ladders; Rauschenberg's "White Paintings" hung overhead while he played Edith Piaf records on an old phonograph; David Tudor performed on the piano; Merce Cunningham danced in and around the audience (chased by a barking dog); coffee was served by four boys dressed in white; and Cage sat on a step-ladder for two hours—sometimes reading a lecture on the relation of music to Zen Buddhism, sometimes silently listening.[13] Everyone did whatever they chose to do during certain assigned intervals of time, and the entire experience was so full of sensory input that no two accounts of it sound much alike. Indeed the individuality of each observer's experience was central to Cage's aspiration. When people began arriving for the performance someone asked Cage where he would have the best viewing position and Cage replied that "everyone is in the best seat."[14] Cage created his outline and organization for the "event" using chance operations, and yet the style is unmistakably his.

Gutai

Contemporary with Cage in New York, members of the Gutai Art Association in Japan began staging art actions that were as radical as Cage's "Event". When the war ended in Japan, General Douglas MacArthur (the commander of the occupying armies) began systematically dismantling the institutions of Imperial Japan in favor of a Western-style democracy. This destabilized conventions in cultural as well as civic realms, while economic matters were also in disarray. On the one hand this situation—which persevered through the 1950s—meant that there was no market for contemporary art. But on the other hand there was new freedom to experiment.

Artists had already made some innovative work in the forties,[15] but the most dramatic and internationally noted work to emerge from the new Japan was that of the artists of the Gutai Art Association from Ashiya, in the Kansai region near Osaka. Jiro Yoshihara founded the group in 1954 and was quickly joined by a number of younger artists, who had already defined radical styles on their own: Kazuo Shiraga, for example, had exhibited paintings done with his feet in 1954

7.4 Kazuo Shiraga, *Challenging Mud.* Photo from the first Gutai exhibition in 1955 at Ohara-Kaikan, Tokyo.
Courtesy Ashiya City Museum of Art and History.

7.5 Saburo Murakami, *Passing Through (21 panels of 42 papers).* Photo from the second Gutai exhibition in 1956 at Ohara-Kaikan, Tokyo.
Courtesy Ashiya City Museum of Art and History.

through the picture plane in his piece. Shiraga in *Challenging Mud* enacted a free sequence of expressive bodily gestures while immersed in a circle of viscous mud. *Challenging Mud* both accented the visceral, bodily primitivism of the expressive act and attempted to go beyond the painterly gesture, still circumscribed in Western modernism by the canvas or sculpted object.

In the early fifties, the Gutai artists saw *Life Magazine* photos of the French action painter Georges Mathieu, costumed and painting with great theatrical manner before television cameras; they arranged their April 1956 Gutai exhibition primarily for the benefit of *Life Magazine* photographers, reenacting performance actions by various members.[16] *Murakami's Passing Through (21 panels of 42 papers)* [fig. 7.5] was an elaboration on *Paper Tearing*; the former was subsequently repeated and of course destroyed in each exhibition, but the artist gave precise instructions so that the paper panels could be reconstructed and even performed upon by others, making it clear that the authenticity of the act and not the original object was what mattered. Shozo Shimamoto also made his *Work (Created by Canon)* in 1956, using a toy canon to fire paint cylinders at a canvas, and Atsuko Tanaka made an *Electric Dress* (1956) of colored (and very hot) illuminated electric light bulbs in which she performed. Just as *Passing Through* alluded to a long history of papermaking and painting, *Electric Dress* superimposed the traditional arts of the kimono, on the one hand, and a reference to the bodily networks of nerves, ducts, arteries, and veins on the other, with this brilliant web of wiring and lights that flashed on and off while the artist wore it.

In 1957, The First Gutai On-Stage Art Show seems to have been staged especially for the *New York Times* reporters who wrote it up in December of that year,[17] and the next year the Martha Jackson Gallery mounted a show of the Gutai's works in New York. The Gutai's art actions precede Cage's "Event" and the happenings in New York, which we will discuss momentarily. But the Gutai seem not to have been known to Allan Kaprow, who inaugurated the happenings in New York in 1958.[18] Instead, his sources were chiefly action painting, Cage, junk art, and the work of Robert Rauschenberg.

and in the same show Saburo Murakami had presented a painting made by throwing a ball soaked in paint at the canvas. The Gutai artists commenced publication of a Gutai journal in 1955 (which continued into the mid-sixties) and arranged several important group exhibitions. The First Gutai Art Exhibition, held in Tokyo in 1955, symbolized both a new formal freedom and an anarchistic critique of making and selling permanent objects by closing with a bonfire in which the artists destroyed all the works in the show.

In retrospect, the two most famous works in The First Gutai Art Exhibition were Murakami's *Paper Tearing* and *Challenging Mud* [fig. 7.4] by Shiraga. With overtones of Japanese martial arts and shocking allusions to the traditional paper arts, Murakami took a running leap

Robert Rauschenberg

The Self as a Mirror of Life

In his 1959 novel *Naked Lunch* William Burroughs asserted that "there is only one thing a writer can write about: *what is in front of his senses at the moment of writing* . . . I am a recording instrument . . . I do not presume to impose 'story' 'plot' 'continuity.'"[19] Robert Rauschenberg [fig. 7.6] pioneered an art style that also ceased to rely on "'story,' 'plot,' 'continuity'"—elements still lingering in the action

painter's armory of focused introspection; instead Rauschenberg promoted an unfocused openness to external events. Beginning with his "White Paintings" of 1951 Rauschenberg tried to redirect the viewer's attention from the psyche of the painter on to the outside world. The relative lack of surface detail in these flat white canvases provided a neutral backdrop for random shadows and for the reflection of the colors of the environment. Gradually found objects (and, later, found images) replaced the neutral surfaces as reflections of the experiential world.

Rauschenberg's art recast the existentialist discovery of the self as a discovery of the environment from which the self takes its form. Where de Kooning and Pollock pursued the refinement of a known artistic identity through introspection, Rauschenberg attempted to deny that there was a fixed core to identity at all, and put forward a relative definition. He tried to push his artistic persona into continual flux, so that he could perpetually reinvent himself through an acutely sensitive response to the prevailing climate. "I don't want my personality to come out through the piece," Rauschenberg explained. ". . . I want my paintings to be reflections of life . . . your self-visualization is a reflection of your surroundings."[20]

Rauschenberg's "combine" paintings (the artist's alternative to the term "assemblage") began tentatively around 1951 with the application of printed matter and other flat materials to the canvas. By 1953 he had begun to incorporate all manner of materials and actual objects into the compositions. *Bed*, for example [fig. 7.7], includes striped toothpaste and fingernail polish[21] as well as a pillow and quilt.

The Bauhaus-influenced exercises assigned by Josef Albers, his teacher at Black Mountain College, fostered Rauschenberg's openness to the inherent character of found materials. His extensive conversations with John Cage in the late forties and early fifties taught him in part to assimilate visual information in a receptive, unfocused way. With objects like the quilt and pillow in *Bed* or the stuffed bird, the flattened can, and the nostalgic family photographs in *Canyon* [fig. 7.8], Rauschenberg extended the action painter's stress on self-actualization through the spontaneous act of painting by exploiting the vividness of the associations attached to real things. Instead of discovering oneself in the act of painting,

one perpetually reconstructs oneself in the process of adapting to one's encounters with the world.

In this association to real experience the images in Rauschenberg's work refer to specific meanings. They do not, however, constitute a systematic iconography.[22] The multiplicity of possible associations to each image in Rauschenberg's work permit one to "read" the individual elements in any number of ways at the same time. Indeed the "decodings" by art historians, which have attempted to straitjacket the artist's associations into a decipherable system, have failed to yield convincing results. Moreover, the artist's stated aims consistently contradict the notion of a systematic iconography: "If you do work with known quantities—making puns or dealing symbolically with your material," he explained, "—you are shortening the life of the work."[23]

Rauschenberg's Early Career

Born in 1925, Robert Rauschenberg grew up in a working-class family in the Gulf Coast refinery town of Port Arthur, Texas. He abandoned his devout fundamentalist Christian training in the early fifties, but, as the art historian Lisa Wainwright has shown, he continued to allude obliquely to Christian themes throughout his career.[24] After the Navy and a brief sojourn at the Kansas City Art Institute, Rauschenberg went to study with Albers at Black Mountain College in the fall of 1948. Albers found the young Texan frivolous and told him he "had nothing to teach him."[25] Nevertheless the endless demonstrations by Albers on the relativity of color in the contexts of different surrounding colors provided the

7.6 Robert Rauschenberg seated in an empty lot next to his loft on Water Street, New York, January 15, 1961.

Photograph © by Fred W. McDarrah.

7.7 Robert Rauschenberg, *Bed,* 1955. Combine painting: oil and pencil on pillow, quilt, and sheet on wood supports, 75¼ × 31½ × 8in (191.1 × 80 × 20.3cm).

The Museum of Modern Art, New York. Fractional gift of Leo Castelli in honor of Alfred H. Barr, Jr. © Untitled Press, Inc./VAGA, New York.

formal foundation for Rauschenberg's "White Paintings." The white panels are hypersensitive to the light around them and are thus affected by events in the environment behind the artist's control.

From the start of his career Rauschenberg displayed a remarkably free, experimental approach to techniques and materials. In 1949 he made striking figure compositions by having a model lie face down on light-sensitive blueprint paper and bathing her in floodlight. On another occasion he directed John Cage to drive his Model A car with an inked tire down a 22-foot strip of pasted-together paper sheets, producing the disarmingly delicate *Automobile Tire Print.* His *Dirt Painting: For John Cage* sprouted real plants and had to be watered—Cage's idea that art should emulate natural processes seems to have inspired the idea.

In the fall of 1949 Rauschenberg moved to New York and began taking classes at the Art Students League. He married Susan Weil shortly after, having met her in Paris in 1948 and gone with her to Black Mountain, and in July 1951 they had a son. Rauschenberg associated with abstract expressionists at the Club on 8th Street, and got to know most of the important artists. He participated in the "event" orchestrated by Cage and Cunningham at Black Mountain College and in the fall of 1952 he left his marriage for an extended trip to Europe and North Africa with Cy Twombly.

Particularly after his return in 1953, Rauschenberg renounced the psychological introspection of the New York School.

There was something about the self-confession and self-confusion of abstract expressionism—as though the man and the work were the same—that personally always put me off because at that time my focus was in the opposite direction. I was busy trying to find ways where the imagery, the material and the meaning of the painting would be, not an illustration of my will, but more like an unbiased documentation of what I observed, letting the area of feeling and meaning take care of itself.[26]

In his black paintings of 1952, Rauschenberg explained that he "was interested in getting complexity without revealing much."[27] He made them by laying down torn and crumpled newspaper and painting over it so that "even the first stroke in the painting would have its position in a gray map of words," he said.[28] In the series of red paintings that followed, Rauschenberg made the urban debris even more visible. *Charlene,* for example, includes printed images, a rotating umbrella, a mirror, bits of metal, and flashing lights.

In 1954 Rauschenberg met Jasper Johns and in the following summer Rauschenberg moved into the Pearl Street loft building above Johns. From then through 1961 the two interacted daily and, although exceedingly different in temperament and style, they came to understand one another's work intimately. Rauschenberg did not read much but absorbed an enormous amount talking with friends like Cage and Johns about what they were reading. Johns, by contrast, was highly intellectual and read a great deal.

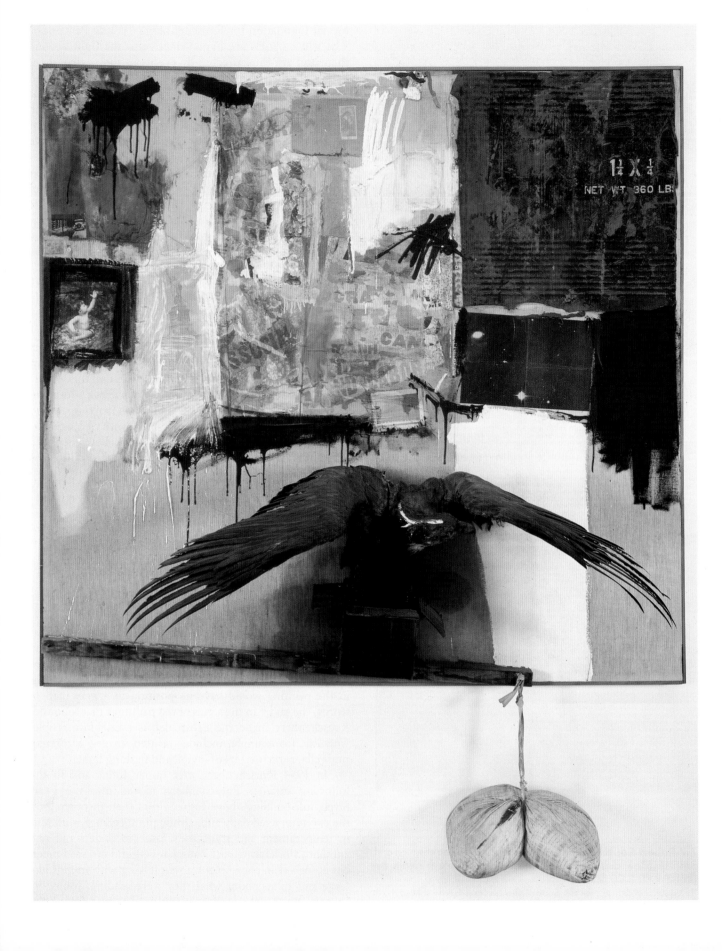

Johns and Rauschenberg both had an ambivalent relation to introspective content in art. On the one hand they admired the subtlety of abstract-expressionist handling—Rauschenberg's sentimentality often brought him to the edge of romanticism—yet on the other hand they resisted the New York School's focus on revelations of personality. In 1957 Rauschenberg even attempted to make two identical, gesture paintings (*Factum I* and *Factum II*). "The point was to see what the difference could be between the emotional content of one and the other," he explained. "I couldn't tell the difference after I painted them!"[29] Like Duchamp's readymades his pair attempts to undermine the idea of the authenticity of the autographic gesture.

With Duchamp and Cage as intellectual mentors Rauschenberg stepped back from personality and focused instead on the world of events and images. "I don't mess around with my subconscious. I try to keep wide-awake,"[30] Rauschenberg explained. "Painting is always strongest when in spite of composition, color, etc. it appears as a fact, or an inevitability, as opposed to a souvenir or arrangement. Painting relates to both art and life. Neither can be made. (I try to act in that gap between the two.)"[31]

Even when a composition failed ultimately to work, the free-associative process offered the exhilaration of fully and spontaneously experiencing everything while it happened. This openness, which comes from action painting, was also embraced in different ways both by the "beat" writers and by John Cage; they celebrated "the coexistence of dissimilars"[32] (Cage). As in Dubuffet's aesthetic, this implies a rejection of the distinction between the beautiful and the ugly.

Cage's inclination to let the audience hear all the sounds of the environment and discover their innate disorder encouraged Rauschenberg in developing an aesthetic of accumulation and randomness, although he never fully embraced chance in the way Cage did. As Rauschenberg explained "I was never able to use it [chance], I would end up with something quite geometric or the spirit that I was interested in indulging in, was gone . . . I felt as though I was carrying out an idea rather than witnessing an unknown idea taking place."[33] Yet Rauschenberg reveled in the bewildering complexity of life.

The Combine Paintings

In the late fifties the found objects and images asserted themselves with increasing clarity and independence. Unlike the surrealists, who used the random juxtaposition of such material to unleash free association as a key to their analysis of the unconscious mind, Rauschenberg sought an experience of

7.8 (opposite) **Robert Rauschenberg,** *Canyon,* 1959. Oil, pencil, paper, metal, photograph, fabric, wood on canvas, plus buttons, mirror, stuffed eagle, cardboard box, pillow, and paint tube, 81¾ × 70 × 24in (207.7 × 177.8 × 61cm).

Collection, Mr. and Mrs. Michael Sonnabend, New York. © Untitled Press, Inc./VAGA, New York.

7.9 Old Gold cigarettes advertisement, *Life Magazine,* April 27, 1953, p.3.

assimilation—*without* analysis of any kind. He did not set out to find objects by going to a junk yard, for example; this would imply a predetermined theme. Instead he wanted to use objects that cropped up in the course of his activities.

Increasingly, what turned up came via the media, and a great deal of the advertising in the media had erotic overtones. *Life Magazine,* for example, ran an advertisement for Old Gold cigarettes in 1953 [fig. 7.9], in which naked female legs, complete with high-heeled shoes, are shown kneeling on an exotic courtesan's cushion. A sleekly dressed man centers the crown (a large open hole) over the unmistakably phallic tubes which burst out of the box. Marshall McLuhan's book *The Mechanical Bride* had alerted Rauschenberg and Cage to read advertising on this subliminal level. In works such as *Odalisk* [fig. 7.1], which Rauschenberg began in 1955, he exploited just this kind of sexual symbolism, reinforced by collage elements drawn from popular culture. In *Odalisk* the phallic post presses into the cushion on one end and on the other supports a box with a light inside. This is "turned on," covered with erotic images like a "dog—lust—barking at a pin-up nude,"[34] and

topped, as one critic described it, with a "cock."

The objects in a work like *Odalisk* create an environment that aims to evoke the complexity of an aspect of life experience—ranging from the sexual symbolism used in advertising to the visual maelstrom of the street. "I like the history of objects. I like humanitarian reportage,"[35] the artist said. "I would like my pictures to be able to be taken apart as easily as they're put together—so you can recognize an object when you're looking at it."[36] This approach maintains the raw spontaneity of the gesture painting of de Kooning and Kline. "After you recognize that the canvas you're painting on is simply another rag then it doesn't matter whether you use stuffed chickens or electric light bulbs or pure form."[37]

Despite the fact that such works as *Odalisk* evolved spontaneously, the latter nevertheless took three years to complete. When Rauschenberg first exhibited works of this kind at the Leo Castelli Gallery in 1959, the show elicited considerable hostility. Some of the abstract expressionists who came to the opening laughed out loud and actually began kicking one of Rauschenberg's sculptures (*Gift for Apollo*). Rauschenberg was terribly upset by this cruel response, all the more because he admired these older artists. But they evidently saw his work as a parody of their high aesthetic purposes.[38]

The Drawings for Dante's *Inferno*

Rauschenberg's desire to be taken seriously almost certainly played a role in motivating him, at the beginning of 1959, to embark on a suite of drawings to accompany the thirty-four cantos of Dante's masterpiece, the *Inferno* [fig. 7.10]. These drawings come as close as anything in Rauschenberg's *oeuvre* to following a consistent iconography,[39] and when he finished the series in early 1960, he exhibited them with the poem to help viewers appreciate the images.

Dore Ashton reported that the artist took the photograph representing Dante from a *Sports Illustrated* advertisement for golf clubs, which showed a man with a towel around his waist, standing stiffly in front of a chart-like grid, as if awaiting some type of medical examination. Rauschenberg wanted to make Dante a representative of the common man and therefore sought a neutral image. The artist portrayed Virgil variously as a diving figure blurred by a scrim-like overpainting that gives him the vague immateriality of a spirit, then as an intellectual—using a photograph of Adlai Stevenson, the great statesman who ran against Eisenhower in the presidential elections of 1952 and 1956. Other images also appear from contemporary life and politics, such as a satanic Richard Nixon and racing cars (to evoke the whirring and wailing sounds of hell).

Although the individual images seem to have taken form intuitively as the artist read each successive line of the narrative, the viewer can follow the images in each of the drawings, correlating them with the poem, generally in sequence from the upper left, across and down to the lower right. Nevertheless even though there are close connections between the visual and the poetic images, Rauschenberg's work is overlaid with other simultaneously functioning meanings—not least a comparison between Dante's peregrinations through hell with the artist's own reflections on the deterioration of his friendship with Jasper Johns—his own "hell" of 1959. Dead center in the drawing for *Canto XXXIII* [fig. 7.7], for example, is a bent arm and hand that resembles the plaster casts Johns had constructed since the early fifties and incorporated into his paintings [fig. 7.51]. Rauschenberg worked for a year and a half on the series, spending six months alone on a deserted wharf in Florida.

Before 1958 Rauschenberg drew very little. Then he discovered, in an irreverent experiment with materials, that if he soaked reproductions from magazines in lighter fluid he could transfer them on to paper by rubbing the back with an empty ballpoint pen. This technique provided the basis for the Dante drawings, which he built around juxtapositions of found images transferred from magazines and advertising.

Rauschenberg's drawings for Dante's *Inferno* involve the sense of time unfolding, despite the lack of a clear narrative sequence. *Reservoir* [fig. 7.11] includes two clocks, addressing time explicitly. Rauschenberg set the first clock at the time when he began work and the other when he finished, but the viewer cannot tell whether the duration was twelve, twenty-four, or some other multiple of twelve hours. The artist explained: "I realized that the details should not be taken in at once glance, that you should be able to look from place to place without feeling the bigger image. I had to make a surface which invited a constant change of focus and an examination of detail. Listening happens in time. Looking also had to happen in time."[40]

Like Cage's embrace of discontinuity, Rauschenberg's visual syntax emulated the rapid scan of the city dweller rather than the fixed stare of the traditional art viewer. He sought to capture "reality" in all its confusion as a collage of details. Thus he pointedly preserved the identity of the individual found objects, leaving the viewer with a sense of their original context rather than letting them disappear into the aesthetic of the work. Nor are the objects in Rauschenberg's combines either metaphors or symbols, though they do have specific associations for the artist that are not necessarily inherent to the individual object or its context.

The End of the Combines

Rauschenberg came to the end of his combine paintings toward the beginning of 1962. He introduced the photosilkscreen into his work and images rather than objects began to predominate, as is prefigured in the drawings for

7.10 (opposite) **Robert Rauschenberg,** *Canto XXXIII: Circle Nine, Cocytus, Compound Fraud: Round 2, Antenora, Treacherous to Country: Round 3, Ptolomea, Treacherous to Guests and Hosts* from the series "Thirty-four illustrations for Dante's Inferno," 1959–60. Transfer drawing, watercolor, and pencil, 14½ × 11½in (36.8 × 29.2cm). The Museum of Modern Art, New York, Given anonymously. © Untitled Press, Inc./VAGA, New York.

Dante's *Inferno*. By eliminating visually dramatic objects and flattening out the literal surface of the canvas, Rauschenberg further dissipated the focus in his works. In contrast to painters like Pollock or de Kooning, who refined their styles around the declaration of their identities, Rauschenberg veered toward disintegration, defining himself anew in relation to the exigent details of each moment. The abstract-expressionist painters needed neutral materials to embody their unique encounters with themselves; Rauschenberg's materials came with external associations that he pointedly sought to retain.

Rauschenberg's *Erased de Kooning Drawing* (1953) is emblematic of this distinction He asked de Kooning to give him a drawing that was good enough to be missed and difficult to erase. He erased for two months, but in the end he could not eliminate the lingering presence of de Kooning's gesture and compositional character. This attempt to obliterate the artistic presence mirrors Rauschenberg's stated effort to erase the assertion of individual identity from his own work. In contrast to the action painter's concept of

7.11 Robert Rauschenberg, *Reservoir,* 1961. Oil, graphite, fabric, wood, metal on canvas, plus two electric clocks, rubber tread wheel, and spoked wheel rim, 85½ × 62½ × 14¾in (217.2 × 158.8 × 37.5cm).
Collection, National Museum of American Art, Smithsonian Institution, Washington, D.C. Gift of S. C. Johnson and Son, Inc. Photograph courtesy Art Resource, New York. © Untitled Press, Inc./VAGA, New York.

starting from scratch. Rauschenberg starts from something concrete and moves toward self-annihilation.

I don't want a painting to be just an expression of my personality. I feel it ought to be much better than that. And I'm opposed to the whole idea of . . . getting an idea for a picture and then carrying it out. I've always felt as though, whatever I've used and whatever I've done, the method was always closer to a collaboration with materials than to any kind of conscious manipulation and control . . . I'd really like to think that the artist could be just another kind of material in the picture, working in collaboration with all the other materials. But of course I know this isn't possible, really."[41]

The flipside of Rauschenberg's readiness to encounter freshly the changing facts of life and art and to redefine himself in response to them is a profound lack of self-worth. "I think my religious experience has built into my ethic an irreversible sense of inferiority . . . When I go to work I have to feel invisible to get away from the inferiority."[42] This feeling reflects, however obliquely, the central importance of identity even in Rauschenberg's work.

In 1961 Rauschenberg moved to a huge fifth-floor loft in Greenwich Village and Johns started spending more and more time in his new house on an island off the coast of South Carolina. The friendship ended during the summer of 1962 in a bitter break-up. Thereafter Rauschenberg shifted much of his energy into performance; in 1962 he logged more hours as a stage manager and lighting director for Cunningham than as a painter. In 1963 he even choreographed his own dance piece, *Pelican* [fig. 7.12]. Rauschenberg also began to drink more and more heavily.

The Silkscreen Paintings

Meanwhile in the summer of 1962 Tatyana Grosman persuaded Rauschenberg to try lithography at Universal Limited Art Editions (U.L.A.E.), her Long Island print shop. The technique required close collaboration with a master printer and Rauschenberg liked collective efforts, as in the performance pieces, though he generally ended up dominating them. In 1961 Andy Warhol started using photosilkscreens to replicate images repeatedly across a canvas, and in 1962 he introduced Rauschenberg and Johns to the medium. The photosilkscreen immediately became Rauschenberg's standard technique in painting. He also successfully photosensitized a lithographic stone at U.L.A.E. The photographic found images replaced the real objects of the combines and permitted an even freer clash of associations in the prints and large paintings [fig. 7.13].

These silkscreen paintings have a documentary flavor, like a television screen jumping from one channel to the next to produce a seemingly arbitrary jumble of images. The photosensitive canvas picks up reflections of the world, recalling the underlying ambition of the earlier white canvases. But here the subject is the overload of imagery itself. It involves the more

7.12 Robert Rauschenberg performing in *Pelican*, New York, 1965, first performed in 1963.
Photograph © by the Estate of Peter Moore/VAGA, New York.

stylistically complex idea of bringing old associations to bear directly on new experience in a stream-of-consciousness style appropriate to the media age. "I was bombarded with television sets and magazines, by the excess of the world," he said. "I thought an honest work should incorporate all of those elements, which were and are a reality."[43]

In one sense these works of the early sixties are modern history paintings that comment on current events. Rauschenberg used President Kennedy more than any other public personality; the photograph of J.F.K. was a symbol of change because of his innovative agenda and Rauschenberg used the image as an expression of his own social conscience. He also used pictures of astronauts as well as material from the immediate environment: street signs, neighborhood buildings in demolition, a box of tomatoes. The details of ordinary things and the impersonal techniques of mechanical reproduction and repetition balanced the charged political imagery. "I needed some very simple images, like perhaps a glass of water, or a piece of string, or the bathroom floor with

a roll of toilet paper on it . . . I needed them to dull the social implications, to neutralize the calamities that were going on in the outside world."[44]

In *Skyway* [fig. 7.13] the images of Venus looking into the mirror and then out of the picture—taken from *Venus at Her Toilet* by Rubens—extend the picture's space to include the viewer. Rauschenberg himself looks into the picture in order to see out; the painting thus mirrors both the world outside and the artist. The repetition and resonances between forms and the abundant particular references function like the subjective thought processes of memory. Rauschenberg's paintings are about who he is in relation to the events he depicts; they are, he said, "a vehicle that will report what you did and what happened to you."[45]

Rauschenberg's March 1963 retrospective at the Jewish Museum gave him credibility. The next year the Museum of Modern Art bought a Rauschenberg, he had a rousing success with an exhibition at the Whitechapel Gallery in London, and then won the main prize in the Venice Biennale. Immediately after the award Rauschenberg called his assistant in New York, had him go to the loft and destroy all the silkscreens with which he had been printing the images on his silkscreen paintings

The Beat Generation: The Fifties in America

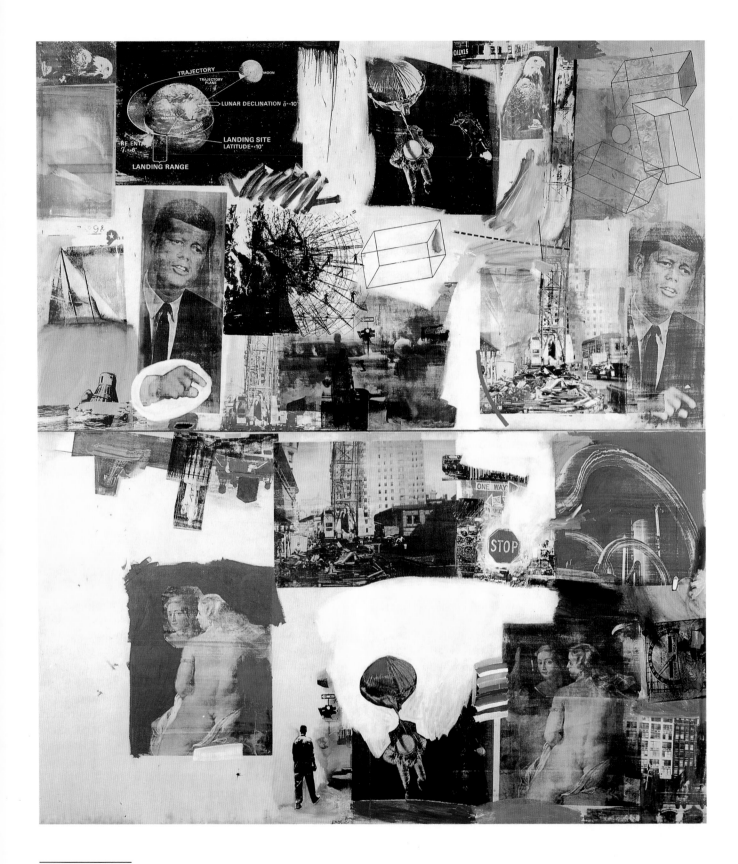

7.13 Robert Rauschenberg, *Skyway,* 1964. Oil and silkscreen on canvas, 18 × 16ft (5.49 × 4.88m) overall.

Collection, Dallas Museum of Art. Purchase, Roberta Coke Camp Fund, The 500, Inc., Mr. and Mrs. Mark Shepard, Jr., and the General Acquisition Fund. © Untitled Press, Inc./VAGA, New York.

of the past two years. This kept him from repeating himself but it also signaled his feeling that he had come to a dead end. At this point he nearly stopped painting in order to immerse himself in the theater.

Performance and the Prints of the Later Sixties

Rauschenberg had long been involved in collaborations with performers from theater and dance. From 1954 to 1964 he served as an artistic advisor to the Merce Cunningham Dance Company, and he also collaborated with the dancer/choreographer Paul Taylor. In the fall of 1965 he began an art and technology performance project, enlisting the help of Billy Klüver (a Swedish laser research engineer from Bell Labs). Rauschenberg's *9 Evenings: Theater and Engineering* of 1966 involved over thirty engineers from Bell Labs in a complex event of performance, dance, and technologically inventive staging. He followed up with the founding of Experiments in Art and Technology (or E.A.T.), into which he poured a considerable amount of energy in the second half of the sixties.

The rest of Rauschenberg's time was taken up with fancy clothes, curled hairdos, heavy drinking, and a groupie scene to rival Warhol's; his work in the studio became increasingly inconsequential. "Rauschenberg was a natural dissipater," wrote the critic Robert Hughes. "The sight of him in his porcupine-quill jacket, erect but reeling slightly, marinated with Jack Daniel's, cackling like a Texas loon and trying to get his arm around everyone at once, was too familiar."[46]

The great graphic work of the late sixties—*Booster* [fig. 7.14] and *Autobiography*—signaled Rauschenberg's return. Measuring six feet from top to bottom, *Booster* was the largest hand-pulled lithograph that had ever been made and Rauschenberg's first collaboration with the innovative Los Angeles-based print workshop, Gemini G.E.L. Rauschenberg composed his *Booster* around a full-length sequence of X-rays of his own body, and it had to be printed with two stones on a single sheet of paper made especially for the project. The work is a self-portrait, filtered through the distance of technological language—the X-ray, the astronomer's chart of celestial movement for the year 1967, and magazine images of drills with arrows diagramming their movement; it also contains the repetition of an empty chair, as though to suggest someone's absence.

The strength of *Booster*, like all of Rauschenberg's work, is that it reacted against the distance of mass culture by appropriating it into an emphatically personal interaction with immediate experience. In this respect he continued the existentialist directness of action painting, but without its emphasis on the isolated identity of the artist. Rauschenberg's work, as John Cage said of his own compositions, are "an affirmation of life—not an attempt to bring order out of chaos nor to suggest improvements in creation, but simply a way of waking up to the very life we're living, which is so excellent once one gets one's mind and one's desires out of its way and lets it act of its own accord."[47]

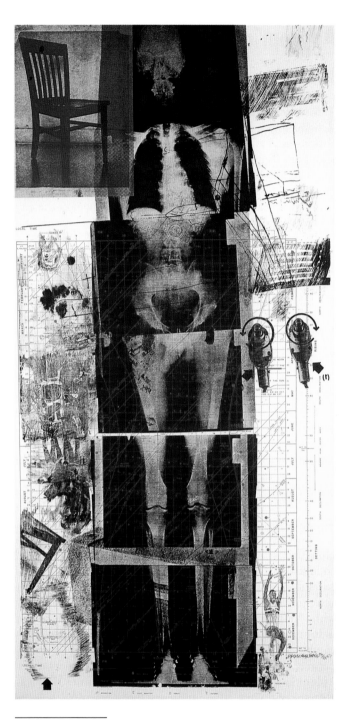

7.14 Robert Rauschenberg, *Booster,* 1967. Lithograph and serigraph, printed in color, composition: 71⁹⁄₁₆ × 35⅛in (181.7 × 89.1cm).
The Museum of Modern Art, New York, John B. Turner Fund. © Untitled Press, Inc. and Gemini G.E.L./VAGA, New York.

Appropriating the Real: Junk Sculpture and Happenings

Junk

In a 1955 meeting at the Club on 8th Street Richard Stankiewicz [fig. 7.15] remarked that for an artist in New York to use junk in making sculpture was as natural as for a South Sea Islander to use shells.[48] The term "junk sculpture" refers to a specialized type of assemblage that involved the welding of discarded metal into sculpture. As such, it is a kind of urban realism, vividly evoking the environment of the city streets, where such debris is ever present. David Smith and Stankiewicz pioneered junk sculpture around 1951 and 1952, although there were notable precedents in the welded sculpture of Picasso and González and in the prewar accumulations of the German dadaist Kurt Schwitters.

John Chamberlain developed an entire *oeuvre* from crushed automobile body parts [fig. 7.16]. Mark di Suvero experimented with a variety of found materials, gravitating increasingly to industrially fabricated parts, such as I-beams [figs. 7.17 and 7.18]. Di Suvero's work of the sixties is particularly important for his success in translating the spontaneity of welded sculpture on to an architectural scale. The British sculptor Anthony Caro [fig. 7.19] also made elegant use of industrial materials in the same period. Louise Nevelson [fig. 7.20] did not, strictly speaking, make sculpture out of metal junk; she mostly restricted her assemblage of found objects to monochromatically painted wood reliefs. Yet the character of her aesthetic is a fusion of junk assemblage and the insistence on the picture plane that she learned from her teacher, Hans Hofmann.

The term "assemblage" was coined in 1953 by Jean Dubuffet to refer to works that went beyond the pasted collages of the cubists.[49] By the time of the 1961 "Art of Assemblage" exhibition at the Museum of Modern Art the accepted use of the term embraced not only Dubuffet's work with "non-art" materials such as butterfly wings and industrial slag, but also junk sculpture, and Rauschenberg's combines. All of this work challenged the boundary between everyday objects and high art, reflecting a widespread concern in the art world of the fifties that was soon taken up in a different way by the pop artists.

The Genesis of the Happenings

In junk sculpture, and even more so in the combines of Rauschenberg, the entire world became one big work of art, extending the urban aesthetic of the New York School to include literally everything on the street. The "happenings" of the late fifties evolved from a similar idea. In a Town Hall lecture of 1957 John Cage speculated: "Where do we go from here? Towards theater. That art more than music resembles nature. We have eyes as well as ears, and it is our business while we are alive to use them."[50] At the time, he was teaching a class at the New School for Social Research from

which came the germ for the first happenings in New York.

Allan Kaprow, who had studied with Hans Hofmann and was painting in an abstract-expressionist style, signed up for Cage's course two years in a row. Kaprow had read about the radical dada events of the twenties in Robert Motherwell's 1951 anthology, *Dada Painters and Poets*. But Cage's discussion of the ideas of Zen, Duchamp, Artaud, and above all his description of the active participation of the audience in the 1952 "event" at Black Mountain College stimulated Kaprow to arrange his own happening in 1958. Kaprow's happening took place on the New Jersey farm of the artist George Segal, at a picnic for members of the Hansa Gallery in New York.

Like many artists at this time Kaprow felt the need to go beyond the conventions of both gesture painting and junk sculpture. "The 'Act of Painting,'" he wrote in 1958, "the new space, the personal mark that builds its own form and meaning, the endless tangle, the great scale, the new materials, etc. are by now clichés of college art

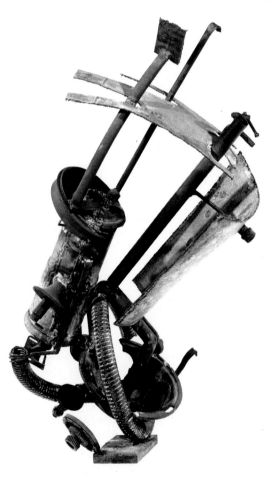

7.15 Richard Stankiewicz, *Diving to the Bottom of the Ocean,* 1958. Welded metal, 53⅜ × 33 × 37¾in (138 × 84 × 96cm).
Collection, Museé National d'Art Moderne, Centre Georges Pompidou, Paris.

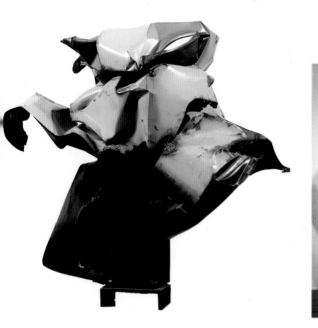

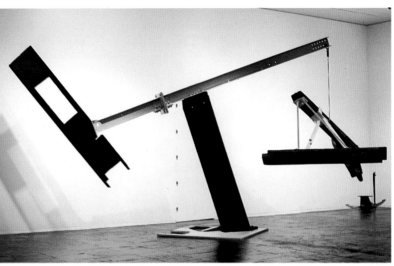

7.16 John Chamberlain, *H.A.W.K.,* 1959. Welded steel,
4ft 1½in × 4ft 5in × 3ft 5in (1.31 × 1.35 × 1.04m).
Photograph by Glenn Steigelman, courtesy Leo Castelli Gallery, New York.
© 2000 John Chamberlain/Artists Rights Society (ARS), New York.

7.18 Mark di Suvero, *Mohican,* 1967. Steel and wood,
15 × 9 × 30ft (4.57 × 2.74 × 9.14m).
Collection, Federal Reserve Bank, Dada County, Florida.

7.17 Mark di Suvero, *Che Faro Senza Eurydice (What Will I Do Without Eurydice),* 1959. Wood, rope, and nails,
7ft × 8ft 8in × 7ft 7in (2.13 × 2.64 × 2.13m).
Collection, Mr. Donald Fisher.

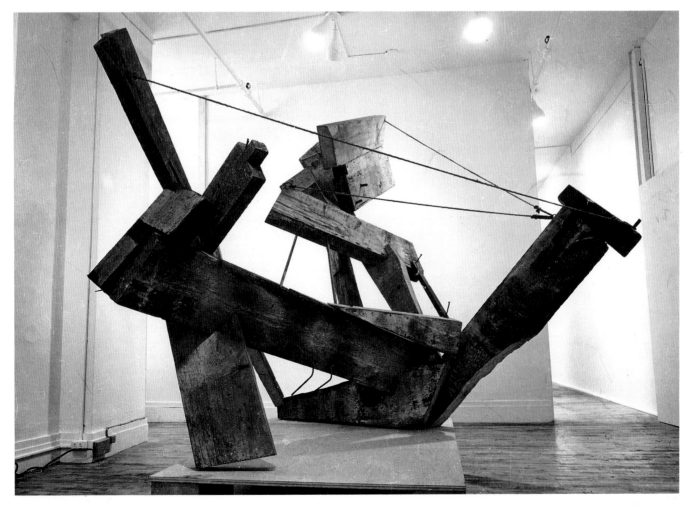

7.19 Anthony Caro,
Midday, 1960. Painted Steel,
91¾ × 37⅜ × 145¾in
(233 × 94.7 × 370.2cm).
The Museum of Modern Art, New York.
Mr. and Mrs. Arthur Wiesenberger
Fund. © Anthony Caro/VAGA, New
York, Marlborough Gallery, New York.

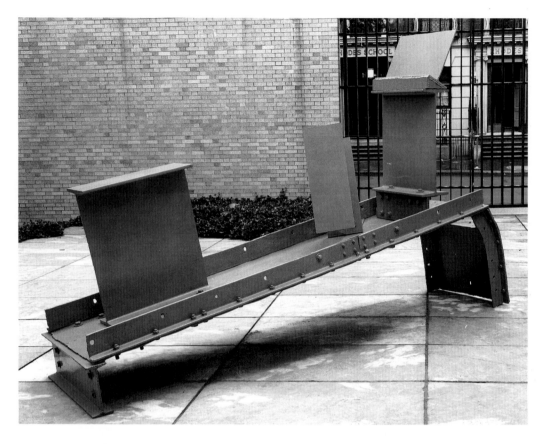

7.20 (below) **Louise
Nevelson,** *Dawn's Wedding
Chapel II,* 1959. White
painted wood,
115⅞ × 83½ × 10½in
(294.2 × 212 × 26.7cm).
Collection, Whitney Museum of
American Art, New York. Purchased with
funds from the Howard and Jean Lipman
Foundation, Inc. Photograph by Geoffrey
Clements, New York. © 2000 Estate of
Louise Nevelson/Artists Rights Society
(ARS), New York.

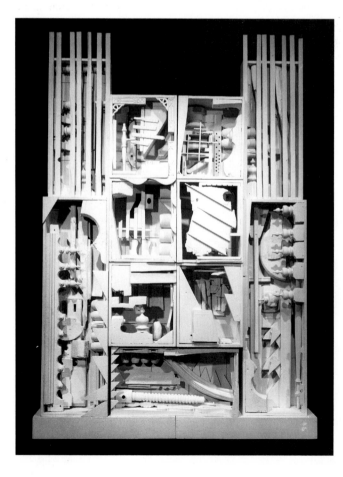

departments."[51] So Kaprow fused the urban realism of junk art with the spatial expressionism that he extrapolated from Pollock and set it in a real environment. He moved from the juxtaposition of found objects to the juxtaposition of "found events." In an article of 1958 entitled "The Legacy of Jackson Pollock" Kaprow reasoned as follows:

Pollock, as I see him, left us at the point where we must become preoccupied with and even dazzled by the space and objects of our everyday life . . . Not satisfied with the suggestion through paint of our other senses, we shall utilize the specific substances of sight, sound, movements, people, odors, touch. Objects of every sort are materials for the new art: paint, chairs, food, electric and neon lights, smoke, water, old socks, a dog, movies, a thousand other things . . .[52]

Harold Rosenberg's idea of action painting also pressed Kaprow to pass beyond gesture into pure action [fig. 7.21]. In action painting the artist concerned him or herself with a creative act of self-discovery, whose result was above all an artifact of the experience. Pollock, Rosenberg argued, was less preoccupied with image-making than the process, even though the finished work was spectacularly beautiful; indeed, the object's visual power relied on its ability to convey the energy of the process.

Although the spirit of collaboration (with Cunningham, Tudor, and others) in Cage's 1952 "event" seemed to contradict the action painter's emphasis on the individual act,

7.21 Allan Kaprow, *Chicken,* 1962. Happening.
Photograph by Edwin Sabol.

Cage did stress individual experience. "The structure we should think about," Cage explained, "is that of each person in the audience . . . [whose] consciousness is structuring the experience differently from anybody else's . . . So the less we structure the theatrical occasion and the more it is like unstructured daily life, the greater will be the stimulus to the structuring faculty of each person in the audience. If we have done nothing he then will have everything to do."[53]

Kaprow had a "show" at the Hansa Gallery in 1958 that consisted of a complex, collaged environment with random sounds from a radio. He performed in the space, but his first full, public happening as such—called *18 Happenings in 6 Parts*—took place at the Reuben Gallery in October 1959. Here too the sources were not theater, but dada provocations, assemblage, and action painting. It therefore required the spontaneity of novices, rather than actors, as Kaprow explained: Actors "wanted to have stellar roles. They wanted to speak for the most part, and I utilized little verbiage in my work. And all the things which I suggested were quite contrary to their background

. . . But my other friends, who were unaccustomed to acting, were quite capable because they sensed the origins of what they were doing in painting."[54]

Robert Whitman studied with Kaprow at Rutgers in New Jersey. He was the youngest of the first happenings artists, and his ideas tended to be more abstract. In general, happenings bombarded the viewer with sensations and the viewer had to make his or her own order out of the events. Often the action included the viewers, and their participation added an unpredictability that dramatized its similarity with real life. Happenings were a kind of theater that took place in real, rather than staged, settings and instead of plots they were structured in juxtaposed units as in an assemblage. The typical happening was nonverbal, discontinuous, non-sequential, multifocused, and open-ended. According to Kaprow: "A Happening is *generated in action* by a headful of ideas or a flimsily-jotted-down score of 'root' directions."[55] Although some happenings engaged the audience extensively, others did not. Kaprow's *Fluids* of 1967, for example, involved tasks executed at various locations around a city, as determined by the performers; the only audience was that which serendipitously happened by, thus creating a true integration of art with life.

Inspired by Kaprow, Claes Oldenburg launched his Ray Gun Theater in January 1960. *The Street* [fig. 7.22] by Oldenburg and Jim Dine's *The House* were environments created at the Judson Gallery, a makeshift space in the basement of the Judson Memorial Church in Washington Square, and they emulated the squalor of the Lower East Side where the artists lived. Oldenburg characterized this kind of art as a "contemporary primitivism achieved through the exploitation of popular culture."[56] As Barbara Haskell has pointed out, by singling out everyday "unaesthetic" objects Oldenburg anticipated pop art.[57]

Red Grooms performed his first happening, *Play Called Fire*, in Provincetown, Massachusetts, on the tip of Cape Cod, in the summer of 1958. He was less concerned than the early Kaprow with viewer participation, and like Oldenburg more involved in visual elaboration and improvisation. Grooms orchestrated his three major happenings—*The Walking Man, The Burning Building* [fig. 7.23], and *The Magic Train Ride*—between the summer of 1959 and January 1960. Jim Dine participated in several Oldenburg happenings but also devised his own, in which he played the principal role. Dine's happenings seemed like staged nightmares; he later wrote that "anyone could do anything and be liked," and that "the audiences were laughing at everything."[58]

Happenings were definitely the "in" thing for a period. Everyone sense the excitement and vitality of a genuine revolution in the definition of art. Yet because they did not leave museum objects and their lifespan was short, they may seem less important in retrospect than they actually were. However, by 1962 the whole phenomenon had grown too commercialized, according to Oldenburg: "People were arriving in Cadillacs."[59] So, except for Kaprow, the major artists all returned to painting and sculpture or went into video and film.

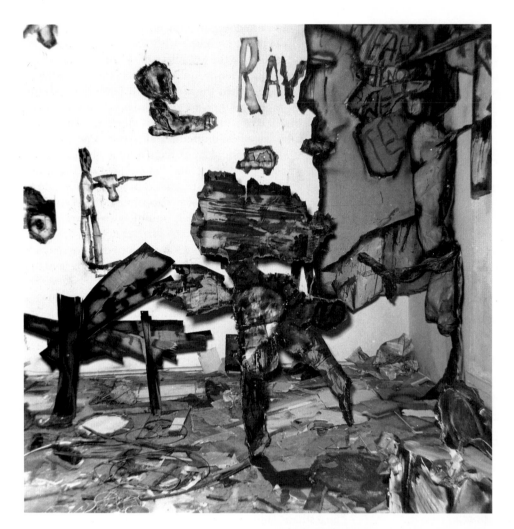

7.22 Claes Oldenburg, *The Street*, spring 1960. As installed at the Judson Memorial Gallery.
Photograph courtesy the artist.

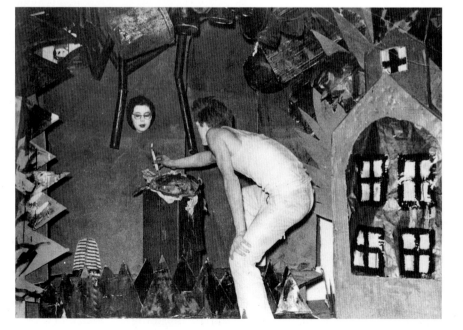

7.23 Red Grooms, *The Burning Building*, 1959. Performance in New York.
Photograph by Max E. Baker, New York. © 2000 Red Grooms/Artists Rights Society.

The Judson Dance Theater

As the Judson Gallery artists moved on to regular galleries, the Judson Dance Theater—including Yvonne Rainer, Steve Paxton, Simone Forti, Lucinda Childs, Judith Dunn, and Trisha Brown—took over the basement space, and with it the Judson Gallery's role as a focal point of the downtown scene. The artists of the Judson Dance Theater choreographed such commonplace movements as walking or sitting down. Yvonne Rainer invented the term "task movement," which characterized the general mood: the performances had no theatrical feel, they were anti-expressionistic (unlike the happenings), and they employed few if any objects or sets.

Like pop art and minimalism—which also emerged around 1962—these Judson Dance performances involved a deadpan delivery of charged subjects. In describing one section of Yvonne Rainer's "love duet" *Terrain*, Barbara Haskell noted that "she delivered hackneyed expressions ('I love you,' 'I don't love you,' 'I've never loved you') in a flat monotone which one critic likened to the recitation of a grocery order."[60] By taking them out of context, Rainer and the others transformed everyday actions into abstract movement and encouraged the appreciation of accidental acts, just as Cage had in the realm of sound. Cunningham was of course the chief inspiration behind this minimalist dance.

Fluxus

While drawing on some of the same sources as artists in New York, those in Europe followed a more metaphysical course. In 1962 George Maciunas (an American), Wolf Vostell (a German), and Nam June Paik (a Korean) founded a group called "Fluxus" in Wiesbaden, West Germany, that largely took off from the ideas of Cage. Maciunas had attended performances by Cage and others, some of them in Yoko Ono's loft on Chambers Street in New York. Robert Morris and his then wife, the Judson dancer Simone Forti, had arrived in New York from San Francisco with Walter De Maria in 1960, and in the fall Maciunas opened the A G Gallery on Madison Avenue to show the early minimalist work of De Maria and to sponsor performances like the ones he had seen in the downtown lofts. Maciunas was the animating force behind Fluxus as a movement.

Fluxus was formed as a Duchampian reaction against the expressionistic and symbolic aspects of happenings. Often the Fluxus events were quite minimal, as in the two performance scores that George Brecht submitted to a 1961 show at the Martha Jackson Gallery; one of them consisted simply of the word "chair," whose realization was a white wicker rocker.[61] Fluxus peaked between 1962 and 1964, and although many important artists from Joseph Beuys to Christo had a vague connection with it, the group was so undefined that even many present at the

time still wonder if a "group" actually existed at all. According to Robert Watts, "The most important thing about Fluxus is that nobody knows what it is. There should at least be something the experts don't understand. I see Fluxus wherever I go."[62]

The two major talents explicitly connected to Fluxus were Joseph Beuys and Nam June Paik. Beuys, although he lacked the intellectual detachment of other artists associated with the group, was nevertheless profoundly influenced by their theatrical orientation. Paik's 1960 *Etude for Pianoforte*, which took place in an artist's loft in Cologne, was widely recounted, and set the tone for his future Fluxus performances. Among other actions, *Etude* consisted of Paik performing a Chopin *Etude*, breaking off in tears, and leaping from the stage into the audience, where he cut off John Cage's tie with scissors and poured shampoo over Cage and David Tudor. (He did not assault the formidable German composer Karlheinz Stockhausen, who sat next to Cage.) Then he pushed his way out of the crowd, who by this time were on their feet, and phoned from the bar downstairs to say the piece was over. Though celebrated for this performance piece, Paik made his most significant contribution in the following years with video and television art.

Walk-in Paintings

Meanwhile in 1958—the same year in which Alan Kaprow organized his first happening on George Segal's New Jersey farm—Segal himself began making life-sized, three-dimensional figures out of wire, plaster, and burlap. "They looked to me as if they had stepped out of my paintings," he recalled, explaining that his "decision to enter literal space was determined by strong urges for total experience."[63] Soon he began constructing environments of real objects, as in *The Subway* [fig. 7.24], which has a real subway car interior and lights flashing by outside the darkened window. Marisol, a Venezuelan emigré in New York, also mixed real objects with wooden blocks—carved illusionistically and detailed with plaster and drawing (or painting) [fig. 7.26].

Red Grooms's painting style, as well as his reputation, was established with his happening *The Burning Building*, presented in the "Delancy Street Museum" (his loft) in December 1959. The expressionistically painted set and the evocative juxtaposition of events created a more controlled and unified structure for happenings than Kaprow's, and was more interesting to watch. In the summer of 1957 the twenty-year-old Grooms had left his native Nashville for the Hans Hofmann School in Provincetown, and although Hofmann made little impression on him the community of younger artists there introduced him to the gestural styles of Lester Johnson and Alex Katz, which shaped his idea of painting [fig. 7.25]. Grooms also painted what he called "stick-outs" that stand up independently in real space like stage flats. As with

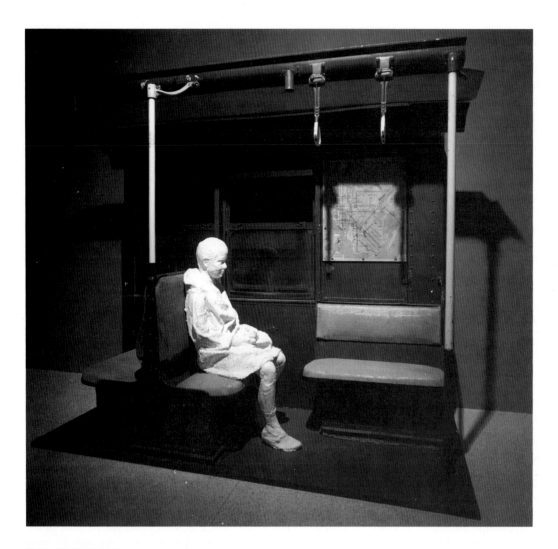

7.24 George Segal, *The Subway,* 1968. Plaster, metal, glass, rattan, electrical parts with lightbulbs, and map, 7ft 4in × 9ft 5½in × 4ft 3in (2.25 × 2.88 × 1.3m).
Photograph courtesy Mrs. Robert B. Mayer, Chicago. © George Segal/VAGA, New York, 1994.

Segal's tableaux and the earlier cutout paintings of Alex Katz, the "stick-outs" came from a desire for a total walk-in environment in order to enhance the "reality" of the painted experience.

Jim Dine began making junk accumulations and at the same time began to incorporate real articles of clothing into his paintings in 1959. Soon he moved on to fixing deliberately selected new hardware to his canvases [fig. 7.27]. In some works the gestural paint surface and the objects interact like distinct voices (as in the contemporary works of Jasper Johns); in other canvases Dine made expressive color or surface integral with the definition of the objects themselves; and in still other works he depicted the common objects as a subject matter. "When I use objects," he explained, "I see them as a vocabulary of feelings . . . my work is very autobiographical."[64] The tools had a particularly strong evocative quality for him because both his father and grandfather (who raised him) had had them on sale in their retail shops in his hometown of Cincinnati.

Lucas Samaras, another assemblagist of the period, got to know Kaprow, Segal, and Whitman at Rutgers (which he attended as an undergraduate from 1955 to 1959) and he participated in many of Oldenburg's happenings of the early sixties. He began to construct abstract objects and boxes [fig. 7.28] in the spring of 1960, having become obsessed by the evocative power of particular materials: nails, pins, broken glass, and razor blades, set off by saturated rainbow colors, Day-Glo and silver paint, tin foil, and mirrors. His works, though sensual and opulent, frequently have a menacing aspect. His material accumulations are fetishistic and highly personal, like small, ecstatic relics of a bizarre, unidentified religious rite.

The "strong urges for total experience" that Segal spoke of when referring to his plaster figures were a defining feature of the happenings in New York. Their very theatricality provided a point of departure for the careers of not only Allan Kaprow but George Segal, Red Grooms, Jim Dine, Lucas Samaras, and Claes Oldenburg.

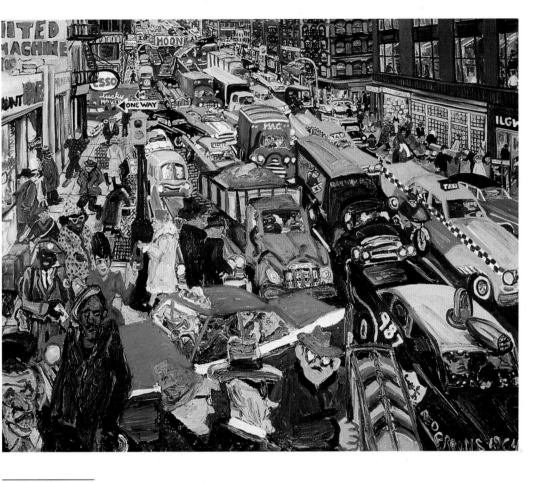

7.25 Red Grooms, *One Way,* 1964. Oil on canvas,
5ft 5in × 6ft 8in (1.65 × 2.03m).

Collection, Ann and Walter Nathan, Chicago. Photograph by I. Carmen Quintana. © 2000
Red Grooms/Artists Rights Society.

7.26 (right) **Marisol,** *The Family,* 1963. Mixed media assemblage,
6ft 7in (2.01m) high.

Collection, Robert B. Mayer Family, Chicago, on loan to the Milwaukee Art Museum.
© Marisol/VAGA, New York, 1994.

7.27 Jim Dine, *Five Feet of Colorful Tools,* 1962. Oil on unprimed
canvas surmounted by a board on which thirty-two painted tools hang
from hooks; overall, 55⅝ × 60¼ × 4⅜in (141.2 × 153 × 10.9cm).
The Museum of Modern Art, New York. The Sidney and Harriet Janis Collection.

7.28 Lucas Samaras, *Untitled Box No. 3,* 1963. Wood, pins, rope, and stuffed bird, 24½ × 11½ × 10¼in (62.2 × 29.2 × 26cm). Collection, Whitney Museum of American Art, New York. Gift of the Howard and Jean Lipman Foundation, Inc. Photograph by Jerry L. Thompson.

Claes Oldenburg

Where Dine steadfastly retained the manufactured identity of objects, Claes Oldenburg persistently undermined them. He anthropomorphized them, eroticized them, changed them from organic to geometric and vice versa, or blew them up into architecture through formal associations that layered each object with alternative definitions. Oldenburg's work is also autobiographical, and as with Dine the happenings led Oldenburg to use objects as though they were stage props in a kind of introspective performance. Yet what interested Oldenburg above anything else was the power of his imagination to alter the shape and meaning of real things. His work, he said, "originates in actual experience however far my metamorphic capacities may carry it."[65]

Born in Stockholm in 1929 and raised in Chicago from the age of seven, Claes Oldenburg was the older of two sons of the Swedish Consul-General. As children and young teenagers, the Oldenburg boys collaborated on a highly detailed fantasy about an imaginary island country in the South Atlantic called "Neubern," which set some important

themes for Oldenburg's mature work. They made scrapbooks with maps, diagrams, and drawings describing the island, its military and industries, and the events that took place there. Meanwhile Oldenburg's mother made collages from advertisements of consumer goods, which may have predisposed him to such subjects later. Oldenburg attended Yale and the School of the Art Institute of Chicago, and then in 1956 he went to New York.

Reading Allan Kaprow's article on "The legacy of Jackson Pollock" in *Art News* and the *New York Times* piece on the Gutai Theater artists prompted Oldenburg to seek out Kaprow and Red Grooms in 1958. Through them, he met Samaras, Segal, and Whitman; his friendships with Jim Dine and Tom Wesselmann also date from this time. Oldenburg's art in 1958–9 followed a free-associative path. "My procedure was simply to find everything that meant something to me, but the logic of my self-development was to gradually find myself in my surroundings."[66] This sensitivity to those objects in the environment that resonated with his personality made Oldenburg a persistent collector of popular-culture trinkets and street debris—stiffened old gloves, flattened cans, bits of wood, and wrappers—that suggested significant meaning through his processes of aesthetic transformation. Rather than letting an object assert its own identity, Oldenburg redefined the found object in his own image: "What I see is not the thing itself but—myself—in its form."[67]

The "Cold Existentialism" of the "Ray Gun" and *The Street*

The phallic Ray Gun, in particular, became an increasingly prevalent icon for Oldenburg, not only in found objects but in his drawings and *papier-mâché* sculptures [fig. 7.29]. "Ray Gun is ultimately the unknowable," Oldenburg noted in 1960, "pursued futilely through all its disguises."[68] His reading of Freud and his attempt at self-analysis in the fall of 1959 may well have prompted his reflections on the sexual drive, which was "unknowable" because sublimated, yet pervasive in the human unconscious. "If form in nature analyzes down to geometry," he observed, "content (or intent) analyzes down to erotic form."[69]

The Ray Gun, personified as Oldenburg's *alter ego*, made its appearance in 1960 on the bulletin board of the Judson Church during his show *The Street* [fig. 7.22]. *The Street* consisted of deliberately coarse figures made from ripped cardboard, burlap, and other shabby materials found on the streets of the run-down Lower East Side and fashioned into a continuous, drab environment of dark browns, black, and tan. Pieces hung from the walls and ceiling and lay across the floor, so that *The Street* resembled a dada event, except for its evident expressionism. "I sought a crudity in style," the artist said, "to match the crudity of my surroundings."[70]

Some of *The Street* figures had speech balloons, revealing the lingering influence of comic strips; but the dark outlines, the ephemeral "non-art" materials, and the formal crudeness

7.29 Claes Oldenburg, *"Empire" ("Papa") Ray Gun,* 1959. Casein on newspaper over wire, 35⅞ × 44⅞ × 14⅝in (91.1 × 114 × 37.1cm).
The Museum of Modern Art, New York. Gift of the artist.

made unmistakable reference to Dubuffet. "I don't come out of Matisse or the sunny concept of art," Oldenburg explained. "I come out of Goya, Rouault, parts of Dubuffet, Bacon, the humanistic and existentialist imagists, the Chicago bunch."[71] Moreover Oldenburg's assertion that "dirt has depth and beauty. I love soot and scorching,"[72] his wish to make art of the "the impossible, the discredited, the different,"[73] and his description of himself as "an outsider"[74] breathe the cold existentialism of Dubuffet and the French *nouveau roman* of Louis-Ferdinand Céline and Alain Robbe-Grillet.

The Store Days

A fter *The Street* Oldenburg began making a more vivacious style of object [fig. 7.30]. The raw, yet colorful textured surfaces of his new work were a departure from the former somber squalor. As if looking up from the pavement and into the shop windows he rendered the lively flurry of activity in crudely painted plaster forms. Yet this work too was indebted to Dubuffet—not to the graffiti-like monochromes but to his rich, elemental "pastes" [figs. 5.4 and 5.11].

In June 1961 Oldenburg rented a storefront at 107 East Second Street, on the Lower East Side, and in December he opened *The Store.* The sensuality, optimism, and humor of the work on display reflected an appreciation for the bustling, tactile and visual variety of the neighborhood—the cheap clothing on

Orchard Street, the arrays of food on Second Avenue, the boxes, wrappers, and signs, and all the energetic buying and selling. *The Store* was a friendly, overfilled room of hamburgers and tennis shoes, prepackaged shirt-and-tie combinations, and reliefs of Pepsi signs and sewing machines—all made of brightly enamelled plaster—with a delicious vulgarity that celebrated "the poetry of everywhere,"[75] as he put it.

The artist's manipulation of form took precedence over any inherent significance in the subject: "i wanted to see if i could make significant form out of a pair of ladys pantys [*sic*]."[76] Indeed Oldenburg used the banality of the subject matter to set off his aesthetic.

I have made these things: a wrist watch, a piece of pie, hats, caps, pants, skirts, flags, 7 up, shoe-shine etc. etc., all violent and simple in form and color, just as they are. In showing them together, I have wanted to imitate my act of perceiving them, which is why they are shown as fragments (of the field of seeing), in different scale to one another, in a form surrounding me (and the spectator), and in accumulation rather than in some imposed design.[77]

The ragged edges on the reliefs suggest the violence with which they have been ripped from their visual context. The fragmentation evokes the feeling that occurs when a multitude of disconnected perceptions are brought together.

People loved Oldenburg's work and yet he sold very little. *The Store* closed after two months with a net loss of $285, which Richard Bellamy (director of the Green Gallery on 57th Street) picked up when he offered Oldenburg a show

7.30 Claes Oldenburg, *Pie à la Mode,* 1962. Muslin dipped in plaster over a frame of chickenwire, painted with enamel, 13 × 20 × 19in (33 × 50.8 × 48.3cm).
Collection, Museum of Contemporary Art, Los Angeles. The Panza Collection. Photograph by Squidds & Nunns, courtesy of Contemporary Art, Los Angeles.

for the fall of 1962. In February 1962 Oldenburg shifted his attention to developing the Ray Gun Theater, and for about five months he organized performances for capacity audiences in his tiny storefront. Like the objects in *The Store* Oldenburg's happenings derived from an overriding interest in using his aesthetic thought processes to integrate his experience of the real environment. The Ray Gun Theater "seeks to present in events what the Store presents in objects," Oldenburg explained. "It is a theater of real events (a newsreel)."[78] In this theater of things, Oldenburg even used his actors like objects, rejecting dialog and plot. The artist's power to defamiliarize the objects he made, as well as the cathartic character of the performances, reflected a faith in the force of mind over matter that may have its roots in his Christian Science upbringing.

Oldenburg had gone several times to see *The Burning Building* by Red Grooms in December 1959, and he organized his own happening, *Snapshots from the City*, the next year. In *Snapshots* Oldenburg created a "living picture" of himself covered in rags and debris, literally and figuratively locating himself within the visual chaos of the street. The happening was a series of expressive but static tableaux, in which he used objects, or more properly "matter," as the stuff of an existential expressionism in the tradition of Pollock. The painterly handling which persisted in Oldenburg's sculpture, at least through the end of the sixties, also revealed his expressionistic approach.

Soft Sculpture

Oldenburg's Green Gallery show was scheduled to open in September 1962. The largest object in *The Store* had been three feet square, and now suddenly Oldenburg had a much bigger space to fill. Walking through midtown on the way to the gallery one day, he passed an auto showroom and admired the way the cars occupied the space. He decided that he wanted to fill the gallery in the same way, so he enlarged his objects to the size of cars, and at the same time he fabricated his first soft sculptures of canvas and later vinyl stuffed with foam rubber, cardboard, or kapok. The display included a nine-foot cake [fig. 7.31], an ice-cream cone over ten feet long, and a hamburger that was seven feet in diameter. The comparison to surrealism was inevitable, since the radical shift in scale and the metamorphosis of familiar objects into soft sculptures gave them a dreamlike aura. The show enjoyed commercial success but the established critics hated it. Not only was it figurative, and therefore—in Greenberg's relentless march toward abstract purity—reactionary, it had a sense of humor and that made it *ipso facto* insufficiently profound.

In November 1962 the Sidney Janis Gallery held the "New Realists" exhibition that scandalized many of the New York School artists whom Janis also represented, and some quit the gallery. Like "A Problem for Critics," held at the Art of This Century almost twenty years earlier, the "New Realists" show attempted to encapsulate what nearly everyone recognized as a new movement. The title came from the French *nouveaux réalistes*, whom Janis included, and indeed the assemblage aesthetics of Oldenburg, Dine, Segal, Samaras, and probably even Grooms had more in common with the French *nouveaux réalistes* and with Rauschenberg than they did with Warhol, Rosenquist, and Lichtenstein, with whom they were eventually (and inappropriately) grouped under the heading of "pop."

At this point Oldenburg entered a period of reassessment. "I experienced a revulsion against my situation in New York, hating my Store (my studio and theater since 1961) on Second Street, my apartment, my body, my wife,

7.31 Claes Oldenburg, *Floor Cake (Giant Piece of Cake)*, 1962. Synthetic polymer paint and latex on canvas filled with foam rubber and cardboard boxes,
4ft 10⅜in × 9ft 6¼in × 4ft 10⅜in
(1.48 × 2.9 × 1.48m).
The Museum of Modern Art, New York. Gift of Philip Johnson.

everything."[79] In September 1963 he and his wife Pat fled New York and moved to Los Angeles. He rented a studio in Venice, California, and stayed there through the following March (1964). The abundance of vinyl and fake furs he found while rummaging through the area's surplus stores inspired him to try working in these materials, and since the cutting patterns for the soft sculptures came from "hard models" constructed in planes of wood or cardboard, the objects typically had "hard," "soft" (that is, vinyl), and "ghost" versions [figs. 7.32 and 7.33], the latter fabricated from canvas but lacking the "realistic" color or finish of the vinyl.

In March 1964 the Oldenburgs drove to New York for his show at the Janis Gallery and then sailed to Europe in May for the Venice Biennale. They stayed most of the year in Europe. While there Oldenburg had a show at Ileana Sonnabend's gallery in Paris, and, stimulated by the food in French shop windows, he made a series of "edible" delicacies in plaster; after all, he quipped, "what could be more appropriate than plaster in Paris?"[80] When they returned to New York in late November they checked into the Chelsea Hotel and he worked in a loft in SoHo until they found a 200-foot-long space on East 14th Street in April 1965.

Oldenburg inaugurated a sequence of soft mechanical devices in 1965, beginning with his *Airflow* (a special model of the 1935 Chrysler) and including a giant fan, drainpipes, a telephone, and the giant Dormeyer mixers. For the most part he chose quaintly old-fashioned devices and exhaustively researched them on paper. Although they have a rich nuance of line quality, these drawings are often realized with the precision of a mechanical engineer [fig. 7.34].

7.32 (above) **Claes Oldenburg,** *Soft Dormeyer Mixer,* 1965. Vinyl, wood, and kapok, 32 × 20 × 12½in (81.2 × 50.8 × 31.8cm).
Collection, Whitney Museum of American Art, New York. Purchased with funds from the Howard and Jean Lipman Foundation, Inc. Photograph by Geoffrey Clements, New York.

7.34 (opposite) **Claes Oldenburg,** *Sketch for Dormeyer Mixer,* 1965. Pencil on white paper, 30⅛ × 22⅛in (76.5 × 56.2cm).
Private collection. Photograph by Bob Kolbrener.

7.33 (left) **Claes Oldenburg,** *Soft Dormeyer Mixers—"Ghost" Version,* 1965. Canvas, kapok, sprayed enamel, and wood, 42 × 26 × 34in (106.7 × 66 × 86.4cm).
Destroyed. Photograph Geoffrey Clements courtesy Sidney Janis Gallery, New York.

Being soft and fleshlike, many of Oldenburg's objects can be seen as analogs to human anatomy. The artist's notebooks track particular examples of his obsessive metamorphosing of things through visual free association [fig. 7.35], as with the ideas for the mixers, which jump from a pair of pendulous breasts, to the collar on a prudish dress, to earrings, and then to the beaters on an electric mixer. There is, then, a wide variety of meanings underlying a form such as the *Soft Dormeyer Mixer* [fig. 7.32]. In this way it is an extraordinary glimpse of an ordinary object, humorously eroticized into a *double entendre* with the human body. The *Soft Dormeyer Mixers— "Ghost" Version* is another visual and anatomical pun, this time referring to male genitals.

Oldenburg's reading of Freud undoubtedly sharpened his sense of the sexual significance with which humans unconsciously imbue inanimate objects. "Basically, collectors want nudes," he remarked. "So I have supplied for them nude cars, nude telephones, nude electric plugs, nude switches, nude fans."[81] From the row of pale mixers with their limp handles and hanging "beaters" [fig. 7.33] to

7.35 Claes Oldenburg, unnumbered notebook page: *Dormeyer Mixer*, 1965. Ballpoint pen and collage on paper, 10⅝ × 8in (27 × 20.3cm).
Collection, the artist.

7.36 Claes Oldenburg, *Woman Figure with Medusa Ornaments of Nudes with Vacuum Cleaners*, 1967. Graphite with black chalk on white wove paper, 26 × 40in (66 × 101.6cm).
Art Institute of Chicago, restricted gift of Dr. Eugene A. Solow, 1968.38.

his overtly sexual drawings [fig. 7.36], eroticism is everywhere in Oldenburg's work. "The erotic or the sexual," he commented, "is the root of art."[82]

Proposals for Monuments

In 1965 Oldenburg also began to design fantastic proposals for monuments.

One day I combined landscapes and objects, only I didn't change the scale. I had a drawing of a vacuum cleaner and another of Manhattan—and I just superimposed them. The result was automatically a "giant vacuum cleaner" because the city held its scale—it didn't become a miniature city. Somehow it worked.[83]

An eighteenth-century folly shaped like a cow by the French visionary architect Lequeu inspired the *Proposed Colossal Monument for Central Park North, New York City: Teddy Bear* [fig. 7.37],[84] but the giant balloon figures in the Macy's Thanksgiving Day Parades in New York every year also played a part. So too, perhaps, did the proposed projects of Christo [fig. 11.21], who was his neighbor in 1964 in the Chelsea

7.37 Claes Oldenburg,
Proposed Colossal Monument for Central Park North, New York City: Teddy Bear, 1965. Lithographic crayon and watercolor on paper, 23 × 17³⁄₁₆in (58.4 × 43.7cm). Mr. and Mrs. Richard Oldenburg, New York.

Hotel. Like Christo, Oldenburg thought up his follies for real sites, such as the addition to the Art Museum at Oberlin College in Ohio, which he drew as a giant three-way plug, or the monumental fireplug intended to replace the Picasso sculpture on the Civic Center Plaza in Chicago. Oldenburg chose the objects based on his sense of the spirit of the place.

Realizing the Monuments and the Architectural Scale

In 1969 Oldenburg moved his studio to an old factory building in New Haven, Connecticut, close to a large-scale, steel fabricating plant called Lippincott and Company. Lippincott specialized in working with artists and began to construct monumental sculptures for Oldenburg, such as the twelve-foot high *Geometric Mouse* of 1969 [fig. 7.38]. (Oldenburg's New Haven studio had a well-established mouse population, so "a rodent subject was unavoidable."[85]) But the idea began in 1965 as a mouse mask for a performance called *Moveyhouse*.[86]

Oldenburg made several drawings [fig. 7.39] showing the metamorphosis of the *Geometric Mouse* into or from a Good Humor ice cream bar with a semicircular bite out of the upper corner, a double light switch, a roller shade with a cord hanging down, a ray gun, a tea bag, an old movie projector, a three-way plug, a stocking, a lipstick on caterpillar tracks, and in one drawing his own face. The mouse—represented only as a head—also suggests a skull and thus possibly a *vanitas*

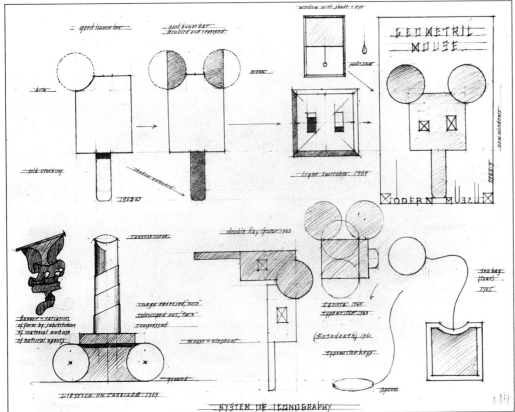

7.38 (above) **Claes Oldenburg,** *Geometric Mouse,* Scale A, 5/6, 1969. Steel and aluminium, 12 × 15 × 7ft (3.66 × 4.57 × 2.13m). Collection, the artist.

7.39 (left) **Claes Oldenburg,** *System of Iconography,* 1969. Pencil on paper, 11 × 14in (27.9 × 35.6cm). Private collection, New York.

theme. In 1972 Oldenburg reworked the idea yet again in the form of a ground plan for a tiny museum building to house his collection of pop-culture trinkets and found objects.

In the *Geometric Mouse* Oldenburg showed himself to be as much a master of the formal language of industrial scale and welded planes as of the rich transmogrification of images. Even in purely formalist terms the *Geometric Mouse* surpasses the works most celebrated by Greenberg and Fried at the time, and that is doubtless a conscious jab at the "Mickey Mouse" academicism of the formalists. Oldenburg sees the formal organization of an object with such remarkable objectivity (as if he can effortlessly turn the subject matter on and off in his mind) that it allows him to layer the content with an extraordinary complexity and interest.

Oldenburg had begun making models for monumental public sculptures as early as 1966, but it wasn't until a group of graduate students in the School of Architecture at Yale approached him in May 1969 that the idea really took hold. He built a 24-foot-high *Lipstick (Ascending) on Caterpillar Tracks* and delivered it to the Beinecke Plaza in front of the Yale president's office in the midst of a student demonstration. It was an unsolicited gift, which the university was at first not certain it wanted. The Yale monument had the quality of a happening, not only because of the dramatic and unpredictable circumstances of its arrival on the campus but because of the collaborative activity at Lippincott, where Oldenburg directed a team of men wielding heavy equipment to construct the piece. The improvisational procedure of testing ideas and reworking even in this final stage of fabrication gave the construction process a theatrical quality.

The formal idea for the monumental lipstick evolved from an early concept (on an altered postcard) to replace the Eros fountain in London's Piccadilly Circus with a cluster of giant lipsticks (clipped from a cosmetics advertisement). The idea is also a permutation of the *Geometric Mouse*, as shown in the lower left corner of the drawing *System of Iconography* (fig. 7.39). In its first incarnation the Yale monument had a collapsing, soft tip that would alternately blow up like a balloon and then deflate. At the height of the antiwar movement the sarcasm of the cosmetic/bullet/phallus was not lost on anyone, and after considerable vandalism the tip had to be reconstructed in steel.

In 1971 Oldenburg reestablished his studio in New York, moving down to Broome Street in SoHo, but he continued to direct the focus of his attention to large fabricated pieces. The work grew in ambition, and in the seventies he actually began to realize some of these ideas on an architectural scale. The *Clothespin* in the city center, Philadelphia [fig. 7.40], is a particularly brilliant example. Coosje van Bruggen, a Dutch museum curator, whom Oldenburg married in the early seventies, became an increasingly important collaborator in the realization of such huge civic projects, and in the late eighties they entered into collaboration with the Los Angeles architect Frank Gehry to carry Oldenburg's monumental aspirations into functional architecture. For *Camp Good Times*, in the Santa Monica Hills, Oldenburg proposed a

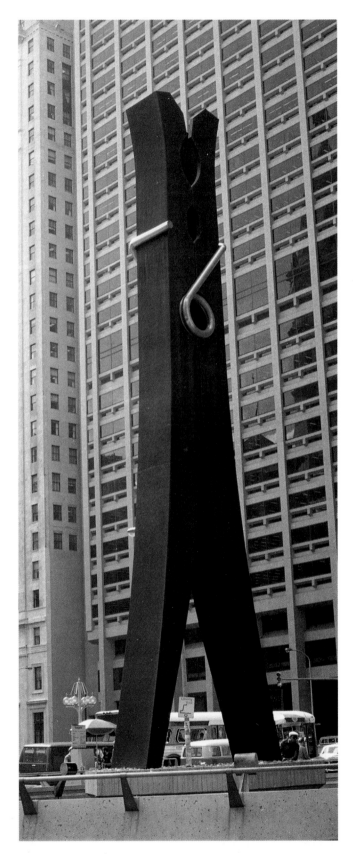

7.40 Claes Oldenburg, *Clothespin,* 1976. Cor-ten and stainless steel, 45ft 11³/₁₆in (14m) high.
Center Square, Philadelphia. Photograph © by Jonathan Fineberg.

pavilion in the form of a giant milk can, and for the Chiat/Day Offices on Main Street in Venice, California, Oldenburg proposed an entrance in the form of a pair of giant binoculars. With Gehry's genius for integrating visual incongruity, these representational forms have in each case been seamlessly blended into the complex of buildings. Constant to the premise of his work of the sixties, Oldenburg's work of the eighties and nineties continued to celebrate the power of the imagination to transform ordinary objects and the everyday environment.

Jasper Johns

"Nature" is How We Describe It

Advanced art, from Walt Whitman to Jackson Pollock, for the most part rested on the romantic assumption that meaningful subject matter emanates from within the individual. But the art of both Robert Rauschenberg and Jasper Johns called this notion into question. In an implicit attack on ontology they recast man as a nexus of information, reorienting input rather than originating content. By the end of the fifties the human mind began to seem to more and more artists and intellectuals like a complex circuit board for processing "nature." Meanwhile "nature" came increasingly to mean representations of things as well as the things in themselves. This radical shift in consciousness affected all quarters of the culture, with the explosive development in electronics and mass media being its major catalyst.

Marshall McLuhan, who became an intellectual celebrity after the publication of his book *Understanding Media* in 1964, pointed out that the electronic media (television, telephone, radio, and computers) had created a new environment, which altered the manner in which people experienced events. Moreover, this new way of apprehending information meant something, independent of the explicit subject matter in the programming. McLuhan's assertion that "the medium is the message"[87] stressed that meaning was vested in the very structure of advertising, say, over and above its ostensible subject. McLuhan had already begun to explore this idea in an earlier book called *The Mechanical Bride: Folklore of the Industrial Man*, which John Cage had read to Rauschenberg in the early fifties.

But McLuhan's books were only one focus of a wider cultural phenomenon. In another prominent example the title of an influential classroom textbook by the literary critic John Ciardi posed the declarative question *How Does a Poem Mean?* Ciardi asserted that "the way *in which* it means is *what* it means."[88] Like McLuhan he focused on the structure of the expressive vehicle (the poem) as a primary aspect of the "message"; he recognized that the "style" of the poem represented a point of view that was as important to the meaning as the explicit subject.

Painting as a Discourse on Language

In painting Jasper Johns formulated a pointedly nonintrospective style that stressed the complex semiotics of the art object (in other words, how it means what it means). For example, the painted targets by Johns [fig. 7.41] are so intractably literal that they almost *are* targets; at the same time the artist is ambiguously presenting them as painterly works of art, explicitly rendered in artistic materials. This substantially closed the gap between the thing and its representation. Moreover, the proximity of the target as a painting to the functional target brings to light the role of artistic intention in defining an object as a work of art. The detailed working of the surface and the restriction of the palette to the primary colors of red, yellow, and blue also foregrounds the artist's concern with analyzing the basic structural elements of the language of painting.

The visible newsprint that Johns used as a foundation for the thin layers of encaustic in a work like *Target with Plaster Casts* has prompted some writers to attempt to "decode" the texts.[89] However, as in the work of Rauschenberg, the evidence does not support an iconographic reading. Johns has said that "whatever printing shows has no significance to me. Sometimes I looked at the paper for different kinds of color, different sizes of type, of course, and perhaps some of the words went into my mind; I was not conscious of it."[90] Rather, the newsprint fragments attracted him because they convey the semiotic complexity (the sense of information overload) of media superimposition, as if one were watching two films running over one another.

The painted flag, as in *Three Flags* [fig. 7.42], is also an inherently flat subject, based on a formal scheme rather than a unique physical object that exists in the world. Perhaps even more than a target, a painted flat is the thing in itself, despite the materials. By making the boundaries of the canvas identical with the image, Johns eliminated any sense of composition, thereby leaving nothing but surface treatment as a basis for formal interpretation. In the same way the numbers and alphabets which Johns painted in the fifties cannot be representations, because by definition a number or letter is a concept with no unique material identity. Yet at the same time the prominence given to the handling of the paint seems to contradict this idea. In these paintings of targets, flags,

7.41 (opposite) **Jasper Johns,** Target with Plaster Casts, 1955. Encaustic and collage on canvas with objects, 51 × 44 × 3½in (129.5 × 111.8 × 8.9cm).
Collection, David Geffen. Photograph courtesy Leo Castelli Gallery, New York. © Jasper Johns/VAGA, New York, 1994.

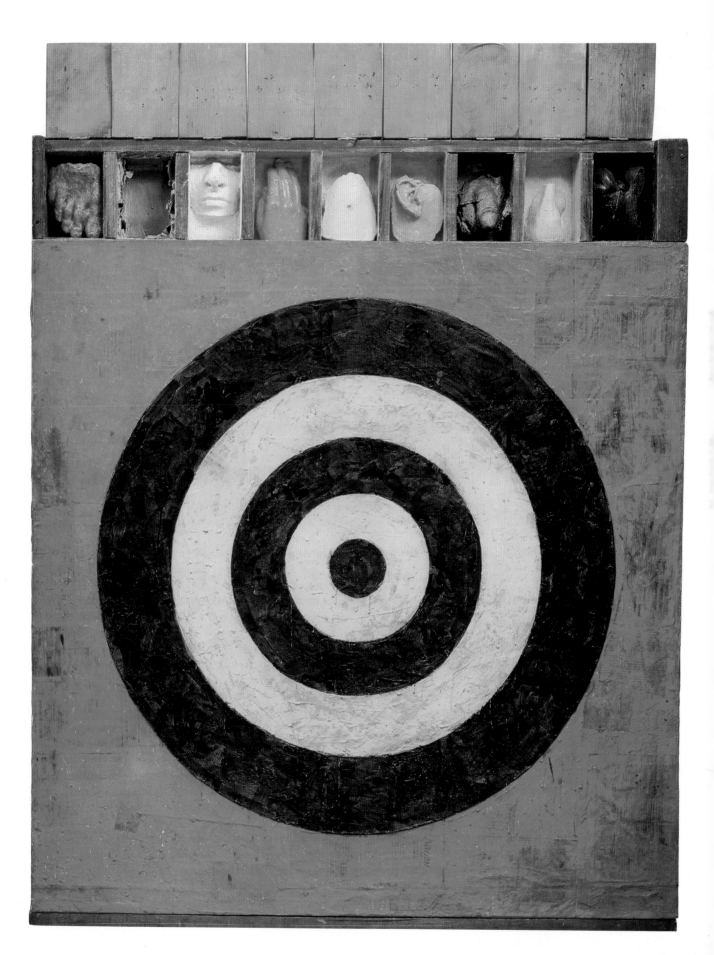

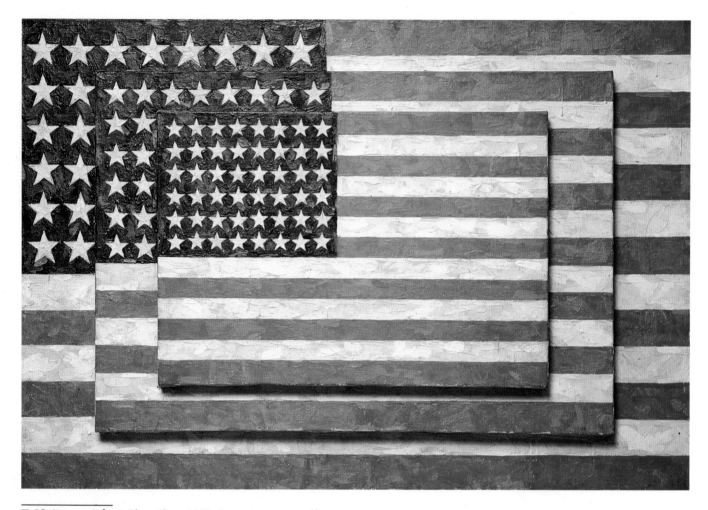

7.42 Jasper Johns, *Three Flags,* 1958. Encaustic on canvas (three levels), 30⅞ × 45½ × 5in (78.4 × 115.6 × 12.7cm).

Collection, Whitney Museum of American Art, New York. 50th Anniversary Gift of Gilman Foundation, Inc., Lauder Foundation, A. Alfred Taubman, an anonymous donor, and purchase. Photograph by Geoffrey Clements, New York. © Jasper Johns/ VAGA, New York, 1994.

letters, and numbers, Johns effectively posed a series of philosophical dilemmas concerning the language of art and the perception of reality. Moreover, the use of such prefabricated imagery tied art into mass-production and popular consumerism in an unsettling way.

An Aesthetic of "Found" Expression

At first glance the brushwork in these Jasper Johns works seems at odds with the literalness of the imagery. Not only did the artist use a sensuously tactile, gestural style, but the encaustic technique (heated wax mixed with pigment) further accentuates the individual identity of each brushstroke; since the hot wax solidifies almost instantly, it allows every touch of the brush to retain its identity without smearing under the pressure of the succeeding one. Nevertheless the beautifully applied surfaces of these paintings do not convey the charged

introspective mood of an abstract-expressionist canvas. They have a surface sensuality, making the artist seem more receptive to the world around him; he is engaged in experiencing and understanding what is there rather than recording an act of introspection. In this respect, the gestural handling also functions as an emblem of psychic expressivity rather than a vehicle for psychic expression. The handling reifies the gestural mark and thus normalizes action painting.

In one sense the general climate of painting in the fifties provided a foundation for such an approach. Rather than inventing a style "from scratch" in response to expressive needs, as Pollock, Newman, and de Kooning thought they were doing, the second-generation gesture painters of the New York School were conscious of inheriting autographic brushwork as a stylistic given. Johns pushed the logic of this situation one step further in making style itself an overt subject in his painting.

Modern artists, from Courbet to the New York School, had sought to make their technique and medium an increasingly transparent vehicle for their metaphysics. Picasso deconstructed solid objects and looked through them, into a deeper conceptual structure. Newman and Rothko wanted the viewer to experience a moment of

epiphany, a purely spiritual event that transcended the materials altogether, making them virtually disappear. Johns turned in the opposite direction. He stopped at what is literally there, enjoying the physical presence of the art object in all its concreteness. Johns was drawn to the rich ambiguity and uncertainty of meaning that exists in the object itself and in all the ways in which the object could be perceived. Each object seemed to offer multiple possibilities for interpretation, and he took pleasure in the sheer variety of that found environment, just as Cage did. "Do you use these letter types because you like them or because that's how the stencils come?" Leo Steinberg asked the artist in 1961. "But that's what I like about them, that they come that way."[91]

The work of Jasper Johns, then, is a way of seeing that is dominated neither by the tangible world outside the frame nor by the artist's intentions; it attempts to avoid imposing a hierarchy of meaning on events, and instead celebrates the full complexity of experience. "Intention involves such a small fragment of our consciousness and our mind and our life," Johns told David Sylvester. "I think painting should include more experience than simply intended statement." Painting, he said, should be a kind of ". . . fact that one can experience individually as one pleases . . . so that experience of it is variable."[92]

Emotion and Distance

In 1959 Johns told *Time* magazine that people should be able to look at a painting in the same neutral way that they look at any ordinary object, "the same way you look at a radiator."[93] But he later elaborated on this statement, saying, "I mean that one shouldn't approach a work of art with a preexisting attitude . . . [*laughing*]. But then someone pointed out to me that I had gone and boxed-in all my radiators, so you didn't see them!"[94] What you don't see in the work of Jasper Johns—the artist's own underlying emotions—is made poignant by its systematic absence.

Johns once remarked to one of his print publishers, Tatyana Grosman, that "when he was young he had so many desires and wishes, that he trained himself to think only of the present, and not of his wishes for the future."[95] From his own words, it seems that he has repressed a great deal of emotion. He is a shy person, nervous, remote, and impeccably polite. He speaks with controlled precision, often following on thoughtful silences. His intelligence is instantaneously obvious, and he focuses—whether on people in a conversation or on an idea in his work—with an unnerving attentiveness and an extraordinary sensitivity.

Jasper Johns came to New York in 1952 at the age of twenty-two. But it was not until the spring of 1954, when he met John Cage and Robert Rauschenberg, that Johns became part of the art scene. What remains of his work from 1954 demonstrates his interest in the improvisational assemblage or junk-art aesthetic of the time. When

someone pointed out the resemblance of his work to that of Kurt Schwitters—with which he was not then familiar—Johns destroyed everything and started again. He saw this as the point of transition into his professional career. "I decided to do only what I meant to do, and not what other people did. When I could observe what others did, I tried to remove that from my work. My work became a constant negation of impulses . . . I had a wish to determine what I was . . . what I wanted to do was to find out what I did that other people didn't, what I was that other people weren't."[96]

Johns deliberately distanced himself from abstract expressionism with the flags, targets, letters, and numbers. Despite the sensuality of the surfaces the targets and flags have a rigid order predetermined by definition and the others are grids. Even the individual brushstrokes in these works have a cool independence from one another, rather than a spontaneous interaction. "I didn't want my work to be an exposure of my feelings," he told Vivian Raynor. "Abstract expressionism was so lively—personal identity and painting were more or less the same . . . But I found I couldn't do anything that would be identical with my feelings. So I worked in such a way that I could say that it's not me."[97]

Yet on some level abstract expressionism did attract him, as one can see in his brushwork. He even told Roberta Bernstein that he used the title "Figure" for his paintings of numbers out of admiration for the figure paintings of de Kooning.[98] And as in the work of Rauschenberg, the persistent use of collage and found objects in Johns's work had to do with a desire for immediacy. Yet the artist's meticulous technical control, his detached analytical mind, and his masterful augmentation of the facticity of the art object itself distance him from direct experience. Indeed underlying all of Johns's painting is a grand tragedy, in the sense of Greek theater, based on the artist's perpetual pursuit of an ultimately unattainable, emotional immediacy.

Incorporating Objects: What One Sees and What One Knows

Across the top of *Target with Plaster Casts* [fig. 7.41] Johns recessed plaster casts of body parts into a row of little boxes with lids. One has to open the lids to uncover the "private" contents. The symbolism is a general evocation of the senses. Johns has always selected his motifs and devices with great deliberation and retained them indefinitely as part of an interconnecting repertoire of pictorial elements. He began making casts of body parts, for example, in 1953 and they have recurred intermittently in his work ever since, as in the 1964 *According to What* [fig. 7.51] and *Perilous Night* of 1982 [fig. 7.53]. These molds have persisted in Johns's *oeuvre* over the years in the same methodical way that he has repeatedly reworked compositional ideas like the flags, targets, and numbers.

In *Tango* of 1955 Johns included the literal presence of the title, stencilled on the surface as a tangible thing in itself, eliding the distinction between the object and the idea it expresses. He also attached a functioning music box to the back of the canvas which remains invisible and intangible except for the key projecting through the front of the painting and the sound. The incorporation of real objects by Johns drew on the assemblage styles of the fifties. But rather than attempting to capture the chaos of subjective experience, as Rauschenberg did, Johns employed objects in a meticulously controlled manner, taking one thing at a time and thoroughly digesting its meanings.

The flags have spanned Johns's career, beginning with the most straightforward first *Flag* (1954–5) and the monochromatic *White Flag* (1955) through the representations of the flag paintings themselves in the autobiographical "Seasons" series [fig. 7.54]. *Three Flags* [fig. 7.42] explores the conventions of pictorial space by making the smallest flag advance literally in space while it recedes perceptually by its sequence in the diminishing sizes of the three flags. The extreme thickness of the three-layered canvases makes *Three Flags* more like an object than earlier flag paintings, and yet at the same time it emphasizes the flatness of the image even more.

Whereas the shimmering surface of *White Flag* has the impressionist delicacy of Monet's *Waterlilies* (which went on view at the Museum of Modern Art in that year), *Three Flags* seems starkly cubist in its concern with the illusion of the picture plane. It follows on the display of Picasso's prewar works at the same museum in the "Picasso: Seventy-fifth Anniversary" exhibition of late 1957. One senses the struggle of the objects in early cubist Picasso to assert their full volumetric identity against the flattening and dematerializing pictorial system. The same tense conflict, between what one knows and what one sees, between the image and the rendering, and on the most fundamental level between the analytical detachment and the lingering traces of romanticism, can be found in Johns's *Three Flags* as well.

As an adjunct to the exploration of volume and solidity in paintings like *Three Flags* Johns also embarked on a series of small sculptures. Beginning with a *Light Bulb* and a *Flashlight* he selected common objects from a hardware store and covered them with a hard-drying material called "Sculpmetal." In these works Johns turned real things into art. But the ironic pun on illumination, both in the sense of elucidating puzzling aspects of the world and as part of an ongoing discussion of the effects of light in art, seems distinctly Duchampian.

The Paintings of 1959

Leo Castelli opened his gallery in May 1957 with a group exhibition that included work by both Rauschenberg and Johns, and then gave them both one-man shows early in 1958. The Johns show was an overnight sensation. The Museum of Modern Art, along with a number of important collectors, bought work, and *Art News* reproduced *Target with Four Faces* on its cover. The show made the artist an instant media celebrity.

In 1959 Johns veered even more directly into the metaphysics of painting. Images and objects ceased to determine his compositions, and instead he cultivated a more loosely brushed, "allover" style, sometimes swallowing up objects, as in *Thermometer* [fig. 7.45]. *Device Circle* [fig. 7.43] exemplifies this direct focus on the means of art, with its palette dominated by the primary colors (the fundamental colors from which all other colors can be made) and the incorporation of a stick, which the artist used as the "device" for inscribing the central motif of the "circle." At the same time he painted over the device, camouflaging it, and absorbing it into the composition. He then literally labelled the "device" and the "circle" in stencilled letters along the bottom edge. In one sense *Device Circle* is a schematic target, stressing the means of manufacture over the image. The brushwork is abstract expressionist in style, while the action painters' preoccupation with process is made more explicit and literal.

In *False Start* [fig. 7.44], Johns used oil rather than encaustic-over-newspaper, which he had been

7.43 Jasper Johns, *Device Circle*, 1959. Encaustic and collage on canvas with wood, 3ft 4in × 3ft 4in (1.01 × 1.01m).

Private collection. Photograph courtesy Leo Castelli Gallery, New York. © Jasper Johns/VAGA, New York, 1994.

7.44 (opposite) **Jasper Johns,** *False Start*, 1959. Oil on canvas, 5ft 7¼in × 4ft 8in (1.7 × 1.37m).

Private collection. Photograph courtesy Leo Castelli Gallery, New York. © Jasper Johns/VAGA, New York, 1994.

The Beat Generation: The Fifties in America

7.45 Jasper Johns, *Thermometer,* 1959. Oil on canvas with object, 51¾ × 38½in (131.5 × 97.8cm).
Collection, Mr. and Mrs. Bagley Wright, Seattle. Photograph courtesy Leo Castelli Gallery, New York. © Jasper Johns/VAGA, New York, 1994.

accustomed to using for the previous four years. The oil permitted a freer gestural style. Johns painted the surface as a weave of interpenetrating patches of primary colors and folded in the names of colors in stencilled lettering—an allusion to the use of lettering in the cubism of 1912 to 1914. But Johns pointedly incorporated the words for colors without rendering them in that color or even necessarily using the color in the area surrounding its name. Thus the painting highlights the dissonance between the name and the visual sensation (between what one knows and what one sees). In the monochromatic painting *Jubilee* (a nearly identical composition) Johns carried the idea one step further by completely eliminating color in visual terms, while retaining its presence in words.

The way in which Johns carried through the implications of such ideas from one work to the next suggests a highly controlled approach to painting, and he denied the possibility of chance events in the process: "There are no accidents in my work. It sometimes happens that something unexpected occurs—the paint may run—

but then I see that it has happened, and I have the choice to paint it again or not. And if I don't, then the appearance of the element in the painting is no accident."[99] Yet the fact that Johns almost never drew studies for a painting—his drawings of a composition nearly always follow rather than precede it—indicates the degree to which he works by improvisation. The wish to be in control and yet open to discovery is one of the central, animating contradictions in his work.

Thermometer [fig. 7.45] has the same palette and starburst pattern of gestural application as *False Start.* But instead of the names of primary colors being woven into a shallow cubist grid the artist has stencilled a scale of numbers flanking a real thermometer, fastened to the center of the composition. The thermometer effectively eliminates compositional movement, as in Barnett Newman's *Onement I* [fig. 4.13], with a perfectly symmetrical zip down the center. In the flags, targets, letters, and numbers, Johns had already done away with perspective, foreshortening, and modeling (the devices of illusionism). In addition, Johns conceived each of these compositions to be seen as a totality, like a Newman, rather than as an amalgam of interacting parts. Johns admired the transcendental dimension of Newman's work and *Thermometer* is a kind of homage. Although the color burst style of *Thermometer* and other works of 1959 is gestural, it is also formulaic rather than autographic like a de Kooning or Pollock. In this sense too it has an affinity with Newman's painting. Finally the concern with measurement in *Thermometer* has a corollary in Newman's measurements for the placement of the zip in his compositions.

At the same time Johns also makes fun of the legendary machismo of abstract expressionism in *Thermometer* by constructing the painting around a bulb, surmounted by a tall vertical (phallic) shaft with liquid rising in it. The contemporary *Painting with Two Balls* pokes fun at this aspect of abstract expressionism even more literally. The seemingly improvisational act of forcing the steel balls between two stretcher bars in *Painting with Two Balls* was in fact achieved with a specially constructed, curved stretcher that kept the canvas from wrinkling. In other words, it was not the impulsive act of the action artist.

In 1958 Johns discovered the work of Marcel Duchamp. He and Rauschenberg traveled to see the definitive collection of Duchamp's work in the Philadelphia Museum, and in 1959 the critic Nicholas Calas brought Duchamp himself to Johns's studio. For Johns and Rauschenberg Duchamp's readymades, in particular, meant that every object could be art, just as for Cage every sound could be music and complete in itself. The measuring stick in *Device Circle* alludes to Duchamp's preoccupation with irrational and chance standards of measurement, as in Duchamp's *Three Standard Stoppages* of 1913–14.

The New Emotional Tone of the Early Sixties

Painted Bronze [fig. 7.46] provokes the viewer to wonder at first whether the ale cans are really what they seem to be. Are they works of art or common objects? "I like that there is the possibility that one might take one for the other," Johns explained, "but I also like that with a little examination, it's very clear that one is not the other."[100] He deliberately gave these sculptures a hand-crafted look when viewed at close range, despite the initially effective *trompe l'oeil*; he cast each ale can and the base as separate objects and rendered the labels in a largely illegible, painterly style.

The subject was in part chosen for its familiarity. Ballantine Ale was not only Johns's regular beer, but the bronze color of the can added an extra measure of alluring ambiguity to the bronze casting.

I was doing at that time sculptures of small objects—flashlights and light bulbs. Then I heard a story about Willem de Kooning. He was annoyed with my dealer, Leo Castelli, for some reason, and said something like, "That son-of-a-bitch; you could give him two beer cans and he could sell them." I heard this and thought, "What a sculpture—two beer cans." It seemed to me to fit in perfectly with what I was doing, so I did them and Leo sold them.[101]

Johns put his thumbprint on the base of *Painted Bronze*. Like the painterly lettering, this emphasized the hand-made character of the sculpture in contrast to the machine-made object (the real can). But it also revealed a new emotional intimacy that entered Johns's work at this time, an introspectiveness which may have gained its impetus from his personal life.

Rauschenberg had gone off to Florida in 1959. He and Johns still shared a place in New York through 1961, but

they went their separate ways with increasing frequency. In the ale cans Johns portrayed himself and Rauschenberg—one open and light, the other solid, heavy, impenetrable. He painted the interlocking rings of the Ballantine symbol and lettered "Florida" on the top of the smaller, open can; he left the top of the closed can blank.

In 1961 Johns took a studio on Edisto Island, off the South Carolina coast. His fame in the art world had shattered his privacy in New York and contributed to his flight from the city; but the deterioration of his relationship with Rauschenberg probably lay at the heart of his move. The words "Dead Man" appear in Johns's 1961 painting *In Memory of My Feelings*, and although he took both the title and the phrase from a poem by his friend Frank O'Hara, he obviously used them to express his own feelings of mourning for the death of his relationship with Rauschenberg. The hanging fork and spoon appeared for the first time in this work and doubtless were a symbol for nourishment and the senses, in contrast to the intellect, as Richard Field has pointed out.[102]

The direct emotional engagement of *In Memory of My Feelings* characterizes the change of mood in the artist's work. Even the titles of that year—*In Memory of My Feelings, No, Water Freezes, Liar, Disappearance, Painting Bitten by a Man, Good Time Charley*—contrast markedly with the neutral, descriptive titles of the fifties. The frequently somber and searching paintings of 1962 and 1963 express anger and disappointment.

Like Rauschenberg, Johns became increasingly involved with performance in the sixties, and the objects in his paintings of the period take on a theatrical character. The cup hanging off the bottom of *Fool's House* [fig. 7.47] and the broom suspended from the top look like stage props. Johns had explored the idea of engaging the viewer's participation in *Tango* (where one needed to go up and wind the key to the hidden music box) and *Target with Plaster Casts* (which invited the viewer to open or close trap doors). In 1960 Johns even made a large-edition print of a blank target with an attached paint brush and three disks of watercolor paint, inviting the view to color in the target and sign his own name on the empty line to the left of the printed signature of Johns.

Explorations of Linguistic Philosophy

Where Rauschenberg selected and juxtaposed objects in his paintings in a spontaneous and improvisational manner, Johns did so with an unnerving deliberateness and focus. The cup suspended from *Fool's House* refers to the *trompe l'oeil* paintings of the nineteenth-century American artist John Frederick Peto. Johns inscribed "PETO" on another canvas entitled *The Cup We All Race 4*, after a composition of the same name painted by Peto around 1900 [fig. 7.48]. In fooling the eye, the works of Peto question the relationship between truth and appearance. Johns reworked

7.46 Jasper Johns, *Painted Bronze*, 1960. Painted bronze, two casts, 5½ × 8 × 4¾in (14 × 20.3 × 12.1cm).
Collection, Museum Ludwig Köln. Photograph courtesy Rheinisches Bildarchiv, Köln. © Jasper Johns/VAGA, New York, 1994.

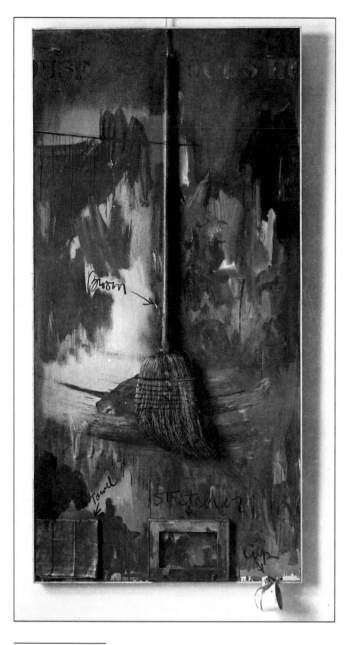

7.47 Jasper Johns, *Fool's House*, 1962. Oil on canvas with objects, 72 × 36in (182.9 × 91.4cm).
Collection, Jean-Christophe Castelli. Photograph by Rudolph Burckhardt, courtesy Leo Castelli Gallery, New York. © Jasper Johns/VAGA, New York, 1994.

the idea by transforming all the familiar kitchen objects in *Fool's House* into tools of the studio: black paint in the cup, a broom as a paint brush, and a towel as a paint rag. The persisting importance of illusionism as an issue in the work of Jasper Johns, however obliquely presented, stems from his interest in the relativity of reality.

Johns also contrasted what we know with what we see by confronting images with their names, as the Belgian surrealist René Magritte had done in, for example, his famous painting, *This is Not a Pipe*, in which he presents a naturalistic rendering of a pipe on a white ground with the

title inscribed in large letters below. "An object never performs the same function as its name or image," Magritte explained. But ". . . in a painting the words are of the same substance as the images."[103] In *Fool's House* Johns introduced handwritten labels, setting the word off against the depicted or real object. He also created a perceptual ambiguity in the pictorial space by lettering the title of the painting across the top in a manner that treats the canvas as a flattened cylinder: "USE FOOL'S HO."

Through the summer of 1961 Johns read substantially in the writings of the philosopher Ludwig Wittgenstein, who had a particular interest in the relation of thought and language to the world of things. Such questions began to attain particular currency among artists around 1960 as part of a growing antiontological mood. "You really get such a queer connexion," Wittgenstein remarked in his *Philosophical Investigations*, "when the philosopher tries to bring out the relation between name and thing . . . For philosophical problems arise when language *goes on holiday*. And here we may indeed fancy naming to be some remarkable act of mind, as it were a baptism of an object."[104] In *The Blue and Brown Books* Wittgenstein remarked: "The use of the word *in practice* is its meaning. Imagine it were the usual thing that the objects around us carried labels with words."[105] This is precisely what Johns did to the objects in *Fool's House* he literally realized Wittgenstein's remark. Moreover the "use"

7.48 John Frederick Peto, *The Cup We All Race 4*, c. 1900. Oil on canvas on wood, 25½ × 21½in (64.8 × 54.6cm).
Collection, Fine Arts Museums of San Francisco.

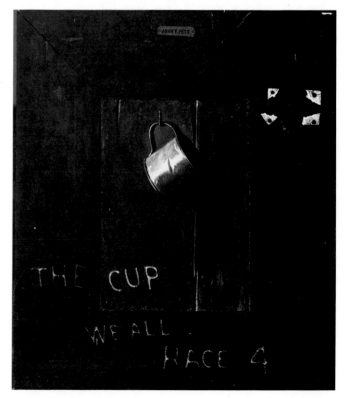

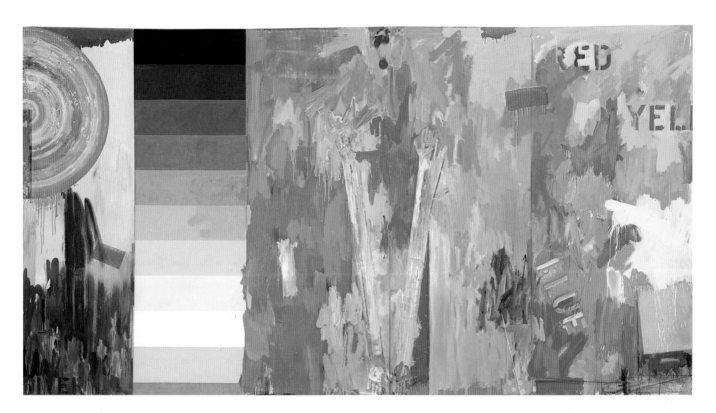

7.49 Jasper Johns, *Diver,* 1962. Oil on canvas with objects, 7ft 6in × 14ft 2in (2.29 × 4.32m) (five panels).
Collection, Irma and Norman Braman, Miami. Photograph courtesy Leo Castelli Gallery, New York. © Jasper Johns/VAGA, New York, 1994.

of, for example, the kitchen broom as a paint brush transforms its meaning in a manner made all the more apparent by the label.

The ease with which such shifts of identity and definition take place in the work of Johns suggests a detached world in which things have no intrinsic identity. In this Johns anticipated the stress on the defining role of the linguistic or interpretative context by the French poststructuralists. "I think the object itself is a somewhat dubious concept," Johns reflected, ". . . one wonders if one couldn't simply shift one's focus a bit in looking at a thing, and have the object be somewhere else, not be there at all."[106]

Diver of 1962

Johns attempted the mural scale of abstract expressionism and pop art for the first time in *Diver* [fig. 7.49], a 7½-by-14-foot painting of 1962. The tape measure extending along the bottom of the third and fourth panels provides a literally "measured" commentary on the scale. Placed symmetrically along the adjoining borders of these two panels, Johns set two footprints and four handprints, the latter connected to plank-like arms. He told the art historian Roberta Bernstein that the figure is making a swan dive and that the positions of the hands and feet indicated different stages of the action.[107] With small directional arrows he choreographed the diver's moves like those of a dancer. The diagrammatic and sequential schema indicates the artist's growing concern with time in painting, probably prompted by his concurrent work with the Merce Cunningham Dance Company.

In the upper left of the first panel of *Diver* Johns painted a multicolored "device circle." The second panel consists of a precisely drawn scale in gradations of gray, recalling the scale of color squares in Duchamp's *Tu'm* of 1919. In the lower corners of each panel Johns painted numbers that match up to the adjacent panel, making explicit the arrangement and the continuity across all five sections. In addition the third and fourth panels relate to the fifth on the right by their loose brushwork and saturated palette. The right-hand panel has the stencilled names of the primary colors—as in *False Start*—and a vertical bundle of cutlery held in tension by two chains pulling horizontally from the bottom two sides. The painterliness and the tableware (recalling *In Memory of My Feelings*) link this panel to the emotional work of the preceding three years.

Finally Johns has connected the fifth panel of *Diver* with the panel to the left by a blocklike bar of paint toward the top, so that it crosses the break between the canvases. This geometric gesture, with paint dripping down, stands out as a stylistic oddity for Johns, though it seems identical with a consciously articulated, recurring element in the work of Rauschenberg (as in *Rebus*, where it appears as a single bar of color, or *Canyon* [fig. 7.8] where it appears as an "X"). The critics Cranshaw and Lewis noted in their essay on Rauschenberg that this "short stroke with calculated dribbles" had been singled out by Johns as a device

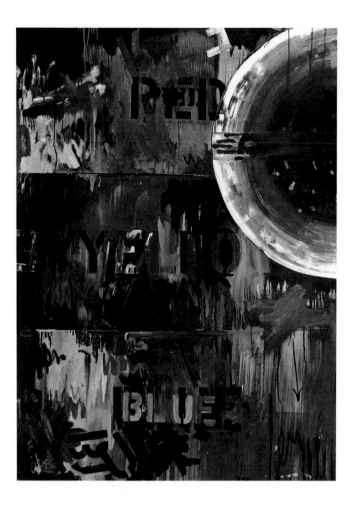

Rauschenberg used to integrate objects into the surface visually and he referred to these strokes as Rauschenberg's "hinges."[108] Thus in *Diver* Johns glanced retrospectively over the preceding three years, and he must have intentionally included the bricklike, dripping stroke as a reference to Rauschenberg, who had so much to do with setting him on this period of probing self-examination.

Periscope (Hart Crane)

Johns also found a sympathetic echo of his emotions in the charged poetry of Hart Crane. In "Cape Hatteras" Crane wrote:

The captured fume of space foams in our ears—
What whisperings of far watches on the main
Relapsing into silence, while time clears
Our lenses, lifts a focus, resurrects
A periscope to glimpse what joys or pain

7.50 (left) **Jasper Johns,** *Periscope (Hart Crane),* 1963. Oil on canvas, 5ft 7in × 4ft (1.7 × 1.22m).
Collection, the artist. Photograph by Rudolph Burckhardt. © Jasper Johns/VAGA, New York, 1994.

7.51 (below) **Jasper Johns,** *According to What,* 1964. Oil on canvas with objects, 7ft 4in × 16ft (2.24 × 4.88m).
Collection, Mr. and Mrs. S. I. Newhouse, Jr. Photograph by Rudolph Burckhardt, courtesy Leo Castelli Gallery, New York. © Jasper Johns/VAGA, New York, 1994.

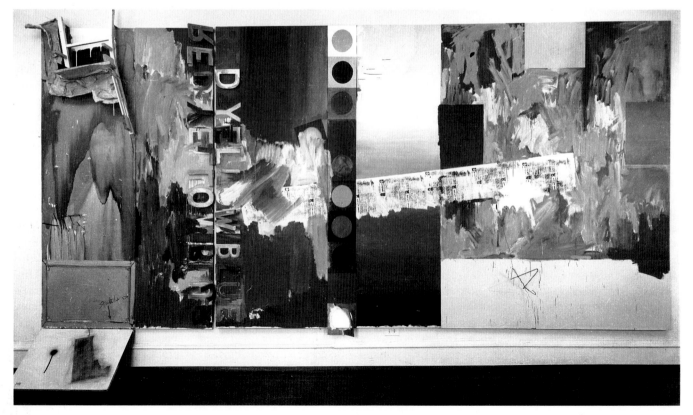

Our eyes can share or answer—then deflects
Us, shunting to a labyrinth submersed
Where each sees only his dim past reversed . . . [109]

John's painting *Periscope (Hart Crane)* [fig. 7.50] declares its relation to this poem, while elaborating on elements from earlier works: the "device circle" incorporating an arm and hand in place of the stick or ruler; and the division of the composition into three, with the names of the primaries lettered across each part in the manner of *Out the Window* (a painting of 1959 in which the "view" out the window is the words for the three primary colors instead of a direct view of nature). Rauschenberg's "hinge" also recurs here just under the "device circle." Cape Hatteras lies off the Carolina coast, where Johns had a studio. The back-to-front letters and perspective with the hands pressing out from within the canvas suggested the "dim past reversed."

The standard biography of Hart Crane, which Johns owned,[110] details the poet's suicide in 1932, when he dove into the ocean from a ship. The biographer described the vivid image of Crane's arm reaching up out of the sea as he disappeared. The disembodied hand and arm in *Periscope (Hart Crane)* reappeared as the "device circle" that marks the progression of life in the artist's autobiographical series of 1985 to 1986 called "The Seasons" [fig. 7.54]. This transformation of the painter's hand into a mechanical device, as well as the fragmentation of the body, imparts a sense of personal dissolution. As Johns remarked about *Land's End*, a closely related painting of the same year, "I had the sense of arriving at a point where there was no place to stand."[111]

The Perceptual Complexity of Looking

*A*ccording to What [fig. 7.51] is another major, mural-sized work. On the far left panel, Johns fastened a small canvas with the silhouette of Marcel Duchamp on the front, turned face down on the surface of this larger composition. This reveals the backside of the little canvas, on which Johns has inscribed the date, his signature, and the title "According to What." Above it, upside down, he has attached a cross-section of a real chair with a mold of a leg and buttock seated on it. "The shadows," he explained, "change according to what happens around the painting . . . Everything changes according to something, and I tried to make a situation that allows things to change."[112]

Johns sought out perceptual complexities and contradictions in the world of things and tried to capture the sheer multiplicity of it all in his work. Yet the consistency of his approach has given his work as a whole great coherence. As early as 1959 he articulated this idea in his "artist's statement" for the Museum of Modern Art's "Sixteen Americans" exhibition catalog: "At every point in nature there is something to see. My work contains similar possibilities for the changing focus of the eye." He also discussed "Marcel Duchamp's suggestion 'to reach the Impossibility of sufficient visual memory to transfer from one like object to another the memory imprint,'" which fed into Johns's idea of communicating perceptual complexity. And he concluded: "Generally, I am opposed to painting which is concerned with conceptions of simplicity. Everything looks very busy to me."[113]

The idea of composing a painting around a "changing focus" places the viewer where he or she is in reality, looking around in different directions, instead of transporting the viewer into an illusionistic space with a contrived single perspective. Johns's work illuminates the fact that we look at the world in fragments, from different perspectives, and in constantly changing contexts over time.

We look in a certain direction and we see one thing, we look in another way and we see another thing. So that what we call "thing" becomes very elusive and very flexible . . . It involves the way we focus . . . I tend, while setting one thing up, to move away from it to another possibility within the painting . . . the process of my working involves this indirect unanchored way of looking at what I am doing.[114]

In 1971 Johns executed a sequence of prints entitled "Fragments According to What," in which he systematically rethought individual parts of the painting. Johns has often used printmaking in this way: "I like to repeat an image in another medium to observe the play between the two: the image and the medium."[115] Johns made his first lithograph in 1960 at Tatyana Grosman's Universal Limited Art Editions (U.L.A.E.) workshop on Long Island. In the course of the decade he made over 120 more, and he has continued to make prints at that pace. His prints provide a running, critical commentary on his painted *oeuvre*, while also forming a kind of technically innovative, aesthetic dialog among themselves.

The Hatch Mark Paintings

*I*n the far left panel of a major transitional work of 1972, known simply as *Untitled*, Johns introduced a pattern of hatch marks which went on to dominate his painting from the end of 1973 until 1981. Johns told David Sylvester that he discovered the hatching on the way to the Hamptons (Long Island) for the weekend; he saw the pattern for an instant on a car passing in the opposite direction.[116] Most of the hatch paintings involve predetermined maps of repeating and non-repeating patterns that the viewer has to ferret out but that never lead to any deeper subject matter.

The right panel of *Corpse and Mirror* (in encaustic-over-newspaper) [fig. 7.52] mirrors the pattern of the left half (in oil). Johns also subdivided each half into three horizontal sections, perhaps alluding to the tripartite order of the "romantic" *Out the Window*. At the lines of division between sections he matched up the ends of the marks as in the surrealist game Exquisite Corpse. In this diversion a person makes a partial drawing of, for example, the head of a fantastic creature. He or she then folds the paper so that the next player cannot see it, and then marks the paper to

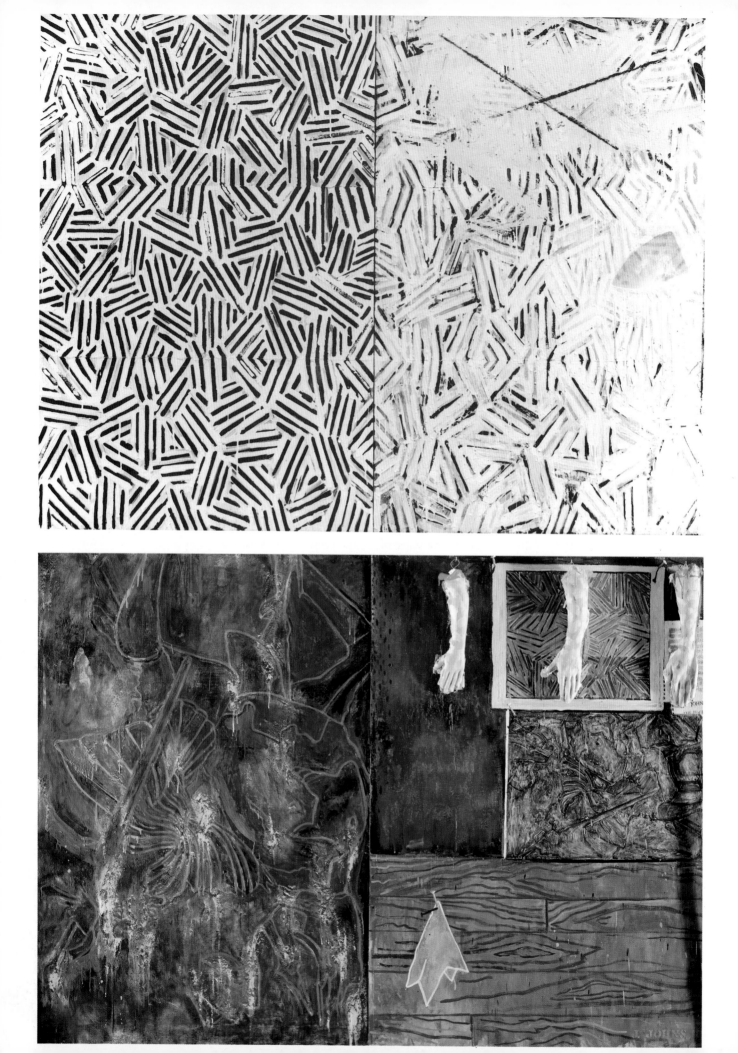

7.52 (opposite, top) **Jasper Johns,** *Corpse and Mirror,* 1974. Oil, encaustic, and collage on canvas, 4ft 2in × 5ft 8⅛in (1.27 × 1.73m).

Collection, Mrs. Victor Ganz. Photograph by Jim Strong, courtesy of the Leo Castelli Gallery, New York. © Jasper Johns/VAGA, New York, 1994.

7.53 (opposite, bottom) **Jasper Johns,** *Perilous Night,* 1982. Encaustic on canvas with objects, 67½ × 96 × 5½in (171.5 × 243.8 × 14cm).

Collection, Robert and Jane Meyerhoff, Phoenix, Maryland. Photograph courtesy of the artist. © Jasper Johns/VAGA, New York, 1994.

7.54 (right) **Jasper Johns,** *Summer,* 1985. Encaustic on canvas, 6ft 3in × 4ft 2in (1.91 × 1.27m).

Collection, Philip Johnson, Photograph by Dorothy Zeidman. © Jasper Johns/VAGA, New York, 1994.

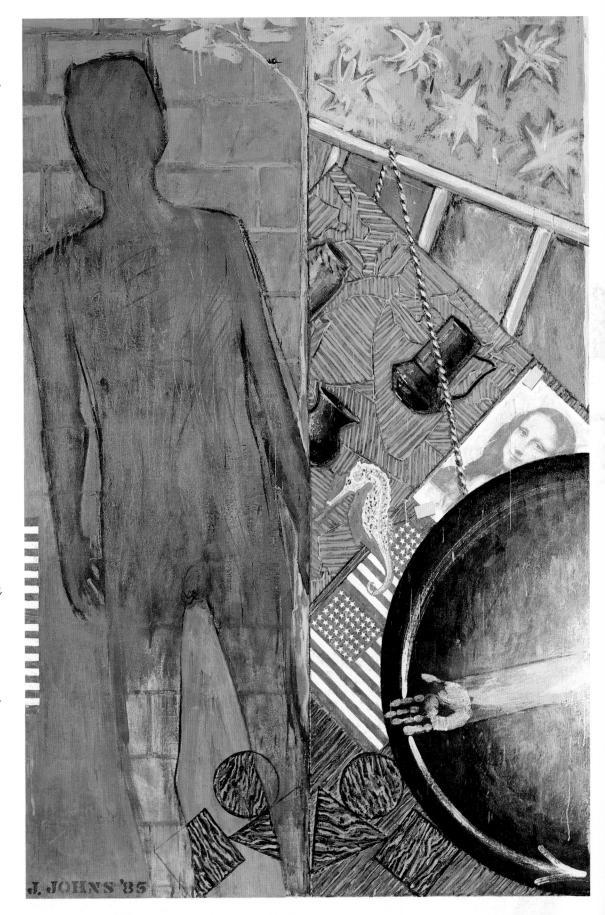

indicate where neck should begin. At the end the paper is unfolded to reveal the always surprising figure.

The iron mark in *Corpse and Mirror* refers simultaneously to the technique of applying encaustic, in which a warm iron is used to spread wax over the newspaper; to Duchamp's iconoclastic remark (cited by Johns in a 1960 essay) about using "a Rembrandt as an ironing board";[117] to the association of the form with a breast; and to a pun on "iron-y." The crossed lines suggest a reference to the top of the chocolate grinder in Duchamp's *Large Glass*, and with the iron and the pink zigzag they also establish the surface of the mirror.

Dropping the Reserve

In 1978 Johns remarked: "In my early work I tried to hide my personality, my psychological state, my emotions . . . but eventually it seemed like a losing battle. Finally one must simply drop the reserve."[118] In the next group of works it seems that Johns attempted to do just that. After abandoning the hatch

7.55 Jasper Johns, *Nothing At All Richard Dadd*, 1992. Graphite pencil on paper, 41¼ × 27½in (104.7 × 69.8m).
Collection of the artist. Photograph by Dorothy Zeidman.

pattern style in 1982, he pursued a more charged and personal subject matter directly, through a new kind of realism. He once again used cast body parts and depicted objects from his home and studio that were not neutral. The stick that casts a shadow over the right edge of *Perilous Night* [fig. 7.53] is related to Newman's zip, and for the first time, Johns seems to have been tentatively seeking the breath-taking confrontation in his art with what Newman called the "absolute emotions."

Inscribed, almost invisibly, into the left side of *Perilous Night* is a quotation from the Resurrection panel of Grünewald's early sixteenth-century *Isenheim Altar*. It shows a detail, oriented sideways and backwards, of the sleeping guard with his sword. The same "found" image is repeated, in the correct orientation and on a smaller scale, in the right center of the right panel, portrayed this time as a reproduction tacked to the studio wall. In the top register of the right side are three casts of arms camouflaged with a flagstone pattern of shadows, and the top of each arm is painted in a different primary color. The arms grow progressively larger and more adult from left to right: the first one hangs over an unarticulated, dark backdrop; the second arm over a rendering of one of the more expressionistic and later hatch-mark drawings by Johns (pinned to the wall with *trompe l'oeil* nails that recall the illusionistic devices of Peto); and the third over a score by John Cage for his 1945 composition *Perilous Night* (silkscreened directly on to the canvas). Below is an illustionistic handkerchief pinned to a horizontally panelled wall. The painting seems to concern the artist's personal confrontation with growing and aging and his accompanying emotional rites of passage.

From such paintings Johns launched into an explicitly autobiographical mode. In 1985 he decided to make an image for a volume of Wallace Stevens poems and painted *Summer* [fig. 7.54]. The seahorse marks the place in which he painted the work, his new studio on St. Maarten Island in the Caribbean; it also contains important motifs from other earlier paintings: George Ohr pottery (which he collects), the disguised "found" pattern from Grünewald, a Mona Lisa iron-on patch he acquired in the late sixties, the flags, and the device circle/arm from *Periscope* [fig. 7.50]. In addition, he included building blocks of the basic geometric shapes floating at the bottom.

Johns was inspired by a reproduction of Picasso's 1936 painting, *The Minotaur Moves his House*,[119] showing the minotaur pulling a cart which holds a ladder, a painting, an olive branch, and a horse giving birth all tied in place with a rope. The minotaur looks back at the cart full of symbols as he traverses the barren landscape under the expressionistic stars. The ladder, the painting, and the handprint from *Periscope* (which may stand for the birth of a new emotional frankness in Johns's paintings) are tied together with a rope in the right half of *Summer* under Picasso's stars. On the left is a shadow traced from Johns's own body. The curator Judith Goldman pointed out that Picasso's 1953 painting *The Shadow* provided a prototype

for the artist's shadow in *Summer*. In this painting Picasso depicted himself, shortly after the departure of his longtime companion Françoise Gilot, as a shadow looking into the bedroom he had recently shared with her. Johns went on to paint three more panels to make up a series of "The Seasons" in 1986. All are either bisected in the middle or composed in some modular relation to the middle, like the paintings of Newman, and include the shadow of himself—surrounded by artifacts of his life as a painter—in the four seasons of life.

"I resent my continuing dependence on preexistent forms,"[120] Johns told an interviewer as recently as 1987, and yet he continues to appropriate them. But the delicate pencil drawing, *Nothing At All Richard Dadd* [fig. 7.55], may suggest a way out. Here Johns portrays elements from the paintings of *The Seasons*, as though discarded into a heap in the lower right corner: the ladder, the stick-figure hanged man, the *chute de glace* sign, the blocks and the silhouette of the child that appear in various of the canvases. The central image, half hidden under the network of lines, is the floor plan of a house. "The plan," he told me, "is my attempt to remember the plan of my grandfather's house, where I lived for a number of years during my childhood."[121] But what of the title, evoking the nineteenth-century painter who murdered his own father? Has Johns discarded the more removed symbols, the "preexistent forms" of *The Seasons* in favor of the more particular feelings of his own memories? Has he reopened the buried emotions of childhood in his work of the nineties?

From one perspective Johns's whole career is built on borrowed images and emotions (always seeking himself in an already formed expression from outside himself, as though to keep his distance from the specificity of his own emotions); to sense one's life in this way is a helpless and terrifyingly empty feeling. This is, however, precisely what gives Johns's work such poignancy and universality. It throws one into confrontation with large philosophical questions of knowing and remembering, of integrity (in the sense of personal wholeness), as against the overpowering forces of dissolution that we encounter in the contemplation of what Barnett Newman called "the absolute emotions." Through painting, Johns has always seen the things around him and let one visual fact lead to another in an intuitive process that emphasizes the vital experience of looking *per se* and, in looking, of being alive. But now in his work of the turn of the century he has perhaps found another kind of vitality on a new level of intimacy. That has never been his intention, but as he said:

One has to work with everything and accept the kind of statement which results as unavoidable . . . one wants from painting a sense of life. The final suggestion, the final statement, has to be not a deliberate statement but a helpless statement. It has to be what you can't avoid saying, not what you set out to say . . . it should match what one is . . .[122]

8

THE EUROPEAN VANGUARD OF THE LATER FIFTIES

Nouveau Réalisme

Yves Klein's Romanticism

The 1956 performance of the costumed Georges Mathieu making action paintings before an audience at the Théâtre Sarah Bernhardt in Paris had a catalyzing effect for French artists, just as Kaprow's first happenings did for artists in New York at the end of the fifties. Like Kaprow, Mathieu made action painting the basis for greater direct engagement and a new theatricality. Between 1958 and 1962 the art actions of Yves Klein infused this theatricality and the tendency toward a more directly physical expressionism with an aura of mysticism that tied them into the traditions of European romanticism. Klein sought a flash of spiritual insight for his viewers, in which he was the medium of revelation: unlike the American action painter's revelation of personal identity, Klein's work purported to evoke an intuition into the cosmic order.

In 1948, the twenty-year-old Yves Klein discovered a book by Max Heindel called *La Cosmogonie des Rose-Croix*. Heindel's book provided the key to the teachings of the Rosicrucianists, an esoteric Christian sect, which Klein studied obsessively for five years. According to Heindel, the world was approaching the end of the Age of Matter, when Spirit lies captive in solid bodies.[1]

Soon after coming to Paris in 1955, Klein began referring to himself as an "initiate," seeking to guide the world into a new "Age of Space," in which "Spirit" would exist free of form, objects would levitate, and personalities would travel liberated from the body. Blue embodied Heindel's new age and also Klein's imagined freedom of the sky. As self-appointed "Messenger of the Blue Void," Klein aspired to enter into the world of color, to exist as a color. Where form and line signaled separateness and limitation, color embodied spirit that had coagulated enough to be visible but not enough to precipitate into form. Color expressed unity, openness, enlightenment—the wholeness and infinity of space. "I espouse the cause of Pure Color, which has been invaded and occupied guilefully by the cowardly line and its manifestation, drawing in art," he proclaimed. "I will defend color, and I will deliver it, and I will lead it to final triumph."[2]

Klein had started painting seriously in Spain, where he had spent ten months prior to his arrival in Paris. His paintings each consisted of a single color, uniformly applied, edge-to-edge [fig. 8.1]. After the rejection of an orange "monochrome" from the 1955 Salon des Réalistes Nouvelles in Paris, Klein sought out the young critic Pierre Restany to help him obtain a gallery show. According to Restany they met in a café, and Klein explained to him the "diffusion of energy in space, its stabilization by pure color, and its impregnating effect on sensitivity."[3] Klein intended the monochrome painting to fix a focus for the cosmic energies traveling through space: it was to provide a locus of intuitions

8.1 Yves Klein, *Untitled Blue Monochrome (IKB)*, 1959. Dry pigment
in synthetic resin on paper, 8½ × 7⅛in (21.6 × 18.1cm).

Menil Collection, Houston. Photograph by Hickey-Robertson. © 2000 Artists Rights Society
(ARS). New York/ADAGP, Paris.

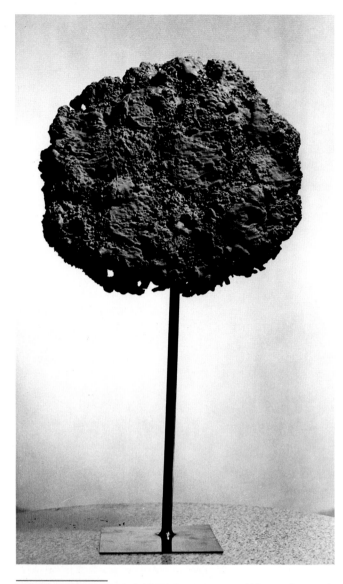

8.2 Yves Klein, *Untitled*, 1957. Sponge, painted blue, on brass-rod stand, 22⅝ × 12½ × 4⅝in (57.5 × 31.8 × 11.7cm), including brass rod, 15in (38.1cm) high × ¾in (1.9cm) diameter, and brass base, ⅛ × 5¼ × 6in (0.3 × 13.4 × 15.2cm).

The Museum of Modern Art, New York. Gift of Philip Johnson. © 2000 Artists Rights Society (ARS), New York/ADAGP, Paris.

which could not be formulated. "The authentic quality of the picture, its very being," according to Klein, "lies beyond the visible, in pictorial sensitivity in the state of prime matter."[4]

"Yves the Monochrome," as he called himself, employed pure pigments, gold leaf, the female body, fire, and water in his art, and in 1958 turned to completely immaterial works in an ongoing effort to become conscious of and hold on to his revelation of the infinite. He persistently spoke of the "impregnation" of spiritual vibrations in a space or a thing (as in the Rosicrucian doctrine of Spirit impregnating solid objects). In 1957 he began using sponges [fig. 8.2] as a metaphor for this spiritual permeation of matter. He mounted them on rods and used them in monochrome reliefs.

At first Klein made his "monochrome propositions" (as Restany called them to emphasize their philosophical and immaterial nature) in a variety of colors. In 1956 he limited his palette to an ultramarine blue, then broadened the palette to blue, pink, and gold (the Rosicrucian trilogy of the colors of fire). Klein had a Paris gallery show in 1956. In January 1957 he launched *l'Epoca Blu* (*The Blue Epoch*) in the Galleria Apollinaire in Milan, where it irrevocably altered the career of the Italian artist Piero Manzoni. In May he had two Paris shows at the Iris Clert and Colette Allendy Galleries simultaneously, in June he exhibited in Düsseldorf (the Zero Group came together in Cologne during 1957, influenced by Klein), and in late June he opened a one-man show in London. Thus, he successfully orchestrated his entrance on to the European scene as though everywhere at once.

Le Vide

Klein went beyond the monochrome to pure immateriality in *Le Vide* (*The Void*) of 1958. For this April "exhibition" he cleaned out and whitewashed the Galerie Iris Clert, "impregnating" the empty space with his spirituality. By arranging to get a cabinet minister on the guest list he succeeded in having Republican Guards in full regalia flanking the door at the opening and nearly 3,000 visitors turned up.[5] The streets were so crowded that police and fire trucks were called to the scene.

After some time, Klein appeared at the door in formal dress and began guiding small groups into the vacant gallery. Many burst out laughing and walked right out, others found *Le Vide* deeply moving and stayed for hours. The writer Albert Camus wrote in the guest book "with the void, full powers."[6] Meanwhile, glasses of a blue drink were offered to those waiting outside, as at a church sacrament. Klein had had the liquid concocted with a biologist's stain so that after the opening everyone who drank it had blue urine for a week.[7]

The "Living Brush"

A little more than a month later, on June 5, 1958, Klein performed his first "Living Brush" painting in a posh apartment on the Isle Saint-Louis in Paris. In this performance a nude model applied blue paint to her torso and then pressed the paint on to the canvas on the floor, directed by the artist. As Klein explained:

I had rejected the brush long before. It was too psychological. I painted with the roller, more anonymous, hoping to create a "distance" between me and my canvases, which should be at least intellectual and unvarying. Now, like a miracle, the brush returned, but this time alive. At my direction, the flesh itself applied the color to the surface, and with perfect exactness. I could continue to maintain a precise distance from my creation and still dominate its execution. In this way I stayed clean. I no longer dirtied myself with color, not even the tips of my fingers. The

work finished itself there in front of me with the complete collaboration of the model. And I could salute its birth into the tangible world in a fitting manner, in evening dress. It was at this time that I noticed the "mark of the body" after each session. They disappeared again at once, since the whole effect had to be monochrome . . . evidence of hope for the permanence (though immaterial) of the flesh.[8]

The apartment in which Klein staged the first "Living Brush" painting belonged to Robert Godet, a former Resistance fighter, a pilot, and a fifth-degree black belt in judo. Klein himself was a fourth-degree black belt and this may be how they knew one another. Godet was also a disciple of Gurdjieff and deeply involved in the occult and in Eastern religions. It was rumoured that Godet supported his high lifestyle from gun-running money and indeed he accidentally killed himself in 1960 on the airfield in Benares, India, while preparing to deliver a planeload of arms to Tibetan revolutionaries. Klein must have seen some of his own fantasies of adventure lived out in Godet.

In February 1960 Klein began leaving the blue imprint of the models' bodies on the canvases, rather than covering the whole of each canvas in a monochrome field. He called the resulting series of paintings "Anthropométries" [fig. 8.3]. The most celebrated public performance of the "Living Brushes" was on March 9, 1960 [fig. 8.4]. Attired in blue formal wear and his ceremonial cross of the Order

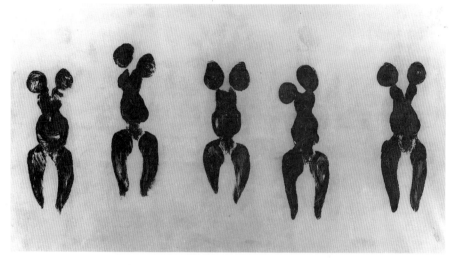

8.3 Yves Klein, *Anthropométrie de l'époque bleue (ANT 82), 1960.*
Pigment in pure synthetic resin on paper mounted on canvas, 5ft 1⅝in × 9ft 3¼in (1.57 × 2.83m).

Collection, Musée National d'Art Moderne, Centre Georges Pompidou, Paris. © 2000 Artists Rights Society (ARS), New York/ADAGP, Paris.

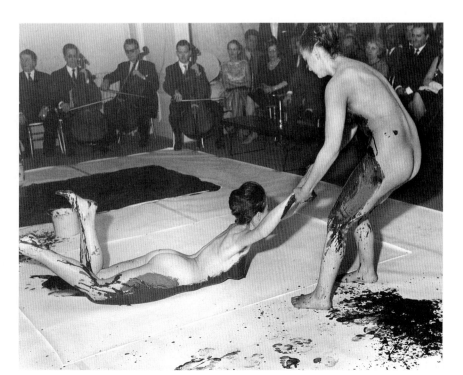

8.4 Yves Klein, *Performance: Anthropométries de l'époque bleue,* March 9, 1960.
Performance, Galerie Internationale d'Art Contemporain, Paris.

Photograph © by Harry Shunk, © 2000 Artists Rights Society (ARS), New York/ADAGP, Paris.

of St. Sebastian (an ancient fraternity of knights he had joined), he appeared before a seated audience at the Galerie Internationale d'Art Contemporain. He gestured to the orchestra, and they began to play his *Monotone Symphony* – a single chord held for twenty minutes, followed by twenty minutes of silence. He gestured again and three naked women came out, smeared themselves with blue paint, and, under his direction, pressed their bodies against sheets of white paper on the floor and wall. Klein never touched the work, remaining at a pure, "immaterial" distance.

Seeking Immateriality

Meanwhile in 1959 Klein pushed still further into the terrain of immateriality. At an exhibition in Antwerp he stood in the space allotted for his work and read a passage from the writings of Gaston Bachelard, impregnating the space with his spiritual vibrations. In August, when he decided to abandon Iris Clert for a more established dealer, he did not tell her directly but went into the gallery, picked up his work and told Clert's assistant that his paintings were invisible and that prospective purchasers should simply write her a check. To her surprise, the very first person to whom she told this agreed to do it, so Klein devised his *Ritual for the Relinquishing of Immaterial Zones of Pictorial Sensibility*. On November 18, 1959 the buyer met the artist on the quai of

the Seine, delivered a prescribed quantity of pure gold in exchange for an "immaterial zone of pictorial sensibility" and received a receipt which, following the terms of the agreement, the buyer solemnly burned. The artist then threw half the gold into the river and the entire transaction was recorded in photographs.

Despite this relentless drive toward the elimination of the object in art, the female form continued to demand Klein's attention. He made some of his "Anthropométries" by spraying paint around the form of the model to produce a negative imprint that has associations with the paleolithic handprints in the caves at Pech-Merle and Lascaux [fig. 8.5]. He also sprayed models with water, had them press themselves on to the canvas, and then attacked the surface with a flame thrower to leave a haunting imprint which he likened to the human shadows left on the walls after the explosion in Hiroshima: "In the desert of the atomic catastrophe they were a terrible proof of the immaterial permanence of the flesh."[9]

In 1959 the Belgian artist Pol Bury published a volume of Klein's writings, which are filled with his visions of ushering in the new age of telepathy, levitation, and

8.5 Yves Klein, *Ant (hropométrie) 96. People Begin to Fly, 1961.* Oil on paper mounted on canvas, 8ft 2½in 3 13ft½in (2.5 × 3.98m). Menil Collection, Houston. Photograph by Paul Hester. © 2000 Artists Rights Society (ARS), New York/ADAGP, Paris.

8.6 Yves Klein, *Leap into the Void,* near Paris, October 23, 1960.

Photograph by Harry Shunk. © 2000 Artists Rights Society (ARS), New York/ADAGP, Paris.

immateriality. This publication intensified Klein's commitment to live up to his proclamations. He not only sold invisible paintings, but to establish his credibility as the highest initiate and "Messenger of the Age of Levitation," he began planning a public demonstration of flying. "He was sure he could fly," his girlfriend Rotraut later reported. "He used to tell me that at one time monks knew how to levitate, and that he would get there too. It was an obsession. Like a little child, he really was convinced he could do it."[10] The artist Jean Tinguely, who became friends with Klein in 1955, also remarked on that aspect of his character: "He read comic books and talked about knights and the Holy Grail. Those marvelous things that exist in the world of a child still worked for him."[11]

Klein asked Pierre Restany to come to his apartment on January 12, 1960 for a matter of importance. Restany arrived late to find the artist on his way back from a demonstration of flying, limping slightly and in a state of ecstasy at having accomplished the feat of levitation! Restany was intended to have been a credible witness. Klein's girlfriend at the time, Bernadette Allain, did see the leap but later remarked that for a judo black belt, trained to fall without injuring himself, it was not spectacular.

When Klein reported his feat he was ridiculed and disbelieved, so in October he arranged another leap into the sky from the second story of a building of an undisclosed location in Paris. He selected a visually unidentifiable spot across from a judo studio and arranged for a group of judokas whom he trusted to hold a tarpaulin to catch him. He then had the photographers created an altered photograph that cut out the net and swore them to secrecy. On Sunday November 27, 1960, the magnificent picture of Klein's *Leap into the Void* (captioned "The Painter of Space Hurling Himself Into the Void") [fig. 8.6] appeared on the front page of a four-page newspaper called *Dimanche, le journal d'un seul jour* (*Sunday, the newspaper of a single day*), which Klein created and distributed to newsstands across Paris. However contrived the actual event, the realization of this gesture expressed magnificently Klein's aesthetic appropriation of all of space and its contents. It was a simultaneously frightening and exhilarating anticipation of dematerialization into the womb of infinite space, the void.

Klein's Demise

In 1959 Klein ceased teaching judo, by which means he had then been supporting himself. His "beautiful megalomania,"[12] as Tinguely called it, veered further out of control and even his relationship with Rotraut came under stress. Early in 1961 she and Klein went for two months to New York for a show of his work at the Leo Castelli gallery but the critical reception was a disaster. His mood was darkening. Back in Paris he started to make "Anthropométries" with blood; he was preoccupied with death and associated it with his progress toward dematerialization. Then he received news that a Japanese artist, influenced by him, had killed himself by leaping from a high building in Tokyo on to a canvas. He was also still suffering from the humiliating portrayal in a film by Claude Chabrol of "an artist" making "Anthropométries": clearly the film-maker did not see it as art.

Rotraut became pregnant at the end of the year, and on January 21, 1962 they had a magnificent church wedding attended by the Knights of St. Sebastian in full dress. But in the spring he suffered another stinging humiliation at the Cannes Film Festival when he went to see footage of himself making "Anthropométries" in the film *Mondo Cane* and found that he had been portrayed like a freak in a

8.7 (above) **Arman,** *Large Bourgeois Refuse,* 1960. Trash in a glass box with wooden base, 25¾ × 15¾ × 3¼in (65.4 × 40 × 8.3cm).
Collection, Jeanne-Claude Christo and Christo, New York. Photograph by eeva-inkeri, courtesy the artist. © 2000 Artists Rights Society (ARS), New York/ADAGP, Paris.

8.8 (left) **Jacques de la Villeglé,** *Rue de l'Electronique,*
8 July 1961. Torn posters mounted on canvas, 62¼ x 46 in (158 x 117 cm).
Courtesy Galerie Georges-Philippe et Nathalie Vallois, Paris. © 2000 Artists Rights Society (ARS), New York/ADAGP, Paris.

8.9 (opposite) **Jean Tinguely,** *Baluba III,* 1961. Motor-driven scrap metal, with feather, wire, rubber belts, bells, and electric light on a wooden base, 4ft 8¾in (1.44m) high
Collection, Museum Ludwig Köln. Photograph courtesy Rheinisches Bildarchiv, Köln. © 2000 Artists Rights Society (ARS), New York/ADAGP, Paris.

sideshow. In mid May he suffered a heart attack after an agitated public exchange on a panel at the Museum of Decorative Arts in Paris and on June 6, 1962 his heart gave out, ending "The Monochrome Adventure."

The *Nouveaux Réalistes*

The critic Pierre Restany and the artists Arman, François Dufrêne, Raymond Hains, Yves Klein, Martial Raysse, Daniel Spoerri, Jean Tinguely, and Jacques de la Villeglé founded *Nouveau Réalisme* (New Realism) in a manifesto of October 27, 1960, issues from Yves Klein's Paris apartment. César and Rotella were invited but not present, while Niki de Saint-Phalle, an American expatriate who later married Tinguely, and Gérard Deschamps were also associated with these artists if not formally in the group. The young Christo was friendly with several of them and shared their inclination toward the appropriation of the real environment, but also never formally joined the group.

Whereas Klein's aesthetic subsumed the entire cosmos, Arman created collections of cast-off earthly materials in his "Poubelles" ("Garbage Cans") [fig. 8.7]. For his famous exhibition "Le Plein" ("Full Up") at the Galerie Iris Clert in 1960, Arman filled the gallery from floor to ceiling with accumulated trash that he had found. The title suggests a direct response to Klein's *Le Vide*.

César became famous for compressing whole automobiles into crushed blocks of supercondensed junk metal. Rotella, Dufrêne, de la Villeglé (fig. 8.8) and sometimes Hains made their compositions by tearing off layers of posters (*affiches* in French) that had accumulated on top of one another. The complex, abitrary layering of fragmentary images and texts in the work of these *affichistes* has come to seem increasingly prescient of the information overload as we enter the new century. Spoerri, Deschamps, and Hains assimilated other kinds of found materials, on occasion creating walk-in installations. Christo's appropriations involved wrapping and stacking collections of found objects but they evolved into a broader attack on the definition of art, to which we will return in Chapter 11. Niki de Saint-Phalle's work evolved from a kind of funk assemblage, resembling that of the early Dine, to a signature vocabulary of funky black female figures with brashly colored detailing. Martial Raysse increasingly used the vocabulary of pop commercial graphics with often ironic subjects from classical painting.

Jean Tinguely—after Klein, the most important signatory of the *Nouveau Réalisme* manifesto—evolved a junk art aesthetic [fig. 8.9] from an interest in motion and impermanence, accident, and indeterminacy. With an ironic iconoclasm, his "meta-matics" were comically collaged machines that mechnically painted "abstract expressionist" pictures. Other works involved radios, lights, and motorized mechanisms that jerked this way and that in an energetic display of pointless activity. Often he even invited the viewer to participate in his carnival-like contraptions.

8.10 Jean Tinguely, *Homage to New York,* 1960. Self-destructing installation in the garden of The Museum of Modern Art, New York. Photograph © by David Gahr. © 1994 Artists Rights Society (ARS), New York/ADAGP, Paris.

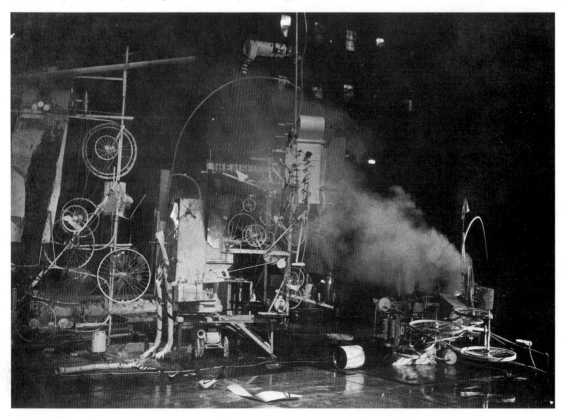

His most celebrated triumph was his *Homage to New York* [fig. 8.10] which, after extensive negotiation, the Museum of Modern Art agreed to have inaugurated in its sculpture garden on March 17, 1960. *Homage* was a giant motorized junk assemblage which included a weather balloon, a klaxon horn, fifty bicycle wheels, a piano, chemicals that emitted horrible smells and smoke at some unpredictable moment, and motors. He painted the entire construction white because, as he confided to Peter Selz (the curator in charge), he wanted the *Homage* to be so beautiful that people would be dismayed when it began to destroy itself (which it was designed to do).[13]

The Museum gave him use of the Buckminster Fuller dome, then in the garden, and he worked under there in the chilling New York weather for three weeks. Dr. Richard Huelsenbeck, the Berlin dadaist who had subsequently become a psychiatrist in New York, introduced Tinguely to a crowd of like-minded artists, including Rauschenberg, Stankiewicz, and Chamberlain, to cheer him on. Rauschenberg even produced a machine that threw money, to be set off as part of the event.

The night of the inauguration was cold and drizzly. Watched by the Governor of New York along with various dignitaries and socialites in black tie, Tinguely started the machine. By accident he had attached the belt backwards on the paper roll for the painting machine; it immediately rolled the paper up and began flapping instead of making "automatic" drawings. From there the whole contraption took on an unpredictable life of its own, like all Tinguely machines. It created a tremendous din and flames began to emerge from the piano, where a can of gasoline had been set to overturn on a burning candle. Then, as Calvin Tomkins recounted it, a "small carriage suddenly shot out from under the piano, its klaxon shrieking, and smoke and flames pouring from its rear end. It headed straight for the audience, caromed off a photographer's bag, and rammed into a ladder on which a correspondent for *Paris-Match* was standing; he courageously descended, turned it around, and sent it scuttling into the NBC sound equipment."[14] Things got sufficiently out of control to frighten museum officials, who visualized the entire building on fire, and called in firemen to quench the blaze.

"I'll tell you what's going to happen," Marcel Duchamp announced. "The public will keep on buying more and more art, and husbands will start bringing home little paintings to their wives on the way home from work, and we're all going to drown in a sea of mediocrity. Maybe Tinguely and a few others sense this and are trying to destroy art before it's too late."[15]

Joseph Beuys

The center for advanced art in the divided postwar Germany evolved in the adjacent cities of Köln and Düsseldorf, on the axis of the industrial Ruhr and North Rhine Valleys. French art dominated the German scene until well into the fifties. The expressionistic use of materials in *l'art informel* and the gestural individuality of *tâchisme* provided the context for the reception of Wols [fig. 6.4], the most admired new German artist of the period. Then American abstract expressionism arrived, profoundly influencing both abstract and figurative painting. In 1957, Yves Klein also became well known in Köln and Düsseldorf, where he inspired Heinz Mack, Günter Ücker [fig. 10.28], and Otto Piene to found the group "Zero" in 1958. But Joseph Beuys was the first artist to emerge in postwar Germany and achieve international celebrity based on the exploration of his German identity. As early as Roman times, observers have consistently commented on the mysticism and the sense of closeness with nature in German culture. Both are central to the work of Beuys.

Born in 1921, Beuys grew up in the small town of Cleves, near the Dutch border. As an adolescent he ran away with the circus and learned to perform stunts. Then at nineteen he joined Hitler's *Luftwaffe*. Certain traumas associated with the war created an internal crisis for Beuys that remained at the thematic core of his artistic career. In particular, he often recounted the story of a plane crash in 1943 in a snowstorm over Crimea, between the Russian and German fronts. His compatriots gave him up for dead, but nomadic Tartars rescued him, covering him in animal fat and layers of felt to raise his body temperature. Whether true or not, the story provides a key to the artist's iconography.

In 1947 Beuys enrolled in the Düsseldorf Art Academy, but it was not until 1949 that "the sense of trauma," according to the art historian Caroline Tisdall, "became a real illness, the season in hell through which every creative person must go." As Beuys explained to her: "The positive aspect of this is the start of a new life. The whole thing is a therapeutic process. For me it was a time when I realized the part the artist can play in indicating the traumas of a time and initiating a healing process."[16]

Germans lived an ascetic life after the war, which Beuys mirrored in the rudimentary methods and materials of his accumulations and sometimes by fasting before performing his art "actions." After a devastating studio explosion in 1954, Beuys's mental condition began to disintegrate[17] once again. In 1955 he disappeared from Düsseldorf to work in the country—toiling in the fields, shifting manure in the stables, and (by his own description) doing "a lot of whitewashing,"[18] symbolically cleansing away feelings of guilt and anxiety. The drawings with which Beuys reappeared at the end of the fifties described not objects but mental processes, an emphasis that became a characteristic of his art.

Revealing the Animism in Nature

Beuys's drawings are not attractive in formal terms [fig. 8.11]. They strike the viewer as notations of an ongoing flow of ideas, fragments of a perpetual work-in-progress which was his life. By extension the art object no longer stands on its own but takes on its significance as an artifact of the artistic action that produced it. Each object by Beuys has an almost archaeological character with a vague sense of familial connections to the Northern European mythology and folklore that had interested him since his schooldays.

For Beuys, animals had special significance, symbolizing a direct connection with the beyond (both literally and figuratively). He imagined the stag and the hare traversing the plains of Eurasia, unconscious of distance and conventional boundaries, linking Cleves to the far steppes of China. On another level, "the figures of the horse, the stag, the swan and the hare constantly come and go: figures which pass freely from one level of existence to another, which represent the incarnation of the soul or the earthly form of spiritual beings with access to other regions."[19]

Beuys's rejection of materialism in favor of an essential spirituality stems from the German romantic tradition in art, as does his ponderous symbolism—both of which he passed on to Anselm Kiefer and Jörg Immendorff, two of his most gifted students. In *Stag Hunt* [fig. 8.12], each different element seems to receive and transmit particular spiritual impulses, linking up with one another in some cosmic unity. From boyhood, Beuys had made collections of what seemed

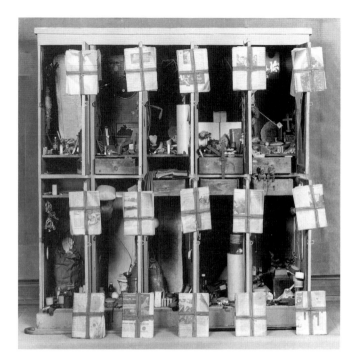

8.12 Joseph Beuys, *Stag Hunt,* 1961. Mixed media, 6ft 10⅝in × 6ft 2⅝in × 3ft 3⅜in (2.1 × 1.9 × 1m).

Hessisches Londesmuseum, Darmstadt. © 2000 Artists Rights Society (ARS), New York/ VG Bild-Kunst, Bonn.

subjectively most relevant to particular places. He said that these accumulations ranged "from beetles, mice, rats, frogs, fish, and flies to old agricultural machinery,"[20] prefiguring the enigmatically ritualistic orderings of esoteric materials in his mature work.

Beuys sought to bring to the surface the fundamental relationship of people to myth and magic. He believed that modern science and technology had obscured that connection with a narrow rationality, and he wanted to enrich scientific methods with a powerful atavistic knowledge. Beuys had a keen early interest in science and described a turning point in a lecture he attended at the University of Posen during the war, given by "a professor who had spent his whole life pondering a couple of fuzzy images of single cells somewhere between plant and animal structure . . . I'm still haunted by the image of those little amoebae on that blackboard."[21] The narrowness of the professor's focus shocked Beuys into the realization that he himself had not engaged life in a more meaningful way. Later, during his art actions of the sixties and seventies, he obsessively drew amoebae-like forms on blackboards [fig. 8.17], as though performing a homeopathic exorcism (healing like with like) of this traumatic revelation.

Nietzsche's description of modern society as hurtling into decline through its overzealous Socratism underlies the philosophy of Joseph Beuys. Beuys wanted his art actions to redress the imbalance Nietzsche pointed out between the intuitive, passionate, irrational soul of mankind (symbolized for Beuys in animals and represented in Nietzsche as the

8.11 Joseph Beuys, *Astral Chemical Goddess,* 1974. Pencil on paper, 10 × 10⅛in (2.54 × 26.7cm).

Courtesy Anthony d'Offay Gallery, London. © 2000 Artists Rights Society (ARS), New York/VG Bild-Kunst, Bonn.

"Dionysian") and the powers of abstract thought and intellect, the Socratic mind (the "Apollonian" in Nietzsche's famous dichotomy).

Beuys's *Fat Chair* [fig. 8.13] offers metaphors for this process of redemption. The chair conforms to human anatomy and order. Fat signifies chaos because it undergoes radical metamorphoses with subtle shifts in temperature. For Beuys, "everything is in a *state of change*"[22] and the resulting "chaos can have a healing character."[23] He sees an analog for spirituality in the passage of fat from one state to another—that is, the potential for spiritual transcendence in man. Some of Beuys's transcendentalism may come from his interest in the writings of the turn-of-the-century Christian mystic Rudolf Steiner.[24] Indeed, Beuys's woolen felt hat and fisherman's jacket (which he wore at all times) may both be Christian references, symbolizing the fish and the Lamb of God.

In 1961 the Kunstakademie in Düsseldorf appointed Beuys professor of monumental sculpture. A decade later, amidst accusations of demagoguery, the Academy dismissed him. His controversial career as a teacher not only echoed the adventure of his art but belonged inextricably to it. He did not maintain the conventional hierarchy of student and professor, nor did he teach art in the normal sense. Instead, he talked in an intimate way to his students about fundamental aesthetic and human problems.

Each person must point out the way towards anthropological understanding through his field of work. That's what life is involved with—politics too. If one of my students should one day rear her children in a better way, then for me that is more important than just having taught a great artist . . . art and the perceptions gained through art can create an element of backflow into life.[25]

The Artist as Shaman

Beuys presented his first public performance in February 1963 as part of the "Festum Fluxorum Fluxus" which he organized at the Staatliche Kunstakademie in Düsseldorf. Performances or, as he called them, "actions," instantly became his principal medium. The objects he made took on their meaning in relation to either proposed or realized actions. Beuys planned the objects and sequence of the performances ahead of time in a "score," always involving sound in a central way. His deliberate use of the musical term *partitur* (or score) instead of "script" had to do with his attraction to Fluxus, the early sixties performance movement that originated out of new music; John Cage and Nam June Paik had set the precedent for performances in a concert format. Yet Beuys's performances never had the emotional neutrality of a Fluxus event.

Beuys first performed *The Chief—Fluxus Chant* in Copenhagen in 1963 and then repeated it at the René Block Gallery in Berlin a year later [fig. 8.14]. This nine-hour event was an expressionistic ritual using the artist's body as a psychologically charged material for sculpture. The viewer entered by way of an adjacent room and looked in to see a roll of felt, which enshrouded a seemingly lifeless body (Beuys) lying on the floor. The stiff corpses of two dead hares extended from the roll at either end, and against the baseboard on one wall ran a long strip of fat. Fat was also methodically wedged into two corners of the room, where the walls and floor met, and on one wall hung two fingernails and a tuft of hair. Two copper rods rolled in felt and various wires also lay about. Through a microphone inside the felt roll Beuys made sounds that related, in his mind, to the hares and the call of the stag; speakers broadcast the sounds in the gallery and out on to the street. In contrast to these animal calls, tapes of modern music played at irregular intervals.

In 1964 many parts of Berlin still had a primitive, bombed-out atmosphere, accentuated by the Wall (erected in 1961), which cut through the heart of the city like a crude gash. The primal disarray of this (and indeed all Beuys performances) has to do with a sense of profound injury as embodied in the face of postwar Berlin and in the memories of the artist's experience in Crimea. "There is certainly an echo of the nomads in *The Chief*," he reflected, continuing:

8.13 Joseph Beuys, *Fat Chair,* Wooden chair with fat, 35⅜ × 11¾ × 11¾in (89.8 11¾in 29.8 × 29.8cm).
Hessisches Londesmuseum, Darmstadt. © 2000 Artists Rights Society (ARS), New York/ VG Bild-Kunst, Bonn.

8.14 Joseph Beuys, *The Chief—Fluxus Chant,* December 1, 1964 (first performed Copenhagen, 1963). Action, approximately nine hours, René Block Gallery, Berlin, showing the artist wrapped in a roll of felt approximately 7ft 4½in (2.25m) long with two dead hares at either end and a microphone inside connected to external speakers; along the baseboard of the wall at left a strip of fat and above it hanging on the wall (out of photograph) a tuft of hair and two fingernails; in the corner a wedge of fat where two walls and the floor meet; next to Beuys on the floor a second roll of felt around a copper rod with another copper rod leaning against the wall.
© 2000 Artists Rights Society (ARS), New York/ VG Bild-Kunst, Bonn.

and something Eurasian in the transmission of the sounds of the stag out on to the still-ruined streets of that part of Berlin . . . The Chief was above all an important sound piece. The most recurrent sound was deep in the throat and hoarse like the cry of the stag: öö. This is a primary sound, reaching far back . . . The sounds I make are taken consciously from animals. I see it as a way of coming into contact with other forms of existence, beyond the human . . . my presence there in the felt was like that of a carrier wave, attempting to switch off my own species' range of semantics.

The point was to reach some profound instinctual or atavistic level of experience, so fundamental as to precede language. He went on:

It takes a lot of discipline to avoid panicking in such a condition, floating empty and devoid of emotion and without specific feelings of claustrophobia or pain, for nine hours in the same position. Such an action, and indeed every action, changes me radically. In a way it's a death, a real action and not an interpretation.

Thus the action goes beyond metaphor into real experience, seeking to evoke transformative insights that prepare the individual for a genuine spiritual evolution. Beuys concluded:

Transformations of the self must first take place in the potential of thought and mind . . . There is no other possibility in my understanding, and this was perhaps too little considered by Marx, for instance. The idea of revolution coming from outer conditions, in the industrial field or the so-called reality of economic conditions, can never lead to a revolutionary step unless the transformation of soul, mind and will power has taken place.[26]

Art as the Creative Life of the Mind

On July 20, 1964—deliberately selected as the twentieth anniversary of the failed attempt to assassinate Hitler—Beuys performed an art action in the Cathedral at Aachen. This performance involved filling a grand piano with various

8.15 Joseph Beuys, *How to Explain Pictures to a Dead Hare,* 1965. Performed at Galerie Schmela, Düsseldorf.
© Ute Klophaus, Düsseldorf/Artists Rights Society (ARS), New York/VG Bild-Kunst, Bonn.

materials, melting some blocks of fat, and then raising a felt-wrapped copper rod over his head. At that moment, before he could finish the action, right-wing students rushed the stage and attacked him. One student hit him hard in the face, making his nose bleed dramatically, and the police had to be called to stop a riot from ensuring.

After that incident, Beuys became more directly political in his work. In particular, he campaigned for a genuine democracy in which the unaligned voter would have a real voice. This shift paralleled the move in Western society at large toward political activism and unrest in the late sixties, associated with growing protests against the American involvement in Vietnam. Beuys founded the German Student Party in 1967 (the precursor to the Green Party); in 1970 he created the Organization for Direct Democracy; and after his dismissal from the Düsseldorf Art Academy in 1972 his art actions increasingly resembled eccentric lectures on social and political issues. At the international *Dokumenta 6* exhibition of 1977 he established a Free International University, with nonstop discussions on nuclear energy, equality for women, global politics, Northern Ireland, and other topical issues.

Beuys had his first one-person exhibition, as such, in 1965 at the Galerie Schmela in Düsseldorf, and for the opening he devised a performance entitled *How To Explain Pictures To A Dead Hare* (fig. 8.15). He covered his head in honey and gold pigment, tied a steel sole on to his right shoe and a felt sole to his left (to represent hard reason and spiritual warmth), and then spent three hours silently mouthing explanations of his pictures to a dead hare that he held in one arm. The work is concerned with the irrelevance of explanations in art and with opening communication to the non-rational world of the soul. Honey embodies a life force and a metaphor for the products of creativity in Beuys's cosmology. The mysterious process by which the bees produce it evokes the idea of fecundity and transformation and provides a parallel to the creative mystery of the artist, not as object-maker but rather as a medium of esoteric knowledge.

For Beuys all creative thought was art. In the same way that the German romantic poet Novalis claimed that every man was a poet, Beuys wanted to counteract the overbalance of rationality in contemporary society by declaring "everyone an artist."[27] Since each individual can find the nature of existence within himself or herself by introspection—an idea Beuys took from the German philosopher Arthur Schopenhauer—each is therefore also capable of creating a revolutionary dialog between art (creative thought) and real events. Thus art serves as a politically liberating force—perhaps, as writers from Herbert Marcuse to Harold Rosenberg have suggested, one of the only viable ones left in a media-dominated society.

Beuys made a felt-covered piano for a performance of 1966 entitled *Infiltration-Homogen for Grand Piano, the Greatest Contemporary Composer is the Thalidomide Child*. The felt skin trapped the sound of the piano inside, and the red crosses which Beuys placed on the flanks were to indicate an emergency. Whereas fat infiltrates other materials—in the

installations where Beuys placed fat up against the wall one can readily see it soaked up into the plaster—felt absorbs everything—fat, dirt, water, and sound. For Beuys the sound, symbolically held in the piano by the felt, offered a metaphor for the much-discussed tragedy of the children who suffered birth defects caused by the drug thalidomide, used widely in Europe in the fifties to alleviate morning sickness in pregnancy. Their inability to lead normal lives gave rise to the inner turmoil that Beuys believed necessary for creativity. Thus the felt objects imply warmth, protection from outside disturbances, and silence, but also isolation, an inability to communicate, and powerlessness. As with his deliberate evocation of the Nazis, here again Beuys took on a subject so emotionally charged that the mere mention of it greatly distressed his audiences.

The Pack of 1969 [fig. 8.16]—with twenty sleds issuing out of the back of a Volkswagen bus—has a sense of urgency about it, implying part invasion, part escape to survival. Each sled carries a roll of felt for warmth, fat for nourishment, and a flashlight to find the way. It is not only one of the artist's most evocative works but a market landmark as well: it sold in 1969 for over 100,000 marks, making it comparable in price to a major Rauschenberg or Johns at the time.

In February 1976, after a grave illness in the preceding summer, Beuys assembled one of his most tragic and disturbing installations, *Show Your Wound*. He set the piece in a barren concrete passageway under a street in Munich. *Show Your Wound* relates, as he said in reference to an earlier work, to "the wound or trauma experienced by every person as they come into contact with the hard material conditions of the world through birth,"[28] or, it might be added, through profound psychic injury. The objects—mortuary tables, filters and glass jars, batteries, fat, and a pair of old three-pronged pitchforks with the center prong broken out—create a sulfurous atmosphere. The presentation of everything in pairs (except the skull of a thrush emerging from a test tube) and the precision of their implied ritual use enhance the piercing, irrational and unconscious realism of the work. *Show Your Wound* goes back to a proposal in 1958 for a monument at Auschwitz. Guilt for the Nazi atrocities has preoccupied Germans of Beuys's generation, and through his art Beuys sought to heal the trauma by reopening the wound. Once again the wound of Christ may be a subtextual reference in this work.

After 1973 Beuys did more and more lecturing. He prompted intense sessions of political consciousness-raising (almost like group-therapy sessions), drawing diagrams and notations on blackboards to punctuate his impassioned delivery [fig. 8.17]. As early as 1963 Beuys used blackboards to carry information that he could change in the course of a performance, but they first achieved an independent status as objects in performances of 1966 like *Eurasia* and *Infiltration-Homogen for Grand Piano*. This shift from actions to lectures did not constitute a break with sculpture, but rather a further evolution toward an encompassing social sculpture. Beuys died in January 1986 (at the age of sixty-four).

The European Vanguard of the Later Fifties

8.16 Joseph Beuys, *The Pack,*
1969. Volkswagen bus with twenty
sleds, each carrying felt, fat, and a
flashlight, dimensions vary.

Collection, Neue Gallery, Staatliche Museen,
Kassell. Photograph by Mary Donlon, © The
Solomon R. Guggenheim Foundation, New York. ©
2000 Artists Rights Society (ARS), New York/ VG
Bild-Kunst, Bonn.

8.17 Joseph Beuys lecturing in
New York in 1974.

Photograph © the Estate of Peter Moore/VAGA,
New York.

British Pop: From the Independent Group to David Hockney

The Institute of Contemporary Arts in London opened in 1946 with the aim of providing focus and encouragement for new artistic developments in postwar England. Sir Herbert Read, its president, belonged to a liberal upper-class art establishment which saw the embodiment of its values in the conservative heirs to classic prewar styles, particularly in Ben Nicholson, Barbara Hepworth, Henry Moore, and Graham Sutherland. In 1952 some younger members of the Institute for Contemporary Arts formed the Independent Group, and from the start their enthusiasm for popular culture and technology set them on a collision course with the mainline modernism of the Institute's founders. The Independent Group attacked the modernist concept of self-referential and "timeless" high art; they opened up the discourse on art to ideas from areas as diverse as cybernetics, game theory, semiotics, science fiction, and the mass media (especially American advertising). They wanted art to be of the moment rather than above it, democratic instead of elitist, and linked to the forward edge of new technology.

Key Figures of the Independent Group

Peter Reyner Banham, a doctoral student in architectural and design history, emerged as the leader of the group in September 1952. The lecture series of the first season reflected his keen interest in the machine aesthetic. The imagery of science and engineering also fascinated the other leading members of the Independent Group: Richard Hamilton, Eduardo Paolozzi, Peter and Alison Smithson, Lawrence Alloway, John McHale, Nigel Henderson, and James Stirling. Richard Hamilton had organized the "Growth and Form" exhibition at the Institute of Contemporary Arts in 1951 (inspired by *On Growth and Form*, a book on form in nature published in 1917). His dynamic installations for "Growth and Form," "Man, Machine, and Motion" (1955), and "This Is Tomorrow" (1956) demonstrated a brilliant design sense. Ironically, its principal source was in constructivism (one of those classic prewar styles against which the group rebelled).

Since the mid forties, Paolozzi had made collages using images of consumer goods, technology, and popular culture culled from books and mass-market magazines (figs. 8.18 and 8.19). For many of these he drew on science fiction, which has always had a close relationship to the forefront of technology. One of the galvanizing events early in the Independent Group's first season was a "lecture" in which Paolozzi showed images from popular media, especially American sources such as *Life Magazine*. The images ranged from advertisements for home appliances to automobiles, comics, pin-ups, and illustrations for science fiction. The presentation lasted for several hours, without commentary.

The architects Peter and Alison Smithson—whom Banham later dubbed "New Brutalists"[29] to connect them with

8.18 Eduardo Paolozzi, *Real Gold*, 1950. Collage 14 × 19¼in (35.7 × 48.9cm).

Collection, the Trustees of the Tate Gallery, London. © 2000 Artists Rights Society (ARS), New York/DACS, London.

the raw use of unconventional materials in Dubuffet's *art brut*, with the toughness of the English working class, and with *béton brut*, the raw concrete of the new architecture—anticipated Robert Venturi by more than a decade in drawing on commercial vernaculars. The Smithsons and the young critic Lawrence Alloway brought to the Independent Group a particular affinity for advertising and communication. As in America, media and information theory grew at a startling rate in mid-fifties England, and in Alloway's view the failure of the British cultural establishment to respond to this was precisely what held it back. "The abundance of twentieth-century communications is an embarrassment to the traditionally educated custodian of culture,"[30] he wrote in 1959.

The Exhibitions

After a year of meetings, the Independent Group organized an inexpensive and accessible exhibition called "Parallel of Art and Life." Inspired by the variety of source material illustrated in such classic texts of design theory as Ozenfant's *Foundations of Modern Art*, Le Corbusier's *Towards a New Architecture*, Sigfried Gideon's

8.19 Eduardo Paolozzi, *It's a Psychological Fact Pleasure Helps Your Disposition,* 1948. Mixed media on paper, 14¼ × 9⅝in (36.2 × 24.4cm).

Tate Gallery, London. © 2000 Artists Rights Society (ARS), New York/DACS, London.

"Growth and Form." "Man, Machine, and Motion," and "Parallel of Art and Life" exhibitions. "This Is Tomorrow" relied on reproductions, often enlarged to a cinematic scale and configured into total environments.

Richard Hamilton, John McHale, and John Voelcker built a pop culture fun house inside the front door of "This Is Tomorrow" [fig. 8.20]; they included films, a live microphone (to prompt an interactive relationship with the viewer), and a working juke box that successfully attracted working-class patrons from the neighborhood around the gallery. This section also included a 14-foot-high blow-up of Robby the Robot carrying off a voluptuous woman—a still from the film *Forbidden Planet*—and in the shadows they superimposed the famous photograph of Marilyn Monroe standing over an air vent in *The Seven Year Itch.* Paolozzi, the Smithsons, and the photographer Nigel Henderson designed a rudimentary shack of pointedly cheap materials, littered with found objects and images.

Behind the activities of the Independent Group lay a serious concern for the direction in which the world was headed. "We still have no formulated intellectual attitudes for living in a throw-away economy,"[31] Reyner Banham worried in 1955. In an essay of 1956 entitled "But Today We Collect Ads," Alison and Peter Smithson observed that: "The student designer is taught to respect his job, to be interested in the form of the object for its own sake as a solution to a given engineering and design problem—but he must soon learn that . . . this is a reversal of the real values of present-day society." They concluded with a quotation from Arthur Drexler, the design curator of the museum of

Mechanization Takes Command, and *The New Vision* by Laszló Moholy-Nagy, they displayed sheets of Pollock-like automatist drawings as well as blown-up photographs of paintings, children's drawings, primitive art, machines, X-rays, microphotographs, athletes, pilots, hieroglyphics, scientific illustrations, and diagrams. They hung these reproductions freely in space with no labels.

During the second and third seasons (1953–5) the group increasingly concentrated on popular imagery, for which they began to use the term "pop art." This implied a genuine appreciation for the imagery of the commercial environment and a rejection of the distinction between highbrow and popular culture.

Though the Independent Group officially disbanded in 1955, the most important group manifestation of their ideas was an exhibition in August and September 1956 at the Whitechapel Gallery in London. The exhibition, called "This Is Tomorrow," consisted of individual pavilions, each designed by a team—generally a painter, an architect, and a sculptor. The different sections of the show represented a wide variety of aesthetic perspectives, but as a whole they evolved from an underlying concept of collaborative design as a vehicle for ideas and an overall stress on popular culture and technology in place of romantic individuality. As in the

8.20 Richard Hamilton, John McHale, and John Voelcker, Pavilion for the 1956 "This Is Tomorrow" exhibition at the Whitechapel Gallery, London.

© 2000 Artists Rights Society (ARS), New York/DACS, London.

8.21 Peter Blake, *Sergeant Pepper's Lonely Hearts Club Band,* 1967. Album cover for the Beatles, 12½ 3 12½ in (31.8 × 31.8cm).

Modern Art: "What is important is to sustain production and consumption."[32] Hamilton delighted in the idea that advertising could actually shape the desires of the consumer rather than merely responding to them.

Paolozzi and Hamilton as Artists

Paolozzi, the son of Italian immigrants, grew up around the docks of Edinburgh during the depression of the thirties. He attended art schools in Edinburgh and London from 1943 through 1947, and then, at the age of twenty-three, moved to Paris for two years. There he met many of the older modern masters, including Léger, who arranged for Paolozzi to see his *Ballet mécanique* (a film that Léger had made in 1924 celebrating the machine aesthetic). To Paolozzi the work of Dubuffet and Giacometti, like that of Pollock, represented freedom from established conventions. Paolozzi's collages of the later forties and afterwards are indebted to the German dada artist Kurt Schwitters, but Paolozzi's unique way of packing his compositions with whole images clipped from magazines displays a newer, McLuhanesque consciousness of semiotics.

Richard Hamilton, who finished at the Slade School of Art in London in 1951, had worked in advertising during the forties. Stylistically, his art came together in 1956, influenced by Paolozzi's collages. His own small collage, *Just what is it that makes today's homes so different, so appealing?* [fig. 8.22], marked the turning point. Using commercial graphic design techniques and imagery from popular media, he undertook a sophisticated exploration of the language of visual signs.

Hamilton described this collage as " 'Instant' art from the magazines. The collage (made for the catalogue of the 'This is Tomorrow' exhibition) is a representation of a list of items considered relevant to the question of the title. The image should, therefore, be thought of as tabular as well as pictorial."[33] Thus he meant the work to be read like a text cataloguing the concerns of the exhibition. In a later commentary on the work he listed these subjects as: "Journalism, Cinema, Advertising, Television, Styling, Sex symbolism, Randomization, Audience participation, Photographic image, Multiple image, Mechanical conversion of the imagery, Diagram, Coding, Technical drawing."[34] For the ceiling of the room in his collage Hamilton used a telescopic photo of the surface of the moon; the nubbly carpet was made by blowing up a Weegee photograph of people on the beach at Coney Island (randomization perhaps?); and with the movie marquee advertising Al Jolson in *The Jazz Singer* Hamilton provided a charged metaphor for his entire semiotic endeavor, for *The Jazz Singer* was the first film to synchronize spoken words and cinematic images.

8.22 Richard Hamilton, *Just what is it that makes today's homes so different, so appealing?*, 1956. Collage on paper, 10¼ × 9¾in (26 × 24.8cm).

Collection, Kunsthalle Tübingen, Sammlung Zundel. © Richard Hamilton/VAGA, New York, 1994.

Reintegrating Popular Imagery into High Art

The use of popular imagery implied an attack on the traditional division of "high" and "low" art, which in turn embodied an assault on the social hierarchy in Britain. The use of American popular imagery carried a consciously radical, social message. The prominence of black people in American popular music particularly struck these Europeans, who lived in a more racially and culturally homogeneous environment with little social mobility.

In addition, pop music had a special connection with pop art and with the British art schools, which offered one of the few mechanisms for lower-class students to cross over the usual social divisions. Many important English pop musicians of the sixties—including John Lennon, Eric Clapton, Cat Stevens (an American expatriate in England), Pete Townshend, and Keith Richards—went to art schools on government grants. The art schools provided them with both a haven and a platform from which they developed their early musical careers.[35]

Artistic self-consciousness, and the high art seriousness that it engendered, was perhaps the leading contribution of the British bands to the pop music scene of the sixties, which was otherwise dominated by African-Americans. As a corollary to this increased intellectual aspiration, the British

pop musicians cultivated their connection with fine artists. The Beatles, for example, commissioned Peter Blake to design the cover for their 1967 album *Sergeant Pepper's Lonely Hearts Club Band* [fig. 8.21] and Richard Hamilton to create the cover and insert for their "white album" of 1968.

The Independent Group broke away from the introspective and expressionistic model of artists like Bacon and de Kooning. Around 1960, their attraction to mass culture was picked up and reintegrated into a fine art context by two successive groups of students and former students from the Royal College of Art in London, notably Peter Blake, Richard Smith, and Joe Tilson (at the Royal College in the mid fifties), and Derek Boshier, David Hockney, Allan Jones, Peter Phillips, and Ronald Kitaj (who studied there between 1959 and 1962). This development paralleled the virtually simultaneous events in New York between 1959 and 1963, beginning with the work of Jasper Johns in the mid fifties and followed by the American pop artists Andy Warhol, Roy Lichtenstein, and James Rosenquist.

The revolutionary aspect of pop art transpired on a level so fundamental that not even the principals quite articulated it in words. What the Independent Group (and concurrently Jasper Johns in New York) had set in motion, and then left for the artists of the early sixties to pursue,

centered on the idea of using culture (ranging from comic books, instruction manuals, and advertising to art history and literature) as the source of art, instead of the direct experience of nature (including one's own human nature, as in de Kooning and Pollock). Indeed, the only meaningful definition of pop art derives from this concept of culture as mediating the terms in which one experiences events.

David Hockney

David Hockney, the most gifted traditional painter among the British pop artists, was influenced by the gesture painting of the fifties. However, he differed from the gesture painters in his semiotic sophistication, which younger artists learned from the new consciousness of images generated by the media around 1960. Born in 1937, Hockney now lives principally in Los Angeles and paints in a lush, coloristic style indebted to Picasso and Matisse. Hockney came from a working-class family in Yorkshire, and in 1959 he began graduate study at the Royal College of Art in London.

Despite the pressure to paint abstractly that prevailed at the time, Hockney abandoned abstraction for narrative painting in 1960. Nevertheless, the gestural handling of Hockney's work of the early sixties [figs. 8.23 and 8.24] still reflects the influence of abstract expressionism (which he encountered in the "New American Painting" exhibition circulated in Europe in 1958 by New York's Museum of Modern Art). The inspiration of Francis Bacon and Dubuffet

8.23 David Hockney, *Adhesiveness*, 1960. Oil on board, 4ft 2in × 3ft 4in (1.27 × 1.02m).
Collection, Winnie Fung. Photograph by William Nettles, Los Angeles, © David Hockney.

8.24 David Hockney, *Picture Emphasizing Stillness*, 1962. Oil on canvas, 6ft × 5ft 2in (1.83 × 1.58m).
Private collection. © David Hockney.

8.25 (above) **David Hockney,** *Henry Geldzahler and Christopher Scott,* 1969. Acrylic on canvas, 7 × 10ft (2.13 × 3.05m).
Private collection. © David Hockney.

8.26 (below) **David Hockney,** *A Diver,* Paper Pool 17, 1978.
Colored, pressed colored paper pulp, twelve sheets, 6ft × 14ft 3in (1.83 × 4.34m) overall, each sheet 36 × 28in (91.4 × 71.1cm).
Private collection. © David Hockney/Tyler Graphics Ltd. 1978. Photograph by Steven Sloman.

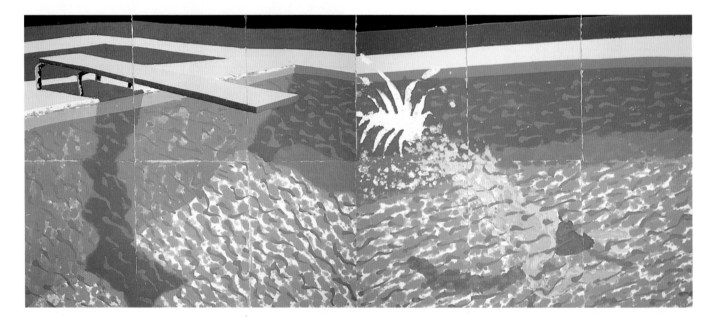

is evident too. Hockney also broke ranks with convention in his frankly homosexual subject matter, militantly asserted by such paintings as *Adhesiveness, Doll Boy,* and *Queer* of 1960.

That summer, Hockney read the complete works of Walt Whitman, who also openly expressed his homosexuality in his work. Hockney took the title for *Adhesiveness* from Whitman as well as the idea of correlating numbers with the alphabet as a code for someone's initials. The two sexually engaged figures in *Adhesiveness* are labeled "4.8" ("D.H." for

David Hockney) and "23.23" (for Walt Whitman).

Hockney made his first trip to New York in 1961, when he was twenty-four. He returned sporting stunning costumes, with his hair dyed platinum blond. He had come to the realization that he could consciously invent his artistic persona along with his style in painting and this consciousness of style came to the fore in his work at that time. The marriage of styles is the theme of several paintings of 1961 and 1962, including *A Grand Procession of Dignitaries in the Semi-Egyptian*

Style, Figures in a Flat Style, Tea Painting in an Illusionistic Style,
and *The First Marriage (A Marriage of Styles)*. "I deliberately set
out to prove I could do four entirely different sorts of pictures
like Picasso," he told Larry Rivers in 1965.[36] Hockney treated
the styles in these works like elements in a still life. The
captions and the recurrent curtains indicate the artist's
orientation toward the world as a landscape of signs.

The vocabularies of pop art and gesture painting
collided head-on in Hockney's early work. In *Picture
Emphasizing Stillness* the armature of lines around the
painterly figures suggests his debt to Francis Bacon, while
the introduction of lettering into a gestural style of
figurative painting shows the influence of Larry Rivers. The
caption "They are perfectly safe. This is a still," implies that
the linguistic context of the picture as a picture (rather than
any referent in nature) defines the reality it describes. "I
realized that what was odd and attractive about it was that,
although it looks as though it's full of action, it's a still; a
painting cannot have any action. It was the incongruity of it
that attracted me to it as a subject."[37]

Hockney made his first trip to Los Angeles at the end of
1963, attracted by homoerotic magazines like *Physique
Pictorial*, which originated there.[38] In January 1964 Hockney
moved to Los Angeles and his work took a turn toward
greater realism. He also switched to acrylic paint at this time,
a medium that made the surface of his painting increasingly
flat. In addition, Hockney bought a 35mm camera in 1967
and began taking pictures incessantly, using many of them as
notes for paintings, as in the portrait of *Henry Geldzahler and
Christopher Scott* [fig. 8.25]. This magnificent painting has a
stark classicism in the precision of its drawing, in the hard-
edge application, and in the order of its composition and one-
point perspective. Nevertheless, Hockney felt that
photographs distort the way we see by taking in too much at
once, so in 1972 he joined multiple photographs of his friend
Peter Schlesinger together to give a closer approximation of the
way in which we actually look at something, focusing on one
detail at a time. From this came a sequence of so-called
"joiners"—composites of several separate photographs into a
unified image. "I realized that this sort of picture came closer
to how we actually see, which is to say, not all-at-once but
rather in discrete, separate glimpses which we then build up
into our continuous experience of the world,"[39] he explained.

These photograph collages as well as Hockney's
paintings of the eighties have a moving focus in which the
eye follows a path from point to point rather than holding to
a conventional one-point perspective. As the art historian
Gert Schiff has pointed out, the eye also wanders through a
cubist painting in this way and the idea may have derived
from Hockney's ongoing dialog with Picasso.[40] Indeed, in
September 1973, Hockney went to Paris for two years to
work on a suite of etchings in homage to Picasso, who had
died on April 8. Shifts in technique often signal jumps in style
for Hockney and in the mid seventies he went back to oil
paint as he turned away from naturalism. Hockney's intense
involvement in designing sets and costumes for opera

between 1975 and 1978 and again in the eighties seems to
have brought out this expressionistic tendency.

It was five years before Hockney returned to Los Angeles,
but not without a final detour. Ken Tyler, the master printer
who left Gemini G.E.L. in Los Angeles in 1973 for Bedford
Village, 35 miles north of New York city, had been pressing
Hockney to make some lithographs with him. On the way back
to California in the fall of 1978, while held up in New York for
a few days waiting to recover a lost driver's license, Hockney
went up to see Tyler. Having just finished the sets for the opera
The Magic Flute, Hockney had intended to let Tyler know he
was going back to Los Angeles for some solitary painting and did
not want to start making any prints—but when Tyler showed
him the colors possible in a new technique of painting with dye
in wet paper pulp Hockney decided to stay over three days to try
it. Forty-five days later he had completed a spectacular series
of twenty-nine "Paper Pools," by "painting" in vats of liquid
pulp. *A Diver* [fig. 8.26] has a Matisse-like simplicity and
richness of color, suggested to some extent by the technique.
The fauvist sensuality anticipates Hockney's stage sets for the
Met in 1980 as well as the saturated hues of eighties paintings
such as *Nichol's Canyon* [fig. 8.27].

8.27 David Hockney, *Nichol's Canyon,* 1980. Acrylic on canvas,
7 × 12ft (2.13 × 1.52m).
Private collection. © David Hockney.

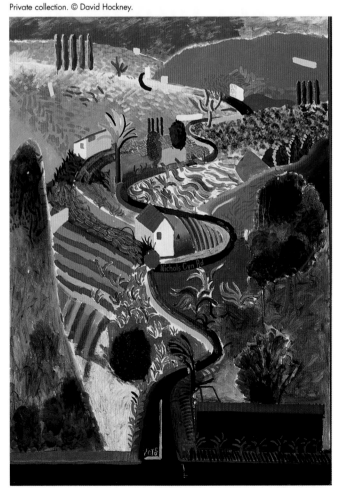

9

THE LANDSCAPE OF SIGNS: AMERICAN POP ART 1960 TO 1965

The Electronic Consciousness and New York Pop

The shift away from existentialism to a focus on semiotics (from identity to a concern with the language of art) in the work of so many of the artists who emerged in the sixties was inseparable from the bewildering new social and political realities of the decade, particularly in America. Things changed radically as the fifties drew to a close, and foremost among the new conditions was the quantity and vividness of information about the world at large that began invading the private domains of the individual. In the ten years after 1947 the number of televisions in the United States jumped from ten thousand to forty million,[1] putting Selma, Alabama and Saigon, Vietnam right there in everyone's living room [fig. 9.1]. We had moved into Marshall McLuhan's "Global Village," playing Buckminster Fuller's "World Game."

But Fuller's Utopia of world cooperation somehow never worked out. Instead of an international pooling of global resources, we began seeing the world's venality in greater detail than ever before, highlighting a myriad of moral dilemmas. The fact that Americans reacted with shock in October 1959 to the revelation that Carl Van Doren had been set up to give the right answers on the popular quiz-show *The Sixty-Four Thousand Dollar Question* points to the late date of the nation's loss of innocence; people had to admit to themselves that not everything on television was as it appeared, and the American faith in the honesty of the common man seemed shaken.

A Turning Point in Theory

The influence that television exerted on the way in which increasing numbers of people viewed the world around them became the profound subject matter for the pop artists of the early sixties. Predicated on the non-selective openness to experience in the work of John Cage and Jasper Johns, pop art went further, detaching the pervasive images of the media from any specific location in time and place. Images suddenly floated freely in the mind, becoming interchangeable parts of the puzzle that made up the new reality of the sixties.

The parallels between pop art and its contemporary, structuralism, help clarify what is revolutionary about them both in altering the way in which the general public were beginning to look at events. Structuralism was the cultural theory pioneered by the anthropologist Claude Lévi-Strauss. Lévi-Strauss focused on the structure of a myth rather than on the individual version of it, encountered in a particular context. Lévi-Strauss argued, for example, that Freud's writings on the Oedipus Complex constituted not an analysis but merely a restatement of the Oedipus myth in terms that contemporary culture could understand.[2] In the same way, pop artists began to treat images as signs that existed independently of any particular context in nature; thus they

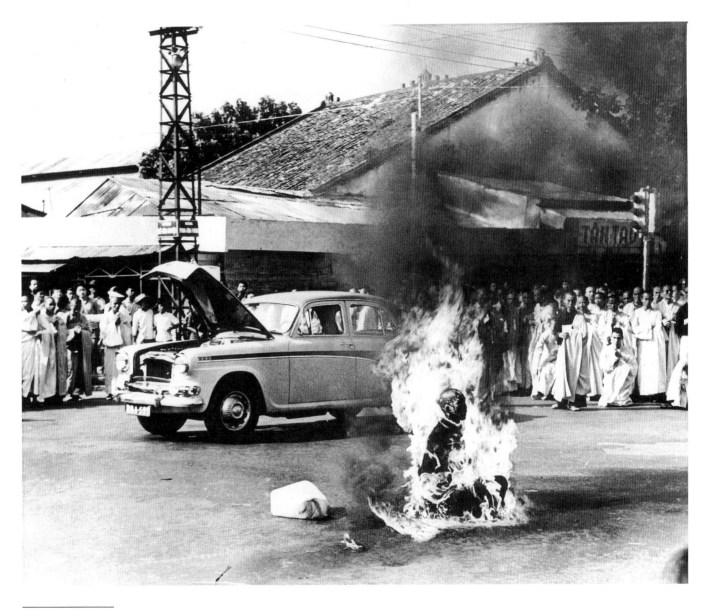

9.1 Quang Duc, a seventy-three-year-old Buddhist monk, soaked himself in gasoline and set himself on fire, burning to death in front of thousands of onlookers at a main highway intersection in Saigon, Vietnam on June 11, 1963. He was protesting against the American-backed government's discrimination against Buddhists. A group of nuns and monks circled the burning martyr with banners that read "A Buddhist Priest Burns Himself For Five Requests."

Photograph courtesy the Associated Press, London.

might be reconfigured at will. Moreover, images became part of nature—equal, in terms of how we perceive them, to a tree or a cloud seen in the landscape. By the seventies, this new definition of nature as a landscape of signs had evolved into what came to be known as "postmodernism"; postmodernism (and its corollary, "poststructuralist theory") went beyond detaching the image from a fixed time and place to relieving images of any necessary coherence at all. With the emergence of the personal computer and the video cassette recorder (VCR) around 1980, the electronic consciousness of pop art took a jump in magnitude so vast that twenty years later we are only just beginning to understand its full implications. Thus the emergence of an electronic consciousness around 1960 has affected the way nature has come to be viewed ever since.

The Events that Shaped the Popular Consciousness

On the political front, great concern had arisen in 1957 about a supposed missile gap with the Soviets when they launched *Sputnik*, the first man-made satellite, and then in 1961 they put the first man in space. Meanwhile Fidel Castro overthrew an American-backed dictator in Cuba in 1959, and invited the Kremlin in to begin setting up an armed camp there, well inside the American early warning defense system. The CIA failed miserably in its Bay of Pigs invasion—designed to oust Castro—and finally, in June 1961, the entire world held its breath as President Kennedy brought the nation to the brink of armed confrontation with the Soviet Union by ordering a naval blockade to stop the deployment of Russian missiles in Cuba. The construction of the Berlin Wall in 1961 summed up the tone of East–West relations.

For a brief time John F. Kennedy raised the spirits of America and Europe. He was the first television President, and the public identified with this young, glamorous, and dynamic First Family whom they came to know in an illusively "personal" way through television and magazines. However, the mood of involvement he engendered also mobilized movements against social injustices of which the expanded media had suddenly made everyone aware; the Civil Rights movement blossomed during the sixties, as did a consciousness of American adventurism abroad. The effect of Kennedy's style on the conscience and activisim of the era demonstrated the power of television.

In Kennedy's "New Frontier," culture became a popular priority. The President initiated the National Endowment on the Arts, and Jackie Kennedy united fashion and culture with her glamorous media image. The Metropolitan Museum's purchase of Jackson Pollock's *Autumn Rhythm* for $30,000 in 1957 had already given contemporary artists a new prestige, and in 1959 the de Kooning show at Sidney Janis sold out on the first day for $150,000—an unheard-of amount of money at the time.

Newly rich collectors were keen to be first in picking up

on the latest trends, and some of the biggest collectors, such as Robert Scull and the Italian Count Panza di Buomo, began buying in quantity. They wanted to build their collections by getting in early and cheap, and they relied on tips from artists to scout out fresh talent, often beating the dealers to the studio door. Before long a class of celebrity artists developed, and they became integrated into the social world of the wealthy. Art openings became the in place for rich socialites to be seen in the sixties, and collectors collected the artists themselves at chic parties. Pop art, which came along just as mass advertising and television took their quantum leap, celebrated media stars and consumer culture, while it in turn could not have produced a more natural subject for the media to focus on.

Almost instantly art became a popular interest nationwide. Rapidly growing numbers of people attended openings at local museums and art centers; they took art courses and subscribed to art magazines; and for the first time, in the early sixties, the demand for avant-garde art exceeded the supply. In 1962 even Sears Roebuck launched an art-selling plan under the aegis of the Hollywood movie star Vincent Price. Assisted by the careful promotion of a few key dealers, the price of work by the most fashionable young artists of the sixties escalated as much as 4,000 percent over the decade.

In the forties and early fifties, the galleries of Samuel Kootz, Sidney Janis, Betty Parsons, Martha Jackson, and Charles Egan became a stamp of authenticity for the major new artists on the scene. These dealers had a great deal to do with shaping the image of the artists and with associating them together as a movement. But in the sixties, the role that art dealers such as Leo Castelli and Sidney Janis played in making a name for their artists—carefully directing the work into important collections and exhibitions and controlling the market supply—set an albeit restrained precedent for the coarse manipulation of the contemporary art market by spectators in the late seventies and eighties. More and more artists organized their social life with their careers in mind. As money and fashion came on to the scene, the intellectual tone of the art world declined. In 1964 Allan Kaprow quipped that "if the artist was in hell in 1946, now he is in business."[3]

Collaging Reality on Pop Art's Neutral Screen of Images

For the members of the Independent Group in London, the elimination of distinctions between high art and popular culture was a vanguard political statement—they wanted to democratize art and anticipate a more egalitarian future. The work of American pop artists, on the other hand, was largely apolitical. Andy Warhol, Roy Lichtenstein, and James Rosenquist (the central figures of pop art in New York) remained unambiguously within the realm of fine art, but within this essentially traditional context they explored the

9.2 Advertisements for the ABC television series *Charlie's Angels* and Arby's Roast Beef Sandwiches in *TV Guide*, vol. 26, no. 37 (September 16, 1978), pages A-104 and A-107.

subject matter and devices of popular culture. They intuitively recognized that the imagery of mass culture, rather than a direct encounter with nature, increasingly defined the norms of experience in the contemporary world.

The flux of free-floating impressions in beat poetry and in the combines of Rauschenberg foreshadowed the passive detachment with which the pop artists treated what came into view. But they, along with Rauschenberg himself in the sixties, replaced found objects with the found images of magazine culture. This laid the groundwork for reality as it has come to be seen in the eighties and nineties. The critic and pop culture producer John Carlin has characterized it as "reality . . . homogenized on the level of the sign," and he pointed out that "the exchange of images has become the symbolic structure through which our seemingly entropic social, cultural, and economic existence is unified."[4]

On this level plane of images, *TV Guide* [fig. 9.2] could market the "girls" in the *Charlie's Angels* detective show just like Arby's roast beef sandwiches. The New York pop artists addressed this aspect of advertising in the neutrality with which they handled their motifs; the utterly non-introspective character of their work was radical with respect to the art that preceded it, although the deadpan representation of commonplace subjects by Jasper Johns in the fifties anticipated this cool attitude, and the stunning semiotic shifts in the work of H. C. Westermann prefigured the structure of its language. The pop artists cultivated impersonality. They even developed commercial

art techniques in order to evoke a strong feeling of mass-production: Warhol used photosilkscreening, Lichtenstein's style alluded to the commercial process of printing flat color areas in dots, and Rosenquist painted in the style of billboards.

New York pop art evolved in the studios during 1959 and 1960, the artists saw one another's work for the first time in 1961, and it burst on to the art scene in 1962, when Rosenquist, Lichtenstein, and Warhol all had major one-person shows in New York. Toward the end of 1962 Sidney Janis opened "The New Realists" exhibition which linked the New York pop artists with others in New York as well as with the French *nouveaux réalistes*. The show also connected (and thereby validated) them by association with the blue chip moderns, for which the Janis Gallery was known. Pop art outraged the abstract expressionists and infuriated the established critics, but it instantly swept the worlds of mass media and fashion.

Tom Wesselmann was one of the larger circle of artists in "The New Realists" show who made it difficult to draw clear perimeters around pop art as a phenomenon. Wesselmann began making collages of found materials in 1959 to 1960. By 1962 he had extended his paintings off the flat surface with three-dimensional objects, and in this sense his work is indebted to environments and happenings. But Wesselmann's art did not have the gestural surface or expressionist tone of works by Oldenburg, Segal, or Dine. Instead he explored the world of the popular imagination

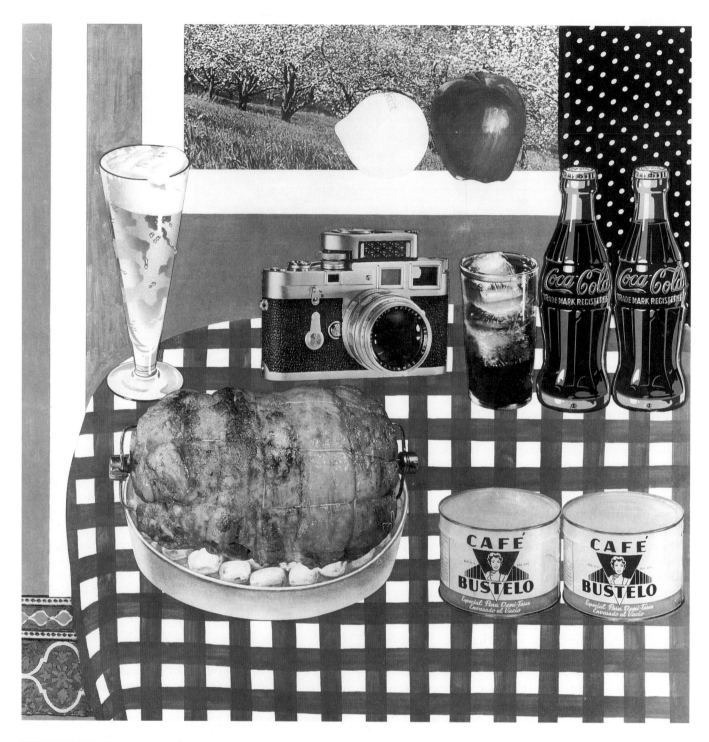

9.3 Tom Wesselmann, *Still Life #12,* 1962. Acrylic and collage on fabric, 4 × 4ft (1.22 × 1.22m).

Collection, National Museum of American Art, Smithsonian Institution, Washington, D.C. Photograph courtesy Art Resource, New York. © Tom Wesselmann/VAGA, New York, 1994.

with an analytical detachment, appropriating images from contemporary advertising and actual objects of consumer culture. On the other hand, his art did not suggest the same leveling of images that characterizes the work of Warhol, Lichtenstein, and Rosenquist.

In *Still Life #12* of 1962 [fig. 9.3], Wesselmann screwed a metal sign depicting two Coke bottles in shallow relief right on to the canvas, alongside magazine illustrations of food and a camera. The clear geometry of the composition sets off the slightly jarring shifts in scale amongst the objects as well as the syntactical jumps from the painted fruit to the magazine ads to the real metal sign, which is at the same time a found representation of Coke bottles. "One thing I like about collage," he told Gene Swenson, "is that you can use anything, which gives you that kind of variety;

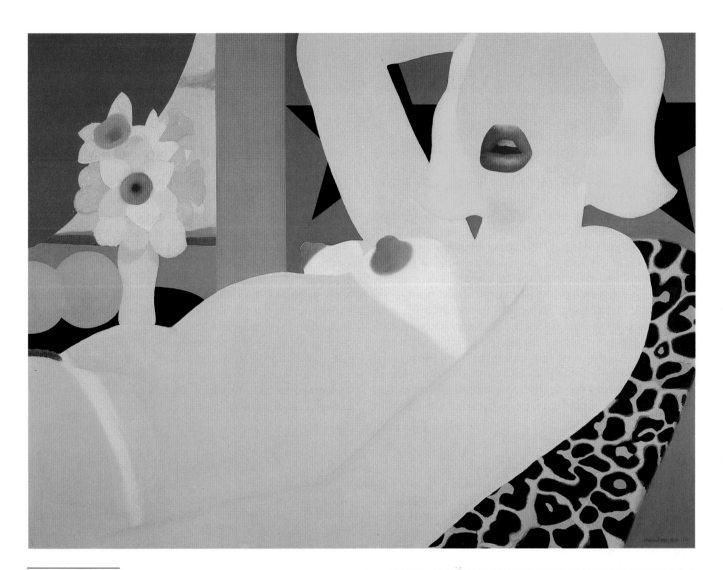

9.4 (above) **Tom Wesselmann,** *Great American Nude #57*, 1964. Synthetic polymer on composition board, 4ft × 5ft 5in (1.22 × 1.65m).

Collection, Whitney Museum of American Art, New York. Purchase, with funds from the Friends of the Whitney Museum of American Art. Photograph by Geoffrey Clements, New York. © Tom Wesselmann/VAGA, New York, 1994.

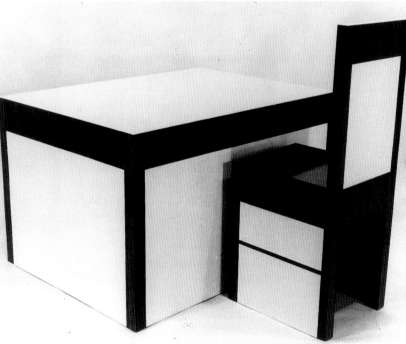

9.5 Richard Artschwager, *Table and Chair*, 1963–4, Formica on wood, table 29¾ × 52 × 37¾in (75.7 × 132.1 × 95.9cm), chair 45¼ × 21 × 17¼in (114.9 × 53.3 × 43.8cm).

Photograph by Richard Pettie, courtesy Leo Castelli Gallery, New York. © 2000 Richard Artschwager/Artists Rights Society (ARS), New York.

it sets up reverberations in a picture from one kind of reality to another."[5]

In 1960, Wesselmann inaugurated a series of "Great American Nudes," drawing from life but evoking an often literally faceless, mass consumer eroticism. In 1962 he began incorporating working televisions, telephones that rang, window blinds, and other real objects, making some of these into three-dimensional tableaux that extend into the viewer's real space, while he simultaneously made the figures increasingly anonymous. In *Great American Nude #57* of 1964 [fig. 9.4] the figure is a simply outlined, flat, flesh-colored shape; instead of rendering the face, Wesselmann provided pointedly detailed glimpses of only the most sexually charged features—the lips, nipples, and pubic hair—which he deliberately quoted in the vase of flowers. Wesselmann depicted the American woman as commodity, seductive and depersonalized, like a page of advertising.

Richard Artschwager is another important artist who doesn't quite fit the definition of pop, but who is nevertheless drawn to the popular taste for the ersatz. His *Table and Chair* of 1964 [fig. 9.5] inverts the customary representational transformation of a flat surface into an illusion of objects in space by rendering the clearly recognizable objects as flat, caricature-like pictures of furniture on the sides of a lifeless but nevertheless fully volumetric cube. Artschwager regarded even the formica itself as a kind of picture of the wood it simulates. His rigorous simplification of prosaic images into geometric objects with coolly impersonal surfaces suggests an ironic crossover between the vocabularies of pop art and minimalism, as does his characteristic use of formica, which reflects an interest in industrial materials. The formica and the synthetic, pretextured board he has used for his paintings attracted him precisely because they make such an unconvincing attempt to simulate wood or a hand-painted surface.

Making the representation of a thing the reality in itself—as Artschwager's formica cube does in relation to a table—implies the variety of simultaneous levels on which any definition of reality exists. This destabilizes any fixed notions of what is real, making reality contingent on any number of fluctuating conditions. The way in which representations—in language or images—affects our experience of the world is one of the most fertile areas of investigation in pop art. In 1962, *Time* reported that the average American was exposed to about 1,600 advertisements per day.[6] There was a comparably vast expansion in the presence of other kinds of images as well. Pop art largely concerned the way in which the individual processed these stimuli from television, magazines, and movies.

Andy Warhol

Andy Warhol's devotion to the aesthetic of television, society columns, and fan magazines was opposed to the European model of the struggling avant-garde artist which the abstract expressionists had emulated. Andy Warhol wanted wealth and fame, and he found anybody who had them fascinating. In addition, his "lipstick-and-peroxide palette" is, as Adam Gopnik has pointed out, "a completely original sense of color ... [which] makes all previous American palettes look European."[7] The originality of Warhol's denial of originality defined his artistic persona, and the fresh look of his paintings validated it.

Part of Warhol's genius lay in his recognition that a persona could be communicated via the media better than an art object could, and he attempted to define his existence entirely on the shallow plane of representation (or reproducible images). "If you want to know all about Andy Warhol, just look at the surface of my paintings and films and me, and there I am," he said. "There's nothing behind it."[8] From the early sixties until his death in 1987 Warhol cunningly exploited both style and the media, and in so doing he exposed the values of contemporary society with an uncomfortable frankness that was both subversive and

9.6 Andy Warhol, *Dick Tracy,* 1960, Casein and crayon on canvas, 48 × 33⅞in (121.9 × 86cm).

Private collection, New York. © 2000 Andy Warhol Foundation for the Visual Arts/Artists Rights Society (ARS), New York.

9.7 (above) **Andy Warhol,** *Storm Door,* 1960. Synthetic polymer paint on canvas, 3ft 10in × 3ft 6⅛in (1.17 × 1.07m).
Courtesy Thomas Ammann, Zürich. © 2000 Andy Warhol Foundation for the Visual Arts/Artists Rights Society (ARS), New York.

9.8 (right) **Andy Warhol,** *Storm Door,* 1961. Synthetic polymer paint on canvas, 6 × 5ft (1.83 × 1.52m).
Private collection, New York. Photography by Bill J. Strehorn, Dallas. © Andy Warhol Foundation for the Visual Arts/Artists Rights Society (ARS), New York.

vanguard. He demonstrated that all fame is equal and essentially meaningless in the world of interchangeable images; his own public persona was irresistibly glamorous, yet its shallowness also left a disquieting emotional void.

Warhol's Background

Andy Warhol was born outside Pittsburgh in 1928 to working-class Czech immigrants. After graduating in graphic design from Carnegie Tech in 1949, he moved into an apartment in New York with his classmate Philip Pearlstein and quickly achieved success as a commercial artist. Warhol's delicate drawings of shoes for I. Miller and Company in the *New York Times* brought him particular acclaim, and by 1959 he was one of the highest-paid commercial artists in the city, earning nearly $65,000 a year.[9] Warhol continued to make his living in advertising until the end of 1962, but from the beginning he also had aspirations as a fine artist, making fanciful drawings and collages of shoes—personified as "portraits"—as well as simple line drawings of other subjects.

Stylistically, Warhol's attempts at art in the fifties closely resembled his work for advertising, and several of the techniques from his graphic design practice anticipated

aspects of his later art as well. For example, he organized "coloring parties" to produce his advertisements and delegated signatures and lettering to his mother, presaging his extensive use of assistants in painting after 1962. Similarly, his technique of drawing—or tracing images from magazines—on non-absorbent paper and then transferring the lines in wet ink by pressing them on to a prepared background set a precedent for the way he subsequently used silkscreens.

Selecting Non-Selectivity

Even though some of Warhol's studio practices of the fifties persisted in his later work, they can scarcely be said to have led up to the shocking directness with which he suddenly began to apply a commercial art style to painting at the end of 1959. Nor was there any precedent for his radical appropriation of subject matter straight out of the pulp media for his large canvases of comic book images and newspaper ads [figs. 9.6–9.8]. Warhol used an opaque projector to transcribe and enlarge his sources with mechanical accuracy[10] in the early sixties, and in his statements about his work he made a point of dismissing any originality in it. Nevertheless he abandoned the comics as a

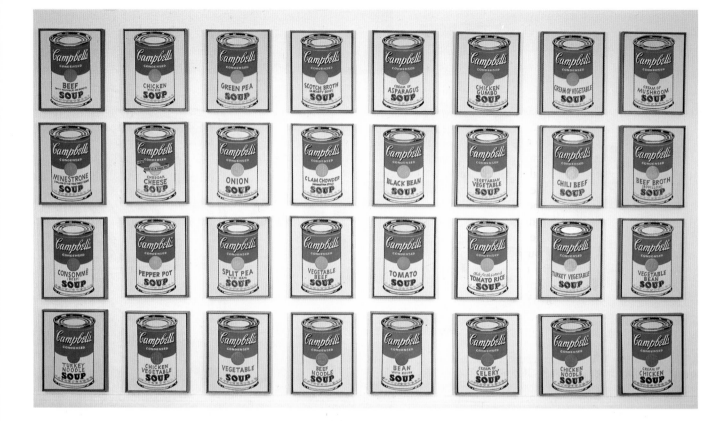

9.9 Andy Warhol, *32 Campbell's Soup Cans*, 1961–2. Acrylic on canvas, thirty-two works, each 20 × 16in (50.8 × 40.6cm).
Collection, Irving Blum, New York. Photograph courtesy Blum Helman Gallery, New York.
© 2000 Andy Warhol Foundation for the Visual Arts/Artists Rights Society (ARS), New York.

subject from the moment he saw Lichtenstein's paintings of comics at the Castelli Gallery in 1961, demonstrating a keen instinct for constructing and marketing an original style.

Having settled on a subject matter—comics, cheap ads, and headlines from the pulp tabloids—Warhol experimented with style between 1960 and 1962. In some compositions he transcribed his sources in a loose, brushy manner with deliberate paint drips to give them an expressive character, as if in a parody of gesture painting. At the same time he rendered other pictures with hard, precise edges. Eventually he decided he preferred these coldly handled, "no comment" paintings, as he called them,[11] indeed he favored the most mechanical look he could render, just as he had sought out precisely the kind of subject matter that went most dramatically against the prevailing prescriptions of high art as individual and expressive.

Warhol made an aesthetic of the non-selectivity encouraged by media advertising. Henry Geldzahler characterized Warhol's "new attitude toward the media . . . not being selective, just letting everything in at once."[12] Warhol took pains to exaggerate the numbing effect of simultaneously bombarding himself with so many sensations that they cancelled each other out. "The music blasting cleared my head out and left me working on instinct alone. In fact, it wasn't only rock and roll that I used that way—I'd also have the radio blasting opera, and the TV picture on (but not the sound)—and if all that didn't clear enough out of my mind, I'd open a magazine, put it beside me, and half read an article while I painted."[13]

Warhol's work celebrated the sameness of mass culture that intellectuals of the abstract expressionist generation abhorred. "What's great about this country," Warhol remarked, "is America started the tradition where the richest consumers buy essentially the same things as the poorest. You can be watching TV and see Coca-Cola, and you can know that the president drinks Coke, Liz Taylor drinks Coke, and just think, you can drink Coke, too. A Coke is a Coke and no amount of money can get you a better Coke than the one the bum on the corner is drinking. All the Cokes are the same and all the Cokes are good."[14]

Nevertheless, Warhol's choice of subjects was not arbitrary. As Kynaston McShine has pointed out, for example, many of the early images—*Wigs, Where Is Your Rupture?, Before and After, Advertisement*—suggest the artist's aspirations for his own metamorphosis: "Promoting devices and products promising improved posture and silhouette, fuller hair, broader shoulders, and bigger arms, these ads touch the core of Warhol's physical insecurities."[15] Even Popeye and Superman, whom he painted in 1960 and 1961, are characters that undergo instant, physical transformations. McShine's speculation is further confirmed by Warhol's attempts to remake himself in the fifties, wearing a silver wig and having cosmetic surgery to refine his nose in 1957.

Warhol did not have a show of his pop paintings in New York until Eleanor Ward exhibited them at the Stable Gallery in the fall of 1962, though he did hang some of them—*Advertisement*, *Little King*, *Superman*, *Before and After*, and *Saturday's Popeye*—as a backdrop to the mannequins in a department store window display he arranged for Bonwit Teller in April 1961. It was Irving Blum of the Ferus Gallery in Los Angeles who gave Warhol his first gallery show, in the fall of 1962: an installation of *32 Campbell's Soup Cans* [fig. 9.9], measuring a uniform 20 × 16 inches each.[16] Warhol, always alert to the latest trend, may have painted them in response to the *Painted Bronze* (ale cans) of 1960 [fig. 7.44] by Jasper Johns, but they surpassed the Johns sculpture in the inexpressive literalness with which they were presented. The cans are so intractibly what they *are*; they are not cans of soup but images, divorcing the signifier from the signified (to use a term from semiotics) more radically than perhaps any painting done up to that time. While some of Warhol's drawings of soup cans retain a delicate, gestural quality as late as 1962, these canvases have no trace of expressive gesture or individuality.

Eliminating the Artist's Touch

Warhol painted the soup cans and newspaper headlines of 1961 and 1962 by hand, but toward the end of 1962 he discovered how to transfer a picture photographically on to a silkscreen and immediately switched over to this technique, eliminating all vestiges of the artist's touch and creating a more mechanically detached image. Moreover, he increasingly relied on assistants to make his paintings. In June 1963 he hired Gerard Malanga to work full-time on the silkscreen paintings and gradually others joined the payroll too, in addition to the occasional help that he always had around. Warhol managed his assistants like the staff in a graphic design office, using them as his tools. "When I first knew Andy they were working on the Marilyn Monroes," one regular reported. "Malanga and Billy

Name did most of the work. Cutting things. Placing the screens. Andy would walk along the rows and ask, 'What color do you think would be nice?' "[17]

Warhol made a style of his non-involvement: "Somebody should be able to do all my paintings for me," he remarked in 1963. "The reason I'm painting this way is because I want to be a machine. Whatever I do, and do machine-like is because it is what I want to do. I think it would be terrific if everybody was alike."[18] Nevertheless, Warhol could have contracted the works out if he had really wanted a perfectly commercial look. Instead, he preferred the human error reflected in the misregistration of the screens, the uneven inking, and the occasional smears.

Marilyn Monroe's Lips [fig. 9.10] looks like an imperfect print run, in which the black line and the color screen do not quite match up and the inking varies widely. The invasive banality created by the mechanisms of consumer culture seems to be at odds with an (albeit passive) individual presence in paintings like this and *Gold Marilyn Monroe* [fig. 9.11]. The repetition forces the images into an anonymous, decorative pattern while particularizing features in each imperfectly fabricated unit continue to assert themselves, creating an expressive dissonance between the machine-like façade and the sense of the individual buried within it. This overwhelming barrage of surface glitter reduces the observer (and the artist) to a helpless voyeur, passively experiencing life as an assembly line of images.

A Terrifying Emptiness

On one hand the proliferation of portraits of Marilyn Monroe, Liz Taylor, Troy Donahue, and other movie stars had to do with Warhol's enthusiasm for the glamour of Hollywood. "I love Los Angeles. I love Hollywood," he said. "They're beautiful. Everybody's plastic . . . I want to be plastic."[19] He was the ultimate fan, acting as though

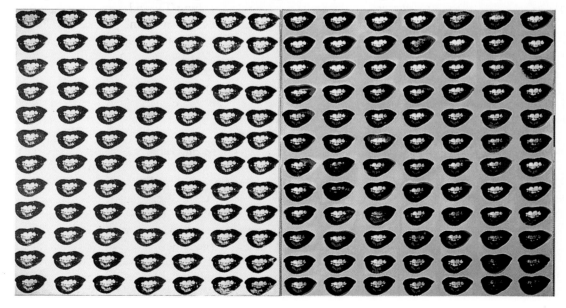

9.10 Andy Warhol, *Marilyn Monroe's Lips*, 1962. Synthetic polymer paint, silkscreened, and pencil on canvas, two panels 6ft 10¾in × 6ft 8¾in (2.1 × 2.05m) and 6ft 10¾in × 6ft 10⅝ in (2.18 × 2.11m).

Collection, Hirshhorn Museum and Sculpture Garden, Smithsonian Institution, Washington, D.C. Gift of Joseph H. Hirshhorn, 1972. © 2000 Andy Warhol Foundation for the Visual Arts/Artists Rights Society (ARS), New York. Photo Lee Stalsworth.

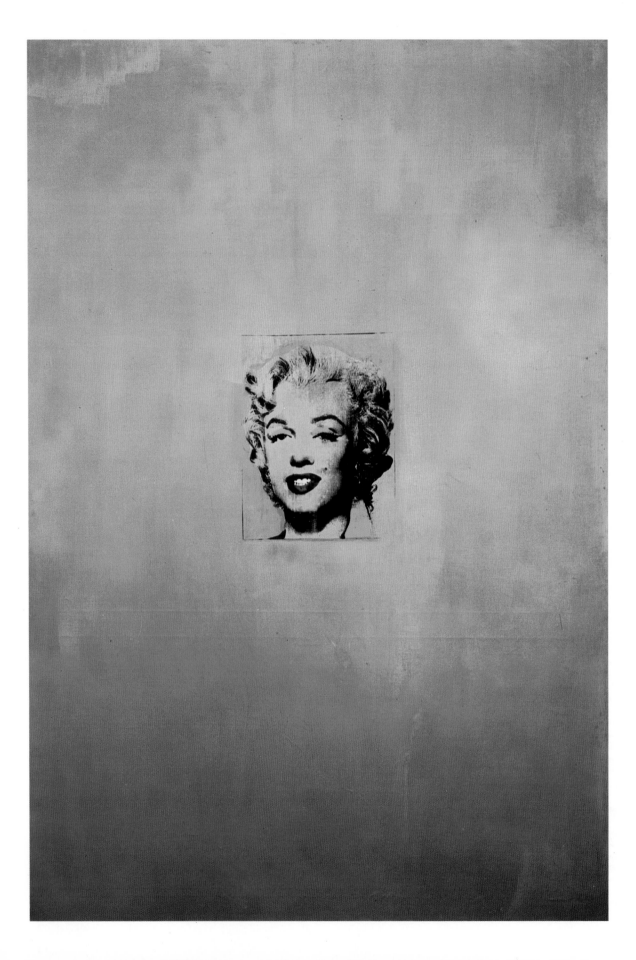

9.11 (opposite) **Andy Warhol,** *Gold Marilyn Monroe,*
1962. Synthetic polymer paint, silkscreened, and oil on
canvas, 6ft 11¼in × 4ft 9in (2.12 × 1.45m).
The Museum of Modern Art. Gift of Philip Johnson. © 2000 Andy Warhol
Foundation for the Visual Arts/Artists Rights Society (ARS), New York.

9.12 Andy Warhol, *Saturday Disaster,* 1964.
Synthetic polymer paint, silkscreened, on canvas, 9ft
10⅞in × 6ft 9⅞in (3.02 × 2.08m).
Collection, Rose Art Museum, Brandeis University, Waltham, Mass. Gervitz-
Mnuchin Purchase Fund, by exchange. © 2000 Andy Warhol Foundation for
the Visual Arts/Artists Rights Society (ARS), New York.

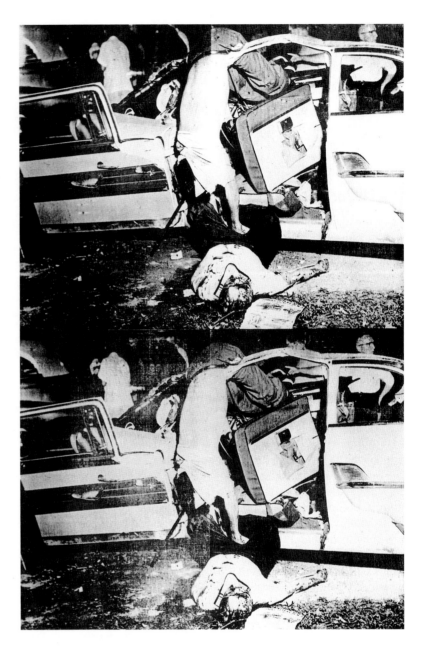

consuming it all vicariously made him a part of it. Yet the
"Marilyns" also have a dark side. The series followed
Marilyn's suicide in August 1962. Moreover, the mechanical
repetition of her portrait makes her seem paper-thin,
robbing her of any sense of existence beneath the
superficial image. It is a frighteningly annihilating
depersonalization and echoes an anxiety that underlies the
artist's image of himself. As late as 1975 he wrote: "I'm still
obsessed with the idea of looking into the mirror and seeing
no one, nothing."[20]

In the television coverage of a national tragedy like the
death of Marilyn Monroe or the Kennedy funeral (which
Warhol also painted obsessively) the same film loops play
over and over on the television for days on end. Warhol's
"Marilyns," especially the double canvas of *Marilyn
Monroe's Lips,* have that same anaesthetizing repetition;
they have the focus of a Hindu mantra, an incantatory
reiteration of the charged event.

In 1963 Warhol embarked on a disaster series [fig. 9.12]
that amplified the morbid preoccupations of the "Marilyns."
He based the series on gruesome tabloid photographs of
mutilated accident victims, the atomic bomb, the electric
chair. He multiplied the images in decorative patterns and
brilliant colors. "The more you look at the same exact thing,"
he said, "the more the meaning goes away, and the better
and emptier you feel."[21] These images not only disturb us
because of their horrifying explicitness, but also because
Warhol's detachment suggests—as in the "Marilyns"—a
depersonalization that is in itself terrifyingly death-like.

In 1962 and 1963 Warhol also made several portraits
of Robert Rauschenberg, whom he admired greatly for
having risen from poverty to fame. Warhol named one of

the Rauschenberg portraits *Let Us Now Praise Famous Men*, appropriating the title of a book by James Agee with photographs by Walker Evans of poor people from the rural South (from which Rauschenberg also came). The book embodied Warhol's fantasy that "in the future everybody will be world famous for fifteen minutes,"[22] in the sense that these anonymous country people became arbitrarily and fleetingly famous. Warhol liked the notion of celebrity as a kind of consumer good that anybody can have.

The Factory Scene

At the end of 1963 Warhol moved his studio to a floor in an old factory building on East Forty-seventh Street. "The Factory," as it came to be called, evolved into an environment lined in silver foil and filled with drag queens, listless "beautiful people," chic fashion personalities, and the rock music underground, many of them wasted on drugs or engaged in bizarre behavior. Warhol seemed to need this circus around him. As his friend Henry Geldzahler recalled, "Andy can't be alone . . . Sometimes he would say that he was scared of dying if he went to sleep."[23]

By 1965 Warhol's celebrity was attracting the rich and famous, who wanted to see and be seen at The Factory. The press hounded Warhol too and everyone vied for his attention. Edie Sedgewick, a rich and pretty young socialite who self-destructed on drugs at the age of twenty-eight, symbolized The Factory of the mid sixties; she was a personification of "mod" style, and for a time she was Andy's constant escort. In the fall of 1965, when Andy and Edie went to his opening at the Institute of Contemporary Art in Philadelphia, nearly four thousand people crushed into the two small rooms and the staff had to take the paintings off the walls for security. It was an art opening *without art*.

"I wondered what it was that had made all those people scream," Warhol later recalled. "I'd seen kids scream over Elvis and the Beatles and the Stones—rock idols and movie stars—but it was incredible to think of it happening at an *art* opening . . . But then, we weren't just *at* the art exhibit—we *were* the art exhibit, we were the art incarnate and the sixties were really about people, not about what they did."[24]

In 1966 The Factory crowd began to spend the evenings in a restaurant on Union Square called Max's Kansas City. It catered to artists and writers and the back room hosted a carnival of exhibitionism, drugs, and the most open homosexual scene anyone had encountered up to that time. Everyone from Bobby Kennedy to Truman Capote showed up there, but Andy was the presiding catalyst. "Andy's like the Marquis de Sade," his friend Emile de Antonio observed, "in the sense that his very presence was a releasing agent which released people so they could live out their fantasies and get undressed, or, in some cases, do very violent things to get Andy to watch them."[25]

"I mean, he doesn't go around hurting people," Henry Geldzahler said, "but they do get hurt."[26] Andy did not actually participate—he watched, and often he took

9.13 Andy Warhol, *Self Portrait*, 1967. Synthetic polymer paint, silkscreened, on canvas, 6 × 6ft (1.83 × 1.83m).
Tate Gallery, London. © 2000 Andy Warhol Foundation for the Visual Arts/Artists Rights Society (ARS), New York.

photographs. Even when he went on the college lecture circuit Andy remained totally passive; he did nothing but sit silently on the stage while Paul Morrissey (his film assistant) answered questions. For about four months in the fall of 1967 Warhol even had Allen Midgette, another Factory hand, spray his hair silver and go as a stand-in until somebody compared a photograph they took at one such appearance with a published picture of Warhol and recognized the deception.

Warhol had always wanted to get into Leo Castelli's gallery, and Castelli finally took him in 1964. His first show, in November, was of the "Flowers." With the "Flowers," Warhol broke further away from naturalism in his palette—not that one could call his earlier works naturalistic, but up until 1964 he had tended either to print the screens in monochrome, so that the scale of values corresponded to nature, or to find more artificial-looking versions of naturalistic colors. In 1964 and 1965 he pushed his palette much further, painting pink and turquoise "Campbell's Soup Cans" instead of red and white ones and making multi-tone "Self Portraits" with a blue face and yellow hair, for example, changing the values of the photograph and dissociating the colors from any reference in nature [fig. 9.13].

Having become the decade's leading art star, with an exhibition in the most fashionable gallery, Warhol publicly announced his retirement from painting in May 1965. It was an outrageous gesture, capped by a show at Castelli the following season in which he covered the walls of one room with his *Cow Wallpaper* and filled the other space with

helium-inflated silver pillows designed to float at head level. It seemed the logical next step to turn art into wallpaper and then say farewell to painting by making "paintings" that would literally float away.

In 1966 film and the celebrity scene completely captivated Warhol. He got bored with painting and virtually stopped, instead promoting and touring with a psychedelic, multi-media performance called "The Exploding Plastic Inevitable," featuring the rock band Velvet Underground. He also made *The Chelsea Girls*, the first financially successful underground film, which Calvin Tomkins described as a "three-hour, twin-screen examination of assorted freaks, drug addicts, and transvestites" and added that "Warhol had removed the artist from art through the use of commercial techniques; he went on to subtract movement, incident, and narrative interest from movies, grinding out epically boring, technically awful films that failed signally to live up to their sex-and-perversion billings."[27]

Warhol's first films, like the six-hour, actionless *Sleep* of 1963, simply involved pointing the camera at someone or something and letting it run; they had no sound tracks. *Eat* (1963) focuses unflinchingly on the head of pop artist Robert Indiana as he eats a mushroom for forty-five minutes; *Empire* (1964) consisted of an unmoving focus on the top of the Empire State Building for eight hours. "I always wanted to do a movie of a whole day in Edie's life," Andy explained. "But then, that was what I wanted to do with most people. I never liked the idea of picking out certain scenes and pieces of times and putting them together, because it ends up being different from what really happened—it's just not like life, it seems so corny."[28]

Business Art and the "Shadows" that Linger Behind It

In 1967 Andy moved The Factory to 33 Union Square West and the scene got more and more bizarre until one day in June 1968 when a groupie walked in and shot Warhol. The side-show atmosphere abruptly ended. Warhol was pronounced dead on the operating table but revived. After spending two months in the hospital he returned to The Factory very frightened. His assistants started limiting access to The Factory, despite his anxiety that he would lose his creativity without the carnival around him. The Factory became a place for the mass-production of art that would sell: commercial souvenirs of the avant-garde that Warhol called "Business Art."[29] To some extent Warhol's work had been an assembly-line product since 1963—in the mid sixties The Factory produced as many as eighty silkscreen paintings a day and at one point a movie every week.[30] At that time, however, the overproduction was part of the tease that gave him celebrity in the first place, and it succeeded so well because it forced into the open the growing sense of alienation that people felt as mass culture came into its ascendancy. "Playing up what things really were was very

Pop, very sixties," Warhol said.[31]

By 1969, however, the point had been made. Looking back over the decade, many critics still feel that Warhol's important work dates from 1960 through 1964. In 1969 the national press carried a quote from one of Andy's studio hangers-on that reinforced this opinion; she said "Andy? I've been doing it all for the last year and a half . . . Andy doesn't do art anymore. He's bored with it. I did all his new soup cans."[32] Warhol had turned his attention to enterprises like his jet-set gossip magazine *Interview*, and to other business ventures. But the idea that his staff was producing paintings without him was part of his ongoing effort to strike a shocking pose. "I really worked on all of them" he later admitted.[33]

In the early seventies Warhol rediscovered his interest in painting with a series of society portraits and pictures of Mao Tse-tung. By this time Warhol had become a household word, the most famous artist after Picasso, and a regular on elite guest lists from Halston's to the White House. The last and most painful phase of the Vietnam War and Watergate dominated the press in the early seventies, and more than ever both the very rich and the counter-culture of political protests alike concerned themselves with images and symbols.

Warhol's paintings of Chairman Mao provided a little ideological pornography. They titillated the wealthy collector while at the same time confirming the triumph of money by transforming the great hero of the anti-capitalist world revolution into a consumer good for the rich. The photograph came from the front of *Quotations from Chairman Mao Tse-tung*

9.14 Andy Warhol, *Gale Smith*, 1978. Synthetic polymer paint, silkscreened, on canvas, 3ft 4in × 3ft 4in (1.02 × 1.02m).
© 2000 Andy Warhol Foundation for the Visual Arts/Artists Rights Society (ARS), New York.

9.15 Andy Warhol, *Skulls,* 1976. Synthetic polymer paint, silkscreened, on canvas, two canvases, 15 × 19in (38.1 × 48.3cm) each.

© 2000 Andy Warhol Foundation for the Visual Arts/Artists Rights Society (ARS), New York.

(the "Little Red Book"), published in 1966, which was carried around by campus radicals of the late sixties.

Meanwhile, Warhol's society portraits of the seventies revitalized the genre of portraiture [fig. 9.14]. Who else could make a portrait in 1978 that could claim to be avant-garde? And that, of course, is also what made them so marketable. The artist printed many of these silkscreen portraits over prepared grounds of textural brushwork in a uniform format of two 40 × 40-inch panels. The sitters are dimensionless, plastic objects of high style. Warhol brought the couturier Halston in to design the decor when the Whitney Museum had a massive show of Warhol's new portraits at the end of the decade, and the museum charged $50 a ticket to attend the opening.

Warhol took on more advertising and design commissions in the seventies and eighties too. The 1986 Christmas catalog for the Neiman-Marcus department stores even advertised a portrait session with Warhol for $35,000, tempting customers to "Become a legend with Andy Warhol . . ."[34] Warhol's intensifying involvement with social status and money played on the superficialities of American culture in the seventies and eighties. The

materialism of those decades left people feeling increasingly alienated from one another, from American society, and finally from themselves. Identity dissolved into the non-being of the voyeur. As Warhol said, "When things really do happen to you, it's like watching television—you don't feel anything."[35] Elsewhere he remarked: "But then everything is sort of artificial. I don't know where the artificial stops and the real starts."[36]

"Before media," Warhol reflected, "there used to be a physical limit on how much space one person could take up by themselves. People, I think, are the only things that know how to take up more space than the space they're actually in, because with media you can sit back and still let yourself fill up space on records, in the movies, most exclusively on the telephone and least exclusively on television."[37] But inextricably linked to this materialistic vanity is a dissolution of self, and while doing his ingratiating society portraits Warhol also embarked on a series of "Skulls" [fig. 9.15] that did *not* sell so well, and then "Shadows," which showed only the indirect evidence that "something" was there. "Everything I do," Warhol observed in 1978, "is connected with death."[38]

Roy Lichtenstein

Like Warhol, Roy Lichtenstein wanted his art "to look programmed or impersonal," mirroring the impersonality of mass culture as America entered the sixties. Unlike Warhol, however, he added "I don't really believe I'm being impersonal when I do it."[39] Lichtenstein sought to use painting as a self-contained arena in which to investigate and respond to this subject matter, and he had a probative interaction with his materials, as in action painting. "I was brought up on abstract expressionism," he said, "and its concern with forming and interaction is, I think, extremely important, even though . . . it's very had to tell where I have interacted with the developing work because the tracks are not there."[40] That lack of any physical evidence of the process in the finished work suggests the more formal nature of Lichtenstein's interest. Rather than a concern with asserting his identity in the work, he seems focused on exploring the imagery and style.

"In abstract expressionism," Lichtenstein explained, "the paintings symbolize the idea of ground-directedness as opposed to object-directedness. You put something down, react to it, put something else down, and the painting itself becomes a symbol of this. The difference is that rather than symbolize this ground-directedness I do an object-directed appearing thing. There is humour here. The work is still ground-directed."[41] By "ground-directed" he meant that the work centers on the internal, aesthetic unity of the painting and the internal dialectic between the formal elements that generated it, rather than on the subject matter. As a metaphor for Lichtenstein's world view, this more detached

perspective with regard to subject matter unambiguously separates him from abstract expressionism.

"The turning point was probably the influence of Happenings," he reflected. "In Happenings, there was the gas station culture and the 'objectness,' with the object not

9.16 Roy Lichtenstein, *Standing Rib,* 1962. Oil on canvas, 21¼ × 25¼ in (54 × 64.1cm).

Collection, Museum of Contemporary Art, Los Angeles. The Panza Collection. Photograph by Squidds & Nunns. © Roy Lichtenstein.

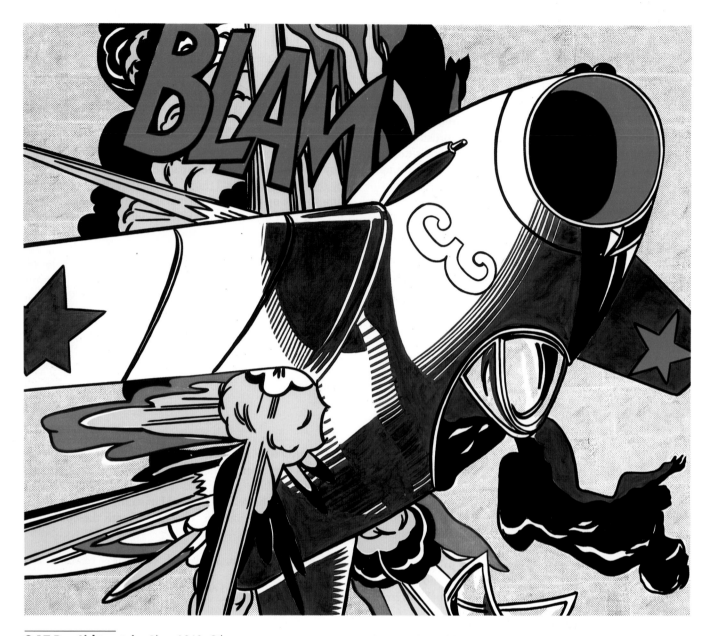

9.17 Roy Lichtenstein, *Blam,* 1962. Oil on canvas,
5ft 8in × 6ft 8in (1.72 × 2.03cm),
Collection, Yale University Art Gallery. Gift of Richard Brown Baker. Photograph courtesy the artist. © Roy Lichtenstein.

connected to its ground by cubist composition."[42] In Lichtenstein's paintings of single objects, like *Standing Rib* [fig. 9.16], the object hangs as though self-contained in a vacuum—it does not relate to the visual ground nor have a spatial context. In addition, he simplified the object and—through the object's frontality—the space into a nearly abstract formal composition. On the one hand this style of rendering objects resembles their presentation in the simple linear sketches of inexpensive product catalogs and back-page advertisements in the newspapers. Like the comics, the advertisements had "a bigness and brashness that is important," he pointed out, "and it is industrial. It stands for

the actual world we are in."[43]

Born in 1923, Roy Lichtenstein grew up in Manhattan and studied briefly with Reginald Marsh at the Art Students League before going off to college at Ohio State. The sentimentality and concern with common culture and life in the paintings of Marsh left an enduring impact on Lichtenstein's work in his choice of subject matter, despite Lichtenstein's irony. The happenings had a similar mixture of expressionism, detached humor, and objectivity—the objectivity of assimilating found objects from the urban environment without alteration.

During 1960 Lichtenstein painted an abstract expressionist picture with Mickey Mouse in it, related stylistically to the de Kooning "Women." Then in 1961 he began painting enlarged frames of comics and images out of advertisements [figs. 9.16–9.19], improving slightly on them in the composition and details. After 1961 he abandoned the easily identifiable

cartoon characters like Popeye and Mickey Mouse in favor of anonymous strips, most often with soap opera romance or action themes. With this kind of imagery, the subject matter comes already translated into the highly conventionalized language of line drawing advertisements or comics. Thus Lichtenstein was not painting things but signs of things. His true subject is not the embracing couple, a rib roast, or jets in a dogfight but rather the terms of their translation into the language of media and the implications of that metamorphosis.

By turning everything into a form that can be reproduced in newspapers or on television, the media homogenize experience. One image can readily be substituted for another on this flat screen of events. Lichtenstein explored this situation in a cool style that he has consistently described in terms of its formal qualities, as if he had little interest in the subject matter. "One of the things a cartoon does," the artist told Gene Swenson in 1963, "is to express violent emotion and passion in a completely mechanical and removed style."[44] But Lichtenstein's detachment from the explicit subject is the *real* subject of his work.

Lichtenstein painted the single objects from 1961 through 1963 and the comics from 1961 through 1965. From the first paintings which he made of the comics, he increasingly used tight rows of small dots to create the color planes. Lichtenstein made stencils to imitate the commercial printing technique of screening flat color areas into regular patterns of what are called Ben Day dots. However, with small holes and heavy pigment Lichtenstein's screens frequently clogged up, so that he had to touch up sections of the painting by hand to enhance the mechanical look! In addition, he often contrasted these dot-patterned areas with flatly painted patches to achieve the crass, visual punch of popular media imagery.

The paintings of 1961 and early 1962 tend to have a patchy application of dots, but by the end of 1962 Lichtenstein had perfected his technique, getting more even results. By 1963 the primitive outlines and hatchings had also receded into a more refined style of drawing, in which each line seems controlled and consciously shaped. Lichtenstein painted *Drowning Girl* [fig. 9.18 and 9.19] in a remarkably impassive style. He also shaped the individual forms with studied elegance—the waves recall the prints of Hokusai. Once Lichtenstein had planned his subject, he focused his attention on the formal refinement of the composition and details. "I think of it as an abstraction. Half the time they are upside-down anyway, when I work," he said.[45]

Lichtenstein was trained in fine art rather than in commercial art and from the outset drew sustenance from art history. Whereas Warhol took no liberties with his subject matter, Lichtenstein subtly reshaped and recomposed his. Moreover he used his comics style to create a distance from the existential authenticity and immediacy of abstract expressionism. He even attempted to neutralize the abstract expressionist brushstroke as, for example, in his series of brushstroke paintings of 1965 and 1966 [fig. 9.20].

James Rosenquist

Since 1960 James Rosenquist has painted large-scale compositions of fragmentary images, mostly from magazines, juxtaposed in a style that Judith Goldman characterized as "noisy, fast, vulgar, overlapping, public, visible."[46] The complex layerings of images evolve from free association rather than from conscious themes, and draw on the formal devices of cubist collage and Pollock's "all-over" composition. But if the inexplicable shifts in the scale and context of Rosenquist's images invite comparison with surrealism, they are not introspective like surrealism, nor did the artist subject the objects to the dream-like metamorphoses of surrealism. Instead the images create a flat screen of impressions that resembles the fast cuts of magazine layouts, television, and film. "I'm amazed and excited and fascinated about the way things are thrust at us," Rosenquist explained. We are "attacked by radio and television and visual communications . . . at such a speed and with such a force that painting . . . now seem[s] very old-fashioned . . . why shouldn't it be done with that power and gusto [of advertising], with that impact."[47]

Despite Rosenquist's externally directed gaze, his paintings are autobiographical in that they draw upon his memory and associations. Yet they do not attempt to define the identity of the artist, as in abstract expressionism. "I want to avoid the romantic quality of paint,"[48] he said. Rosenquist relives his experience through his associations to the things and images he paints, yet he only reluctantly reveals his feelings. "Painting," the artist reflected, "is the ability to put layers of feeling in a picture plane and then have those feelings seep out as slowly as possible, and those feelings, a lot of them, have to do with where you are from."[49]

Rosenquist was born on November 29, 1933 in Grand Forks, North Dakota, and grew up in various places around the Mid-West. The solid technique he acquired in art classes at the University of Minnesota and the skills he learned doing summer work as a sign and billboard painter laid the technical foundation for his pop style. After three years at the university, Rosenquist headed for New York in 1955. He shopped around in classes at the Art Students League for a while and then began working as a billboard painter again.

By 1958 Rosenquist knew many of the most interesting younger artists and was actively painting (on canvas) himself, though he had not yet found his voice artistically. Meanwhile, he continued to earn a living painting billboards of movie characters over Times Square and salamis over Brooklyn. The huge, simple forms of the billboards looked abstract close up, from the scaffolding; to him they resembled the sensuous abstractions from nature by his friend Ellsworth Kelly. He also admired the sheer pleasure of laying on pigment that he saw in the work of Jasper Johns, though he probably did not yet see its relation to the sweeping gestures of liquid paint he was laying on the billboards.

9.18 (below) **Roy Lichtenstein,** detail of *Drowning Girl,* 1963. Oil and synthetic polymer paint on canvas, 60¼ × 36¼in (153 × 92cm).
The Museum of Modern Art, New York. Philip Johnson Fund. © Roy Lichtenstein.

9.20 (above) **Roy Lichtenstein,** *Little Big Painting,* 1965. Oil and synthetic polymer on canvas, 5ft 8in × 6ft 8in (1.72 × 2.03m).
Collection, Whitney Museum of American Art, New York. Purchase, with funds from the Friends of the Whitney Museum of American Art. © Roy Lichtenstein.

9.19 Roy Lichtenstein, *Drowning Girl,* 1963. Oil and synthetic polymer paint on canvas, 60¼ × 36¼in (153 × 92cm).
The Museum of Modern Art, New York. Philip Johnson Fund. © Roy Lichtenstein.

cuts to black and white to keep the imagery on a single perceptual plane in contrast to the varied contexts of the individual pictorial references. This style reduces the subjects to equivalent units of signage. In other works of 1961 he disoriented figures, in addition to fragmenting them and painting them in grisaille, and he created even more radical shifts in scale that made many of the images hard to decipher.

Rosenquist's style of enlarging forms does not provide more detail. Instead of a microscopic view of every pore in the skin, he rendered the blow-up vague at close range like a billboard, implying a hugely expanded space. "I wanted the space to be more important than the imagery," he said.[51] In *White Cigarette* the shaped canvas also emphasizes the literal presence of the work as an object at the expense of the natural reference in the subject matter. "Nature becomes increasingly modified by man until the natural and artificial blend into each other," Rosenquist explained.[52] This in turn precipitates a breakdown between the images and the meanings to which they refer.

The sexual metaphor of the burning, phallic cigarette thrust at the opening of the bottle, which is poised just above the top of a woman's legs, is a deliberate appropriation of the way in which advertising exploits subliminal sexual messages. The falling glass below echoes this theme with a symbol for

9.21 James Rosenquist, *White Cigarette,* 1961. Oil on canvas, 60½ × 35¾in (153.7 × 90.8cm).
Collection, Museum of Contemporary Art, Los Angeles. The Panza Collection. Photograph by Squidds & Nunns. © James Rosenquist/VAGA, New York, 1994.

9.22 Robert Indiana, *The Demuth American Dream #5,* 1963. Oil on canvas, five panels, 4 × 4ft (1.22 × 1.22m) each, 12 × 12ft (3.66 × 3.66m) overall.
Collection, Art Gallery of Ontario, Toronto. Gift from the Women's Committee Fund. © Robert Indiana.

In 1960 the sense of scale that abstracted the images on the signs at close range and the sure hand he had developed in making them coalesced with his ambitions as a fine artist. "I decided to make pictures of fragments, images that would spill off the canvas instead of recede into it . . . I thought each fragment would be identified at a different rate of speed, and that I would paint them as realistically as possible. Then I thought about the kind of imagery I'd use . . . I wanted to find images that were in a 'nether-nether-land.' "[50]

He painted the 5-foot-high *White Cigarette* [fig. 9.21] on canvas, and he made the images in the composition all legible. But he used fragmenting, shifts in scale, and abrupt

9.23 James Rosenquist, *Nomad,* 1963. Oil on canvas, plastic, and wood, 7ft 6in × 11ft 9in (2.29 × 3.58m).

Collection, Albright-Knox Art Gallery, Buffalo, New York. Gift of Seymour H. Knox, 1963. Photograph by Biff Henrich. © James Rosenquist/VAGA, New York, 1994.

9.24 James Rosenquist, *F-111,* 1965. Oil on canvas with aluminum, 10 × 86ft (3.05 × 26.21m).

Private collection. © James Rosenquist/VAGA, New York, 1994.

the loss of virginity that dates back as far as Greek black-figure pottery and confirms the consciousness with which the artist has manipulated the pictorial language. By 1962 the complex juxtapositions cohere only in extremely oblique ways, and it is rare that such a literal reading can be carried through. Rosenquist's sophisticated control over the pictorial semiotics makes him the most direct and subtle heir to Jasper Johns.

In 1961 Allan Stone visited Rosenquist's studio, followed almost immediately by Ileana Sonnabend and Ivan Karp (all important dealers), Henry Geldzahler (the new associate curator for twentieth-century art at the Metropolitan Museum), and Richard Bellamy (who was just then organizing his Green Gallery). Stone offered Rosenquist a two-person show with Robert Indiana [fig. 9.22], whose work dealt more explicitly with signage, but the two artists discussed it and decided to decline. Nevertheless, Bellamy started bringing collectors around who wanted to buy Rosenquist's work. While Rosenquist needed the money, he did not want to part with these paintings just yet because he was still working with the ideas set out in them. Even so, he did sell some pictures, and in February 1962 he had his first show at the Green Gallery. It sold out before it even opened.

The real objects, which Rosenquist had intermittently incorporated into his paintings of 1961 and 1962, took on greater importance in compositions of 1963, such as *Nomad* [fig. 9.23], which includes a flimsy, transparent funnel with paint drips suspended from the top of the canvas over a pile of paint-splattered wood on the floor. Rosenquist also pushed his experiments with the found objects into independent sculptural assemblages in 1963, and although the objects did heighten the flatness of the depicted images, they never held their own against his self-assured rendering and composition.

Political, and especially anti-war, imagery became prominent in Rosenquist's painting after the assassination of John F. Kennedy in November 1963. Lyndon Johnson had taken over the Presidency and was elected the following year. By that time, public debate about the war in Vietnam had begun heating up and Rosenquist found new impetus for his painting in his mounting feelings

against the war. The military allusions in works like *Silo* and *Pad* of 1964 anticipated the imagery of *F-111* [fig. 9.24], Rosenquist's ambitious masterpiece of 1965. Designed to cover all four walls in the main room of the Castelli Gallery, this 86-foot-long panoptican of American mass culture immersed the viewer in a gaudy Day-Glo stream of consciousness: the sharp treads of a Firestone tire, a premixed cake staked-out like a minefield with little pennants listing the vitamins, a light bulb, an enlarged field of spaghetti in artificial orange as if from a can, a nuclear explosion under a multicolor beach umbrella, and a picture-perfect little girl under a hairdryer that looks like the nose cone of a missile.

The imposing profile of the newly deployed F-111 fighter-bomber runs the entire length of the mural. It underlies everything, just as the public's concerns over the war did in 1965, when the United States began the bombing of North Vietnam. The reflective aluminum panels follow by association from the cold, metallic plane. "I'm interested in contemporary vision—the flick of chrome, reflections, rapid associations, quick flashes of light. Bing-bang! Bing-bang! I don't do anecdotes; I accumulate experiences," Rosenquist explained.[53]

Rosenquist led a highly active and success-filled life in the early sixties. But on February 12, 1971 a car accident in Florida left his son John unconscious for five weeks and his wife Mary Lou in a coma for four months. Rosenquist himself had a punctured lung and some broken ribs, but the worst of his agony was the worry over his family, exacerbated by the mounting medical expenses. *Paper Clip*, a monumental masterpiece of nearly 20 feet in width [fig. 9.25], sums up, as it says, "This is Love in 1971": a roll of adding machine tape, a worn billfold, and nostalgic memories from the late thirties of his father's Mobil station in Atwater, Minnesota (the flying red horse was Mobil's corporate symbol), all tenuously held together with a paper clip.

In the mid seventies Rosenquist settled permanently in Florida, near Tampa, and began a major commission for the state capitol in Tallahassee. A new self-confidence and renewed productivity burgeoned in his work, and an escalated level of aggression also emerged as the scale of

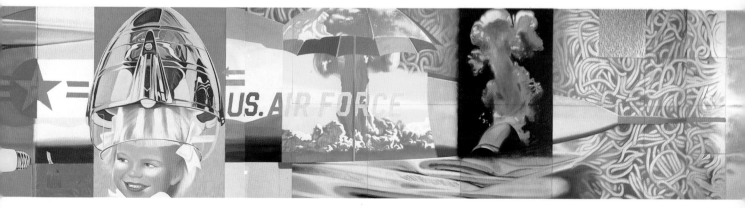

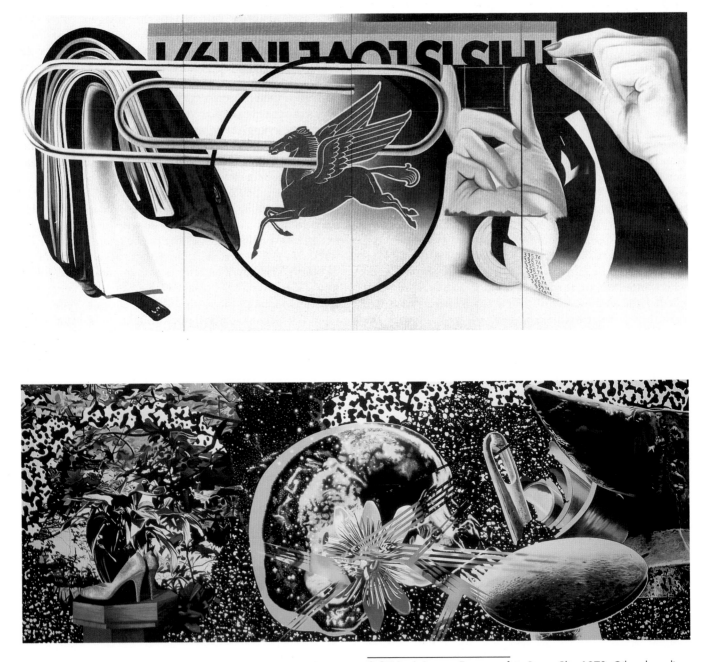

some works increased over the next decade to extraordinary dimensions. *Through the Eye of the Needle to the Anvil* [fig. 9.26], a work of the late eighties, measures 46 feet in width. An increasing number of high-tech allusions appeared in Rosenquist's painting at this time along with cosmic themes and a more exaggerated manipulation of the images into a dream of the common objects gone wild. *Through the Eye* seems to be shot through with charged fields that operate on multiple levels of experience simultaneously. The red lipstick and flesh tones of a woman's face seem to slice across alternating wavelengths in and around the X-ray like images of the brain in its cradle, portrayed as a kind of nexus of information and agency.

9.25 (top) **James Rosenquist,** *Paper Clip*, 1973. Oil and acrylic on canvas, 8ft 6in × 18ft 7½in (2.59 × 5.68m) on four panels.
Collection, Dallas Museum of Art. Gift of The 500, Inc., Mrs. Elizabeth B. Blake, Mr. and Mrs. James H. W. Jacks, Mr. and Mrs. Robert M. Meltzer, Mr. Joshua Muss, Mrs. John W. O'Boyle, Mrs. R. T. Shalom, and Dr. Joanne Stroud in honor of Robert M. Murdock. © James Rosenquist/VAGA, New York, 1994.

9.26 James Rosenquist, *Through the Eye of the Needle to the Anvil*, 1988. Oil on canvas, 17 × 46in (43.2 × 116.8cm).
Collection of the artist. © James Rosenquist/VAGA, New York, 1994.

H.C. Westermann, Peter Saul, and the Hairy Who

H.C. Westermann

H.C. ("Cliff") Westermann inaugurated a tendency in Chicago in the mid fifties to turn away from the psychological introspection of the Monster Roster toward the complex simultaneity of popular culture. Contemporary with Rauschenberg and Johns in New York and with the Independent Group in London, Westermann combined an assemblage aesthetic with an intuitive

sophistication about visual language that rivalled that of Johns. But Westermann did not aestheticize the objects he assimilated; instead he permitted their original, often vulgar, context to survive their incorporation into his work. This makes the viewer acutely aware of the multiplicity of contexts and semantic levels that coexist in Westermann's work and, by implication, the multilayered complexity of any context within which one interprets events.

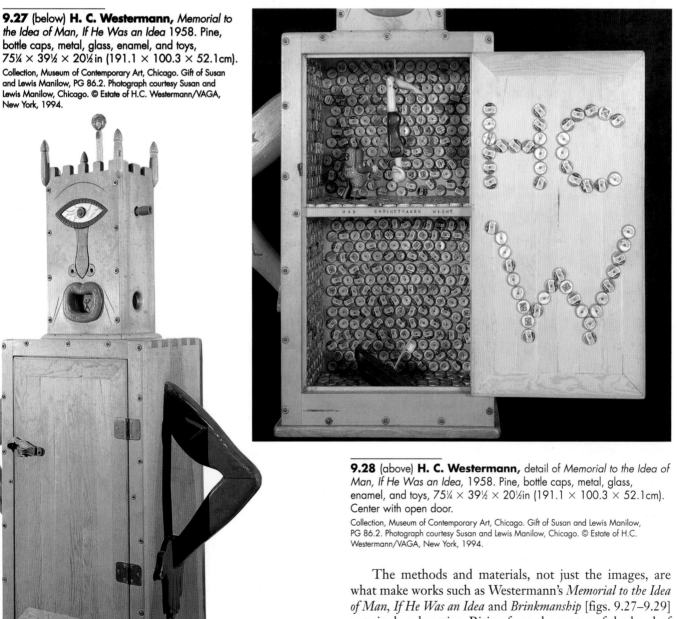

9.27 (below) **H. C. Westermann,** *Memorial to the Idea of Man, If He Was an Idea* 1958. Pine, bottle caps, metal, glass, enamel, and toys, 75¼ × 39½ × 20½ in (191.1 × 100.3 × 52.1cm).
Collection, Museum of Contemporary Art, Chicago. Gift of Susan and Lewis Manilow, PG 86.2. Photograph courtesy Susan and Lewis Manilow, Chicago. © Estate of H.C. Westermann/VAGA, New York, 1994.

9.28 (above) **H. C. Westermann,** detail of *Memorial to the Idea of Man, If He Was an Idea*, 1958. Pine, bottle caps, metal, glass, enamel, and toys, 75¼ × 39½ × 20½in (191.1 × 100.3 × 52.1cm). Center with open door.
Collection, Museum of Contemporary Art, Chicago. Gift of Susan and Lewis Manilow, PG 86.2. Photograph courtesy Susan and Lewis Manilow, Chicago. © Estate of H.C. Westermann/VAGA, New York, 1994.

The methods and materials, not just the images, are what make works such as Westermann's *Memorial to the Idea of Man, If He Was an Idea* and *Brinkmanship* [figs. 9.27–9.29] genuinely subversive. Rising from the center of the head of *Memorial* is a tiny, dimestore globe atop a carved, red-nailed finger. The box-like head and the larger box-torso seem an undefinable hybrid of architecture, cabinetry, and knick-

9.29 H. C. Westermann, *Brinkmanship,* 1959. Assemblage of plywood, electroplated and welded metal, bottle caps, and string on plywood base, 23¼ × 24 × 19⅜in (59 × 60.8 × 49.2cm).
Hirschhorn Museum and Sculpture Garden, Smithsonian Institution, Washington D.C. Gift of Allan Frumkin, 1984. Photograph by Lee Stalsworth. © Estate of H.C. Westermann/VAGA, New York, 2000.

9.30 H. C. Westermann, *Death Ship Run Over by a '66 Lincoln Continental,* 1966. Pine, plate glass, ink, and currency, 15½ × 32 × 11¾in (39.4 × 81.3 × 29.9cm).
Collection, Ann Janss. Photograph by Nathan Rabin, courtesy George Adams Gallery, New York. © Estate of H.C. Westermann/VAGA, New York, 1994.

knack shelf in a dream-state of human animation. Meanwhile, the meticulous carpentry, with its beautiful brass hardware and screws, asserts yet another, completely self-sufficient level on which the viewer encounters the work—as hand-crafted cabinetry.

Westermann lined the lower box with bottle caps [fig. 9.28], using shifts in context to redefine them on to five separate semantic levels: writing his initials with them on the inside of the door, using them as the backdrop for narrative scenes of a sinking ship in a bottle-cap sea, and above that as background for two athletes at play, while a pop-top on this background also stands in visually for the head of the batter. Yet neither the bottle caps nor the cheap little toys (the globe, the acrobat, the batter), nor the rustically simple wooden model of a ship, ever lose their identities as pop-tops, toys, or models. This continuing connection of the incorporated objects to their real origins effectively integrates the rude reality of popular culture into the representation, thus compromising the usual boundary that sets high culture apart. Yet Westermann appropriated the pop materials and images because he felt a genuine affinity for them.

The title, *Memorial to the Idea of Man, If He Was an Idea,* suggests the death of existential metaphysics about man in the same way that the components of the assemblage— prefabricated elements, such as toys and bottle caps, lifted whole from popular culture—undermine the abstract expressionist idea of the autographic gesture. *Memorial* commemorates the dissolution of identity itself into the enigmatic relativity of cultural context. The sudden shift of the batter's head into a bottle cap and back again, or the box itself which is now a cabinet, now a human torso, are both analogies for the instability of things. The wry comment "A

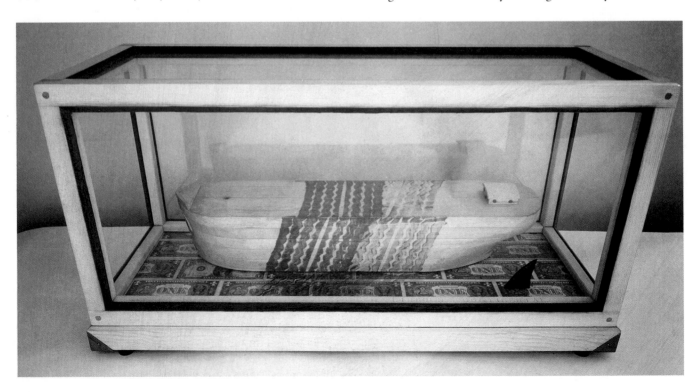

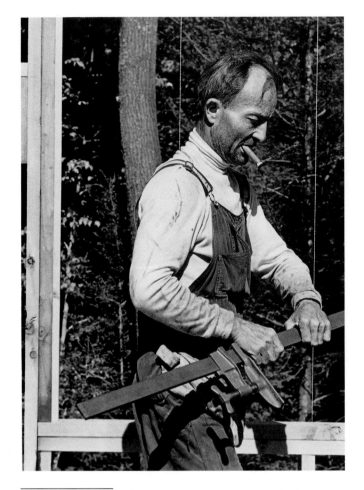

9.31 H. C. Westermann building his studio at Brookfield Center, Connecticut, 1969.

MAD CABINETMAKER MIGHT" (inscribed on the edge of the inner shelf) seems to consign even the artist's intentions in to the inexplicable realm of madness while also suggesting the idea of open-ended possibility.

Like *Memorial*, Westermann's *Brinkmanship* (fig. 9.29) relies on a kind of wisecracker's humor to talk about serious things. As David McCarthy has shown, the title of *Brinkmanship* refers to the Cold War policy of John Foster Dulles (President Eisenhower's Secretary of State) and enforced by General Curtis LeMay, the cigar-smoking chief of the Strategic Air Command (SAC) which deployed the American nuclear arsenal. *Life Magazine* pictured LeMay in a profile feature of 1954 entitled "Toughest Cop of the Western World,"[54] and it seems as though Westermann may have used those photos as his source. Westermann, a decorated war hero of both World War II and Korea, adamantly opposed the U.S. policy of repeatedly taking the nation to "the brink" of nuclear confrontation in the fight against Communism.

Here Westermann portrays LeMay's plump face as a metal toilet float. The rim at the seam divides the top off as a helmet (surmounted by an American eagle), and the artist uses grommets for the eyes and mouth (one of LeMay's

popular nicknames was "the grommet"). The Pepsi bottle-top is like the general's star on the front of his helmet. He has a metal stogy in his mouth with a flat cutout puff of smoke, and—miniature by comparison to the cigar—he has a tiny penis sticking out from the lower part of the pole of his torso.

Meanwhile, the "ground troops," so to speak, are Westermann himself with his wooden profile (labeled with his military "dog tag" number) laid down on the platform. The door of the ramshackle out-house, with the tin smoke stack at the back, is framed by the legs of a humble little smiling figure with the number 25 (Westermann's address on East Division Street in Chicago) across the face. On the facade is a much more robust-looking organ than the general's, pointing off to the right, and the inscription "Sail on, old bird" over the door. Here the reference to Longfellow's famous poem "Sail on, Oh Ship of State!" is turned into a bawdy joke about the sexual displacement of military power. Westermann's style of sarcastic humor in his political critique is distinctly American in its appropriation of jokes into serious works of art about serious issues.

In Westermann's *Death Ship Run Over by a '66 Lincoln Continental* [fig. 9.30] the menacing shark fin circles, endlessly waiting, in a sea of dollar bills. The fin has a strong illusionistic presence on the gray-green water, despite one's awareness of the money as money. In the same way, the fast cut from the narrative of the death ship surrounded by predators to the idea of inking the tires of the family car and literally driving over the piece has a comic book absurdity. The extreme conceptual distance from the narrative of the boat and shark to the bills to the car is simultaneously disturbing and ridiculous. As in *Memorial to the Idea of Man, If He Was an Idea*, part of the humor of the work derives from the almost slapstick jumps from one mental context to another.

Westermann made a number of lonely "Death Ships" followed by an ominous shark fin in dangerous waters and the subject has a specific autobiographical source. In 1942, the twenty-year-old Westermann enlisted in the marines and went to sea in the Pacific on the aircraft carrier USS *Enterprise*. On March 20, 1945 he experienced a terrifying kamikaze attack.

I was the gunner there of that time. One morning early a lone Japanese kamikaze attacked us . . . I saw my tracers going into the god-damned thing but he kept coming . . . Well it was a terrific explosion + many people up forward were killed + wounded + there was a terrific fire up there . . . I looked down on the fantail of the ship + they had all the dead people stacked there like cordwood. It was a pretty ungodly sight.[55]

One can already see the first phase of Westermann's fully developed narrative drawing style in letters he sent home from the war, but his sculpture didn't emerge until the mid fifties. As a student at the School of the Art Institute of Chicago in 1952 Westermann began studying carpentry from manuals, seeking a way to support himself. By 1954 his interest in carpentry had developed into an obsession that drew him into sculpture and soon his craftsmanship became

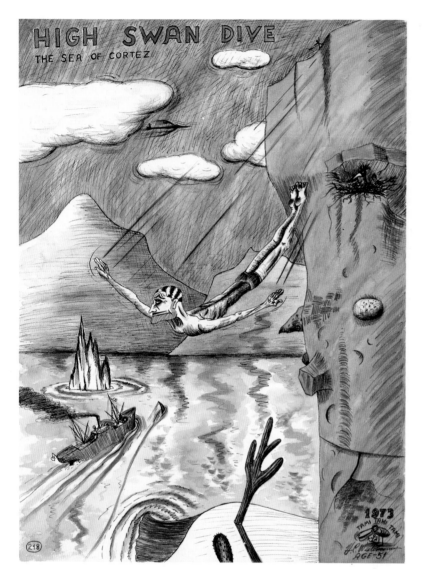

9.32 H. C. Westermann, *High Swan Dive: The Sea of Cortez,* 1973. Ink and watercolor on paper, 30 × 22¼in (76.2 × 56.5cm).
Private collection, New York. © Estate of H.C. Westermann/VAGA, New York, 1994.

too exacting to take on household building projects for clients who wanted quick and simple results. In 1958 Westermann began showing at the Allan Frumkin Gallery in Chicago, and the sale of his sculpture brought in a modest income. In 1959 Allan Frumkin opened a gallery in New York, giving Westermann regular exposure there, and Westermann was finally able to stop hiring out to do carpentry. In the fall of 1961 Westermann left Chicago for his wife's family farm in Connecticut (fig. 9.31), where he stayed (except for a year in San Francisco in 1964 to 1965) until his death in 1981.

Westermann's work of the sixties and seventies had an increasing indebtedness to the spirit of comics, not only in his cartoon-like self-caricatures as Mr. Swami, The Human Fly, Champion of Justice, and the aging Romeo with slicked-back hair in *High Swan Dive: The Sea of Cortez* [fig. 9.32], but also in the comic book's methods of representation. In comics, as in Westermann's works, the images refer to concepts, not to the actual appearance of things. This point

of reference in ideas rather than directly in the physical world results in a revolutionary concept of figuration in which a recognizable abstract symbol—like Popeye's anchor tattoo, which Westermann used for his signature—functions on the same level as an image with a direct reference in nature. This involved a radical rethinking of representation that profoundly influenced such artists as William Wiley and the young Chicagoans of the nascent Hairy Who, in the sixties, and (more or less directly) many important figurative artists in New York in the seventies and eighties, especially David Salle and Keith Haring.

Peter Saul

The untransformed character of the materials that Westermann assimilated into his sculpture of the fifties gives that work a vernacular overtone of folk art. Comic books were also always in the background in his work, though more obviously so in his drawings of the

late sixties and seventies. Peter Saul also drew heavily on pop culture and, like Westermann, had a profound influence on Chicago artists of the sixties, who became familiar with his work through regular shows at the Allan Frumkin Gallery, even though Saul never actually lived in Chicago.

Peter Saul's packed compositions of the early sixties have a pop art layering of common images (rather than objects) in arbitrary profusion, manipulated in the manner of *Mad Magazine*'s satirical, adolescent fantasies. In *Mickey Mouse Vs. The Japs* [fig. 9.33], Saul sends a vicious-looking Mickey Mouse with teeth to fight Japanese war machines in a sequence of disconnected actions. Neither rational space nor proportional scale apply. A comic strip thought-bubble saying "Banzai" emanates from a Japanese fighter plane, a large Mickey Mouse on the graph paper grid leers to the right while the left half of his torso metamorphoses into a solid mass with a hole through the middle. A hammer grows out of this left side of the torso and smacks a war plane on the nose and off the side of the hammer an arm and hand come out thrusting a knife into a disembodied penis that happens to be floating by. These permutations reflect a free train of thought that goes from one idea to the next without looking back, modelled on the kind of doodle one might find in the margins of a high-school notebook. "I'm guarding very carefully against any loss of vulgarity," Saul insisted.[56]

Saul was born in San Francisco in 1934. From 1952 to 1956 he studied painting at Washington University in St. Louis, where he began painting from pictures in *National Geographic*. While in St. Louis he also discovered the complex political compositions of Max Beckmann and developed an admiration for Francis Bacon's " 'adults only' psychology," as he described it.[57] He then lived in Europe—in Paris, Rome, and in a small seaside town in Holland—for eight years, until 1964. Matta "discovered" him in Paris and introduced him to Allan Frumkin who started showing his paintings in 1960. "The years 1959–61 were pretty much used in reconciling specific drawings from *Mad Comics* [sic] with my need to resemble de Kooning," Saul wrote to Frumkin some years later.[58] Indeed, such early works as *Mickey Mouse Vs. The Japs* have rich, gestural passages with an eccentric pop iconography. Perhaps the most widely discussed work in Saul's 1962 show depicted Superman on the toilet.

Saul finally returned to San Francisco in 1964 and stayed there through the ten stormiest years of protest against the war in Vietnam. During this period he shifted his attention to political subjects like the Vietnam War, increasingly rendered in a crass, Day-Glo palette. The war is "a filthy pervert game," he told Allan Frumkin and noted that his "work is an accusation."[59] Adamantly iconoclastic and hardcore in its description, a painting like the

9.33 Peter Saul, *Mickey Mouse Vs. The Japs*, 1961–2. Oil on canvas, 4ft 11in × 5ft 11in (1.5 × 1.8m).

Collection, Susan Wexler, Chicago. Photograph by Michael Tropea, Highland Park.

9.34 (above) **Peter Saul,** Typical Saigon, 1968. Oil, enamel, acrylic on canvas, 7ft 9in × 12ft (2.36 × 3.66m).

Collection, Krannert Art Museum and Kinkead Pavilion, University of Illinois, Urbana-Champaign. Purchased out of the "Illinois Biennial" exhibition of 1969.

monumental *Typical Saigon* [fig. 9.34] indicts the cruelty of the American soldiers as well as the enterprise that brought them to Indochina.

In an orientalized script, Saul wrote "Start Praying You Bastards" down the left side of *Typical Saigon* and lettered the title down the right. While the lurid Day-Glo palette and the slippery plastic surface are hard to look at, they pale compared to the violence with which he portrayed the American GIs sodomizing, assaulting, and crucifying Vietnamese women, whose bodies distort and metamorphose (especially in their sexual anatomy) like comic book superheros to deflect the bullets and attack the soldiers. The painting makes its political statement by its deliberate attack on good taste. "My pictures always give me a hard time psychologically," he said. "[They] are meant as a kind of 'cold shower.' "[60] Toward the end of the sixties Saul began depicting recognizable public figures in this shocking manner, explaining to Frumkin that he hoped to read in the press: " 'Upper Classes of Chicago Terrified by Mad-dog Sex Pervert at Art Gallery. Hundreds Faint.' "[61]

Saul's work directly influenced R. Crumb [fig. 9.51] and S. Clay Wilson, the originators of *Zap Comix*, who first saw his paintings in an exhibition at the University of Nebraska in 1965. He also had a profound impact on William Wiley. But Saul is more strongly associated with Chicago than with San Francisco, because his work was shown principally by Allan Frumkin and had an important influence on Chicago artists of the sixties.

The Hairy Who

In Gladys Nilsson's *Enterprize Encounterized By the Spydar People* [fig. 9.35], the particular manner of the surrealistic distortion and the complex, energetic composition seem indebted to Peter Saul. Nevertheless, the strange, elongated appendages, intertwining with what Whitney Halstead has called a "madcap sense of abandon,"[62] contribute to the uniqueness of the style. The title, inspired by the TV series *Star Trek*, evokes a vivid science-fiction fantasy. As in the narratives of Saul and Westermann, each vignette in Nilsson's composition evolves as a complete thought in itself, a sort of mini-adventure, before going on to the next idea. They proceed along a train of association that builds the whole of the composition in a cumulative fashion, unlike a work of the pop art mainstream—a Warhol or a Rosenquist—in which the details are subsumed by the overall design.

The same sequential composition characterizes the work of Jim Nutt and Karl Wirsum as well as much psychotic art, adolescent doodling, and naive or unschooled art—the so-called "outsider" art which the Chicago artists have long admired. Nilsson, Nutt, Wirsum, James Falconer, Art Green, and Suellen Rocca all finished school at the Art Institute of Chicago in the early or middle sixties and banded together for a sequence of five exhibitions under the collective banner of the Hairy Who. While no ideological program united them, they shared certain predominant interests, including an attraction to funky popular kitsch, comic books and toys (which they presented along with their work), and a propensity to play with language (using puns or having fun with spelling as in "Encounterized" and "Spydar" people). Perhaps most importantly, they tended to view popular culture and outsider art not only as a source but as art in its own right.

9.35 Gladys Nilsson, *The Enterprize Encounterized By the Spydar People,* 1969. Watercolor on paper, 22¼ × 30in (56.5 × 76.2cm).
Collection, the artist. Photograph by William H. Bengston, courtesy the Phyllis Kind Gallery, Chicago and New York.

The Hairy Who existed as a group for four years. They had three shows in 1966, 1967, and 1968 at the Hyde Park Art Center in Chicago, a fourth in 1968 at the Gallery of the San Francisco Art Institute, and a final one in 1969 at the Corcoran Gallery of Art in Washington. In the third show the artists covered the walls with gaudy flowered linoleum and hung bright yellow tags off each work with a bargain price in dollars and odd cents. The style of the exhibition, like the different styles of the six artists, accentuated that which upper-class "good taste" had left out.

For each exhibition except the one in San Francisco the Hairy Who produced a collaborative catalog in the form of a comic book. The sci-fi he-man figures on the front and back covers of the Corcoran catalog [fig. 9.36] are joined with stitches at the shoulder, playfully responding to the way figures are pulled apart when the covers are folded around the booklet. In the other direction the figures tear apart a pair of boxer shorts with "Hairy Who" written across the front as the booklet is opened. The label on the waistband of the putty-headed creature on the back reads "Hairy but true!" while the inscription from the tight lips of the weight lifter on the front with the surrealistically deformed limbs says "gǐ'-me. (one dollar)" using a phonetic spelling and diacritical marks. Above,

9.36 James Falconer, Art Green, Gladys Nilsson, Jim Nutt, Suellen Rocca, and Karl Wirsum, *Hairy Who (cat-a-log)*, 1968. Exhibition catalog cover in paper, printed in color, 11 × 14in (27.9 × 35.6cm) (open).
Private collection.

9.37 Karl Wirsum, *Screamin' J. Hawkins,* 1968. Acrylic on canvas, 48 × 36in (121.9 × 91.4cm).
Collection, Art Institute of Chicago. Mr. and Mrs. Frank G. Logan Prize and Logan Fund, 1969.248.

9.38 Jim Nutt, *Miss Sue Port,* 1967–8. Acrylic on plexiglas and enamel on wood, blue screws and red rubber, 61 × 37in (154.9 × 94cm).
Collection, the artist.

indicates spatial relations through overlapping rather than perspective, and completely eliminates all surface texture by painting on the back of plexiglas and then reversing it so that the viewer looks at the images through it, as in *Miss Sue Port* [fig. 9.38]. The glassy surface with bright colors evokes pinball machines, yet there is nothing mechanical in the genesis of these paintings.

Despite the stylistic individuality of each of the Hairy Who artists, they all built their vocabularies from blends of surrealism and expressionism. Nutt, in particular, found inspiration in Miró's metamorphosis of anatomy [fig. 3.27], especially his exaggeration of sexual parts. In *Miss Sue Port* (a pun on "support"), for example, Nutt distended the pubic

9.39 H. C. Westermann, *Angry Young Machine,* 1960. Painted wood and metal on casters, 6ft 5 in × 3ft 4in × 3ft 4in (2.26 × 1.02 × 1.02m).
Collection, Art Institute of Chicago. Restricted gift of Mr. and Mrs. Edwin A. Bergman, 1975.132. © Estate of H.C. Westermann/VAGA, New York, 1994.

to the right, "cat-a-log" is written as a rebus with the visual symbols of a cat and a log. These and other details make clear the intellectual sensitivity of these artists to the way in which language frames both reality and art in the human mind.

The Corcoran catalog consists only of images—there is no text, though many of the compositions incorporate phrases or words. A version of Karl Wirsum's 1968 painting *Screamin' J. Hawkins* [fig. 9.37] (the title refers to a well-known blues singer) fills one page with its jarring clash of patterns and brilliant colors, influenced by the folk art Wirsum saw on a trip to Mexico in 1961. However complex the forms, they nevertheless have a comic-book clarity of definition and flatness against the simple background color.

Jim Nutt also uses notational devices from the comics, such as motion marks and narrative frames within frames. He

area and then annotated it with the words "shiny hair." The hardware and the rubber square in the center of *Miss Sue Port* derive from Westermann's assemblage aesthetic. In addition, Westermann's cartoon-like drawings, as in the mechanomorphic head on the side of *Angry Young Machine* [fig. 9.39], are a primary influence for Nutt and the other artists of the Hairy Who.

Ed Paschke and Roger Brown were the most important Chicago imagists apart from (but contemporary with) the Hairy Who, and they share many of the same interests, although Paschke and Brown were less language-oriented. Paschke, a native Chicagoan, injects the most perverse imagery of marginal subcultures into the language of high culture. He portrays the truly popular culture of pimps, side-show freaks, hookers, transvestites, and wrestlers, all with a

9.40 Ed Paschke, *Ramrod*, 1969. Oil on canvas, 44 × 26in (111.8 × 66cm).
Jones/Faulkner Collection, Chicago.

9.41 Roger Brown, *Tropical Storm*, 1972. Oil on canvas, 6ft ⅛in × 4ft ⅛in (1.83 × 1.22m).
Collection, Marlene and Gene Siskel, Chicago.

bizarre sexual ambiguity. In *Ramrod* of 1969 [fig. 9.40] he even creates a transition through the facial and body tattoos to the cartoon image of Mighty Mouse.

Roger Brown [fig. 9.41] came from Alabama and Nashville to the School of the Art Institute of Chicago in 1962 and studied there (at first intermittently) until 1968. His first important show was with a group of artists who called themselves False Image (modelled on the pattern of the Hairy Who). He credits Ray Yoshida, one of his Art Institute teachers, with helping him, as he said, to "put myself into my art."[63] Although his work has more variety of paint surface than that of Nutt or Wirsum, it nevertheless retains a comic-book narrative (sometimes literally inscribed under the images on the painting) with a cartoon-like description and flatness. Brown typically painted fantastic, anecdotal scenes filled with amazing, dramatic details in luminous color, often located in familiar Chicago landmarks.

West Coast Pop

Far Eastern culture—particularly Zen Buddhism and Taosim—has long influenced the intellectual climate of California and the Pacific Northwest. The contemplative spiritualism of Mark Tobey [fig. 2.20] and his student Morris Graves was reflected in their meditative response to nature, while in the fifties the familiarity with Eastern philosophy contributed to the receptive climate for the meditative Dynaton painters in Los Angeles—Wolfgang Paalen (who began the journal *Dyn* in Mexico City in 1942), Lee Mullican, and Gordon Onslow-Ford. Zen also had a formative impact on the beats, who sought their escape from the mainstream by retreating into their own consciousness.

Funk Art

Alienation was at the core of beat culture, as in Jack Kerouac's *On the Road*, Allan Ginsberg's *Howl*, J.D. Salinger's *Catcher in the Rye*, and William Burroughs's *Naked Lunch*. For these beat writers, Samuel Beckett's sense of the absurd had replaced Sartre's existentialist "responsibility" in each of their consuming journeys inward. Whereas the New York art world spotlights what is in, the artists of San Francisco have, since the fifties, cultivated a tradition of being out—"far out" to use a phrase from "hip" (the language of jazz and the beats). The beat counterculture of San Francisco centered on

9.42 Bruce Conner, *THE CHILD*, 1959–1960. Assemblage: wax figure with nylon, cloth, metal, and twine in a high chair, 34⅜ × 17 × 16½in (88 × 43.2 × 41.9cm).

The Museum of Modern Art, New York, Gift of Philip Johnson. Photograph by Geoffrey Clements, New York, courtesy the artist.

9.43 Bruce Conner, *SENORITA*, 1962. Assemblage on wood, 34× 21 × 5in (86.4 × 53.3 × 12.7cm).

Collection, Museum of Contemporary Art, Los Angeles. Photograph by Squidds & Nunns, courtesy Museum of Contemporary Art, Los Angeles.

the coffee houses and jazz clubs of North Beach—places with names like the Coffee Gallery, The Co-Existence Bagel Shop, and The Jazz Cellar—where poets, musicians, and artists gathered for readings, often to a background of cool jazz.

Bruce Conner's assemblages, *THE CHILD* and *SENORITA*, embody this beat sensibility [figs. 9.42 and 9.43],

conveying the priority of improvisation with whatever material was at hand. The intuitive process of making the object takes precedence over any preconception of a final product. Conner shunned conventional art materials and craftsmanship precisely to celebrate the triumph of spontaneous creativity over the grimy reality of the material world, underscoring the emphasis on living for the moment. Borrowing from the parlance of hip, this art came to be known as funk, meaning something visceral and earthy, often so powerful and primitive as to threaten the perimeters of "good taste."[64]

Conner, who arrived in San Francisco in 1957, belongs to a group of funk assemblagists and collage makers in California that also included Joan Brown, Wally Hedrick, Jess Collins, Wallace Berman, and Ed Kienholz. Funk assemblages not only attacked the boundaries between one art form and another—Conner, for example, also collaged together underground films, such as *A Movie* of 1958, from discarded Hollywood film clips—but also the separation of art from life. The humorously awkward, improvisational compositions and the bright polychromy that came to be associated with California sculptors such as Robert Hudson [fig. 9.44] in the sixties was one major offshoot of this assemblagist style, influenced by surrealist abstraction and pop color.

Jess Collins, one of the most gifted of the Bay Area assemblagists, cut up and reassembled Dick Tracy comic strips in seven "Tricky Cad" compositions, dating from 1953 through 1959. By scrambling both words and images, he subverted the clarity of communication that normally characterizes comics. Jess, who goes by his first name only, trained as a scientist, worked on the Manhattan and Hanford Projects, and then left the field in 1949 in response to the horrifying implications of the atomic bomb. He sought to create "an antidote to the scientific method."[65] In

9.44 (above) **Robert Hudson,** *Double Time,* 1963. Painted steel and aluminum, 58¾ × 50 × 35in (149.2 × 127 × 88.9cm). Collection, Oakland Museum. Gift of the Women's Board of the Oakland Museum Association. Photograph by M. Lee Fatherree.

9.45 Jess Collins, *The Face in the Abyss,* 1955. Paste-up, 30 × 40in (76.2 × 101.6cm). First National Bank of Chicago.

Working from drawings rather than a live model helped him accentuate the gestural independence of the plaster surface and the splashes of brilliant color. The gesture and color tie Neri's work into the tradition of Bay Area figurative painting, while his unconventional use of the plaster as a final material reveals his link with funk improvisation.

9.47 Joan Brown, *Self Portrait with Fish,* 1970. Enamel on masonite, 8 × 4ft (2.43 × 1.21m).
Photograph courtesy George Adams Gallery, New York.

9.46 Joan Brown, *Portrait of Bob for Bingo,* 1960. Oil on canvas, 29 × 29in (73.7 × 73.7cm).
Collection, Dr. Jay Cooper, Phoenix, Arizona.

his photo-collage *The Face in the Abyss* [fig. 9.45] the crown of the Statue of Liberty rests on top of a menacing machine, flanked by another enigmatic device that shoots out a jet of steam. They seem to have harnessed the forces of the scenic landscape into a frightful science fiction.

The funky paint surfaces of Joan Brown's expressionism around 1960 is another development out of the beat assemblage aesthetic. Brown discovered the classes of Elmer Bischoff [fig. 6.31] in the summer of 1956, when she was eighteen. His influence proved decisive. In 1958 and 1959 Brown made crude, fetish-like figures (often animals), wrapped and tied in crumpled fabric, cardboard, and wire. Her heavily painted canvases of the early sixties, such as *Portrait of Bob for Bingo* [fig. 9.46], show more clearly the influence of Bischoff, as well as that of Francis Bacon and Willem de Kooning, whose work she had seen in San Francisco. Over the summer of 1965 Joan Brown left these densely painted, expressionistic surfaces and shifted her attention to an increasingly eccentric and original subject matter, including a magnificent series of self-portraits on imaginary voyages and another group of self-portraits with fantastic accoutrements [fig. 9.47].

Manuel Neri returned in 1955 from two years in the Korean conflict and immediately settled into the North Beach scene. It was Neri and another artist who invited Allen Ginsberg to give the historic first reading of *Howl* at the Six Gallery on October 13, 1955. Neri consolidated his style of expressionistic plaster figures by 1957 [fig. 9.48].

9.48 Manuel Neri, *Untitled,* 1959. Plaster with enamel, 60 × 22 × 13½in (152.4 × 55.9 × 34.3cm).
Collection, San Francisco Museum of Modern Art. William L. Gerstle Collection, William L. Gerstle Fund Purchase.

Peter Voulkos

One of the first classes Neri took in 1951 at the California College of Arts and Crafts in Oakland was taught by Peter Voulkos, who made an indelible impression upon him. Indeed, Voulkos excited a number of emerging artists over the course of the fifties. As early as 1950 to 1952, while still a graduate student, Voulkos began pushing the limits of clay in both scale and form. He worked in a center for ceramic artists in Montana over the summer of 1952 and there a Zen-inspired Japanese potter named Shoji Hamada taught him about the "courting of the accidental."[66] This encouraged Voulkos to move away from the symmetry of the potter's wheel. Further inspired by his encounter with abstract expressionism in New York the following year, he developed an abstract expressionist style of ceramic sculpture between 1954 and 1958 while he was teaching at the Otis Art Institute in Los Angeles.

This stylistic breakthrough in ceramics had a particularly direct effect on Voulkos's students at Otis, who included Ken Price, John Mason, and Billy Al Bengston. In 1959 Voulkos went on to Berkeley, where he built a foundry (the Garbanzo Iron Works), and by 1960 he had shifted largely to using metal. Robert Hudson and Manuel Neri worked with him in the foundry and he also influenced the young ceramicists Ron Nagle and Stephen De Staebler, who built up clay compositions of monumental scale with independently fired components.

In clay, Voulkos pierced and sliced forms in a loose, improvisational way. His organic response to the material suggests his affinity with the expressionism of Japanese Zen pottery. In works of the later fifties, such as *Sevillanas* [fig. 9.49], he achieved the freedom and gestural boldness of abstract expressionist painting. Yet, even though Voulkos followed Picasso and Miró in making ceramic sculpture, he still had to overcome the conventional notion that anything made in ceramic is necessarily craft rather than art.

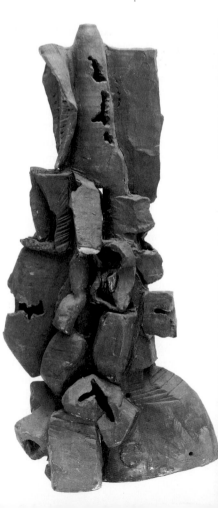

9.49 Peter Voulkos, *Sevillanas,* 1959. Glazed stoneware, 56¾ × 27¼ × 20in (144.1 × 69.2 × 50.8cm).
Collection, San Francisco Museum of Modern Art. Photograph courtesy San Francisco Museum of Modern Art.

The Politicized Cultural Climate of the Sixties

In the mid sixties the cultural climate changed abruptly with the escalation of the Vietnam War, and the protest in the Bay Area set the pace for the nation. The Free Speech Movement in Berkeley started in 1964, using mass demonstrations to disrupt "business as usual" and make the voice of young people heard on matters of national policy. Folk music and the Beatles replaced cool jazz, and the emphasis in everything was on youth. Radical revolutionaries rose up on university campuses and in city centers side by side with hippies, who turned the Zen introversion of the hip beatniks into a popular pastime of the young with the discovery that psychedelic drugs let you "tune-in" to yourself.

"Doing your own thing" was one of many new buzzwords heard at "love-ins," psychedelic light shows, mass audience rock concerts, and rising in the smoke of marijuana "joints" from college dorm rooms and public parks all across America. An aggressive scrutiny of public policy on every level, coupled with an unprecedented openness to a complex variety of opinion, also characterized the ranks of this youth culture. Postermaking flourished as a natural corollary to this highly politicized atmosphere, and out of the widespread interest in posters came the underground comics, originated by R. Crumb [fig. 9.50], S. Clay Wilson, Rick Griffin, and Victor Moscoso of *Zap Comix*. For a few brief years it seemed as if the counterculture would rival the mainstream.

William Wiley

Thank You Hide by William Wiley [fig. 9.51] emerged from this polarized context of intellectual activism on the one hand and an increasing retreat into complex, personal reference on the other.

'I picked up the hide at a rummage sale—it was already there, so I felt absolved of any responsibility for killing [the animal]. *Then Brenda* [Richardson, a curator in Berkeley] *gave me Nietzsche's* Beyond Good and Evil *to read. One day on the can, I just opened it to the middle and read a statement. I can't remember what it was, but it made me think, and I said "thank you" to myself. Then I saw the words cut out on the hide. The hide seemed like a perfect net for a whole lot of things, in terms of the history of objects—Indian artifacts, for example; I used to sift the ground for them when I was growing up in Washington. The broken bottle, a friend brought by one day.'*[67]

To the hide itself Wiley attached a rusted spike, a broken bottle, an arrowhead, an iguana skin from his son's collection, and a piece of petrified wood surrounded by wavy lines. He inscribed "Nomad is an Island," punning on the famous line by the seventeenth-century poet John Donne, "No man is an island."[68] On the shelf above he set bottles, forked branches, a jar labelled "Fresh Bait" and a copy of Nietzsche's *Beyond Good and Evil*. A fishing pole arches over the shelf and around with a line to a pickaxe

resting on the floor. Wiley's aesthetic involves an openness to every object one encounters as the embodiment of an association, in a free, experiential juxtaposition. It is highly intellectual in the puns and in the deliberateness with which he selects and places each object, and freely eclectic both in the use of materials and in the references to other artists. The iconography seems almost, but not quite, decipherable. Influenced by Duchamp and Johns, Wiley's work has the enigmatic anti-rationalism of a Zen *koan*.

Wiley worked in an abstract expressionist style around 1960. By the middle of the decade he had begun incorporating words with images in highly conceptual works that fluidly shifted from one semantic context to another, as from illusionistic rendering to a diagram to a verbal assertion. By 1970, Wiley's materials had also gotten more complex and conceptual. Often he would base a sensitive watercolor on the elements of an assemblage of objects, and then exhibit the assemblage on the floor in front of the watercolor.

9.50 R. Crumb, *"Mr. Natural and Flakey Foont in 'A Gurl in Hotpants,'"* front panel of comic strip from *Mr. Natural*, No. 2, 1971, p. 1. 9¾ × 6¾in (24.8 × 17.2cm).
Photograph courtesy Modernism, San Francisco.

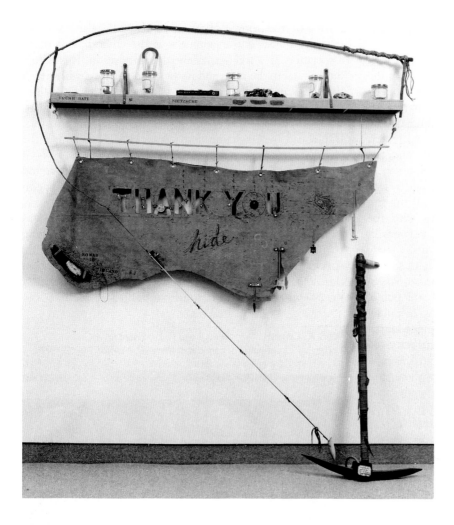

9.51 William T. Wiley, *Thank You Hide,*
1970–1. Wood, leather, ink, charcoal, cowhide,
pickaxe, and found objects, 6ft 2in ×
13ft 4½in (1.88 × 4.08m).
Des Moines Art Center. Purchased with funds from the Coffin Fine
Arts Trust, Nathan Emory Coffin Collection of the Des Moines Art
Center, 1977.9.

9.52 (below) William T. Wiley, *Tankard's
Avail,* 1976. Mixed media on canvas,
5ft 11¾in × 6ft ¼in (1.82 × 1.84m).
Private collection. © William Wiley/VAGA, New York.

The title of *Tankard's Avail* ["Tankards of Ale"], a
characteristic work of 1976 [fig. 9.52], makes no
decipherable sense, though it seems on the verge of doing
so. It doubtless evolved through a private train of
association that occurred in the process of painting—
indeed, Wiley's work has the feeling of a diary written in
incomplete phrases. There are recurring autobiographical
elements (like the striped surveyor's range poles, based on
the tools from his father's brief career as a surveyor) while
other images reappear with sufficient frequency to be
familiar, but never in a context that makes their meaning
clear: the triangle, a figure-eight or the infinity symbol, a
checkerboard, a tic-tac-toe grid, knives, hatchets, logs,
skins, lightning bolts, and moons.[69]

Wiley, inspired by Duchamp's alter egos and by H. C.
Westermann's puns and personas, has several invented
personas for himself in his paintings. Mr. Unnatural, with
the false nose and dunce cap (as in *Tankard's Avail*), usually
appears in a kimono and high *geta* sandals. The name is a
take-off on R. Crumb's short, balding, pop guru,
"Mr. Natural," but Wiley's lanky character is also a
befuddled and absent-minded version of himself in a
borrowed bathrobe.

Ed Kienholz

Ed Kienholz was the most visible figure on the Los Angeles scene in the late fifties, and his Ferus Gallery was the closest Los Angeles got to having a focus of artistic activity. The city had no center, physically or ideologically. The cosmological abstraction of Dynaton had nothing to do with the funk aesthetic of Kienholz—the Southern California strain of abstract expressionist ceramics had more to do with Bay Area figurative painting than with anything going on in Los Angeles.

Ed Kienholz moved to Los Angeles in 1953 from his native Washington State. During the fifties he made funk assemblages that evoked the squalor of the urban environment, stressing its psychological and social dimensions. Like the Bay Area assemblagists, he found inspiration in beat poetry and in surrealist juxtapositions of images and materials. He began making the full scale, walk-in tableaux for which he is best known in 1961. He constructed the aged lady in *The Wait* [fig. 9.53] mostly out of desiccated animal bones. Her head is a plastic-encased photo of a young woman's face, as if the woman of her youth still lives on in her mind. She sits patiently

waiting in her heavy, dark, antique chair, dressed in brittle, yellowed garments. A necklace of jars around her neck seems to contain tokens of memories. The old lady's knitting and shawl lie at her feet and a nostalgic display of old photographs rests on the table beside her. Her immobility is set off by a live canary chirping in a cage that stands to one side.

L.A. Pop

By 1962, when Warhol showed his soup cans at the Ferus Gallery, Ed Ruscha and his boyhood friend Joe Goode had already pioneered indigenous pop styles in Los Angeles. Goode's thirteen milk bottle paintings, for example, each consist of a glass milk bottle, painted with the label left showing, sitting about 3 inches in front of a 5½-foot-square painted canvas. In *Small Space* the brightly painted bottle stands to one side with a double silhouette of it on the heavily handled monochrome canvas behind it [fig. 9.54]. In this combination of the assemblage aesthetic, color field painting (in the backdrop), and the representation of a common object juxtaposed with the real thing (anticipating aspects of the conceptual art of the late sixties while also referring back to Jasper Johns). Goode presses a comparison between the reality of things and the reality of signs of things.

Signage is a particularly omnipresent aspect of the landscape in Los Angeles. Ed Ruscha's trademark and word paintings make an equivalence between words,

9.53 Edward Keinholz, *The Wait,* 1964–5. Tableau, 6ft 8in × 12ft 4in × 6ft 4in (2.03 × 3.75 × 1.98m).
Collection, Whitney Museum of American Art, New York. Gift of the Howard and Jean Lipman Foundation, Inc. Photograph by Gerry L. Thompson, New York.

9.54 Joe Goode, *Small Space,* 1963. Oil on canvas with painted glass bottle, 69¹/₁₆ × 67¹¹/₁₆ × 2¾in (175.4 × 171.9 × 7cm). Collection, Whitney Museum of American Art, New York. Gift of Frederick R. Weisman Art Foundation, Los Angeles, California, 90.28a–b. © 1988 photograph by Steven Slaman.

9.55 Ed Ruscha, *Standard Station, Amarillo, Texas,* from the book *Twenty-six Gasoline Stations,* first edition 1963. Collection, the artist.

signs, and objects feel like a matter of course. He rendered the *Large Trademark with Eight Spotlights* [fig. 9.56], for example, with the convincing three-dimensionality of objects in a landscape, yet the objects are the letters of a sign for Twentieth Century-Fox and the landscape has the hard edges and simplicity of a cartoon. The reality in the picture hovers uneasily between abstraction and representation, undermining the conventional distinction between them. As with New York pop art, Ruscha's painting also attacks aesthetic and semiotic hierarchies by setting advertising and commercial art devices in a high art context.

In 1963 Ruscha published a book of photographs of *Twenty-six Gasoline Stations* between Oklahoma City and Los Angeles on Route 66 [fig. 9.55]. Like his sign and word paintings, the book concerns the interchangeability of images—the uniformity of the gas stations transforms the road into a conveyor belt of mass-produced and therefore reproducible images. It is as if the experience related to the image is not tied to a geographical reality but to the mobile reality of the reproduction. Ruscha also made photo books of *Some Los Angeles Apartments* (1965), *Every Building on Sunset Strip* (1966), and *Thirty-four Parking Lots in Los Angeles* (1967), anticipating some of the issues raised by the conceptual artists in the later sixties.

Vija Celmins, a young artist at the beginning of her career in Los Angeles in the sixties, could hardly be called a pop artist. But she did have a very focused aesthetic on single, often common utilitarian objects like her 1964 *Hot Plate* [fig. 9.57], which resonates interestingly not only with Ruscha and Goode but with the beginnings of minimalism. Like them, her work has a detached objectivity about it; it makes you want to look at something long and hard to see naunces in it that aren't about an outpouring of artistic emotion but rather a kind of wonder about familiar things. Finally, the degree of focus makes them unfamiliar and that is what is so interesting about them. The cord for the *Hot Plate* heads right for the viewer, making the object seem to be part of the viewer's space; and in this rather spare setting the red glow of the hot coils seems so important. A drama of some uncertain kind is implied. It also introduces a sense of time that is at odds with the timelessness of the presentation of the object. Celmins often takes a dramatic subject but looks at it with an eerily steady calm, sometimes representing it as a picture within a picture—making an almost photorealist rendering of a newspaper clipping, as she did with the atomic bomb blast on Bikini Atoll.

Beginning in the late sixties, she began making graphite images and paintings of the moon's surface, segments of oceans, and the night sky [fig. 9.58]. In these images the Zen-like wonder at what was seen or imagined to be seen was aptly characterized by Stuart Morgan in this way: "For Celmins, art depends on slowness of making, slowness so extreme it resembles a belief."[70]

9.56 (above) **Ed Ruscha,** *Large Trademark with Eight Spotlights,* 1962. Oil on canvas, 5ft 6¾in × 11ft 1¼in (1.69 × 3.38m).

Collection, Whitney Museum of American Art, New York. Purchase, with funds from the Mrs. Percy Uris Purchase Fund. Photograph © 1988 by Steve Sloman.

9.57 (below) **Vija Celmins,** *Hot Plate,* 1964. Oil on canvas, 25 × 35in (63.5 × 88.9cm).

Collection Renee and David McKee, New York. Photo © Sarah Wells, courtesy of McKee Gallery, New York.

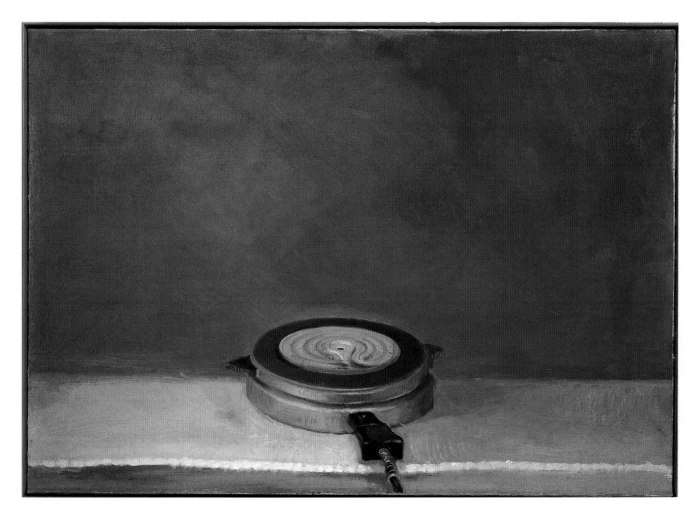

9.58 Vija Celmins, *Untitled,* 1988. Oil on canvas, 15¾ × 18½in (40 × 46.9cm).
Collection The Edward R. Broida Trust, Florida. Photo © Sarah Wells, courtesy of McKee Gallery, New York.

Robert Arneson

Robert Arneson was the most influential figure on the Bay Area arts scene in the seventies and eighties, though he emerged at the beginning of the sixties as a key figure in California "funk art" with his outrageous sculpture in clay. As with Manuel Neri and Robert Hudson, Arneson's encounter with the fifties work of Peter Voulkos was pivotal for him. Arneson first laid eyes on a Voulkos pot in 1957 and was simultaneously impressed and intimidated. "At that time," he recalled, "I never thought I'd be an artist. Just being a good potter would be enough. And then I saw Voulkos's piece."[71] Arneson had acquired a solid technical mastery by then but he was still reactionary in his ideas about ceramics. Within two years, however, he was experimenting with rough, non-functional pots and by 1960 he had begun breaking through to his own organic, abstract expressionism.

Arneson's Break with Conventional Ceramics

In September 1961, while manning a demonstration booth at the State Fair, Arneson threw a pot on the wheel that reminded him of a quart beer bottle, so he put a ceramic cap on it and lettered it "No Deposit, No Return." Although he had no thought of making a statement with this beer bottle, it nevertheless brought commercial culture into a fine art context, as the pop artists in New York were beginning to do, and heralded a major transformation in Arneson's work. However, like Newman's first *Onement* or the initial sketch for Motherwell's "Elegy" series, the full implications of *No Deposit, No Return* for Arneson needed some time to germinate.

The beer bottle's sarcastic jab at the tradition of elegant vases and at the pottery establishment that maintained the compartmentalizing of clay as craft signaled Arneson's radical departure from that kind of work. In the summer of 1961 he had already begun making primitive, gestural sculptures in clay, drawing inspiration from Asian ceramic works on display in the Avery Brundage Collection in San Francisco and from Miró's ceramics.

In the fall of 1962 Arneson was brought in to establish a ceramic sculpture program at the University of California at Davis. Wayne Thiebaud [fig. 6.34], Arneson [figs. 9.59 and 9.60], William Wiley, Manuel Neri, and Roy De Forest [fig. 9.61] all joined the Davis art faculty around that time, making it a singularly exciting place. The remarkable list of graduates from that program included not only important clay artists such as David Gilhooly [fig. 9.62] and Richard Shaw [fig. 9.63] but sculptors such as Deborah Butterfield and the conceptualist Bruce Nauman, both of whose experimental approaches to natural materials and process owe something to the physical directness of Arneson's example.

The Toilets

In the summer of 1963, Arneson received an invitation to exhibit alongside Voulkos and John Mason in an important show at the Kaiser Center in Oakland, called "California Sculpture." With his own style still somewhat unformed and feeling in awe of these celebrated clay artists, Arneson concluded that the occasion called for a personal manifesto. "I really thought about the ultimate ceramics in western culture," Arneson explained, ". . . so I made a toilet."[72] He attributed sexual anatomy to the flush handle, the seat, and the opening of the bowl, put fingernails on one end of the horseshoe seat and, as in *John with Art* of 1964 [figs. 9.58 and 9.59], he even installed a pile of ceramic excrement inside. Then he inscribed the piece with scatological jokes.

Though many critics seized on Duchamp's *Fountain* as a precedent, Arneson explained that he had no such source in mind. "Duchamp did *not* make a toilet, he made an untoilet. It's about transformation—he took a toilet and made a work of art out of it—I wasn't transforming anything. I was looking at a toilet like someone would look at a figure, you know, a very traditional kind of art, and then I started to talk about it, putting the graffiti on."[73]

The director of the Kaiser Center insisted that Arneson remove *Toilet* from the exhibition, causing the artist to realize that although it was offensive, shocking, and in bad taste, he had succeeded in making something original. "This produced a presence of the artist," he explained, . . . I had finally arrived at a piece of work that stood firmly on its ground. It was vulgar, I was vulgar."[74]

With *Toilet* (retitled *Funk John* about two years later[75]) and *John with Art* Arneson aimed a biting satire at the abstract expressionist aspiration of letting everything within the artist spill out freely in the work. The heavy, monochromatic stoneware of *Toilet* resembled the ceramic sculpture of Voulkos. In addition, Arneson treated the surface with an abstract expressionist touch. Despite his satirical irreverence, Arneson's outrageousness stems from and even pays homage to the iconoclasm of abstract expressionism itself.

A Technical Breakthrough

Arneson worked for the whole of the summer of 1965 on an academic self-portrait to get away from "the silly stuff,"[76] as he described it, and was very upset when the bust cracked in the kiln. On an impulse, he glued some marbles into the crack to look as if they were spilling out. Retaining cracked pieces and assembling elements with glue were procedures that ceramicists never used, but from this point forward Arneson did so without inhibition. In effect, the accident liberated him technically and later Arneson would regularly insist that his students build something, destroy it, and then rework it in order to free them from a sense of preciousness about the materials.

9.59 Robert Arneson, *John with Art,* 1964. Glazed ceramic with polychrome epoxy, 34½ × 18 × 25½in (87.6 × 45.7 × 64.8cm).
Collection, Seattle Art Museum. Gift of Manuel Neri. Photograph by Paul Macapia. © Estate of Robert Arneson/VAGA, New York, 1994.

9.60 Robert Arneson, *detail of John with Art,* 1964. Glazed ceramic with polychrome epoxy, 34½ × 18 × 25½in (87.6 × 45.7 × 64.8cm).
Collection, Seattle Art Museum. Gift of Manuel Neri. Photograph by Paul Macapia. © Estate of Robert Arneson/VAGA, New York, 1994.

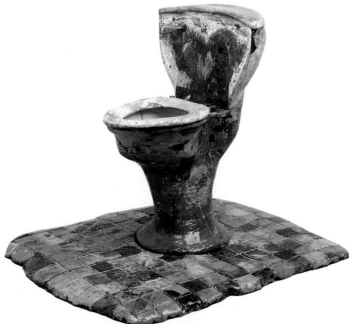

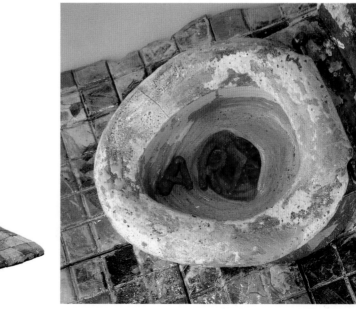

9.61 (above) **Roy De Forest,** *Wise Horse's Dream,*
1972. Acrylic on canvas, 5ft × 5ft 6¼in (1.52 × 1.68m).

Collection, Whitney Museum of American Art, New York. Purchase with funds
from the National Endowment for the Arts. Photography by Geoffrey
Clements, New York.

9.62 (far left) **David Gilhooly,** *Mao Tse Toad on a
Ming Base,* 1976. Glazed earthenware, 32 × 19 × 19in
(81.3 × 48.3 × 48.3cm).

Photograph by See Spot Run, Toronto, courtesy John Natsoulas Gallery,
Davis, California.

9.63 (left) **Richard Shaw,** *Mike Goes Back to T.,* 1980.
Glazed porcelain with overglaze transfers,
41¾ × 13½ × 17½in (106.1 × 34.3 × 44.5cm).

Collection, Whitney Museum of American Art, New York. Purchase, with
funds from the Burroughs Wellcome Purchase Fund. Photograph by Gerry L.
Thompson, New York.

Objects of the Mid Sixties

Around 1965, Arneson began working in the low-fired bright colors on white earthenware that James Melchert and Ron Nagle were using at the San Francisco Art Institute. Nagle had learned the technique from Ken Price, who started working with it in Los Angeles around 1959. Arneson concentrated increasingly on the expressive possibilities of glazing as a kind of painting and soon had an extraordinary mastery of the techniques. This interest in painting also belongs to Arneson's ongoing dialog with abstract expressionism, a recurrent theme in his career from the sarcasm of *Toilet* and this painterly glazing through his explicit investigations of Philip Guston and Jackson Pollock in the 1980s.

Toaster, created in 1965, has a surrealist tone, with the toasted fingers reaching out of the slot. Arneson deliberately pushed the idea too far, scratching a small swastika on the side to turn the piece into a pun on the Nazi ovens, a joke in shockingly bad taste. Yet that startling offensiveness is precisely what raises everyone's emotions to maximum poignancy, prompting serious thought on the subject. No artist has ever been simultaneously so objectionable and endearing—that combination is Arneson's signature. His preoccupation with common objects in the mid sixties has neither the cool, dry cynicism of New York pop nor its tastefulness. Instead, his black, Brechtian humor rests on an outraged morality founded on a fundamental warmth toward his fellow man.

Immediately after *Toaster*, Arneson made *Typewriter* [fig. 9.64]. Both probably date from the winter of 1965 to 1966. He covered *Typewriter* with thick, funky glazes and transformed the keys into fingertips. This piece was high-fired, with the red nail polish painted on afterwards. Here Arneson displayed his mastery of glazes as well as his involvement with painting. In the mid sixties, the women's movement was suddenly making rapid progress in raising the American consciousness about sexism in the workplace. Arneson deliberately toyed with the ambiguity of the object as a woman and the woman as an object, the sexist stereotype of the secretary.

The Self-Portraits

In 1971 Arneson embarked on a concentrated series of self-portraits with works such as *Smorgi-Bob, the Cook* [fig. 9.66]. He turned to his own face [fig. 9.65] not out of an introspective urge but, on the contrary, as an infinitely malleable, neutral vehicle through which to explore ideas. In *Smorgi-Bob, the Cook* he used the pictorial device of one-point perspective to give an illusion of greater depth. He deliberately made the scheme explicit by forming the elements into a perfect receding triangle and then humorously put a portrait of himself at the apex. This ironic underlining of the formal device to point to himself parodies all the talk about flatness, illusionism, and the framing edge in the pretentious art jargon of the late sixties. It also demonstrates the artist's ongoing dialog with painting. "My work," he noted in 1974, "is not about sculpture in the traditional sense, volumes and planes, . . . I am making drawings and paintings in space."[77] Moreover, the finish of *Smorgi-Bob, the Cook* looks like shiny porcelain dinnerware, which is what potters are expected to make anyway, and since the potter cooks his art in a kiln, Arneson sarcastically celebrates his achievement as a master chef.

9.64 Robert Arneson, *Typewriter*, 1966. Glazed ceramic, 6⅛ × 11⅜ × 12½in (15.6 × 28.9 × 31.8cm). Collection, University Art Museum, University of California at Berkeley. Gift of the artist. © Estate of Robert Arneson/VAGA, New York, 1994.

Like plumbing fixtures and place settings, bricks also belong to the historic concerns of the ceramic craft that beckoned Arneson in the late sixties. He did a numbered edition of them, made surrealist transformations of them with ears and wings, set one in ceramic flames, and even finished one with a delicate celadon glaze as in classic Chinese pottery. There is also a brick tableau called *Fragment of Western Civilization*, which resembles the antique ruins of a colossal self-portrait wall, inspired by pictures in *National Geographic* of ancient sites in Mexico with impressive, monumental heads lying about on the ground.[78]

In this piece he wanted to break away from the singular object and make a scatter work of the kind that Barry Le Va or Robert Morris were doing in the late sixties [figs. 10.15 and 10.16], although the idea may actually have been prompted by the experiments of his students with the latest "anti-form" styles. "You never have to read anything," he joked, "just look at what your graduate students are doing."

It was in part to avoid offending anyone that Arneson so frequently used his own face as a vehicle in the seventies. In *Klown* [fig. 9.67] he poked fun at himself in the best comic tradition, and yet the lifelike mask also appears to

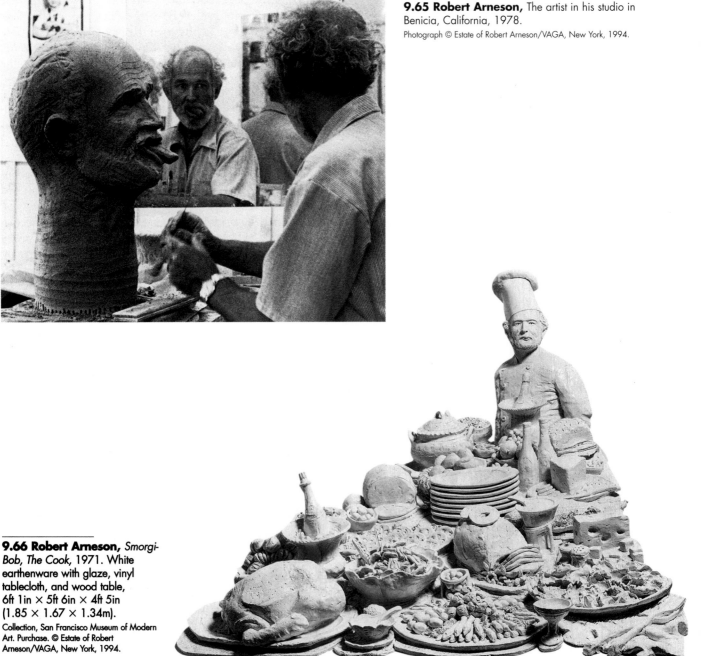

9.65 Robert Arneson, The artist in his studio in Benicia, California, 1978.

Photograph © Estate of Robert Arneson/VAGA, New York, 1994.

9.66 Robert Arneson, *Smorgi-Bob, The Cook,* 1971. White earthenware with glaze, vinyl tablecloth, and wood table, 6ft 1in × 5ft 6in × 4ft 5in (1.85 × 1.67 × 1.34m).

Collection, San Francisco Museum of Modern Art. Purchase. © Estate of Robert Arneson/VAGA, New York, 1994.

trap the artist underneath. In this work Arneson seems to have been more focused on the disconcerting "second skin" than on the internal character. The physical distortions of a self-portrait sketch by the seventeenth-century Flemish artist Adrian Brouwer, in which he is pulling faces in a mirror, and the psychologically impenetrable sculptures of the eighteenth-century psychotic sculptor F. X. Messerschmidt both informed the train of association that led up to *Klown*.[79] The graffiti scrawled all over the base are Arneson's rendition of the satirical humor of the *vox populi*, the anonymous voice of the people.[80]

In 1975 Jack Lemon of the Landfall Press in Chicago persuaded Arneson to make some prints and that exercise refocused his attention upon drawing. From that point until the end of his career, Arneson continued to make large, finished drawings, in a loose, Pollock-like, color gesture that reflects his ongoing preoccupation with action painting. *Klown* and other sculptures of the late seventies have some Pollock-like splashes of color on the base, but it was not until 1983 that Arneson took up Jackson Pollock explicitly as a subject. The juxtaposition of Pollock's extreme emotional anguish and the lush, sensual beauty of his surfaces attracted Arneson in part because Arneson identified with this same juxtaposition, which also characterizes Arneson's art. *The Eye of the Beholder*, for example [fig. 9.68], is both beautiful and cruel.

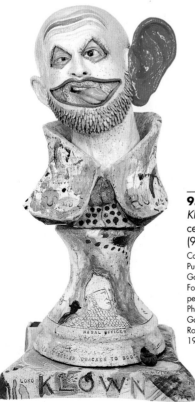

9.67 Robert Arneson, *Klown*, 1978. Glazed ceramic, 37 × 19 × 19in (94 × 48.3 × 48.3cm). Collection, Des Moines Art Center. Purchase, with funds from the Gardner and Florence Call Cowles Foundation, Des Moines Art Center permanent collection, 1980.4. Photograph courtesy George Adams Gallery, New York. © Estate of Robert Arneson/VAGA, New York, 1994.

Discovering a Political Voice

Arneson had hit a terrific stride in his work by early 1981, when he was asked by the San Francisco Art Commission to make a monumental portrait bust of the late Mayor George Moscone for the new Convention Center. The head captured Moscone's likeness to everyone's satisfaction, but the inscriptions on the pedestal—that sarcastic voice of the people—caused a national scandal.

Dan White, a former San Francisco city official, had lost his position to an openly homosexual politician named Harvey Milk. On November 17, 1978 White walked into Mayor Moscone's office and shot him four times. White then reloaded, went down the hall to the office of Harvey Milk and shot him five times. Six months later a jury convicted White of voluntary manslaughter rather than first-degree murder on the basis that he had hypoglycemia and had consumed a large quantity of Hostess Twinkies before the shooting spree, making him temporarily insane. This outrageous verdict caused the "White Night" riot at City Hall, which left 119 injured (half of them police officers), and over a million dollars in damage.

On the base of the Moscone portrait Arneson portrayed a Twinkie and five bloody bullet holes as well as numerous inscriptions related to Moscone's career, including the headline "and Feinstein becomes mayor." Mayor Feinstein asked the artist to replace the pedestal, but he refused because it was part of the conception of the piece. So the mayor draped the pedestal for the dedication of the building on December 2, after which Arneson returned the money and withdrew the sculpture.

The base of the Moscone portrait surprised no one who knew Arneson's work, and the artist was not expecting the storm of controversy that blew up nor the scale of national news coverage it attracted. But the publicity over the Moscone piece made him realize that he had a platform from which to take up a cause,[81] so toward the end of 1982 he turned to a theme so sober it shocked even those who knew his work well.

In *Ass to Ash* of late 1982 Arneson used his own head as the target of a nuclear holocaust. On the base of the charred and deformed *Holy War Head* [fig. 9.69] he inscribed a lengthy passage from John Hersey's *Hiroshima*, describing the effects of radiation. In 1983 Arneson began focusing on nuclear weapons, radiation poisoning, and above all on the terrifyingly detached attitude with which nuclear materials are handled and discussed.

Introspection Via Pollock

In 1984 and 1985 Arneson turned even more directly on the military establishment, portraying it as a savage martial court presiding over total annihilation. Then he looked to Jackson Pollock as a subject through which he could investigate his own psyche. Donald Kuspit described

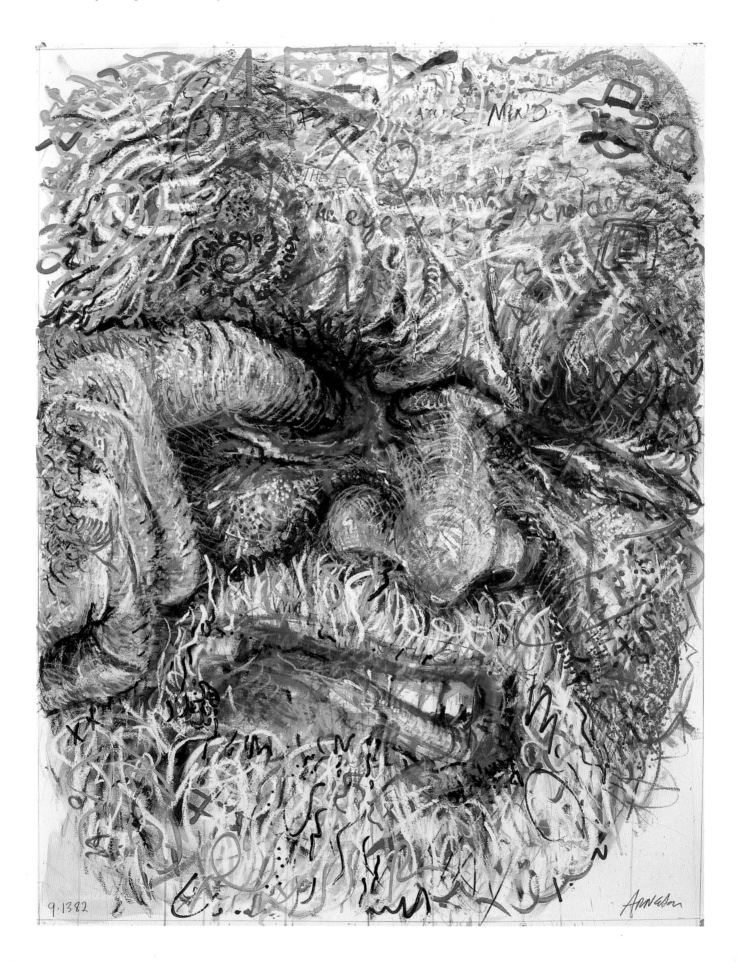

Arneson's growing interest in Pollock during the eighties as an identification with the artist as the brutalized and isolated victim and survivor.[82] But Pollock self-destructed, whereas Arneson overcame the odds. Far from being a hapless victim, Arneson externalized momentous rage and a corresponding terror in the anti-nuclear works and faced them head on in his works on Jackson Pollock.

This exploration of Pollock seems to have contributed to the emergence of a later style in Arneson's work, with the loose gesture of his red conte crayon drawings of 1991 and a series of sculptures in 1991 and 1992 (the year of his death) that transcend the ephemeral emotions of present situations. Whereas the eccentricity of Arneson's wry humor had always represented rebellion against convention, these late works no longer concern themselves with external standards at all. Instead a work such as *Head Eater* of 1991 (a double self-portrait mask of one self-image taking a bloody bite out of the head of the other) foregrounds the unruly forces of the unconscious mind as the norms against which to measure experience and form.

9.68 (opposite) **Robert Arneson,** *The Eye of the Beholder,* 1982. Acrylic, oil pastel, and alkyd on paper, 4ft 4in × 3ft 6in (1.32 × 1.07m).

Collection, Estate of the artist. © Estate of Robert Arneson/VAGA, New York, 1994.

9.69 Robert Arneson, *Holy War Head,* 1982. Glazed ceramic, 72 × 28 × 28in (182.9 × 71.1 × 71.1cm).

Collection, Rita and Irwin Blitt. Photograph by M. Lee Fatherree, courtesy the Estate of the artist. © Estate of Robert Arneson/VAGA, New York, 1994.

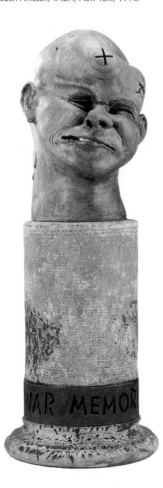

10

IN THE NATURE OF MATERIALS: THE LATER SIXTIES

Back to First Principles— Minimal Art

In an important essay of 1965 entitled "ABC Art," Barbara Rose wrote about the recent emergence of "an art whose blank, neutral, mechanical impersonality contrasts so violently with the romantic, biographical abstract expressionist style which preceded it that spectators are chilled by its apparent lack of feeling or content."[1] This new art asserted an overtly unsymbolic physicality as opposed to the abstract expressionist idea of the object as a vehicle for dramatic, emotional introspection. "Minimal art," as this work came to be known, gravitated toward regular, geometric forms or modular sequences with uninflected surfaces, especially in sculpture which was placed not on pedestals but directly on the floor or wall to stress its continuity with real space. Donald Judd, whose clear prose style made him an unofficial spokesman for this new art, coined the term "specific object"[2] in 1965 to refer to the literalness with which this new sculpture and painting revealed itself to the observer as precisely what it was in the physical sense rather than as a metaphor or representation.

The reductive appearance of minimal art shocked viewers accustomed to the visual complexity of gesture painting. Indeed Lucy Lippart (another critic close to these artists) felt compelled to argue in 1966 that the monotony of minimal sculpture (her choice of words) was, in itself, an avant-garde gesture: "The exciting thing about . . . the 'cool' artists," she said, "is their daring challenge of the concepts of boredom, monotony and repetition."[3] The antagonism to minimal art, however, involved more than a response to its boredom: minimalism came to be seen by some as aggressively authoritarian, a "displaced will to power,"[4] and in particular white male power.

Inspired by the work of Ad Reinhardt [fig. 6.13], Frank Stella's schematic, monochrome paintings of 1959 through 1961 [fig. 10.2] launched minimalism. During the mid sixties, Donald Judd, Tony Smith, Carl Andre, and Dan Flavin gave definition to it as a movement, with Robert Morris pushing out the perimeter in the direction of "process art" (so-called for its focus on procedures interacting with materials), and later in the decade Sol LeWitt using minimalist ideas as the foundation for "conceptual art"—an art which struck out for independence from the physical object altogether. These artists were united above all in their attempt to treat works of art literally as objects instead of as vehicles for abstract ideas or emotions, and yet, as we shall see, a hint of romanticism (see page 33) perseveres in the works of both Flavin and Andre.

Minimalism depended upon a prodigious amount of polemic—written largely by the artists themselves—to reveal the motives behind these apparently simple works. As in Clement Greenberg's formalism, the simplest object might generate the most complex, theoretical *raison d'être*. Morris,

10.1 (opposite) **Eva Hesse,** *Several,* November 1965. Acrylic paint, papier mâché over seven balloons with rubber cord, 84 × 11 × 7in (213.4 × 27.9 × 17.8cm).

Saatchi Collection. London. © Estate of Eva Hesse, courtesy Robert Miller Gallery, New York. Photography courtesy of Timken Publishers.

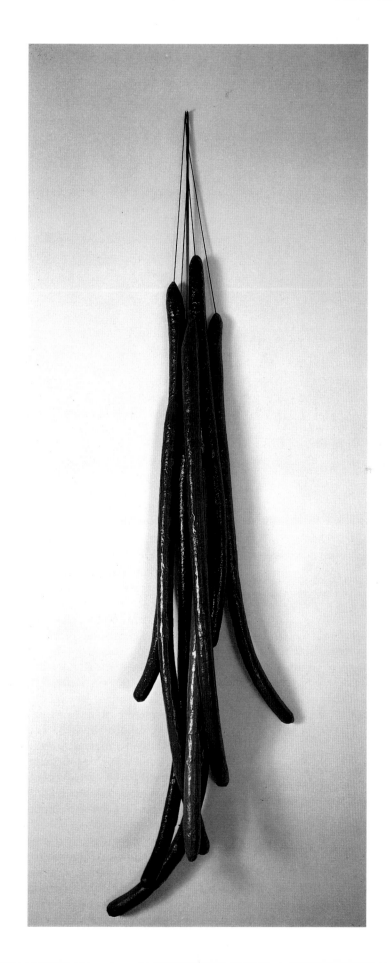

In the Nature of Materials: The Later Sixties

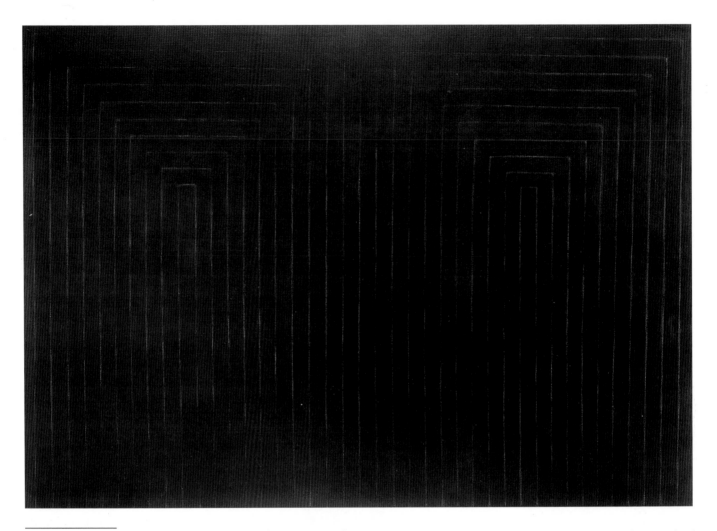

10.2 Frank Stella, *The Marriage of Reason and Squalor*, 1959. Oil on canvas, 7ft 6½in × 10ft 11½in (2.3 × 2.34m).

Collection, Saint Louis Art Museum. Purchase and funds given by Mr. and Mrs. Joseph Helman, Mr. and Mrs. Ronald K. Greenberg. © 2000 Frank Stella/Artists Rights Society (ARS), New York.

for example, wrote that where painting was optical, sculpture was tactile, literal, and had a monolithic physicality. Judd concurred on "the lesser position of painting";[5] sculpture as sculpture, in Greenberg's modernist reduction too, had made it the most current stage of modernist art. Yet Morris rejected Judd's relief sculpture [fig. 10.3]:

Relief cannot be accepted today as legitimate. The autonomous and literal nature of sculpture demands that it have its own, equally literal space—not a surface shared with painting. Furthermore, an object hung on the wall does not confront gravity; it timidly resists it. One of the conditions of knowing an object is supplied by the sensing of the gravitational force acting upon it in actual space . . . The ground plane, not the wall, is the necessary support for the maximum awareness of the object.[6]

Ironically, Clement Greenberg disliked the work of Stella and his friends, even though they pursued his theoretical prescriptions for modernism with greater rigor than more compliant formalists like Louis. Greenberg discounted

minimalism as contrived, "something deduced instead of felt or discovered,"[7] while Michael Fried attacked the minimalists in a virulent and personal tone, threatening to "break the fingers of their grip." Fried argued that "the entire history of painting since Manet could be understood . . . as consisting in the progressive . . . revelation of its essential objecthood,"[8] but, exempting Stella from the movement, he admonished minimal artists for going too far, making objects so literal they directed the viewer to external relationships, which Fried called "theatrical," thereby detracting from their aesthetic purity.

Minimal art made the reductive geometry and theory of Ad Reinhardt newly relevant in the sixties. "The one object of fifty years of abstract art," Reinhardt wrote in 1963, "is to present art-as-art and as nothing else, to make it into the one thing it is only, separating and defining it more and more, making it purer and emptier." He sought an "art preoccupied with its own process and means."[9] Reinhardt attacked any suggestion of external references in art and he championed a psychological emptiness that rivalled Warhol's. In his "Twelve Rules for a New Academy," Reinhardt proclaimed that: "The laying bare of oneself . . . is obscene."[10] The "Twelve Rules" were: no texture, no brushwork, no drawing, no forms, no design, no color, no light, no space, no time, no

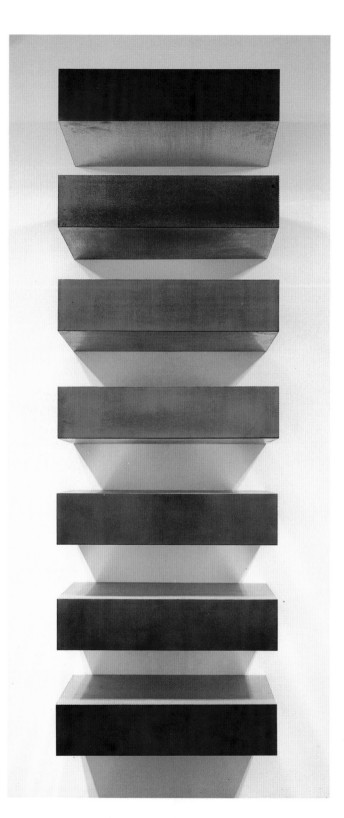

10.3 Donald Judd, *Untitled,* 1967. Galvanized iron with green lacquer on front and sides, twelve units 9 × 40 × 31in (22.9 × 191.6 × 78.7cm), each with 9in (22.9cm) intervals.

Helman Collection, New York. Photograph courtesy Blum Helman Gallery, New York. Art © Donald Judd Estate/VAGA, New York.

size or scale, no movement, and finally no object.

Reinhardt, an articulate and ardent formalist, remained principally committed to exploring the epistemological potential of paining. He rooted his style in a formal reading of the work of Mondrian and Malevitch rather than in that of the surrealists and Picasso, though he was of the abstract expressionist generation. He had become increasingly interested in Zen after the war and from 1954 until his death in 1967 he worked at version after version of one painting. The "black paintings" [fig. 6.14] which comprise this final series produce the initial effect of a uniform black field until one's eyes acclimate to see the subtle division into nine squares and even some trace of brushwork.

Frank Stella

In the flag paintings of Jasper Johns the objects themselves are the image, and this made a powerful impact on Frank Stella when, as a senior in college at Princeton, he saw the 1958 Johns show at the Leo Castelli Gallery.[11] Indeed, the thickness of the stretcher made a Johns flag more object-like than a real flag. Johns thus furthered a development—inaugurated in symbolism at the turn of the last century and inflected by Picasso's collage—toward transforming the painting from an illusion into an object. In addition, the flags provided an example of making a painting from clearly set out, preconceived ideas: "The thing that struck me most," Stella later explained, "was the way he [Johns] stuck to the motif . . . the idea of stripes—rhythm and the interval—the idea of repetition. I began to think a lot about repetition."[12]

Stella singled out formal ideas from the paintings of Jasper Johns one by one, and then followed them to a logical extreme in abstract terms. In this distillation he eliminated not only the subject but the painterly touch (both of which Johns had retained precisely for their provocative ambiguity). Stella also enlarged his pictures to a greater scale than those of Johns, yet one nevertheless sees the Stellas all at once rather than lingering over details. The idea of eliminating foreground and background by painting a single motif, identical with the form of the canvas (as in the flags), led directly to Stella's most celebrated innovation—the shaped canvas [figs. 10.4 and 10.5].

Such paintings by Stella as *The Marriage of Reason and Squalor* (which Dorothy Miller exhibited in the Museum of Modern Art's "Sixteen Americans" show in 1959) and *Lake City* married the influences of Reinhardt and Johns. Stella asked Carl Andre to write his artist's statement for the *Sixteen Americans* catalog, thus keeping Stella at an expressive remove from this too. In it Andre explained:

Art excludes the unnecessary. Frank Stella has found it necessary to paint stripes. There is nothing else in his painting. Frank Stella is not interested in expression or sensitivity. He is interested in the necessities of painting . . . Frank Stella's painting is not symbolic. His stripes are the paths of brush on canvas. These paths lead only into painting.[13]

In the Nature of Materials: The Later Sixties

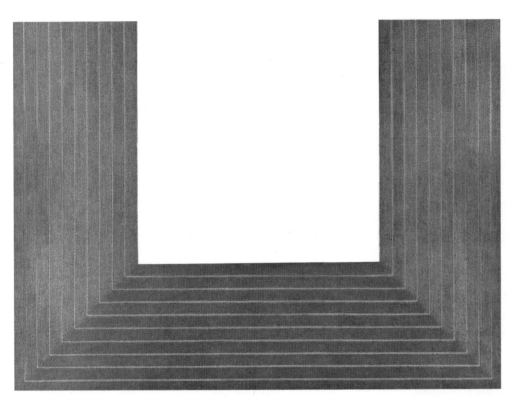

10.4 Frank Stella, *Lake City,* 1962. Copper paint on canvas, 22⅝ × 30in (57.5 × 76.2cm).

Menil Collection, Houston. Photograph by Allan Mewbourn. © 2000 Frank Stella/Artists Rights Society (ARS), New York.

10.5 (below) **Frank Stella,** *Hatra I,* 1967. Acrylic on canvas, 10 × 20ft (3.04 × 6.09m).

Collection, Art Institute of Chicago. Major Acquisitions Fund, 1970.842. © 2000 Frank Stella/Artists Rights Society (ARS), New York.

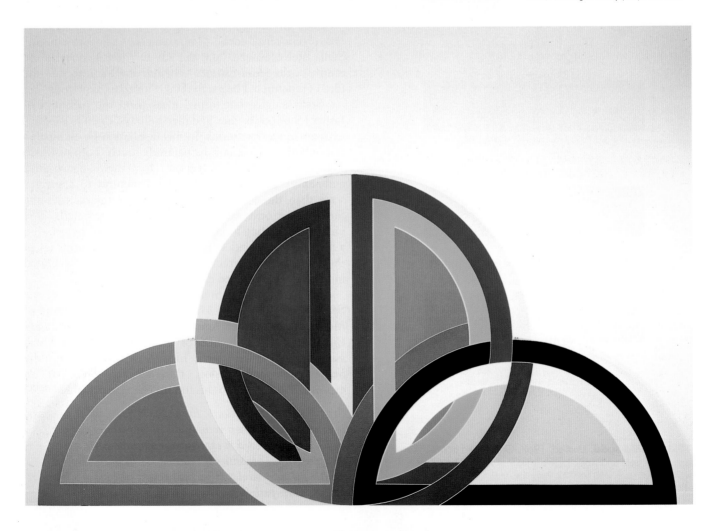

Despite this avowed neutrality of expression, Stella endowed many of his early pictures with emotionally charged titles. As Brenda Richardson observed, "death and especially suicide are prevalent references" along with allusions to Nazi Germany, as in *Die Fahne Hoch* ("raise the flag high") from the Nazi marching song of Horst Wessel and *Arbeit Macht Frei* from the inscription over the gates of the Auschwitz concentration camp.[14] It almost seems as if Stella segregated the expressive aspects of his work into discretely contained and controllable areas just as he separated out the formal issues one at a time.

In Stella's black paintings there was still a discernible brushwork—visible paths of the brush—to make every aspect of the process entirely clear. Unlike Reinhardt's black on black squares, Stella made the stripes completely visible too. He also cut notches in the edges, holes into the centers, or altered the shape of his canvases (as in *Lake City*) to conform to the projections of his geometric designs. In this way, Stella avoided an illusion of spatial recession and enhanced the object's presence as an object, making a flatter and less referential canvas than anybody had painted up to that time. The new flatness of Stella's black, copper, and aluminum paintings made even the shallow space of abstract expressionism seem old-fashioned. Michael Fried claimed that in doing this Stella had posed and solved the central formal problem in modern art since impressionism—namely, asserting the painting's presence as an object (its "objecthood").[15]

Stella delineated a radical posture by systematically inverting the assumptions of abstract expressionism. His friend Walter Darby Bannard explained:

Abstract expressionism was repudiated point by point: painting within the drawing replaced drawing with paint; overt regularity replaced apparent randomness; symmetry replaced asymmetric balancing; flat, depersonalized brushing or open, stained color replaced the smudge, smear and spatter . . . The entire visible esthetic of abstract expressionism was brutally revised.[16]

Above all, Stella attacked the introspective motive in abstract expressionism: "My painting is based on the fact that only what can be seen there *is* there," he said. "It really is an object . . . you can see the whole idea without any confusion . . . what you see is what you see."[17] Like Greenberg's Post Painterly painting, Stella's work is an attack on transcendence. Thus even though Stella's large scale, lack of gesture, and definition of the surface as an overall field are all indebted to Barnett Newman, he couldn't have been less interested in Newman's subject matter.

Stella went from single colors to industrial Day-Glo in the mid sixties [fig. 10.5], probably under the influence of Warhol. Shape, configuration, and pattern all continued to refer to one another in a closed—if increasingly complex—system that asserted the work as an object. As studio assistants increasingly did the painting for him, Stella's work also lost its painterly edges.

Stella's denial of expressive content—"what you see is what you see"—echoes Warhol's famous maxim: "If you want to know all about Andy Warhol, just look at the surface of my paintings and my films and me, and there I am. There's nothing behind it."[18] As in Warhol's language, there was a persistent brilliance in Stella's invention of a vocabulary suitable to the psychic detachment of the sixties. But Stella's persistent recourse to the logic of formal structure for content, rather than as a vehicle *of* content, made it clear that "what you see" is not in fact "what you see" but rather an illustration of all that theory about flatness and objecthood, and after a while, that began to seem less and less interesting.

Donald Judd

Meanwhile, Donald Judd's antipathy toward illusionism led him to abandon painting in 1961 in favor of sculpture. He attempted to fulfill Tatlin's machine-age prescription for "real materials in real space," but unlike Tatlin, Judd had no social message, no Utopian aspiration expressed in the work. Judd insisted that his objects lacked any significance beyond what was literally there. If an image suggested three dimensions, the three dimensions existed; they were not illusions or representations.

Barbara Haskell pointed out that Judd's training in philosophy as an undergraduate at Columbia and in particular his affinity with the writings of the eighteenth-century Scottish empiricist David Hume confirmed an intuitive disposition toward concrete experience.[19] Judd's rejection of abstract expressionism derived in part from his belief in the dialectical progress of ideas in art (making abstract expressionism outmoded) and from his insistence on experientially verifiable truth (which excluded existential introspection). In a 1962 review for *Arts Magazine*, Judd wrote:

Frank Stella's new paintings are one of the recent facts. They show the extent of what can be done now. The further coherence supersedes older forms. It is not only new but better, not necessarily on an onlooker's scale of profundity which can measure Pollock against Stella, but on the scale . . . of development. The absence of illusionistic space in Stella, for example, makes abstract expressionism seem now an inadequate style, makes it appear a compromise with representational art and its meaning.[20]

Judd's red sculptures of 1963 consist of enclosed volumes with visible interiors: open frames, boxes, and constructions of wood and pipe. He was interested in clarifying all aspects of the structure and materials. In the works of the mid sixties [fig. 10.3] be began exploring forms with patterned variations or modular units, spaced equidistantly, symmetrically, or in mathematically determined intervals, which the viewer would immediately recognize as a pattern instead of as compositional elements in balance. Indeed, these arrangements eliminated the idea of composition while at the same time allowing a more complex form. However, Judd said, "The series doesn't mean anything to me as mathematics."[21]

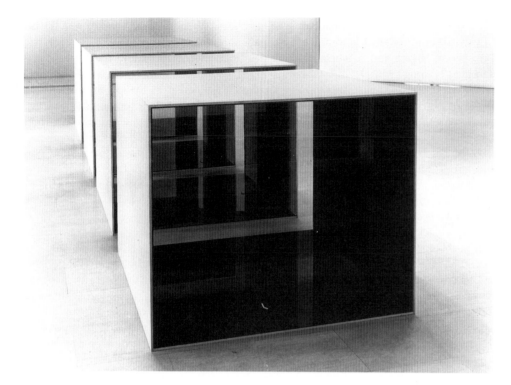

10.6 Donald Judd, *Untitled,* 1969. Anodized aluminum and blue plexiglass, four units 4 × 5 × 5ft (1.22 × 1.52 × 1.52m), each with 12in (30.5cm) intervals.
Collection, Saint Louis Art Museum. Gift of the Schoenberg Foundation, Inc. Art © Donald Judd Estate/VAGA, New York.

For Judd, even the use of pure geometry implied its opposite in the wildness of nature and it was that idea—which he found in the work of Stella—that compelled him. "Geometry," Judd said, "could be used in a non-Neo-Plastic way, an impure way, without the purity that geometric art seemed to have. Mondrian, though really great, is too ideal and clean. In another way, Reinhardt is too. That was not a believable quality for me. Stella's painting had a possibility that became evident of an impure geometric art."[22]

By the mid sixties Judd had begun making enough money to have his work fabricated commercially instead of handcrafting it himself. Whereas he made the red boxes of the early sixties out of wood, by 1964 he was working regularly in metal and plexiglass. Judd's reliefs of galvanized metal boxes cantilevered from the wall and given automobile lacquer finishes express an aesthetic affinity for the detachment of industrial materials and processes. Although David Smith anticipated their geometric modularity and Jasper Johns their semantic fundamentalism, Judd's floor boxes [fig. 10.6] and box reliefs achieved a singleness of focus on the literal object that was genuinely new.

Tony Smith

Tony Smith, born in 1912, was of the abstract expressionist generation and taught (either formally or informally) several of the minimalists. Smith's greatest contribution involved the delicacy with which he calibrated the scale of his works in relation to their sites, undercutting the conventional notion of monumentality and making his sculptures remarkably responsive to their architectural or

10.7 (below) **Tony Smith,** *Die,* 1962. Steel, edition of three, 6 × 6 × 6ft (1.83 × 1.83 × 1.83m).
Private collection. Photograph by Ivan Dalla Tana, courtesy Paula Cooper Gallery, New York. © 2000 Estate of Tony Smith/Artists Rights Society (ARS), New York.

10.8 Tony Smith, *Amaryllis,*
1965. Steel, edition of three,
11ft 6in × 7ft 6in × 11ft 6in
(3.51 × 2.29 × 3.51m).
Private collection. Photograph by Ivan Dalla Tana,
courtesy Paula Cooper Gallery, New York. © 2000
Estate of Tony Smith/Artists Rights Society (ARS),
New York.

natural setting. "Why didn't you make it larger so that it would loom over the observer?" someone asked Smith about *Die*, the 6-foot-high black steel cube of 1962 [fig. 10.7]. "I was not making a monument," he replied. "Then why didn't you make it smaller so that the observer could see over the top?" "I was not making an object."[23]

Smith took his cue from Barnett Newman, who had been exploring the idea of the holistic image as a spatial concept. (The holistic image is an image seen all at once as a single form, rather than as parts making up a whole.) Smith conceived his forms as whole, unified (holistic) images and suppressed the intimacy of details and relations among parts that might promote a detachment from the central concept. He even eliminated all signs of the fabrication process so as not to detract from the unitary gestalt; for *Die* he merely gave the specifications to a fabricator over the telephone, thus separating himself completely from the physical object. The more complex *Amaryllis* of 1965 [fig. 10.8] charts the hypothetical path of a regular geometric solid moving in space; it is a three-dimensional map, so to speak, of an accretion of modular units, as in the formation of a crystal.

Carl Andre

By the mid sixties, the minimal artist's predilection for certain types of materials and generative systems—whether the topological maps of Smith or Carl Andre's stacks of timber [fig. 10.9]—began to look as individual as the abstract expressionist splash of paint. Carl Andre met Frank Stella in 1958 and worked in Stella's studio while Stella was making the black paintings of 1959. It was under this influence that Andre

10.9 (below) **Carl Andre,** *Pyre (Element Series),* constructed 1971, Minneapolis, from a 1960 plan. Wood, eight units, 12 × 12 × 36in (30.5 × 30.5 × 91.4cm) each, 48 × 36 × 36in (121.9 × 91.4 × 91.4cm) overall.
Gilman Collection, Texas. Photograph courtesy Paula Cooper Gallery, New York. © Carl Andre/VAGA, New York, 1994.

10.10 Carl Andre, *Steel Magnesium Plain,* 1969. Steel and magnesium, thirty-six units, 12 × 12in (30.5 × 30.5cm) each unit, 6 × 6ft (1.82 × 1.82m) overall.

Private collection, Switzerland. Photograph courtesy Paula Cooper Gallery, New York. © Carl Andre/VAGA, New York, 1994.

arrived at the basic principle of an axial symmetry in which any part of a work can replace any other part, as in *Pyre (Element Series)* [fig. 10.9]. Over the next three years Andre gradually abandoned carving and the assemblage of found materials in favor of arranging his sculptures from modular units. The rigidly arranged scheme of *Pyre* or *Steel Magnesium Plain* [fig. 10.10] sets off the natural eccentricities of the materials. The clear geometry relates to Frank Stella's early shaped canvases, while the overall structure implies infinite continuation as in Brancusi's modular series of "Endless Columns."

Andre explained: "Brancusi to me is the great link into the earth and the *Endless Column* is, of course, the absolute culmination of that experience. They reach up and they drive down into the earth with a kind of verticality which is not terminal. Before, that verticality was always terminal: the top of the head and the bottom of the feet were the limits of sculpture. Brancusi's sculpture continued beyond its vertical

limit and beyond its earthbound limit."[24] Brancusi also provided a precedent for the minimalists' interest in the inherent qualities of the materials.

In 1965 and 1966 Andre shifted from stacked wood— which had an object-like presence—to commercially prefabricated materials, disposed in a particular space. The specificity of the work for its site caused it to blend into the space, dissipating its object-like quality. *Lever* was Andre's first site-specific piece, consisting of 137 fire bricks laid side by side in a line on the floor at the "Primary Structures" exhibition of 1966. Then he went on to squares of metal— aluminum, steel, zinc, magnesium, copper, lead, iron— which he placed directly on the floor for viewers to walk on and experience in a directly tactile way. Site specificity in the sense of *Lever* was not the central concern in these works— rather the focus was on their physicality.

"I severed matter from depiction, in the way Turner severed light and color from depiction," Andre explained. "My work is about critical mass. The flat squares let you see the mass and form rather than the same mass in a cube where you would see only a little."[25] This underscores the literal presence of the material, its hardness, color, and weight. On the one hand the raw presence of the materials evokes a sense of nature—the artist's idea of positioning himself in a lineage from Turner is quite to the point here. On the other hand the plates are also materials in and of the industrial world, fashioned into regular squares and patterns.

Andre experimented with the subversion of reasoned order by chaos in several works of the mid sixties and later. He made wavy lines of nails and laid pieces of pipe end to end on the floor; these materials resisted the regularity of their

10.11 Carl Andre, *Stone Field Sculpture,* 1977. Thirty-six glacial boulders, Hartford, Connecticut.

Photograph courtesy Paula Cooper Gallery, New York. © Carl Andre/VAGA, New York, 1994.

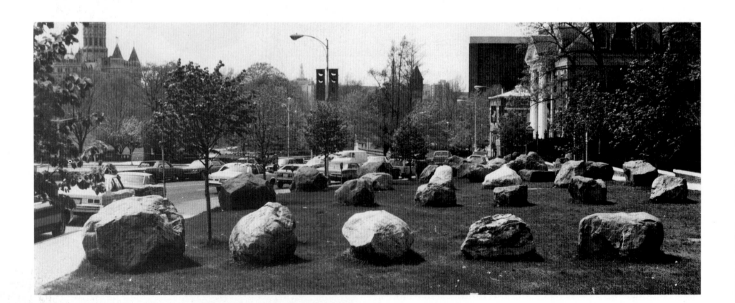

placement by the sheer awkwardness of their form. In the formless *Spill* of 1966, the artist scattered 800 small plastic blocks randomly across a gallery floor. Andre also took his systems out of doors, arranging units in nature, as in *Joint* of 1968, where he arranged bales of hay; in the *Stone Field Sculpture* of 1977 [fig. 10.11] he conceived a monumental work that exists at the interface between natural matter and the rational ordering systems of the human mind.

Dan Flavin

Dan Flavin began working exclusively with new, industrially prefabricated fluorescent tubes and fixtures in 1963. He merely arranged the parts and any hardware store patron could reproduce them indistinguishably from the originals. Thus Flavin's works tease the viewer's definition of art as dependent on an original object. For Flavin they assert the continuity with the real world of everyday things.

Choreographing the light from the tubes, Flavin investigated the idea of sculpture as space rather than form. The light articulates the space in a way that makes each piece particularly interdependent with its site. *Untitled* of 1963 [fig. 10.12], for example, fills a confined alcove with green light, marking off an area (as it was originally displayed at the Castelli Gallery) even when the tubes themselves remained hidden around the corner. The series of "Monuments for V. Tatlin" [fig. 10.13], in homage to the Russian constructivist who embraced industry and insisted on the continuum of art and life, involves multiple permutations in the arrangement of the same set of plain white tubes. The boundlessness of the

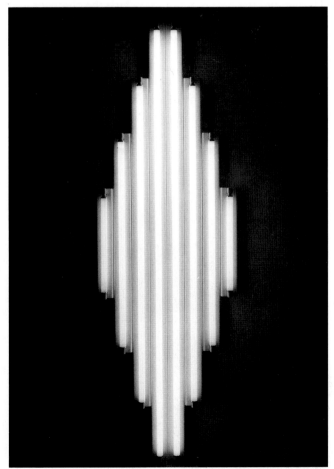

10.13 Dan Flavin, *Monument for V. Tatlin,* 1968. Cool white fluorescent light, 8ft (2.44m) high.
Private collection. Photograph courtesy Leo Castelli Gallery, New York. © 2000 Estate of Dan Flavin/Artists Rights Society (ARS), New York.

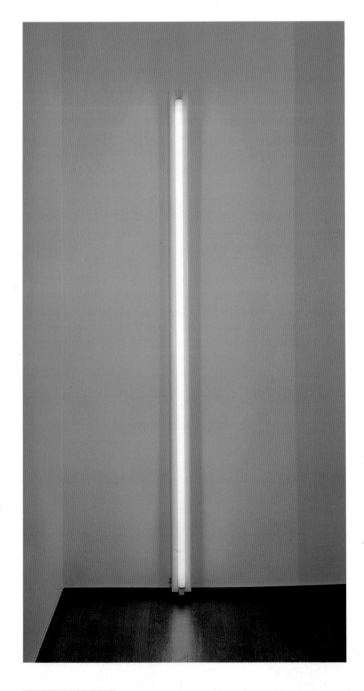

10.12 Dan Flavin, *Untitled,* 1963. Green fluorescent light, edition of five, 8ft (2.44m) high.
Private collection. Photograph courtesy Leo Castelli Gallery, New York. © 2000 Estate of Dan Flavin/Artists Rights Society (ARS), New York.

light implied the sublime for Flavin—he called it "a modern technological fetish."[26] This romantic aspect separates Flavin and Andre from Stella, Judd, and Morris, although they share an affinity for industrial materials, simplified forms, systems, permutations, and a concern with focusing on real materials and space.

Robert Morris

Robert Morris followed a less specialized course than Judd or Flavin but his approach was no less anti-illusionistic. He consistently worked with an experimental objectivity in his investigations of process, materials, and actions. In 1961 he made *Box With the Sound of Its Own Making*, enclosing a three-hour tape loop playing a recording of himself in the process of constructing the box. In 1963 he completed *Cardfile* by alphabetically indexing all decisions related to transforming the found object into a work of art, including how long it took to find the thing, all the different kinds of files he looked at, interruptions, and so on. He also had an electroencephalogram taken while he thought about himself for the time it took to make a tape as long as he was tall and designated it a self-portrait.

Morris invented a task and then carried it out in a routine manner, leaving the details to chance as in the reductive dance pieces of the Cunningham-inspired Judson Dance Theater and the Fluxus actions to which the choreography of his performances seemed particularly indebted. The influence of Duchamp is also evident.[27] The idea of the "L" beams [fig. 10.14] was to take a given form and see how many different ways he could dispose it in the space. Other works of the mid sixties had to do with cutting up a form and then reassembling it in a variety of ways to see what happened to its gestalt (its identifying mental image).

In "Notes On Sculpture," Morris methodically analyzed the characteristics of how we visualize forms: "One need not move around the object for the sense of the whole, the gestalt, to occur," he said. "One sees and immediately 'believes' that the pattern within one's mind corresponds to the existential fact of the object . . . A sixty-four sided figure is difficult to visualize, yet because of its regularity one senses the whole even if seen from a single viewpoint . . . The fact that some [polyhedrons] are less familiar than the regular geometric forms does not affect the formation of a gestalt. Rather, the irregularity becomes a particularizing quality."[28]

Anticipated by Carl Andre's 1966 *Spill* and the scatter pieces by Richard Serra and Barry Le Va (who worked with felt squares, shattered glass, powder, and ball bearings [fig. 10.15]), Morris began exploring the idea of sculpture without fixed form. In 1968, he randomly spread industrial threadwaste (the extra threads clipped off in garment manufacturing), along with other random materials, across the gallery floor [fig. 10.16]. To move the piece, Morris simply ordered another bale to be sent directly to the museum or collector and let them dump it on the floor. In some he added double-sided mirrors that undermined the perception of finite form still more.

The threadwaste pieces extended Duchamp's attack on the concept of the aesthetic object and his assertion of the dominance of the idea in art. It also drew on the inspiration of Cage and Cunningham in the use of chance. In addition, these pieces prompted a fresh look at the boundary of order and chaos, emphasized the role of sculpture in defining space rather than form, and directed the viewer to the literal specificity of the context. "When you build something rigid

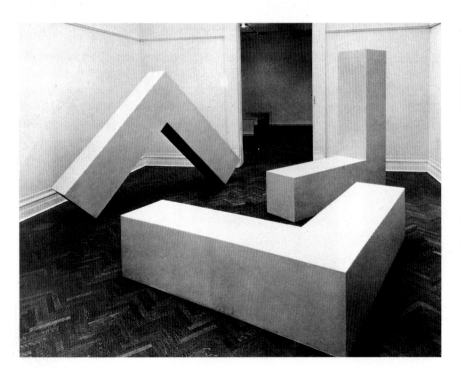

10.14 (left) **Robert Morris,** *Untitled ("L" beams),* 1965 and 1967. Three pieces, painted plywood, 96 × 96 × 24in (243.8 × 243.8 × 61cm).
Original destroyed. © 2000 Robert Morris/Artists Rights Society (ARS), New York.

10.15 (opposite, top) **Barry Le Va,** *Continuous and Related Activities: Discontinued by the Act of Dropping,* 1967 (reconstructed in 1990). Glass and maroon felt, 15 × 25ft (4.57 × 7.62m) in this view, but dimensions vary.
Collection, Whitney Museum of American Art, New York. Purchased with funds from the Painting and Sculpture Committee. Photograph courtesy Sonnabend Gallery, New York.

10.16 (opposite) **Robert Morris,** *Untitled,* 1968. Threadwaste, mirrors, asphalt, aluminum, lead, felt, copper, and steel, 30 × 30in (76.2 × 76.2cm).
Private collection. Photograph by Rudolph Burckhardt, courtesy Leo Castelli Gallery, New York.© 2000 Robert Morris/Artists Rights Society (ARS), New York.

10.17 Robert Morris, *Untitled,* 1967–8. Felt, ⅜in (0.9cm) thick, dimensions variable.

Collection, Philip Johnson. Photograph by Rudolph Burckhardt, courtesy Leo Castelli Gallery, New York. © 2000 Robert Morris/Artists Rights Society (ARS), New York.

you know what it's going to look like . . . I wanted a material that I could predict even less about," Morris explained. "The particular concrete situation in a given time. That's where the fascination is."[29] Morris's well-known industrial felt pieces [fig. 10.17] also arise from these concerns, exploring space and gravitational mass (like sculpture), as well as the idea of mutable form—the soft felt can be disposed in the space in an infinite number of ways.

Sol LeWitt

Sol LeWitt applied the minimalists' systemic logic and literalness to the generative procedures in his work without sharing their interest in the literal object. Indeed, by the late sixties he had reasoned his way beyond the object into conceptual art, consciously separating the abstract idea system that produces an object from the object itself. "The idea or the concept is the most important aspect of the work," he wrote in a seminal article for *Artforum* in 1967 entitled "Paragraphs on Conceptual Art." In it, he asserted:

When an artist uses a conceptual form of art, it means that all of the planning and decisions are made beforehand and the execution is a perfunctory affair. The idea becomes a machine that makes the art. This kind of art is not theoretical or illustrative of theories; it is intuitive; it is involved with all types of mental processes, and it is purposeless. It is usually free from the dependence on the skill of the artist as a craftsman.[30]

In 1965 LeWitt began constructing modules of open cubes, first in black and then by the end of the year in white [fig. 10.18]. He arbitrarily decided on a ratio of 8.5:1 between the thickness of the structural members and the spaces between them. These visually complicated works embody simple structural ideas that the viewer can extrapolate from their form. LeWitt referred to the underlying concept of these works as a "grammar."[31]

LeWitt's allusion to language derived from structuralism, which posited meaning as a decipherable, universal structure underlying the form. Moreover, LeWitt recognized that while the underlying logic in a work may be a simple scheme set on a predictable course, the object itself is experientially unpredictable. This establishes a dissonance between sensation and system that suggests the arbitrariness with which (according to structuralist theory) signifiers and signifieds (or words and the objects to which they refer) are linked.[32]

LeWitt made his first wall drawings in 1968 in the Paula Cooper Gallery [fig. 10.19]. They involved a set of predetermined procedures carried out directly on the wall by assistants. His most radical formal innovations, these wall drawings further eroded conventional notions of the art object because they could be removed and re-created according to instruction without benefit of the artist's hand. In several of the wall drawings, the instruction that generated each line is written directly on the wall next to it.

10.18 Sol LeWitt, *Wall/Floor Piece #4,* 1976.

Private collection. Courtesy John Weber Gallery, New York. © 2000 Sol LeWitt/Artists Rights Society (ARS), New York.

10.19 Sol LeWitt, *Wall Drawing #1, Drawing Series II 18 A & B,*
1968. Black pencil, drawn directly on the wall of the Paula Cooper
Gallery, New York.
Private collection, San Francisco. Photograph by Walter Russell, courtesy the artist. © 2000
Sol LeWitt/Artists Rights Society (ARS), New York.

The Los Angeles Light and Space Movement

Meanwhile, in Los Angeles, Robert Irwin and James Turrell formed the nexus of a Light and Space movement in the late sixties that had a literalness and an experimental tone resembling that of Robert Morris. The Light and Space movement centered on the exploration of visual perception itself in works so subtle in their visual calibration as to be near meaningless in reproduction. Irwin dematerialized objects, then space, while Turrell worked chiefly with light and space. By the mid sixties Irwin was using principles of Gestalt psychology, manipulating different kinds of light, shadows, scrims, and controlled environments to fool the eye into seeing something other than what was actually there. Nevertheless, Irwin conceived such experiments in the broader context of "a construction and ordering of individual reality."[33] Art, he said, is "the placing of your attention on the periphery of knowing. It is . . . a state of mind."[34]

Turrell had a more spiritual cast of mind, influenced by Eastern philosophy. In a work of 1967 entitled *Afrum* he created a visually "solid" cube in the corner of a room with projections of white light; this is a characteristic example of his work of the mid sixties, in which he boldly confronts the viewer with a contradiction between what is there and what seems to be there. He went on to create other light forms and then rooms in which the viewer sees walls where there are none. In *Daygo*, for example, the viewer can walk right up to the blue rectangle and still be unable to discern

In the Nature of Materials: The Later Sixties

whether it is a hole in the wall with blue light behind it, or a sharply delineated blue surface on the wall [fig. 10.20]. "This is not minimalism and it is not conceptual work," Turrell explained, "it is *perceptual* work."[35] But it is also a kind of work that teases the viewer's perceptions into an unsteady reality. "The daydream," he explained, ". . . is, I think, the space that we inhabit most of the time, much more than this conscious awake space that is called reality. It's this daydream space overlaid on the conscious awake reality that I like to work with . . . I'm interested in having a work confront you where you wouldn't ordinarily see it. When you have an experience like that in otherwise normal surroundings, it takes on the lucidity of a dream."[36]

In 1972 Turrell began thinking about constructing a monumental earthwork that would then provide a contemplative experience of light and space on a grand scale and in 1974 he selected a site—an extinct volcano called the Roden Crater, north of Flagstaff, Arizona. By carefully shaping the crater rim, Turrell attempted to control the viewer's perception of the open space above as seen from the bottom of the crater's bowl. Turrell also calculated movements of the celestial bodies in relation to this viewing point and made plans to shape different parts of the site to exploit their efforts.

Many of Turrell's works of the seventies and eighties involved ideas related to this large work in progress. In *Meeting* of 1983 to 1986 for example, a room for P.S. 1 (then an alternative art space in New York) in which the roof opens to the sky, the viewer sits on benches that ring the featureless, square room and looks up to a pure patch of sky. The sky takes on a fascinating panoply of perceptual variations in color and space as the exterior light shifts and eventually fades, gradually bringing out the artificial lights around the perimeter of the opening. One seems to see what is there with a preternatural acuity but also to encounter the presence of one's own mind. "The sites I like to use are ones that . . . are really inhabited by consciousness . . . generated not by the architecture of form but by the overlay of thought," Turrell said.[37]

10.20 James Turrell, *Daygo,* 1990. Light into space, dimensions variable.
Photograph courtesy Barbara Gladstone Gallery, New York.

Object/Concept/Illusion in Painting

By the end of the sixties a number of artists had begun methodically separating the work of art into overlays of distinct systems, like medical specialists isolating the vascular system or the network of endocrine glands for a focused evaluation. Mel Bochner began using mathematical formulas to derive the forms in his paintings, while Robert Mangold played off physical qualities of the object against pictorial concepts or illusions. In Mangold's *Four Color Frame Painting #1* (1983), for example [fig. 10.21], he juxtaposed the framing edges and seams of the canvases with drawn lines that allude to a continuous geometry. In some cases he deliberately created perceptual contradictions to underscore the incompatible realities of the different systems.

For Ellsworth Kelly, the whole picture had become the unit in a hard-edge style of painting as early as 1958. Unlike Mangold and Bochner, Kelly arrived at this in the more intuitive manner characteristic of the late fifties. At the beginning of the fifties Kelly had already evolved a style of painting in large, flat, hard-edged forms juxtaposed (rather than interacting) on big rectilinear canvases. Nevertheless, his stress on dividing the entire space of a painting, juxtaposing flat forms on a plane rather than arranging them within a composition, resulted in an articulation of the surface as a single field of color which in turn became the form [fig. 10.22]. "By removing the content (brush marks, subject matter, etc.) from my work," Kelly remarked, "I shifted the visual reality of painting to include the space around it."[38] In avoiding the effect of figures on a field, Kelly's reduction asserted the painting as an object and that in turn undermined the convention of the rectangular format for Kelly, as it did for Stella.

10.21 Robert Mangold, *Four Color Frame Painting #1,* 1983. Acrylic and black pencil on four canvas panels, 9ft 3in × 12ft 6in (2.82 × 3.81m) overall.

Photograph by eeva-inkeri, courtesy Pace Gallery, New York. © 2000 Robert Mangold/Artists Rights Society (ARS), New York.

10.22 Ellsworth Kelly, *Three Panels: Orange, Dark Gray, Green,* 1986. Oil on canvas, A: 8ft 8½in × 7ft 10in (2.65 × 2.38m), B: 7ft 4in × 8ft 2in (2.23 × 2.48m), C: 8ft 1½in × 9ft 11½in (2.47 × 3.03m).

Collection, Douglas S. Cramer Foundation, Los Angeles. Photograph courtesy Blum Helman Gallery, New York.

A Focus on Surface Handling in Painting

In a similar way, Robert Ryman's concentrated focus on the nuances of the abstract mark seemed to open a whole new range of possibilities in painting for him [fig. 10.23]. "Abstract painting is just beginning," he said in 1986. "All possibilities are open to it."[39] Restricting himself to an all-white palette since the beginning of the sixties, Ryman has heightened the pure visibility of each component of the painting—the gestural mark, the surface, even the mechanical support and the way it is fastened to the wall. These investigations have highlighted the subtleties of seeing what is there rather than aspiring to a transcendental experience. The same is true for Brice Marden [fig. 10.24], whose exquisitely refined sense of touch and surface concerns the literal but sensuous experience of the paint itself.

10.23 Robert Ryman, *Untitled,* 1963. Vinyl on unstretched linen glued onto stretched cotton canvas, 25¼ × 22¾in (64.1 × 57.8cm). Private collection. Photograph by Gordon R. Christmas. Courtesy of PaceWildenstein. © Robert Ryman.

10.24 Brice Marden, *D'après la marquise de la Solana (After the Marchioness of Solana),* 1969. Oil and wax on canvas, 3 panels, 6ft 5in × 9ft 9in (1.95 × 2.97m). Solomon R. Guggenheim Museum, New York. Panza Collection. Photograph by Cathy Carver, 91.3784 a–c. © 2000 Brice Marden/Artists Rights Society (ARS), New York.

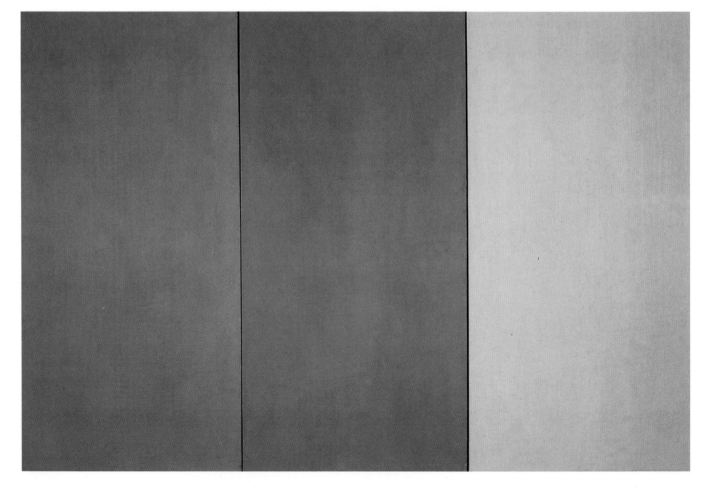

Eva Hesse and Investigations of Materials and Process

In the mid sixties, the somber, detached objectivity of minimalism and the emotional disengagement of pop art and formalism prompted some artists to seek a way back to the individual psyche. Corporate culture, like the cool aesthetic that had come out of the early sixties, was alienating, and these artists wanted to reestablish a continuity with subjective experience. Lynda Benglis recollected that when she came to New York in 1964 she felt the need for "something very tactile, something that related to the body."[40] So Benglis sought out the most visceral, physically engaging materials and procedures she could devise. Her solidified spills of brilliantly pigmented latex and her amorphous, poured mounds of foam or cast metal of 1969 to 1970 [fig. 10.25] had a counterculture tone that echoed the rebellious social and political atmosphere. Most importantly, her work employed materials and processes in ways that centered on a sense of the artist's physical identification with them. They provided an immediate, tactile extension of the body.

Louise Bourgeois [fig. 10.26] and Lucas Samaras [fig. 7.24] pioneered an expressionism of organic forms and unusual materials at the beginning of the decade. Coming out of more than a decade of surrealist-inspired construction (in the case of Bourgeois) and out of the assemblage aesthetic and happenings of the late fifties

(Samaras), they made sculpture with an especially vivid sensation of touch. What made the new, radically expressionistic sculpture of Eva Hesse and the intensely personal explorations of Bruce Nauman, Richard Tuttle, and Richard Serra different and exceptionally important was not only that they (in particular Hesse) succeeded against the prevailing trends of the art world (which favored reduction and impersonality), but that they created this personally engaged style in a manner that took the anti-illusionist preoccupation of minimalism as a foundation while at the same time remaining so palpably involved with their own intimate body experience.

In part it was the connection with the anti-illusionist aspect of minimalism that caused this new expressionist tendency to emerge in sculpture rather than in painting. Moreover, the need to make something that felt real and present in the most personal terms called for the tactile experience that a sculpture of new materials provided. The remarkable freedom from convention in the works of Hesse, Nauman, and Serra made it possible for them to animate the unique materials and procedures they used with a convincing projection of their own personalities.

10.25 Lynda Benglis, *Untitled,* 1969–70. Pigmented polyurethane foam, 15 × 48 × 36in (38.1 × 121.9 × 91.4cm).

Collection of the artist. Photograph courtesy Paula Cooper Gallery, New York. © Lynda Benglis/VAGA, New York, 1994.

10.26 Louise Bourgeois, *Double Negative,* c. 1963. Latex over plaster, 19⅜ × 37½ × 31⅜in (49.2 × 95.3 × 79.7cm).

Collection, Rijksmuseum Krökker-Müller, the Netherlands. Photograph courtesy of Robert Miller Gallery, New York. © Louise Bourgeois/VAGA, New York, 1994.

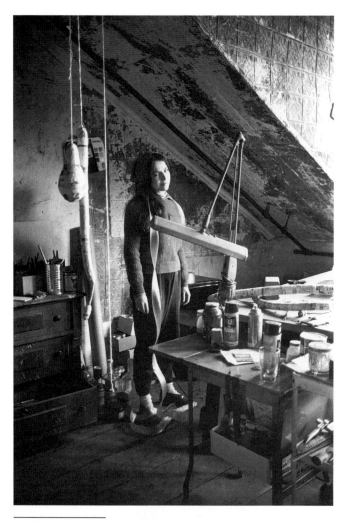

10.27 Eva Hesse in her New York studio, c. 1967.
Photograph © The Estate of Eva Hesse, courtesy Robert Miller Gallery, New York.

Eva Hesse

I n Hesse's case, the sheer force of her drive to find form (in whatever material seemed most evocative) for her profound emotional struggles presses the viewer irresistibly into identifying with her discovery of herself in the objects she created. Eva Hesse [fig. 10.27], a German-born Jew, narrowly escaped the concentration camps in 1939, when she fled with her sister to Amsterdam at the age of two. After two months in an orphanage Hesse and her sister were reclaimed by their parents, who took them to New York. But shortly thereafter the parents divorced and in 1946 Hesse lost her mother to suicide. This early history left severe anxiety and depression related to issues of intimacy, abandonment, and self-image that Hesse continually explored in her art.

Hesse graduated from the Cooper Union and then in 1959 from the Yale School of Art. In 1961 she met and married a sculptor named Tom Doyle and in June 1964 they went off together to work in Germany for fourteen

months. When she arrived, the twenty-eight-year-old Hesse still saw herself as a painter. It was a year filled with tensions and self-doubt: "I cannot be so many things," she confided to a notebook in 1964. ". . . Woman, beautiful, artist, wife, housekeeper, cook, saleslady, all these things. I cannot even be myself."[41]

Nevertheless, this year in Germany was the turning point in Hesse's development as an artist. She shifted into three-dimensional work and at the end of their stay she had her first one-person show at the prestigious Düsseldorf Kunstverein. Doyle and Hesse lived near Düsseldorf, where the influences of the city's two leading artists, Günter Ücker [fig. 10.28] and Joseph Beuys, seem to have had a formative effect on the character of her stylistic transformation.[42]

Hesse created the twenty breastlike hemispheres (her association) in *Ishtar* of December 1965 [fig. 10.29] by painstakingly winding and gluing spirals of cord around the forms, painting them, and fixing them to the evocatively handled gesso surface. The black plastic strings, loosely issuing from the centers of each mound, provide a sensual, fragile connection to this ritualistically reiterated maternal image. The erotic orbs in *Ishtar*, the dangling phallic shapes in *Several* of November 1965 [fig. 10.1], and the other overtly sexual forms that permeate Hesse's sculpture from 1965 through most of 1976 have a

10.28 Günter Ücker, *Table,* 1963. Oak, nails, white spray paint, 31½ × 25½ × 25½in (80 × 64.8 × 64.8cm).
Collection, Kunstsammlung Nordrhein-Westfalen, Düsseldorf.

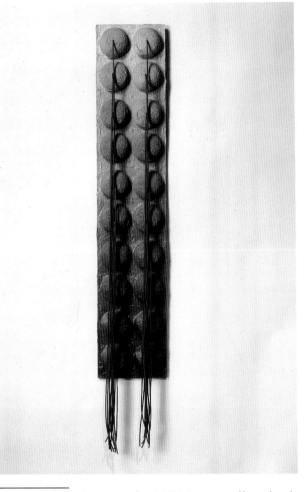

10.29 Eva Hesse, *Ishtar,* December 1965. Twenty cord-bound and painted hemispheres, with black cords mounted on heavy paper stapled and nailed on wood; paper gessoed and painted with acrylic, 36 × 7½ × 2½ in (91.4 × 19 × 6.3cm), height with cords 3ft 6½in (1.07m). Collection of Florette and Ronald B. Lynn, New Jersey. © Estate of Eva Hesse, courtesy Robert Miller Gallery, New York.

fetishistic character not only in the obsessive process of their manufacture but in their repetition. Indeed both the title and composition of *Ishtar* evoke the multi-breasted ancient fetish *Diana of Ephesus,* which is a cognate of the Semitic goddess of love, fertility, and war for whom Hesse named her work.[43]

The serial structure of the breastlike forms in *Ishtar* also alludes directly to the systemic character of minimal sculpture, which Hess successfully appropriated and personalized in works such as this. She saw right through to the generally unacknowledged, expressive content of minimalism and was moved by it, as is evident in her response to the work of Carl Andre. "I feel very close to Carl Andre," she said. "I feel, let's say, emotionally connected to his work. It does something to my insides. His metal plates were the concentration camp for me."[44]

Soon after Hesse returned to New York at the end of 1965 her husband left her, and a year later her father died. Hesse was panic-stricken with a sense of abandonment. Yet at the same time influential exhibitions like "Eccentric Abstraction" (organized by Lucy Lippard in the fall of 1966), Robert Morris's "Nine at Leo Castelli" (the so-called "Warehouse Show" of December 1968), and the Whitney Museum's "Anti-Illusion: Procedure/Materials" (which Marcia Tucker and James Monte put on in the summer of 1969) created an escalating trajectory for Hesse's reputation as central to the emergence of a new kind of abstract sculpture. The increasingly positive public reception of her work and a group of exceptionally supportive friends—among them Mel Bochner, Lucy Lippard, Robert Smithson, and above all Sol LeWitt—fostered a growing artistic self-confidence that kept Hesse emotionally afloat.

The Direct Sensuality of Fiberglass and Latex

During 1967, Hesse's work shifted away from overtly erotic imagery toward a more direct sensuality that was immediately present in the materials themselves—"not symbols for something else," as she wrote in a note to herself of 1970.[45] Her decision to begin working in fiberglass and latex rubber early in 1968 had to do with their translucence and luminescence, the hands-on physicality of building up the body of the work in layers like a skin, and the sensitivity of both materials to the touch. The chain-like sequences of simple units that serve as the compositional principle of many of these late works deliberately echo the underlying structure of the polymers themselves—Hesse sought to relate, in a fundamental way, with the invisible nature of her materials.[46]

In the late spring of 1968, Hesse had begun working with a plastics fabricating company on Staten Island. Like so many artists in the sixties, she found that the help of outside fabricators and studio assistants could quicken the pace of production and the development of ideas as well as letting her increase the scale of her work. Doug Johns, one of the owners of the plastics company, became so absorbed in working with Hesse that by September he had closed his business in order to devote himself full-time to her. Having Johns right there solving the structural problems as she went along allowed Hesse much greater spontaneity and the ability to generate and realize ideas rapidly.

In works of 1969 such as *Expanded Expansion, Contingent,* and the *Untitled (Ice Piece),* Hesse explored the idea of infinite expansion. They "take a stand on absurdity,"[47] as she put it, by courting the incomprehensibility of infinite extension in space, the improbable transformation of repulsive surfaces into beautiful effects of light and form, and the contradiction between the strength of the fiberglass and the fragility of the

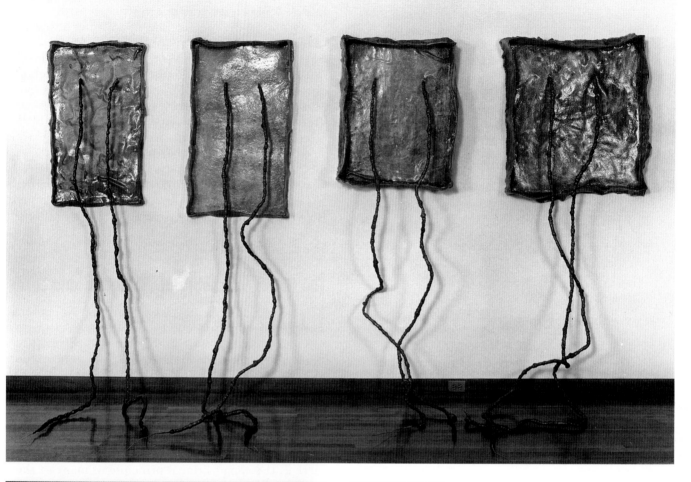

10.30 (above) **Eva Hesse,** *Untitled,* 1970. Fiberglass over wire mesh, latex overcloth and wire (four units), 7ft 6⅞in × 12ft 3⅝in × 3ft 6½in (2.31 × 3.75 × 1.08m) overall.

Collection, Des Moines Art Center. Purchased with funds from the Coffin Fine Arts Trust, Nathan Emory Coffin Collection of the Des Moines Art Center, 1988.6. © The Estate of Eva Hesse.

10.31 Eva Hesse, detail of *Untitled,* 1970.

Collection, Des Moines Art Center. © The Estate of Eva Hesse.

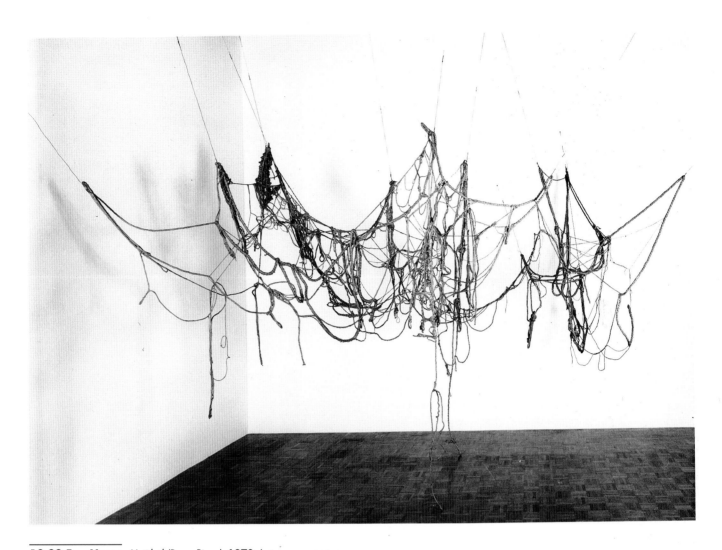

10.32 Eva Hesse, *Untitled (Rope Piece)*, 1970. Latex over rope, string and wire, two strands, dimensions variable.

Collection, Whitney Museum of American Art, New York. Purchase, with funds from Eli and Edythe L. Broad, the Mrs. Percy Uris Purchase Fund, and the Painting and Sculpture Committee. Photograph by Geoffrey Clements, New York. © The Estate of Eva Hesse.

latex. She even chose to build impermanence into the work (giving it a morbid evanescence) by using the latex in ways that disrupted its proper curing.[48]

"Art and work and art and life are very connected and my whole life has been absurd," Hesse told Cindy Nemser. "There isn't a thing in my life that has happened that hasn't been extreme—personal health, family, economic situations . . . absurdity is the key word . . . It has to do with contradictions and oppositions. In the forms I use in my work the contradictions are certainly there. I was always aware that I should take order versus chaos, stringy versus mass, huge versus small, and I would try to find the most absurd opposites or extreme opposites."[49]

This attraction between polarities underlies both the eroticism and the conscious humor of Hesse's work. In the *Untitled* ("Wall Piece") of 1970 [figs. 10.30 and 10.31] the four fiberglass boxes with tenuous strings dangling out clearly set an overall order. Yet the endearingly anthropomorphic eccentricity of each unit mocks the rigor of a serial regularity.

In early April 1969 Hesse collapsed from a brain tumor and then underwent three operations before she finally died in May 1970 at the age of thirty-four. The fact that she had already developed a system of working with assistants in 1968 made it possible for her to continue working right to the end, and indeed she produced her greatest work in that final year. The *Untitled (Rope Piece)* of 1970, for example [fig. 10.32], undermines the notions of fixed form and scale. As with the gestural field of a Pollock, the detail in this work pulls the viewer in, yet disorients him or her with its unfamiliarity of material and form. "I wanted to totally throw myself into a vision that I would have to adjust to and learn to understand," she said. ". . . I want to extend my art perhaps into something that doesn't exist yet."[50]

Bruce Nauman and Richard Serra

Bruce Nauman

Bruce Nauman's art is introverted without being psychological in the sense of Hesse's, and although he has focused on the literal presence of each work it may not necessarily yield an object at all. Nauman's curiosity about the nature of immediate experience—embodied in a unique style of questioning—is what unifies his work and compels the viewer's interest. By 1965 it was already clear to Nauman that whereas minimalists like Judd wanted to be in control, Nauman wanted precisely not to be—he was bent on the experience of discovery. Nauman said that as often as not "I was using my body as a piece of material and manipulating it. I think of it as going into the studio and being involved in some activity. Sometimes it works out that the activity involves making something, and sometimes the activity itself is the piece."[51]

Nauman's earliest surviving sculptures date from 1965 [fig. 10.33], made during his two years as a graduate student in art at the University of California at Davis. The eleven crudely finished fiberglass abstractions of 1965 announce Nauman's fully developed artistic character. Their forms relate to the body positions and gestures of the rudimentary performances that Nauman inaugurated that year, while at the same time they emphasize the literal process of their fabrication, thus attacking any notion of transcendence.

These fiberglass pieces involved making a cast, then throwing away the object and constructing the sculpture from the hollowed halves of the mold. The lack of finish avoids a sense of preciousness or finality to the object, emphasizing instead an ongoing investigative process. Nauman set up tasks for himself "just to see what would happen.[52] In order "to find things out," he said, he would do ". . . things that you don't particularly want to do, . . . putting yourself in unfamiliar situations, following resistances to find out why you're resisting, like therapy."[53] He did anti-form pieces in rubber latex and began making works in neon during 1965 and 1966, the pieces relating in specific ways either to his body or to the spaces that it occupied. *Neon Templates of the Left Half of My Body, Taken at Ten Inch Intervals* [fig. 10.35] precisely conveys the process of its origin in the title. Yet as Brenda Richardson pointed out, even the tubing, cords, and transformer have the elegance of an abstract expressionist drawing.[54]

In the fall of 1966, after Nauman finished his master's at Davis, he took a storefront studio in San Francisco. He described himself as having "the normal artist's paranoia . . . kind of cut off, just not knowing how to proceed at being an artist."[55] He made some performance pieces and films and then, in the late fall, saw a Man Ray retrospective in Los Angeles that prompted a series of photographic self-parodies, including *Self Portrait as a Fountain* [fig. 10.34]. Although Arneson has said that Nauman "was already an

10.33 (left) **Bruce Nauman,** *Untitled,* 1965. Fiberglass, 96 × 5 × 10in (243.8 × 12.7 × 25.4cm). Photograph by Rudolph Burckhardt, courtesy Leo Castelli Gallery, New York. © 2000 Bruce Nauman/Artists Rights Society (ARS), New York.

10.35 (opposite) **Bruce Nauman,** *Neon Templates of the Left Half of My Body, Taken at Ten Inch Intervals,* 1966. Neon tubing on clear glass tubing frame, 70 × 9 × 6in (177.8 × 22.9 × 15.2cm). Collection, Philip Johnson. Photograph courtesy Leo Castelli Gallery, New York. © 2000 Bruce Nauman/Artists Rights Society (ARS), New York.

10.34 Bruce Nauman, *Self Portrait as a Fountain,* 1966–7. Color photograph, 19¾ × 23¾in (50.2 × 60.3cm) (from eleven color photographs of 1970, edition of eight). Courtesy Sperone Westwater, New York. © 2000 Bruce Nauman/Artists Rights Society (ARS), New York.

artist" when he arrived at Davis,[56] the unflinching, ethical self-scrutiny of Arneson's work has an echo in the integrity of Nauman's self-examination and Nauman also shares with both Arneson and Wiley a passion for the kind of provocatively witty enigmas and word-plays transformed into visual puns that underlie *Self Portrait as a Fountain*.

Nauman read Wittgenstein's *Philosophical Investigations* in 1966 and the philosopher's examination of contradictory and nonsensical arguments that pushed logic to irrational extremes intrigued him. In his neons of 1967, Nauman began exploring semiotics and verbal propositions like "The true artist helps the world by revealing mystic truths," a sentence that spirals out in neon letters from the center in *Window or Wall Sign* of 1967. "It was a kind of test—like when you say something out loud to see if you believe it," Nauman explained. "[It] was on the one hand a totally silly idea and yet, on the other hand, I believed it."[57]

During the following year Nauman met the performance artist Meredith Monk in San Francisco. They talked about the work of Cage and Cunningham, and Nauman began to think of the simple task-oriented actions in his performance pieces as related to dance. He was also impressed with the new music of La Monte Young, Steve Reich, Philip Glass, and Terry Riley, and their work as well as Monk's inspired him to work more with sound. In his *Separate Touch and Sound* (1969), Nauman hid a microphone behind a wall to pick up the friction of the viewer touching the surface. Speakers hidden in another wall, some 40 feet away, broadcast the sound, creating a time lag. The idea was to push the viewer into confronting himself or herself in the space. In the various video corridors that Nauman constructed between 1968 and 1970, he involved the viewer more actively in the work, enticing him or her to enter the space and then playing the viewer's image back on a video monitor.

In the seventies and eighties, Nauman and Tuttle shifted to more overtly social and political concerns. In a disquieting installation of 1972 entitled *Get Out of My Mind Get Out of This Room* a tape with this message permeated the space, seemingly from all directions at once. Jacopo Timermans's accounts of his political imprisonment and torture as a political dissident in Argentina inspired a powerful series of sculptures built around empty chairs suspended by wires in a timeless isolation, cordoned off by raw steel girders. The theme of *Mean Clown*, a video installation, is of malevolence and libido under the sexless clown's traditionally happy façade. Yet on one level the anger, the frustration, the repetitive reworking, even the sense of entrapment and then exhilarating freedom in Nauman's works of the seventies and eighties are all aspects of the creative act itself. Josef Beuys asserted that everyone is an artist in the creative act of living. Nauman's work embodies the assertion that only in the creative act is one fully alive.

Richard Tuttle

Richard Tuttle's work is also very much engaged with the immediate experience of living. What might seem almost too subtle a detail for most people to even notice can engage him completely, such as a Zen monk wrapped in the contemplation of a blade of grass. For many people walking into the Whitney Museum's Richard Tuttle Exhibition in 1975, it took a moment to even find some of the work. There was a tiny yellow triangle painted at the base of a large gallery wall, for example, and he made a wire sculpture that consisted of an almost invisible light pencil line on the wall, describing a small square; he drove tiny nails into each corner and ran a square of very fine wire around it. *Canvas Dark Blue* of 1967 [fig. 10.37] seems so deceptively simple, like the William Carlos Williams poem of "The Red Wheelbarrow" [see page 26]. After all, it is only a faded rectangle of wrinkled blue fabric with a hole cut in the middle. Well, it isn't quite a rectangle; there is a notch in the side, and the top and bottom edges are slightly curved. Actually, the curve on the bottom comes to a point and the edges are hemmed. And suddenly there seem to be so many little things that make it more complicated to describe than you thought at first. The essence of Richard Tuttle's work is precisely that simple pleasure, like Calder's playful cutting up of a coffee can into a flying bird [fig. 3.2]. Tuttle makes something that is so refreshingly simple that it leaves you noticing nuances, in a state of heightened sensitivity, for some time to come.

Richard Serra

Like Nauman and Tuttle, Richard Serra reconceived the anti-illusionism of minimal art as an aesthetic of direct physical experience. He concentrates on palpable qualities of the materials and on the improvisational process of making sculpture. "The significance of the work," he said, "is in its effort not in its intentions. And that effort is a state of mind, an activity, an interaction with the world."[58]

Serra derived the form for *Belts* [fig. 10.38] from, on the one hand, the intrinsic character of the vulcanized rubber strips (particularly as expressed in their response to gravity) and, on the other, from minimalist ideas of serial repetition, indeterminate form, and of creating a continuum with the real world of industrial or commercial materials. The neon contrasts so strikingly with the flaccid strips of rubber that the two materials each help to bring out a vivid sense of the physical nature of the other. As in Hesse's work, Sera's rubber and neon pieces project a moving personal presence, though the artist has always been reticent about this aspect of his work.

Serra did several neon and rubber works late in 1966 and early 1967, perhaps inspired by Nauman, whom he met (along with Hesse, Andre, Johns, and Smithson) when he moved to New York late in 1966. Within two years, Nauman's neons had become entirely concerned with writing and signage, and Serra had abandoned the medium altogether for more direct processes. However several artists continued to work with neon, notably the Italian Mario Merz

(figs. 10.57–10.58) and Keith Sonnier, a New Yorker whose poetic abstractions in a mixture of materials that centered on incandescent fixtures and freely bent neon tubes celebrated the new formal freedom of the late sixties [fig. 10.40].

At about this time, Serra made himself a now-celebrated list of verbs denoting activities one could undertake in relation to sculpture.[59] "To splash" is about a quarter of the way down the column and is the motive for his 1968 piece *Splashing* [figs. 10.36 and 10.39], in which Serra threw molten lead against the wall in Castelli's upper West Side warehouse. *Splashing* literally splattered up and out from the angle where the floor and wall met, adhering fast to both surfaces; it could not be moved without completely destroying it. Other versions were made, including one in the studio of Jasper Johns, and occasionally the artist has repeated the process for retrospective exhibitions.

Serra also created *Casting* of 1969 by similar means, although a greater build-up of the lead allowed him to remove cooled forms, repeat the procedure, and lay out a

10.36 Richard Serra throwing lead, Castelli warehouse, New York, 1969.
Photograph © Gianfranco Corgoni.

10.37 Richard Tuttle, *Canvas Dark Blue,* 1967. Dyed and shaped unstretched canvas, 70 × 35⅞in (178 × 90cm).
Courtesy Sperone Westwater Gallery, New York.

10.38 (above) **Richard Serra,**
Belts, 1966–7. Eleven vulcanized
rubber belts and neon tubing,
84 × 288 × 20in
(213.4 × 731.5 × 50.8cm).

Solomon R. Guggenheim Museum, New York.
Panza Collection, 1991. Photograph by Peter
Moore, courtesy Leo Castelli Gallery, New York. ©
2000 Richard Serra/Artists Rights Society (ARS),
New York.

10.39 Richard Serra, *Splashing,*
1968. Lead, 18 × 312in
(45.7 × 792.5cm).

Installed Castelli Warehouse, New York, 1968,
destroyed. Photograph courtesy Leo Castelli Gallery,
New York. © 2000 Richard Serra/Artists Rights
Society (ARS), New York.

collection of cooled lead forms on the floor. Both *Splashing* and *Casting* focus uncompromisingly on the physical process by which they are made. They take their form from the procedure and the specific shape of the space, enhancing the viewer's experience of the reality of the time, place, and materials. The work is inseparable from the space in which it exists and discourages any kind of metaphorical reading. Yet the burns on the wall and the violent action implied in the form evoke a sense of danger and vulnerability.

In other works of 1969, the artist simply distributed the materials on the floor, emphasizing their literal weight and character. Similarly, Serra's drawing style—densely applied build-ups of thick oil crayon—highlights the process of making the work, providing a palpably physical experience for both artist and viewer. Serra's propped lead pieces from 1968 and 1969 rivet the viewer's attention on the physical weight of the material and its manner of disposition in the space even more compellingly. In *One Ton Prop (House of Cards)* (1969) he leaned four 500-pound lead sheets into one another like a house of cards. In *Corner Prop* [fig. 10.41] he leaned a 2-foot cube of lead, balanced 6½ feet up in the air, between the wall and a soft lead pipe which holds the weight from below. The work is not fastened in any way, despite its weight. It seems—and is—dangerous.

10.40 Keith Sonnier, *MM (Neon Wrapping Light Bulbs),* 1968. Incandescent bulbs with porcelain fixtures wrapped in neon tubing, 45 × 40 × 12in (114.3 × 101.6 × 30.5cm).
Photograph by Brian Albert, courtesy Leo Castelli Gallery, New York. © 2000 Keith Sonnier/Artists Rights Society (ARS), New York.

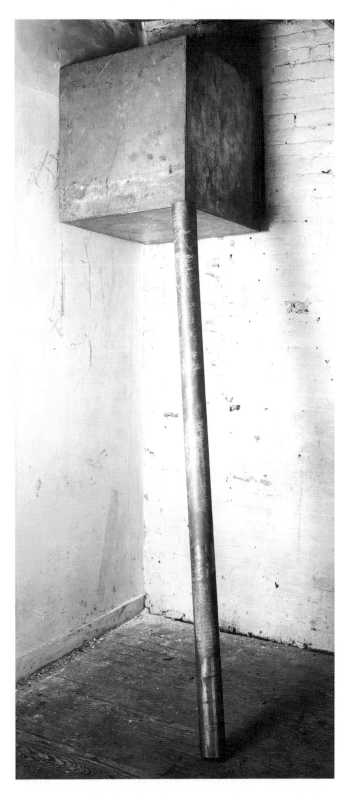

10.41 (above) **Richard Serra,** *Corner Prop,* 1969. Lead antimony, box 25 × 25 × 25in (63.5 × 63.5 × 63.5cm), pole 6ft 8in (2.03m).
Gilman Paper Company Collection, New York. Photograph by Peter Moore, courtesy Leo Castelli Gallery, New York. © 2000 Richard Serra/Artists Rights Society (ARS), New York.

In the Nature of Materials: The Later Sixties

"There is a difference between definite literal fixed relationships, i.e., joints, clips, gluing, welding, etc.," he noted in 1970, "and those which are provisional, non-fixed, 'clastic.' The former seem unnecessary and irrelevant and tend to function as interposed elements." So in works such as these propped lead pieces he has eliminated any such imposition that might falsify the impression of the real balance and weight of the materials. By way of analogy with the same principle, he went on to remark that: "A shift in interest in recent films is from subject matter, qua literature which utilizes a narrative time, to that of those films in which time can be equated with 'live time' or with procedural time: the time of the film in its making."[60]

10.42 Richard Serra, *Tilted Arc,* 1981. Cor-ten steel, 12ft × 120ft × 2½in (3.66 × 36.58 × 0.06m).

Installed Federal Plaza, New York, General Services Administration, Washington, D.C. Photograph by Glenn Steigelman, Inc., courtesy Leo Castelli Gallery, New York. © 2000 Richard Serra/Artists Rights Society (ARS), New York.

Films of the late sixties, such as Warhol's *Empire* (which focuses fixedly on a still object, the Empire State Building, for eight hours) or Yvonne Rainer's *Hand Movie,* which merely shows her hand as she does finger exercises, inspired Serra's own foray into films. His *Hand Catching Lead* (1968) shows a block of lead dropping through the frame as his hand attempts to catch it. Here too the emphasis is on an action in real time. Serra has denied the existence of any kind of expressionism in his work: "My works do not signify any esoteric self-referentiality. Their construction leads you into their structure and does not refer to the artist's persona."[61] And yet in his best work, like the prop pieces and *Splashing,* Serra achieves a terrifyingly threatening presence.

In the seventies Serra began using hot rolled steel, which allowed him to increase the scale. The work is tough; there is a brutality—one might even say a defensiveness—to the reduction. Serra's best outdoor pieces also force themselves uncomfortably on the viewer. They dictate the paths of

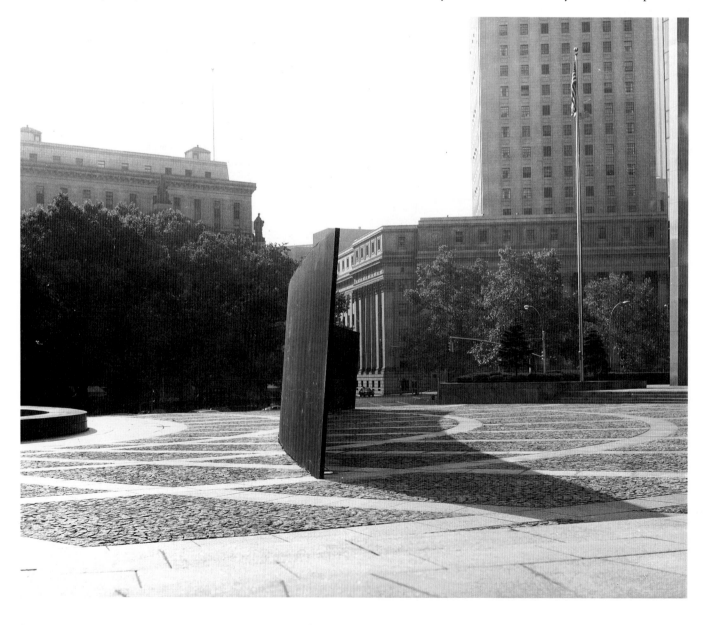

movement around them, and their monolithic massiveness feels frightening, even dangerous, with the unforgiving walls of steel overpowering anyone in range. You sense the massive weight that could crush you in an instant. It is a painfully backhanded compliment that in the notorious case of *Tilted Arc* [fig. 10.42] this disturbing quality ultimately caused the Federal Government, which had commissioned the piece, to have it removed from Federal Plaza in New York. As it was a site-specific work (namely one designed and scaled precisely to this location), this removal effectively destroyed it.

Artists Working in the Landscape

Michael Heizer

The issue of site specificity reached its most extreme expression in the work of Michael Heizer, who pioneered the new genre of site-specific art (art that defines itself in its precise interaction with the particular place for which it was conceived). Heizer had come from a family of geologists and archaeologists and grew up in Northern California and Nevada where he developed a great affinity for the landscape of the West. In 1966, at the age of twenty-one, he came to New York for a year and a half and then went out to the Nevada desert to begin doing "dirtwork"[62] projects in 1967. He began with temporary works such as trenches, "drawing" with his motorcycle tracks, and dispersals of pigment and soil. In 1967 he also embarked on a planned four-part work called NESW, after the points of the compass. The first part consisted of a single-stepped, rectilinear depression dug into the ground at Carson Sink in Nevada.

In *Displaced–Replaced Mass* of 1969 [figs. 10.43–10.45], Heizer transported three solid granite boulders—30, 52, and 68 tons respectively—a distance of 60 miles from the High Sierras

10.43 Michael Heizer, *Displaced–Replaced Mass, #1/3, 1969.* Granite and Concrete in playa surface, 100ft × 800ft × 9ft 6in (30.48 × 243.84 × 2.89m). Silver Springs, Nevada (dismantled). Commissioned by Robert Scull.

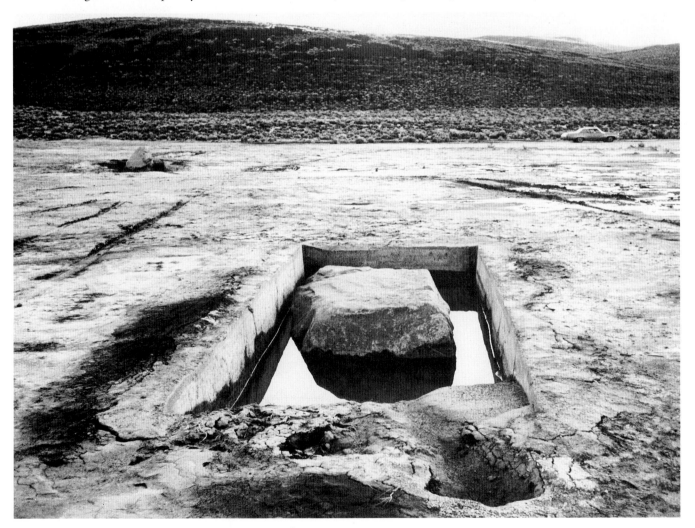

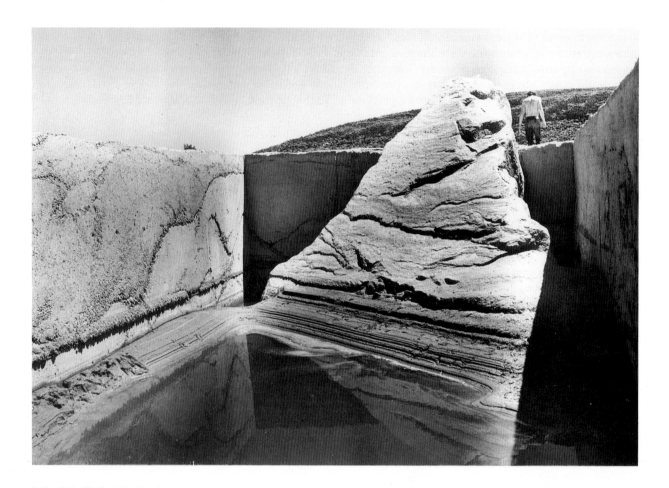

10.44 (opposite, top) **Michael Heizer,** *Displaced–Replaced Mass, #2/3,* 1969. Granite and concrete in playa surface, 100ft × 800ft × 9ft 6in (30.48 × 243.84 × 2.89m). Silver Springs, Nevada (dismantled). Commissioned by Robert Scull.

10.45 (opposite, bottom) **Michael Heizer,** *Displaced–Replaced Mass, #3/3,* 1969. Granite and concrete in playa surface, 100ft × 800ft × 9ft 6in (30.48 × 243.84 × 2.89m). Silver Springs, Nevada (dismantled). Commissioned by Robert Scull.

down to the Nevada desert and placed them in cement-walled depressions that he had cut into the ground. The work had to do with exploring the large forces of nature—bringing rocks from the Sierras back down to their original elevation in the desert reversed the mountain building processes of geological evolution. The work also rejected illusionism by focusing on the actual mass and weight. John Beardsley suggested that *Displaced–Replaced Mass* also refers to ancient cultures: the moving of the great monoliths that form the colossi of Memnon in the Valley of the Kings in Egypt, which Heizer's father had studied, and the well-known "tired rocks" that were moved hundreds of miles into the desert in Bolivia some time before the Inca civilization.

Later in 1969 Heizer disappeared into the desert again, procured another site, earthmoving equipment, and a crew, and at the end of the year returned to New York with photographs of an even more massive site-specific work called *Double Negative* [fig. 10.46]. He had gouged 240,000 tons of rhyolite and sandstone out of the landscape of the Virgin River Mesa in Nevada to create a huge excavation 30 feet wide, 50 feet top to bottom, and 1,500 feet long. A small canyon intersects this cut in the landscape, splitting it into two sections of a straight line facing each other across the gap.

Heizer's line in the desert recalls Newman's genetic moment (see p. 101)—an existential assertion of man's place in the chaos. "In the desert," Heizer explained, "I can find that kind of unraped peaceful religious space artists have always tried to put in their work."[63] Heizer's works in the desert attack the idea of art as a portable object, dominated by historical necessity. Instead, they are about space and an experience of the landscape, of geologic time and of the ancient past. If in this sense they echoed the radical political climate of the late sixties by rejecting the established

10.46 Michael Heizer, *Double Negative,* 1969–70. 240,000-ton displacement in rhyolite and sandstone, 1,500 × 50 × 30ft (457.2 × 15.24 × 9.14m). Mormon Mesa, Overton, Nevada.

institutions of museum and gallery, which could neither exhibit nor readily sell his major works, this too was a by-product rather than the central focus of the works. In 1969 Heizer wrote in a rough-edged, telegraphic prose: "the position art as malleable barter-exchange item falters as the cumulative economic structure gluts. The museums and collections are stuffed, the floors are sagging, but the real space still exists."[64]

Walter De Maria

Walter De Maria and Heizer shared an interest in the western landscape, but De Maria's work was consistently more concerned with systems of ordering and measurement rather than with geological time and the experience of the landscape itself, as in Heizer's work. In 1968, perhaps stirred by Heizer's work in the open land, De Maria filled the Heiner Friedrich Gallery in Munich with 3 feet of dirt. Eventually, De Maria re-created his *Earth Room* as a permanent installation on the second floor of a New York loft owned by the Dia Art Foundation. *The New York Earth Room* of 1977 [fig. 10.47] consists of 250 cubic yards of black soil, 22 inches deep. It covers the floor of a 3,600-square-foot loft and weighs 280,000 pounds. The presence of the work is critical—one cannot successfully reproduce it in pictures or by description. As visitors ascend the stairs they slowly begin to feel the moisture and smell the rich humus. The soil also has a distinctive muting effect on the sounds in the space.

The *Earth Room* evokes a romantic apprehension of landscape in an enclosed urban space—which is antithetical to the experience of nature. In this sense it relates to Serra's disposition of his materials in ways that test their natural weight or strength, a practice that relies on (and brings out in the viewer) an acute sensitivity to the nature of the materials. But the *Earth Room* also reflects the influence of John Cage in the way it emphasizes the ambient experience over the expression of the artist's personality.

De Maria had come to New York in 1960, gotten involved with the Judson dancers and Fluxus, played drums with the rock group Velvet Underground in 1964, and in 1968 began working with specific sites using real landscape as an artistic material. In deliberate contrast to the hyper-accessible New York pop art that was so popular in the later sixties, Heizer, De Maria, and (in his last works, his large-scale earthworks) Smithson all made their art conceptually complex and, by siting most of it in remote areas of the southwestern desert, literally inaccessible as well.

In most of the major examples of land art, as these large projects in the wilderness have come to be known, the pilgrimage through the lost landscape to the site was an important aspect of the experience of the work itself. John Weber, then the director of the Dwan Gallery, once took a collector out to see De Maria's 1969 *Las Vegas* piece and could not even find it. In addition, by setting the work so far out in the middle of nowhere, these artists made visitors feel acutely vulnerable to the elements. If your car broke

10.47 Walter De Maria,
The New York Earth Room,
1977. 250cu. yd (191.25cu. m) of black soil in a 3,600sq. ft (334.44sq. m) loft.
All reproduction rights reserved.
Photograph by John Cliett, © Dia Center for the Arts.

10.48 Walter De Maria, *The Lightning Field,* 1977. Stainless steel poles, average height 20ft 7½in (6.29m), overall 5,280 × 3,300ft (1,609.34 × 1,005.84m). Near Quemado, New Mexico.
All reproduction rights reserved. Photograph by John Cliett, © Dia Center for the Arts.

down, Weber remarked, you might die of dehydration before anyone could find you.[65]

De Maria's *Lightning Field* [fig. 10.48] sits in a flat, semi-arid basin of southern New Mexico with awe-inspiring vistas of distant mountains all around. Here the artist has constructed a 1 mile by 1 kilometer (⅝ mile) grid of 400 stainless steel poles, arranged in sixteen rows of twenty-five, 220 feet apart. The 2-inch diameter poles have an average height of 20 feet 7½ inches and they are set so that the tops all terminate on a unified, level plane despite the variations in the terrain. When they are viewed from a distance the bleaching sun makes the grid nearly invisible except in the reflected light of dawn and dusk. The desolate beauty of the site seems to exist beyond time, with the power of nature brought home most dramatically by the play of lightning in the sky behind the grid.

Robert Smithson

Where Heizer is in romantic communication with nature and De Maria engaged in a cerebral encounter with it, Robert Smithson explored the sublimity of nature with a darker, more melodramatic tone. Questions of personal identity, struggles of good and evil, and Christianity figured importantly in Smithson's abstract expressionist beginnings, but science fiction and geology provided the vocabulary for him to move beyond those issues by 1964. As Robert Hobbs has pointed out, Smithson's interest in crystals in particular allowed him to begin dealing with nature without the biological metaphor.[66]

In a 1966 essay called "Entropy and the New Monuments,"[67] Smithson expanded upon the Second Law of Thermodynamics—the idea that energy dissipates toward a disintegrated homogeneity of matter. Entropy negates the concept of progress on the scale of geological time. Consequently, Smithson regarded monuments to disintegration as the most valid form of art and he attacked the idea of an art centered on human beings. "The myth of the Renaissance still conditions and infects much criticism

In the Nature of Materials: The Later Sixties

with a mushy humanistic content," he wrote in 1967.[68]

An interview with Tony Smith, published by *Artforum* in 1966, acted as a catalyst for Smithson's idea of the entropic monument as realized in man-made sites. Smith described an experience of driving at night on an unfinished section of the New Jersey turnpike. He said it opened his eyes to the aesthetic possibilities of an "artificial landscape without cultural precedent." For Smith "this drive . . . couldn't be called a work of art. On the other hand, it did something for me that art had never done . . . It seemed that there had been a reality there that had not had any expression in art . . . Most painting looks pretty pictorial after that. There is no way you can frame it, you just have to experience it."[69]

Smithson began making regular trips to abandoned industrial sites and quarries in New Jersey during 1966, and the following year he wrote about them in an article for *Artforum* called "Tour of the Monuments of Passaic." Smith's remarks encouraged Smithson to think about the man-made environment as part of nature, and he developed a morbid aesthetic based on an appreciation of sludge heaps, tailings ponds, and the ubiquitous commercial strips of American suburbia. This apotheosis of the ordinary had something in common with the assimilationist aesthetic of Oldenburg and Rauschenberg except for its profoundly pessimistic emphasis on the irreversible destruction of the universe and the decline of distinctness in all matter. John Cage's suppression of self-expression and his abrogation of control came full circle with Smithson, who determined that man's willful acts were minor events in this larger trend toward cosmic disintegration.

Smithson conceived the idea of his "Nonsites" in 1967 [fig. 10.50]. These consisted of topographical maps or aerial photographs of a particular site mounted on the wall with earth, rocks, or gravel from the actual place in trapezoidal bins on the floor. The bins looked like minimal sculpture and typically echoed the shape of the map or the plot of land. Smithson described the "Nonsites" as a "dialog . . . between indoors and outdoors . . ." He explained, "The site, in a sense, is the physical, raw reality—the earth or the ground that we are really not aware of when we are in an interior room . . . [whereas] the Nonsite . . . is an abstract container."[70]

On the most direct level, Smithson's "Nonsites" concern space, mental projection, and mapping. Standing in a site, one recognizes the material from the "Nonsite" but

10.49 Robert Smithson, *Spiral Jetty,* April 1970. Black basalt and limestone rocks and earth, length 1,500ft (457.2m). Great Salt Lake, Utah.

Photograph by Gianfranco Gorgoni, courtesy John Weber Gallery, New York. Art © Estate of Robert Smithson/VAGA, New York.

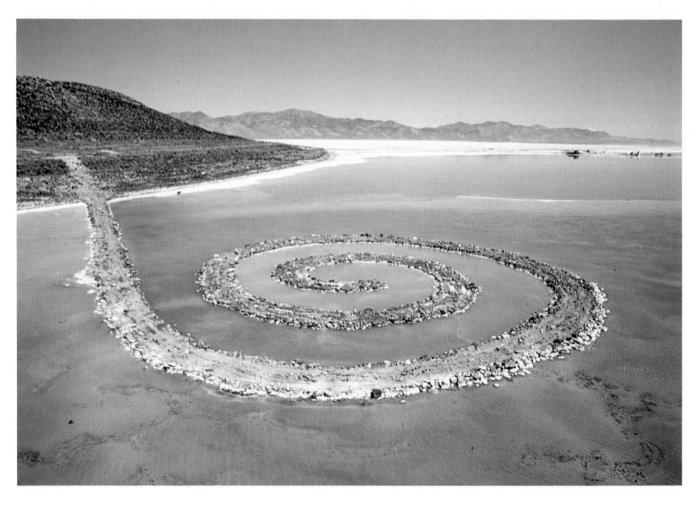

one cannot see whence it was extracted. In this way it subverts one's sense of boundaries and definition. Smithson used the metaphor of the enantiomorph—a pair of crystals that are similar in form but cannot be superimposed because they are mirror images of one another—to describe the relation of his "Nonsites" to the actual sites. The "Dialectic of Site and Nonsite," as he elaborated it, consists of a series of inversions such as: open limits versus closed limits, subtraction (from the site) versus addition (to the "Nonsite"), indeterminate certainty versus the determinate uncertainty (of the "Nonsite"), some place (physical) versus no place (abstract).[71]

In the mirror and salt pieces, such as *Rock Salt and Mirror Square* [fig. 10.51] from the "Cayuga Salt Mine Project," the salt gradually dissipates with exposure to the air, conveying the hopelessness of ordering something that will ultimately disorganize itself into randomness. The mirrors involve a minimalist concern with measurement, in effect mapping the forms by reproducing them in reflection. In addition to the spatial displacement of images in the mirrors, these works involve the displacement of the salt from the earth to the gallery, and a metaphorical displacement of Smithson's formal concept for the "Nonsite" by surrounding the geometrically fixed forms of the mirrors with the amorphous piles of salt instead of containing the salt in rigid bins. Yet on a molecular level the salt, which appears random, has a clearly defined crystalline structure while the overtly regular glass mirrors are actually in a liquid state, creating one more conceptual displacement within the work.[72] Moreover, this compounding series of displacements within the piece keeps repeating the same structural principle, as in the growth of a crystal.

In another series of 1969, Smithson poured or dumped flows of viscous material, such as glue, cement, and asphalt. Works like *Asphalt Rundown* extended the artist's exploration of geophysics, passively acknowledging the natural force of gravity. They took place in locations which few viewers would witness firsthand and, recognizing that his work would largely be seen in photographs or experienced through his increasingly influential essays written between 1966 and 1973, Smithson sought to exaggerate this effect of displacing the museum or gallery with the art journals.

In April 1970, Smithson began constructing his best-known work, the *Spiral Jetty* [fig. 10.49], in an abandoned industrial site on a remote corner of the Great Salt Lake in Utah. Virtually no one ever saw the work in actuality before it was destroyed by the natural fluctuations in the lake, but it was widely viewed in the art press and in Smithson's film of it, in which the artist cleverly used the possibilities of cinematic time and space to set the *Spiral Jetty* in the context of its underlying ideas.

The *Spiral Jetty* film opens by juxtaposing the site with a map of the "Geography of the Jurassic Period." The camera pans the continents of Australia, Tethys, Angora, Gondwanaland, and Atlantis to the place now occupied by the Great Salt Lake and dissolves into a U.S. Geological Survey map of Utah. The map marks the site with precise specifications, and yet the calculations seem meaningless in terms of geologic time, during which whole continents appear, disappear, and shift around. The sound track superimposes mythology, geiger counter sounds, and repetitious refrains of surveyors' descriptions: "West by North—mud, salt crystals, rocks, water. Northwest by West—mud, salt crystals, rocks, water . . ." As the camera enters the approach to the spiral, overlays of the earth-moving machines as prehistoric dinosaurs and then as futuristic robots create a strange warp in time like an old science-fiction movie.

The art historian Eugenie Tsai has pointed out that Smithson's entropic landscapes relied heavily not only on science writing but on the inspiration of the desolate landscapes of the science-fiction writers.[73] In the case of *Spiral Jetty*, the site attracted Smithson precisely because it seemed like a strange, futuristic wasteland. The micro-organisms in the water colored it an eerie red and the shoreline was littered with abandoned machinery and vehicles from the time when prospectors had attempted to mine it for oil and tar. Smithson noted that "a great pleasure arose from seeing all those incoherent structures. This site gave evidence of a succession of man-made systems mired in abandoned hopes."[74]

Here, the artist bulldozed 6,650 tons of material into a coil of rocks and earth 1,500 feet long and 15 feet wide, swirling out into the water. Salt crystals precipitated all around the edges of the jetty and, Smithson observed, "each cubic salt crystal echoes the Spiral Jetty in terms of the crystal's molecular lattice."[75] The "matter collapsing into the lake" was also "mirrored in the shape of the spiral,"[76] according to the artist, as was the giant mythological whirlpool in the middle of the lake under which, legend had it, a channel existed to the ocean.

Smithson died in 1973 in a plane crash while making an aerial survey of a site in Texas. His last work centered on (unrealized) proposals for reclaiming abandoned industrial sites as entropic monuments—parks structured according to his aesthetic of disintegration. In 1971, he transformed an exhausted sand quarry in Emmen, Holland, building a black, cone-shaped hill with a white sand path spiraling up it and describing a broken circle, 140 feet in diameter, with a 12-foot-wide, semicircular canal and a half-circle jetty. This work, called *Spiral Hill and Broken Circle*, suggests a romantic exaltation in the morbidity of man's industrial processes laying waste to the earth. Even the underlying contradictions of Smithson's attempt to order the world while simultaneously acknowledging its inevitable tendency toward entropic disorder expresses his aesthetic of existential hopelessness. "A bleached and fractured world surrounds the artist," he wrote. "To organize this mess of corrosion into patterns, grids, and subdivisions is an esthetic process that has scarcely been touched."[77]

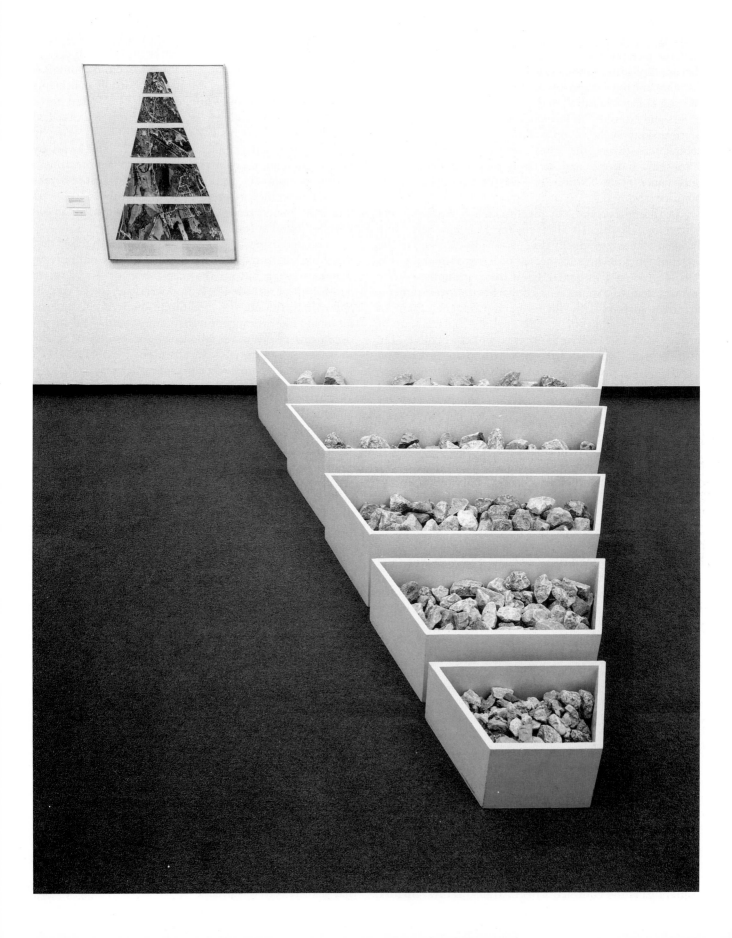

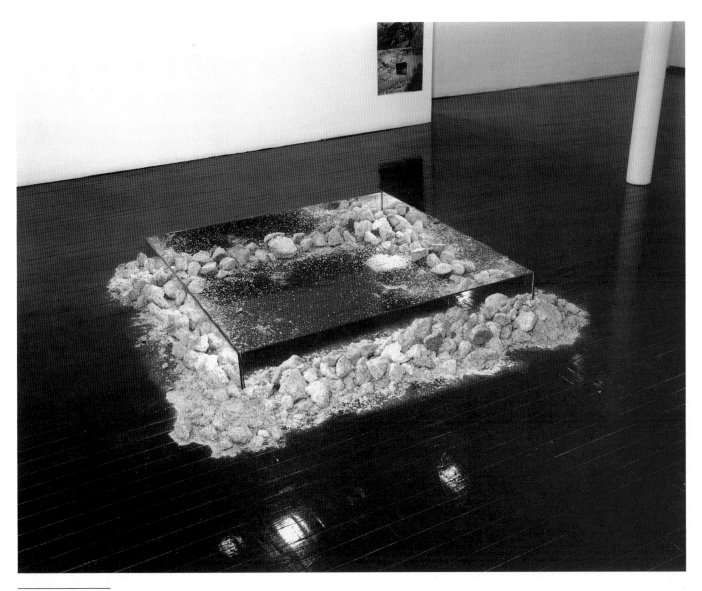

10.50 (opposite) **Robert Smithson,** *A Nonsite (Franklin, N.J.),*
1968. Two parts: five painted wooden bins and limestone;
photographs and typescript on paper with pencil and transfer letters,
mounted on mat board. Bins installed: 16½ × 82¼ × 103in (41.9 ×
208.9 × 261.6cm), board: 40¹⁄₁₆ × 30¹⁄₁₆in (101.8 × 76.36cm).
Collection, Museum of Contemporary Art, Chicago. Gift of Susan and Lewis Manilow.
Art © Estate of Robert Smithson/VAGA, New York.

10.51 (above) **Robert Smithson,** *Rock Salt and Mirror Square,*
1969. Rock salt and mirrors, 10 × 78 × 78in (25.4 × 198.1 ×
198.1cm).
Courtesy John Weber Gallery, New York. Art © Estate of Robert Smithson/VAGA, New York.

An Accidental Rubric

The works of Heizer and the large outdoor projects of De
Maria and Smithson have in common their allusion to
geologic time and prehistory. In addition, these artists all relate
to minimalism in their concern with the literal presence of the
materials and in the extent to which they derived their works
from preconceived systemic ideas. All saw associations with

the sublime in the frightening vastness and desolation of the
American West. They even played up the ethos of virility
celebrated in myths of the West—De Maria's movie *Hardcore*
(filmed in the desert with Heizer in 1969) tellingly opens with
cowboy music, horses, and the imagery of the range hand. The
camera comes in on a close-up of an old western gun and then
pans around 360 degrees on the rugged terrain with the harsh
roar of the wind in the background.

In 1968 Heizer took Smithson out to the western desert
to work on the former's *Isolated Mass/Circumflex*. Inspired by
the experience of the desert landscape, Smithson organized
an exhibition at the Dwan Gallery in New York in October
1968 called "Earthworks," a title that has ever since linked
these fundamentally different artists. Walter De Maria's
contribution to the exhibition was an expansive (20-foot-
wide), chrome yellow painting with a brass plate embedded
in the center, bearing the inscription "the color men choose
when they attack the land." The show also included
Smithson's *Nonsite, Franklin, New Jersey,* a 6-foot-high,
backlit transparency of a vast tract of the Nevada desert

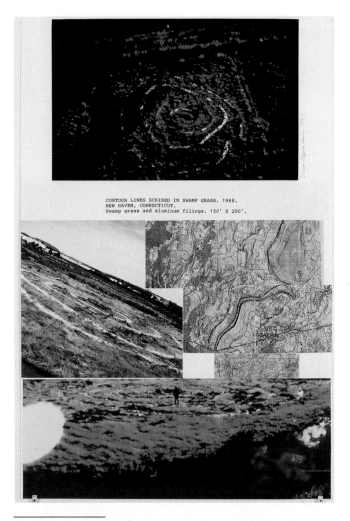

10.52 Dennis Oppenheim, *Contour Lines Inscribed in Swamp Grass,* 1968, New Haven, Connecticut. Inscribed with the title and "swamp grass and aluminum filings," 150 × 200ft. Black-and-white and color photographs, hand-stamped collage map dry mounted on rag board, 150 × 100cm.

Collection Fundação de Serralves, Oporto. Photograph courtesy Fundação de Serralves.

where Heizer had dug a series of trenches in the earth, and works by several friends experimenting with site-specific ideas, including Carl Andre, Herbert Beyer, Steven Kaltenbach, Sol LeWitt, Robert Morris, Claes Oldenburg, and Dennis Oppenheim (fig. 10.52).

Yet whatever Smithson, De Maria, and Heizer may have had in common, the earthworks of Smithson are largely minimalist sculpture in form and only in the case of the late *Spiral Jetty* did he make a work that interacts in a significant way with the unique geology of the site—his reclamation parks could be built in any of a number of industrial waste sites, for example. The core of his idea is based on large philosophical ideas and on myth. De Maria's two land projects—notably *The Lightning Field* and *Earth Room*—use the sublimity of nature to set off human principles of mensuration and ordering and, again, De Maria's projects don't really depend upon a particular site. Only Heizer was

centrally concerned with the experience of the site and its real geological matter. "Anything is only part where it is," he insisted.[78] Moreover, Heizer's earthworks were too big to be seen at once like a sculpture, whereas the *Spiral Jetty* and *The Lightning Field* do have defining gestalts. In *Displaced–Replaced Mass,* for example, the viewer perceived the work in disjointed impressions while traversing it a little at a time. Indeed, Heizer's work centers on the idea of sculpture as place rather than object, invoking the precedents not only of Barnett Newman but of such prehistoric sites as the colossal line drawings on the Nazca plain in Peru and the Great Serpent Mound constructed by the Hopewell culture of the ancient Ohio Valley.

Arte Povera, and a Persevering Rapport with Nature in Europe

As in the rest of Europe and North America, the late sixties was a period of social upheaval in Italy. The unbroken power of the Christian Democrats over the twenty-five years since World War II had led to massive corruption and inefficiency as well as the imposition of repressive public policies that were tailored to suit big business interests and conservative Catholic mores rather than to benefit the populace. The workers' revolution of 1968 began in the universities, but the government's insensitivity to the widespread poverty—especially in the less industrialized South—resulted in massive migrations northward and a climate of instability and disaffection. This lasted to the end of the seventies, culminating in the abduction and murder of Prime Minister Aldo Moro by the leftist Red Brigades in 1979.

Artists took up a radical stance at the end of the sixties too, attacking the values of established institutions of government, industry, and culture and even questioning whether art as the private expression of the individual still had an ethical reason to exist. The critic Germano Celant organized two exhibitions in 1967 and 1968, followed by an influential book called *Arte Povera,* promoting the notion of a revolutionary art, free of convention, the power structure, and the market place. Although Celant attempted to encompass the radical elements of the entire international scene, the term properly centered on a group of Italian artists[79] who attacked the corporate mentality with an art of unconventional materials and style. Michelangelo Pistoletto began painting on mirrors in 1962, connecting painting with the constantly changing realities in which the work finds itself. In the later sixties he began bringing together rags with casts of the omnipresent classical statuary of Italy to break down the hierarchies of "art" and common things. An art of impoverished materials is certainly one aspect of the definition of *Arte Povera.* In his 1967 *Rag Wall* [fig. 10.53] Pistoletto makes an exotic and opulent tapestry wrapping

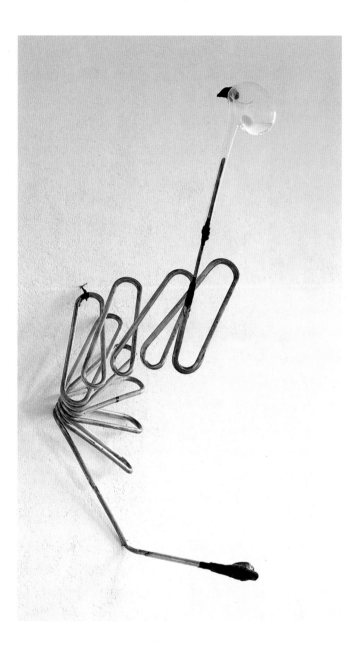

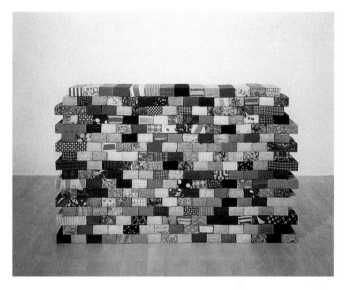

10.53 (above) **Michelangelo Pistoletto,** _Muretto di straci (Rag Wall)_, 1967. Fabric-covered bricks, dimensions variable.
Collection Fundação de Serralves, Oporto. Photograph courtesy Fundação de Serralves.

10.54 (left) **Gilberto Zorio,** _Serpentine_, 1989. Copper, glass, wax, alcohol, 63 × 32 × 48in (160 × 81.3 × 121.9cm).
Collection of Anne and William J. Hokin, Chicago. Photograph by Marc Rapilliard, France, courtesy Margo Leavin Gallery, Los Angeles.

common bricks in discarded scraps of fabric. Building on the work of Burri, Fontana, and Manzoni, artists such as Jannis Kounellis and Mario Merz attempted to make the experience of art more immediately real while also more closely connecting the individual to nature.

In 1967 Kounellis exhibited a parrot sitting on a perch that extended from a monochrome plane of painted steel. The "painting" (i.e. the painted steel plate) looked pale by comparison with the vitality and brilliant plumage of the bird. In 1969 he tethered eleven live horses to the walls of the Galleria L'Attico in Rome lined up equidistantly like paintings [fig. 10.55]. Kounellis implied in this exhibition that a work of art is not transcendent but rather just like any other form of life: an identity that contains an idea.

Kounellis often incorporated fire into his works, along with the scorch marks and the apparatus of the process [fig. 10.56]. "Fire, in medieval legend," he explained, "goes

with punishment and purification."[80] It suggests the entropic dissolution of matter which is, perhaps, the final form of purification. Gilberto Zorio, another _arte povera_ sculptor, also invokes alchemical allusions with evaporating alcohol or acid in glass crucibles or with other unusual materials that often remain visible only faintly and by implication, as with the traces of chartreuse left by the evaporated liquid in _Serpentine_ [fig. 10.54]. Here the forms unfold like an intimate, or perhaps esoteric, conversation with the copper tubing spiraling down in one direction to an accumulation of black wax while ascending in the other into the glass flask above.

The work of Mario Merz [figs. 10.57–10.58] brings about a fusion of natural elements with fragments of urban society in a way that also seems to suggest the idea of nature overwhelming culture from within. For Merz, the artist is like a nomad using humble materials from everyday life, both from culture and from the organic world, mediating between the two. Merz began making his "Igloos" in 1968, covering segmented metal armatures in nets, wax, mud, glass, and bundles of twigs. These small hemispherical dwellings use the materials indigenous to the sites at which the exhibitions take place, and Merz thus creates a hypothetical artist who is at home everywhere. The Igloo is architecture, shelter, and an abstract idea associated with the nomad. It is a skin that embodies the receptivity of the artist to nature and to culture.

In the Nature of Materials: The Later Sixties

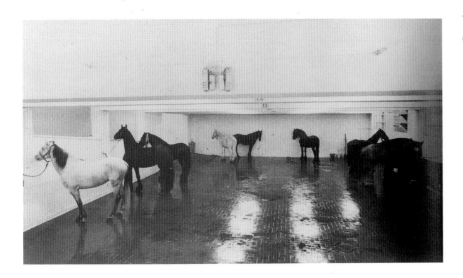

10.55 Jannis Kounellis, *Cavalli,* shown at the Galleria L'Attico, Rome, 1969.

10.56 (below) **Jannis Kounellis,** *Untitled,* 1984. Steel, iron, and wood, 9ft 8in × 18ft (2.95 × 5.5m).
Collection, Kunstmuseum, Düsseldorf. Photograph by Philipp Schönborn.

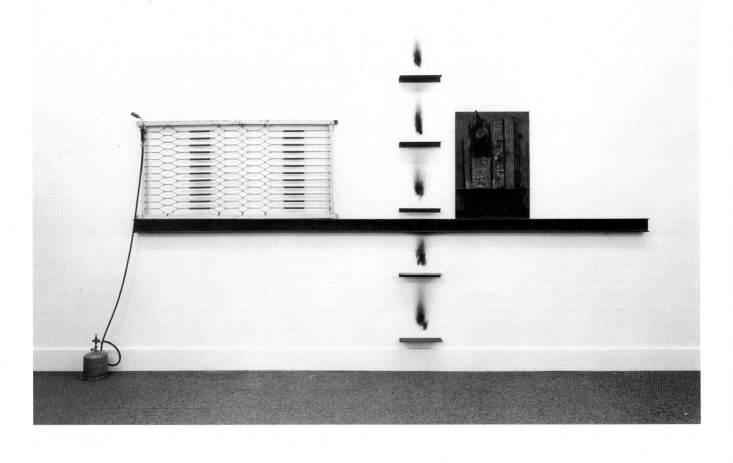

Merz described his working method in an account of his drawing:

I had spent all day drawing that endlessly convoluted line, . . . following my thoughts and everything happening around me—for example, the twittering birds, the falling leaves, the distant rumble of a van. All these things entered the drawing not in a natural way, of course, but as time, as a recording, as if the pencil lead were the point of certain instruments registering on a sheet of paper.[81]

Merz often used neon to inscribe political and literary references in his installations, as in *Giap Igloo*, named after a North Vietnamese general and bearing his maxim: "If the enemy masses his forces, he loses ground; if he scatters, he loses strength." The recurring stuffed iguanas and alligators in Merz's installations evoke the primitive, prehistory, and geologic time balanced by the "reproduction of words and thoughts"[82] in the stacks of newspapers that also recur in Merz's work. In addition, many works include sequences of numbers illuminated in neon. These refer to the arithmetic progression discovered

10.57 Mario Merz, *Giap Igloo,* 1968. Metal tubes, wire mesh, neon tubes, dirt, 9ft 10⅛in (3m) diameter.
Photography by P. Bressano, Torino, courtesy Archivio Mario Merz, Torino.

10.58 Mario Merz, *Double Igloo,* 1979 (showing *Alligator with Fibonacci Numbers to 377* on the ceiling). Outer structure: metal tubes, clamps, glass, and hat; inner structure: metal tubes, wire mesh, dried mud, neon tubes; 9ft 10in (3m) high × 19ft 8¼in (6m) diameter overall.
Installation at Sperone Westwater Gallery, New York. Photograph courtesy Sperone Westwater Gallery, New York.

In the Nature of Materials: The Later Sixties

10.59 Richard Long, *Red Slate Circle,* 1980. Red slate,
28ft (8.53m) diameter.

Collection, Solomon R. Guggenheim Museum, New York. Photograph courtesy Sperone
Westwater Gallery, New York.

by a thirteenth-century monk known as Leonardo of Pisa,
or Fibonacci.

The Fibonacci series—in which each number is the sum
of the preceding two (1, 1, 2, 3, 5, 8, 13, 21, 34 and so on)—
corresponds to the rate of simple growth in nature. As the
number in the series increases, the ratio of each number to
the last one approaches the "divine proportion," also known
as the ratio of the "golden section." This is the ratio between
two sides of a rectangle or two halves of a bisected line such
that the smaller side is to the larger as the larger is to the sum
of the two. Fibonacci based his discovery on the reproductive
rate of rabbits, but there are countless growth patterns in
nature that correspond miraculously to the Fibonacci series
and the golden ratio, including the rate of increase in the
radius of the spiral cross-section of a nautilus shell, and the
growth of trees and leaves, the scales on an iguana's skin, deer
antlers, and pinecones. For this reason, the golden section
has fascinated artists since ancient times. Merz incorporated

many of these natural objects, as well as individual numbers
from the Fibonacci series itself, into his work to refer to this
arithmetic discovery. To Merz, the series symbolizes
constant, open-ended change, infinity, and integration with
nature. "This parabolic, deep breathing whole," he said, "is the
real subject of art."[83]

The appearance of fruit became important for me, from an
existential point of view: I am impressed by the tremendous
reproductive capacity of nature . . . Faced with the enormousness
of a thing, such as a heap of fruit, you are bound to discover
something similar to innocence. You have to rediscover an
elementary imagination and a kind of innocence inside yourself
. . . When the painter's hand becomes nature, it represents the
imagination.[84]

The romantic tradition runs deeper in Europe than in the
United States, and the relationship of European artists to
nature has tended to be more profoundly spiritual. Richard
Long and Hamish Fulton, who studied at St. Martin's
School in London, both independently introduced walking
in nature as their principal medium. In 1967, while still a
student, Long began treading paths in grass and arranging
stones on a Somerset beach. In 1969 he walked four

10.60 Hamish Fulton, *Grims Ditch* (ancient pathways, Hertfordshire), 1969–70. Photograph, 22⅝ × 37in (57.5 × 94cm). Collection Fundação de Serralves, Oporto. Photograph courtesy Fundação de Serralves.

concentric squares in the Wiltshire countryside as accurately as he could with the time noted and the path drawn on the map. For Long, the walk was the work of art, but for Fulton the walk was a reverent encounter with nature, and the photographs he took, together with the matter-of-fact texts framed with them (fig. 10.60), *were* the art. Fulton touched nothing and left no trace of his romantic rambles in nature beyond his footprint. Long also made photographic records of his incursions into nature, but unlike Fulton, he stopped to arrange stones or twigs into a pattern and then photographed the site.

Long also arranged materials he encountered on walks into geometrically composed collections on the floor of an art gallery or museum [fig. 10.59]. These may consist of pieces of wood or stone quarried from a particular location

in which Long walked, and sometimes he has splashed mud from the site on the gallery wall or made handprints in it. From low down the view across the circles or lines of stone even in the controlled space of the gallery evokes the vastness and sublime irregularity of the landscape itself. The precision of these installations in circles and lines laid down within a pencilled circumference on the floor brings home the interaction of reason, in the Enlightenment sense, with raw nature and recalls the planned "randomness" of the eighteenth-century English garden.

11

POLITICS AND POSTMODERNISM: THE TRANSITION TO THE SEVENTIES

11.1 (opposite) **Sigmar Polke,** *Bunnies*, 1966. Acrylic on linen, 58¾ × 39⅛in (149.2 × 99.4cm).

Collection, Hirshhorn Museum and Sculpture Garden, Smithsonian Institute, Washington, D.C. Joseph H. Hirshhorn Bequest and Purchase Funds, 1992.

Re-Radicalizing the Avant-Garde

The Critical Atmosphere of the Late Sixties

As America left the uncomplicated innocence of sock-hops and Brylcreem for Bob Dylan and the burning of Detroit, art too assumed an increasingly ideological and critical tone in the latter half of the sixties. The escalating movement against the controversial Vietnam War in particular caused heated debate that gave rise to a broad range of radical forces for change in virtually every aspect of Western culture. In art, the self-consciously specialized focus in minimal and process art on the literal presence of the materials and on the generative basis of a work, the excessive theorizing of formalist critics (whether on behalf of color field painting or in the context of the emerging debate on critical theory from Europe), and the cool detachment of the painting of Jasper Johns and of pop art pointed many younger artists toward the idea of a purely "conceptual art."

In addition, consumerism had careened out of control in the early sixties, swallowing up everything in sight, and many artists reacted against that too. In the catalog for an exhibition matter-of-factly entitled "January 5–31, 1969," the conceptual artist Douglas Huebler noted: "The world is full of objects, more or less interesting: I do not wish to add any more."[1] The show, organized by Seth Sieglaub in New York, had a catolog, but no objects. At roughly the same time, Jan Dibbets, a Dutch artist, "discovered it's a great feeling to pick out a point on the map and to search for the place for three days, and then to find there are only two trees standing there, and a dog pissing against the tree. But someone who tried to buy that from you would be really stupid, because the work of art is the feeling, and he couldn't buy that from me."[2] In 1967 Terry Atkinson and Michael Baldwin, two artists from the English Art+Language group, held an "Air Show" by making a series of assertions about a theoretical column of air with a base of 1 square mile and an unspecified vertical dimension. No particular location was mentioned.

What stood out was the sheer cacophony of all the different, often conflicting, voices in the art world. Broadly speaking there was a growing tendency toward what Lucy Lippard called the "dematerialization of the art object."[3] As Sol LeWitt had explained in 1967, conceptual art "is made to engage the mind of the viewer rather than his eye or emotions."[4] Meanwhile, it seemed as though everybody wanted to liberate or be liberated from something: some artists wanted to liberate themselves from producing commodities, others wanted to be free of the convoluted language of contemporary art theory. In 1966 the English artist John Latham chewed up and spat out pages from Clement Greenberg's book *Art and Culture*, borrowed from the library of St. Martin's School of Art in London. Latham's piece was a visceral purge of formalist criticism.

John Baldessari wanted to rid himself of the clutter of old work in his studio, so he burned it, put the ashes behind a wall in a show at the Jewish Museum in New York (he exhibited a label describing the deed), and then he announced in a San Diego newspaper: "Notice is hereby given that all works of art done by the undersigned between May, 1953, and March, 1966, in his possession as of July 24, 1970, were cremated on July 24, 1970, in San Diego, California."[5] Finally, there were the ubiquitous liberations from inhibition, ranging from performance pieces such as Yayoi Kusama's *Naked Event*, staged at various sites around Manhattan in 1968 [fig. 11.2], to the Woodstock Festival, where 450,000 rock-music devotees celebrated the peak of the youth counterculture in August 1969.

Language and Measure

More and more artists also began to write art theory in the sixties, at first in defense of their formal innovations (as in the dry, formal theories of the Minimalists),

11.2 Yayoi Kusama, *Naked Event,* at the New York Stock Exchange (one of several sites around Manhattan), July 14, 1968.

11.3 (below) **Joseph Kosuth,** *One and Three Hammers (English Version),* 1965. Hammer, photograph of a hammer, photostat of the definition of hammer, 24 × 53⅜in (61 × 135.6cm).
Photograph courtesy Leo Castelli Gallery, New York. © 2000 Joseph Kosuth/Artists Rights Society (ARS), New York.

11.4 Walter De Maria,
The Broken Kilometer, 1979.
500 brass rods, 6ft 6¾in (2m)
each, 45 × 125ft (13.71 ×
38.1m) overall.

All reproduction rights reserved.
Photograph by John Cliett, © Dia
Center for the Arts.

but then as an alternative medium for more philosophically inclined artists such as Joseph Kosuth and Robert Smithson.[6] The effect on artists of hyperintellectual debates about theory had already become significant by the mid sixties. For example, Wittgenstein's assertion that explanation obstructs one's perception of an object fed the minimalists' concern for the direct, literal experience of the material fact and nurtured the personal detachment in the paintings of Jasper Johns after 1960. Some conceptual artists (for whom there was frequently no object anyway) made explanation a work in its own right, as with Joseph Kosuth's "Art as Idea as Idea" (a title used by Kosuth for several works of the late sixties, including one consisting of a blow-up from the dictionary of the definition of the word "idea"). Kosuth examined verbal assumptions and definitions with disconcerting literalness. In *One and Three Hammers (English Version),* for example [fig. 11.3], he juxtaposed three distinct by overlapping realities, with a hammer mounted on the wall, a photograph of the hammer, and a blow-up of a dictionary definition of a hammer. "The art I call conceptual," Kosuth wrote, "is . . . based on . . . *the understanding of the linguistic nature of all art propositions.*"[7]

Some artists of the late sixties began a cool analysis of the structure of language itself. Lawrence Wiener stopped painting in 1968 and began writing impenetrable verbal propositions directly on the gallery wall, for example:

IN RELATION TO AN INCREASE IN QUANTITY
REGARDLESS OF QUALITY:
HAVING BEEN PLACED UPON A PLANE
() UPON A PLANE
HAVING BEEN PLACED ()

"As I see it," he explained, "it's an imposition to impose my personal life on the art which attempts to present something to people that is not *just* about me. It is about materials, and about the world they live in, perhaps, but it is not about themselves, their own personal everyday lives, which is what I try to take out of my art."[8]

Detached analysis as an approach to art also fostered an interest in measurement. Mel Bochner, for example, used mathematical systems as a foundation for painting and Walter De Maria's *The Broken Kilometer* of 1979 [fig. 11.4] was an orgy of measurement, consisting of 500 highly polished, round, solid brass rods, each measuring precisely 2 meters (6½ ft) in length and 5 centimeters (2 in) in diameter. The 500 rods were placed in five parallel rows of 100 rods each. The sculpture weighs 17,000 kilograms (18¾ tons) and would measure 1 kilometer (⅝ mile) if all the elements were laid end-to-end. Each rod is placed so that the spaces between the rods increase by 5 millimeters (¼ in) with each consecutive space, from front to back; the first two rods of each row are placed 80 millimeters (3⅛ in) apart, the last two rods 580 millimeters (22⅔ in) apart. Metal halide stadium lights illuminate the work, which is 45 feet wide and 125 feet long overall. *The Broken Kilometer* is a companion piece to De Maria's 1977 *Vertical Earth Kilometer* in Kassel, Germany, where the artist drove a single brass rod of the same diameter, weight, and total length down 1 kilometer (⅝ mile) into the ground.

The indexical tendency in this work was also evident in many other works of the period. The Japanese-American artist On Kawara made an ongoing series of paintings in which the small, square canvas itself consisted simply of the date meticulously painted on it. But each canvas was also

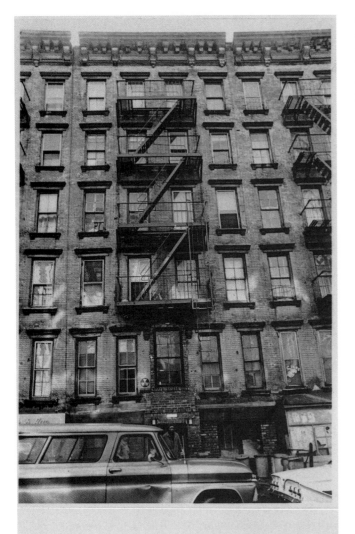

214 E 3 St.
Block 385 Lot 11
5 story walk-up old law tenement

Owned by Harpmel Realty Inc., 608 E 11 St., NYC
Contracts signed by Harry J. Shapolsky, President('63)
 Martin Shapolsky, President('64)
Principal Harry J. Shapolsky(according to Real Estate
Directory of Manhattan)

Acquired 8-21-1963 from John the Baptist Foundation,
c/o The Bank of New York, 48 Wall St., NYC,
for $237 600.- (also 7 other bldgs.)

$150 000.- mortgage at 6% interest, 8-19-1963, due
8-19-1968, held by The Ministers and Missionaries
Benefit Board of the American Baptist Convention,
475 Riverside Drive, NYC (also on 7 other bldgs.)

Assessed land value $25 000.- , total $75 000.- (includ-
ing 212 and 216 E 3 St.) (1971)

11.5 Hans Haacke, *Shapolsky et al, Manhattan Real-Estate
Holdings, a Real-Time Social System, as of May 1, 1971,* detail.
Photograph by Fred Scruton. © ARS, New York/VG Bild-Kunst, Bonn.

accompanied by a box that included a newspaper from the day the painting was made, and the work was subtitled in the language of the place in which the work was painted. Thus July 29, 1969, for example, is subtitled "Man Walking on Moon" with a newspaper bearing that headline included in a box. Robert Morris's *Cardfile* of 1962 (see page 304), the series of books made by Ed Ruscha (see page 288), and Gerhard Richter's *Atlas* (begun in 1964; fig. 11.41) are all expressions of this interest in documentation in the sixties and early seventies. Hans Haacke's 1971 *Shapolsky et al, Manhattan Real-Estate Holdings, a Real-Time Social System, as of May 1, 1971* [fig. 11.5] included 2 maps and 142 typewritten data sheets attached to photographs giving each property's address along with other information such as the owner, the value, and 6 charts on business transactions related to these buildings. Like much of Haacke's work, this project used detailed research to highlight socio-political issues—in this case the business practices of a prominent New York slum lord.

Documentary photography played a key role in this work by Haacke. In addition, so many works of art produced around 1970 were either so ephemeral (as in performance art) or inaccessible (as in the works of Michael Heizer) that the documentary objectivity of photography was reasserted. This, in turn, led to a wider interest in the photograph generally. The German couple Bernhard and Hilla Becher, perhaps the most interesting documentary photographers to emerge at the time, catalog functionally and visually related architectural structures with a tone of detached neutrality [fig. 11.6]. Their collective authorship and the exclusion of any incident of light or atmosphere reinforces this neutrality. By stressing unintended visual relationships in the man-made environment, they cause such buildings to be seen as a form of anonymous sculpture, created by social function and convention.

Art from Nature

Some artists sought anonymous aesthetic structures in nature itself. The rows of colorful soil core samples in Alan Sonfist's *Earth Monument to Chicago* (1965–74) and the moving patterns of live ants he created using chemical trails in his *Army Ants: Pattern and Structures* (1972) combine an artistic sensibility with scientific procedures and natural processes.

In 1961 the Italian artist Piero Manzoni redefined art to include the entire world, which he put on a sculpture pedestal labeled *Socle du Monde (Pedestal for the World)* [fig. 11.7]. Influenced by Yves Klein, Manzoni also made "living sculptures" in 1961 by signing the backs or arms of his models. For Manzoni individuality itself became art in real time, expressing "being and living." His most scandalous gesture was to produce ninety cans of artist's "shit," to be sold at the same price per gram as gold. Making art out of his own blood and excrement verified the physicality of the work with an even more shocking reality than Lucio Fontana's assault on the canvas with a knife.

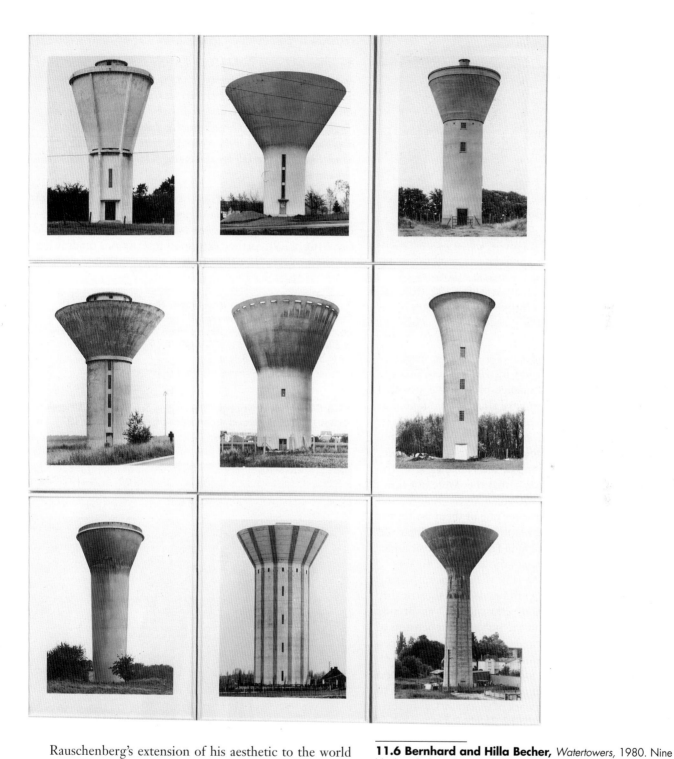

11.6 Bernhard and Hilla Becher, *Watertowers,* 1980. Nine black-and-white photographs, 20¼ × 16¼in (51.4 × 41.3cm) each. Courtesy Sonnabend Gallery, New York.

Rauschenberg's extension of his aesthetic to the world and Warhol's "de-definition" of reality (to use Harold Rosenberg's term[10]) into an aesthetic collage also prefigured such artists of the late sixties as Gilbert Proesch and George Passmore (known only as "Gilbert and George"), who began collaborating as Living Sculpture in 1969. They reasoned that as artists they themselves constituted living art and that everything done by an artist is art as long as it is conceived in an aesthetically conscious way. In 1967 a fellow student at St. Martin's School of Art in London, Bruce McLean, made "Floataway Sculptures" by throwing scraps of board and linoleum into a river and "Splash Sculptures" by skipping stones on the water's surface. Like John Latham, McLean and Gilbert and George were reacting against the narrow aesthetic of their teachers—artists such as Anthony Caro—whom they saw as being too much influenced by Clement Greenberg's formalism.

11.7 Piero Manzoni, *Socle du Monde (Pedestal for the World),*
1961. Iron and bronze, 32¼ × 39⅜ × 39⅜in (81.9 × 100 × 100cm).
Herning Kunstmuseum, Denmark. Photograph by Thomas Pedersen, courtesy Herning
Kunstmuseum, Herning, Denmark. Piero Manzoni/VAGA, New York.

In their performance piece *The Singing Sculpture*
(*"Underneath the Arches"*) [fig. 11.8], Gilbert and George
stood on a table dancing a sequence of highly controlled
movements and poses while singing along with a tape that
played "Underneath the Arches" literally under their feet.
Their props—a rubber glove, a walking stick, primly
bourgeois, worsted suits, and bronze make-up for their faces
and hands—attempted a leveling of individuality. Like the
glove, these artists meant to imply that they were not those
who form but those who have taken form, hollow and
interchangeable. Every five minutes one of them would get
down to restart this recorded rendition of the popular old
song which tells of two tramps lost in fantasy as they sit under
the arches of a bridge: "underneath the arches we dream our
dreams away." The implication is of the all-encompassing
totality of an artistic vision, "an impression of theatricality
which can be frightening in its consistency," as Brenda
Richardson put it. "There is in the public apprehension of
the persona only the most negligible of distinctions between
life and art as conducted by Gilbert and George."[11]

In the early seventies, the San Diego artists Newton and
Helen Mayer Harrison began to use scientific research to
create a far more elaborate network of metaphors, as in their
"Lagoon Cycle." The Harrisons' idea developed around their
attempt to replicate the ecosystem of the Sri Lankan crab in
a San Diego laboratory. Structured as a dialog between a
"Lagoon Maker" and a "Witness," an evolving text is
augmented by maps and images. The hubris of the Lagoon
Maker's ambitious plans to re-create the habitat of a
mangrove thicket in a tank in California is challenged by the
Witness, who sees its artificiality and the narrowness of its
ecological isolation from global systems. The discourse
becomes a confrontation of the romantic notion of the self-
contained creative ego against the interactive model of global
symbiosis. The microcosm of the Sri Lankan lagoon contains
metaphors for all global political, social, and ecological

systems. In commentary to the *Third Lagoon*, they wrote:

*An estuarial lagoon is the place where fresh and salt waters meet
and mix. It is a fragile meeting and mixing, not having the
constancy of the oceans or the rivers. It is a collaborative
adventure. Its existence is always at risk . . . Life in the lagoon is
tough, and very rich. It breeds quickly. Like all of us, it must
improvise its existence, very creatively, with the materials at
hand. But the materials keep changing. Only the improvisation
remains constant.*[12]

In the nineties the Harrisons succeeded in pushing their
ecological aesthetic into land projects, as in their *Boulder—
Underground/Overground Seep—a Wetlands Walk for Boulder
Creek* [fig. 11.9]. As they explain in inscriptions on drawings
for the project, "If a four to five acre wetland were to be

11.9 (opposite) **Newton and Helen Mayer Harrison,**
*Boulder—Underground/Overground Seep—a Wetlands Walk for
Boulder Creek,* 1990. Photograph collage with mixed media, drawing
and text, two panels 17⅛ × 30¾in (43.5 × 78.1cm) and
29 × 30¾in (73.7 × 78.1cm).
Photograph by D. James Dee, courtesy Ronald Feldman Fine Arts Inc, New York.

11.8 Gilbert and George, *The Singing Sculpture ("Underneath the
Arches"),* 1969, performed at Sonnabend Gallery, October 1971.
Photograph courtesy Sonnabend Gallery.

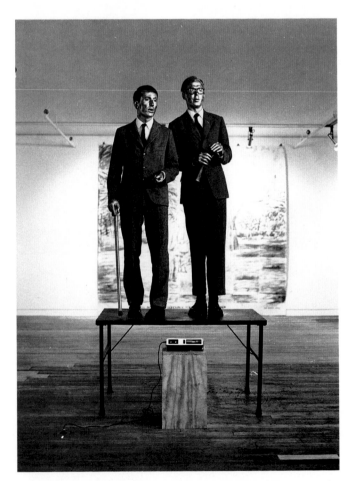

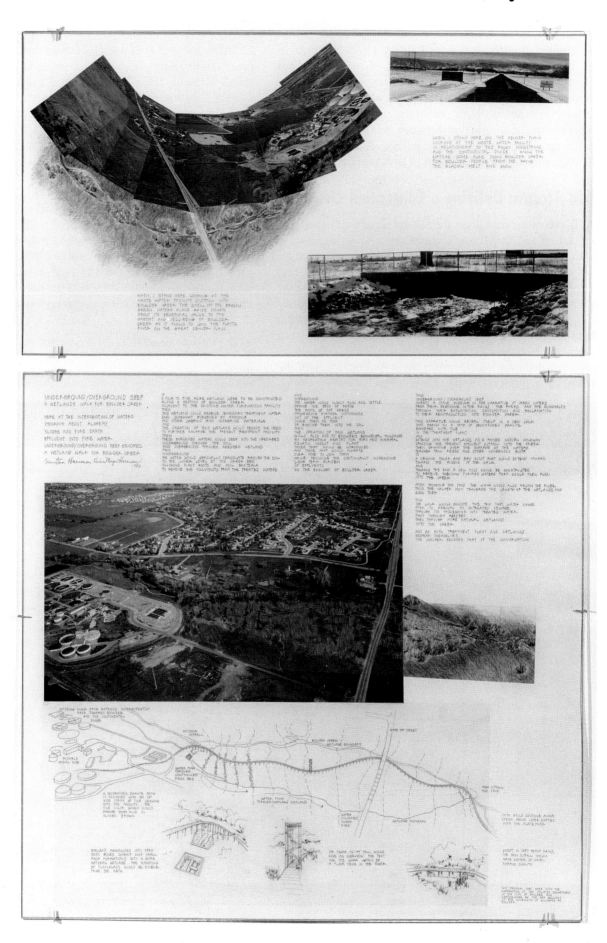

constructed along a section of Boulder Creek adjacent to the existing water purification facility, then this wetland could receive secondary treatment water. …,' ultimately transforming this necessary incursion of civilization into nature into an aesthetic experience. Here the artists intervene in the interaction between man and the ecology with a design that purifies the sewerage effluent and makes the walk a metaphor for the water's path to near potability.

Vito Acconci: Defining a Conceptual *Oeuvre*

Much of conceptual art focused on the artistic experience itself and its theoretical components, such that recourse to an object was frequently superfluous or entirely irrelevant. For example, Vito Acconci (one of the most thoughtful and articulate artists of his generation) explored the artist–viewer relationship in his *Following Piece* of 1969 [fig. 11.10] by randomly selecting individuals on the street in New York and following them until they went into someplace that wasn't public. "I was a passive receiver of someone's time and space," he explained. One episode lasted nine hours, ending when Acconci followed the person into a theater showing a film entitled *Paranoia*![13]

After this group of works, Acconci decided that the next piece ought to be about the person making the piece. He asked himself: "How do I prove I'm concentrating on myself? I do something to myself (attack myself)." In 1970 he sat in a restaurant and rubbed his arm until it bled to see if viewers could more easily approach him if he made himself more vulnerable. This led to a group of actions designed to stress himself physically. Like so much of the art of the time, these actions survived only as documentation on film and in photographs.

In 1971 Acconci became concerned that he had left the viewer out by being so self-obsessed, so he devised a piece called *Telling Secrets* in which he stood at the end of a deserted pier in New York between one and two in the morning while people came one at a time to hear a secret—something sufficiently self-incriminating that the person would be able to blackmail him. Each secret was told to only one visitor.

11.10 Vito Acconci, *Following Piece*, 1969. Black-and-white photographs with text and chalk, text on index cards, mounted on cardboard, 30¼ × 40¼in (76.8 × 102.2cm). Photograph by Larry Lame, courtesy Barbara Gladstone Gallery, New York.

"They were about being on the spot," the artist said. But he quickly ran out of secrets—it turned out he could only think of four or five really incriminating things to tell.

Some of Acconci's most notorious pieces belong to this group of psychologically charged works of the early seventies that directly engage the viewer. In an action of 1972 called *Seedbed*, for example, he attempted to explore the distinction between public and private space. In this work, the artist crawled under a ramp and masturbated while viewers walked on the ramp over him. The viewers could not see him, but they were informed that he was under the ramp masturbating, and they could hear him through a sound hook-up, which he used to invade their psychological space by making uncomfortably transgressive statements such as, "I'm touching your ass."

Body Art

Intense bodily involvement was not uncommon on the art scene in the late sixties and early seventies. In 1970 Dennis Oppenheim spent three hours on a California beach "painting" his body by laying objects on himself and getting a sunburn around them (documented in color photographs). In *Rocked Circle . . . Fear* (1971) he stood in a circle in his backyard and videotaped himself as friends threw rocks at him from second- and third-story windows for half an hour.

The best known body artist in the United States, Chris Burden, went in for startling acts of self-mutilation. He dragged himself bare-chested through broken glass, shot a bullet through his arm, and performed a series of symbolic rituals such as those that resulted in the "relics" he showed at the Ronald Feldman Gallery in New York in 1976. *Trans-fixed*, for example, consisted of two blood-stained nails accompanied by a label that read:

TRANS-FIXED, Venice, California, April 23, 1974. Inside a small garage on Speedway Avenue, I stood on the rear bumper of a Volkswagen. I lay on my back over the rear section of the car, stretching my arms onto the roof. Nails were driven through the palms into the roof of my car. The garage door was opened and the car was pushed halfway out into Speedway. Screaming for me, the engine was run at full speed for two minutes. After two minutes the engine was turned off, and the car pushed back into the garage. The door was closed.

Only the nails and the description remained as artifacts of this machine-age crucifixion.

The pioneers of body art were the Viennese actionists. The Austrian artist Hermann Nitsch made an expressionistic use of his own body in a series of bloody rituals that he began enacting in 1962 [fig. 11.11] and continued performing through the seventies. Inspired by action painting as well as by Freudian psychology, he sought a psychological catharsis through fear. In one characteristic Nitsch performance, the artist's assistants brought in a slaughtered lamb, strung it up, and disemboweled it before the audience. Then they poured buckets of the blood over the artist, nude and tied upside down to a cross. The aim was to liberate the socially repressed but natural aggressive instincts of both artist and spectator.

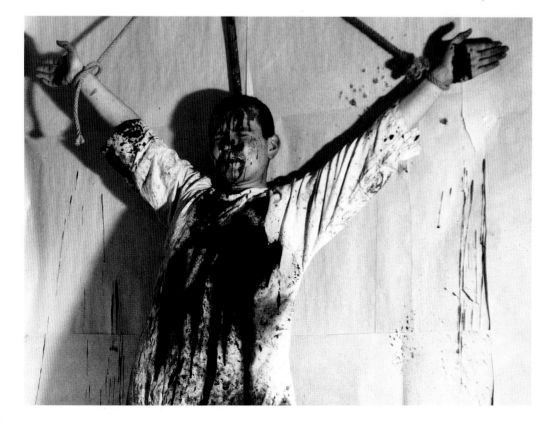

11.11 Hermann Nitsch,
1st Action, 1962, Vienna.
© 2000 Artists Rights Society (ARS),
New York/VBK, Vienna.

Politics and Postmodernism: The Transition to the Seventies

Arnulf Rainer took this style of visceral expressionism on to the streets of Vienna, getting himself arrested, for example, when he painted dried blood in streaks down his face to attack the complacency of bourgeois society. However, Rainer is best known for his paintings (beginning around 1960), which he often made by smearing on the paint with his hands and feet, sometimes working on them until his hands bled. The physical intensity of Rainer's involvement in the act of painting made these works extensions of body art rather than painting in the usual sense. Later, he employed these intensely physical painting procedures in a series of magnificent self-portrait photographs, altered with paint.

Perhaps the most talked about manifestation of Viennese actionism was the "fatal" performance by Rudolf Schwartzkogler, who cut off his own penis as an "art" action in 1969. In fact, he cunningly substituted a sausage, but he did commit suicide (by other means) soon thereafter.

The work of the Serbian body artist Marina Abramovic in the seventies pushed this kind of intense body expressionism beyond metaphor into performances that genuinely put her at risk. In *Rhythm 10*, 1973, for example, she lined up twenty sharp knives, spread her fingers out, and stabbed between her fingers one after another as quickly as possible. Each time she cut herself she changed knives until she had used them all.

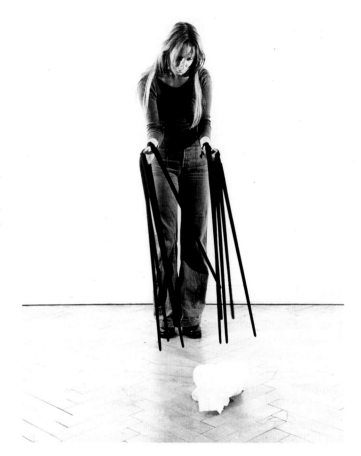

11.13 Rebecca Horn, *Finger Gloves*, 1972. Fabric and balsa wood, 27½in (70cm) long.
Appears in the film *Performances II* (1973). Photograph courtesy Sean Kelly, New York.

She tape-recorded the rhythm of this action and then played the tape back, following the rhythm as she repeated the action again. In another performance, she stepped into a burning star and let herself be overcome with smoke; the viewers had to pull her out to rescue her. *Rhythm 0*, 1974, performed in a gallery in Naples, consisted of her standing next to a table with seventy-two objects (including weapons) and inviting the visitors to use her and the implements as they saw fit. Her clothes were cut away and then she was forced to put a pistol in her mouth, at which point someone stopped the performance. This kind of work tested on a visceral level both her own and the viewer's sense of their own bodies, their boundaries, and the feelings of exposure and vulnerability inherent especially in human encounters.

At the same time in New York, Adrian Piper undertook art actions in public, non-art spaces that centered on the conventions of social interaction, especially with regard to the idea of difference or "otherness" (originating in her own experience as a black woman). In her *Catalysis* series of 1970–71, Piper appeared on the streets of New York deliberately doing something that would objectify herself in an exaggerated way as different from (and often disturbing to) other people in the public space, to see how it affected

11.12 Adrian Piper, *Catalysis IV*, street performance, New York City, 1970–71.

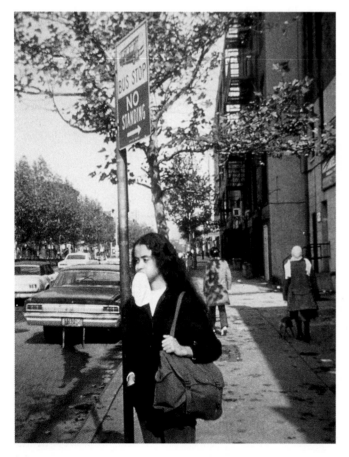

their interaction with her. In *Catalysis I*, for example, she explained: "I saturated a set of clothing in a mixture of vinegar, eggs, milk, and cod-liver oil for a week, then wore them on the D train during evening rush hour, then while browsing in the Marlboro bookstore on Saturday night." In *Catalysis IV* [fig. 11.12], she "dressed very conservatively but stuffed a large red bath towel in the side of my mouth until my cheeks bulged to about twice their normal size, letting the rest of it hang down my front, and riding the bus, subway, and Empire State Building elevator."[14] In these pieces she effectively made her own body a site of social discourse.

The German artist Rebecca Horn also experimented with body actions, beginning around 1970, but her work had more to do with examining her own bodily sensations. *Finger Gloves* [fig. 11.13], for example, extends the function of the hands as an interface between the inner self and the task of acting in the external world. Many of her works are costumes, devised for performances (and increasingly films), as in the fabric and wood horn and straps for her *Unicorn* of 1970 to 1972, which she performed nude, in natural surroundings, and recorded on film. The artifacts of Horn's performances have developed an increasingly opulent visual presence as objects and her work, though directly engaged with the body, creates a sensuous and introspective rather than either a social or a disturbingly cathartic experience.

Ana Mendieta

Ana Mendieta inscribed her own body onto nature in a way that brought out both the sensuality of bodily experience and the opulence of nature. Mendieta came from a prominent Cuban family that was abruptly shattered by the Cuban Revolution and in 1961, at the age of 12, she was sent by a Catholic relief agency to live in a foster home in Iowa. Underlying her work was always a longing to reconnect with her Cuban childhood.

Mendieta's *Tree of Life Series* [fig. 11.14] and her *Siluetas* (her best-known works) were a celebratory assertion of the female body as a primal source of life and sexuality, like the paleolithic "Venuses" of Europe. But her insertion of her own body into these landscape settings "covered in mud, flowers, earth, sticks"[15] and later into molded or carved forms that resembled prehistoric effigies in place of the actual presence of her body—these were also a return to early childhood. This psychic return had to do with her early memories of stories overheard or told to her by the household servants in her family home. These stories painted an animistic portrait of nature for her that was rooted in the Santería religion, a New-World fusion of Catholicism with the magical personifications of nature and the occult practices that came to the Caribbean with the first Yoruba slaves in the early sixteenth century.

For Mendieta, all these organic materials that she used in her body tableaux in the landscape, and even the places she invested with these constructions, had magical spirits connected to the world of her childhood memories. With these works, she sought to establish, as she put it, "a dialogue between the landscape and the female body (based on my own silhouette)," but, she added it was also ". . . a return to the maternal source."[16]

Mendieta studied art at the University of Iowa, where she began using her body as a medium in 1973. Among the first of her body works was a direct response to a rape that had occurred on the Iowa campus; people were invited to her apartment at an appointed hour, and when they entered they found her stretched out and bound, stripped from the waist down and smeared in blood. This shocking encounter brought home to the viewer the horror of rape with breathtaking immediacy. But it also announced some fundamental characteristics of Mendieta's artistic vocabulary: the use of blood and other organic materials, the visceral immediacy achieved by the use of her own body, and not least the way in which the artist seized power over the subject through her control of the installation or image. Both in Mendieta's celebration of the female body and in her authority over the representation of her own body, her work is a consciously feminist statement.

Feminist issues continued to play an important role in her work. But so did other aspects of her rich exploration of her own identity and her unique sense of the materials in natural settings. Since most of Mendieta's work was impermanent and executed in remote areas of Iowa or during the summers in Mexico, photography played an important role in documenting and communicating her artistic vision. Mendieta died at the age of thirty-six in a fall from an apartment window in New York in 1985, leaving behind her an important oeuvre of more than 200 color photographs.

Lygia Clark and Hélio Oiticica

Between 1959 and 1961, fully a decade before conceptual art in New York and largely unknown in the United States until the 1990s, artists of the "Neo-Concrete" movement in Brazil explored issues of social engagement and also bodily sensation in a way that seems strikingly prescient of some of the issues raised by artists in the U.S. and Western Europe in the context of the anti-war movement of the late sixties. Lygia Clark's work, in particular, constantly undermined the boundaries between what is inside and outside the body, between the self and other, between individual and public space. In the 1959 "Neo-concretist Manifesto" she wrote: "We neither consider the work of art a machine, nor an object, but rather an almost-body, which is to say, a being whose reality is not exhausted in the eternal relationships between its elements; a being which, even while not decomposable into parts through analysis, only delivers itself up wholly through a direct, phenomenological approach."[17] Her work is participatory and involved with immediate bodily sensation; it is not intended for a detached spectator. "The work, being the act of making the work," she pointed out, "you and it become wholly indissociable."[18]

In a sense there is no "viewer" of a Lygia Clark work because the "viewer" must always physically interact with the

object to experience it. She made the *Six Sensorial Masks* of 1967 [fig. 11.15], for example, to be worn by the "viewer" who would experience a variety of visual, olfactory, and auditory sensations in wearing it. Her works are very much centered in the moment of making and interacting with them and have little concern for a residual life in a museum or even in pictures. As she noted in 1965: "The instant of the act is not renewable. It exists by itself: to repeat it is to give it another meaning. It doesn't contain any trace of past perceptions. It's another moment. At the very moment in which it happens it is already a thing-in-itself. Only the instant of the act is life. . . . To become aware is already to be in the past. The raw perception of the act is the future in the process of making itself."[19]

The work of Hélio Oiticica dovetails with the concerns of Lygia Clark in its physical immediacy and in its focus on the catalyzing effect of participatory action in the present. But Oiticica's work is more explicitly political and sociological in orientation. Several of Oiticica's works are more strictly body actions with costumes, others are installations into which the viewer enters. With regard to his 1967 installation *Tropicália* [fig. 11.16], for example, he said that he wanted "to characterize a Brazilian condition *Tropicália* is the very first conscious, objective attempt to impose an obviously Brazilian image upon the current context of the avant-garde and national art manifestations in general."[20]

11.14 Ana Mendieta, *Serie arbol de la vida (Tree of Life Series)*, 1977. Color photograph of earth-body work with tree and mud executed at Old Man's Creek, Iowa City, Iowa, 20 × 13¼in (50.8 × 33.7cm).

Collection, Ignacio C. Mendieta. Photograph courtesy the Estate of Ana Mendieta and Galerie Lelong New York, © the Estate of Ana Mendieta.

11.15 Lygia Clark, *Six Sensorial Masks*, 1967. Fabric masks of various colors and odors, and with different mechanisms to affect hearing, vision, and smell.

Alvaro Clark collection, Brazil. Photo courtesy Fundacão de Serralves, Oporto.

11.16 Hélio Oiticica,
Tropicália, 1967, detail.
Installation; wood, plastic,
canvas, sackcloth, eucatex,
cotton fiber, sand, cracked
stone, tropical plants and
birds, television set.
Dimensions variable.
Hélio Oiticica project collection, Rio
de Janeiro.

The Brazilian image he had in mind was that of the marginal settlements of the poor in the big cities like Rio de Janeiro, where people crowd into makeshift shanty towns with no amenities for living but which nevertheless all seem to have televisions. The viewer enters into a complete environment with flimsy shacks constructed of light wood and fabric walls. All around are lush tropical plants and a cage with beautiful, live parrots. You walk the dirt or gravel paths and step inside the curtained rooms, going from one to the next, and in a third chamber of the central structure is a television, perpetually switched on. Oiticica loved the art of the streets, the samba music, the interplay of Brazilian popular culture; "it is an image which then devours the participant, because it is more active than his sensory creating."[21] On the one hand *Tropicália* is engaged with radical social politics, underscoring the reality of life in the Brazilian inner-city—not only its poverty but its mixture of races (Black, Indian, White), its rich layerings of popular culture with different traditions, giving the work an inherently antihieratic fluidity. At the same time it has echoes of early European abstraction; the German Bauhaus and constructivism of the twenties and thirties (which had a strong influence on Brazilian art of the fifties and sixties) is evident here in the geometry and in the clear, visual planes of red and white.

Performance Art

Another impetus for the burgeoning of art actions and the performance scene in New York around 1970 came from vanguard dance and new music. They, in turn, fed into the momentum begun in the late fifties and early sixties by the happenings, Fluxus, and the Judson Dance Theater. It was, for example, an innovative dancer-choreographer in New York, Trisha Brown, who in 1969 outfitted a man in mountaineering gear to stroll sideways down a seven-story building, in her matter-of-factly titled *Man Walking Down the Side of a Building.*

Robert Wilson's *The Life and Times of Sigmund Freud* (1969) and his *Einstein on the Beach* (1976) had a grander, almost Wagnerian scale and staging. These works, and those of Meredith Monk, also defied traditional boundaries between visual art, music, and theater to address the experience of perceptual abundance that dominates life in the media era. In *Einstein,* a five-hour extravaganza at the Metropolitan Opera House in New York, Wilson collaborated with the radical composer Philip Glass and engaged such avant-garde dancers as Lucinda Childs to perform in this theater of metaphysical dream images, projected on to minimalist structures on the stage.

In 1980, performance art crossed over into mainstream popular culture when Laurie Anderson's recording of "O Superman" made the hit record charts. The following year Warner Brothers signed Anderson on for a six-record contract. "O Superman" alludes to a song written by Massenet, an appeal to God that begins "O Souverain" ["O Lord"]. RoseLee Goldberg, who wrote a survey of performance art, described Anderson's piece as "an appeal for help. About the media culture that controls, it appeals to a generation exhausted by its artifice."[22]

Anderson began doing performance works in 1972, often involving the violin, which she had played since the age of five. In *Duets on Ice,* Anderson selected four locations in New York City during the summer of 1974 and stood by herself playing a Bach violin duet while wearing ice skates embedded

in a block of ice. When the ice melted and the blades hit the pavement the piece was over. Increasingly, Anderson altered her violin in various ways. In one piece, for example, she put a recording head on the violin and replaced the hair on the bow with a tape on which she had recorded the sentence "I dreamed I had to take a test in a Dairy Queen on another planet." By moving the bow across the head at different speeds she could distort the sound and pace of the voice. The intuitive collage of images—taking a test, a Dairy Queen, space adventure—has the familiarity of recollections from an American childhood of the fifties. At the same time the electronic manipulation disembodies the voice disturbingly. Janet Kardon, in her catalog to the Anderson retrospective in 1983, aptly characterized Anderson's performances as "a theatrical artifice, cross-fertilizing whimsical pyschodrama with the intimacy of the diary."[23]

By the time Anderson performed her monumental, four-part *United States* (the first part was performed in 1980 [fig. 11.17] and the full composition, divided into two long evenings of performance at the Brooklyn Academy of Music, in February 1983), the simple self-presentation of works like *Duets on Ice* had been superseded by a complex opera of light, sound, movement, and text on the order of *Einstein on the Beach*. In *United States* enigmatic narratives slip through one another in a disorienting subversion of time and space, as in a William Burroughs novel. The critic Michel Serres described the work as a discourse on the media as a "scramble system." Anderson's voice through a harmonizer shifts octaves back and forth from male to female. As Craig Owens, another critic, reported: "The woman repeatedly asks: 'Hello, excuse me, can you tell me where I am?' To which the [gas station] attendant responds over and over, 'You can read the signs.' . . . Communication grinds to a halt; messages miss their destinations, and drift aimlessly off into space."[24]

Nam June Paik's Electronic Nature

At the same time that pop art was rendering the experience of nature as a perceptual screen of images, the Korean-American artist Nam June Paik juxtaposed vivid sensations of the body in real time (especially sexuality, as one of the most vivid body experiences) with the removed experience and the collapsed and recombinant time of television (time that can be reconfigured at will). Paik came to art from a background in Western music, acquired in Japan, and works with the fundamentally immaterial medium of electronics in the field of sculpture, which traditionally concerns palpable volumes in real space.

Paik pioneered the formal exploration of television in his art of the early sixties. "We are moving in tv away from high fidelity pictures to low fidelity, the same as in painting," he explained in 1970. "From Giotto to Rembrandt the aim was fidelity to nature. Monet changed all that. I am doing the same."[25] Paik's work is revolutionary precisely because of this shift from "content-level perception" to "process-level

perception." His emphasis is on both how we see and what we see, simultaneously; his work is a collage of overlapping information structures that cut across media from atonal music and performance to sculpture.

Paik's first widely celebrated work was *Etude for Pianoforte* in 1960, which culminated in his jumping from a stage (set up in an artist's loft in Germany), cutting off John Cage's tie with scissors, and dousing him with shampoo. He left a motorcycle running on the stage, filling the space with carbon monoxide, ran out, and then telephoned from downstairs to say that the piece was over. Paik met Cage while studying new music composition in Germany and Cage introduced Paik to Zen. After exploring the extension of music into visual form and theater Paik then turned to video, incorporating television equipment and video imagery into art.

Paik had his first video exhibition at the Galerie Parnass in Wuppertal (near Düsseldorf) in 1963. His *Exposition of Music—Electronic Television* included thirteen "prepared" televisions, three prepared pianos, and noisemakers. He experimented with distortions of broadcast test patterns and in 1965 (when Sony introduced it) began using portable video equipment to make art, having immediately recognized the revolutionary potential of decentralizing control over media with the new availability of inexpensive equipment and the possibility of virtually limitless numbers of laser channels.

While performing in Japan in the early sixties, Paik met Shuya Abe, an electronics engineer, with whom he collaborated on ways to transform the video image and on *Robot K-456*, a remote-control robot that walked, talked, and defecated beans. In 1964, after spending a year in Japan, he went to New York, where George Maciunas and Dick Higgins—Fluxus artists whom he had met in 1961 in Europe—introduced him to Charlotte Moorman. Moorman, a cellist, then became the principal actor for his performances, as in *TV Bra for Living Sculpture* of 1969 (fig. 11.18).

In an effort to integrate sex into music, a theme that Paik felt had not been sufficiently developed, he included instructions for incorporating sexual acts into several of his compositions from the late sixties. In *Opera Sextronique*, for example, Charlotte Moorman had to do a striptease while playing the cello and in *Young Penis Symphony*, ten young men behind a paper curtain stuck their penises in sequence through the paper at the audience. In 1968 Charlotte Moorman was arrested for indecent exposure during her topless performance of *Opera Sextronique* at the New York Film-Makers' Cinemathèque.

In *Video Fish* of 1975 [fig. 11.19], tanks of live fish stand in front of television monitors which videotape loops of fish swimming around. This seems to turn the real tanks into monitors and the monitors into fish tanks, as if equating representation and reality. Paik also subverted concepts of time and space, as in *TV Buddha* (1974), where the live monitor is constantly regenerating the image of a motionless statue of the Buddha.

11.17 (above) **Laurie Anderson,**
United States Part I, 1980, at the
Orpheum Theater, presented by
The Kitchen.
Photograph © by Paula Court.

11.18 Nam June Paik, *TV Bra for*
Living Sculpture, with Charlotte
Moorman, 1969.
© Photograph by Peter Moore.

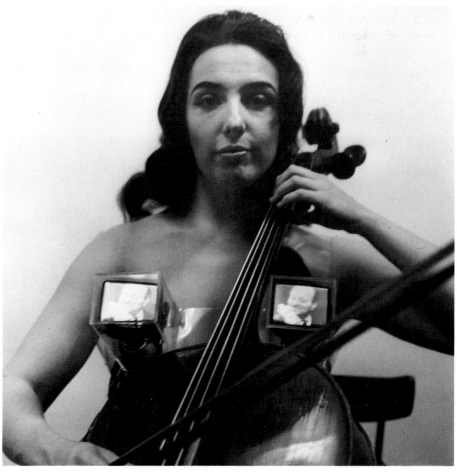

Paik's *The Moon Is The Oldest TV* (1965) consists of twelve black-and-white monitors, each showing a partially eclipsed circle of light that looks like a phase of the moon. In *TV Clock* (1963) he compressed the image on each of the twenty-four sets to a line, like hands on a clock. The works allude to time and yet he uses television, a medium of moving pictures and temporal events, for static images. For Paik all time collapses into the present as he juxtaposes multiple sequences of images. One needn't see a whole sequence on the tape loops he composes for the television sets in his sculptures to get the mind-bending effect of their simultaneous contrast and conflation between immediate experience and the artificiality of images and media time. This radical simultaneity of multiple cross-tracking systems of thought and experience was both intrinsic to the form of Paik's work and was also the content; his exploration of television and video had implications for understanding the impact of television and the still unanticipated influence of computers and the Internet on how we think about the world.

Direct Political Comment

In the highly charged political atmosphere of the late sixties, many artist wanted more than metaphors. In 1968 the French artist Daniel Buren wrote: "Art is the safety valve of our repressive system. As long as it exists, and, better yet, the more prevalent it becomes, art will be the system's distracting mask. And a system has nothing to fear as long as its reality is masked, as long as its contradictions are

11.19 Nam June Paik, *Video Fish*, 1975–9. Video installation: five aquariums, five monitors, two video tapes, live fish, 26 × 110¼ × 29½in (66 × 280 × 75cm).
Collection, Musée National d'Art Moderne, Centre Georges Pompidou, Paris.

hidden."[26] Buren painted a signatory pattern of regular stripes in public places as an act of political appropriation. He even appropriated art history, as in his 1977 *Forms: Painting Under "Composition" of Theo Van Doesburg, A Fabric of 136 × 86.4 cm. Black and White Vertical Stripes of 8.7 cm of Which The First White Band is Recovered with White Acrylic*. He attached his stripe pattern to the wall behind the painting by Van Doesburg that hangs in the Musée National d'Art Moderne in Paris. All you would normally see is the label on the wall, and then if you look closely behind the painting you can see that Buren's canvas is there.

Hans Haacke wanted the artist to engage in direct political action, creating a widespread critical atmosphere that challenged the political *status quo*. In the "Information" show at the Museum of Modern Art in 1970, he installed a ballot box where visitors could express their opinion of then Governor Rockefeller's stand on President Nixon's Indo-China policy. The results came in two to one against the Governor, whose family were (not coincidentally) founding trustees of the museum. The Guggenheim Museum also invited Haacke to show his work but when the director, Thomas Messer, discovered that Haacke wanted to put up photographs of slum real-estate holdings owned by associates of the museum trustees, Messer cancelled the show and fired the curator.[27]

Marcel Broodthaers

The Belgian artist Marcel Broodthaers also undertook a critique of museums, although in a more poetic fashion. Broodthaers was a poet, and like his compatriot René Magritte whom he greatly admired, he was deeply interested in the way in which language shapes experience. In 1962 he met Piero Manzoni, who signed Broodthaers' arm and gave him a certificate of authenticity as "a work of art."

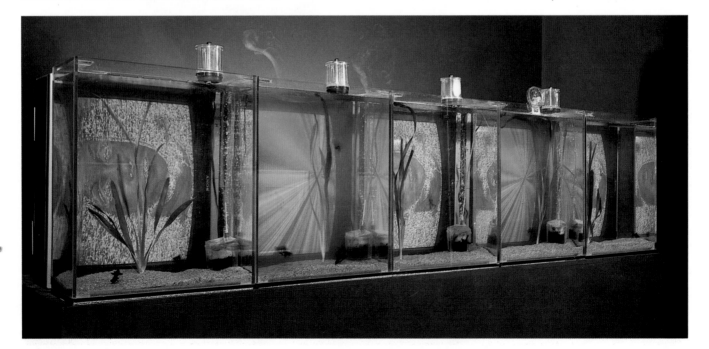

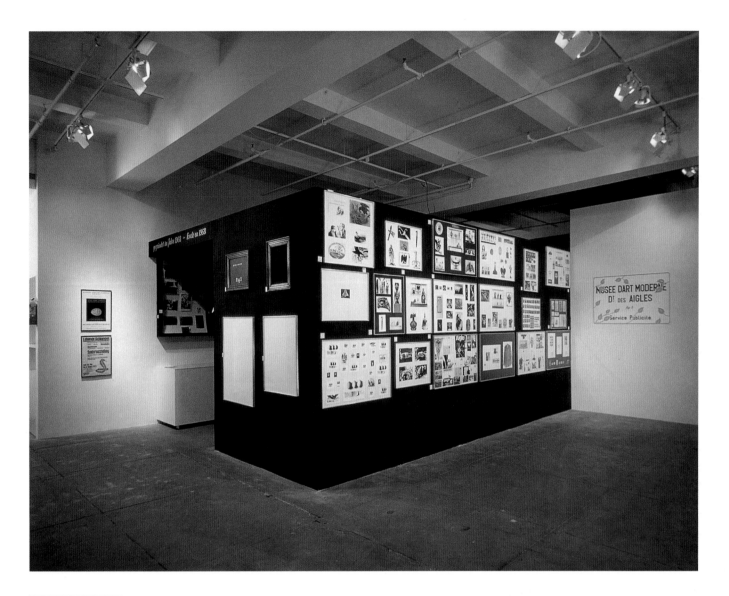

11.20 Marcel Broodthaers, *Section Publicité Musée d'Art Moderne, Département des Aigles,* created Brussels 1968–72. Installation, mixed media, and dimensions variable.
Courtesy Marian Goodman Gallery, New York. © Estate of Marcel Broodthaers/VAGA.

Broodthaers later described the event as very important in prompting him "to appreciate the distance which separates the poem from a physical work which implicates the space in fine arts."[28] In his brief, twelve-year career as a visual artist, Broodthaers made a number of memorable poetic objects in assemblages of egg or mussel shells; following on a tradition from Magritte, he painted a number of "typographic" paintings playing on words, and created an ongoing series of installations for which he is perhaps best known.

The 1967–68 revolution on the streets of Paris seems to have led Broodthaers to his critique of the museum as the principal class of institution that mediated an artist's work. In September 1968 he transformed the ground floor of his Brussels apartment into the first of his "museums": *Le Musée d'Art Moderne, Département des Aigles, Section XIX^ème Siècle*

(Museum of Modern Art, Department of Eagles, Nineteenth-Century Section). Over the succeeding four years different "departments" came into existence as he was commissioned to do different exhibitions [fig. 11.20].

One of the critical themes of the work is the authority of systems of classification in museums–whether by period, function, nationality, or other categories–over the viewer's understanding of the meaning of an object. At this time the French cultural theorist Michel Foucault was writing about power relations in the modern state, concerned as he was with such issues of categorization and control of individuals in a society. So Broodthaers created a museum of objects, all of which contained the representation of an eagle (a symbol of power and authority). The Musée Royale des Beaux-Arts in Brussels, which was the main public museum space for contemporary art, had a lion as its symbol and Broodthaers' eagle was in part a reference to that. *Le Musée* consisted of packing cases for works of art, postcards from museums from all over the world, some slides being projected, and an empty, motionless transport truck. By the time Broodthaers

reinstalled the work for a show in Düsseldorf a few years later, the presentation had more than three hundred different representations of the eagle. The concept is akin to the famous proposition of the French minister of culture André Malraux, who talked of the great possibilities in the age of mechanical reproduction of images, of an "imaginary museum" in which one could juxtapose objects in reproduction without regard to their location in the physical world; it was a discourse of objects as pure ideas.

Situationism

Another set of ideas connected to the 1968 student worker revolution in Paris was "situationism." In 1957, the French writer Guy Debord founded a group called the "Situationist International," in which the Cobra artist Asger Jorn was involved until the group disavowed works of art in favor of street actions in the mid-sixties. Debord mockingly called the bureaucratized, media-saturated, postwar culture of Europe and the United States a "society of the spectacle."[29] He wanted to dislodge public passivity and prompt widespread critical engagement through a kind of guerrilla tactic of "situations" or street events that would shake passersby out of their conventional habits of looking and thinking. The Situationist International developed a critique of Western capitalism that focused on how media spectacles serve to depoliticize citizens and replace public participation in urban environments with passive consumerism. In the book that served as the manifesto of "situationism" (*The Society of the Spectacle*, 1967), Debord wrote: "THE SPECTACLE IS NOT a collection of images; rather it is a social relationship between people that is mediated by images."[30] Like the constructs of other French cultural theorists of the period,

such as Jean Baudrillard's concept of "simulacra," Michel Foucault's "governmentality," and the "hegemony" that the underlying political agenda of Jacques Derrida's "deconstruction" is meant to supplant, the "spectacle," as Debord described it, "is the very heart of society's real unreality."[31] Like Foucault he describes an evolution in this control of political relations: "An earlier stage in the economy's domination of social life entailed an obvious downgrading of being into having," and then, he says, "having" becomes "appearing."[32] As vision focuses on representation, it becomes more abstract and more easily deceived. The commodity itself becomes spectacle. For Debord, as for the Cobra artists, creativity mediates life and may undermine this "society of the spectacle."

The Potential for Broader Political Action

In 1945 Jean Dubuffet wrote of "the arts that have no name . . . the art of speaking, the art of walking, the art of blowing cigarette-smoke gracefully or in an off-hand manner. The art of seduction. The art of dancing the waltz, the art of roasting a chicken."[33] Dubuffet's remarks underscored the perennial concern of modern artists with the idea of art as a means of revising life. "Painting . . . is a way of living today," de Kooning explained,[34] while Yves Klein declared that "life itself . . . is absolute art."[35] Joseph Beuys stated that "Man is only truly alive when he realizes he is a creative, artistic being," and that "even the act of peeling a potato can be considered a work of art if it is a conscious act."[36] Throughout the twentieth century, modern art has been associated with vanguard social ideology. In the politicized climate at the end of the sixties, many artists wanted to substitute actions in real time for work in the more traditional media of painting and sculpture.

Christo and Jeanne-Claude

When the revolt of May 1968 swept through Paris, the revolutionaries threw red paint on the decorative statues in the Tuileries [fig. 11.21] and hung nooses around the necks of the busts of Poussin and Puget on the gates of the Ecole des Beaux-Arts. The students correctly perceived that those harmless old sculptures symbolized the stability of the tradition-oriented governing aristocracy, an *ancien régime* that has remained remarkably intact over the two hundred and some years since the French Revolution. The point, which has been made with increasing frequency over the last twenty-five years, is that the words and images with which a problem is described limit the range of possible solutions one can see.

The students in Paris intuited the power of those seemingly apolitical sculptures as part of a class of symbols which defined the context of the reigning discourse on social structure, so they used red paint to appropriate those visible signs into the language of their revolution. The paint

on the statues, however crude and destructive, moved the debate forward by symbolically attacking the *status quo*. This act of appropriation made change—even in the royal gardens of the Louvre Palace—seem possible.

Art in the Theater of Real Events

No artist has had a more sophisticated understanding of political appropriation than Christo. His art relies on the use of his subtle political insight, empowered by the sheer visual beauty of his projects, to engage the public en masse in a critical debate on values. The political upheaval of the late sixties centered on the growing realization that those with wealth and power could control a democracy by shaping what people saw on television and read in the newspaper, that the "military-industrial complex" had indeed gained the "unwarranted influence" against which President Eisenhower had warned the American people in

1961.[37] Christo was the first artist to communicate his aesthetic ideas successfully on a scale that enabled him to compete with big corporations in shaping the public's perception of events.

In September 1985 Christo and Jeanne-Claude wrapped the Pont Neuf, the oldest bridge in Paris, in a shimmering, sandstone-colored fabric for fourteen days. The Pont Neuf, completed in 1606 under Henry IV, links the right and left banks of the river Seine to the Ile de la Cité (the heart of Paris for over two thousand years). This solidly proportioned historic monument—and indeed the perfectly preserved center of Paris as a whole—seems to embody the timeless identity of France. Yet, for the duration of their temporary *The Pont Neuf Wrapped, Paris 1975–85* [fig. 11.24], Christo and Jeanne-Claude effectively transformed the context for viewing the bridge to underscore ephemerality and the power of an individual creative vision over the stable and anonymous monolith of social convention. They even persuaded the conservative mayor of Paris to help them do it!

It is part of the complexity of meaning in a Christo and Jeanne-Claude project that it sets in bold relief all the mechanisms within a society as each constituency attempts to appropriate the reality of their monumental, temporary work of art into its normal manner of functioning. The old man painting a touristic view of their wrapped bridge [fig. 11.26], as if it were no different from the unwrapped monument he had rendered for sale on countless canvases before, parallels the policemen directing traffic around the crowds, the factory worker sewing the fabric into patterns, the lawyers negotiating the permits, and Mayor Jacques Chirac himself triumphing in this public celebration of his "enlightened" patronage. Everyone finds themselves doing their usual job, but now in relation to something that has no practical purpose—a work of art. This idea has important parallels with Guy Debord's "situationist" aesthetics.

Taken together, the fundamental irrationality of these situations that Christo and Jeanne-Claude create, the startling scale and presence of the work in the theater of real events, and its disarming formal beauty prompt nearly everyone to look with fresh eyes at themselves and at the world around them. "The project is teasing society," Christo explained, "and society responds, in a way, as it responds in a very normal situation like building bridges, or roads, or highways. What we know is different is that all this energy is put to a fantastic irrational purpose, and that is the essence of the work."[38]

Christo and Jeanne-Claude embark on each project by talking to people about it and by showing them drawings and collages in which Christo convincingly visualized it. His magnificent draftsmanship makes the concept seem entirely plausible and he further reinforces this credibility with technical data—maps, photographs of the sites, engineering diagrams, and specifications—incorporated into the drawings and collages. One is left in no doubt of the artist's determination to construct these works, and this conviction, combined with the aesthetic attraction of the studies, makes it hard to resist imagining how the project might look. This, in turn, builds the reality of the idea in people's minds, and initiates the momentum that may ultimately drive the project to completion.

The political and social forces so delicately interwoven into Christo and Jeanne-Claude's process require an involved dialog with people at every point. In the end, the realization of each project depends directly on the outcome of that interaction. Without winning the cooperation of the public, they could neither obtain the construction permits nor the commitment of the collectors, whose purchase of drawings, collages, prints, and small sculptures ultimately finances the work. They insist that people talk about their idea and as they do their involvement deepens. "I don't think any of the museum exhibitions have touched so profoundly three hundred people (as our ranchers)," Christo pointed out after the *Running Fence* project [fig. 11.25], "or three hundred thousand cars who visited *Running Fence*, in a way that half a million people in Sonoma and Marin counties were engaged in the making of the work of art for three and a half years."[39]

Christo Javacheff was born in Bulgaria in 1935. He grew up amidst the bombardments of World War II and then the country's brutal postwar Stalinization. He escaped through Czechoslovakia to Vienna in 1957, and within a year was in Paris, painting portraits for a living and exploring the formal possibilities of packaging and stacking as a visual language.

The employment of real objects—oil barrels, bottles, and the various other items he has wrapped—rather than representing things coincided with the interest of his contemporaries and friends, the *nouveaux réalistes*, in appropriating found materials at the end of the fifties. The loosely spilled paint on Christo's wrapped bottles and cans of 1958 and 1959 owes a debt to the still overpowering legacy of gesture painting. Yet this work also has a quite new sense of continuity with the real environment, a trait that soon emerged as central to Christo's aesthetic.

In the *Dockside Packages* of 1961 [fig. 11.23], Christo and Jeanne-Claude stacked and draped oil barrels and industrial paper rolls on the docks outside a Cologne gallery where they were having a show of their work. The Christo wrappings fitted so naturally into the normal setting that they seemed scarcely distinguishable from the goods that had been unloaded on the docks. The surprising discovery that they were a work of art caused the viewer to do a double take, a device Christo and Jeanne-Claude developed to great effect in large-scale projects of the seventies and eighties such as *Running Fence*, *Surrounded Islands*, and *The Pont Neuf Wrapped*.

During the early sixties Christo extended and refined his vocabulary of packaging, elaborating on the variety of cords, knots, and fabrics like a language of autographic brush-strokes. He also used photomontage to visualize his packages on an architectural scale, setting them on the site of such monuments of Paris as the Arc de Triomphe and the Ecole Militaire. Christo wrapped a range of objects from magazines to furniture to automobiles, though as often as not the contents of his packages remained unidentifiably mysterious,

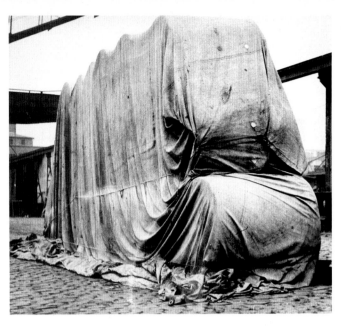

11.23 (above) **Christo and Jeanne-Claude,** *Dockside Packages,* Cologne Harbor, 1961. Rolls of paper, tarpaulin, and rope, 16 × 6 × 32ft (4.87 × 1.83 × 9.75m).
Photograph S. Wewerka, © Christo, 1961.

11.21 (above) Classical statue in the Tuileries in Paris defaced by revolutionaries with red paint, May 1968.
Photograph © by Jonathan Fineberg.

11.24 (opposite) **Christo and Jeanne-Claude,** *The Pont Neuf Wrapped, Paris, 1975–85,* September, 1985.
Photograph by Wolfgang Volz, © Christo, 1985.

11.22 (below) **Christo,** *Package on a Wheelbarrow,* 1963. Cloth, metal, wood, rope, and twine, 35⅛ × 59½ × 20¼in (89.2 × 151.1 × 51.4cm).
The Museum of Modern Art, New York. Blanchette Rockefeller Fund. Photograph by Ferdinand Boesch, © Christo, 1963.

11.25 (opposite, bottom) **Christo and Jeanne-Claude,** *Running Fence, Sonoma and Marin Counties, California 1972–76,* September 1976.
Photograph by Jeanne-Claude, © Christo and Jeanne-Claude, 1976.

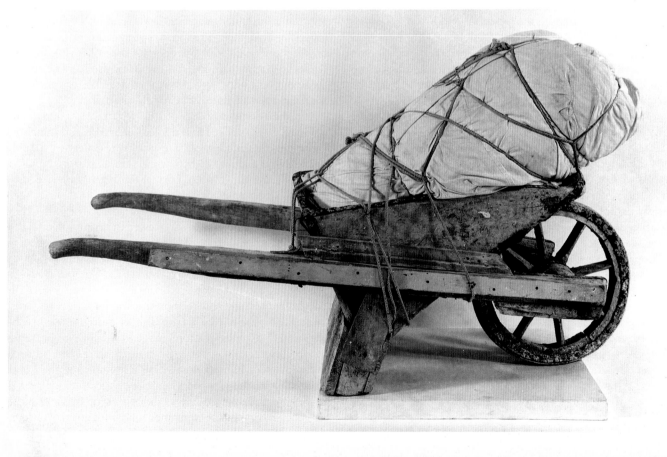

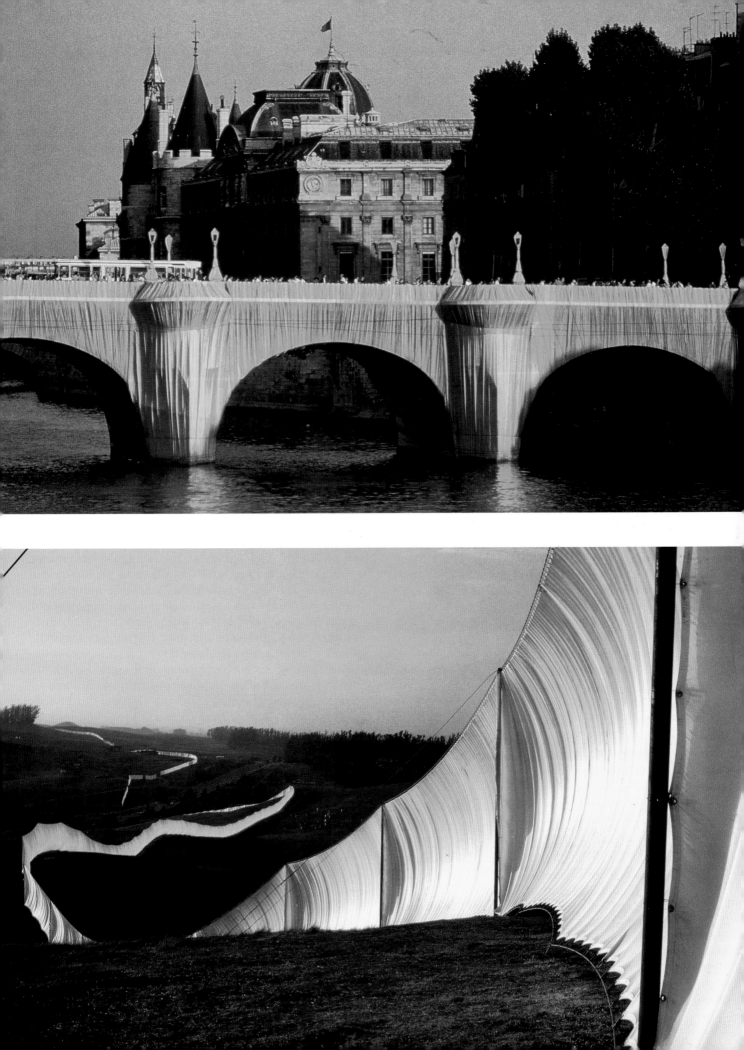

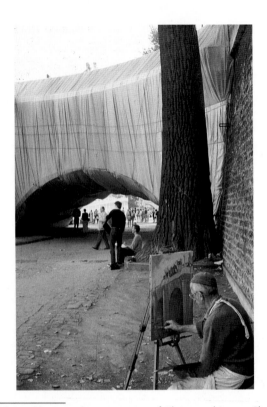

11.26 An old man making a painting of Christo and Jeanne-Claude's *The Pont Neuf Wrapped, Paris, 1975–85*

Photograph © by Jonathan Fineberg.

11.27 (opposite) **Christo,** *Two Lower Manhattan Wrapped Buildings, Project for #2 Broadway and #20 Exchange Place,* 1964–6. Photomontage, detail from collage, 20½ × 29½in (52.1 × 74.9cm). Collection, Horace and Holly Solomon, New York. Photograph by Raymond de Seynes, © Christo, 1964–6.

11.28 (opposite, bottom) **Christo and Jeanne-Claude,** *5,600 Cubicmeter Package, Kassel,* 1967–8. Dokumenta IV, Kassel, height 280ft (85.34m), diameter 33ft (10.06m), 22,000sq. ft (2,043.80sq. m) of fabric, 12,000ft (3,657.6m) of rope, weight 14,000lb (6,356kg). Photograph by Klaus Baum, © Christo, 1968.

as in *Package on a Wheelbarrow* of 1963 [fig. 11.22]. When the Galleria del Leone in Venice exhibited this work in 1963, leaving the contents to the viewer's imagination, it caused the local bishop to order the exhibition closed on grounds of obscenity! The recognizable forms, from wrapped trees to the *Packed Girl* of 1963 (the temporary wrapping of a live model), have an even more sensuous allure. Like the drapery in classical statuary, the fabric makes the forms—whether recognizable or not—all the more enticing by suggesting, rather than revealing, them.

The Shift to an Architectural Scale

In 1964 Christo moved to New York with Jeanne-Claude and son Cyril. His fantastic projections of giant packages on to architectural sites continued to evolve in New York [fig. 11.27] until in 1968 he succeeded in obtaining a commission to wrap a real building for an art exhibition in Bern, Switzerland. Then, the following summer, he and Jeanne-Claude erected a *5,600 Cubicmeter Package* [sic] (a package of air, inflated by a power fan) [fig. 11.28] for the *Dokumenta* art fair in Kassel, West Germany. Christo and Jeanne-Claude's monumental air packages and wrapped buildings of 1968 and 1969 forced them for the first time to employ machinery they could not operate themselves as well as the services of professional engineers. This pushed them still further out of the insulated fine art context and into the realm of real events.

In *Wrapped Coast—One Million Square Feet, Little Bay,*

Australia (1969), the increased scale and the siting of the work in a non-art context added a new dimension to Christo and Jeanne-Claude's task—the necessity of handling public relations successfully. Christo wanted to cover a mile-long section of Australian coastline with fabric and rope. The land belonged to a private hospital and the nurses at the hospital thought that the institution was paying for the work at the expense of things they needed for the patients. In addition, they assumed that their recreational beachfront would be closed. In fact, Christo and Jeanne-Claude paid for the project themselves and designed the work so that people could walk and sunbathe on it, but they failed to communicate this information and the nurses threatened a strike that nearly scuttled the project.

For *Valley Curtain* (1972) Christo and Jeanne-Claude hung an orange curtain across a mountain pass in Colorado. Here the engineering was still more complex, the cost greater (about $800,000), and instead of a familiar group of art enthusiasts with a few heavy-equipment operators and engineers, dozens of highly skilled (and organized) steel workers, carpenters, and high-wire riggers were required. Christo and Jeanne-Claude entered a whole new arena, learning about union labor relations. In the summer of 1971, with the project halfway unfurled but unsecured, the foreman told the union workers to knock off when the shift ended, and the wind destroyed the curtain. Christo and Jeanne-Claude had to come back the following summer with a new curtain and fresh resolve in dealing with union practices. They did eventually succeed, and *Valley Curtain* looked as magnificent as Christo and Jeanne-Claude had envisioned.

Ever since *Wrapped Coast* Christo and Jeanne-Claude had professional photographers traveling with them, documenting possible locations as well as all the events leading up to the final realization of each project. Christo has also based drawings on the photographs or painted on them directly to study his formal concepts in relation to the sites. For example, Christo tried out his first ideas for *Running Fence* in 1972, painting on photographs of different sites. Once he and Jeanne-Claude chose the site, they commissioned careful engineering drawings as well as topographical maps and scale models. As early as 1967 Christo had included such documentation in their collages, setting a formal precedent for the collage sections of Smithson's "Nonsites" and other such documentary presentations by artists in the late sixties.

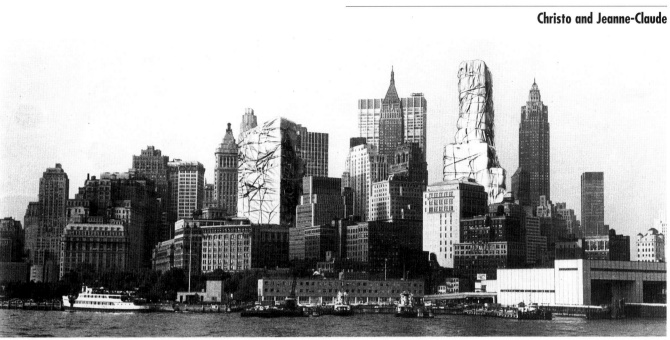

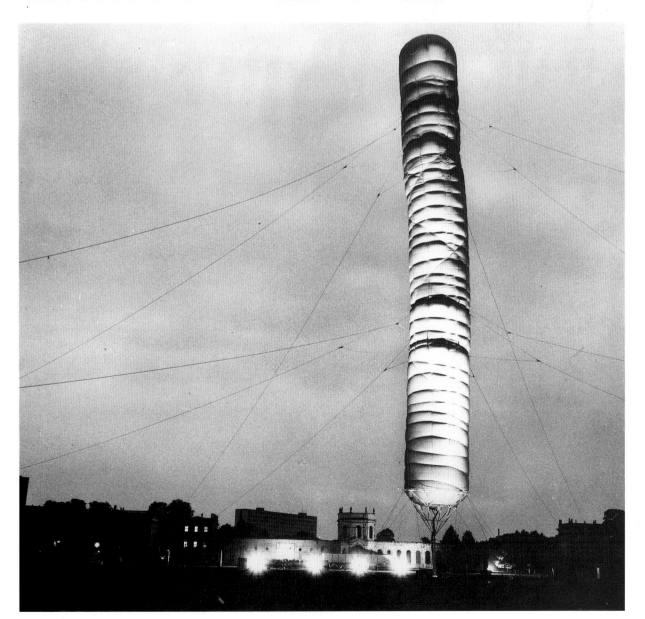

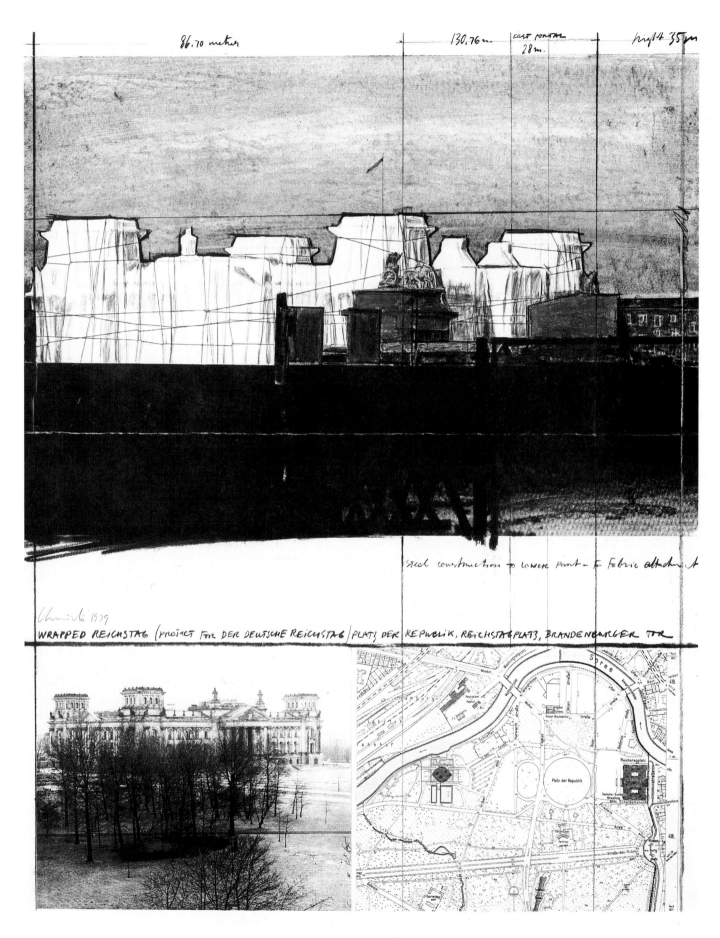

The Logistics of the Projects

Christo and Jeanne-Claude's *Running Fence* was an 18-foot-high, 24½-mile-long line of fabric panels that ran across Sonoma and Marin counties just north of San Francisco, traversing private ranches, intersecting fourteen roads and a highway, passing through the middle of a town and descending into the ocean at Bodega Bay. It was so large that one couldn't see the entire project even from the air. *Running Fence* took four years of negotiations with the fifty-nine private ranchers who owned the land, required a 450-page environmental impact statement, prompted eighteen public hearings (including three sessions of the Superior Court of California) to obtain the permits, and cost a total of $3.2 million—paid entirely from the sale of the artist's original drawings, wrapped objects, and collages.

Since Christo and Jeanne-Claude set all their huge temporary projects in public spaces, no one pays to see them. They have not accepted grants or sponsorship for these projects, nor do they profit from films or souvenirs. Christo stops making collages and drawings of a project once he has built it. In sum, there is no way in which Christo and Jeanne-Claude make money on their projects. Instead, they raise the extraordinary sums required by selling small sculptures and works on paper, and then they spend all the money thus accumulated (and more) to build the work, which they remove after a one- to three-week display period. Christo and Jeanne-Claude deliberately exploit all the mechanisms of capitalism, finding collectors to invest in their collages and drawings, contracting out the manufacturing tasks, managing public relations—then they negate capitalism's most distinctive feature, namely the accumulation of capital, and leave people incredulous.

Christo and Jeanne-Claude believe that their projects have their most poignant effect during a brief display period. After that they remove them because in their view their relevance diminishes with the passage of time. "I don't believe any work of art exists outside of its prime time," he explained, "when the artists likes to do it, when the social, political, economical times fit together."[40] Underlying Christo's working process is his indefatigable optimism and a fundamental faith that everything is in a state of perpetual evolution. A work of art should, from this point of view, engage the issues of its time and place, contribution to a constructive dialectic. This was as true for Fra Angelico, for example, as it is today. "To do valid work then, it was necessary to be profoundly religious," Christo pointed point, whereas ". . . we live in an essentially economical, social

and political world. Our society is directed to social concerns of our fellow human beings . . . That, of course, is the issue of our time, and this is why I think any art that is less political, less economical, less social today, is simply less contemporary."[41]

This dialectical aspect of Christo's thinking has its roots in his Marxist education. AgitProp theater, as exemplified by Burian and Brecht, attempted to create a didactic continuum with reality rather than to take the viewer out of reality and into a realm apart (on the Aristotelian model of theater). This training also predisposed Christo to work in the real environment with teams of people.

Along with his fellow students at the Academy in Sofia, Bulgaria, Christo was sent out on weekends to the farms that bordered the rail lines in order to arrange the equipment and produce—in the fifties. Westerners saw Bulgaria only from the windows of the international trains that passed through, and the government wanted the farms to look prosperous.

The Surrounded Islands

After *Running Fence* Christo and Jeanne-Claude juggled several major projects but all of them were held up by frustrating political struggles. They had wanted to wrap the Reischstag in Berlin since 1972 [fig. 11.29] and the Pont Neuf in Paris since 1974. They had also proposed the installation of between eleven and fifteen thousand golden "gates" along the paths of Central Park in New York, but they hadn't gotten clearance on any of these projects. Thus, when they received an invitation in 1980 to do a major project for a government-sponsored festival of the arts in Miami, it seemed a welcome relief.

Christo and Jeanne-Claude dissociated themselves from the festival, but after some time looking around Miami they decided to go ahead on their own to surround the tiny spoil islands in Biscayne Bay with floating skirts of pink fabric. In 1936, the Army Corps of Engineers had dredged the bay to create a navigational channel for oceangoing ships and had dumped the excavated material in fourteen piles that formed a chain of islands. These islands sat, unnoticed for decades, between the cities of Miami and Miami Beach, in the midst of the heavy cross-bay traffic of boats and automobile causeways.

Over the next two and a half years Christo and Jeanne-Claude painstakingly studied the environmental issues, as well as all the engineering problems and logistics. They found that the shallow bay contained a plethora of protected wildlife—endangered birds, manatees, and a variety of seagrasses—and eliminated three of the fourteen islands from the project for environmental reasons. Different fabrics, anchors, and flotation booms were tested, scientific studies of everything from the microorganisms in the sand to the birds were commissioned, and the most up-to-date instruments were used to locate the anchors and create computer maps for the fabric patterns.

11.29 (opposite) **Christo,** *Wrapped Reichstag, Project for Berlin,* 1979. Collage, pencil, fabric, twine, pastel, charcoal, crayon, photograph by Wolfgang Volz, and map, on photostat and paper, 28 × 22in (71.1 × 55.9cm).
Private collection. Photograph by Wolfgang Volz, © Christo, 1979.

Christo and Jeanne-Claude also met endlessly with lawyers, government agencies, and public groups to present the idea, win support, and negotiate permits. After numerous lawsuits, and cliff-hanger hearings they finally won the permits, and installed the *Surrounded Islands* in May 1983 [figs. 11.30–11.32], the most expensive project they had so far undertaken. Though the project sat in the middle of a major city and stretched 11 miles from one end of the bay to the other, it nevertheless seemed oddly isolated and unreal. In addition, it so closely resembled the artist's renderings (as in all the large Christo projects) that when one saw the actual work one had a sense of *déjà-vu*, compounding the feeling of unreality. It was at the same time unexpectedly overpowering, even in the open expanse of the bay.

Another striking aspect of the *Surrounded Islands* project is that it blended so remarkably into the visual surroundings. Here the idea prefigured in *Dockside Package* reached a glorious climax. Not only did the project pick up on the pastels of the local architecture in this beautiful Latin city but it even echoed the pinks and blues of the indigenous flora. *Surrounded Islands* seemed more like a magnification of nature than an imposition upon it.

Surrounded Islands was perhaps Christo and Jeanne-Claude's most photogenic work, and unlike any of their other projects the best view of it was either from a helicopter or on television. Most people experienced it through the media. Communicating an aesthetic idea to a mass audience is certainly one of the most important new issues in the art of the late twentieth century and Christo and Jeanne-Claude have been more successful than any other artists in developing the radical potential of media, including television. Not only have they sited nearly all of their projects in or near populous areas but they have made all the preliminary planning for them public through the media, thereby forcing large and diverse populations to become involved in the making of the work over a long period of time. Robert Arneson, who lived near *Running Fence*, observed, "When the *Fence* was up it was great! The checkout ladies in the supermarket were arguing about the definition of art!"[42]

This argument has been fundamental to almost all the opposition to Christo and Jeanne-Claude's projects, because in that challenge to conventional definitions lies a metaphor for the loosening of other definitions as well. Of *Surrounded Islands*, Christo said:

I think the project has some kind of subversive dimension and this is why we have so many problems. Probably all the opposition, all the criticism of the project is basically that issue. If we spend three million dollars for a movie-set there would be no opposition. They can even burn the islands to be filmed and there would be no problem. The great power of the project is because it is absolutely irrational. This is the idea of the project, that the project put in doubt all the values.[43]

Shortly after surrounding the islands in Miami, Christo and Jeanne-Claude received permission to wrap the Pont Neuf in Paris [fig. 11.18]. They had fought for that idea since 1975 and the success in Miami may have played a role. *The Pont Neuf Wrapped* went up in September 1985. It was genuinely picturesque, and it drew some three million spectators. It is interesting to note that in Europe Christo and Jeanne-Claude have consistently chosen to wrap well-known public monuments—in effect accepting their form—whereas in the United States and the Pacific they have worked with abstract forms that interact more freely with the landscape.

Christo and Jeanne-Claude in the Nineties

Christo and Jeanne-Claude's subsequent and even more ambitious project, *The Umbrellas, Japan–U.S.A. 1984–91* [fig. 11.33], opened simultaneously in Ibaraki prefecture (about 60 miles north of Tokyo) and in California (roughly the same distance north of Los Angeles) on October 9, 1991 for slightly less than three weeks. The project involved the seemingly random scattering of 3,100 specially designed umbrellas (1,340 blue ones in Japan and 1,760 gold ones in California) over 12- and 18-mile lengths respectively of the two inland valleys. The project took five years of preparation with a price tag of $26 million, more than seven times the cost of *Surrounded Islands*.

There was no shortage of difficulties to overcome, yet from the start this project benefited from a wide public admiration for Christo and Jeanne-Claude's work both in California and in Japan, as well as the years of experience on which they built a finely tuned organization. As one approached the project on the interstate highway in California, official highway signs appeared with notices like "The Umbrellas viewing area next 2 exits." Here was no anonymous vanguardist, overlooked by the authorities.

While the contrast of the 459 landowners in Japan with only 26 on the somewhat larger California site underscored real differences in the social character of the two countries, it was the sheer scale of the organization in negotiating that many contracts that seems really eye-opening. Christo and Jeanne-Claude coordinated over two thousand workers (about evenly divided between the two venues), prepared for the more than three million visitors that came to see the project, and attended to the prodigious quantity of details in the design, manufacture, and delivery of the umbrellas themselves with remarkable finesse.

Each umbrella had 470 different parts, weighed nearly 500 pounds, measured 19 feet 8 inches high by 28 feet 6 inches wide, and had a detailed file of careful engineering, calculated to ensure its accurate location and proper attention to the unique installation requirements of its particular patch of terrain. Setting umbrellas in a river bed required a different kind of anchoring and leveling to that needed for placing them on a rocky hillside or near roads and towns with underground utilities.

For all of the escalation in logistics, what was really

breathtaking and new about *Umbrellas* was its aesthetic. Here, for the first time, Christo and Jeanne-Claude placed a collection of discrete objects into the landscape rather than using the fabric in a more receptive response to the forms of nature, as in *Running Fence* or *Surrounded Islands*. Compared to these earlier works, politics also seemed relatively less prominent than formal expression. One might almost say that *Umbrellas* was unabashedly romantic in highlighting nature, using gold or blue accents to bring out the crest of a hill much as Constable dramatized his paintings of the English countryside with brilliant flecks of white.

In June of 1995, Christo and Jeanne-Claude finally wrapped the Reichstag in Berlin, and because of the long gestation of that project (and inflation) the final cost was nearly twice that of *Umbrellas*! Indeed the scale of the financing was the outstanding aspect of that project. At this writing, they have in mind for the twenty-first century to realize the Gates project in New York, but many political obstacles still remain there.

Postmodernism

The revolt against the normalizing functions of tradition is a defining feature of modernity, but while the classical modernist believes absolutely in the truth of the point of view that he or she offers as an alternative to the prevailing mainstream postmodernism questions the very concepts of objectivity (or truth), the monolithic authority of a mainstream, and the possibility of fixed meaning (especially in language). Around 1960, French structuralist theory had made it clear how much our interpretation of the world is shaped by the language we use to describe the world. Pop art brought home the priority we give to the images we see in magazines and television as our points of reference in experience.

Postmodernism views both images and concepts as radically polyvalent. This permits a fluid reconfiguring of one's experience of the world, continually changing juxtapositions and sequences in a manner that fundamentally destabilizes their meaning. Duchamp's readymades set an important precedent because they established a dialog among everyday objects that pointedly does not refer to the everyday life from which they come.[44] John Cage and Jasper Johns (influenced by Duchamp) reoriented art away from the vehement assertion of identity (as in abstract expressionism) toward the essential undecidability that underlies postmodernism.

The dominant stylistic feature of postmodernism is the lack of stable historical referents, whether in the sense of detaching a snow shovel from its commonly understood function (as in Duchamp's *In Advance of the Broken Arm* [fig. 7.2]) or in the narrower fashion of cannibalizing advertising images or past styles in art without regard to their original intent. Postmodernism is an inclusive aesthetic that cultivates the variety of incoherence. But, as Neil Postman pointed out, this attitude already permeated

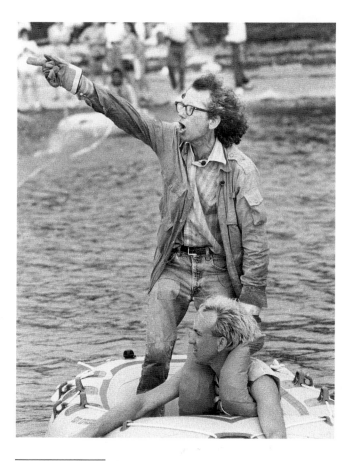

11.30 Christo directing the work during the installation of his *Surrounded Islands*, Biscayne Bay, Greater Miami, Florida, 1980–83, May 1983.
© United Press International.

the popular media in the sixties as in the randomness of the juxtaposed sound bytes on the television news, where "all assumptions of coherence have vanished. And so, perforce, has contradiction. In the context of *no context*, so to speak, it simply disappears."[45]

Sigmar Polke

The sixties paintings of the German artist Sigmar Polke anticipated some of the key issues of postmodernism. For him, the enigmatic *oeuvre* of Marcel Duchamp and Francis Picabia's "Transparencies" (paintings of the late twenties in which seemingly unrelated images are superimposed) inspired a liberation from coherence and from the idea that art emanates from personality (the romantic core of German art for the past two hundred years). In 1963, Polke and two other young Düsseldorf artists, Gerhard Richter and Konrad Lueg (a.k.a. Konrad Fischer), founded "capitalist realism" (an ironic counterpart to socialist realism) in response to the realities of capitalist mass culture.

Polke, born in East Germany in February 1941, crossed into the West on the Berlin subway in 1953 and by 1961 was studying at the Düsseldorf Academy with Josef Beuys. Polke

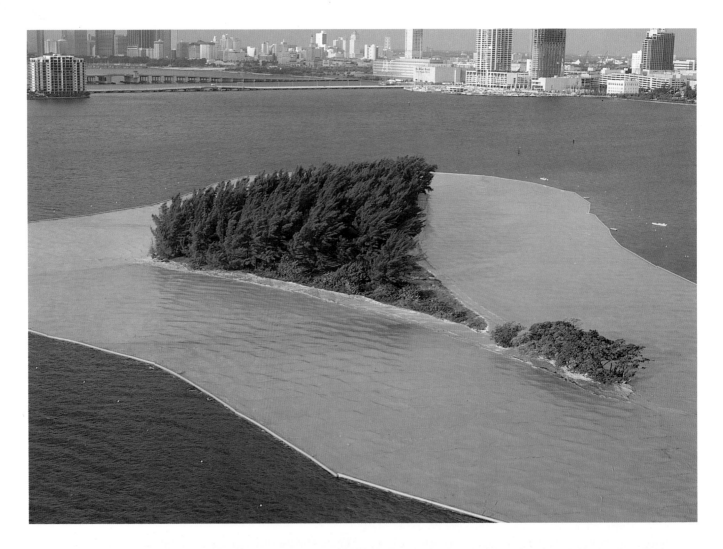

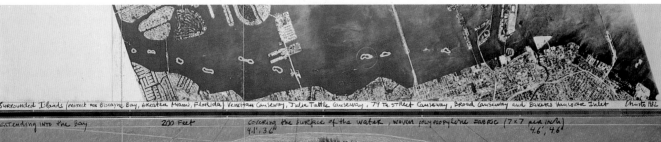

Surrounded Islands (Project for Biscayne Bay, Greater Miami, Florida) Venetian Causeway, Julia Tuttle Causeway, 79 th. Street Causeway, Broad Causeway and Bakers Haulover Inlet Christo 1982

extending into the bay 200 Feet covering the surface of the water, woven polypropylene Fabric (7x7 per inch)
 4.1', 3.6" 4.6', 4.6'

Island # 3: length - 1100 Feet (width 225 Feet)

anchor 4.6', boom 4.1' 6.1', 5.6'

the Floating Fabric will be attached to a long Boom (section 180' dia 10")

11.31 (opposite) **Christo and Jeanne-Claude,** *Surrounded Islands, Biscayne Bay, Greater Miami, Florida, 1980–83,* May 1983. Photograph © by Jonathan Fineberg, 1983.

11.32 (opposite, bottom) **Christo and Jeanne-Claude,** *Surrounded Islands, Project for Biscayne Bay, Greater Miami, Florida.* Drawing, 1982, in two parts: 15 × 96in (38.1 × 243.8cm) and 3ft 6in × 8ft (1.07 × 2.44m), pencil, charcoal, pastel, enamel paint, and aerial photograph. Collection, John Kaldor, New York. Photograph by Wolfgang Volz, © Christo, 1992.

11.33 Christo and Jeanne-Claude, *The Umbrellas, Japan–USA 1984–91,* California USA site, October 1991. Photograph by Wolfgang Volz, © Christo, 1991.

made a number of drawings like *Little Sausage* (*Würtschen*) of 1963 in ballpoint pen (fig. 11.34). The medium itself is a mass-market instrument that permits none of the advanced variation in line associated with a traditional fine artist's pen, the subject is not a woman eating a hot dog but an image of a woman eating a hot dog, and the inclusion of the lettering suggests a cross between cheap newspaper ads (even more raw than the contemporary Warhol) and an adolescent doodle. The style too seems pointedly "artless" in its awkwardly unbalanced composition and bad drawing; the hand looks as though a child rendered it. This deliberate flirtation with antiaesthetic values is both radical and prescient of the issues raised by the evolving mass culture of the sixties.

In the mid sixties Polke painted a group of twelve canvases, collectively entitled *The Fifties* [fig. 11.35], in which he deliberately employed an incoherent selection of kitsch fifties styles. In this composite work, he found himself absorbed into the vulgarity of popular taste. There is doubtless some cynicism in this work about the cultural level of the German economic miracle of the fifties and sixties, but it is at the same time mixed with genuine nostalgia. Rather than dwelling in depth on any one image in this series, the installation prompts the viewer to see a profusion of disparate images all at once, to see across the surface, as in pop art. However, the simultaneous multiplicity of styles in *The Fifties* differs from pop art, which also exploits kitsch or popular culture, because it

Politics and Postmodernism: The Transition to the Seventies

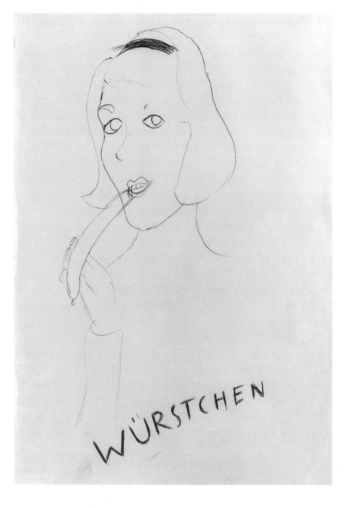

attacks the very idea of stylistic coherence and the normalizing force of personality in art.

In 1963 Polke began simulating the dot patterns of commercial four-color printing (Raster dots) only months after Lichtenstein turned to this commercial metaphor (the Ben-Day dots) in New York [figs. 9.17–9.20]. For Polke, these patterns represented a dissolution of the self into commercial culture—he cast himself as the involuntary transmitting instrument, very much in the sense that William Burroughs meant it. In the 1966 painting *Bunnies* [fig. 11.1], Polke played ironically on the subject of Playboy Club Bunnies (mass-market sex) in a mass-media technique that breaks down in such a way that the viewer actually sees less the closer he or she looks. Indeed, when you look closely there is no substance at all. The difference in expression between the printer's dots, derived from the mechanical process of rendering half-tone images, and the clichéd sexuality of the subject matter creates a provocative interplay of meanings.

Polke painted *Alice in Wonderland* of 1971 [fig. 11.36] on a patchwork of preprinted fabrics with images of soccer

11.34 Sigmar Polke, *Little Sausage,* 1963. Ballpoint pen, 11¾ × 8¼in (30 × 21cm).
The San Francisco Museum of Modern Art. Fractional gift of Robin Quist Gates.

11.35 (below) **Sigmar Polke,** *The Fifties,* 1963–9. Mixed media on twelve canvases, installation dimensions variable.
Collection, Karl Stroeher Foundation, Hessisches Landesmuseum, Darmstadt.

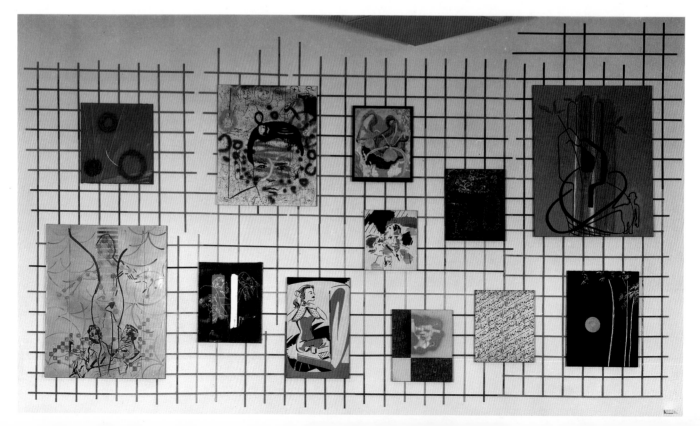

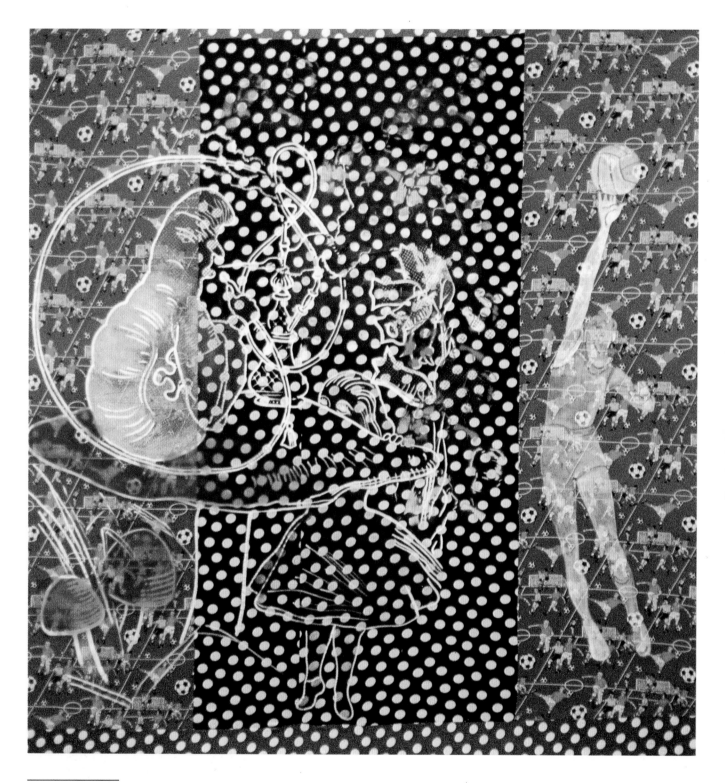

11.36 Sigmar Polke, *Alice in Wonderland,* 1971.
Mixed media on fabric strips, 10ft 6in × 8ft 6⅜in (3.2 × 2.6m).
Private collection, Cologne.

Politics and Postmodernism: The Transition to the Seventies

11.37 (opposite) **Sigmar Polke,** *Mrs. Autumn and Her Two Daughters,* 1991. Artificial resin and acrylic on synthetic fabric, 9ft 10⅛in × 16ft 4¾in (3 × 5m).
Collection, Walker Art Center, Minneapolis. Gift of Ann and Barrie Birks, Joan and Gary Capen, Judy and Kenneth Dayton, Joanne and Philip Von Blon, and Penny and Mike Winton, with additional funds from the T.B. Walker Acquisition Fund, 1991.

11.38 (opposite, below) **Gerhard Richter,** *Eight Student Nurses,* 1966. Oil on canvas, 37½ × 27½in (95.3 × 69.9cm) each.
Photograph courtesy Marian Goodman Gallery, New York.

players and polka-dot patterns, making an obvious word-play on "polka" dots. In this work, the artist superimposed a ghostly white, almost stencil-like rendering of a basketball player from a sports magazine, a transcription of Tenniel's illustration of the caterpillar and Alice from *Alice in Wonderland,* and a repeated outline stamp of the heads of a fifties-style man and woman over the preprinted images of the commercial fabrics that he used as a canvas. In this way he deliberately enhanced the dissonance between these appropriated images and the visual seductiveness of the color and patterning underneath. This creates multiple layers of conceptual "static" superimposed on one another. It is in this sense that Polke—more like Burroughs than Beuys—is the innocent transcriber, approaching only dead, second-hand or mediated forms to point up our entrapment within them. Things as they exist in images are the reality, a hallucinatory reality in which Polke plays out what Robert Storr described as an "enduring dynamic between reason and terror, expanded consciousness and derangement."[46]

In *Mrs. Autumn and Her Two Daughters* of 1991 [fig. 11.37], Polke has lifted the figures and landscape from mid-nineteenth-century engravings by the French illustrator Grandville[47] and rendered them in a precise technique that mimics the fine control of the original wood engravings. The scene itself seems to be an allegory of the seasons, with "Mother Autumn" cutting up confetti which her daughters scatter in anticipation of the coming snows of winter. Yet the remaining three-quarters of the painting is a luminous abstraction, experimenting in the chemistry of synthetic polymers and esoteric minerals. This chemical exploration invites chance effects as though seeking an entrance into the mystic dimension of alchemy. These wildly disparate voices in the work nevertheless make a grand, irrational, and inclusive whole.

Gerhard Richter

The *oeuvre* of Gerhard Richter also has this oddly integral diversity; for Richter it is a conscious attack on ideology per se (both political and aesthetic) and at the same time an expression of the state of postmodernity. "I pursue no objectives, no system, no tendency; I have no program, no style, no direction. I have no time for specialized concerns, working themes, or variations that lead to mastery. I steer clear of definitions. I don't know what I want. I am

inconsistent, non-committal, passive; I like the indefinite, the boundless; I like continual uncertainty."[48]

Born February 9, 1932, Richter moved to West Germany in 1961, just two months before the Berlin Wall was erected. He saw the work of Pollock and Fontana in 1959 at the Documenta II exhibition, and the unashamedness of their work deeply affected him. His encounter with the antiaesthetic attitudes of Fluxus (with its chance procedures and political engagement) and of pop art, which he saw after he came to the West, also shocked but at the same time liberated him.

Richter was in his late twenties when he left the east bloc for Düsseldorf and had already mastered the skills of socialist realism. In his painting of the sixties, he turned this training to account in rendering images that looked like out-of-focus, black-and-white snapshots of everyday subjects. He intuitively took a postmodern posture of trying to remain open to the full complexity of experience and made "reality" itself the main preoccupation of his painting in the 1960s, using photography—especially amateur snapshot photography and photojournalism—as his point of reference. "The photograph," he said, "reproduces objects in a different way from the painted picture, because the camera does not apprehend objects: it sees them. In freehand drawing, the object is apprehended in all its parts, dimensions, proportions, geometric forms. These components are noted down as signs and can be read as a coherent whole. This is an abstraction that distorts reality and leads to stylization of a specific kind."[49] It is for this reason that a photograph you take never really captures your experience.

The photograph takes in the incongruous multiplicity of reality, whereas the painting depicts a synthesized (and therefore interpreted) view, which has the undesirable effect (from Richter's perspective) of normalizing the reality into the already known. "A picture presents itself as the Unmanageable, the Illogical, the Meaningless. It demonstrates the endless multiplicity of aspects; it takes away our certainty, because it deprives a thing of its meaning and its name. It shows us the thing in all the manifold significance and infinite variety that precludes the emergence of any single meaning and view."[50]

Richter's 1966 painting of *Eight Student Nurses* [fig. 11.38] looks, at first, like a row of blurry black-and-white photos of eight smiling girls from a high-school yearbook. Then you discover that these are the victims of Richard Speck, who entered a random apartment on Chicago's south side on July 14, 1966, and strangled and stabbed them; it was the first highly publicized mass-murder case in America. The viewer's discovery of the subject matter sets in high relief the dissonances created in the mediation of experience; Richter effectively separates the signifier from the signified, as Andy Warhol did in his *Campbell's Soup Cans.* In a painting like *Woman with Umbrella* of 1964 Richter's blurring and general degradation of the image makes the subject (Jackie Kennedy shortly after the assassination of her husband) unrecognizable; the blurring in the photo pictures of the

Politics and Postmodernism: The Transition to the Seventies

sixties effectively undermines closure on the definition of the subject, leaving the viewer less clear rather than more clear about the state of the object. The unfocused technique undermines the boundary between photography and painting, challenging the truth claim of the photograph and the distinction between "reality" and "distorted reality."

The distortion of the image by blurring localizes the beholder's perception in the act of comprehension rather than in the identity of the subject. Richter's openness suggests his uncertainty, his reluctance to bring closure to the task of defining. In his 1986 interview with Benjamin Buchloh, Richter explained: "The only paradoxical thing is that I always set out with the intention of getting a closed picture, with a proper, composed motif—and then go to great lengths to destroy that intention, bit by bit, almost against my will. Until the picture is finished and has nothing left but openness."[51]

Like Warhol, Richter pointedly undercut charged subject matter with generalizing techniques and neutral titles; he painted most of the works of the sixties in grisaille: grey, he remarked, "like no other color is suitable for illustrating 'nothing.'"[52] Moreover, the photo from which

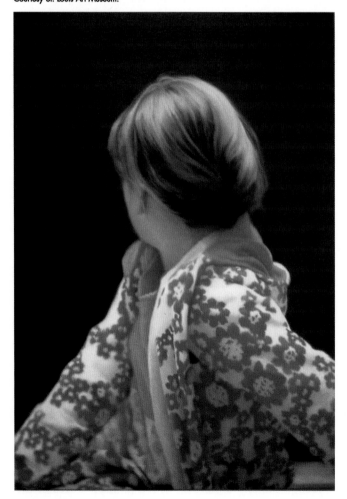

11.39 Gerhard Richter, *Betty* (663–5), 1988. Oil on canvas, 40⅛ × 28⅝in (102 × 72cm).
Courtesy St. Louis Art Museum.

he painted might in one instance be a banal snapshot of a kitchen chair and at the next moment a newsphoto of the arrest of a Red Brigade terrorist (blurred into generic and unrecognizable indistinctness), as though one was no more charged for him than the other. He especially liked images from the media because they were available in profusion and were artless: "Suddenly, I saw it (the photograph) in a new way, as a picture that offered me a new view, free of all the conventional criteria I had always associated with art. It had no style, no composition, no judgement. It freed me from personal experience. For the first time, there was nothing to it: it was pure picture. That's why I wanted to have it, to show it—not use it as a means to painting but use painting as a means to photography."[53]

In 1988 Richter painted a portrait of his teenage daughter Betty [fig. 11.39] coolly turned away from the camera. It is done in a blank, photorealist style, from a photograph. Quite soon after that, he painted in black-and-white an innocent-looking girl, *Youth Portrait*; the young girl, looking straight into the camera, is Gundrun Ensslin, one of the leaders of the brutal terrorist Baader-Meinhof gang, which evolved into the Red Army Faction. One painting comments on and undermines the reading of the other. In the same way, Richter also undermines the coherence of his own style by painting broadly brushed, colorful abstractions [fig. 11.40] side by side with his photorealist paintings; indeed he subverts the distinction between abstraction and representation, painting both in a deliberately detached manner.

In 1964 Richter began compiling the source photos for all of his paintings on panels, and in December 1972 he showed them in Utrecht as the *Atlas of Photos and Sketches* in 343 sheets. By 1995–96, when he showed the *Atlas* at the Dia Center for the Arts in New York [fig. 11.41], it contained 583 sheets, all of them published in a complete book documenting the *Atlas*, so anyone could compare to see precisely how he altered his sources in the final composition. He also meticulously documented the sequence of all his works by numbering them in a published *oeuvre* catalogue, reproduced accurately in scale with one another. In thus making all aspects of the process behind his work as transparent as possible, he both "condenses a much more complex reality into a grid system,"[54] as Rainald Schumacher pointed out, and at the same time he also makes it clear how little the facts really tell us.

The most photorealistic paintings, like the portrait of Betty, are for Richter pehaps the most unstable form of truth. Abstraction is at first seemingly more stable in that "abstract paintings . . . visualize a reality which we can neither see nor describe but which we may nevertheless conclude exists. We attach negative names to this reality; the unknown, the ungraspable, the infinite, and for thousands of years we have depicted it in terms of substitute images like heaven and hell, gods and devils. With abstract painting we create a better means of approaching what can be neither seen nor understood because abstract painting illustrates with the

11.40 Gerhard Richter, *Untitled (591–2)* 1986. Oil on canvas,
38⅛ × 36¼in (96.8 × 92.1cm).
Photograph courtesy Marian Goodman Gallery, New York.

11.41 Gerhard Richter, *Atlas,* 1962–1995.
Installation view, Dia Center for the Arts, New York.
Photograph by Cathy Carver. Courtesy Dia Center for the Arts.

greatest clarity, that is to say, with all the means at the disposal of art, 'nothing.' . . . (in abstract paintings) we allow ourselves to see the un-seeable, that which has never before been seen and indeed is not visible."[55]

But even in the abstractions, Richter's lack of theoretical commitment and his sense of the elusiveness of meaning highlights a fundamental state of uncertainty. The gestural brushstroke (an emblem of personality and expression) is created by Richter in his abstractions with the same cold detachment that characterizes his photorealist works. This is especially true after he began, in the early eighties, to create his thickly painted "gestural" works by laying paint on a glass plate and then pressing it onto the canvas. This effectively conceals the real mark of the hand while teasingly alluding to it in gestural-looking daubs. As the paint builds up, the identity of the paint erodes and inconsistencies arise; an application of wet paint may tear the skin off a dry surface underneath, leaving a piece cutting through the surface of new paint to a lower and earlier level. Richter initiates a mechanical process, but then he will touch it up in small details, randomly. Despite the detachment of this approach, the abstract paintings nevertheless often create an illusionistic space, like a romantic landscape. Everything about Richter's painting is riddled with contradictions: not least the contradiction that he never escapes from painting despite negating its premises in every way. But his humanness is asserted through this fallibility.

John Baldessari

Since the early seventies the work of John Baldessari, a Southern California artist, has also centered on the barrage of informational input from daily life [fig. 11.42]. He sees in a kind of fast surface scan, picking up images that can be reconstituted at a distance and in the privacy of his imagination. As he told the art historian Coosje van Bruggen: "It's like when I am in an airplane cabin and overhear two conversations: one says something and another one says something else. I could not have thought up those phrases on my own, and I respond to it by connecting one to the other, taking both out of their own context and by making them a part of my imagination."[56]

In the mid sixties, Baldessari had a friend in an advertising agency where advertising posters would be cut up into regular squares before being discarded. Baldessari began collaging these small, arbitrarily cropped fragments, painting over some and in the others dealing with the abstract shapes created by the random fragmentation of the original images. Whether using snippets of unrelated conversation, recycled images, or the accidental forms left from chopped-up posters, Baldessari works by intuitively reinventing found images as meaningful symbols of his own thoughts.

Talking about a work of the mid seventies, Baldessari explained that:

I wanted the work to be so layered and rich that you would have trouble synthesizing it. I wanted all the intellectual things gone, and at the same time I am asking you to believe the airplane has turned into a seagull and the sub into a mermaid during the time the motorboat is crossing. I am constantly playing the game of changing this or that, visually or verbally. As soon as I see a word, I spell it backwards in my mind. I break it up and put the parts back together to make a new word.[57]

Baldessari implies that each individual constitutes a separate reality. Christo is even more explicit about this idea when he talks about the unique way in which each individual viewer defines the reality of the artist's projects for himself or herself, from the perspective of his or her own life experience. Broadly speaking, the pluralism of the seventies grew out of a widespread assault in the late sixties on hierarchies of authority, political as well as cultural, in favor of the uniqueness of each individual's experience as an equal (and mobile) component of the cultural whole.

11.42 (opposite) **John Baldessari,** *Heel,* 1986. Black-and-white photograph, oil tint, oil stick, acrylic, 8ft 10½in × 7ft 3in (2.7 × 2.2m).
Collection, Los Angeles County Museum of Art, Modern and Contemporary Art Council Fund. Photograph by Douglas M. Parker, Los Angeles, courtesy of Margo Leavin Gallery, Los Angeles.

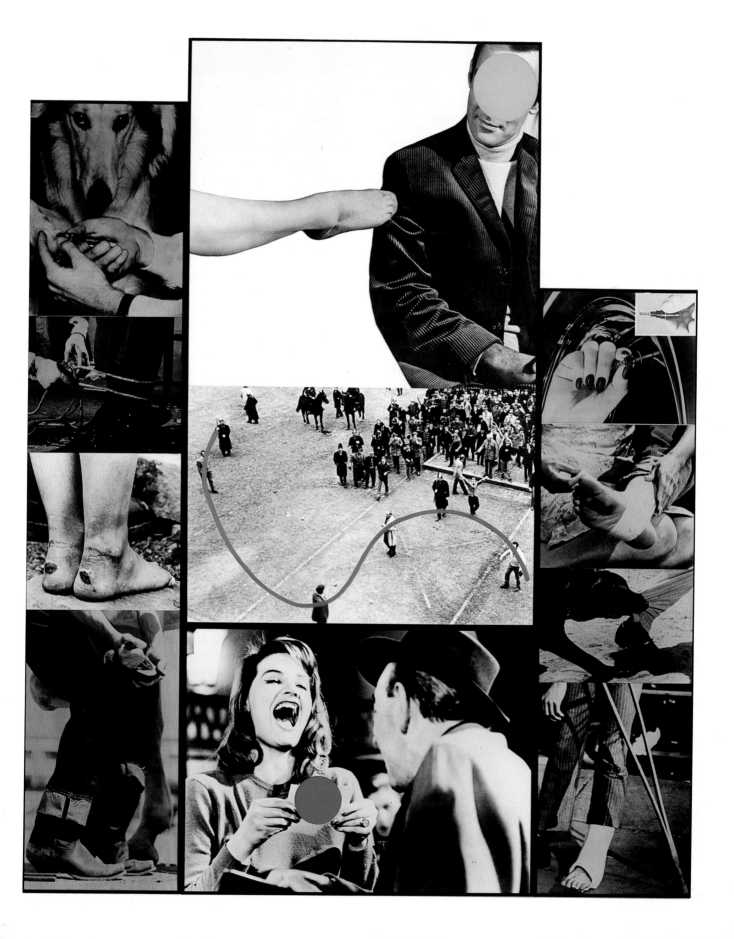

12

SURVIVING THE CORPORATE CULTURE OF THE SEVENTIES

A New Pluralism

To many critics, curators, and even artists, the art world of the seventies seemed lacking in direction. No new movements dominated the scene in the way that pop art and minimalism had in the early and middle sixties respectively. Indeed, minimalism and conceptual art continued to prevail in the galleries, but both seemed to have lost their spark by the mid seventies and a widespread feeling existed that painting had died somewhere along the way. In 1976 Robert Motherwell capped off the general malaise with a letter to the *New York Times* in which he claimed that his generation had taken the last significant step in abstract art. "Painting," he wrote, "has reached a point where youngsters can only add a footnote. It depresses me a little to think that what was once Indian territory is now pretty thoroughly mapped out."[1] At the end of the decade, the critic Calvin Tomkins stated categorically in the *New Yorker* that "no major new artists emerged in America during the 1970s,"[2] and in 1980 Barbara Rose, another New York critic, went so far as to launch a preemptive strike by organizing an exhibition entitled "American Painting: *The Eighties*"[3] in the hope of setting the terms for the approaching decade so that the eighties would not "go wrong" too.

Yet, in retrospect, a number of "major new artists" clearly did emerge in the seventies, as radical changes took place not only in art but in Western culture as a whole. Foremost among those changes was the broadening recognition of a richer, pluralistic culture, signaled by the very same complex multiplicity of cross-tracking directions in the art world that so worried seasoned art trackers. In essence, that pluralism *was* the new movement, and it manifested itself in many ways, including the unprecedented numbers of women emerging at the forefront of new artistic developments in the seventies and the challenge of artists from Europe, California, and elsewhere to the previously exclusive focus on New York in the art press.

In addition, the brief burst of social egalitarianism in the late sixties had opened the door for the entry of black and hispanic minorities into institutions of high culture in America, while at the same time the enervation of the established art movements created a fresh opportunity for artists who did not conform to the mainstream. Rafael Ferrer, a Puerto Rican artist working in New York, recalled: "It was obvious to me that it was a very frenzied moment when suddenly there's an opening."[4] Ferrer's own success, beginning in the mid seventies, relied not on his relation to pop, minimalism, or conceptual art, but precisely on his distance from them as a predominantly figurative artist, with an expressionistic style and Latin sensibility that was both fresh and authentic.

Art in America featured Ferrer's *Puerto Rican Sun* [fig. 12.2] on the cover of its issue of March 1980. This monumental steel sculpture, erected in a predominantly black and Puerto Rican neighborhood of the South Bronx,

12.1 (opposite) **Faith Ringgold,** *Aunt Bessie and Aunt Edith,* from the "Family of Women Mask" series, 1974. Acrylic paint on canvas, fabric, yarn, beads, raffia, foam base, 65½ × 19 × 13in (166.4 × 48.3 × 33cm) and 64 × 19 × 13in (162.6 × 48.3 × 33cm). Collection, the artist. Photograph by Karen Bell.

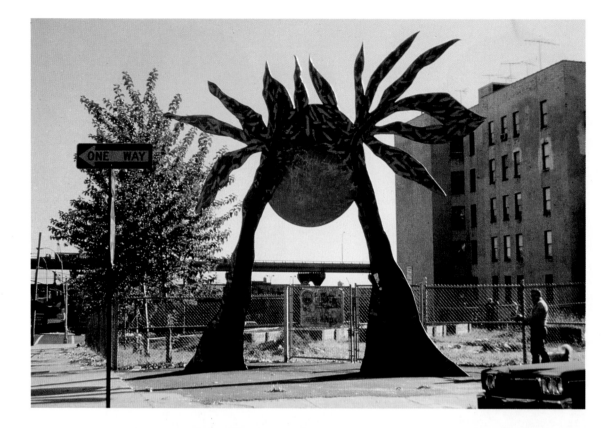

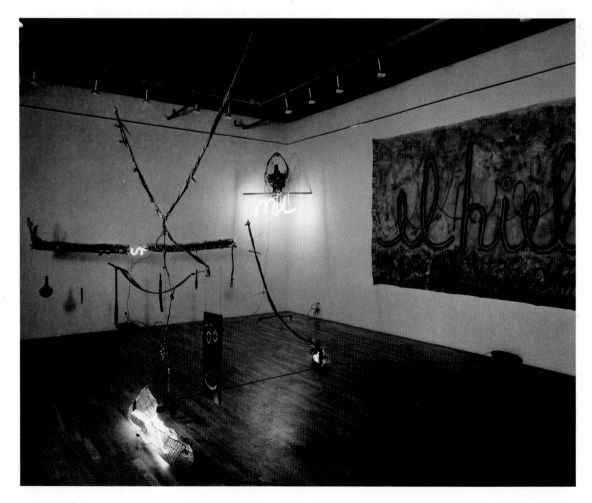

depicts the hot, orange orb of the Caribbean sun setting between two tropical palms. A cool blue moon appears on the flipside. The nostalgic Latin idiom of *Puerto Rican Sun* contrasts with the blighted urban setting of the northern ghetto. In *My Faraway Southern Land*, an installation of 1975 [fig. 12.3], Ferrer narrated an imaginary voyage through visceral accretions of colorfully painted found objects, wired or strung on primitively fashioned forms, with glowing touches of neon. The work defined an aesthetic that had little to do with the conventions of "New York art."

Likewise, the growing fascination in the seventies with the work of black and female artists such as Betye Saar and Faith Ringgold reflected a widening understanding of what "American" culture is. In Faith Ringgold's effigies of *Aunt Bessie and Aunt Edith* [fig. 12.1], the intense, contrasting patterns and the elegant abstraction of the facial expressions both draw directly on West African textiles and sculpture. In this sense the work is a deliberately political gesture, emphasizing the African roots of her artistic lineage. The theatrical manner in which Ringgold often installed her figures, with real props in real space, also evokes the African-American and Chicano "yard shows." which in turn draw on Afro-Caribbean traditions as well. These visionary yard shows—magical accumulations of found and fabricated objects, which one can see on front lawns from Port-au-Prince to Watts—linger behind the work of Betye Saar too, side by side with a sophisticated understanding of pop art and cubist construction.[5] Saar used found emblems from popular advertising as points of embarkation into a transcendental spiritism, side by side with a socio-political content, as in her 1972 assemblage *Is Jim Crow Really Dead?* [fig. 12.4].

The African-American traditions on which the works of Ringgold and Saar drew began to be recognized by the art world of the seventies as offering something authentic, exciting, and, in their very *difference* from Clement Greenberg's mainstream, central to a new understanding of the diversity that defines American culture. Romare Bearden, a major African-American master of the abstract expressionist generation, remarked in 1964 that: "What I've attempted to do, is establish a world through art in which the validity of my Negro experience could live and make its own logic."[6] The validity of Bearden's "Negro experience" was indeed what finally pushed his work after 1964 to a level of first importance, and in the more open atmosphere of the seventies it began to be recognized as such.

The pluralism of the seventies expressed a unifying concern with the radical potential of individuality. Artists,

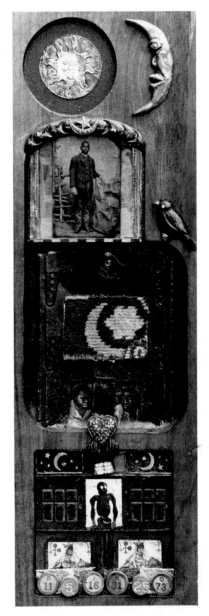

12.4 Betye Saar, *Is Jim Crow Really Dead?* 1972. Mixed media assemblage, 17 × 5¼ × 1 in (43.2 × 13.3 × 2.54cm).
Photograph by Tracye Saar.

12.2 (opposite, top) **Rafael Ferrer,** *Puerto Rican Sun (the sunny side),* 1979. Painted steel, 25ft (7.62m) high, Fix & 156th St., S. Bronx.
Photograph courtesy Nancy Hoffman Gallery, New York.

12.3 (opposite) **Rafael Ferrer,** *Mi Lejana Tierra Austral (My Faraway Southern Land),* 1975. Mixed media installation, detail.
Photograph courtesy Nancy Hoffman Gallery, New York.

like everyone else, were alienated by the fractured existence of life in the electronic era, made hyperconscious of political and semiotic issues, supersaturated with visual stimuli, and overwhelmed by the anonymity of mass culture. Consequently, for many of them, a more self-contained search for the integrity of their individuality superseded any interest in collective movements. Even the loose consensus of the minimalists and pop artists seemed anathema. Instead, a fierce nonalignment characterized the best artists to emerge in the seventies, and that vehement assertion of individuality in itself has vanguard implications for a society of mass markets and media. De Kooning—a preeminent

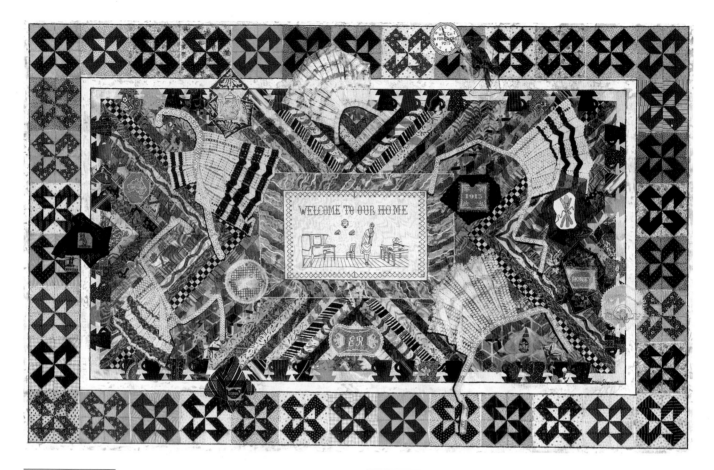

12.5 (above) **Miriam Schapiro,** *Wonderland,* 1983. Acrylic and fabric collage on canvas, 7ft 6in × 12ft (2.29 × 3.66m).
Photograph by Pelka/Nonle, courtesy Steinbaum Krauss Gallery, New York.

12.6 (below) **Joyce Kozloff,** *Plaza Las Fuentes,* Pasadena, 1990. Glazed ceramic tiles; sculpture Michael Lucero, landscape architecture Lawrence Halprin.
Photograph by Tom Vinetz, courtesy the artist.

precursor for this radical individuality—in turn pointed to Duchamp, describing him as a "one-man movement . . . for me a truly modern movement because it implies that each artist can do what he thinks he ought to—a movement for each person and open for everybody."[7]

Art and Feminism

Feminist criticism became particularly important in the seventies as part of the general interest in finding out what makes each of us who we are. In January 1975, Miriam Schapiro [fig. 12.5] and Robert Zakanitch founded a "Pattern and Decorative Artists" group and the Holly Solomon Gallery, which opened that year in SoHo (the new artist's quarter "So"uth of "Ho"uston St. in New York), became the focus of a widely touted "pattern and decoration movement." The new dimension to the reassertion of patterning and decorativeness by artists such as Schapiro and Joyce Kozloff [fig. 12.6] was given by the attack on the modernist division of high art from the minor arts of decoration. Schapiro and Kozloff saw this as a gender-based

12.7 Bea Nettles, *Suzanna . . . Surprised,* November 1970. Photoemulsion on muslin, photolinen, stitching, 28 × 35in (71.1 × 88.9cm).
Collection, the artist. © Bea Nettles, 1970.

distinction—for them, "decorative" connoted "women's work." In addition, they wanted to reverse the tendency toward a reduction of means (as in minimalism) for an additive and inclusive aesthetic (as in Robert Venturi's rejection of the international style in architecture).

In the seventies feminist artists also focused on photography, which they perceived as a newer fine art medium and thus less hidebound by traditions of male dominance. Bea Nettles, a photographer who emerged at the beginning of the decade, combined a late sixties irreverence for technical conventions with the "minor art" of sewing. Out of nostalgia for her home when she went to graduate school in 1968, Nettles started sewing herself a quilt. This led to the idea of painting on quilted canvas, and by the summer of 1970 she was experimenting with sewing paper photographs and then painting photo emulsion on fabrics, which she stitched into reliefs like *Suzanna . . . Surprised* [fig. 12.7].

The rebellion against the pristine quality of the traditional photographic silver print demonstrated in the uneven brown-stained surface of *Suzanna . . . Surprised* echoes the defiant subject matter. Nettles made this work at the height of the counterculture protest against the American involvement in Vietnam. She stuffed this unmistakably confrontational nude self-portrait and sewed it around the edges, then fixed it on to a faint image of a formal garden. This version of "Susanna and the Elders" shows only the bather in her garden, forcing the viewer into the role of the elders, caught peering from the bushes. Nettles looks the viewer square in the eye; and instead of the passive embarrassment of Giorgone's or Rembrandt's *Susanna,* the gaze of this nude overpowers the spectator and assumes control.

The feminists of the late sixties and early seventies were among the first to identify the body as not only a social but also a political site. Nancy Spero, for example, reported that "I was so enraged. Coming back from Europe, I was shocked that our country, which had this wonderful idea of democracy, was doing this terrible thing in Vietnam. I wanted to make images to express the obscenity of war."[8] The powerful antiwar images she made used sexual anatomy as metaphors, both the victimization of the female body as the locus of this broader cruelty and the penis as surrogate for the war machine. In *Rifle/Female Victim* of 1966 [fig. 12.8], ferocious heads seem to fly out of a vertically aimed rifle to bite off the feet, hair, and one hand of a bleeding female nude, flung upside down in the skirmish.

In retrospect we can argue that Eva Hesse's wrappings were a gendered process and we know that she debated in her private notebooks some fundamental feminist issues. It wasn't until the 1970s, however, that strictly feminist concerns commonly took the foreground in defining an important oeuvre, as in Ana Mendieta's exploration of the sexuality of the female body (her body) or Eleanor Antin's imaginary narratives in which she cast herself in different gendered identities (both male and female). Carolee

Surviving the Corporate Culture of the Seventies

12.8 Nancy Spero, *Rifle/Female Victim,* 1966. Gouache and ink on paper, 24 × 19in (60.9 × 48.2cm).
Photo courtesy of the gallery. Photo by David Reynolds.

Schneemann is the notable exception in ground-breaking performance works such as *Meat Joy* of 1964, in her film *Fuses* of 1964–65, and in subsequent performance works, all visceral celebrations of sexuality and of the female body. Certainly artists have focused on the joy of sexuality before; what made Schneemann's contribution so important was that, as a woman, she took control over the production of the sexualized female image.

Her first body action, *Eye Body* of 1963, is among the earliest explicitly feminist works. "In 1962 I began a loft environment built of large panels interlocked by rhythmic color units, broken mirrors and glass, lights, moving umbrellas and motorized parts," she later wrote. "I worked with my whole body, the scale of the panels incorporating my own physical scale. I then decided I want my actual body to be combined with the work as an integral material, a further dimension of the construction . . ." in order to turn her body into "visual territory, [exploring] the image values of flesh as material." As a painter, Schneemann wanted her body to "remain erotic, sexual, desired, desiring but [also] votive."[9]

Schneemann's *Interior Scroll* [fig. 12.9], a performance piece of 1975, is one of the most memorable icons of seventies art. In this work, performed first for an entirely female audience and then two years later before a mixed group, the artist stroked the contours of her body with paint and read from a book. At the end she dropped the book and the apron, and pulled a long, thin scroll of paper out of her vagina, reading from the scroll as she extracted it. The text begins: "I met a happy man/a structuralist filmmaker. . ./you are charming/but don't ask us to look/at your films. . ./we cannot look at/the personal clutter/the persistence of feelings. . . ."[10] This work too celebrated the female body. But it also addressed a critique of "the woman's" work and the imposition of predetermined (gendered) criteria of quality, rather than standards developed in appropriate relation to the intentions of a work, on which a significant part of the feminist writing of the seventies turned. Not only did the feminists make clear that those criteria were often inappropriate to a woman's expression, but the power of the feminist critique also helped everyone to see the "hegemonic" criteria (as they have come to be called) that favored a range of established racial, national, or socio-economic cultural practices over others less "privileged."

Another signal, feminist work in the seventies was Judy Chicago's *Dinner Party* [fig. 12.10], a collaboration by more than 400 women, completed between 1974 and 1979. Although it is not universally admired on formal grounds, it was a lightning rod for discussion about the place of women in the art world and in the record of history. The work is a symbolic history of women's achievements and struggles, with inscriptions of the names of important women on the ceramic floor and on the table runner below the thirty-nine place settings (thirteen on a side with a vaginal form at the center of most of the plates). Anne Wagner criticized "Chicago's closure on the various possibilities [as] absolute and brooks no contradiction,"[11] but in the 1970s feminist art almost had to take a hard line against an equally inflexible male orientation of the art world. Feminism in the seventies was chiefly concerned with societal definitions of women's roles; with practices such as collaboration that undermined what was viewed as a patriarchal interest in the authorial role of the artist; with the body (both in respect to its cultural construction and its natural processes); with a broad questioning of authority; and with expressive directness, especially as carried out in installation and performance. These issues came up in debate over the *Dinner Party*, and now twenty years later it still seems to provide a rallying point in the debate on important social issues of gender.

12.9 (opposite, top) **Carolee Schneemann,** *Interior Scroll,* 1975.
Courtesy of the artist. Photo by Eddie Owen.

12.10 (opposite) **Judy Chicago,** *The Dinner Party,* 1979. Mixed media, 48 × 42 × 3ft (17.6 × 12.8 × .9m).
Collection The Dinner Party Trust. Photo by Donald Woodman. © Judy Chicago.

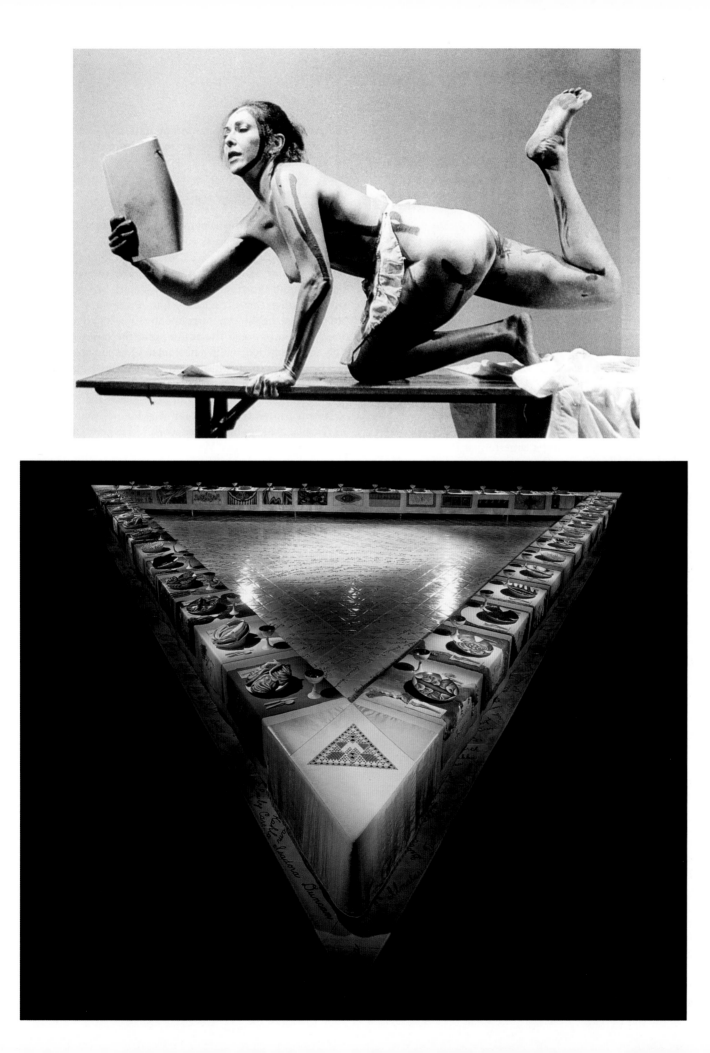

Photography in the Mainstream

In much of the art of the late sixties and early seventies—particularly in conceptual art, performance, temporary installations, and works in remote settings—photography offered the only vehicle for a wider dissemination of the idea. The customary separation of photography into a specialty medium with a discourse apart from the general course of contemporary art, largely disappeared as more artists turned to the camera. William Wegman, for example, began making photographs and short, vaudevillian performance videos in 1969 with a side-splitting, dead-pan humor. The videos typically show the artist in his T-shirt and jeans, working with minimal props and delivering an absurd monolog in a flat, emotionless tone. In 1970 he bought a Weimaraner puppy, which he named Man Ray; in "Ray," he found his ideal collaborator. The dog made a perfect straight "man," accepting every command with absolute sincerity and transparent devotion. Wegman drew goatees, glasses, and berets on photographs of Ray, superimposed the dog's image on evocative settings, and in 1978, when he began using a large-format Polaroid camera, elaborated the ludicrously funny costumes, make-up, and sets for the dog into beautiful compositions of color and texture that made full use of the Polacolor's subtlety [fig. 12.11]. With phrases like "bad dog" or "who's coming," Wegman prompted

12.11 William Wegman, *Polynesian,* 1981. Color polaroid, 24 × 20in (61 × 50.8cm).
Photograph courtesy the artist.

poignant expressions and the pathos of the dog—whose loyalty and wish for affection persists through all manner of indignity—ultimately comes through.

A Dazzling Photorealism

The aesthetic of the photograph also entered painting around 1970. Painters such as Richard Estes and Chuck Close used opaque projectors, slides, and other mechanical aids to produce an image that seemed technically precise and had its point of reference in photography (the reproduced image) rather than in nature. The photograph no longer simply fixed the subject, it became the subject in its intriguing intervention between the painter and the motif. This new "photorealism" fed on the detachment of sixties art—the work of Jasper Johns, minimalism, pop, and conceptual art.

Richard Estes [fig. 12.12] turned to photorealism in 1967, maintaining that he continued to be "an old-fashioned academic painter trying to paint what I see . . . Nor do I have any verbal theories behind the work."[12] He painted nostalgic views of the old upper West Side in a dazzling technique, using photographs as the source for his paintings. The photographs equalized the variety of textures and objects in the scene to a common denominator as formal elements, an effect the artist further enhanced by painting everything in a uniformly sharp focus (unlike photographs).

Many seventies realists specialized in particular subjects, such as Robert Cottigham's paintings of vintage commercial signs and marquees, Robert Bechtle's cars of the fifties and early sixties, and the concentration on old pick-up trucks, diners, and trailers by Ralph Goings [fig. 12.13]. Some painters seem to have gone back to the "one hair brush" in oil paints, as in William Beckman's astonishingly lifelike (and beautifully painted) *Double Nude (Diana and William Beckman)* of 1978, which finds revelation in the minutest details of nature, like a modern Van Eyck [fig. 12.14]. Duane Hanson and John De Andrea perfected a fully lifelike style in sculpture [fig. 12.15]—like the wax effigies of Madame Tussaud, these figures have an unnervingly real presence. By focusing such detailed attention on the polyester homeliness of the average American, Duane Hanson in particular illuminates the real popular culture of America.

Chuck Close painted his 9-foot-high *Self Portrait* [fig. 12.16] and the series of monumental portraits of friends that followed from photographs, using an airbrush (a commercial art technique). As in minimalism, Close set arbitrary rules for himself: the mugshot compositions, the restriction to black and white, the colossal scale. In each case, he carefully prepared the surface with multiple layers of smoothly sanded gesso, laid on a light pencil grid for scaling up the photograph, roughed in the image with the airbrush, and then meticulously refined and finished the image. When Close introduced color in 1970, he overlaid four monochrome paintings (in the primary colors and black) as in the color separations made for color printing. Close made many photographs of the people around him, and when he chose

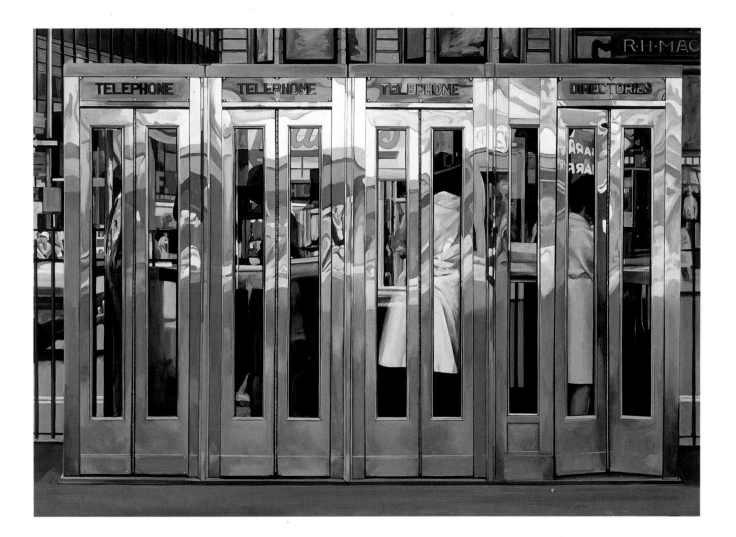

12.12 (above) **Richard Estes,** *Telephone Booths,* 1968.

Fundación Colección Thyssen-Bornemisza
© Richard Estes/VAGA, New York,
Marlborough Gallery, New York.

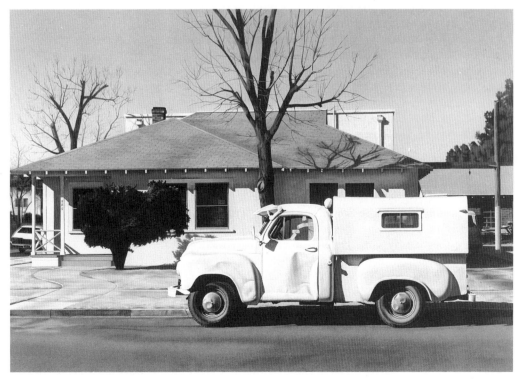

12.13 Ralph Goings, *Moby Truck,* 1970. Oil on canvas, 4ft × 5ft 8in (1.21 × 1.72m).

Private collection. Photograph by D. James Dee, New York, courtesy O.K. Harris Works of Art, New York.

12.14 William Beckman, *Double Nude (Diana and William Beckman)*, 1978. Oil on panel, 5ft 4in × 4ft 11in (1.63 × 1.5m).
Herbert W. Plimpton Collection, Rose Art Museum, Brandeis University, Waltham, Mass. Photography courtesy Frumkin/Adams Gallery, New York, used by permission of Forum Gallery, New York.

12.15 (above) **Duane Hanson,** *Woman with Dog*, 1977. Cast polyvinyl, polychromed in acrylic, with mixed media, life-size.
Collection, Whitney Museum of American Art. Purchase, with funds from Frances and Sydney Lewis. Photograph by Gerry L. Thompson, New York.

one to paint he based his selection on whether the forms in the photograph had interesting edges to paint. Once he had selected the subject, his process was so methodical that he could accurately calculate the length of time it would take to finish a work by measuring the area left to be painted and could also visualize exactly how the finished work would look.

Audrey Flack broke through from a conventional, late-fifties style of gestural realism in 1971 to a disturbingly garish photorealism, charged with an equally unsettling personal content. Using an airbrush to create the effect of the slick surface and the depth of field variations of a photograph, she composed still-life objects as in a baroque allegory. In *Marilyn (Vanitas)* of 1977, for example [fig. 12.17], Flack painted a lexicon of classic symbols for vanity (the make-up pots, lipstick, mirrors), the ephemerality of life (the burning candle, the flower, the shifting hourglass), and eroticism (the open peach and orange and the pears). "We were touched by some deep pain and beauty in her [Marilyn Monroe],"[13] Flack said. Meanwhile Flack also included a childhood photograph of herself, leaving no doubt that she also intended an exploration of her own vulnerabilities through the subject.

12.16 Chuck Close, *Self Portrait*, 1968. Acrylic on canvas, 8ft 11½in × 6ft 11½in (2.73 × 2.12m).
Collection, Walker Art Center, Minneapolis, Art Center Acquisition Fund, 1969.

12.17 Audrey Flack, *Marilyn (Vanitas),* 1977. Oil over acrylic on canvas, 8 × 8ft (2.44 × 2.44m).
Collection, University of Arizona Museum of Art, Tucson. Purchased with funds provided by the Edward J. Gallagher, Jr., Memorial Fund.

Entering the Real Space

Pop art's attack on the boundary between high and low art, minimalism's sense of literal presence in real space, and the undermining of the aesthetic object *per se* in conceptual art prompted a number of artists in the seventies to enter their work into a non-art context. Scott Burton's functional sculpture [fig. 12.18] deliberately hovers over the ambiguous line between fine and applied art. Burton made functional objects but drew on an art tradition—Artschwager, Judd, Tony Smith—for his formal vocabulary, and the audience for his work was an art audience.

Populists like Terry Schoonhoven and Victor Henderson (who made up the "L. A. Fine Arts Squad") simply weren't concerned with the approbation of the art world. Startling illusionistic paintings on blank walls in the workaday environment of the inner city sprang up in neighborhoods around the United States at the beginning of the decade. These artists often chose topical themes, as in the depiction of the *Isle of California* [fig. 12.19], painted just after the earthquake of 1971.

Richard Haas also started painting the sides of buildings in the seventies [figs. 12.20 and 12.21], but he nostalgically delved into the real architectural past of his sites, making his murals seem even more real by their total integration into their visual and historical contexts. "My work," Haas explained, often involves, among other things, bringing back an aspect of a place that was somehow lost."[14] Even in his most historicist moments, however, Haas did not render the past with complete faithfulness—he chose instead to adjust the architectural past of the site to what had evolved around it since. Haas thus effectively unhinges historical styles, using them in a decidedly post-sixties (postmodernist) collage of architectural fantasy. In the dramatic cutaway-rendering on the west wall of the Boston Architectural Center (seen here both before and after its completion in 1977), Haas amalgamated Etienne-Louis Boullée's visionary project for a museum of the 1780s, the early-nineteenth-century Federal Hall in New York, and the profile of the dome on the Pantheon in Rome with echoes of the nearby Christian Science complex in the Boston Back Bay.[15]

Alison Sky, Michelle Stone, and James Wines chartered SITE Projects in 1970, addressing the singularly non-art audience that populates retail chain stores and shopping mall parking lots—as in their 1978 *Ghost Parking Lot* in Hamden, Connecticut [fig. 12.22]. Theirs is a more genuinely "pop"ular art sensibility than that of Haas and is largely a design practice rather than art. But the collaborative nature of SITE's design process, as well as the brilliantly imaginative results, reflects the unanchored multiplicity of overlapping frames of reference that characterized the cultural climate of the seventies.

12.18 Scott Burton, *Two-Part Chairs' Obtuse Angle (A Pair),* 1983–4. Granite, 33 × 24 × 33in (83.8 × 61 × 83.8cm) each.
Collection, Walker Art Center, Minneapolis. Gift of the Butler Family Fund 84.3. Photograph courtesy Max Protetch Gallery, New York.

12.19 (above) **Los Angeles Fine Arts Squad** (Terry Schoonhoven and Victor Henderson), *Isle of California*, 1972. Enamel on stucco, 42 × 65ft (12.8 × 19.81m).
Los Angeles, California.

12.20 (right) Boston Architectural Center before the painting by Haas.

12.21 (below) **Richard Haas,** Boston Architectural Center, with *trompe-l'oeil* painting by Haas, 1977.
© Richard Haas/VAGA, New York.

Public Sites

Increasing numbers of talented artists gravitated to civic and corporate design commissions in the seventies and eighties, reintroducing a vitality that had largely disappeared from view in the subways, airports, parks, and sterile corporate structures of the fifties and sixties when the best artists retreated into a more autonomous context for their work. Joyce Kozloff's 1990 ceramic tiles for the Plaza Las Fuentes in Pasadena provide an exuberant reprieve from the working milieu of the city [fig. 12.6].

Jackie Ferrara also began collaborating with architects and working in public spaces at the end of the seventies. The most interesting aspect of her work has persistently been the injection of an eccentric individuality into highly schematic programs of construction, whether in a small piece of sculpture such as *A209 Zogg* [fig. 12.23] or in the 100-foot-square floor pattern for the *Garden Courtyard* of the Fulton County Government Center in Atlanta (a collaboration with the architect Paul Friedberg) [fig. 12.24].

Ferrara had been involved in the happenings of the late fifties and early sixties and made small sculptures during the sixties in funky materials. One series involved a batch

12.22 James Wines, SITE, *Ghost Parking Lot,* 1978. Plaza and environmental sculpture, Hamden, Connecticut. Used automobiles, bloc bond, and asphalt.

of 400 stuffed pigeons, which she acquired from a taxidermist's warehouse in 1964.[16] Ferrara's work of the early seventies hints at that background in the eccentricity of the form of works such as *Zogg*, set off by their meticulous planning and construction. The artist titled *Zogg* after the personality it took on, "awkward looking, pugnacious, even kind of ugly . . . And I confess I thought of Godzilla too."[17]

The drawings for a Ferrara sculpture are integral to the meaning. In a work such as *Zogg*, Ferrara attempted to visualize all aspects of the sculpture in drawings and in her head, then she would figure out the measurements for each of the small wooden elements, list them (there could be a hundred or more), cut each of them precisely and then, working from the plan, neatly construct the form. The drawings include the cutting list and various views—aerial perspectives, isometrics, side elevations, and particularly complex views which the studies on paper helped her visualize. The juxtaposition of the three-

Surviving the Corporate Culture of the Seventies

12.23 Jackie Ferrara, *A209 Zogg,* 1980. Pine, 112 × 46½ × 31½in (284.5 × 118.1 × 80cm).
Collection, Donald Sussman, Greenwich, Conn. Photograph by Roy M. Elkind, courtesy the artist.

12.24 (below) **Jackie Ferrara,** *Garden Courtyard,* 1989. Collaboration with M. Paul Friedberg, granite and slate steps, walkways, platforms, seating; water, grass, and trees, 100 × 100ft (30.48 × 30.48m).
Fulton County Government Center, Atlanta, Georgia. Photograph courtesy the artist.

12.25 Tadashi Kawamata, *Spui Project,* May–July 1986.
Spui Street, The Hague. Supported by the Haags Gemeentemuseum. Photograph by Leo van der Kleig Studio, The Hague.

12.26 (below) **Mary Miss,** *Pool Complex: Orchard Valley,* 1985. Curved walkway, wood, stone, concrete, 3-acre (1.21-ha) site.
Collection, Laumeier Sculpture Park, St. Louis, Missouri. Photograph by Mary Miss.

dimensional form with the various two-dimensional interpretations of it in the drawings intriguingly highlights the relation of an idea to the variety of possibilities for interpreting it in material form, and despite all the careful planning each work yields unexpected revelations in its three-dimensional incarnation.

The Japanese sculptor Tadashi Kawamata trained as a painter. Then he said, "it seemed to me that the structural support of the canvas, i.e. the wooden frame, could itself become the basis of my work."[18] In 1979 he began constructing ever-more complex temporary installations of wood. Like the *Spui Project,* which he constructed over the spring and summer of 1986 in the Hague, most of these site projects involve the spirit of an architectural space or structure [fig. 12.25].

The site projects of Mary Miss—for example the one at Laumeier Park in St. Louis [figs. 12.26 and 12.27]—have an affinity to Noguchi's gardens in that they promote an individual and intimate encounter with nature, but where Noguchi relied on natural form, Miss created a more complex experience of sculpture as space. "When I am looking at structures that interest me," she has noted, "I am focusing on the experience I am seeing contained within them."[19] The work of Mary Miss draws on early

12.27 Mary Miss, *Pool Complex: Orchard Valley,* 1985. Wood, stone, concrete, 3-acre (1.21-ha) site.
Collection, Laumeier Sculpture Park, St. Louis, Missouri. Photograph by Mary Miss.

memories of the American West, particularly on prehistoric sites such as Mesa Verde, which she visited as a child. When she came to New York from Colorado in 1968 her work seemed preoccupied with recapturing that experience of the extended landscape in the confined space of her New York studio, something she tried to do by distributing the compositional elements in implicitly infinite sequences across the floor.[20] By the end of the seventies she had moved into ambitious excavation and construction projects in the natural landscape, as in the Laumeier piece.

Appropriated Sites: Charles Simonds

Charles Simonds came to be known on the Lower East Side of New York in the early seventies not for commissioned site works but for work in appropriated sites. Unsuspecting pedestrians would happen upon his miniature clay villages [fig. 12.28] under eaves, in cracked walls of condemned buildings, and on outdoor window ledges, where most were eventually lost to the elements or to the curious, who destroyed them in trying to take them home. These dwellings, which look like miniature ancient ruins, have to do with a sense of dynamic transition from the ephemeral present to a mysterious and undisclosed future. Simonds elaborated mythological civilizations of "Little People" that moved on, through organic growth and chance encounters, to perpetually evolving self-conceptions. Their cosmologies were reflected in their styles of building and they left a natural history in these artifacts as they migrated through different neighborhoods of New York, building and then abandoning sites.

The dwellings of Charles Simonds concern organic growth in architecture, culture, and civilization and their evolution began with the earth—literally, the clay from which they are all made. In 1970 and 1971 Simonds did a couple of important generative pieces using his own body: In *Birth* he buried himself in a New Jersey clay pit and enacted a filmed rebirth from the earth, while in *Landscape/Body/Dwelling* he lay down nude on the ground, covered himself with clay, modeled his body into a landscape and built a dwelling on his torso. The contact with the earth was a directly sensuous experience in both of these body works, and their sequence mirrored the development from the earth of animal life, culminating in mankind, which in turn built dwellings, and then communal civilizations.[21]

The dwellings in empty lots and the like followed directly on these body pieces. The impermanence of the outdoor pieces, fragile and exposed in the most vulnerable settings, heightens that sense of the evanescence of things. They leave the viewer with the unsettling conviction that someone has lived there but has now mysteriously vanished—indeed, one might return tomorrow for another look only to find even these small traces gone. For Simonds, this was a gesture against the materialism and conformity of

12.28 Charles Simonds, *Dwelling,* detail, 1981. Unfired clay wall relief, 8 × 44ft (2.44 × 13.41m).

Collection, Museum of Contemporary Art, Chicago. Gift of Douglas and Carol Cohen, 81.19. © 1994 Charles Simonds/Artists Rights Society (ARS), New York.

the corporate culture of the seventies. "If you leave thoughts behind you that other people can develop," Simonds pointed out, "you've had an effect on how the world looks or how it's thought about. I don't see any reason to leave behind 'things' which lose their meaning in time, or even exist as a symbol of meaning at a given time past."[22]

Gordon Matta-Clark's Site Critiques

Like Simonds, Matta-Clark appropriated sites for a social critique, and as in the site projects of Mary Miss and Kawamata, his work involved a sense of place rather than form. But instead of constructing a site, Matta-Clark attacked the structural integrity of existing buildings, cutting gaping holes through the walls, ceilings, and floors as shown in the pair of photos entitled *Bronx Floors: Floor Above, Ceiling Below* [fig. 12.29]. "I wanted to alter the whole space to its very roots," he explained. "[This] meant a recognition of the building's total (semiotic) system, not in any idealized form, but using the actual ingredients of a place."[23]

Matta-Clark's "anarchitecture," as he called it—a play on words, fusing anarchy and architecture—was a deliberate political expression. "By undoing a building," he said, "there are many aspects of the social conditions against which I am gesturing."[24] He saw the housing of the New York ghettos as akin to prison cellblocks, and the isolation of the suburban "box" as scarcely any better. Matta-Clark's aim was to destroy the barriers between people, literally and figuratively opening up these "non-u-mental"[25] structures, to use another of his acerbic puns. Matta-Clark's aggressive "destructuring" was designed to create a new biography for abandoned buildings, "to convert a place into a state of mind."[26]

The son of the surrealist painter Matta, Gordon Matta-Clark studied architecture at Cornell and the Sorbonne, returning to New York in 1969 to make sculpture. He died of cancer in 1978 at the age of only thirty-five, but his short career nevertheless had a profound effect on the tone of the New York art scene in the seventies, undermining fixed ideas of art as a cohesive entity. He also figured importantly in fostering a sense of community among young artists in SoHo at the time, helping to organize a collective exhibition and work space at 112 Greene Street as well as an inexpensive cafeteria called Food run by and for artists in the neighborhood. Vito Acconci, Alice Aycock, Jackie Ferrara, Joseph Kosuth, Dennis Oppenheim, Susan Rothenberg, Alan Saret, and Richard Serra were just a few of the artists who ran into one another at 112 Greene Street, and the range of styles among this group of artists once again points to the pluralistic attitude of the decade.

Matta-Clark courted danger on several counts—gangs roamed the deserted neighborhoods in which he worked, he risked being caught by police (since he generally cut up these abandoned buildings without permission from their owners), and his assault on the support systems of the buildings made them liable to structural collapse. This recklessness was manifested in other ways too—in 1976 he was invited to participate in an exhibition for artists and architects called "Idea as Model," but instead of submitting a proposal for new architecture he decided to exhibit photographs of the current state of some former "model buildings" in the South Bronx in which the occupants had smashed out the windows. On the eve of the show's opening he used Dennis Oppenheim's BB gun to shoot out the windows of the gallery to drive the point home. (They were repaired in time for the opening but the unhappy organizers removed Matta-Clark's work from the show.)

In 1974 Matta-Clark cut a suburban New Jersey house in half and chopped out the corners [fig. 12.30]. The house was scheduled for demolition and belonged to the art dealers Holly and Horace Solomon, who sponsored the project. Like all of Matta-Clark's work, *Splitting: Four Corners* was undocumentable. The artist exhibited fragments cut out of his various projects and struggled to find a way of collaging photographs to suggest the radical feeling of his idea, but nothing could recapture the sensation of entering the spaces he altered. As the painter Susan Rothenberg recalled from her experience of *Splitting*: "From outside, the cut had a real formal look. The insides were like a chasm opening up the earth at your feet. Realizing that a house is home, shelter, safety . . . being in that house made you feel like you were entering another state. Schizophrenia, the earth's fragility, and full of wonder."[27]

The Complexity That Is Culture

Culture is never an orderly package, but an accumulated sediment in the mind. It consists of all the ideas, people, things, and events that are assumed by or seem commonly memorable to the participants. The multiplicity of (often contradictory) directions in the art world of the seventies was new not because other periods weren't equally complex, but because the art world had begun to recognize that diversity as defining its "mainstream."

12.29 Gordon Matta-Clark,
Bronx Floors: Floor Above, Ceiling Below, 1973.
Site project in a building in the Bronx, New York.
Photograph courtesy Jane Crawford.

12.30 Gordon Matta-Clark,
Splitting: Four Corners, exterior,
1974. Six black-and-white
photographs, two 12½ × 8¼in
(31.8 × 21cm) each and four
16 × 20in (40.6 × 50.8cm).
Photograph by Adam Reich, courtesy Holly
Solomon Gallery, New York.

Romare Bearden

Romare Bearden, an African-American contemporary of the abstract expressionists, enjoyed a rediscovery after his retrospective at the Museum of Modern Art in 1971. He began his artistic career as an undistinguished social realist during the W.P.A. and then painted in established idioms through the forties and fifties. In 1964 he turned to collages of African-American life and emerged as the most brilliant new collage-maker of the decade. Two traits in particular made his work after 1964 so important and relevant to the changing cultural ethos of the seventies and eighties. First, he anticipated the collage aesthetic of postmodernism by his recontextualization of images into a perception of reality on the picture plane. Secondly, the way in which he brought his own Afro-Caribbean cultural heritage into a rich relation with the Eurocentric traditions in which he was formally educated provides a paradigm for the awakening of a broader multiculturalism.

"I work out of a response and need to redefine the image of man in the terms of the Negro experience I know best," Bearden said.[28] Until his death in 1988 he applied his acute powers of observation to contemporary African-American life, in which he found variations on the timeless human concerns raised by writers of the Western classical mainstream from Homer to Joyce, and by the more recent African-American writers, notably Ralph Ellison, Richard Wright, and James Baldwin. In addition, he drew on a sophisticated understanding of art history (favoring styles of maximum complexity, such as the baroque and Picasso's early cubism) to describe the variety of street life in the Harlem of his childhood and his memories of black life in the rural South. The inherent prominence of improvisation and appropriation in collage made it the ideal form for such an aesthetic. The fact that cubist collage was itself partly derived from the complex rhythms and analytical fragmentations of African art may have made it all the more

attractive to Bearden. In adapting the language of collage for his particular expressive synthesis, Bearden broadened the canon of art history with a contribution that was significant not only in terms of its subject matter but in its approach to the medium.

Bearden was born in Charlotte, North Carolina, in 1912, and was reared in North Carolina, Pittsburgh, and Harlem. He earned a degree in mathematics at New York University in the early thirties and began to paint seriously around 1935. It was in that year that he attended a meeting of about fifty African-American artists at the Harlem YMCA, out of which the Harlem Artists Guild was formed.[29] Discovering the existence of a substantial community of black artists was important in helping Bearden to visualize himself as a professional painter. The "Harlem Renaissance" of the late twenties and early thirties (a great flowering of African-American art, celebrating African-American subjects) made this a particularly auspicious moment for Bearden to seek such models.

In the late thirties, Bearden studied with George Grosz at the Art Students League. The work of this German expatriate [fig. 12.31] provided Bearden with a model of direct social and political commentary in high art which ultimately encouraged him to see the possibilities of an African-American subject matter.[30] Bearden served in the military during World War II, showed with the abstract expressionists at the Samuel Kootz Gallery in the late forties, and went to Paris on the GI Bill in 1950. It was the Civil Rights movement in the early sixties, together with his discovery of black Caribbean culture on the island of St. Martin in 1960, that seems to have galvanized him into focusing his artistic gifts on the complexity of the black experience, with all its heritage and adaptations, in late twentieth-century America.

Bearden's Collages of the Sixties

*T*he *Dove*, a collage of 1964 [fig. 12.32], portrays contemporary Harlem, overlaid with reminiscences of childhood. The busy scene, crowded into a shallow pictorial space, vibrates with activity. On the left a figure lifts his enlarged fist in a black power salute. A hunched-over pedestrian scurries from the left side toward the center as a young dandy struts across the picture from the opposite direction, sporting a cap, pulled down over his eyes on his oversize head, and holding a large cigarette between monumental fingertips. Three men sit contemplatively on their stoops, watching the life of the neighborhood pass by, and from everywhere faces peer out on to the street. A mysterious "conjur woman" with a half-veiled face reaches out and steps down into the right corner of the picture, leaning on a caduceus of intertwined stalks (a symbol of both

12.31 George Grosz, *Circe*, 1927. Watercolor, pen and ink, and pencil on paper, 26 × 19¼in (66 × 48.9cm).
The Museum of Modern Art, New York. Gift of Mr. and Mrs. Walter Bareiss and an anonymous donor (by exchange). © Estate of George Grosz/VAGA, New York, 1994.

12.32 (below) **Romare Bearden,** *The Dove*, 1964. Cut-and-pasted paper, gouache, pencil, and colored pencil on cardboard, 13⅜ × 18¾in (34 × 47.6cm).
The Museum of Modern Art, New York. Blanchette Rockefeller Fund. © Romare Bearden Foundation/VAGA, New York.

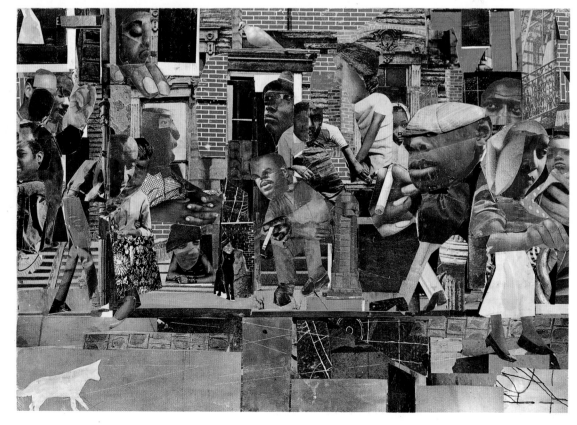

Surviving the Corporate Culture of the Seventies

Hermes and of the medicine healer). "Even in Pittsburgh, living in the house in back of my grandmother's," Bearden recalled, "there was an old woman much feared for her power to put spells on people."[31]

The unpopulated foreground in *The Dove* sets off the intensity of the street life, which seems overpopulated to the bursting point, while the radical fragmentation and shifts in scale within in each form keep the viewer constantly readjusting. In some details, such as the legs of the hunched-over walker, Bearden has cut forms from photographs of patterns and textures that bear no relation in source or scale to the object they are called on to represent in the collage. Even more than in the contemporary works of Rosenquist, these semiotic breaks in the description of every detail increase the visual speed of the work, with the strong vertical and horizontal grid making the visual cacophony even more pronounced. *The Dove* pays homage to the cubist grid as a way of setting off the energetic fragmentation of the subject. The brick wall in the background, obstructing a long view into space, is directly inspired by seventeenth-century Dutch street scenes such as those by de Hooch. Meanwhile, the dove of the title,

perched above the central doorway, suggests the presence of Christian faith as a part of the overall setting, without, however, suggesting any systematic allegory.

Bearden's collages have some recurrent symbols, such as the train in the upper left corner of the *Prevalence of Ritual: Baptism* [fig. 12.33], for example. "I use the train," he explained, "as a symbol of the other civilization—the white civilization and its encroachment upon the lives of blacks. The train was always something that could take you away and could also bring you to where you were. And in the little

12.34 (opposite) **Romare Bearden,** *Black Manhattan*, 1969. Collage of paper and synthetic polymer paint on composition board, 25⅜ × 21in (64.5 × 53.3cm).
Art and Artifacts Division, Schomburg Center for Research in Black Culture, New York Public Library. Astor, Lenox and Tilden Foundations. © Romare Bearden Foundation/VAGA, New York.

12.33 Romare Bearden, *Prevalence of Ritual: Baptism*, 1964. Photomechanical reproduction, synthetic polymer and pencil on paperboard, 9⅛ × 12in (23.2 × 30.5cm).
Collection, Hirshhorn Museum and Sculpture Garden, Smithsonian Institution, Washington, D.C. Gift of Joseph H. Hirshhorn, 1966. Photograph by Lee Stalsworth. © Romare Bearden Foundation/VAGA, New York..

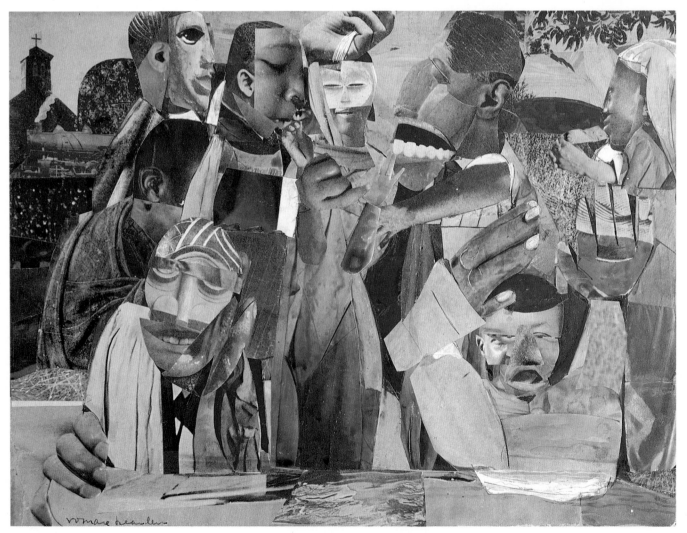

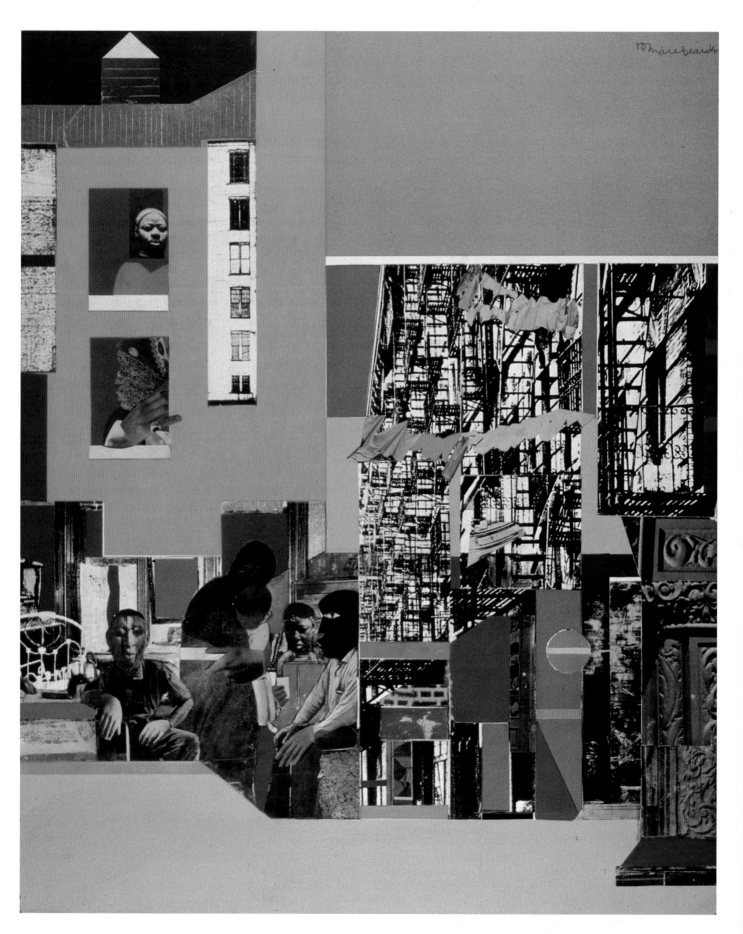

towns it's the black people who live near the trains."[32] Yet Bearden seems always to stop short of confining himself within a deliberate iconography of any kind. Instead, the conceptual unity of his work centers on his acute observation of the people and the way his improvisational technique conveys the pace and rhythm of their lives. Moreover he collages the subject matter, like the forms, in an additive manner that is distinctly postmodern.

In the *Prevalence of Ritual: Baptism*, Bearden consciously quotes historical styles of art in the four faces borrowed from West African masks, and in a general way he also quotes art history in the compositional structure, which takes inspiration from the paintings of Zurburan, as Sharon Patton has pointed out.[33] In *The Dove*, the conjur woman with her mysterious knowledge of African spiritual powers is an alternative incarnation of the Greek oracle. In the same way, the art historical appropriations in *Prevalence of Ritual: Baptism* are another means of filtering the events of life and memory through the myths of other eras and cultures. "I seek connections so that my paintings can't be only what they appear to represent," Bearden explained. "People in a baptism in a Virginia stream are linked to John the Baptist, to ancient purification rites, and to their African heritage."[34] This multiplication of voices makes clear Bearden's proprietary attitude toward all great traditions in art and literature.

At the end of the sixties, Bearden augmented his innovations in collage composition—especially the speed of the informational breaks in the fragmentation of individual figures—with a unique color sense, involving large, flat areas of intense saturation and often contrasting hue. By juxtaposing complementary colors of the same value (brightness), like the orange and blue in *Black Manhattan* [fig. 12.34], for example, Bearden made the colors vibrate with the same frenetic intensity as the imagery while simultaneously using the blankness of the orange, gray, and blue fields to set off the busy collision of patterns and forms around them. Bearden—a one-time song writer, whose love of jazz profoundly influenced the percussive contrasts of pattern, color, and subject matter that defined his collage—created a harmony of inclusiveness in his style, a celebration of complexity rather than a modernist reduction that excludes the extraneous.

Alice Aycock

The variety of competing logics assimilated into Alice Aycock's art give it a fantastic character. In a single work she may overlay suggestions from a Babylonian diagram explaining the structure of the universe, the tumbler on a cement truck, the image of an angel floating on a yellow cloud in an obscure Renaissance painting, and a chart of the paths of particles in a nuclear accelerator. Each implies a system of ideas to her, and she visualizes such ideas into forms and even machines that function, not as symbols, but as incarnations of cross-tracking trains of thought; they are maps of the mind. Aycock uses her art as a vehicle for living the fullest range of different discoveries and ways of thinking that she can encompass at any one time. In this sense, her work epitomizes what was genuinely new about the pluralism of the seventies. She approaches sculpture as an interdisciplinary arena for exploring ideas, an open system which perpetually expands and thus, by definition, undermines all canons.

Aycock has generated her prodigious output of sculpture and drawings by weaving her sources into richly detailed stories. She scans across historical experiments in science, linguistic structures, and the magical fantasies of children; she may imagine herself as that particle traveling through an accelerator or see the drum of the cement truck as a whirling vortex that opens a hole in the universe with a stairway to paradise. Curiosity overcomes fear in Aycock's work—a frightening whirring of blades or an awesome breakthrough in astrophysics will draw her in for a closer look and she masters the technology through projections of imagination.

I want to crack it open. A machine is a tool and the tool is a mental extension of your body . . . it reflects on the structure of your mind. It's that that I'm interested in, the structure of the mind . . . my work is a very personal attempt to deal with the period that we are in . . . Duchamp who really had one foot in the Middle Ages and the other in quantum mechanics . . . played very poetically with these ideas . . . I play with history. It's also necessary to play with science.[35]

At the very core of Aycock's self-realization as an artist is an early childhood memory of watching her father, an engineer and contractor, build a small model of a house. It was so small she could hold it in her hand.

Night after night, I would watch him make this. Afterwards, he gave me the model to play with and he built the house. This was the house I grew up in. So I had an experience which I think was very important because I could mentally possess something, control it, see it as a whole, literally hold it in my hand and then later, I was inside of it, surrounded by a physical, large structure. I was given an early chance to conceptualize a space that I would live in. A space in which all sorts of emotional events took place. But it was a visual concept.[36]

In 1972 Aycock built a wooden maze 32 feet across on an isolated farm in Pennsylvania. She was fresh out of her master's degree at Hunter College, where Robert Morris had encouraged her interest in making sculptures as tools for exploring certain experiences. Bruce Nauman's video corridors also suggested to her this kind of psychological confrontation with oneself. Aycock got the idea for *Maze*

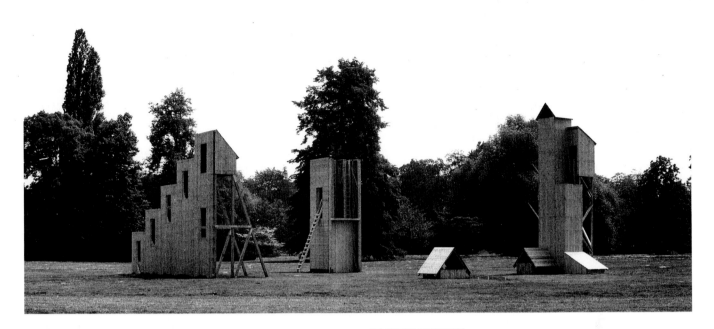

12.35 (above) **Alice Aycock,** *Project Entitled "The Beginnings of a Complex . . .,"* 1977, Dokumenta, Kassel, Germany. Wood and concrete, wall façade: 40ft (12.19m) long, 8ft (2.44m), 12ft (3.66m), 16ft (4.88m), 20ft (6.1m), 24ft (7.32m) high respectively; square tower: 24ft (7.32m) high × 8ft (2.43m) square; tall tower group:32ft (9.75m) high.

Photograph courtesy the artist. © Alice Aycock, 1994.

12.36 (below) **Alice Aycock,** *Project Entitled "The Beginnings of a Complex . . .,"* 1977, Dokumenta, Kassel, Germany. Interior view looking down into shaft with ladder.

Photograph courtesy the artist. © Alice Aycock, 1994.

Surviving the Corporate Culture in the Seventies

from the circular plan for an Egyptian labyrinth which she came across in the *World Book Encyclopedia* while looking for a definition of magnetic North. "Originally, I had hoped to create a moment of absolute panic," she said, "when the only thing that mattered was to get out."[37]

Aycock's work through the mid seventies centered on physical actions that led to a conflicting mixture of extreme psychological sensations from claustrophobia to exhilaration. In her seminal *Low Building With Dirt Roof (For Mary)* (1973), the viewer had to crawl on all fours into the entrance of the 3-foot-high shack, under a roof laden with 7 tons of earth. One felt frightened and closed in by the weight overhead, and yet oddly secure as in a dream state. *Project Entitled "The Beginnings of a Complex . . ."* [figs. 12.35 and 12.36], an elaborate wooden complex which Aycock built for the "Dokumenta" exhibition in Germany in 1977, consisted of five separate structures connected by a system of underground tunnels. The subterranean maze provided the only access to the interior ladder which in turn led up into the enclosed tower. When one finally did emerge from the dark, crushingly narrow tunnels of the labyrinth into the light, one was trapped in a well shaft or tower.

Project Entitled "The Beginnings of a Complex . . ." simultaneously evoked claustrophobia, euphoria in the sensation of heights, and at the same time vertigo. The narrow and low underground passages referred back to Aycock's trip in 1970 to the Egyptian pyramids and the Greek beehive tombs at Mycenae, when she fantasized about being buried alive at the heart of these great masses of stone and earth. Many of Aycock's works of the seventies and early eighties forced the viewer into seemingly dangerous situations, as in a frightening amusement park attraction.[38] In 1979 she constructed *The Machine That Makes the World*, a fenced-in wooden maze that leads the viewer under a series of heavy steel guillotines into a

confining circular labyrinth and in the early eighties, she built a series of motorized blade machines that seemed sharp and dangerous. In these works she courted disaster with obvious pleasure—the fear inherent in them has an almost erotic quality. "I like to scare myself for the pleasure of it," she said.[39]

Seeing 2,000 people climbing around on the construction for "Dokumenta" undermined for Aycock the privacy of this psychologically complex experience, and in *The Angels Continue Turning the Wheels of the Universe* [fig. 12.37], her next major work, the viewer could enter in concept only. In this installation, she constructed a detailed set that implied an extended dramatic narrative. "Because the archaeological sites I have visited are like empty theaters for past events, I try to fabricate dramas for my buildings, to fill them with events that never happened," she explained.[40] Aycock took inspiration for *The Angels Continue* from many sources, including an Islamic diagram describing how a rainbow forms, medieval paintings of angels levitating in mid-air (only a levitating angel could ascend the inverted stairs), and frightening childhood memories and dreams.

On 1979 Aycock moved from the wooden structures to apparatuses that resembled the laboratory in a vintage Frankenstein movie, as in her *How to Catch and Manufacture Ghosts* (1979). She had read somewhere that when people first discovered electricity and magnetism they thought those phenomena were magical and could be used to conjure up ghosts. As her imagination went to work on this she concluded that ghosts probably come out of light, so she constructed *How to Catch and Manufacture Ghosts* with intense theater lights trained on a platform surrounded by various elements of steel, glass, and wire. A live woman was recruited to sit on a bench, blowing bubbles at a pan of water, in which there was a bottle with a little bird inside. Attached to the pan was a "lemon battery," taken from the

12.37 Alice Aycock, *The Angels Continue Turning the Wheels of the Universe: Part II In Which the Angel in the Red Dress Returns to the Center on a Yellow Cloud Above a Group of Swineherds,* 1978. Wood, 23ft × 23ft × 16ft 3in (7 × 7 × 5m). Stedelijk Museum, Amsterdam, destroyed. Photograph courtesy the artist.
© Alice Aycock, 1994.

12.38 Alice Aycock, *From the Series Entitled How to Catch and Manufacture Ghosts, "Collected Ghost Stories from the Workhouse,"* 1980. Cable, copper, galvanized steel, glass piping, steel, wire, wood, 30 × 75 × 120ft (9.14 × 22.86 × 36.58m). University of South Florida, Tampa. Photograph courtesy the artist. © Alice Aycock, 1994.

instructions in a science book for children.

When the work was first shown, Aycock put a quotation on the wall beside it from a schizophrenic who had written down his dreams. "This person really felt that he was the air, he thought that he had created Alaska, he felt speed moving through his body, he felt himself being pushed along the walls, and all the time he seemed to be experiencing sensations which we can only imagine. In one of his writings he said 'sometimes I dream my mother dreaming me and that's how I travel home.' "[41]

What Aycock liked especially in this man's writings was that she could identify with the way he thought, "with the simultaneous insertion of multiple levels of diverse matter that I go through when I make a piece."[42] As an example: "He would talk about moving through space and time. At one moment he was fighting a battle with the archangel Michael in the sky and at the next moment, because he had eaten beef stew and he was not supposed to, he caused World War I."[43]

Metaphor Replaces Physicality in Aycock's Work of the Eighties

*F*rom the Series Entitled How to Catch and Manufacture Ghosts, "Collected Ghost Stories from the Workhouse" [fig. 12.38] developed out of *How to Catch and Manufacture Ghosts.* To visualize the parts, the artist borrowed from early experiments in electricity, a Standard Oil refinery on the New Jersey Turnpike which resembles a futuristic city, the launch pad for Montgolfier's pioneering balloon ascent of 1783, and elements of Marcel Duchamp's *Bachelor Apparatus.*

According to the artist the galvanized drums—which resemble Duchamp's *Chocolate Grinder* (from the *Bachelor Apparatus*)—are " 'agitation canisters.' When I was a child I thought that my soul looked like the inside of a washing machine . . . So I designed this with a movement like that."[44] The canisters and platform have multiple mechanized parts and originally she intended the work to include live birds in cages as well, though that proved too problematic.

Alice Aycock's work from the late seventies through the mid eighties re-creates the magic, the nostalgia, and the mysterious threatening forces of dreams. Often, individual works comprise only a small fragment of what initially seems like a convoluted narrative but which does not actually follow the sequential logic of a narrative at all. Her blade machine of 1984, *A Salutation to the Wonderful Pig of Knowledge (Jelly Fish, Water Spouter, . . . There's a Hole in My Bucket, There's a Hole in My Head, There's a Hole in My Dream),* [fig. 12.39], has a disquieting presence, with moving glass blades and electrical parts that seem dangerous to approach. Yet at the same time the imaginative bravado of the title and the innocence with which Aycock had manipulated these forbidding materials and devices suggests the transformative power of a child's fantasy.

The ambiguity of the title in this work mirrors the double-edged formal conception. The grand gesture implied in the "salutation," and the reference to the repetitious children's song "There's a hole in my bucket" evoke warm images of childhood. Casting knowledge as a pig and twisting the innocent song into an expression of existential disillusionment turns these sensations inside out. The title and the piece are childlike in their vulnerability, and yet cruel. The poetry of the work lies in this

12.39 Alice Aycock, *A Salutation to the Wonderful Pig of Knowledge (Jelly Fish, Water Spouter, . . . There's a Hole in My Bucket, There's a Hole in My Head, There's a Hole in My Dream),* 1984. Mixed media, 11ft 7in × 9ft 4in × 6ft 10in (3.53 × 2.85 × 2.08m).
Photograph courtesy the John Weber Gallery, New York. © Alice Aycock, 1994.

12.40 (opposite, top) **Alice Aycock,** *Circling 'Round the Ka'Ba: The Glass Bead Game,* 1985. Pencil, pastel, and watercolor, 4ft 9½in × 6ft 11in (1.46 × 2.11m).
Private collection, New York. © Alice Aycock, 1994.

12.41 (opposite) **Alice Aycock** drawing *Circling 'Round the Ka'Ba: The Glass Bead Game,* 1985.
Photographer unknown.

juxtaposition of the delicately elaborated associations to childhood and the perversely threatening character of the physical components.

After the treacherous blade machines and magical complexes such as *The Wonderful Pig of Knowledge* and *Collected Ghost Stories from the Workhouse,* Aycock stepped into a more abstract and philosophical mode during the mid eighties, concentrating on esoteric diagrams of the universe and mystical languages. In a drawing of 1985 entitled *Circling 'Round the Ka'Ba: The Glass Bead Game* [figs. 12.40 and 12.41], Aycock rendered the universe as a board game. The swirling forms at the center derive in part from a Renaissance representation of the cosmos by the English mystic Robert Fludd (whose fanciful drawings also inspired the curving forms for many of Aycock's blade machines). Aycock metamorphosed these swirling curves into the idea of a small, disk-like amphitheater, for which she found prototypes in the constructivist "Total Theater" designed by

Walter Gropius for Berlin in 1927. At the center is the secret edifice of the Ka'Ba, a Moslem shrine in Mecca that houses a black stone said to have been given by the archangel Gabriel to Abraham—the object toward which Moslems all over the world face to pray. Ka'Ba also means "box" in Arabic, and a "black box" is the term used in science for an "unknown" to be deduced by experiment. Here it embodies a cosmic mystery that one can't penetrate; it is also a shack, like the *Low Building With Dirt Roof (For Mary)* (1973). So the drawing combines architecture, nature, and the magic that is in so much of her work.

In *Tree of Life Fantasy: Synopsis of the Book of Questions Concerning the World Order and/or the Order of Worlds* [fig. 12.42] of 1990 to 1992, Aycock turned the stepped amphitheater upright, making it vertical "so that the steps are

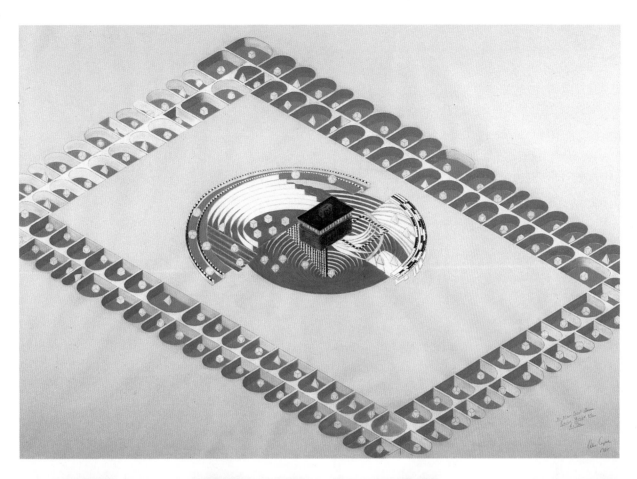

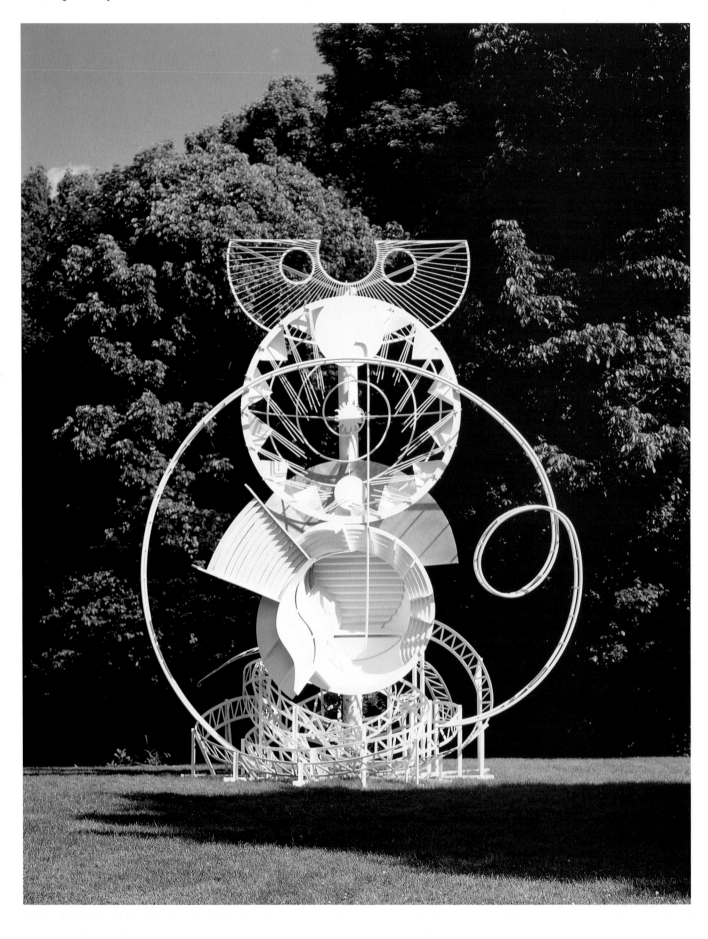

12.42 (opposite) **Alice Aycock,** *Tree of Life Fantasy: Synopsis of the Book of Questions Concerning the World Order and/or the Order of Worlds*, 1990–2. Painted steel, fiberglass, and wood, 20 × 15 × 8ft (6.1 × 4.57 × 2.44m). Collection, University of Illinois at Urbana-Champaign. Photograph courtesy the artist. © Alice Aycock, 1994.

not steps that you can walk on . . . They're not quite of this world," she explained. In addition, she had for some time been working with bowls, inspired by ancient Indian observatories. The work also has references to the helices of DNA, to fragmentations of the Gropius theaters, and to medieval and Renaissance illustrations of people walking off to Paradise through a whirling hole in the sky.[45] Here that ladder to heaven has undergone a radical metamorphosis into a "loop-the-loop" roller coaster surmounted by cosmograms, and on the trellis at the apex the artist imagines a live wisteria growing up from the back, a garden in paradise and a tree of life. The white represents the purity that the real world lacks.

Alice Aycock is, in one sense, a traditional maker of objects. In the early seventies her highly personal, complex vision was radical in relation to the minimalist cube, the pop icon, and the conceptual art action that dominated sculpture at that time. Her work is inclusive and maximal instead of exclusive and minimal—it is about everything at once, filtered through her perpetually expanding network of imagination. It is also a simultaneously feminist and postmodernist rejection of an authorial center. Each object has layer upon layer of unexpectedly intersecting stories and allusions that keep reappearing in her work as a way of bringing everything together into some complex whole, while at the same time undermining the fixed relations of a stable world view with a constant influx of new ideas. "I think that it's just simply the desire to push farther, to go beyond the known structures, and, in a sense, the work is a metaphor for that."[46]

Philip Guston's Late Style

"In the anti-historical position," Philip Guston insisted in a lecture of 1974, "each artist is . . . himself."[47] In contrast to postulates of historical inevitability or the social construction of meaning put forward in the latest critical theory of the seventies, to the impersonality of minimalism, and to the language-based signscape that preoccupied Johns, the pop artists, and many conceptualists, Philip Guston's reassertion of the self as the procreative nucleus of art in the seventies announced, and influenced, a rejuvenation of introspective painting.

What made Guston's work of the late sixties and seventies so important was not its political dimension—its "imaginative grasp on the epoch," as Rosenberg put it—even though that was present, but that the depth of its existential struggle made painting real again. To most of the art world, painting had become irrelevant as a response to the pressing concerns of connecting oneself to the world in the later sixties. Rosenberg hinted at Guston's role in reconnecting painting to the self when he wrote of Guston's late work as a "liberation from detachment."[48] For Guston and other artists of the abstract expressionist generation, painting made concrete one's thoughts about the most important questions of ethics and identity—who one was in relation to events and to the painful dilemmas of the human condition. Their deliberations became palpably visible forms and thus points of style engendered passionate exchanges.

The sheer courage of Guston's leap to a figurative style at the end of the sixties [fig. 12.43], as if willfully tossing out his "old master" status as an abstract expressionist [fig. 6.9], brought on a storm of rebuke from his established colleagues and former friends. For that very reason it also reaffirmed painting as an arena for radical ideas in so far as Guston, in the service of authenticity, had no alternative.

Guston was a painter perpetually beginning again, risking everything to follow an idea into the unknown, both seduced and tortured by doubt. "My whole life is *based* on *anxiety*," he wrote to his friend Dore Ashton, "where else does art come from, I ask you?"[49]

Ashton described Guston's character as one of "extreme nervous tension (he was a chainsmoker and a pacer) and the high irritability that existentialist philosophers regarded as the hallmark of the artist."[50] What particularly struck the critic Peter Schjeldahl about Guston's late work was that it "appeared to deal with a level of doubt that would paralyse anyone else."[51] Even in the early fifties, when the abstract expressionists all hung out at the Cedar Bar, Guston's friend Mercedes Matter recalled that "he'd come in one night in an absolute gloom. He'd say, 'I just scraped off months of work on the floor. I'm not a painter. It's no use.' And he'd have everybody down . . . And it never failed that the following week he would float in, not touching the ground, and say, 'I've just finished the first painting I've ever done!' "[52]

Guston's Early Career

Guston was born Philip Goldstein in 1913 to an impoverished Russian immigrant family. He grew up in Los Angeles and at the age of twelve started drawing seriously, encouraged by his mother. He loved the comics, especially *Krazy Kat* and *Mutt and Jeff*, and wanted to be a cartoonist. Guston attended the Manual Arts High School, where he established lifelong friendships with Reuben Kadish and Jackson Pollock, but he left without ever finishing high school. Instead, he hung out with a small and rebellious group of highly intellectual and artistic friends who educated themselves by reading literature and

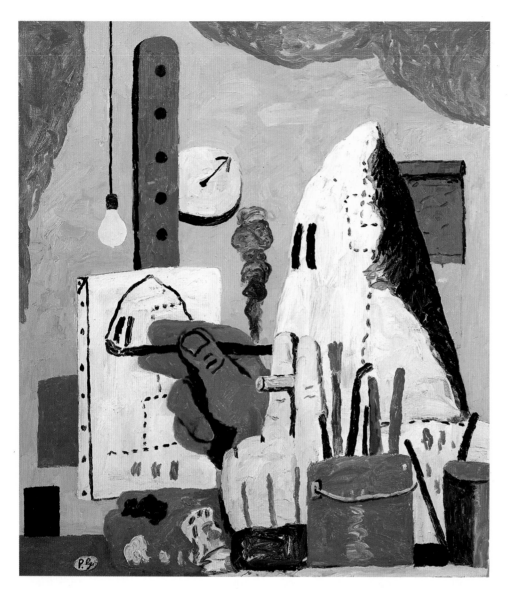

12.43 Philip Guston, *The Studio,*
1969. Oil on canvas, 4ft ×
3ft 6in (1.22 × 1.07m).
Private collection, New York. Photograph by Eric
Pollitzer, courtesy David McKee Gallery,
New York.

philosophy and vanguard art journals like *Transition*, *The Dial*, and *Cahiers d'Art*. At seventeen he got to see the magnificent collection of modern art that belonged to Walter and Louise Arensberg. This was a turning point, and Guston later credited the de Chirico paintings in particular with helping to crystallize his ambition to become a painter.

Guston read avidly—especially in the fields of philosophy and literature—and taught himself to paint. There wasn't much to see in the public collections in Los Angeles at the time, but he studied reproductions, especially of paintings by Picasso and by the Renaissance masters. In 1932 the Mexican muralist David Siqueiros painted a wall at the Chouinard Institute (an art school in Los Angeles) and then caused a political stir with an outdoor work for The Plaza Arts Center on Olvera St. By this time Guston was already involved in leftist politics and keenly interested in the Mexican muralists. He and Pollock even went out to see Orozco at work on his *Prometheus* at Pomona College.

Guston painted some portable frescoes of his own in 1931, on the theme of the notorious racist trial of the Scottsboro Boys. In one painting of the period he depicted Ku Klux Klansmen whipping a roped black man; in another, hooded Klansmen armed with crude weapons huddle in front of a primitive gallows [fig. 12.44]. He showed the frescoes in a friend's bookstore shortly after painting them. Early one morning a group of Klansmen and American Legionnaires brandishing lead pipes and guns broke into the bookstore, smashed it up, and shot the eyes and genitals out of the figures in the paintings. Because there was an eyewitness the artist and his friend were able to sue, but the judge, who obviously disliked their leftist politics, dismissed the case, teaching Guston a lesson about "justice" in America he never forgot.

In 1934 Guston worked on two mural painting commissions, one in Morelia, Mexico, and another in California, and then moved to New York where he stayed with Pollock until he got settled. In the late thirties he

painted murals for the W.P.A. in New York and New England. The federal projects brought together a real community of intellectuals and artists in New York. With the Pollock brothers and the painter James Brooks, for example, Guston would go to Orozco's lectures at the New School or to a play put on by the federal theater project and stay up half the night talking about it with the others.

In 1941 Guston left this lively scene to teach at the University of Iowa for four years and then at Washington University in St. Louis for two. Whereas Guston's painting *Conspirators* of 1932 [fig. 12.44] has not only the monumentality but the dramatic volumes and spatial recession of Renaissance and Mexican frescoes and of de Chirico, his painting *The Porch* (1946–7) [fig. 12.45] is squeezed into a shallow cubist space. The figures in *The Porch* reveal Guston's late thirties discovery of Max Beckmann, then in St. Louis, with their emblematic but

12.45 Philip Guston, *The Porch,* 1946–7. Oil on canvas, 56⅛ × 34in (142.6 × 86.4cm).
Collection, Krannert Art Museum and Kinkead Pavilion, University of Illinois, Urbana-Champaign. Purchased out of the "Illinois Biennial" exhibition of 1948.

12.44 Philip Guston, *Conspirators,* 1932. Oil on canvas, 50 × 36in (127 × 91.4cm).
Location unknown. Photograph courtesy David McKee Gallery, New York.

undecipherable props: the flute, a crown, a child with a paper bag hat turned away playing the drum, a little girl covering her eyes with a handkerchief or paper hat, a masked harlequin in white with the sole of his shoe flattened against the picture plane, and a figure with one leg wrapped as though in the ribbons of a ballet slipper, holding cymbals that recall the garbage can lids used by the children at play in Guston's W.P.A. murals.

The powder blue sky and orange ground plane in the backdrop to *The Porch* suggest the continuing influence of Piero della Francesca's *Flagellation,* a kind of artistic beacon for Guston from the beginning of his career. In addition, the building in the left distance evokes an Italian piazza but this (like the wide wooden floorboards) may have more to do with

the Arensbergs' de Chiricos. Guston's interest in cubism, and specifically in Picasso's *Guernica* [fig. 2.10], emerged between the time he painted *Conspirators* and *The Porch*, inspiring him in the latter work to flatten the figures and use the wood frame porches of the houses in Iowa (as Piero della Francesca used the columns and beams on the left side of *The Flagellation*) to create a visual tension between the diagrammatic recession and the anti-illusionistic flattening of patterns on the picture plane. There is a classical rigor to this formal structuring that lends a timelessness to the composition. However, the uncomfortable compression also relates to newsreels the artist had recently seen of the piles of bodies in the Nazi concentration camps—he said he "was searching for the plastic condition, where the compressed forms and space themselves expressed my feelings about the holocaust."[53]

In 1947 Guston left teaching for a rustically appointed house in Woodstock, an old artist's colony in upstate New York. In October 1948 he left for Europe on a Prix de Rome for a year, and of course went to see the Pieros and Masaccios and Uccellos. His painting was at another crossroads and he once again used the isolation to find his direction. In 1947 to 1948, Guston began radically abstracting the shallow space and emblematic figures of paintings such as *The Porch*, while the palette carried the reduction even further toward just black, red, and some touches of brown. In 1950, Guston moved into a more purely improvisational dialog with the painted surface by itself.

Guston's Action Paintings of the Fifties

Guston's paintings from 1951 through the early sixties [fig. 6.8] each evolve organically through the artist's interaction with the paint and surface. Guston's unique variation on the idea of action painting concerns "touch" more than "gesture"—the sensuality of the surface complements an increasingly rich spectrum of saturated color through the fifties. At first the artist constructed clouds of little vertical and horizontal strokes, like the "plus and minus" stokes in Mondrian's "Pier and Ocean" series. These paintings are all about openness and freedom—Guston largely dissolved solid form and yet the legacy of Piero and Cézanne still persists in the way he seems to locate the brushstrokes in a defined space. In 1957 the strokes became a little more aggressive, heavier and more irregular, with a deeper palette. At the same time the increasing specificity of the titles accompanied a gradual consolidation of the touches of color into forms.

The fifties was a period of masterful action paintings for Guston. He worked largely in a loft in Greenwich Village and was once again involved with the community of painters in New York, staying up all night for conversation, working off nervous energy on long walks in the streets, smoking and drinking heavily in bars with other artists or at the Friday night meetings of "The Club." In January 1952 he showed the light, calligraphic action paintings of 1951 at the Peridot Gallery, his first show in New York since 1945. The next year

he joined the Egan Gallery, where his work prompted talk of "abstract impressionism," although the real ancestry of these works was not in *plein air* painting but in the psychologically charged glow that illuminated the paintings of Rembrandt.

The Reemergence of the Figure

By the end of the fifties, Guston began to feel that it had become "too easy to elicit a response"[54] with these sensuous abstractions. Thus his first major museum retrospective, at the Guggenheim Museum in 1962, marked another turning point. In that year he had not only drastically reduced the color—or rather painted it out with layers of broad gray and black brushstrokes—but in the process had begun to discover palpable forms in space. In *Winter I* of 1965 [fig. 12.46] the black mass is a head—not a preconceived head, but one arrived at in the act of painting. As he told Harold Rosenberg in 1966:

To preconceive an image, or even to dwell on an image, and then to go ahead and paint it is an impossibility for me . . . it's intolerable—and also irrelevant— because . . . it's simply and only recognizable . . . Paul Valéry once said that a bad poem is one that vanishes into meaning. In a painting . . . it vanishes into recognition. The trouble with recognizable art is that it excludes too much. I want my work to include more. And "more" also comprises one's doubts about the object, plus the problem, the dilemma, of recognizing it.[55]

Thus in the sixties, Guston's painting turned into a dialog about touch and form as a prolog to a more complex exploration of the tension between touch and image in the works of 1969 to 1980, as in *Central Avenue* [figs. 12.47 and 12.48] where the same sensual touch and palette as in *Oasis* [fig. 6.8] still exist, but now with another layer of discourse about the subject matter superimposed on top of them. "Sometimes I know what [the forms] are," he said of his black-and-white compositions of the mid sixties. "But if I think 'head' while I'm doing it, it becomes a mess . . . I want to end with something that will baffle me."[56]

The mid sixties were an anxious period for Guston and his drinking ran out of control. At that point his painting nearly ground to a halt for two years as he swung back and forth between an abstraction of Zen-like purity (drawings of just two or three bold black lines on a white ground) and sketches of little objects around the studio.

I remember days of doing "pure" drawings immediately followed by days of doing the other—drawings of objects. It wasn't a transition in the way it was in 1948, when one feeling was fading away and a new one had not yet been born. It was two equally powerful impulses at loggerheads. I would one day tack up in the house a bunch of pure drawings, feel good about them . . . And that night go out to the studio to the drawings of objects—books, shoes, buildings, hands . . . The next day, or day after, back to doing the pure constructions and to attacking the other. And so it went, this tug-of-war, for about two years.[57]

12.46 Philip Guston, *Winter I,* 1965. Oil on canvas, 5ft 8in ×
6ft 6in (1.73 × 1.98m).
Private collection, New York. Photograph by Sarah Wells, courtesy David McKee Gallery,
New York.

In 1967 Guston retreated to the isolation of Woodstock
again, even disconnecting the ring on his phone so no one
could call in. Then, as Dore Ashton reported,[58] he began
making little paintings of objects. It was the time of the
intensifying protests against the war in Vietnam and a
pointing finger emerged in Guston's work—the same
accusatory hand that reappeared in the top left center of
Flatlands of 1970 [fig. 12.49]. As he grew more and more
outraged by what he saw on television—the Democratic
Convention of 1968, and assassinations of the Kennedys,
Martin Luther King, and Malcolm X; government violence
against students; the war—the rebellion of his youth came

rushing back. First he painted dozens of blocky cartoon-like
shoes, buildings, clocks, and books, and then in 1969 the
hooded figures emerged in increasingly ambitious
compositions [figs. 12.43, 12.47–12.49].

In 1967–68 I became very disturbed by the war and the
demonstrations. They became my subject matter and I was
flooded by memory. When I was about 17–18, I had done a
whole series of paintings about the Ku Klux Klan, which was
very powerful in Los Angeles . . . In fact I had a show of them in
a bookshop in Hollywood, where I was working at that time.
Some members of the Klan walked in, took the paintings off the
wall and slashed them . . . This was the beginning. They are self-
portraits. I perceive myself as being behind a hood.[59]

That these cigar-smoking hoods represent the artist himself
is plain enough in paintings like *The Studio* [fig. 12.43],

Surviving the Corporate Culture of the Seventies

12.47 (above) **Philip Guston,** *Central Avenue,* 1969. Oil on canvas, 4ft 9⅛in × 6ft 8in (1.45 × 2.03m).
Collection, University Art Museum, University of California at Berkeley. Gift of Mrs. Philip Guston and Musa Jane Mayer.

12.48 Philip Guston, detail of *Central Avenue.*

12.49 Philip Guston, *Flatlands*, 1970. Oil on canvas, 5ft 10in × 9ft 6½in (1.78 × 2.91m).

Collection, Byron Meyer, San Francisco. Photograph by Otto Nelson, New York, courtesy David McKee Gallery, New York.

where the hood paints his own portrait in a closed-off room with a bare bulb hanging down from a wire. The scene itself goes back to Guston's childhood memories of hiding in a closet on Sundays when his relatives came to visit. A single light hung down on a cord in this closet so he could draw and read, and he would hear his mother telling the family that he wasn't home.

From 1969 through 1972 the hoods obsessed Guston. He issued a constant flow of notes to himself for paintings: "Have them playing poker, have them sitting around drinking beer and eating hamburgers."[60] He explained that his intent "was really not to illustrate, to do pictures of the Ku Klux Klan, as I had done earlier. The idea of evil fascinated me, rather like Isaac Babel who had joined the Cossacks, lived with them and written stories about them. I almost tried to imagine that I was living with the Klan. What would it be like to be evil? To plan, to plot."[61]

The hoods are the ambiguously frightening and lovable sides of the artist's own creativity. The dangling light bulb goes back to Picasso's *Guernica*, and this Jekyll and Hyde view of the artist's creative force resembles Picasso's identification with the simultaneously sympathetic and frightening minotaur. In *Central Avenue*, the hoods with their wooden cross are also artists with an easel and stretchers; the sensuous, "fat pink paint"[62] (as Guston described the kind of passages he used for the tops of the highest background buildings in *Central Avenue*) revisits abstract works of the fifties like *Oasis*, but in *The Studio* it suffuses everything.

The idea of the *golem*, which fascinated Guston,[63] seems particularly germane to the hoods. Mystic Cabbalists of the Middle Ages would model a human figure (a *golem*) out of red clay (like the "fat pink" paint?) as a pious reenactment of the creation of Adam. But that was a double-edged blade, since Jewish law forbade graven images—only God had the right to make things in his own image. Likewise, Guston's reintroduction of graven images in his paintings transgressed the laws of abstract expressionism and was even more of an affront to Greenberg's "pure painting."

In 1970 Guston absorbed the hoods into fields of symbols. In *Flatlands* the legs and the sole of the shoe (as in *The Porch*) come back, along with the brick wall (here a chimney) and the board with nails from works like *Conspirators*. The clock, the stony pictures hanging from wires, and books persist from the small oil sketches of 1968. New forms such as the sunrise enter as recurrent motifs, while some images (like the truncated foot) seem new and yet reverberate with old meanings. The works of 1970 also seem to broach new, more complex structural ideas.

Surviving the Corporate Culture of the Seventies

Flatlands, for example, opens out laterally rather than holding a centrally organized composition. It is not an "all-over" picture so much as one that deliberately defies classical balance—an idea that Terry Winters later developed with radical results [fig. 14.3].

Guston showed his figurative work for the first time in October 1970 at Marlborough Gallery. The critical response to his show was predictably withering and it took nearly a decade for even his friends to catch up with the total rethinking that these works represented. The Marlborough show was another watershed for Guston, marking the final phase of his work that lasted from 1972 until his death in 1980.

The black and gray paintings of the first half of the sixties simultaneously reveal form and cross it out, while the hoods mask the identity of the ambivalently endearing and menacing artist. In this new work of the middle and late seventies, the painter is revealed everywhere. *Head and Bottle* [fig. 12.50] unmasks the painter's vision and his vice. The hoods began disappearing in 1972, replaced by raw images of the artist's disembodied eye and head as in this drawing, piles of legs and the soles of shoes as in *The Floor* [fig. 12.51], paintbrushes, ugly bugs, and strange lunar landscapes as in *Moon* [fig. 12.52].

Guston's late style is torn between Piero della Francesca and the comics, Rembrandt and Kafka. While on the one hand there is his exhilaration in discovery—"What you want is an experience of making something that you haven't seen before"[64]—there is also the anxiety: "Our whole lives

12.50 Philip Guston, *Head and Bottle*, 1975. Ink on paper, 19 × 24in (48.3 × 61cm).

Collection, Armando and Gemma Testa. Photograph by Steven Sloman, New York, courtesy David McKee Gallery, New York and the Estate of Philip Guston.

12.51 Philip Guston, *The Floor*, 1976. Oil on canvas, 5ft 9in × 8ft 2in (1.75 × 2.5m).

Private collection, New York. Photograph by Steven Sloman, courtesy David McKee Gallery, New York.

12.52 Philip Guston, *Moon,* 1979. Oil on canvas, 5ft 9in ×
6ft 11½in (1.75 × 2.12m).
Collection, Philip Johnson. Photograph courtesy David McKee Gallery, New York.

(since I can remember) are made up of the most extreme
cruelties of holocausts," he wrote Dore Ashton after the
CIA coup in Chile. "We are the witnesses of the hell. When
I think of the victims it is unbearable."[65] And yet it is the
peculiar fate of such an artist to want to see everything.
Guston's friend Ross Feld recalled going up to Woodstock
and standing silently in front of a group of these new
paintings. "There was silence. After a while Guston took his
thumbnail away from his teeth and said, 'People, you know,
complain that it's horrifying. As if it's a picnic for me, who
has to come in here every day and see them first thing. But
what's the alternative?' "[66]

13

PAINTING AT THE END
OF THE SEVENTIES

New Expressionist Painting in Europe

In 1971, just as the New York art world was lamenting the death of painting, the twenty-six-year-old Düsseldorf artist Jörg Immendorff was personally rediscovering its relevance in a series of poignantly soul-searching compositions. The increasingly politicized atmosphere of the sixties was reaching its climax, and Immendorff was seeking to reconcile his own strong commitment to political and social activism with his deep-seated desire to paint. His studies with Joseph Beuys (1964–70) had reinforced his dedication to a politically engaged art as he watched Beuys himself move increasingly in this direction over the second half of the decade.

In particular, the 1965 Beuys performance *How To Explain Pictures to a Dead Hare* seems to have had a catalytic effect on Immendorff, bringing home the limitations of pictures and words as Beuys, his head covered in gold leaf and honey, walked around an exhibition explaining the works on display to a dead hare, held cradled in his arm. Pamela Kort, in a catalog on Immendorff's work, has described how the artist turned to childhood in 1966 for a language that satirized what he regarded as the elitist bourgeois hierarchies of high art, the veneration of artistic genius, and the preciousness of the art object.[1] He issued "baby talk" manifestoes and painted works like *Teine Tunst Mache* or "top toing art" (a quasi-infantile rendering of *keine Kunst mache* or "stop doing art"). At the same time, this work embodies Immendorff's ambivalence about his growing inability to justify "doing art"—which is politically ineffective—and his continued attraction to painting. Beuys had taken an important turn toward political engagement in 1964 and entreated his students to abandon painting.

Immendorff labeled his work between 1968 and 1970 "Lidl" (based on the sound of a baby rattle). A child's pantheon of symbols populated the "Lidl" paintings (turtles, dogs, goldfish, and polar bears), offering alternatives to the vocabulary of adult artists whose creativity Immendorff saw as confined by bourgeois convention and by the spiritual wounds still lingering from the Nazi period. The child art stood for beginning again, free of history and convention, but it also brought back the accusation of childishness, used by the Nazis as a weapon against modernism. Nor could Immendorff keep his *fausse naïveté* pure of his unconscious ambitions—as Pamela Kort noted, Immendorff identified himself with the turtle out-racing the hare, an emblem for his teacher Beuys.

13.1 (opposite) **Jörg Immendorff,** *Untitled,* 1993. Pencil and gouache, 12¼ × 10in (31.1 × 25.5cm).
Private collection, courtesy Galerie Michael Werner, Köln.

13.2 Jörg Immendorff, *Can one change anything with these?*,
1972. Acrylic on canvas, 19¾ × 31½in (50.2 × 80cm).
Photograph courtesy Galerie Michael Werner, Köln and New York.

Jörg Immendorff's Political Analysis of Painting in the Seventies

In an autobiography published in the early seventies entitled *Here and Now: To Do What Has To Be Done*,[2] Immendorff invoked Lenin's plan of 1905, *What Is To Be Done?* Yet, despite his dedication to leftist ideology, the artist analyzed himself, his political convictions, and the social relevance of painting with excruciating honesty in untitled paintings of 1971. "Can one change anything with these?" he wrote across one of them [fig. 13.2]. Centered on the white canvas like an illustration on a page, he depicted himself three times. In each pose he holds one of the painter's most basic materials, captioned with small yellow labels like a diagram in a technical manual: "This is a simple brush for 70 pfennigs. This is normal housepaint. This is a canvas stretched on a wooden frame. It is where the artist's ideas take shape."

Below the picture, the artist hand-printed a text in the improvised manner of a political placard. Here he speculates in response to his own question about whether painting can change anything: "Surely not," he writes, "but when ideas take shape we can investigate the conditions from which they develop. We can ask what aims motivate them. We can

determine whether they superficially reflect social conditions, serve to decorate walls, or whether they contribute to revealing contradictions and enter into the struggle to resolve these contradictions."[3]

"I wanted to be an artist," he wrote above another painting in this series. The work shows him on the floor of a romantic artist's garret, staring at a blank canvas by candlelight while a gleaming full moon hangs in the dark sky out the window above him. The caption below explains: "I dreamed about seeing my name in the newspapers, having a lot of shows, and naturally I intended to do something 'new' in art. My guideline was egoism." In yet another work he reflected, "I was unable to put myself in the place of working people, I was unable to fight for their interests. This will not change until one begins to struggle, on a daily basis, against one's own egoism and against the philosophy of egoism and profit."

Immendorff simplified his style in these works for the sake of legibility, as in socialist realism. But if the style attacks the preciousness of painting by invoking the syntax of illustration, the hand-made character of everything from the lettering to the brushiness of the images asserts the perseverance of a romantic individualism. Moreover, the series is autobiographical. Beuys too struggled with the contradiction of personality as against the political imperative for a collective practice (as Marxist theory demanded). Beuys knew he needed his own biography, he even mythologized it as the ground plane for his charismatic authority. This contradiction both in Beuys's work and in his own did not escape Immendorff's draconian self-scrutiny, and the fact that he accomplished

13.3 E. L. Kirchner, *Erich Heckel and Otto Müller Playing Chess*,
1913. Oil on canvas, 14 × 15⅞ (35.6 × 40.3cm).
Collection, Brücke-Museum, Berlin. Photograph by Henning Rogge.

his self-analysis through his painting must also have been apparent to him. In 1976 he dropped the didactic style of the early seventies for a more introspective approach.

Grappling with Identity

Immendorff began painting his "Café Deutschland" cycle in 1977. The Café is the metaphor for the artist's own psyche—a tumultuous swirl of current political figures, German national heroes, and the working class of Marxist theory in a thick soup of inherited symbols. In *Café Deutschland III* (1978) [fig. 13.4],

Immendorff created a crowded, tipped-up space that recalls the anxious compositional angularity of such paintings as Kirchner's *Erich Heckel and Otto Müller Playing Chess* of 1913 [fig. 13.3]. But unlike the classic German expressionists, Immendorff provides no stable grounding in nature against which to measure the expressive distortions of color or form. In

13.4 Jörg Immendorff, *Café Deutschland III,* 1978. Oil on canvas, 9ft 3in × 8ft 11½ in (2.82 × 2.73m).
Photograph courtesy Galerie Michael Werner, Köln and New York.

Immendorff's work, the hackneyed symbol of the German eagle, for example, inhabits the same reality as the artist's self-portrait; memory, perception, fantasy, and mediated knowledge all interact on an equal footing.

Immendorff shows himself at the center of *Café Deutschland III* asleep, slumped over a round table, clutching a paintbrush. A mirrored column behind him reflects (in grisaille) the Brandenburg Gate in Berlin—the most visible interface of the totalitarian East Bloc with the West in the still-divided Germany of the seventies. There are reliefs of menacing characters carved into the columns in the foreground of *Café Deutschland III*—a shadowy figure encircles one of the columns in rope—and above the hall a bespectacled man (Erik Honnecker, the party chief of East Germany) hurls lit candles as though he were casting symbols lifted ready-formed from a painting by Max Beckmann. Brilliantly illuminated nudes in scenes of sexual abandon highlight the background while a fierce eagle (the German national symbol) swoops down on the painter, who wields a club and falls back on the theater ropes in a scene to the upper left. The simultaneity of these self-portraits within a single, continuous space (as in the untitled works of 1971) reflects a new kind of reality in which perceptions coexist on the same plane as abstract concepts and need not conform to the structure of sequential time. There is no simple story line or message here but rather a plethora of images and vignettes, charged with enigmatic and cross-tracking associations as in a dream.

The animism of such symbols grew even more pronounced in Immendorff's paintings of the eighties. In the eighties, the anarchy that reigned in the theater of the *Café Deutschland* intensified. The focus then shifted from the complexity of the theatrical space and the chaotic simultaneity of events toward the depth and individuality of the characters. Immendorff's painting took on an increasingly introspective mood in the nineties.

In 1993, Immendorff received a commission to design sets for Stravinsky's opera, the *Rake's Progress*. The story comes from a morality tale (told in eight engravings by the eighteenth-century English artist William Hogarth) about young Tom Rakewell (engaged to marry Anne Truelove), who suddenly comes into an unexpected inheritance (presented by Nick Shadow, the devil). Tom goes to London, squanders his money, forsakes his fiancée, and ends up destitute in Bedlam (the dismal asylum of the insane) believing he is Adonis. An entirely new cast of symbols entered Immendorff's painting with this commission, as he turned the travails of Rakewell into a parable of the artist.

Untitled [fig. 13.1], a beautiful drawing of 1993, shows Immendorff with his face in white stage make-up and lips painted bright red, sleeping on top of the aft section of an airplane. The plane alludes to the legend of Joseph Beuys (cast as Truelove, Anne's father, in Immendorff's version of the *Rake's Progress*); Beuys was a World War II pilot who was rescued from a crash by nomadic Laplanders, who allegedly wrapped him in felt and animal fat to preserve his body heat

and heal his burns. Here, the plane stands for Beuys's invocation to abandon painting for a more politically engaged art, but it also represents the means by which Beuys wielded artistic power.

The inscription in the lower right reads "Vorbereitung für den 3 Wunsch" ("Preparation for the Third Wish"). Immendorff interpreted the story as being about three unfulfilled wishes, of which the third concerns the wish to do good for humanity. But the artist fails in this because he first has to be happy himself and he doesn't know how to achieve that. As he sleeps, in the drawing, Immendorff dreams of a cannon that refers back to his Lidl performances of the sixties in which he shot crumpled wads of paper into his audience with notes that said things like "I love you" or "Be happy." But in this dream the cannon has become a phallic object, suggesting the artist's own narcissism as the real motive behind his "altruism," and it seems to be firing a loaf of bread. The bread refers to a machine that Nick Shadow brings to Rakewell, making the fraudulent claim that it turns stone into bread; Rakewell is so gullible he believes it.[4]

Georg Baselitz and A. R. Penck

The power of symbols weighed heavily on this whole generation of German artists. Some had formative childhood memories of the war or of the privations in its aftermath. Georg Baselitz and A. R. Penck, the oldest of the German neo-expressionists, had grown up just outside Dresden and as children had witnessed the firebombing of the city; Baselitz described it as the most riveting memory of his life.[5] Penck and Baselitz were just six and seven at the end of the war, and though this generation of German artists bore no responsibility for the war or the atrocities of the Third Reich, they inherited them as part of the German national consciousness.

As the critic Donald Kuspit has observed, this situation endowed abstract symbols with a particularly profound psychic force in the work of contemporary German painters.[6] By successfully giving form to such powerful psychic experience, these artists elucidate it, creating a fundamental truth. The vitality of the symbols—the fact that they hold their own with conventional figurative imagery in these paintings—underscores the abstract distance with which everything is experienced in the late twentieth century. If nature is conspicuously absent in the work of the German neo-expressionists, it is also rarely encountered, unaltered by man, in the reality of modern urban life. Thus the preoccupation of many of these German painters with asserting a tactile immediacy—as in the viscosity of the paint in the work of Baselitz [fig. 13.5] or the use of straw and lead in Anselm Kiefer's compositions [figs. 13.8 and 13.10]—is as critical in coming to terms with contemporary experience as the more explicitly theory-conscious postmodernism of other contemporary artists.

Georg Baselitz and A. R. Penck [fig. 13.6] came to the fore of a group of outstanding gestural painters in Berlin

13.5 (above) **Georg Baselitz,** *Late Dinner in Dresden,* February 18, 1983. Oil on canvas, 9ft 2¼in × 14ft 9¼in (2.8 × 4.5m).

Collection, Kunsthaus, Zürich. Photograph courtesy Galerie Michael Werner, Köln, New York.

13.6 (below) **A. R. Penck,** *Untitled (Group of Friends),* 1965. Oil on fiberboard, 5ft 7in × 9ft ¼in (1.7 × 2.75m).

Collection, Museum Ludwig Köln. Photograph courtesy Rheinisches Bildarchiv, Köln.

Painting at the End of the Seventies

13.7 A. R. Penck, *Standart,* 1971. Acrylic on canvas, 9ft 6¼in × 9ft 6¼in (2.9 × 2.9m). Photograph courtesy Galerie Michael Werner, Köln and New York.

in the sixties. Along with Eugen Schönebeck, K. H. Hödicke, Markus Lüpertz, and Bernd Koberling, Baselitz and Penck came from East Germany. Baselitz studied at the West Berlin Hochschule für Bildende Künste from 1957 to 1962 and had his first show with the fledgling gallery of Michael Werner and Benjamin Katz the following year. He began isolating and then fragmenting the figures in his compositions in the mid sixties; in 1969 he came upon the idea of turning the whole painting upside down and sideways in what has become a signature device to take the focus off the subject matter and redirect it toward the expressive surface. The build-up of thick, bravura brushwork in the painting of Baselitz runs head on into the late-sixties denial by the theorists of the political left of heroic individuality (or romantic "genius") in painting.

A. R. Penck (a *nom de plume* for Ralf Winckler) worked in East Berlin until 1980 and, as in the case of Immendorff, his internal struggle with leftist ideology peaked around 1971. He wanted to make paintings that would communicate as clearly as the information signs that direct people to escalators and bathrooms in public places. His formulation in 1970 of the generic "standart"—a primitive stick figure with its arms thrown up submissively into the air [fig. 13.7]—was partly derived from the vocabulary of the signs and his fascination with cybernetics (the science of the regulation and control of humans and machines). Penck used the standart as a fixed organizing principle around which he varied the style to test a wide range of emotions.

Both Penck and Baselitz consciously cultivated the independence of their subject matter from the abstract concerns of painting. This not only anticipated the new imagist painters in the United States in the seventies, it sharply distinguished Penck and Baselitz from their expressionist precursors. Moreover, as Siegfried Gohr has pointed out,[7] the range of emotion that is possible in manipulating abstract qualities of the painting touched on the underlying irrationality behind the apparently rational systems that regulate German life as a whole.

Anselm Kiefer

Anselm Kiefer taps into this well of irrationality even more directly, working unabashedly in the German romantic tradition. He conveys a heavy authorial presence and, like Beuys, his materials—lead, straw, and dense pastes of pigment [fig. 13.8]—seem at once linked to nature and to some esoteric mystery that transcends the physicality of nature. Kiefer's search for parallels in world mythology—Nordic, Greek, Egyptian, Early Christian, and the Jewish Cabbala, to name a few—is a romantic trait, as is his morbid preoccupation with death, destruction, and renewal.

Kiefer's subject matter has continually centered on his personal identity and cultural origins. In 1969, at the age of twenty-four, he made a book of photographs of himself giving the Hitler salute in front of a variety of monuments on his vacations in Italy and France. Instead of traveling as the curious tourist eager to explore another culture he went to experience the sensation of the Nazi occupation force and to understand better this undiscussed facet of his heritage. The artist probed a sadistic urge in another photographic book of 1969 entitled *The Flood of Heidelberg.* Here he cast himself as the perpetrator of a dam explosion that causes a disastrous flood which he then enjoys, like Nero watching the burning of Rome, from a castle overlooking the city. For Kiefer, this acknowledgement of his own dark thoughts mirrors the idea that Satan belongs inextricably to the totality of God.

In his 1973 painting *Quaternity* [fig. 13.9] he obliquely evokes the dark German forest in the wood that dominates the painting. The abstract presence of the Trinity, incarnate as three patches of fire on the floor, is complemented by Satan (the snake) to make up the inseparable quaternity of the title. The flames transmit an atmosphere of spiritual transcendence, while at the same time threatening to consume the wooden room in an apocalyptic blaze. "I think a great deal about religion," Kiefer explained, "because science provides no answers."[8] Painting, it seems, offers him

redemption from the horrors of a dark history and from the specters in his own unconscious.

In 1974, Kiefer's attention shifted from the imagery of the German forest and the spiritually inhabited wooden rooms (based on his attic studio in an old rural schoolhouse) to the scorched landscapes on which he fantasized the battles of German history having taken place. In *Wayland's Song (with Wing)* of 1982 [fig. 13.8], an immense lead wing surmounts the burnt black field. The grand scale of Kiefer's painting—this work measures nearly 10 by 12 feet—and the density of the materials expresses the monumentality of his theme.

The story behind *Wayland's Song (with Wing)* derives from the anonymous Scandinavian poems (the *Eddas*) that tell the history of the Teutonic gods. Richard Wagner based the operas of *The Ring of the Nibelung* on these stories and thus Kiefer's choice of subject also carries the aura of this most romantic and histrionic of all German composers. Moreover, Wagner (like Nietzsche) was appropriated by Hitler in the latter's melodramatic celebrations of German nationalism. Kiefer deliberately courts such emotional and symbolic extremes.

13.8 Anselm Kiefer, *Wayland's Song (with Wing),* 1982. Oil, emulsion, and straw on photograph, mounted on canvas, with lead, 9ft 2¼in × 12ft 5⅝in (2.8 × 3.8m).
Photograph courtesy Anthony d'Offay Gallery, London.

13.9 Anselm Kiefer, *Quaternity,* 1973. Charcoal and oil on burlap, 9ft 10⅛in × 14ft 3¼in (3 × 4.35m).
Private collection, Germany. Photograph by Malcolm Varon, New York.

The last part of the *Eddas* tells of *The Twilight of the Gods* (*Die Götterdämmerung*) in which the greed and deceitfulness of the gods (who are not immortal) lead to their own demise. The King of Sweden captures Wayland, the greatest of all metalsmiths, cripples him so he cannot flee, and places him on an island as a prisoner, thenceforth to forge treasures for the court. In revenge, Wayland rapes the king's daughter and murders his two sons, presenting the king with drinking cups made from their skulls. Then he fashions himself wings and flees.

The smith is an ancient metaphor for the artist. He is also the alchemist who magically fashions base metal (lead) into gold (or, in Christian symbolism, redemption). Kiefer is, as it were, handing Germany the heads of its children on a plate. He incorporated straw into the painted surface of this and other paintings after 1980, intending the organic deterioration of the straw to mirror the natural cycle of life, devolving to death and dissolution. The straw is "transfigured" (to use the artist's term)[9] by fermentation, evoking not only the metaphors of alchemy and redemption but Kiefer's prognosis on the fate of Germany.

The self-destructing organic materials in Kiefer's work had precedents in the Italian *arte povera*, in which they also brought home the proximity of nature. However, for the Italians of the *arte povera*, the resulting impermanence of the object also serves as an attack on the commodification of art—the commerce in "things" that transforms the spiritual act of making art into a saleable object. By contrast, it is only the material presence and the symbolism that attract Kiefer to such material. Kiefer also admired the materiality of Joseph Beuys's work and the physicality of the American minimalist and process artists of the sixties.

The pages of Kiefer's books are made of lead, and rely for their expressive impact on the changing effects of oxidation, chemical impurities, and the palpable weight and softness of the lead itself, similar to a work by Carl Andre or Richard Serra. However, Kiefer also invests his books with historical allusions or mystic content, as in the books in *Breaking of the Vessels* [fig. 13.10]. This work consists of 15,000 pounds of these lead books, crammed into a 16-foot-high steel bookcase. The bookcase is positioned amid a field of shattered glass and has corroding copper wires trailing from part to part. The daunting material presence of the

13.10 (opposite) **Anselm Kiefer,** *Breaking of the Vessels,* 1990. Lead, iron, glass, copper wire, charcoal, and aquatec, 16ft × 6ft × 4ft 6in (48.7 × 1.82 × 1.37m), weight 7½ tons (7.65 tonnes).
Collection, Saint Louis Art Museum. Purchased with funds given by more than twenty-five donors throughout the St. Louis area.

work resembles the large steel pieces made by Richard Serra, but the concept of the construction derives from the mystic Jewish Zohar which posits ten divine emanations—the attributes of god (Ain Soph)—contained in the *sefirot* (vessels or spheres). Kiefer inscribed "Ain Soph" on the glass semicircle (the dome of heaven) above the work, and the names of nine of the vessels on the sides and fronts of the shelves below, omitting the hidden *sefira*—"Daath" or knowledge. The three shelves correspond to the three pillars—Mercy, Judgment, and Mildness.

Underlying Creation, according to the Zohar, is the act of Zim Zum in which the infinite (Ain Soph) contracted inside Himself to allow for the existence of something other than Himself. The vessels were created to catch the emanations that fell from primordial space and, in the process of doing so, six of them were shattered, releasing evil into the world. In the sculpture, menacing spears of shattered glass jut out from the books and litter the floor. The books allude to knowledge, the secret *sefira*, which contains wisdom and history within itself. Thus on one level

the *Breaking of the Vessels* encompasses the totality of good and evil, heaven and hell, resurrection and death. On another level, the shattered glass, as an allusion to the broken dome of the heavens, brought home Kiefer's persistent examination of German identity by also calling to mind *Kristallnacht* (the November night in 1938 when Nazis shattered the windows of Jewish-owned shops all over Germany, signaling what was to come).

Italian Neo-Expressionism

Like Germany, Italy produced a dazzling group of neo-expressionist painters in the seventies, including Enzo Cucchi, Mimmo Paladino, and Francesco Clemente. Although they are sometimes grouped under the rubric of the *transavanguardia*, it would be a mistake to think of them as a movement—rather, they are compatriots with important commonalities. Above all, they share the influence of *arte povera*, especially in their strong sense of the primal force of nature and of man's place in nature as an animal among other animals. They are also all figurative painters, one might say painters of the visceral presence of the body (Clemente spoke of his admiration for "those who have 'thought' with their bodies"[10]) and all have an especially Italian sense of the living presence of the history of art. In addition, each conveys a

13.11 Mimmo Paladino, *Sull'orla della Sera,* 1982–3. Oil on canvas, 7ft 10¼in × 14ft 5½in (2.39 × 4.4m).
Private collection, Rome. Photograph by Zindman/Fremont, courtesy Sperone Westwater Gallery, New York. © Mimmo Paladino/VAGA, New York, 1994.

unique and curious mixture of sensual proximity in his work and an uncentered sense of individual identity.

Enzo Cucchi and Mimmo Paladino [fig. 13.11] are both artists deeply entrenched in Italy, indeed in the particular landscapes in which they each live. As with Chia, there is a persistent tension in their work between the intensely sensual demeanor of the painting and a curiously dissipated sense of self or identity in the subject matter, as though one's self is morbidly overwhelmed by the scale and variety of nature. But for Cucchi and Paladino the conflict is not played out so much on the surface, giving their paintings a more traditionally expressionist and symbolist flavor respectively. This sense of nature swallowing up identity is certainly a recurrent aspect of *arte povera* as well, but nowhere is it so strikingly conveyed as in the work of Francesco Clemente.

Francesco Clemente

Francesco Clemente's *Myriads* [fig. 13.12] consists of nineteen small pastel drawings belonging to a larger group of eighty-five such works (the so-called "Pondicherry Pastels") done in Pondicherry and Madras, India. The drawings express a spirituality in the smallest detail of nature, an aspect of Clemente's work that is very much at home in the religions of India. Clemente read the beats in translation during his youth and hung out with conceptual artists in the early seventies. These influences undoubtedly contributed

13.12 Francesco Clemente, *Myriads,* 1980. Nineteen drawings, ink, pastel, gouache, charcoal, and graphite on paper, 6⅜ × 3½in (16.2 × 8.9cm) to 13½ × 13in (34.3 × 33cm).
Photograph courtesy Anthony d'Offay Gallery, London.

respectively to the eccentricity and notational character of these drawings. The "Pondicherry Pastels" vary widely in size, overt subject matter, and style, defining an aesthetic of inclusiveness and diversity.

Clemente explained, "My overall strategy or view as an artist is to accept fragmentation, and to see what comes of it—if anything . . . Technically, this means I do not arrange the mediums and images I work with in any hierarchy of value. One is as good as another for me." And he views the multiplicity of the self in the same way: "I believe in the dignity of each of the different levels and parts of the self. I don't want to lose any of them. To me they each exist simultaneously, not hierarchically . . . One is not better than another."[11]

The pastels in *Myriads* are conceived as a group within a group and introduce a way of seeing art in profusion and simultaneity. As a composition, *Myriads* has the same undecidability, open-endedness, and emphasis on seeing across the surface that we have discussed as a trait of postmodernism. Clemente emphasizes fragmentation and polarities, wandering from image to image, subverting control and cohesion. Where Kiefer obsessively seeks to define his identity, Clemente seems determined to deconstruct his.

"I feel a lack of affinity, a dislocation that gives me room to work."[12] To balance this precarious dissolution, his sexuality provides an affirmation of his existence as part of the overwhelming and infinite processes of nature. The curator Kathy Halbreich called him "a voyeur of his own homelessness, and his sexuality gives him his portable dwelling, the shelter of identity. In Hindu fashion, he often portrays evanescent or out-of-body experiences reached (paradoxically, in Western terms) through the widening of orifices and erotic possibility. This opening of the senses to the world creates a visage alternatingly vulnerable, terrified, resigned, preterhuman."[13]

In the left-hand section of *He Teaches Emotions with Feelings*, a portable fresco painting [fig. 13.13], Clemente portrays himself as though helplessly bound while a shower of arms reach out from all directions, the fingers invading and penetrating every orifice of his body. The individual forms in the three sections of the fresco not only have no explicit relation to one another, they also float in undefined space within each segment, like motifs in some of the Roman frescoes at Pompeii. The composition within each segment of this work, as in several of the drawings in *Myriads*, deliberately undermines conventional notions of pictorial balance. In this, one senses the influence of the even more notational drawings of Joseph Beuys and more proximately of Cy Twombly, who shares with Clemente a classical aesthetic elegance.

Clemente was born into the titled aristocracy of Naples in 1952 and had a privileged background of elegant surroundings and classical education, which he himself has described as detached from the realities of modern urban life.[14] He moved to Rome at the age of eighteen and traveled to India for the first time in 1973, when he was twenty-one. He returned there for longer and longer periods, as well as spending time in New York, where he finally relocated the center of his activities in 1982. Clemente's constant physical dislocations to Madras, Rome, and New York, as well as travels to Afghanistan, Japan, and elsewhere, mirror the dislocated sense of self in his paintings. He even displaces his sexuality in his paintings, often reinventing himself with a kind of amorphous sexuality that is at once feminine and masculine.

Clemente seeks to achieve a kind of limbo in his work, making it possible to experience everything, even to become something else. This remarkable openness can only exist by suspending a strong sense of identity. His remarks about the 1981 print *Not St. Girolamo* might apply generally to his work: "The images are results . . . of wandering from one idea to another without giving more weight to one or the other . . . you forget where you began. So what you see there, I don't know myself. I made a safe . . . and I lost the key. And losing the key makes the work, gives the work this autonomy."[15] Under these conditions it doesn't matter where one enters the composition—one begins wherever one engages it, like picking up a newspaper after months of not reading them and moving forward with current events without ever looking back.

It is part of the rich ambiguity of Clemente's work that an artist so dedicated to the suspension of self should also focus relentlessly on the self-portrait as his vehicle. He is an enchanting fabulist [as in fig. 13.14], reawakening the fantasy and sensual pleasure of art by placing an infinitely malleable self into constantly changing places in the imagination. In his receptivity to chance encounters he is mesmerized by the rituals that codify them.

The Internationalization of Neo-Expressionism

The New York art world did not take note of the new expressionist painting of Germany and Italy until the early eighties, but once the discovery was made it inaugurated a rapid internationalization of the art world. In the nineties it included Japan, where there has emerged a fusion of indigenous philosophy and contemporary international trends. Even as far away from Europe and New York as Australia, the electronic communication and jet travel of the last two decades have made it possible to participate actively in the international discourse.

The Australian artist Mike Parr [fig. 13.15], for example, worked with the Viennese actionists in the mid seventies and was inspired by their stirring emotionalism. He is well read in philosophy, linguistics, and psychology and was drawn not simply to the reason of major theoreticians in social science and the humanities but to the irrational that is masked behind their theories. In particular, he focused on works such as the late writings of Antonin Artaud and those of the psychoanalyst Wilhelm Reich,

13.13 Francesco Clemente, *He Teaches Emotions with Feelings,*
1980. Fresco, 9ft 10⅛in × 19ft 8¼in (3 × 6m).
Private collection. Courtesy Bruno Bischofberger, Zürich.

13.14 Francesco Clemente, *Untitled,*
1983. Oil on canvas, 6ft 6in × 7ft 9in
(1.98 × 2.36m).
Collection, Thomas Ammann, Zürich.

13.15 Mike Parr, *The Inertia of Night (Self Portrait as a Slat),* 1983. Charcoal and Girault on paper, 8ft 11⅞in × 6ft (2.74 × 1.83m). Private collection. Photograph courtesy Roslyn Oxley Gallery, Sydney, Australia.

when their language lost grammatical structure and devolved into a sequence of images. Parr's neo-expressionist style of drawing emerged in the early eighties, driven by his exploration of this hidden content in theoretical texts. Many of these monumental drawings center on the artist's head, deformed by rendering a photograph twisted in perspective space. In counterpoint to the meticulous, if tormented, transcription of the head is a response to its deformity in a free gestural field of abstract line and color.

The Peculiar Case of the Russians

Prior to the dissolution of the East Bloc in 1990, the repressive climate made it impossible for Russian artists to exhibit anything that varied from the official formulas. In Moscow, a tight-knit community of dissident artists staged one-night exhibitions in one another's

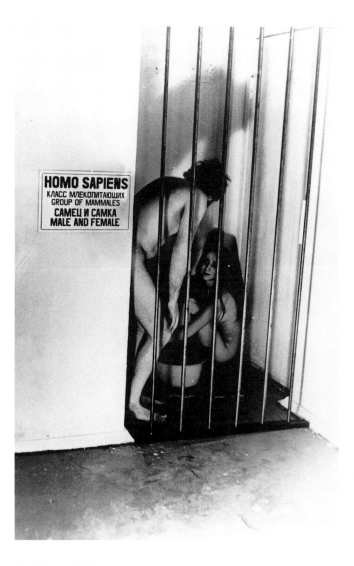

13.16 Valerii Gerlovin and Rimma Gerlovina, *Zoo, March 1977,* 1977. Gelatin silver print.

Collection Jane Voorhees Zimmerli Art Museum, Rutgers; the State University of New York; the Dodge Collection of Nonconformist Art. Photograph by Jack Abraham.

apartments (by invitation only) and depended upon the stimulation of lively debate amongst themselves. They were almost totally cut off from developments in the West, so that the work of those who attempted to respond to the international scene looked out-of-date, even tediously derivative. They also existed in a strange limbo within their own society, cut off from entering their work into any form of public discourse on values.

An "unofficial" or "unconformist" art movement arose from the reforms of the late fifties, but it was suppressed again after the fall of Kruschev in 1964. Then in the early seventies an innovative vanguard emerged, based on conceptual art; there were performance artists such as "Red Star" and the "Collective Actions Group," as well as individuals such as the Gerlovins (Valery and Rimma), who both made objects and did ironic performance works. In their 1977 action, *Zoo* [fig. 13.16], they appeared on display

nude and behind bars with a plaque that read "Homo Sapiens, Group of Mammals, Male and Female."

This work had a political edge as a commentary on the place of the individual in Russian society, but it also exhibited a gloomy, Russian existentialism that is not politically motivated. Indeed, this duality characterizes the Russian vanguard of the seventies and eighties generally: on the one hand artists such as Erich Bulatov or the team of Vitaly Komar and Alexander Melamid appropriated the language of Socialist Realism (the official language of State-sponsored art) and undermined it with ironic contradiction, while on the other hand artists such as Ilya Kabakov concentrated mainly on the existential absurdities of daily life in Russia.

For the Moscow artists Komar and Melamid (who emigrated to New York via Israel in 1978), socialist realism had a nostalgia that evoked the atmosphere of their childhoods in the last years of the Stalin period. *Stalin and the Muses* (from the "Nostalgic Socialist Realism" series) [fig. 13.17] has the tenebrous light and palette of the poorly conserved Rembrandts and other old master paintings that hang in the gloomy light of the great Russian museums. The scantily clad muses approach a smiling Stalin, who accepts

13.17 Komar and Melamid, *Stalin and the Muses,* 1981–2. Oil on canvas, 6ft × 4ft 7in (1.82 × 1.4m).

Photograph by D. James Dee, courtesy Ronald Feldman Fine Art, New York.

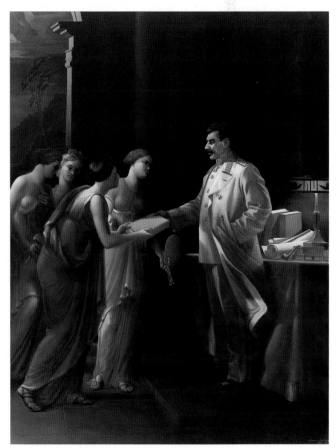

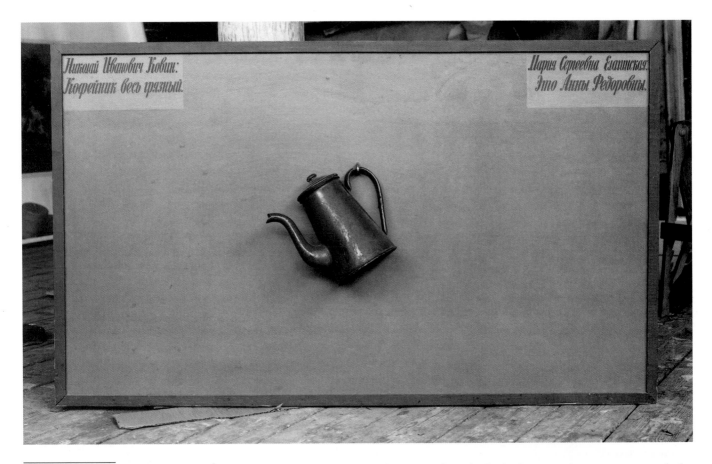

13.18 Ilya Kabakov, *Nikolai Ivanovich Kovin: The Kettle Is All Dirty,* May 1982. Coffee pot, enamel on masonite, 27⅝ × 47¼in (70 × 120cm).

Private collection, Paris. Photograph by D. James Dee, courtesy the artist. © 2000 Ilya Kabakov/Artists Rights Society (ARS), New York/VG Bild-Kunst, Bonn.

their offering of divine inspiration. Dressed in his gleaming white military uniform, with its highlights of red and gold and rich azure lining, he is an imperial presence of historical grandeur, not the bloodthirsty tyrant of the history books.

On the one hand this work satirizes the saccharine glorification of Soviet history that the style of Soviet realism was fashioned to depict, pushing the clichés to a ridiculous extreme in this ludicrous apotheosis of Stalin. Yet it also evokes a genuine nostalgia for the past. Moreover, the fabulous invention of deities visiting Stalin, in an incongruous setting patched together from baroque and Renaissance paintings, creates a sense of displacement in time and social reality. This resonates with the surreal existence of the Soviet dissident artist of the seventies and eighties, and with the alienation that seems increasingly familiar in the mass culture of the West.

Komar and Melamid became close friends in art school and in 1972 (five years after graduating) they decided on a collaborative career making what they dubbed "Sots" art. The term referred to socialist realism (which was the old-fashioned academic vocabulary in which they were trained), but it also alluded to American pop art by lifting socialist

realism out of its ideological context just as pop art took the clichés of consumer goods and popular media (the heart of American ideology) out of their commercial context in order to manipulate them as icons of the culture.

Ilya Kabakov

Ilya Kabakov, another "unofficial" Soviet artist, did not address ideology in his work of the mid-seventies to mid-nineties, but the stolid inefficiency and oppressive drabness of quotidian existence in Russia. Kabakov's work centers on the immediacy of lived experience and the flight of creative imagination that transcends it. "It's not the artistic tradition but daily life that brings new ideas," he explained.[16]

In paintings of 1970–71, Kabakov already announced his use of fragments of prosaic text together with common objects mounted on spare, flatly painted canvases. His 1982 painting, *Nikolai Ivanovich Kovin: The Kettle Is All Dirty* [fig. 13.18] exemplifies the simultaneous authenticity and irony in his approach. It consists of a rude, tin coffee pot, hanging in the center of a flat enamel panel; the panel is painted like any of the miles of drab, monochrome walls in nondescript Soviet buildings, and the composition is crudely framed in a rustic wooden molding. In the two upper corners, small rectangles contain inscriptions recounting a conversation: "Nikolai Ivanovich Kovin: The coffee pot is all dirty." And from the other corner: "Maria Sergeevna Elaginskaya: That's Ana Fedorovna's."

In this most prosaic of exchanges over such a common object are embedded intimations of the trivial conflicts of everyday life in the kitchen of the communal apartment. This kind of painting uses the poorly made, familiar objects of Soviet existence to evoke the grim claustrophobia of these Moscow dwellings, where one's tiny bedroom may have opened onto a crowded corridor with three families sharing a single kitchen and bath. Kabakov extended painting into the space of the real world with commonplace objects. On another level, it's hard not to read into this a sidelong critique of Vladimir Tatlin's famous slogan of constructivist idealism, "real materials in real space." Nor is it hard to see in the commonness of the placard-like "thought-bubbles" in which this vulgar narrative is inscribed a formal parody of the banners in the constructivist drawings of the 1920s, which bear slogans of the Revolution's (now so painfully failed) utopianism:— slogans like "proletariat!" (as in El Lissitzsky's Lenin Podium of 1924), or "The Press Is Our Weapon" (in one of Alexander Rodchenko's advertising posters of 1923).

"It is our task to describe the state of mankind, of the world and of our own psyche in this post-utopian world,"[17] Kabakov told an interviewer in 1987, and he described this "state" for himself in an internal dialogue of voices. Beginning in 1970 Kabakov invented characters and told their stories in albums—the perfect vehicle for an "unofficial" art that was not permitted to be exhibited in public and for the life of a person living in a society that requires a separation between public expression and private feeling. The very first of these albums concerns "Sitting-in-the-closet Primakov," a character who retreated into the dark for half a year as a child so that he could only imagine what went on outside from the sounds coming through the wall. The first eight pages of illustrations accompanying the text in this album are merely black squares with yellow text blocks (implicitly offering ironic explanations for Malevich's Black Square!). With age, Primakov became more eccentric and incoherent; "he pronounced only nonsensical words."[18]

In a series of drawings entitled In the Apartment (from the late sixties), Kabakov deliberately misidentified simple objects from the apartment in the text-key below—an apt aesthetic metaphor for the common Soviet disjunction between public and private mental space. Then in the album Anna Petrovna Has a Dream there is a key at the bottom of each page identifying totally abstract forms—little circles—as the souls of specified individuals or things. Kabakov formalized the complex intertwining of real feelings, private thoughts, one's spirituality, and the survivor's dissimulation that is required in Soviet life, by displacing all of this onto a "net of commentaries. . . . These were not my commentaries, although of course I wrote them with my own hand. But mentally, internally, it was as though these originated from others; they were in the very precise sense others, voices, . . ."[19]

With Ten Characters of 1988, Kabakov made the experience of this internal dialogue still more real by creating a physical space within which the viewer is totally absorbed. Like "Sitting-in-the-closet Primakov," Kabakov himself mediates daily life and the real memories of formative experience by distancing himself from the "other" and creating an utterly free mental space in which the imagination can mediate "what is heard through the wall." The seemingly chaotic and always open-ended narratives that generate the installations—which have become Kabakov's primary medium—are fantastic tales filled with irony and a profound sense of the absurd, but also with an almost childlike wish to believe, a spirituality in the tradition of Gogol's "The Overcoat."

To accompany The Man Who Flew Into Space From His Apartment [fig. 13.19], Kabakov wrote:

The lonely inhabitant of the room, as becomes clear from the story his neighbor tells, was obsessed by a dream of a lonely flight into space, and in all probability he realized this dream of his, his "grand project." The entire cosmos, according to the thoughts of the inhabitant of this room, was permeated by streams of energy leading upward somewhere. His project was conceived in an effort to hook up with these streams and fly away with them. A catapult, hung from the corners of the room, would give this new "astronaut," who was sealed in a plastic sack, his initial velocity and further up, at a height of 40–50 meters, he would land in a stream of energy through which the Earth was passing at that moment as it moved along its orbit. The astronaut had to pass through the ceiling and attic of the house with his vault. With this in mind, he installed powder charges and at the moment of his takeoff from the catapult, the ceiling and roof would be wiped out by an explosion, and he would be carried away into the wide-open space. Everything was in place late at night, when all the other inhabitants of the communal apartment are sound asleep. One can imagine their horror, fright, and bewilderment. The local police are summoned, an investigation begins, and the tenants search everywhere—in the yard, on the street—but he is nowhere to be found. In all probability, the project, the general nature of which was known by the neighbor who told the investigator about it, was successfully realized.[20]

Kabakov left the Soviet Union in 1988 for Western Europe, just two years before the collapse of communism, and in 1992 he emigrated to New York. His first installation in New York was his Ten Characters, a complex installation for the Ronald Feldman gallery in 1988. Kabakov has since dedicated himself to what he calls "total installation" in which he attempts to insert the viewer actively into the field of the painting.[21] In the later nineties Kabakov also moved beyond the subject matter of his earlier life in Russia.

Kabakov's 1998 Palace of Projects [figs. 13.20 and 13.21] is a building with translucent walls, spiral in plan (like a snail shell), containing models and diagrams for sixty-seven different ideal projects on how to improve yourself or the world, or how to increase creativity: Kabakov has invented a chauffeur from Kishinev who has designed wings that you strap on for several 5–10 minute sessions a day, in the privacy

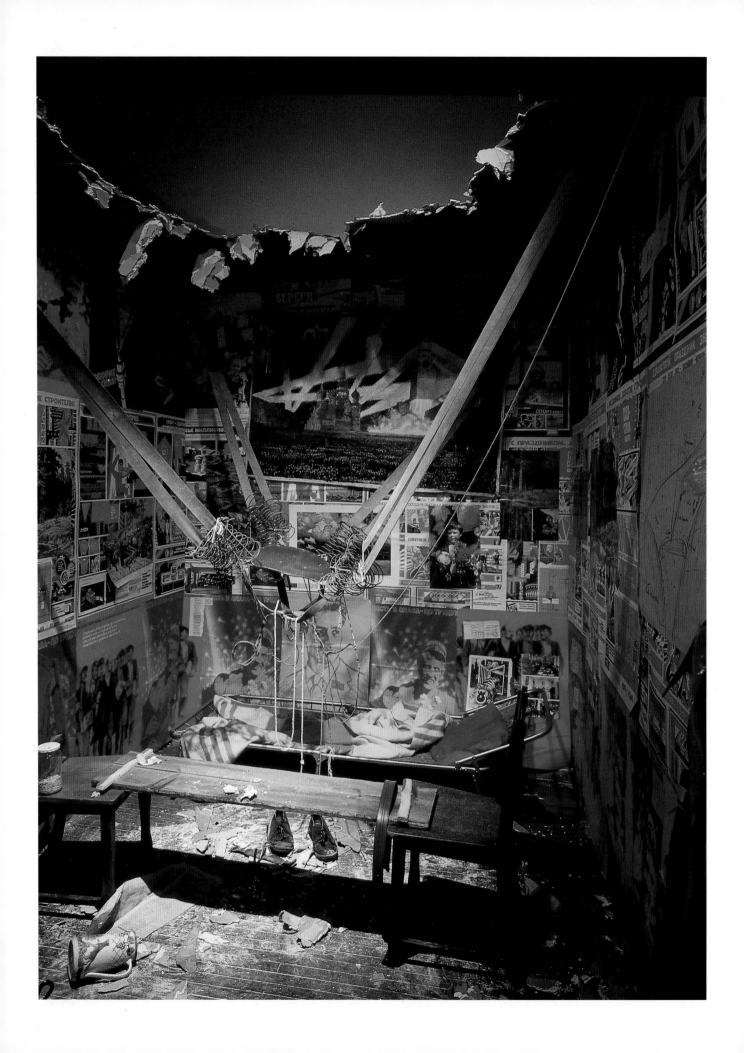

13.19 (opposite) **Ilya Kabakov,** *The Man Who Flew Into Space From His Apartment,* from "Ten Characters," 1981–8. Installation at Ronald Feldman Fine Art, New York, six poster panels with collage, furniture, clothing, catapult, household objects, wooden plank, scroll-type painting, two pages of Soviet paper, diorama; room 8ft × 7ft 11in × 12ft 3in (2.44 × 2.41 × 3.73m).
Photograph by D. James Dee, courtesy the artist. © 2000 Ilya Kabakov/Artists Rights Society (ARS), New York/VG Bild-Kunst, Bonn.

13.20 Ilya Kabakov, *The Palace of Projects,* May 1998, London. Installation, approx. 23½ × 53½ × 76½ft (7.2 × 16.3 × 23.3m) overall, exterior view.
Photograph by Dirk Powels, courtesy the artist. © 2000 Ilya Kabakov/Artists Rights Society (ARS), New York/VG Bild-Kunst, Bonn.

13.21 Ilya Kabakov, *The Palace of Projects,* 1998, London. Interior detail.
Photograph by Dirk Powels, courtesy the artist. © 2000 Ilya Kabakov/Artists Rights Society (ARS), New York/VG Bild-Kunst, Bonn.

New Imagist Painting and Sculpture

Meanwhile in New York the "New Image Painting" show, which opened at the Whitney Museum in December 1978, focused attention on a genuinely new aspect of painting that had been evolving over the preceding decade. The curator, Richard Marshall, singled out ten painters who used recognizable images in their work but whose execution was principally in dialog with abstraction, not traditional figurative painting. These artists—and it proved true of other important artists who emerged in the seventies—were consciously working with multiple, interacting but independent layers of discourse simultaneously in their works, carrying off this separation of style and imagery without subordinating one to the other.

"New Image Painting" included the work of Nicholas Africano, Jennifer Bartlett, Denise Green, Michael Hurson, Neil Jenney, Lois Lane, Robert Moskowitz, Susan Rothenberg, David True, and Joe Zucker. Apart from Moskowitz these painters were still in their twenties during the late sixties, when rules of all kinds were thrown open to question, and they were raised on the more multidimensional world made available through television. In their work, they freely selected ideas from abstract expressionism, minimalism, pop, and conceptual art without feeling constrained by the dogmas of any of them.

Jennifer Bartlett created a sensation among artists on the downtown scene in New York with three shows, each of which filled a whole gallery with a single work made up of hundreds of 1-foot-square steel plates, hung in regular rows. She had the

of your own room, to help you change "in a better, more moral direction."[22] There is also a Mr. Sabirov from Vitebsk, whose instructions for sawing a hole through the floor of your apartment will liberate you from the "low, room, horizon" of your dull private life, and a V. Korneichuk (a writer from Ulan-Ude) who provides an elaborately furnished closet in which you can concentrate better. These are all replies both to the grandiose projects of Soviet communism and to the history of modernism with its collection of personal utopias. While no longer so explicitly concerned with Kabakov's previous life in Russia, it nevertheless still has the mordant irony about human nature that has always characterized his work.

plates commercially coated with a layer of baked-on white enamel like the signs in the New York subway (from which she got the idea in 1968).[23] The final show, held in 1976 at the Paula Cooper Gallery—a work entitled *Rhapsody* [fig. 13.22]—involved the installation of 988 plates. Bartlett had grand ambitions for the work to include "everything": figurative imagery—a house, a tree, a mountain, the ocean; geometric forms (a circle, a square, and a triangle); and a catalog of different styles of drawing (freehand, ruled, and dotted).

Bartlett painted on the plates with Testor's enamel, and the shapes and images could appear miniaturized on a single square or rendered large across multiple squares. She worked according to an elaborate set of self-imposed rules, even using a mathematical scheme to determine the precise placement of the dots. Although Bartlett painted the circle freehand, dotted, and measured in small, medium, and large sizes in the first section of the mural, she forgot to do the same in subsequent sections for the square and triangle.[24] Thus she made rules but then lost interest in them as she went along, disregarding or modifying them, so while *Rhapsody* seems fastidiously procedure-oriented, like a LeWitt, modularized like an Andre, codified into various catalogs in its language like a conceptual work, Bartlett only used each of these stylistic ideas as one of several, overlaid for expressive purposes in the work. Finally, there is even an iconographic dimension in such works—for example, the individual names of the composite title *Falcon Avenue, Seaside Walk, Dwight Street, Jarvis Street, Greene Street* of the same year [fig. 13.23] each refer to one of her former addresses in New York or California. In her work of the eighties [fig. 13.24] Bartlett frequently juxtaposed jarringly different styles or played off illusionism against real, constructed forms in space within a single work.

Michael Hurson could spin out elaborate soap operas around such intrinsically banal objects as a pair of eyeglasses [fig. 13.25]. He retreated from the complex macrocosm of the world and magnified the ordinary into the most incredible grid of event and emotions. The commonest details of life imply intricate melodramas filled with events "still to be explained . . . dramas that are inconclusive, absent of people,

and missing the narrative itself . . . intimations of a dramatic situation, like a chair overturned, or a door left ajar."[25] Hurson's revelation of nuances that no one else notices is comic in its naivety and at the same time frightening in its acuity. He transformed everything into an anecdote, trivial in scale and yet somehow credibly important.

Hurson constructed beautiful, miniature rooms in balsa wood during the early seventies, as if to imagine the space in which these dramas took place. At the end of the decade he wrote a play called *Red and Blue*, which opened at The Public Theater in New York in 1982. There were no actors on stage in his play, only an empty, miniature room with an overturned chair and a red and a blue light bulb conversing, exchanging fragments of gossip, and dimming on and off.

Despite the relaxed spontaneity of Hurson's drawing style and the witty informality of his subject matter, a formal underlying grid controls his compositions. The style and images in Hurson's drawings lead independent lives, and each detail, each brushstroke, each structural schema has its own highly developed and insular significance. Hurson remarked that the images in his *Eyeglass Painting #1* have nothing directly to do with what is happening expressively in the paint.[26] In this sense, the paintings are figurative and abstract at the same time.

Neil Jenney's paintings of 1969 and 1970, like *Girl and Doll* [fig. 13.26], have a viscerally expressive, gestural brushwork—in some he even seems to have used his hands directly to manipulate the paint. At the same time, the imagery is presented in a strikingly neutral way: "I was more concerned with approaching the viewer with relationships," he explained in the *New Image Painting* catalog, "for instance, a crying girl and a broken vase, birds and jets, or trees and lumber . . . I'm not interested in a narrative . . . I wanted the objects to be stated emphatically with no psychological implications."[27] So if the brushwork has associations with abstract expressionism, the images—single objects, isolated in a visual field—seem like a minimalist reduction and the psychological remove of the subjects into neutral images like a work of pop art.

After 1971 Jenney took a stylistic jump into a meticulous naturalism of a seemingly nineteenth-century

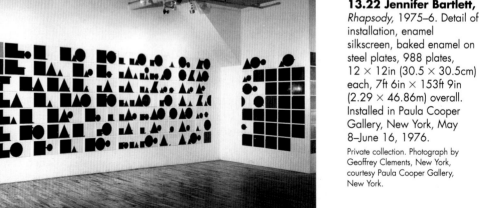

13.22 Jennifer Bartlett, *Rhapsody*, 1975–6. Detail of installation, enamel silkscreen, baked enamel on steel plates, 988 plates, 12 × 12in (30.5 × 30.5cm) each, 7ft 6in × 153ft 9in (2.29 × 46.86m) overall. Installed in Paula Cooper Gallery, New York, May 8–June 16, 1976.

Private collection. Photograph by Geoffrey Clements, New York, courtesy Paula Cooper Gallery, New York.

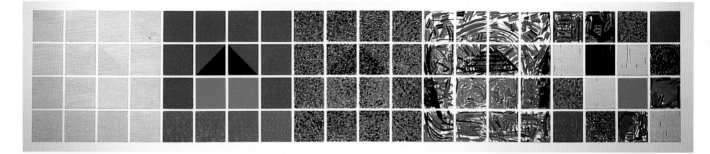

13.23 (above) **Jennifer Bartlett,** *Falcon Avenue, Seaside Walk, Dwight Street, Jarvis Street, Greene Street,* 1976. Enamel on silkscreen grid, baked enamel on steel plates, 4ft 3in × 21ft 7in (1.3 × 6.58m).
Collection, Whitney Museum of American Art, New York. Purchase, with funds from the Louis and Bessie Adler Foundation, Inc., Seymour M. Klein, President, and the National Endowment for the Arts. Photograph by Geoffrey Clements, New York.

13.24 (right) **Jennifer Bartlett,** *Volvo Commission,* 1984. Relaxation room, detail: table, painted wood, 29 × 35 × 35in (73.7 × 88.9 × 88.9cm); chair, painted wood, 35 × 18 × 18in (88.9 × 45.7 × 45.7cm); portfolio of twenty-four drawings, pen, brush, and ink on paper, 20 × 16in (50.8 × 40.6cm); house cigarette box, painted wood, 5 × 5 × 5in (12.7 × 12.7 × 12.7cm); boat ashtray, silver, 5 × 2in (12.7 × 5.1cm); screen, enamel on six wood panels, 6ft × 10ft 3in (1.83 × 3.12m).
Volvo Headquarters, Sweden. Photograph courtesy Paula Cooper Gallery, New York.

13.25 Michael Hurson, *Eyeglass Painting #1,* 1970. Oil and silkscreen on canvas, 24 × 48in (61 × 121.9cm).
Private collection. Photograph courtesy Paula Cooper Gallery, New York.

13.26 (right) **Neil Jenney,** *Girl and Doll,*
1969. Acrylic on canvas, 4ft 10in × 6ft 4½in
(1.47 × 1.93m).
Private collection. Courtesy Thomas Ammann Fine Art,
Zürich.

13.27 (below) **Robert Moskowitz,**
Skyscraper 2, 1978. Latex, acrylic, and oil
on canvas, two panels, 10ft × 4ft 9¾in
(3.05 × 1.46m) overall.
Collection, Mr. and Mrs. Gerald Greenwald, New York.
Photograph courtesy Blum Helman Gallery, New York.

sort, and his use of exaggeratedly heavy black frames with
the titles lettered on them emphasizes the nineteenth-
century idea of painting as a "window on to nature," in
contrast to the self-contained object put forward in
formalist theory. The anachronism underscores a pop art
conception of nature as inherently mediated, an attitude
echoed in Jenney's remark that: "I don't think the artist
should deal with space or think about dealing with space.
He should think about adjusting culture."[28]

In 1964, Robert Moskowitz started teaching a seminar
at the Maryland Institute in Baltimore in which he simply
showed slides of works of art he liked, in alphabetical
order, by artist.[29] There is a simple, Warhol-like deadpan
quality to this that also characterizes his best paintings.
The two grand simplified images of *Skyscraper 2* (1978)
[fig. 13.27] each fill a 10-foot-high canvas precisely
proportioned so as to have a nearly even margin all the
way around the regular geometry of the near-identical
forms. It could be a minimalist painting but for the
subtlest hint of spatial recession in the fact that one is just
slightly smaller. Naturally, once the viewer recognizes the
allusion to the World Trade Towers in New York, what at
first seemed like a minimalist abstraction changes
completely for the viewer.

Susan Rothenberg exhibited six of her horse paintings
in the "New Image Painting" show. She began the series—
her first body of mature work—in 1974, describing it as
paintings about "placement in space" (a minimalist idea).
The point, as she explained it, was to take the charged image
of the horse and deenergize it (as Warhol did with his
subject matter) while at the same time putting the emotion
(not a minimalist concern) into the field of brushwork.[30] She
drew all the horses in this first series as flat outline figures,
in left profile, more or less centered and filling the
composition. She dealt with the paint surface (influenced by
the bravura brushwork of Neil Jenney's canvases of 1969 to
1970[31]) and the color (which had no relation to the color of
an actual horse) as elements of an abstract gesture painting.
The expressive use of materials in the work of Eva Hesse as

well as the remarkable synthesis of abstract expressionist handling with an emotionally reserved, indeed ostensibly neutral, treatment of imagery in the work of Jasper Johns had an important impact on her thinking.

For Rothenberg, the painting process is a corrective experience in which she starts with an idea then keeps correcting all the things that she thinks are wrong with it until she gets it right. The antagonism between elements is crucial but the elements are also interdependent—in each case the field, for example, evolved in relation to the image.[32] In addition, Rothenberg in some manner cut the image with geometric divisions or lines or the bisection of the composition—as in *Two Tone* (1975) [fig. 13.28]—to emphasize the physicality of the canvas over the image.

Nevertheless, as Joan Simon pointed out, in her book on Rothenberg, the horses tend toward a human scale, and their movement—even in some sense their anatomy—seems reminiscent of human beings too. The artist herself was aware of the connection and in 1974 photographed a friend in poses related to the horses (all in left profile) and then did three paintings of her that in every other way belong to this first series of horse compositions. But, she said, "I got more concerned with the articulation of the figure than painting and was having a hard time keeping them flat, silhouetted. Finally I had to stop it."[33]

Why horses? To be sure, the artist identified with the horses but at the same time also wanted to maintain a distance from herself in her subject matter. In *For the Light* (1978–9) [fig. 13.29], the horse has broken out of the controlled silhouette and charges at the viewer. Rothenberg blocks this advance with a bone-like form hovering in front of the animal, on the picture plane. This device contradicts both the volume and the implied movement, locking the form into the space of the composition. The sheer sensuality of these paintings suggests an immediacy, a body

presence (as in Hesse's work and in *arte povera*). As Simon suggested, this may be related not only to feminist issues in the air at the time but also to the physicality of the dance and body performances Rothenberg had been involved with over the preceding decade.[34]

Rothenberg was born in 1945 and lived a counterculture existence in the late sixties, finishing a B.A. at Cornell in 1967 and finally settling in New York in the fall of 1969.[35] There she reconnected with friends she had known at Cornell, including Gordon Matta-Clark and Alan Saret, who brought her in touch with the downtown art scene. She studied dance and performance with Deborah Hay and Joan Jonas and the direct bodily expressionism of this work came out in her subsequent paintings. Rothenberg made her first horse paintings of 1974 in a raw sienna color, like clay, relating to the earth, to the body, and to prehistoric cave paintings.

It was during a lonely fall semester at Cal Arts in 1977 that Rothenberg started taking the horses apart. As they become more volumetric, mobile, alive (and more human), she headed them off—as in *For the Light*—with surface forms, or dissected them into free-floating legs and heads. In 1979 Rothenberg made a painting called *My Bones* and with this her subject matter became more directly personal. The horse transformed itself, she recalled:

It turned almost into a figure. And it turned up in the bare bones. No superfluous geometry dealing with the edges of the painting, but just the bare bones of the frontal horse, which suggested that a figure was appearing—that the horse was metamorphosing into a human figure. I realized that there weren't very many of those images left, that it had absolutely naturally reduced itself to a place where I was going to be forced to continue—differently.[36]

So "the horse just ran out," and she was left "scared again."[37]

In 1980 and early 1981, Rothenberg painted a series

13.28 Susan Rothenberg, *Two Tone*, 1975. Acrylic on canvas, 5ft 9in × 9ft 5in (1.75 × 2.87m). Collection, Albright-Knox Art Gallery, Buffalo. Gift of Mr. and Mrs. Armand Castellani.

of schematic faces and hands. In the summer she shifted to oil paints at the suggestion of her friend Elizabeth Murray, and that promoted a finer, longer, impressionistic brushstroke—a directional gesture with more color, as in *Half and Half* (1985–7) [fig. 13.30]. This work of the mid eighties was very different from what had come before. All of a sudden she found herself struggling with more complicated compositions and focusing on movement, painting dancers, jugglers, and spinning figures in cinematic motions. The strange, split figure in *Half and Half* seems Giacometti-like in its existential anxiety, while the intensity of color and brushwork recalls Bonnard. Then, at the end of the eighties, the horses returned in a calmer and more erotic form.

13.29 (left) **Susan Rothenberg,** *For the Light,* 1978. Acrylic and flashe on canvas, 8ft 9in × 7ft 3in (2.66 × 2.2m).
Collection, Whitney Museum of American Art, New York. Purchase, with funds from Peggy and Richard Danziger. Photograph by Geoffrey Clements, New York.

13.30 (below) **Susan Rothenberg,** *Half and Half,* 1985–6. Oil on canvas, 5ft × 7ft 1in (1.52 × 2.16m).
Private collection, New York. Photograph courtesy Sperone Westwater Gallery, New York.

13.31 (left) **Joel Shapiro,** *Untitled,*
1973–4. Bronze, edition of two,
3 × 1¼ × 1¼in (7.6 × 3.2 × 3.2cm).
Private collection. Photograph by Geoffrey Clements,
New York.

13.32 (below) **Joel Shapiro,** *Untitled,*
1980–1. Bronze, edition AP/3, 4ft 4⅞in ×
5ft 4in × 3ft 9½in (1.34 × 1.63 × 1.16m).
Private collection.

There were several other interesting artists in 1978 whom one might have included in a "new image" show, including the sculptor Joel Shapiro. In 1971, Shapiro was still experimenting with process works such as *One Hand Forming/Two Hands Forming*—two piles of modular forms in raw fired clay made into an oblong volume (with one hand) and a ball (with two hands) respectively. He made pieces concerned with physical weight and measurement, and simple, abstract, geometric forms. One of these "minimal" geometric forms turned out to be a bronze house, like a hotel from a Monopoly game, and another a miniature bronze chair [fig. 13.31]. As in the work of Bartlett and Rothenberg, Shapiro rendered his house and chair in a manner more concerned with abstraction.

The 3-inch-high bronze chair (like the little house) sat on the floor in a large public space, raising peculiar issues of scale and perspective. It both disappeared and at the same time brought the viewer along. "I was insisting on an intimate experience in a public situation," he explained.[38] By the end of the decade, Shapiro's simple geometric configurations (cast largely from constructions of wooden two-by-fours) became more and more overtly recognizable as active, mobile figures [fig. 13.32]. He contradicted the motility of the athletic poses with the relatively untransformed identity of the wooden blocks, which persevered as such, even when formally frozen into bronze.

Elizabeth Murray

Alice Aycock once made the observation that the work of many women artists derived an interesting and particularizing eccentricity from an exceptional responsiveness to the realities of their lives.[39] According to Elizabeth Murray, one finds art "in the street. Or you find it at home, right in front of you. I paint about the things that surround me—things that I pick up and handle every day. That's what art is. Art is an epiphany in a coffee cup."[40] Murray paints the

439

encounter of her inner life with the world and renders this collision of internal and external by superimposing several trains of thought over one another in her compositions without for a moment losing the independence or momentum of any of them. The figurative subject matter and narrative, the abstract construction of forms in relief, the expressive brushwork, and the interplay of depicted abstract forms all maintain their own identities, development, and associations, while at the same time interacting with one another, with the artist's personal history, and with the history of art.

The Origins of Murray's Style

Elizabeth Murray's daily encounters with the great Cézannes in the Art Institute of Chicago while she was a student in the School of the Art Institute from 1958 to 1962 taught her to see the way pictorial structure, handling, and description could imbue a vital spirit into the simplest inanimate objects. She would also "go upstairs to de Kooning's *Excavation* to see how he manipulated the paint," she remembered. "I had an idea of what it ought to feel like to make a painting. It's a very 'inner' experience. When things go well, you stop thinking about what you're doing. I was in my last year of art school when I finally put it together and discovered how to get my feelings out. It's not that you learn how to paint—anybody can do that—but you learn how to be *expressive* with paint."[41]

Murray went to Mills College for an M.F.A. There she met Jennifer Bartlett, who, when Murray finally moved to New York City in 1967, introduced her to a group of like-minded artists. At that time, Murray felt simultaneously connected to and also competitive with process art and minimalism, especially the work of Richard Serra, Keith Sonnier, and Brice Marden. The prevalent attitude "that painting was out . . . was unnerving," she recalled, "but then I didn't give a damn . . . For the first time in my life I was exactly where I wanted to be."[42]

Murray's unique vocabulary of biomorphic abstraction and expressive surface handling came together around 1975, and in that year she was enlisted into Paula Cooper's gallery. Cooper and Murray were a good match, both fiercely independent, dedicated to their work, and little interested in the fashions and careerism of the marketplace. In 1968 Cooper had chosen to open her gallery in the run-down area where the artists were taking up residence rather than uptown near the collectors. Cooper's was the first commercial gallery in SoHo, and her first show was a benefit for Veterans Against the War in Vietnam. Joining Cooper's gallery allowed Murray to concentrate on her painting.

If the title of *Tempest* [fig. 13.33], a canvas of 1979, suggests some turbulence in Murray's emotional life in the late seventies, the style provides a rejuvenating escape into the comics. The cartoon-like black outlines and clear, brilliant, and intensely contrasting color areas recall the drawings of Donald Duck, Little Orphan Annie, and Dick Tracy. "I remember writing to Walt Disney to ask if I could be his secretary," she said. ". . . I think cartoon drawing—the simplification, the universality, the diagrammatic quality of the marks, the breakdown of reality, its blatant, symbolic quality—has been an enormous influence on my work."[43] In *Tempest*, the fine yellow line that connects and penetrates the figures seems almost narrative and at the same time like the emblematic signs used by cartoonists to indicate motion, surprise, or an aside that is not meant to be seen within the narrative frame.

Intimations of the figure increased steadily in Murray's abstraction at this time. Yet, like her contemporaries in the "New Image Painting" show, she had a paramount interest in the paint and structure. Indeed, Murray's focus on being "*expressive with paint*" connects her to abstract expressionism, while her use of figural references enhances the associational depth of the handling, rather than leading the viewer away from the abstract content toward a recognizable subject. "I sort of know what they are," she remarked about the sometimes complex forms, "but I don't completely know what they are either."[44]

Formally, *Tempest* relates to pop art in its palette and in the reference to the comics. The shaped canvas, which she introduced in 1978, derives from Stella's paintings of the sixties, but instead of confirming the structural logic of the interior in the fashion of formalist painters Murray (in a decidedly postmodern attitude) set the perimeters of the work off against the interior action. Similarly, she explored a variety of surface handling, from a delicately refined touch in monochromatic fields (inspired by the surfaces of Brice Marden's paintings of the late sixties) to flatly painted or improvisationally variegated passages. By 1981 she had developed this simultaneous variety of handling with sufficient deliberateness to remark that she "felt it was possible to paint all the ways I can paint in one painting."[45]

Pursuing the Logic of the Shaped Canvas

The shaped canvases of 1978 and 1979 soon proliferated into composite paintings made up of multiple canvases, like puzzles that don't quite fit together. The transition took place in 1980 with a painting called *Breaking*. Murray had made four shaped panels, painted two, and then put the other two "down on the floor and looked at them together. It was an enormous step because it had never occurred to me to break up or use the shapes together . . . The beer glass [the central motif] is breaking in half in an illusionistic as well as in a physical way, and that's the first time I realized that I could do both at once."[46]

In *Painter's Progress* [fig. 13.34], Murray broke apart the central image of the artist's palette and brushes, scattering it across nineteen separate canvases, as though realizing in tangible form the shattered surface of facet planes in a cubist Picasso of the early teens. "I was imagining a whole thing—dropped or fallen and then shattered—on the ground, in the air, or perhaps in the body or mind. The image inside is trying to form the pieces whole again . . . The psychological meaning of the painting for me is my own conscious and unconscious efforts to bring disparate conflictive parts of [my] self together."[47]

13.33 Elizabeth Murray, *Tempest*, 1979. Oil on canvas, 10ft × 14ft 2in (3.05 × 4.32m).
Collection, Memphis Brooks Museum of Art, Memphis, Tenn. Photograph courtesy Paula Cooper Gallery, New York.

Although Murray's painting has too many crosscurrents of association to permit one to read in it literal correspondences with the events in her life, she did venture that *Painter's Progress* was "so psychologically satisfying because I finally realized the meaning of shattering and of putting an image inside the shattered parts that would make them whole again,"[48] and remarked that "this applied to my art and my life."[49] As in *Tempest*, the passionate colors and the cartoon-like drawing in *Painter's Progress* provide counterpoint to a darker side and offer an exit into fantasy, like the cartoon paintbrush that introduced the Walt Disney *True Life Adventure* movies (such as *The Living Desert*) that Murray saw as an adolescent. In these films the brush would paint a stroke of color across the screen and as the paint dripped down the cartoon would magically fade out and the live filmed images would take over the screen, turning into the opening scene of the story.

A clearly discernible coffee cup emerged as the central motif in Murray's painting during the summer of 1981 and became the dominant theme in the paintings of the following year. Meanwhile, Murray also began constructing more complicated supports that literally overlap one another, building out toward the viewer and leading to such complex supports as in *Her Story* (1984) [fig. 13.35]. By the nineties she was modeling the surfaces. She had experimented with overlapping sheets in her pastels in 1980 (since 1979 she had often used colored pastels, along with the small memo-pad sketches in ballpoint pen or pencil that she had always done, to experiment more freely with new ideas). The subject of *Her Story* concerns, in part, the death of the artist's mother in 1983. In this painting Murray adopted an almost story-telling mode to deal with the subject. She explained, "I associated books with my mother. *Her Story* is really a portrait of her sitting with a book, holding a cup."[50] At the same time Cézanne's portrait of *Madame Cézanne in a Yellow Armchair*, which Murray studied closely in the Art Institute, also seems present as a lingering influence on this portrait of a seated woman.

In *Her Story*, the blue figure (abstracted into simple angular forms) sits on a red chair with a pink book in her left hand and a coffee cup in her right. Under the book rests a freeform low table and, behind her, one sees the spines of the chair back. Murray painted these images right over the negative spaces and tiers of relief in the canvases, making unmistakable both the independence of the subject from the sculptural structure of the surface, and the enriching dynamic of their juxtaposition. The artist has elaborated each object with the same degree of engaged emotional commitment as she has the abstract constructed elements.

Such oppositions even exist within the color, as in the way Murray plays off the refinement of the blue, red, and lavender against the rustic browns and greens and the gritty unfinished surface application. The palette and handling also have another history in relation to the hotly debated Julian Schnabel exhibition at the Mary Boone Gallery that year. Schnabel's crude application of paint over fields of shattered crockery [fig. 14.7] corresponded with and may perhaps have catalyzed Murray's deliberate awkwardness of paint application. Murray experimented with a cruder, dryer, and less elegant style of application in the later part of 1982 at the same time as she started to assemble her overlapping forms and build out toward the viewer with multivalent pictorial and constructed elements. As in Murray's separation of her work into several overlapping but independent lines of

13.34 Elizabeth Murray, *Painter's Progress,* 1981. Oil on canvas in nineteen parts, overall 9ft 8in × 7ft 9in (2.94 × 2.36m).

The Museum of Modern Art, New York. Acquired through the Benhill Fund and Gift of Agnes Gund. Photograph by Geoffrey Clements, courtesy Paula Cooper Gallery, New York.

development, the palpable reality of Schnabel's plates also functioned independently of his imagery and handling.

Murray has remarked on "how interesting it is to paint on these surfaces."[51] The physical structure and depth refer to the evolution of the shaped and constructed canvas from Picasso through Stella. In addition, Murray turned the shaped canvases into another thread of literal subject matter. The individual canvases of *Her Story* consist of two letter "A"s set bottom to bottom at the middle of the composition (the top of one points down to the lower right and the other to the upper left) and over them a backwards letter "E," playing with language as a tangible reality.

Her Story is a portrait of a woman, pulled in different directions yet cohesive and calm. The painting portrays simple, ordinary things—a chair, a book, a cup of coffee—yet it is layered with complexity in structure and allusion. It is a contemplative moment to do with reading, remembering, thinking about how all the pieces fit together (both literally and figuratively). It is at once a portrait of the artist's mother and a self-portrait.

Domestic subjects dominated the iconography of Murray's painting through 1985 as she awaited the birth of her second daughter (Sophie was born in 1982 and Daisy in

1985). She even "did two drawings right before Daisy was born about babies, spoons and organs," she pointed out.[52] In 1985, Murray also followed the sculptural implications of the layered canvases into more fully rounded protrusions where gigantic molded forms extend above and below and out from the center of the composition. Some paintings became almost fully rounded sculpture, as in *Tomorrow* of 1988 [fig. 13.36], where the relation to comic-book description comes out in a witty exaggeration. Here Murray penetrated the soles of the giant shoes with openings that shift in cartoon fashion into knotholes in a plank of wood. These become eyes on faces in profile and orifices.

Whereas in the mid eighties Murray could make paper templates for her studio assistants to translate into wooden stretchers, paintings like *Tomorrow* required small clay maquettes for their wood foundations. Even so, the artist still did not visualize the works completely in advance. She made the forms by an intuitive process and then painted in an intuitive response to the forms, often modifying the structures in the course of painting.

One of the most remarkable aspects of Murray's work is her courage in following a train of association wherever it leads, whether it be a formal development from the surface into

13.35 Elizabeth Murray, *Her Story*, 1984. Oil on three canvases,
8ft 9in × 11ft (2.67 × 3.35m).
Collection Robert K. and Loretta Lifton. Courtesy Paula Cooper Gallery, New York.

three-dimensional space (as in *Tomorrow*) or in terms of the subject matter or expressive handling. It is often a conflict-filled struggle: "I never finish a painting without hating it first. There's always a point when I want to throw the painting away. But then over time you start to pull it together; you figure out what you've been struggling for. It's thrilling when you feel like you've got the painting, when you really get it. And then it's over. And then all you have . . . well, maybe this isn't a good thing to say. But I'm glad that my dealer can sell my paintings because I don't have any use for them."[53]

13.36 Elizabeth Murray,
Tomorrow, January–February
1988. Oil on two canvases,
111½ × 132¾ × 21½in
(283.2 × 337.2 × 54.6cm).
Collection, Fukuo Sogo Bank, Ltd., Fukuoka,
Japan. Photograph by Geoffrey Clements,
courtesy Paula Cooper Gallery, New York.

14

THE EIGHTIES

A Fresh Look at Abstraction

Along with the exciting resurgence of imagistic painting at the end of the seventies a remarkable generation of young abstract artists emerged too, characterized by an explicit eccentricity of style that reflected the less monolithic tone of intellectual discourse generally in the eighties. James O. Clark, for example, built an aesthetic around the pervasive debris on the streets and empty lots of the Brooklyn waterfront area where he lived. The bits of broken machinery, car fragments, discarded packaging, shattered glass, and old tires that litter the streets of this urban industrial wasteland are the stuff of Clark's constructions. He transforms materials such as the helium tanks, latex balloons, argon lights, and reused electrical mechanisms in *Hermes* [fig. 14.2] into something exotically beautiful—the wires stream down like delicate hairs and the glow of red, yellow, and blue light from inside the balloons suggests an apparition.

Terry Winters stands out among an exceptional group of abstract painters who began attracting attention in New York in the late seventies. Winters found inspiration in Twombly's pictorial structure [see fig. 6.7], in the surface handling of Guston and Johns, and in the material presence of the surface in the late sixties paintings of Brice Marden and in the drawings of Richard Serra. In *Good Government* [fig. 14.3], Winters did not balance the composition in the manner of traditional painting—rather, he gave it coherence through the continuity of his train of association. The forms derive from nature (developing organisms, primitive cell clusters, crystals, plant parts), but above all Winters seeks the invisible aspects of nature that are accessible only through the abstraction of technology. Whether the suggestions come from the intervention of the microscope or the theoretical configurations of computer-generated fractals, Winters projects the imagination beyond the knowable.

This aesthetic exploration of natural science has near antecedents in both Smithson and Aycock and in Buckminster Fuller, Frei Otto, D'Arcy Thompson (two engineers and a biologist who provided specific sources for Winters); Winters is interested in those who have sought to imagine vivid form beyond what is literally visible in nature. Perhaps this ability to create sensual immediacy despite the distancing of technological intervention and emotional displacement is also a part of what gives Winters his virtuosity as a printmaker (a medium that imposes a distance in its technical processes).

The eccentricity of the structure in *Good Government* parallels a deliberately ungraceful sense of form, color, and surface. The organic origins of the materials is an important aspect of the content in these works too—Winters went back to the ancient naturalist Pliny to learn about the sources of pigments and this information contributes to the train of organic association that generates these works. Lisa Phillips, in her catalog essay for his mid career retrospective, aptly

14.1 (opposite) **David Wojnarowicz,** *Installation,* November 1–25, 1984.
Gracie Mansion Gallery, New York. Photograph by Adam Fuss, courtesy Gracie Mansion Gallery.

described his paintings as "totally uningratiating and visceral, they are nonetheless tactile and sensual. The paint itself is a psychologically and sexually charged material. Its mucilaginous texture reeks of a sticky sexuality."[1]

That same eccentricity of form and visceral sensuality is evident in the strong crop of abstract sculptors who appeared in Britain at the end of the seventies, among them Tony Cragg, Richard Deacon, Bill Woodrow, and Anish Kapoor. They all use materials in novel ways. Kapoor, for example, powders intensely saturated pigment over and on to the floor around organic forms that look like overgrown gourds of an especially odd variety.

Cragg's perceptually intriguing found plastic pieces engage several levels of content simultaneously [fig. 14.4].

14.2 (left) **James Clark,** *Hermes,* 1979. Helium, three latex balloons, argon lights, electrical mechanisms, 8 × 6 × 6ft (2.44 × 1.83 × 1.83m).
Photograph courtesy Max Protetch Gallery, New York.

14.3 (below) **Terry Winters,** *Good Government,* 1984. Oil on linen, 8ft 5¼in × 11ft 5¼in (2.57 × 3.49m).
Whitney Museum of American Art, New York. Purchase, with funds from The Mnuchin Foundation and the Painting and Sculpture Committee, 85.15.

14.4 Tony Cragg, *Green Leaf,* 1983. Found plastic fragments,
7ft 7in × 9ft (2.31 × 2.74m).

Photograph courtesy Marian Goodman Gallery, New York.

He is in one sense a materialist in scattering his motley
collection of found plastic fragments on the floor or the
wall, like a Carl Andre, emphasizing real space and real time
and also like Andre subordinating the individual elements to
a larger system of ordering. Unlike Andre, however, Cragg
has used plastic detritus as his medium and his schemata
involve both ordering by color and the creation of a
representational silhouette that cuts to another level of
perception and interpretation entirely.

Informed by the ongoing vitality of conceptual art,
Cragg explores these cognitive jumps as definitive of "Man's
relationship to his environment and the objects, materials
and images in that environment." Cragg described his
subject matter as '. . . celluloid wildlife, video landscapes,
photographic wars, polaroid families, offset politics. Quick
change, something new on all channels. Always a choice of
second hand images." For this artist, such conceptual jumps
are a matter of survival: "Reality can hardly keep up with its
marketing image. The need to know both objectively and
subjectively more about the subtle fragile relationships

between us, objects, images and essential natural processes
and conditions is becoming critical."[2]

The sculpture of the American artist Martin Puryear
[figs. 14.5 and 14.6] lies at the other end of the spectrum
from the plastic accumulations of Tony Cragg, although it
shares the particularizing eccentricity of the English
abstractionists and of Winters and Clark. Puryear's work
relies above all on a unique style of working the surface of
each object and maintaining the expressive integrity of that
surface as distinct from (and at the same time in dialog
with) the free, organic improvisation of the form. Living in
Sierra Leone as a Peace Corps volunteer, studying print-
making and woodworking in Sweden, and later visiting
Japan all nurtured Puryear's sensitivity to the variety of
materials in nature, and his working of the materials has a
profoundly personal and spiritual character. In the late
seventies, the revitalized interest in expressionistic
handling in painting made Puryear's subtlety of surface in
sculpture newly relevant too.

Puryear entered his first body of mature work when he
resettled in Brooklyn in 1973, where the stimulation of the
New York art scene seems to have catalyzed the transition.
From there his work has only increased its self-assurance.
Martin Puryear's sculpture centers on a solid practice of
making objects and its pronounced physicality represents a

14.5 Martin Puryear, *To Transcend,* 1987. Stained Honduran mahogany, poplar, 169 × 13 × 90in (429.3 × 33 × 228.6cm).
Walker Art Center, Minneapolis. Walker Special Purchase Fund, 1988. Photograph courtesy Donald Young Gallery, Seattle.

14.6 Martin Puryear, *Maroon,* 1987–8. Steel wire mesh, wood, and tar, 6ft 4in × 10ft × 6ft 6in (1.93 × 3.05 × 1.98m).
Milwaukee Art Museum. Gift of the Contemporary Art Society. Photograph courtesy Donald Young Gallery, Seattle.

return to bodily experience. As in the work of Brancusi and that of the African carvers who influenced both Brancusi and Puryear, this expression of the body in connection to nature is an important facet of Puryear's sculpture and anticipates a more general reassertion of such concerns in the art of the nineties.

American Neo-Expressionism

"All my images are subordinate to the notion of painting," Julian Schnabel announced in 1983. What matters, he said, is ". . . not what is painted, but how it's painted."[3] But in another statement he warned: "To those who think painting is just about itself, I'm saying the exact opposite. The concreteness of a painting can't help but allude to a world of associations that may have a completely different face other than that of the image you are looking at."[4] This kind of self-contradictory pronouncement, mixed with a baroque energy and ambition, has characterized Schnabel's paintings as well as his public persona. What other painter would attempt a *Portrait of God*, as Schnabel did in 1981, or refer to himself (a Jewish artist from Brooklyn) as *St. Sebastian—Born in 1951* (1979)?

Schnabel simultaneously infuriated and entranced the New York art world in the early eighties, focusing attention on the emergence of a new expressionist current in American painting. The new Mary Boone Gallery sold out Schnabel's first one-person show of February 1979 before it even opened and then enticed Leo Castelli (the world's most famous dealer in contemporary art) to lend his imprimatur by joining in on a two-gallery show of Schnabel's work. Schnabel and Mary Boone orchestrated a media blitz that caused considerable resentment, and to many it symbolized the supercharged careerist tone of the New York art world of the eighties. This made it very difficult to look at the work objectively, and many of the critics were inclined to write Schnabel off.[5]

Schnabel's work is an outrageous explosion of inarticulate energy, filled with contradiction, good passages and bad, all at maximum intensity. That very inconsistency is also its greatest strength. Schnabel takes formal risks and pursues grandiose ambitions that no cautious or deliberate artist would, and that had an immediate and profound effect on other important artists in the early eighties. Elizabeth Murray, for example, remarked at the time that "people forgot how to work with all the material Johns gave us. Schnabel brought that back."[6]

In *The Patient and the Doctors* [fig. 14.7], Schnabel cemented a field of broken dishes, cups, and other ceramic fragments to a disjointed sequence of wooden planes as the support for the painting. The colorful relief of jagged edges and awkward lumps is so distracting that one can barely make out the images painted over them. Moreover, the various crudely painted figures and objects seem to have no more to do with one another than with the pot shards or, for

14.7 Julian Schnabel, *The Patient and the Doctors,* 1978. Plaster, oil, plates, and tiles on masonite, 96 × 108 × 12in (243.8 × 274.3 × 30.5cm). Courtesy Pace Gallery, New York.

that matter, the title. "I wanted to make something that was exploding as much as I wanted to make something that was cohesive,"[7] he said of the plate paintings, which he began with this work in 1978 after seeing Antoni Gaudí's use of tile fragments in Barcelona.

Schnabel mixed multiple styles of drawing within a single composition and in the eighties would incorporate antlers, paint on velvet, and freely change styles altogether from one painting to the next. His strength was the ability to assimilate everything he saw into his compositions. Schnabel attempted to be as uncensored as possible. By way of explanation he offered the metaphor of an "incredible computer with all the information in the world on it. But it's going around so fast that it's too hot to be able to get the information. If they can ever figure out how to cool it off then we can get all that information. The simultaneity of it all is what interests me."[8]

Schnabel calls the integration of painting and image as well as the premise of stylistic continuity into question. He paints a representational and an abstract picture at the same time. In addition, he said, "I want my life to be embedded in my work . . . crushed into my painting, like a pressed car."[9] However much Schnabel sought to carry forward the heroic individualism of the abstract expressionists, the world of the

eighties was too full of confusing input to focus with that kind of certainty. Indeed, what distinguishes American neo-expressionist painting from classical forms of expressionism is precisely this diffuse sense of identity, together with a pervasive materialism.

Whereas Schnabel thrashes about in his compositions, filled with vitality, wanting to assert himself in the world no matter the odds, Robert Longo seems deliberately to make his person disappear into the corporate woodwork. Longo started out drawing cool black-and-white figures in freeze-frame dramatic poses as though he were lifting stills from *film noir* detective stories (in which he has a considerable interest). He has an elegant formal finesse with minimalist form and pop art appropriation (including its arbitrary juxtaposition of images), while the theatricality with which he three-dimensionalizes pictorial concepts seems to feed, and to be fed by, set-building for his simultaneous work in film and performance.

In *National Trust* [fig. 14.8], for example, Longo joined two slightly larger than life-size drawings of single figures by a cast aluminum relief of a simplified block of urban buildings. Longo is morbidly fascinated by evocations of authority in its most obdurate forms (from Albert Speer to General Motors) and he persistently leaves the viewer craning his or her neck up from below at the towering

buildings that embody it. The figures lie contorted as though shot down but they float in a void, utterly without reference in time or space—not even the ground plane is articulated. Likewise, the relation of the relief to the figures is inexplicable, except in the intuitive sense that the emotionless objectivity of these powerless bodies is an acquiescence to the cold corporate authority expressed by the office block.

What has become considerably clearer in the aftermath of pop art is that corporate culture and mainstream values have colonized everyone's identity, undermining the sense that one has uniqueness or originality. For Eric Fischl "the whole struggle for meaning since the 1970s has been a struggle for identity . . . a need for self."[10] But Fischl's subject is suburbia, where the veneer of normalcy forbids acknowledgement of what doesn't fit the community's image.

14.8 (above) **Robert Longo,** *National Trust,* 1981. Two charcoal and graphite drawings on paper, one cast fiberglass and aluminum bonded sculpture, three panels, 5ft 3in × 19ft 6in (1.6 × 5.94m) overall. Collection, Walker Art Center, Minneapolis. Art Center Acquisition Fund, 1981.

14.9 (below) **Eric Fischl,** *Bad Boy,* 1981. Oil on canvas, 5ft 6in × 8ft (1.68 × 2.44m). Private collection. Photograph by Zindman/Fremont, courtesy Mary Boone Gallery, New York.

Fischl's works unfold like stories. His startling 1979 painting of the *Sleepwalker,* for example, shows a naked boy standing ankle-deep in a suburban backyard pool, masturbating. "What's an adolescent boy's masturbation about anyway," Fischl asked, "if it's not, in some sense, a separation technique? He's separating from his parents. He's becoming aware of himself."[11] Fischl's *Bad Boy* [fig. 14.9] is beautifully (indeed seductively) painted, drawing the viewer

14.10 Robert Colescott, *Grandma and the Frenchman (Identity Crisis),* 1990. Acrylic on canvas, 7 × 6ft (2.13 × 1.83m).

Courtesy Phyllis Kind Gallery, New York and Chicago. Collection of James and Maureen Dorment, Rumson, New Jersey.

in as an accomplice to an act in which he or she may not wish to participate. Fischl has made explicit a common but normally unacknowledged situation—here one doesn't know if the title refers to the theft from the purse or the guilt the boys feels for his sexual curiosity, and we are left undecided about who's exploiting whom.

In the seventies and eighties culture at the margins of the mainstream became a mainstream idea, fostered both by discovering new intellectual models such as "deconstruction" (which attacks not only the idea of a dominant mainstream but also the idea of any fixed meaning), and by the more generalized assault on orthodoxy and authority in the culture as a whole in the aftermath of Vietnam and Watergate. Robert Colescott's painting of *Grandma and the Frenchman (Identity Crisis)* [fig. 14.10] deals with an inherited conflict that only became visible in the mainstream art world with the emergence of this more pluralist perspective. Colescott is a black artist who went to Egypt for two years in 1964 and discovered a 3,000-year-old history of African narrative art that catapulted him into an analysis of the complexity of his own identity and situation.[12]

Colescott trained in the French school, including a year in the atelier of Fernand Léger in Paris (1949–50). In *Grandma and the Frenchman*, he used cubist fragmentation in the description of the central figure's head and showed the influence of Léger in the monumentality of the composition. However, his expressive handling of the surface is unique and very unFrench. In this painting, the white doctor (who seems to have reached for his white-figured crucifix rather than his stethoscope) takes the black woman's pulse while staring fixedly at her sexy breasts. Meanwhile, the African witch doctor's snake coils around the other side of her chair. It is ironic that the African doctor's mask and the head of Grandma herself derive from the African-influenced figure in the lower right corner of Picasso's famous *Les Demoiselles d'Avignon* (a landmark of the white art historical canon). The cubist oscillation of Grandma's head, from black to Caucasian and back again, is amplified in the vignettes around the canvas showing her as she conceives herself in alternating aspects of black and white identities, brought out, presumably, by her ambivalent liaison with the Frenchman. This, of course, has important parallels with the artist's own conflicts about his French classical training.

The authentic discovery of one's own identity was the fundamental goal of all the most important American exponents of the new "decentered" expressionism of the eighties just as it had been for the abstract expressionists. However, the degree to which contemporary life intruded upon and destabilized identity in the eighties redefined the task. Notwithstanding the differences between Jonathan Borofsky's formal and psychological emphasis, Jean-Michel Basquiat's powerful emotionalism, and the sociopolitical aspirations in the work of David Wojnarowicz, these three artists in particular emerged as heroic figures in the sense intended by the abstract expressionists.

Jonathan Borofsky

Borofsky finished graduate school at the Yale School of Art in 1966. At that time he turned away from making objects toward a more conceptual form of art. Conceptual art dominated the scene when, sometime toward the end of 1968, Borofsky started counting and recording the numbers on sheets of paper. Whenever he returned to his work after a break he would check to see where he had left off and start up again from there. He explained:

After counting for a few hours at a time I often found myself making little scribbles on the page—stick figures, heads attached to trees—but I let them go by. Then one day I looked at one of the past scribbles and thought, I'd like to make a painting of that . . . Then I took the number I had been on in my counting and put it in the corner of the painting. Something connected there. I had both a recognizable image and conceptual ordering in time . . . Looking back on it now I see it as a reaction to Minimalism.[13]

In 1973 Borofsky exhibited several stacks of the numbered papers as *Counting Piece* in a show curated by Sol Le Witt at the alternative Artists Space in New York. Borofsky had started painting again in 1972 and, as he told Kathy Halbreich, practically every work was a kind of self-portrait, in the sense that he was attempting to represent the content of his head.[14] Moreover, his work became a continuous, total project. His first show at the Paula Cooper Gallery in 1975 was an overfilled installation into which he jammed everything he had been doing for the last year or so with relatively little selection. It included self-portraits, sketches on scraps of paper (often intermixed with various notes of one kind or another, some completely mundane), and dreams he had written down. This heterogeneity and informality continued to characterize subsequent exhibitions [fig. 14.11]. These shows aspired to giving people "a feeling of being inside my mind."[15]

After installing virtually the entire contents of his studio in the Paula Cooper show, Borofsky started drawing directly on the floor and walls of his then-empty loft. He worked on this new piece solidly for over a month, doing all the drawing freehand. After this Borofsky created all his subsequent installations using a opaque projector to transfer his small notes and drawings on to the wall—he would arrive with only a briefcase of drawings instead of a truckload of objects and this is the origin of the black silhouette of a man with a briefcase that has appeared in so many of his works (see the center of fig. 14.11). Borofsky felt that, by drawing directly on the walls in these installations, he was creating something that could not be purchased—the viewer had to be there out of a genuine interest in the experience.

Borofsky's installation in the Paula Cooper Gallery in 1983 was one of his greatest works. He created a bafflingly chaotic environment of sounds, images, movement, and light as well as incorporating painting, drawing, and sculpture in a range of styles and states of completion [fig.

14.11 Jonathan Borofsky, *Installation, Philadelphia Museum of Art,* October 7–December 2, 1984. Detail showing drawings pinned to the wall.

14.12]. The bare canvas stretcher, the walls of pinned-up notes and drawings (often on scraggly scraps of paper), the notations of dreams and childhood memories created an emotion-filled atmosphere that evoked not only the intimacy of the artist's studio but a revealing look straight into his psyche.

Borofsky painted *The Maidenform Woman, You Never Know Where She'll Turn up at 2,841,779* in an illustrational style as though straight out of the omnipresent underwear advertisement of the time. The free association from the line of faceless soldiers staring at the woman in her bra and panties to the featureless Chattering Men is the kind of associative structure with which Borofsky wove together the entire installation. Instead of painting in a single, signatory style of his own, he rendered each object in a fashion true to itself as a predefined, received image in his memory, so the

discontinuous jumps in style, subject, scale, and sound from work to work do, in the end, replicate a unified experience—that of the artist's mental landscape.

In this sense, the memory traces of quotidian existence are vividly evoked. The Chattering Men are featureless robots with mechanical jaws that repeat the same movements and (with a tape loop) emanate a constant din of meaningless chatter. *The Dancing Clown at 2,845,325,* with its twisting foot, seems to dominate the room intrusively, insistently singing "I did it my way"; a brilliantly colorful and gesture-filled canvas called *Sing* shows Borofsky transfixed by a glowing tablet with the commandment "sing" inscribed on it while the melodic sound from a tape behind the canvas plays songs composed and sung by the artist. The *Universal Groan Painting* recites facts and groans, while the perforated silhouettes of *Two Wrestlers* have an aggressive verbal exchange. With images projected on to the ceiling, a string of blue neon circles blinking on and off in a wave pattern overhead, and visitors wandering through the space it was a truly Whitmanesque cataloging of contemporary experience.

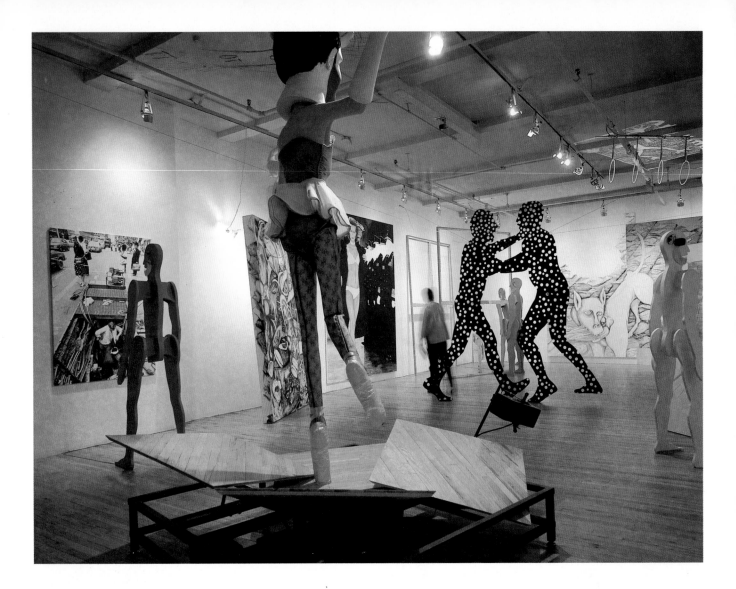

14.12 Jonathan Borofsky, *Installation at Paula Cooper Gallery,* November 5–December 3, 1983. View showing (left to right): *Chattering Man with Photograph at 2,845,312* (1983), *Painting with Hand Shadow at 2,841,780* (1981–3), *The Dancing Clown at 2,845,325* (1982–3), *The Maidenform Woman, You Never Know Where She'll Turn Up at 2,841,779* (1983), *Chattering Man with Two Stretcher Frames at 2,845,313* (1983), *Molecule Men at 2,945,318* (1982–3), *The Berlin Dream at 2,841,792* (1982–3), *Split Wire Dream with Chattering Man at 2,841,784* (1978–83), and (including neon loops and projection on ceiling) *Flying Frog with Chattering Men at 2,845,322* (1983).

Graffiti Art

With this kind of installation, Borofsky opened the door to a graffiti aesthetic within the art world at precisely the moment when a new wave of expressionist graffiti emerged in the real cacophony of the city streets. Coming from the poor neighborhoods of Brooklyn and the Bronx, the graffiti writers appropriated the train cars of the New York subway system like traveling exhibition walls that permeated the entire city with their influence [fig. 14.13]. The graffiti writers were not naive, either in theme or style, even though they had little formal education and gravitated toward forties and fifties gestural abstraction at just the moment when the Anglo art world was embracing postmodernism. Rammellzee, for example, wrote a manifesto of 1979 to 1986 called IONIC TREATISE GOTHIC FUTURISM ASSASSIN KNOWLEDGES OF THE REMANIPULATED SQUARE POINT ONE TO 720° RAMMELLZEE which, as John Carlin described it, "reads like Jacques Derrida on acid linking the

14.13 Lee (Quinones), *Stop the Bomb,* 1979. Whole car, spray paint, New York subway, destroyed.
Photograph © by Henry Chalfant.

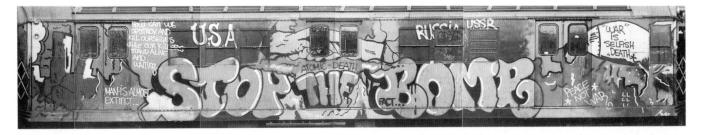

biophysical structure of the universe to the shape and evolution of letters. The thrust of the treatise is the ability of symbolic creation to undermine institutional control. It sets forth a symbolic war wherein the artist's ability to manipulate letters will change the reality structure."[16]

The start of graffiti art in the early seventies is usually attributed to TAKIS 183, as the first to "tag up" (write his alias and the street on which he hung out) repeatedly in the subway cars. The graffiti writers' simple script of names in black marker or spray paint moved to the outside of the cars around 1973. It then evolved into the more elaborate "bubble letters," inspired by underground comics (especially the "Cheech Wizard" cartoons by Vaughn Bodé), and in 1975 Caine and Fabulous Five painted the first "whole car" compositions. The eighties was the golden age of graffiti writing with complex, abstract letter forms (called "Wild Style") as well as political and allegorical themes. Some of the other leading artists were Crash, Dondi, Futura 2000, Lady Pink, Lee, Phase II, Rammellzee, Revolt, Seen, and Zephyr. When one of their cars rolled into the gray gloom of a New York subway station it was, as Claes Oldenburg remarked, "like a big bouquet from Latin America."[17]

Keith Haring

Efforts were made to transplant the work of the graffiti writers into the art galleries, but it could not survive that transition because the political appropriation of the city trains was integral to its character. However, Keith Haring, a twenty-two-year-old painter from rural Kutztown, Pennsylvania [fig. 14.14], inaugurated a major body of work in more conventional media in 1980 that was inspired by graffiti writing. Haring came to New York in 1978 and went to the School of Visual Arts. He was painting in a brushy, abstract style when, toward the end of 1980, he noticed that the transit authority covered the posters on the subway platforms with black paper after the rental period on the advertisement expired. Haring found these black panels irresistible surfaces and his white chalk line drawings in the subways soon became a consuming passion for him—by his own estimate, he drew over 5,000 of them between 1981 and 1985 [fig. 14.15].[18] The subway

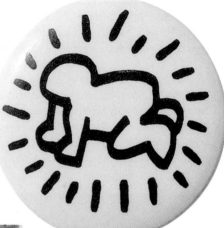

14.14 (above) **Keith Haring,** *Radiant Baby Button,* 1982. Printed plastic button, with metal back and pin, 1in (2.4cm) diameter.

14.15 (left) **Keith Haring** drawing in the New York City subway, 1982.
© The Estate of Keith Haring 1994.

authorities would remove the drawings in a matter of days (arresting the artist if they caught him), but Haring replaced them as fast as new black frames appeared. The subject matter was a recurring repertoire of simple narrative images that travelers all over Manhattan began to recognize and look for: flying saucers with beams of energy empowering radiant babies and barking dogs, little androgynous people (often masses of them, all exactly the same), composite monsters with some human or animal body parts and often with television sets for heads.

Haring's drawings deal with the life of Everyman in our television culture. Sometimes he put dollar signs on the television screens (suggesting advertising) or showed a barking dog (perhaps politicians or a soap opera). In one, an arm reaches out of the screen and grabs a helpless little figure by the throat (implying the ruthlessness with which television sometimes manipulates the unsuspecting viewer). In the catalog for a show of Haring's work, Barry Blinderman described the artist's underlying subject matter as:

the hallucinatory interface of biology and technology in our increasingly cybernetic society. Audio-visual surveillance, monitoring of bodily fluids as an employment prerequisite, genetic engineering, mass-media anesthesia that is beginning to seem as much inherited as culturally induced—these are the conditions that characterize our so-called postmodern era.[19]

The writing of William Burroughs was a formative influence on Haring (as on many of his contemporaries) in his efforts to come to terms with this postmodern condition. For Burroughs, experience comes in too much profusion and emotional intensity to attempt integration. Instead, he portrays himself as a neutral conduit through which all these psychic states pass: "I am a recording instrument . . . I do not presume to impose 'story' 'plot' 'continuity.'"[20] But where Burroughs is desperately alienated from himself, Haring's figures are life-affirming, taking comfort in their communal anonymity.

Some of Haring's subway drawings had obvious political themes, such as the one labelled "South Africa" in three narrative frames: a little figure leads a giant by a rope around the neck, then the big figure rubs its sore neck (evidently assessing the situation), and in the third frame the giant stamps on the small figure. In another drawing Haring showed a little person pulled painfully in four directions by big hands that reach into the composition from the four

14.16 Keith Haring, all works untitled, black light installation for an exhibition in the Tony Shafrazi Gallery, New York, 1982.
© The Estate of Keith Haring, 1994.

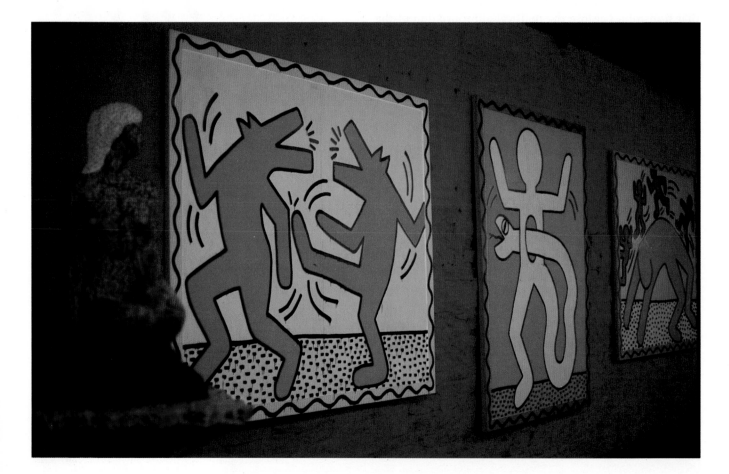

corners, each grasping one of the little person's limbs. Haring created icons of mass culture to which everyone could relate, using the same devices as advertising: repeated trademark images with simple, instantly understandable messages. He saturated his audience with them, painting on any surface at hand and even passing out free buttons and posters, as in an advertising campaign. He also mass-marketed his images as inexpensive souvenirs through The Pop Shop, which he opened on the edge of the SoHo gallery district in 1986.

In the work Haring did for the art galleries—as distinct from the public venues—he drew many overtly sexual subjects: copulating people and dogs (frequently mixed), masturbating figures (including that of Mickey Mouse, which in some sense represents American mass culture), and winged phalluses. He wanted to address sexuality as the driving force in life. But even in the work Haring made strictly for art audiences he also courted the taste for popular entertainment, as in the fluorescent works he painted for his show at the Tony Shafrazi Gallery in 1982 [fig. 14.16].

The East Village Scene of the Eighties

A series of early eighties shows by Keith Haring at a downtown punk-rock music club called the Mudd Club inaugurated "fun art" and this in turn spawned the first East Village gallery—the Fun Gallery, run by Patti Astor. The seedy, low-rent East Village quickly blossomed as a boom town for new art, with young people in their twenties (many of them artists) opening galleries in tiny storefronts side by side with the drug dealers, hookers, and gangs who had long occupied the neighborhood. This resulted partly from frustration about the inability of young artists to break into the chic SoHo art world and the names of these galleries emphasize the difference between the East Village and SoHo, where most of the galleries are named, like law firms, after their founders. CASH gallery, which opened in 1983, suggests in its name the cynicism about commercial culture that pervaded the East Village. There was also a sophistication about language as a tool of political and social appropriation and about the use of appropriation generally as the basis of art. *Nature-Morte* gallery, which opened in May 1982, took the French term for a still life (one of the most traditional artistic subjects and one associated with moral allegory) and made a *double entendre* on the literal meaning of "nature dead" as a comment on an age of reproduction and appropriation when no one paints from life any more and nature itself has come under attack as a viable term. Finally, the more visible presence of down-and-out people on the streets in the East Village made social issues—especially drug addiction and the AIDS crisis that emerged in the early eighties—particularly poignant. Galleries with names like Civilian Warfare and PPOW (written like sound effects in a superhero comic book) signal these dimensions of the East Village scene.

Jean-Michel Basquiat

Like his friend Keith Haring, Jean-Michel Basquiat made his network of art-world connections through the downtown clubs like CBGB's, the Mudd Club, and Hurrah, where he performed with his own "noise band" in 1979 and 1980. Haring and Basquiat also both burst on to the art scene with instantaneous celebrity in 1980 (they were twenty-two and twenty respectively) and then were gone as suddenly as they had appeared: Haring died of AIDS in 1990 at the age of thirty-one and Basquiat of a drug overdose in 1988 at the age of twenty-seven. Finally, Basquiat also had a formative connection to graffiti writing, but for him it had the particular value of providing a coterie of other black artists. He was especially close to Rammellzee, Fab 5 Freddy, and Toxic.

Basquiat, however, grew up in a middle-class neighborhood in Brooklyn. His father was an accountant of Haitian descent and his mother a black Puerto Rican with an artistic sensibility but a fragile character that led to her institutionalization while he was still a child. Basquiat was bilingual in Spanish and English and an avid reader from childhood, although he dropped out of high school and largely educated himself. At seventeen he left home and lived from 1977 to 1979 on the streets (sometimes literally, sometimes in abandoned buildings or staying with friends).[21]

During this period of homelessness Basquiat collaborated with a schoolfriend named Al Diaz on a sequence of "SAMO" texts (originating from a combination of "Sambo" and "same old shit"), which they inscribed up and down the D-train and on walls around SoHo and the East Village. Unlike other graffiti, the "SAMO" texts were puzzling aphorisms like "SAMO as an end of mindwash, religion, nowhere politics, and bogus philosophy" or "Plush safe he think; SAMO." By 1980 Basquiat had taken over the SAMO writings, and through them gained some degree of personal notoriety in the downtown art world. He also established a fixed address and showed his art for the first time (in the counterculture "Times Square Show" of 1980).

In February 1981 Basquiat installed a wall of paintings and drawings in the important "New York/New Wave" exhibition at P.S.1, a highly visible alternative space on the Long Island side of the 59th Street Bridge. This exhibition included some of the graffiti writers, as well as Warhol, Haring, and his friend Kenny Scharf. Basquiat's contribution attracted the notice of the SoHo dealer Annina Nosei, who gave him the basement of her gallery as a studio and began to represent him in September of that year. He also won the allegiance of Bruno Bischofberger, an important Swiss dealer, who represented him in Europe.

From this point onward Basquiat's career followed a meteoric trajectory, driven by his relentless productivity. Annina Nosei gave him a one-person show in March 1982 that drew considerable attention, but by fall he had split

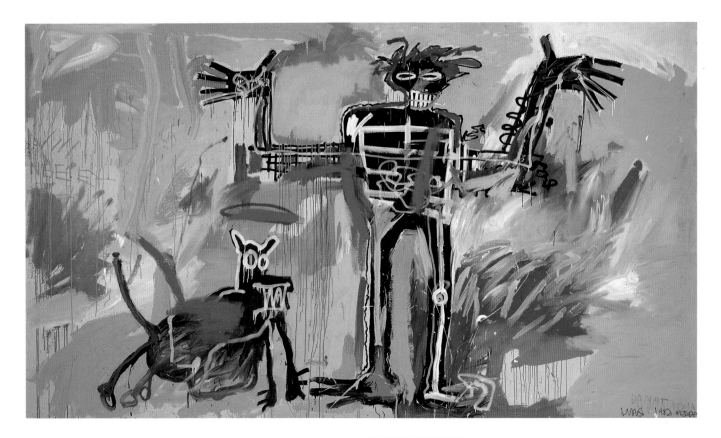

14.17 Jean-Michel Basquiat, *Boy and Dog in a Johnnypump,*
1982. Acrylic, oil paintstick, and spray paint on canvas,
7ft 10½in × 13ft 9½in (2.4 × 4.2m).
© The Estate of Jean-Michel Basquiat, courtesy Galerie Bruno Bischofberger, Zürich.

with Nosei and organized a show at the Fun Gallery. It wasn't until March 1984 that he signed on with another New York dealer, Mary Boone, and although that relationship deteriorated too in 1986 it firmly established his market. Meanwhile, Basquiat had formed a close friendship with Andy Warhol and had become an art celebrity in his own right. In the spring 1984 sale at Christie's (one of the two major art auction houses in New York) a Basquiat painting sold for $19,000—an extraordinary price for a twenty-three-year-old artist—and in February 1985 his photograph appeared on the cover of the *New York Times Magazine.*

Basquiat was a brilliant success almost from the start but torn up by self-doubts to the end. In a painting like *Boy and Dog in a Johnnypump* [fig. 14.17], one immediately feels the exalted exhaustion of a Jack Kerouac or Allen Ginsberg. The beauty of the color and the sublimely expressive brushwork overwhelm the viewer and, at the same instant, one experiences the terrifying vertigo of what the seventeenth-century philosopher Pascal referred to as "the eternal silence of these infinite spaces";[22] Basquiat's paintings portray a breathtaking existential absence. As a black artist in a white world he was out there alone to an even greater degree than other major artists.

In this painting the black boy stands, palms out, in a gesture of supplication and spiritual disguise with a red-haloed familiar at his side. He has an ingratiating smile, but the face is a vacant mask with the inner person of the artist hidden from view. Meanwhile, the boy's dreadlocks flash

brilliant red, as though lit from within; the bones glisten against the black, animating the skeleton like a spirit brought back to life. Basquiat has raised every color and brushstroke to its maximum intensity, as in the rhythmic structure of jazz, giving the work what the art historian Robert Farris Thompson has called an "Afro-Atlantic vividness."[23]

The black gestural line in the left forearm of the figure in *Boy and Dog in a Johnnypump* is "written," as in a graffitero's script, and "NEEET" is inscribed as though on a wall to the left. Yet the broad gestures of red, yellow, and green reveal Basquiat's indebtedness to Franz Kline, Pollock's early work, and de Kooning's figures of the sixties. The expressive excess of the surface in this painting provides at once an outpouring of feeling and a wall through which the outsider cannot penetrate to the core of the artist's being. As bell hooks has written, "Basquiat's work gives that private anguish [of the black experience] artistic expression."[24]

Charles the First, also of 1982 [fig. 14.18], shows another characteristic side of Basquiat's style. The composition has a notational quality like graffiti but it also resembles the paintings of Cy Twombly, which Basquiat had scrutinized in the museums and in books. Basquiat's summary of his subject matter in an interview with Henry Geldzahler as "Royalty, heroism, and the streets,"[25] seems particularly germane here.

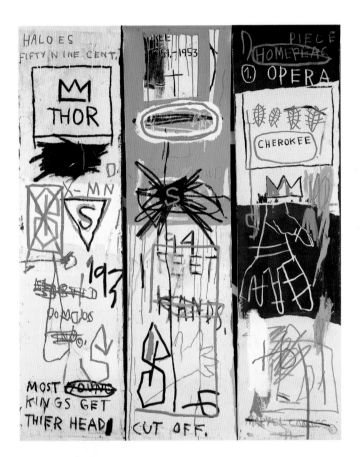

14.18 Jean-Michel Basquiat, *Charles the First,* 1982. Acrylic and oilstick on canvas, triptych: 6ft 6in × 5ft 2¼in (1.98 × 1.58m).
© The Estate of Jean-Michel Basquiat, courtesy Robert Miller Gallery, New York.

Charles the First is a coronation of the great jazz saxophonist Charlie Parker and belongs to a recurring set of homages to black heroes with whom Basquiat identified especially: the baseball player Hank Aaron; the boxers Sugar Ray Robinson, Cassius Clay (aka Muhammad Ali), and Jack Johnson; the jazz musicians Parker, Dizzy Gillespie, and Louis Armstrong; and the writer Langston Hughes.

In an off-white square to the right Basquiat wrote "Cherokee," the title of one of Parker's most famous tunes, right up there with the word "Opera," suggesting a parallel in artistic stature between "Cherokee" and this most aristocratic of musical genres. Below this he placed a crown, which is both a symbol of Parker's artistic royalty and Basquiat's own tag. (In another painting of this year, *Portrait of the Artist as a Young Derelict,* Basquiat wrote below his self-portrait: "Hic est rex," Latin for "This is the king.") On the top of the left-hand panel of *Charles the First* the artist placed a crown labelled "Thor," suggesting a parallel with the mythological king of the Norse gods. The four feathers in the painting allude to Parker's nickname "Bird," and the black hand suggests the powerful bodily presence of both horn player and painter. Basquiat has also included the words "Marvel Comics" in two places, drawn the emblem of Superman, and written "X-Man" (another superhero who

appeared in Marvel Comics) above it. So here the fantasy world of the comics merges with history in supplying a spiritual genealogy for the artist.

But in *Charles the First* Basquiat also expressed a pervasive ambivalence. "Hall of Fame" is also "Hall of Shame," as he has noted in paintings like *Mitchell Crew* of 1983. In *Piscine Versus the Best Hotels* Basquiat lists "I. Bald, II. Fat, III. Simple" as attributes with crowns, exploratorily connected to Charlie Parker while drawn from the "facts"[26] in books of medieval kings: Charles the Bald, Charles the Fat, and Charles the Simple. In *Crowns (Peso Neto)* and elsewhere Basquiat pairs the royal crown with a crown of thorns and in *Charles the First* even the status of haloes is undercut by their price of "fifty nine cent."

The very ambition of Basquiat's painting *Charles the First,* and of his identification with the "royalty and heroism" of his personal black pantheon, comes with a corresponding anxiety; in the lower left corner of the painting he wrote: "Most young kings get thier [sic] head cut off." He crossed out "young" the qualifier that clearly refers to himself, only to enhance the self-referential overtone: "I cross out words so you will see them more; the fact that they are obscured makes you want to read them."[27] The same might be said of the impassiveness of all that one cannot read in the iconography of Basquiat's paintings and persona. His works cry out for connection and yet ward it off—Basquiat's *oeuvre* is a double portrait of absence and presence with an uncanny bodily and spiritual immediacy.

David Wojnarowicz

The art of David Wojnarowicz leaves no ambiguity about the identity of the artist. On the contrary, Wojnarowicz uses the sharp delineation of his identity, principally in its divergence from the culture's norms, to lay bare society's ethical flaws and dissimulation. The aesthetic he created out of this painfully uncompromising self-scrutiny and exposure nevertheless embodies the remarkable beauty of a complex and incisive mind.

Wojnarowicz had been a child prostitute on the street in Times Square (his terrifying homosexual encounters in subway tunnels, and sleazy hotel rooms are recounted in excruciating detail in his writings[28]) and he died of AIDS at the age of thirty-eight. At the same time he had one of the most brilliant collage sensibilities of the late twentieth century and used it in a lucid exposition of the layered interaction between nature, his personal identity, and contemporary cultural values.

My whole life I've felt like I was looking into society from an outer edge, because I embodied so many things that were supposedly reprehensible—being homosexual or having been a prostitute when I was a kid, or having a lack of education. All my life I looked at the world with a longing to be accepted, but . . . the only way I could be accepted would be to deny all those things. At the moment of diagnosis [of AIDS] I fully gave up

that desire to fit in, and started realizing that those places where I didn't fit and the ways I was diverse were the most interesting parts of myself. I could use that diversity as a tool to gain a sense of who I was.[29]

In *Water* [fig. 14.19], a painting that belongs to a cycle of compositions on earth, air, fire, and water, a dark ocean liner surges into a vast night sea. A cut-away on the hull—as though we can see with Superman's X-ray vision—reveals a strange tangle of viscera in muted color, all drawn with a comic-book simplicity of style. Above and overlapping the ship is a frog, rendered with meticulous naturalism in a palette rich as only nature itself could conceive it. A window opens through the back of the frog and looks down on a black-and-white photograph of a trashed automobile hulk, abandoned on the side of the road. Here the striking contrasts between the lush, human rendering of nature (the frog) and the starkly mechanical realism of the colorless photograph (recording the detritus of urban decay) set up one of the many charged levels of discourse within the composition.

Wojnarowicz filled the center of *Water* with an organically contoured grid of small black-and-white pictures in an illustrational style. The subject matter of these pictures relates to the various images around the periphery of the composition. Some frames contain energetically swirling spirals, like eddies of water: there are river and oceanscapes with a swimmer, fish, views of the steamship in daylight, superimpositions with other images; the frog recurs, once in a surreal scale looking over a railing, and in another section it is prefigured as eggs and tadpole; and other allusions to ontogenesis or to the biology of internal organs also crop up around the grid. Finally there are three overtly erotic scenes, depicting sexual encounters between two women, three men, and in the third the nude male torso and an implied onlooker.

14.19 David Wojnarowicz, *Water*, 1987. Acrylic, ink, collage on masonite, 6 × 8ft (1.83 × 2.44m). Private collection, New York.

14.20 David Wojnarowicz, *The Missing Children Show: 6 Artists from the East Village on Main Street,* December 6–10, 1985, Louisville, Kentucky.

Photograph courtesy Gracie Mansion Gallery, New York.

In the upper right corner of *Water* the artist superimposed a colorful, circular vignette over this monochromatic checkerboard, showing an expression-istically painted hand swathed in bandages, reaching out through prison bars. A flower seems to drop from the hand into a snowy sky with tiny white figures scattered below like snowflakes. Finally the inky blue water and night sky that form a perimeter around the painting are traversed by a school of sperm cells, animating the composition with a delicate pattern in their free profusion.

Part of the impact of this painting, and of Wojnarowicz's work generally, involves a radical insight into the complicated layering of impressions from nature, from subjective frameworks of interpretation, and from the languages of culture that make up what we understand today as "reality." Wojnarowicz seems to have experienced all these levels with remarkable distinctness, and yet that very analytical clarity also seems to engender a kind of detachment:

Inside my head behind the eyes are lengthy films running on multiple projectors; the films are images made up from information from media . . . some of the films are childhood memories of the forests I lay down in; the surfaces of the earth I scrutinized and some are made up of dreams. Sometimes the projectors run simultaneously sometimes they stop and start but the end result is thousands of feet of multiple films crisscrossing in front of each other thereby creating endless juxtapositions and associations.[30]

The career of Wojnarowicz resembles that of Basquiat and Haring to the extent that he first attracted notice on the downtown scene through the clubs, where he began playing with a post-punk noise band called *3 Teens Kill 4—No Motive* in 1979. But the core of his early work was a guerrilla-style political activism, stencilling images on walls (and gallery doors) that he derived from the tabloid media, politics, and the street—burning houses, dinosaurs, guns, muggers, soldiers, young male torsos, addicts shooting up. His aim was to call attention to the ethical state of emergency he found in American culture of the eighties.

Wojnarowicz frequently made powerful use of the media of performance and installation, sometimes in galleries [fig. 14.1] and at other times in derelict buildings [fig. 14.20] or even illegal sites like the abandoned piers at the west end of Canal Street in New York. As an act of conscience, he never permitted his art-world success (which verged on becoming considerable by the mid eighties) to overshadow his political and social statement. Sometimes he directly attacked the complacent ease of the

14.21 David Wojnarowicz, *The Death of American Spirituality,* 1987. Acrylic and mixed media on plywood, two panels 6ft 8in × 3ft 8in (2.03 × 1.12m) each. Private collection, New Jersey.

art establishment—in 1980 he and his friend Julie Hare dumped a load of bloody cow bones from the meat-packing district into the stairwell of Leo Castelli's chic SoHo gallery on a Saturday when it was full of visitors, and in 1982 they made an unsolicited contribution to the "Beasts" exhibition at P.S.1, releasing live cockroaches with tiny glued-on bunny ears and tails ("cockabunnies") into the galleries at the opening.[31]

Moved to a new kind of self-awareness by the writings of the French novelist Jean Genet and later by William Burroughs, Wojnarowicz developed a confrontational style of working that pushed his art out of the comfort zone. His work concerns the real immediacy of bodily experience and identity in a culture filled with unacknowledged violence, which society masks in a barrage of consumer fiction and contradiction. "You can turn and see some bum or some image of decay," he pointed out, "and then turn again and see some restaurant where it costs $40 for a meal. So you're constantly superimposing images upon images and sandwiching them. TV, magazines, information, memory, grocery store signs—and there's all this suggestion of consumption . . . of images,"[32]

The Death of American Spirituality [fig. 14.21] is a summarizing painting for Wojnarowicz, bluntly stating his grandest theme. He divided the composition into four panels, joined by the continuity of the bull across three of them, the mountains across another two, the sky across two others. Yet while the sky continues over the top and the red bolts of electricity join all four frames, the gray rocks in the upper right bluntly stop at the edges and the right border of the mountain is abruptly cut by the midline of the composition when other elements are not. This jarringly reinforces the multileveled reality of experience for Wojnarowicz, as in his painting *Water.*

The terrifying images of the Hopi snake charmer and the kachina with its radiating streaks of energy are the avatars of the ancient culture of the Americas and perhaps the purifying force of nature itself. They seem to emerge from flames of destruction, encircling the bearings collaged from dollar bills (top center) and the gears painted on a political map of the American continents (below right), even lassoing the arm of the cowboy, who derives from Wojnarowicz's earlier graffiti stencil of Ronald Reagan as a nuclear "buckaroo." Wojnarowicz once pointed out that children are the only people in society today who think

about good and evil.[33] He despaired of this "diseased society,"[34] and yet he seems to have had a glimmer of hope that the directness of his confrontation with its moral failure might contribute to its salvation.

Post-Modern Installation

Installation works in the eighties and nineties became increasingly important as a medium for artists who wanted to assert a vivid, emotional experience. But if Kabakov is the master of what he has called "total installation," some of the younger installation artists have moved toward a deliberately less defined expressive character in their work; these installations are both more diffuse in personality and experientially open-ended, in a post-modern sense. Despite the loaded subject matter evoked by the French artist Christian Boltanski, for example, his own character is less delineated and less clearly set into the foreground of his work than would be the case in one of Kabakov's installations. Boltanski reconfigures simple, nostalgically aged objects from daily life and anonymous old photos into mementos of fictive identities [fig. 14.22]. He has even revised his own past: "I've recounted so many invented memories about my childhood," he said, "that now I have no real ones."[35]

Using archives of low-quality photos—dated snapshots of families on the beach; babies; people gathered around the dinner table; a soldier in uniform—he creates the prosaic record that adds up to the intimation of a biography. He may add rows of old biscuit tins as reliquaries or lay out in a vitrine the most undistinguished household items, like evidence. Some of the photos purport to be of pre-war Jewish children from Dijon or Vienna or Paris who have disappeared into a terrifying anonymity. With the bare bulbs of cheap metal lamps turned into their faces, like an interrogation, the photos in these installations evoke images of the Holocaust. Boltanski's installations are still more poignant because of the way in which they take the viewer back to the indistinct and yet emotional vividness of childhood memory; not that one remembers these particular old photographs or objects—they were, of course, never part of our own individual pasts—but they evoke what is personal to each of us in our oldest memories and remind us of the experience of remembering.

Yet Boltanski's work is not precisely expressionist in that it insists on an act of interpolation from the viewer and maintains a distance too by obscuring the personal identity of the artist in the work. "I began working in the period of Minimalism," he explained, "and my vocabulary is often close to that. A biscuit tin is a minimal object but, if I use such tins rather than a steel cube, it's because the tin is also a sentimental object that evokes something familiar to all Westerners. It evokes the idea of basic protection (this is the box in which children keep their little treasures), of a funeral urn and, more generally, of storage. I don't want spectators faced with my work to discover but to recognize, to appropriate."[36]

14.22 Christian Boltanski, *Reserve of Dead Swiss (small)*, 1990. Photographs, fabric, tin boxes, and lamps, 116 × 37 × 13½in (294.6 × 94 × 34.3cm).
Private collection. Photograph by Michael Goodman, courtesy Marian Goodman Gallery, New York. © 2000 Artists Rights Society (ARS), New York/ADAGP, Paris.

The installations and objects by David Hammons, an African American artist who lives in Harlem, address the person on the street in the black community:

The art audience is the worst audience in the world. It's overly educated, it's conservative, it's out to criticize, not to understand, and it never has any fun. Why should I spend my time playing to that audience? . . . I'll play with the street audience. That audience is much more human, and their opinion is from the heart. They don't have any reason to play games.[37]

14.23 David Hammons, *Higher Goals,* 1982. Poles, basketball hoops, and bottle caps, 40ft (12.19m) high, shown installed in Brooklyn, New York, 1986.
Photograph by Dawoud Bey.

Since his arrival in New York in the mid-seventies (from Springfield, Illinois, via Los Angeles), Hammons has made installations and objects that deal directly with the African American experience. He makes his works from found materials—frequently ones that have a heavy weight of association to the environment of the black inner-city—such as nappy hair gathered from the floor of black barber shops, bottle caps and wine bottles found on the street, *Greasy Bags and Barbecue Bones* (as one installation was called), or discarded chicken parts.

Hammons made *Higher Goals* (1982) [fig. 14.23] by fastening basketball hoops to the tops of unreachably high poles (in which there is the obvious metaphor, commenting ironically on the frustration of black youth). He decorated the poles in highly patterned arrays of bottle caps and other materials that simultaneously clash and complement one another like beautiful African beadwork. As in all of his objects and installations, this cluster of poles has a powerful, bodily physicality, and the charismatic formal strength of his work lends value to these materials which have been marginalized both as inartistic detritus from the street and as belonging to aspects of the black experience which are not acknowledged precisely because of their difference. "There's nothing negative about our images," he pointed

out. "It all depends upon who's seeing it, and we've been depending on someone else's sight . . . we need to look again and decide."[38] Thus Hammon's work is a homage to the black community and at the same time a direct reappropriation of the means of producing culture from the mainstream of mass culture.

Ann Hamilton

Ann Hamilton's work is always a powerful bodily experience—whether her medium is photography, video, installation, even text—and it always arises from the artist's own desire for personal discovery. Hamilton wants "people to be absorbed into the physical experience of a piece."[39] She creates "situations which implicate you as an active participant,"[40] she explained, ". . . letting the work work on you up through your body instead of from your eyes down. So that you allow yourself to experience something before you try to name it."[41] Hamilton's work taps directly into a preverbal level of thought that has deep emotional roots in early childhood; it is the world of tactile reasoning and affective logic.

In *Malediction,* an installation of 1991–92 [fig. 14.24] for example, the viewer entered a gallery strewn with stiff rags, wrung from washing and occasionally wine-stained. Stepping carefully through this field, she or he then came into a second room to find Hamilton, sitting at a refectory table, slowly and methodically taking wads of bread dough from a large bowl and pressing them into the upper palate of her mouth, and then one by one filling a wicker casket with the impressions. She faced a wall of bed linens piled high and cascading down; behind the wall a recording played a woman quietly, blandly reading Walt Whitman's prose poems, "Song of Myself" and "Body Electric." On one level the piece concerned the gender-stereotyped tedium and melancholy of domestic work. It is ". . . the culture of domestic activity . . . comprised of small creative practices that privilege the cumulative power of iteration . . ."[42]

Yet *Malediction* also brings to the fore other simultaneously cross-tracking emotions—self-absorption, tactile sensations, the sense of straining to hear the voice (which is like an inner voice in one's own head), and at the same time a feeling of the outer silence around. There is a sensuality mixed with the tedium, a sense of violation of the internal cavity of the mouth but, with that, the warmth of closeness, of contact. "The mouth is a negative space. The transgression of that border is a source of taboos and phobias . . . but it's just empty space."[43] The woven casket is of a type used to carry bodies from a nineteenth-century battlefield and the stain on the rags also suggested blood; at the time she made *Malediction* Hamilton was reading Civil War poetry.

Even before leaving art school (at Yale) in 1985, Hamilton began work on a series of sixteen black and white body-object photos (1984–93), which combine her own

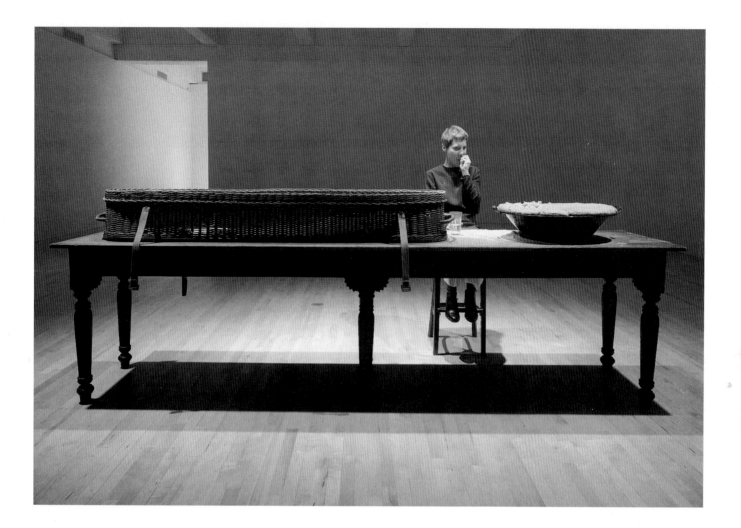

14.24 Ann Hamilton, *Malediction*, December 7, 1991–January 4, 1992. Installation and performance: gesture of filling, molding, and emptying the mouth with raw bread dough; filling the wicker casket with the molds of the mouth, as performed in two rooms of the Louver Gallery, New York.

Photograph by D. James Dee, New York. Courtesy Sean Kelly, New York.

body with objects—hanging chairs front and back from her shoulders (*untitled body-object series number one, chairbody*), engulfing the front of a shoe in her mouth (*untitled body-object series number three, shoemouth*)—in a manner that blurs the border between the human and the object and suggests an object-like character to the human sense of self. Gradually her work moved from objects and things put on the body into total environments which also had this diffuse definition of identity, acquired variously from the artist, the materials, and the active participation of the viewer.

In *Mattering*, an installation of 1997–98 [fig. 14.25], Hamilton covered a vast room in a museum in Lyon, France, with an undulating, red-orange canopy of silk, rising and falling in waves and glowing from the brilliant light of the skylight above. Five male peacocks clipped across the hardwood floors, with the clicking sound of their talons and the swoosh of their long tails punctuated by an occasional screech. In the background, one barely heard the sound of an opera singer giving lessons to a student. Atop a telephone pole that went up through a circular hole on the fabric ceiling, a man perched on a high seat, pulling up an endless line of blue-black typewriter ribbon through a hole in the floor, far below. He repetitiously wound the ribbon around one hand, creating a woven mitt which he would then cut free and drop in a pile at the base of the pole, only to begin winding again. The ceiling was like a skin—"that permeable edge of the body"[44]—and the artist described the sensation of rising into the orange silk with the line of blue ribbon as "coming up through language."[45] Like so many of Hamilton's installations, the piece is an open-ended peregrination through a number of very different tactile sensations, transformations of language into bodily experience and back, like the constant overlapping of warp and weft in a weaving, which she studied before going to Yale. "Cloth is an accumulation of many gestures of crossing which, like my gestures of accumulation, retain an individual character while accreting to become something else."[46]

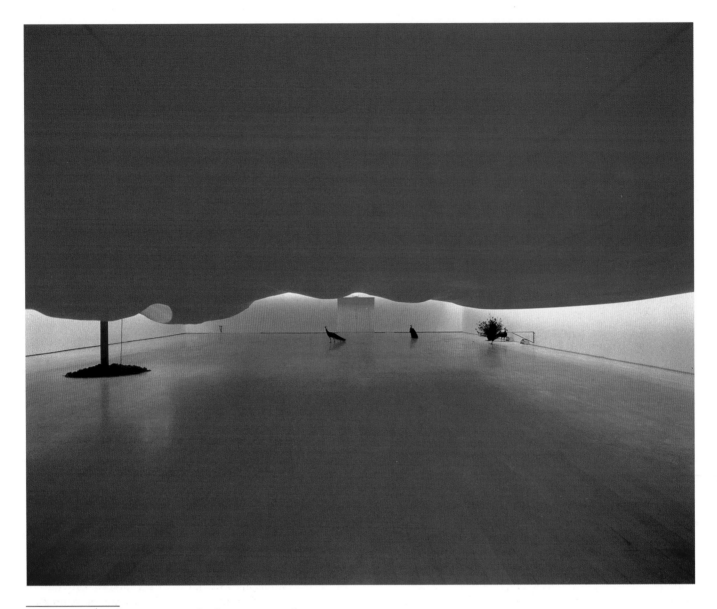

14.25 Ann Hamilton, *Mattering*, detail, 1997–98. Installation, Musée d'art contemporain, Lyon. Rising and falling silk bisects the horizontal space, five peacocks, telephone pole with performer, inked typewriter ribbon from the floor below, and recorded vocal exercises.

Appropriation

In an influential essay of 1967 entitled "The Death of the Author," the French literary critic Roland Barthes stated that "a text is not a line of words releasing a single 'theological' meaning (the 'message' of the Author-God), but a multidimensional space in which a variety of writings, none of them original, blend and clash," and he attacked traditional ways of reading in which ". . . the *explanation* of a work is always sought in the man or woman who produced it, as if it were always in the end . . . the voice of a single person, the *author* 'confiding' in us . . ."[47] Whereas, Barthes argued, every sign (a word or, by extension, an image or a brushstroke) is a product of history and social convention.

By assigning a role to the reader and to culture (both of which are perpetually changing) in defining the content of a text, Barthes negated the possibility of finding a stable interpretation of any text or image. Rather than a fixed entity with an unchangeable meaning, language is inherently unstable, he insisted, and not governed by artistic intention. Moreover, he denied the concept of originality: "The text is a tissue of quotations drawn from the innumerable centers of culture . . . The writer can only imitate a gesture that is always anterior, never original . . . Did he wish to *express himself*, he ought at least to know that the inner 'thing' he thinks to 'translate' is itself only a ready-formed dictionary."[48]

Following the lead of Polke and Baldessari and often influenced by the poststructuralist theories of Barthes, many artists of the late seventies increasingly looked to ready-made images or ideas as the data of personal experience as well as the raw material of one's own expressive work. This approach, which came to be known as "appropriation," grew out of collage, via pop art. Indeed, as John Carlin has written: "Pop art wasn't just a 60s phenomenon. It has become the dominant form of realism in the late 20th century." He pointed out that pop art replaced "the mimetic basis of realism . . . with a purely semiotic one. The primary artistic reference is no longer nature, but culture—the fabricated system of signs that has taken the place of things in our consciousness. In short, landscape has become signscape."[49]

The art world took up the issue of appropriation and the arbitrary overlay of ready-formed images in the later seventies as part of a reexamination of the possibility of originality and authenticity in the growing corporate mass culture. Influenced by Barthes, the critic Thomas Lawson, for example, praised David Salle's paintings [fig. 14.26], for being "dead, inert representations of the impossibility of passion in a culture that has institutionalized self-expression."[50] For this writer, the impassiveness of Salle's work was a new value in art precisely because it responded to what this critic saw as the new cultural situation.

Sherrie Levine and Mike Bidlo attracted attention in New York by making look-alikes of celebrated works from the history of art. Their art explores the possibility of expressing oneself using the ready-made expressions of someone else (in particular a well-known historical artist) as if to ask: can this method express authentic feeling? is it original? Similarly, Richard Prince introduced the concept of "rephotography" in 1977, making photographs of pictures in magazine advertisements and then blowing them up, cropping or rearranging them [fig. 14.28]. His work underscored the postmodern emphasis on the surface of events, "scanning" experience as in media and computers rather than penetrating its depth.

David Salle, a student of Baldessari's [see fig. 11.42], began overlaying images in 1979 and, as with Polke ten years earlier, the primary stimulus was the experiential complexity of a culture defined by images from advertising and media. "Everything in this world," Salle explained, "is simultaneously itself and a representation of the idea of itself. This was in a sense my big art epiphany . . . The pleasures and challenges of simultaneity continue to be one of the driving forces in my work."[51]

The visual busyness of the graphic design in Salle's paintings (variously anticipated in the styles of Johns, Polke, and Rosenquist) deflects emphasis away from considering the imagery as icongraphically significant. Indeed, the artist has repeatedly downplayed any reference external to the paintings: "To focus on where the images come from," he has said, "distorts their life together *in a painting*."[52] Thus Salle encourages us to see the female nude, for example, as an image among images, part of the undifferentiated—and by

14.26 David Salle, *His Brain,* 1984. Oil and acrylic on canvas, acrylic on fabric, two panels, 9ft 9in × 8ft 9¾in (2.97 × 2.69m) overall. Photograph by Zindman/Fremont, New York, courtesy Gagosian Gallery, New York. © David Salle/VAGA, New York, 1994.

implication ethically neutral—stuff of received experience. The fact that we cannot is one of the inherent contradictions that, for Lisa Phillips, made Salle's work poignant and relevant; she saw it as "embracing the intensity of empty value at the core of mass-media representation."[53]

Gary Panter [fig. 14.27], who began overlaying forms in Los Angeles in the mid seventies, leaves the viewer with a more unsettling and thought-provoking ambiguity about where, conceptually, to place his images. One isn't sure in Panter's work whether to read them as appropriations from life or advertising or as caricature from the underground comics (a genre in which he has a considerable reputation). Panter's famous comic character "Jimbo" a disconcerting fusion of man and automaton, roams the dehumanized fantasy city of Dal-Tokyo which is simultaneously futuristic and antiquated. Thus unhinged from rational time, even the setting of Panter's narratives undermines the conceptual hierarchies on which one's sense of orientation in the world relies.[54]

For Richard Prince, the mass media provides a stock catalog of contemporary desires (symbolized in advertising images, for example) which he can appropriate as vehicles for his own experience. He dislocates the images by projecting his own fantasies into them, superimposing and recoloring them. In *Untitled (Three Women Looking in the Same Direction)* [fig. 14.28] the similarities between the three images from different advertisements became the content,

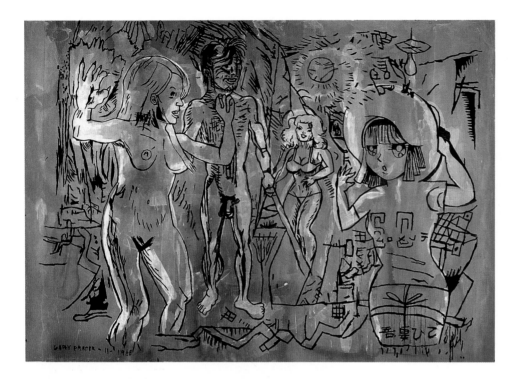

14.27 Gary Panter, *Untitled,*
1988. Acrylic on canvas,
5ft 6in × 7ft 8in (1.67 × 2.34m).
Private collection.

making a conceptual connection that is individual (and unintended by the advertiser). Thus Prince is a kind of passive witness, yet he controls the camera, so he can manipulate the images in his own way. In this sense, he reclaims authority over his own identity in the depersonalized world of the mass media, and that reassertion of self is at the heart of his work: "I have always found it difficult to talk about what it's like to rephotograph an image," he has said, "but 'what it's like' is what it's about."[55]

The threat of dissolution in mass culture is clear enough, and so is the solution proposed by Richard Prince: "I think the audience has always been the author of an artist's work. What's different now is that the artist can become the author of someone else's work."[56] He acknowledges "the commonality of this information retrieval, the fact that we've shared it and think it's somehow part of us, makes us think

about the information as a genuine experience.[57] Thus Prince seeks a route into individual authenticity through media culture rather than against it.

A puzzling narrative fragment—very often literally written right over a collage of appropriated images—brings the experience of mass culture back to the level of individual anecdote in the installations, assemblages, and paintings of Vernon Fisher from Dallas. In Fisher's *Show and Tell* [fig. 14.29], for example, the artist has blown up what seems to be a snapshot of the catch by two men out for an afternoon's fishing and then punched the lettering through the surface for a long narrative text which has nothing explicitly to do with the image. Then next to that he has hung a school blackboard with white paint spattered across it, and to the right a cutout of a young woman dressed in a fancy hat and gloves and polka-dot blouse. The stencilled text is a poignant story of a shy child so wrapped in the world of her creative imagination that her reality completely fails to connect with the reality of her classmates and teacher in school. It is a microcosm of the alienation of the individual in a mass culture:

14.28 Richard Prince, *Untitled (Three Women Looking in the Same Direction),* 1980. Set of three Ektacolor prints, edition of ten,
3ft 4in × 5ft (1.01 × 1.52m) each.
Collection, Chase Manhattan Bank, New York.

14.29 Vernon Fisher, *Show and Tell,* 1981. Photograph on laminated paper, blackboard, oil on wood, overall dimension 60 × 174 × 6in (152.4 × 442 × 15.2cm).
Collection, Michael Krichman and Leslie Simon. Photograph courtesy the artist.

One little girl never brought anything to sharing time. Other children might bring an authentic Indian headdress acquired on a vacation in Arizona, or a Civil War sword handed down from Great Granddad, but whenever the teacher asked: "Dori, do you have anything to share with us today?" she only stared at the top of her desk and shook her head firmly from side to side. Then one day, long after her turn had mercifully disappeared, Dori abruptly left her seat and walked to the front of the class. With everyone's startled attention she began: "Today on the way to school I found something that I want to share." She held her arm stiffly out in front of her and began slowly dropping tiny pieces of shredded Kleenex. "See?" she said. "Snow."

Raymond Pettibon had graduated college and begun teaching high school mathematics in Los Angeles when, at the end of the seventies, he decided to dedicate himself to drawing. His career is built around a feverish production of nothing but small pen and ink drawings; he had little career ambition and his work circulated chiefly among friends for nearly twenty years, until he found a wider public in the late nineties. Though generally influenced by comic book line drawings, he has never settled into a single style of rendering, but his drawings all depend upon sometimes lengthy inscriptions and there is a disjunctive manner of putting together image and text that is uniquely his own. In his untitled (*Since You Can't*), a drawing of 1983 [fig. 14.30], for example, the surreal vision of a distraught nude woman inside a bottle is captioned "Since you can't get her out anyway, the thing to do is to throw out the whole thing." The text has such a matter-of-fact tone of common sense advice and yet the situation, the tone, and the suggestion are all together so peculiarly irrational! The intriguing oddness

14.30 Raymond Pettibon, *Untitled (Since You Can't),* 1983. Pen and ink on paper, 13 × 9in (33 × 22.8cm).
Courtesy Regen Projects, Los Angeles.

of it all—the way it simply won't hold together—creates a conceptual fragmentation that recalls the definition of "postmodernism" by the French cultural theorist Jean-François Lyotard as "incredulity toward metanarratives. . . . The narrative function . . . is being dispersed in clouds of narrative language elements—narrative, but also denotative, prescriptive, descriptive, and so on. . . . Each of us lives at the intersection of many of these."[58]

Cindy Sherman

Cindy Sherman [figs. 14.31 and 14.32] also uses intimate narrative fragments in her photographs to create multiple layers of open-ended, simultaneous readings. But her narratives are implied in the costumes and settings.

Around 1977 she began photographing herself in campy fifties outfits and then in other costumes and settings. "These are pictures of emotions personified,"[59] and although she is the model in nearly her entire *oeuvre*, none of the pictures are self-portraits in the ordinary sense. Instead she created imaginary narratives in which she acted, using the common faith in the truth of the photograph to explore a wide range of roles. She often turned to stereotypical roles for women, but her point of reference seems to have been the representation of the prefabricated roles of movies and media rather than the roles themselves. This second degree of remove is especially intriguing since her work is so emotionally evocative.

Sherman challenges fixed identity by taking on so many guises. Yet the specificity of each image suggests how fully

14.31 (above) **Cindy Sherman,** *Untitled Film Still #3*, 1977. Black-and-white photograph, 8 × 10in (20.3 × 25.4cm).
Collection, the artist. Photograph courtesy Metro Pictures, New York.

14.32 (right) **Cindy Sherman,** *Untitled #119*, 1983. Color photograph, 3ft 9½in × 7ft 10in (1.16 × 2.39m).
Collection, the artist. Photograph courtesy Metro Pictures, New York.

the artist threw herself into every character. In the seventies she made only small black-and-white photographs, directly influenced by film and television. She shifted to a larger scale and to the use of a rich color technique around the end of 1980. Then, in the late eighties she turned to increasingly bizarre, sometimes macabre themes, testing an ever-widening range of subjects and emotions.

Sherman's work has had a great impact in encouraging younger artists in the nineties (especially women) to use photography in this personal narrative way. Just as Robert Arneson's self-portraiture of the seventies and eighties explored the narcissistic self-reflection that unfolds in the culture of common human interaction, Cindy Sherman's photographs of the eighties and nineties allowed the viewer to look over her shoulder as she examined narcissistic self-projection into media types. In the hypothesis of living pre-existing identities from mass culture, one by one—whether inspired by Hollywood celebrity photos as in her early work or by horror film stills as in her more recent work—her photos provide the collateral pleasures of erotic exhibitionism and tabloid drama while at the same time opening a window onto the emptiness of this narcissistic existence. As Cindy Sherman has said about her photos, "They're not at all autobiographical."[60] Yet the pictures "should trigger your memory so that you feel you have seen it before."[61] They

do, and the reason for this sense of familiarity is not because any of the images really come from a particular movie or advertisement (they don't), but because the types are so pervasive in shaping the fantasies and desires of our consumer culture. Sherman's work evokes an existential anxiety of personal dissolution into the clichés of our contemporary mass marketing.

The Aesthetic of Consumerism

For some of the artists emerging in the eighties, mass-market consumerism in itself offered imaginative possibilities. "Ali Baba's cave is not unlike Macy's," Haim Steinbach remarked, "but then it was more recognized as fantasy."[62] The East Village artists Haim Steinbach, Jeff Koons, Peter Halley, Ashley Bickerton, and Meyer Vaisman found a genuine aesthetic pleasure in contemporary consumer culture. The commodification of art—art treated as an item for sale and consumption—attracted them as a fascinating new aspect of contemporary culture.

Steinbach [fig. 14.33] was visually excited by seeing the way things were presented in stacks in the store and

14.33 Haim Steinbach, *Ultra Red 1,* 1986. Mixed media construction, 59 × 107 × 19in (149.9 × 271.8 × 48.3cm). Private collection. Photograph by David Lubarsky, courtesy Sonnabend Gallery, New York.

built special shelves for lining up these manufactured objects in repetitive rows. His art concerns "taking pleasure in objects and commodities . . . being complicit with the production of desire."[63] Halley painted reductive geometric abstractions derived from circuitry diagrams in a revival of geometric abstraction—an especially appealing style precisely because it was the ideologically empty form of commercial abstraction against which abstract expressionism rebelled and which finally became completely debased as op art in the sixties.

14.34 Ashley Bickerton, *Solomon Island Shark,* 1993. Rubber, leather, canvas, rope, coconuts, acrylic, PVC, Scope®, 9ft 5in × 3ft 1in × 2ft 3in (287 × 94 × 68.5cm).
Neumann Family Collection, New York.

14.35 Allan McCollum, *Drawings,* 1988–90. Installation at John Weber Gallery, New York, 1990, over 2,000 framed drawings, pencil on museum board, various sizes.
Photograph by Fred Scruton, courtesy John Weber Gallery, New York.

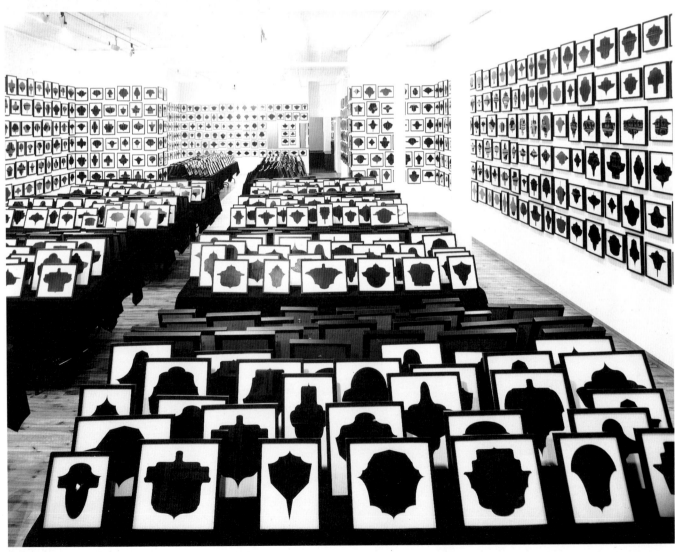

Meyer Vaisman's work is charged with a passion for the appropriation of simulated appearances, historical art styles, and subject matter that has deteriorated as an artistic language from over-use, while Ashley Bickerton produced objects which seem like high-tech consumer goods, covered in commercial logos, and yet oddly without identifiable function. Bickerton's *Solomon Island Shark* of 1993 [fig. 14.34] takes this instability of identity in an even stranger direction, constantly flipping from one line of association to another completely different one; at one moment this nine-foot, leather-clad, rubber creature seems like a fugitive from an "S and M" bondage dungeon, and at the next it evokes the exotic "natural" surroundings of the South Pacific. But then the beautiful blue-green "sea water" sacks hanging from the belts and cords are actually filled with Scope® mouth-wash and the weirdly erotic coconuts are the only "natural" items included.

Allan McCollum, who moved to New York from Los Angeles in 1975, probed the issue of commodified artistic language by making "art surrogates" or neutral "vehicles" to see in what way one can separate and perfect the forms in artistic language as if they were mass-produced goods. His 1992 installation of *Drawings* [fig. 14.35] has a wonderful complexity embedded in its matter-of-fact treatment of the drawings as infinitely recombinable prefab units, stacked in a store.

14.36 Jeff Koons, *New Hoover Quadraflex, New Hoover Convertable, New Hoover Dimension 900, New Hoover Dimension 1000 doubledecker,* 1981–86. New Hoover vacuum cleaners in plexiglas vitrine with fluorescent lighting.
Courtesy Deitch Projects, New York.

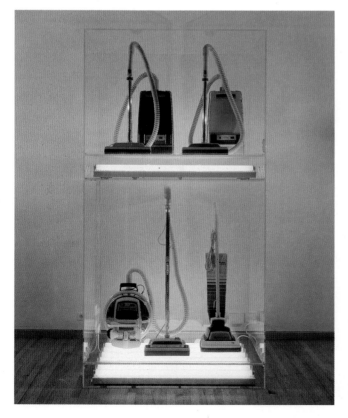

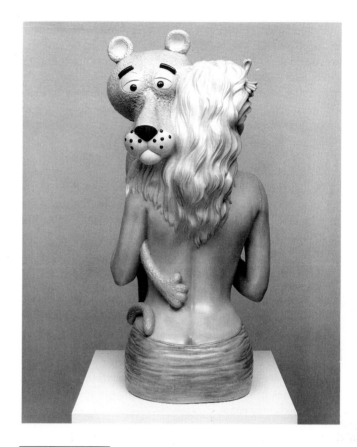

14.37 Jeff Koons, *Pink Panther,* 1988. Porcelain, 41 × 20½ × 19in (104.1 × 52.1 × 48.3cm).
Private collection. Photograph courtesy Jeff Koons.

In "The New," the principal series of work by Jeff Koons in the early eighties, the artist explored not only modernism's perpetual hunger for "newness,"[64] but the sense of pristine newness that accompanies the acquisition of consumer goods and provokes such "a strange excitement in people."[65] Taking a utilitarian object like a vacuum cleaner out of its functional context [fig. 14.36], Koons gives it heroic status by enshrining it in an elegant Plexiglas vitrine with fluorescent showcase lighting. For Koons it is both an aesthetic object (unlike the readymades of Duchamp) and a social icon. "One receives objects as rewards for labor and achievements," he theorized. "Everything one has sacrificed in life . . . in the effort to obtain these objects, has been sacrificed to a given labor situation. And once these objects have been accumulated, they work as support mechanisms."[66]

Thus Koons faces unflinchingly the dynamics of the old aphorism "the hat makes the man," recognizing the way the individual establishes "confidence in his position by virtue of the objects with which he surrounds himself. These objects will not be looked at in a contemplative way, but will only be there as a mechanism of security. And they will be accessible to all, for art can and should be used to stimulate social mobility."[67] Koons then deliberately moved into kitsch [fig. 14.37] and from there into explicit pornography (photos and sculptures of himself graphically

"engaged" with an Italian porn star, whom he also briefly married), making cynical consumer icons for the rich that were shocking both for their commercial ambition and for their bad taste. Yet in both respects, the work forced the viewer into an uncomfortably raw confrontation with the prevailing values of those who have come to "own" culture in America today.

Political Appropriation

While Koons reveled in the consumer culture of the eighties a forceful political counterculture also emerged within the New York art world, signaled by the founding of COLAB (in 1977), Fashion/Moda and Group Material (both in 1979) as neighborhood-based art collectives. Like the British artists of the Independent Group in the fifties, these artists took in the whole range of cultural production from paintings to kitsch curios and the television news in their collaborative installations. Moreover, they included not only the imagery of contemporary popular culture but also its manner of presentation. They were more militantly political than their British precursors, however, in seeking to use popular culture to connect art with communities, often specifically addressing social issues in the poor neighborhoods of New York City from which they came.

These artists wanted to intervene directly in events, serving as agents for social change, but as Tim Rollins, a founding member of Group Material, pointed out: "a political art can't really be made *at* working people or *for* the oppressed. A radical art is one that helps organize people who can speak for themselves."[68] COLAB's first major project was to take over an abandoned city building on the Lower East Side in order to stage an event that focused attention on tenants' rights issues in New York. The "Real Estate Show," as it was called, opened on January 1, 1980 and was immediately closed by police. As Rollins remarked: "It's a radical art with a radical methodology, because it's illegal."[69]

Tom Otterness, John Ahearn, and other artists from COLAB and Fashion/Moda organized the 1980 "Times Square Show" [figs. 14.38 and 14.39] in an abandoned sex shop by Times Square, the Manhattan porn district. They jammed the space with videos, graffiti, posters, installations, and ongoing performances, crystallizing the fusion of schooled art and Bronx graffiti that was taking place in the East Village with artists like Keith Haring and Jean-Michel Basquiat. Meanwhile, in September 1980 Group Material opened one of the first East Village galleries in a storefront, where for about a year they staged exhibitions that spotlit broad sociopolitical issues such as gender discrimination or U.S. adventurism in Central America.

There were a number of reasons why such artists became so focused on political matters in the eighties. Prominent among them was the AIDS crisis, which first appeared in 1981 and escalated into an epidemic at a terrifying pace. The explosive growth in homelessness and unemployment also made many feel that government in the eighties served only the interests of the rich. Finally, there were fundamental new threats to freedom in America, in particular the consolidation of media (daily newspapers, magazines, television, books, and motion pictures) into the

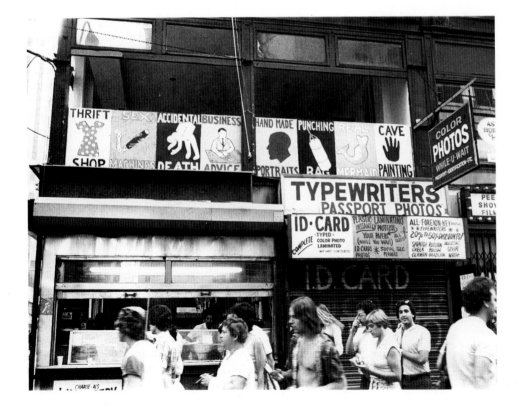

14.38 Times Square Show, June 1980, second-floor window with paintings on masonite by Tom Otterness announcing attractions inside.
Photograph © by Lisa Kahane, New York.

14.39 Times Square Show, June 1980, anonymous chalk graffiti on the walls of the building's fourth floor in front, Tom Otterness's Punching Bag.
Photograph © by Lisa Kahane, New York.

hands of a few powerful corporations. In 1981, forty-six corporations controlled most of the business in media; by 1986, that number had shrunk to twenty-nine. It was estimated that by the year 2000 ownership of the American media industry might be in the hands of only six conglomerates, and global communication dominated by only twelve.[70] This take-over of the media seemed especially pernicious since the political events of the eighties had made it painfully clear that slick advertisements could sell the public a perception of a candidate or issue that might bear no resemblance to the truth.

Jenny Holzer, a participant in the "Time Square Show," appropriated the vehicles of advertising and graffiti for an ironic personal expression that undermines the stereotyped messages in the media [fig. 14.40]. She started her "truisms" in 1977, printing (and later electronically encoding) phrases such as "Murder has its sexual side," "Raise boys and girls the same way," "Abuse of power should come as no surprise" on

posters, flyers, T-shirts, hats, and then electronic signs. Holzer's manipulation of "almost" familiar phrases displaces the clear presence of a personal voice—the words seem impersonal, underscoring the essential emptiness of the media and the strange isolation of people from one another in this society of mass-culture clichés.

Like Holzer, Barbara Kruger [fig. 14.41] combines ambiguous slogans with black-and-white images, pasted up together like a page of trendy graphic design from *Mademoiselle*, one of the magazines where she worked for eleven years learning her graphic design skills. She also hands out her messages on matchbooks, T-shirts, tote bags, posters, and photomontages, but hers is an angry and accusatory voice, with phrases like "We won't play nature to your culture," "We won't be our own best enemy," "You colonize lacerated objects." Kruger also deliberately leaves both the voice in the text and the intended auditor in anonymity.

There is no such ambiguity in the texts of the Guerrilla Girls. After the Museum of Modern Art held its vast "International Survey of Contemporary Art" in 1984, in which almost no women or minorities were included, a number of professional women in the New York art world founded this collective organization. The Guerrilla Girls

14.40 Jenny Holzer, *Truisms,*
1977–79: Abuse of Power Comes As
No Surprise, 1982. Spectacolor
Board No. 1, Times Square,
New York.

Photograph courtesy Jenny Holzer.
© Jenny Holzer.

appeared on television (wearing rubber gorilla masks to maintain their anonymity), they advertised, and distributed leaflets and posters to bring attention to the widespread race and gender discrimination that exists in the art world [fig. 14.42].[71]

Krzysztof Wodiczko, an artist writing from Communist Poland in the mid seventies, pointed out that in a totalitarian state, "individuals don't own images; the state does. The result is that it is impossible to change the context of images."[72] However, the observation also applies to the corporate control of the media in America today. Wodiczko's answer to this, like Christo's, is to create astonishing spectacles in the workaday setting of the city that will startle the casual passer-by out of his or her routine habits of thought about the world.[73] In particular, Wodiczko insisted that "today more than ever before, the meaning of our monuments depends on our active role in turning them into sites of memory and critical evaluation of history as well as places of public discourse and action."[74]

Wodiczko fled to Canada in 1977 and then, in 1983, moved to New York. His best-known work involves the use of high-powered lanterns to project evocative images on public buildings, provoking his largely non-art audiences into a fresh encounter with the political and social forces that linger behind these structures. Just days before the 1988 presidential election, for example, Wodiczko projected an ominous pair of hands on the Hirshhorn Museum on the Mall in Washington [fig. 14.43]. The campaign had been marred by racist advertisements showing the face of a black convict named Willie Horton and attempting to scare the public into believing that the Democratic candidate would release dangerous criminals from the prisons. In Wodiczko's projection one hand held a candle and the other a gun, symbolizing the rhetoric of hope and fear that had characterized the presidential campaigns of Michael Dukakis and George Bush.

14.41 Barbara Kruger, *Untitled (You Rule By Pathetic Display),*
1982. Photograph, 6ft 1in × 4ft 1in (1.85 × 1.25m).

Krannert Art Museum and Kinkead Pavilion, University of Illinois at Urbana-Champaign.
Purchased by the Art Acquisition Fund. Courtesy Mary Boone Gallery, New York.

14.42 (above) **Guerrilla Girls,** *Do women have to be naked to get into the Met. Museum?,* 1989. Poster, 11 × 28in (27.9 × 71.1cm).
Private collection.

14.43 (below) **Krzysztof Wodiczko,** *WORKS,* October 25, 26, and 27, 1988. Projection on to the Hirshhorn Museum, Hirshhorn Museum and Sculpture Garden, Smithsonian Institution, Washington, D.C.
Photograph by Lee Stalsworth, 1988. © Krzysztof Wodiczko.

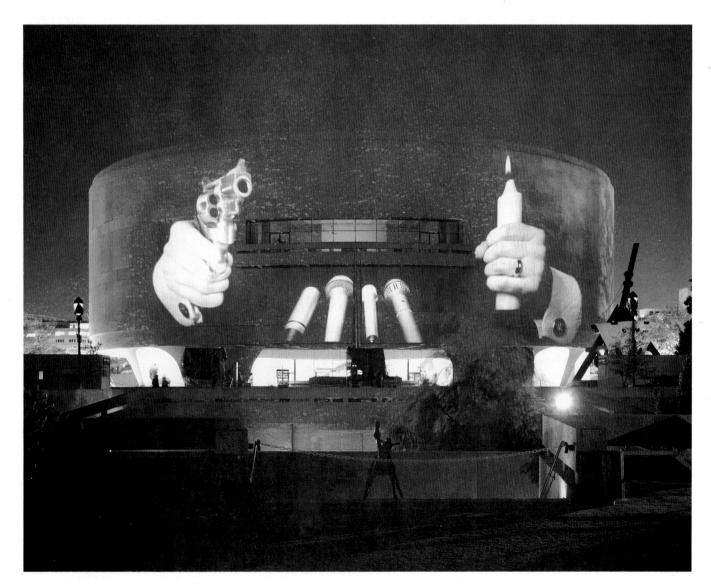

15

NEW TENDENCIES OF THE NINETIES

The nineties began as the decade in which the easy millionaires from the leveraged buyouts and junk bonds of the eighties lost their fortunes and started looking for jobs. There was hope in the art world that art would also become less about careers and more about ideas again. But the herds of Wall Street were soon replaced by a new breed of overnight millionaires in the computer and entertainment industries, and the apotheosis of global consumerism continued. In the United States, marketing all but eliminated issues in both news reporting and political campaigns; the value of a stock portfolio soared, but the buying power of a schoolteacher's salary went down. Huge corporations got even bigger, local businesses disappeared (and so did Main Street), in favor of global sameness in the shopping malls, airports, and commuter traffic lines where people increasingly lived their lives. The nineties became the decade in which everyone bought a cellular phone, logged onto the Internet, and found themselves endlessly on hold, listening to medleys of prerecorded menus and Muzak.

Money and marketing also dominated the art world, but serious artists in the nineties persevered in trying to make sense of their experience and the variety of what they created reflects the many different complex issues that came to the fore all at once, not least, the often overwhelming information flow itself. For some artists, a focus on immediate, bodily experience helped restore a sense of self in the increasingly anonymous culture. The particularizing features of one's identity also became important as a force against dissolution. The art world became more multicultural and global during the nineties, but at the same time worldwide consumer marketing began eroding global difference. Above all, the decade was transformed by a breathtaking advance in new communications and computer technology and, by the close of the nineties, managing the flow of data had emerged as the key issue for the twenty-first century.

Return to the Body

The feminists of the early seventies had made it clear how much a woman's body served as a political site. The raw, witheringly direct feminism in the early nineties paintings of Sue Williams [fig. 15.2] acquires its edge from its frankness about the body and its insistence on bringing social issues home—"in your face"—to the level of personal experience. The style picks up on the vocabulary of comic book illustrators like those in *Mad Magazine*, giving the work a broad legibility with a sarcastic edge. The subject matter, centered on violence against women, is hard to look at.

Some artists contextualized feminist issues in a broader critique of the way in which the entire art world (like the corporate world) was threaded with gendered values. Ann Hamilton's installation for the 1999 Venice Biennale, for example, implicitly took issue with the aggressive masculinity of the very architecture of the United States Pavilion in the

15.1 Fred Tomaselli, *Bug Blast,* 1998. Photographs, collage, pills,
leaves, insects, acrylic, and resin on panel, 5 × 5ft (1.524 × 1.524m).
Private collection.

New Tendencies of the Nineties

15.2 Sue Williams, *La Sistine*, 1992. Acrylic on canvas, 5ft 8in × 4ft 10in (1.72 × 1.47m).
Private collection. Photograph courtesy 303 Gallery, New York.

Venice fairgrounds with a multilayered, total environment, using text, voice recording, and a gentle rain of red powdered pigment falling from the trim at the top of the walls, in wispy clouds, to the floor. The receptivity to the viewer, the gentleness with which the work (nevertheless entirely) took control of the space, the attention to details of materials and the complex layering of the content were in every sense different than the boldly asserted [read "masculine"] abstract expressionist brush stroke against which "value" in the art world is still largely measured.

The work of David Wojnarowicz in the later eighties had brought forward the politicized nature of bodily reality with regard to homosexuality too, and, by extension, to anyone marginalized by mainstream values. Robert Gober's work carries this issue onto a metaphorical plane by embodying a dissonance between public and private identity. Gober first came to the attention of the art world with a series of beautifully hand-crafted, plaster sinks, made between 1983 and 1992. They were unremarkable domestic sinks and these objects looked at first sight identical to their models, except that they had no plumbing or hardware attached. In 1984 he had an exhibition of handmade pewter drains, mounted chest-high in the gallery wall, emphatically disconnecting them from any relation to function.

In 1990, Gober began making legs [fig. 15.3]—fetishized body parts, cut off below the knee, sticking out from the wall along the floor. The legs began, he told Richard Flood, when "I was in this tiny little plane sitting next to this handsome businessman, and his trousers were pulled above his socks, and I was transfixed in this moment by his leg."[1] Gober also made other anti-heroic objects and even large installations, all of which hovered ambiguously at this interface of verisimilitude and dysfunction. What is so provocative and interesting about this work is the intense, erotic focus on the simplest things, even fragments of things, in incongruous juxtapositions—the lovingly fabricated sinks, the hair by hair realization of an exposed two inches of leg, a leg with a candle projecting out of it—pointedly (and oddly) dissociated from the "normal" relations between things and the world; he makes three-dimensionally palpable the arbitrariness of the postmodern flux of images.

A visceral preoccupation with the body also came to the fore in other ways in the art of the late eighties and the nineties. The performance work of Karen Finley, for example, relied on a raw evisceration of her audience's body taboos. C. Carr characterized her work this way:

Wafting onto the stage in some polyester good-girl get-up at one or two in the morning, Finley first showed the audience her stage

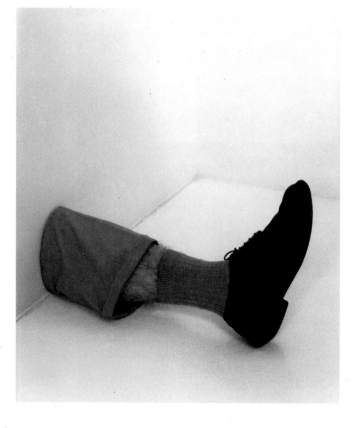

15.3 Robert Gober, *Untitled*, 1990. Beeswax, cotton, wood, leather shoe, and human hair, 12½ × 5 × 20in (31.75 × 12.7 × 50.8cm).
Collection Hirshhorn Museum and Sculpture Garden, Smithsonian Institution, Washington, D.C. Joseph H. Hirshhorn Purchase Fund, 1990. Photograph by Lee Stalsworth.

fright or self-doubt—the prelude to holding nothing back. Then, the deluge: monologues that erupted out of the gross forbidden subtext of everyday where grannies soak in their own piss, men forcefeed boys to produce the perfect shit, and daddy works "his daughter's little hole." The monologues were disgusting and cathartic—like pus escaping from some subconscious wound. This was obscenity in its purest form—an attempt to explore emotions too primal for words.[2]

The explicit content of Finley's performances made her a target for censorship by the right wing of the U.S. Congress, which correctly perceived that her work challenged its status quo. Vehement censorship battles were fought in the U.S. courts and Presidents Reagan and Bush even attempted to dismantle the broadly popular National Endowments on the Arts and Humanities as a way of winning the approval of the religious right and silencing dissent. The most visible battles centered on Finley, Andres Serrano (who juxtaposed his own bodily fluids with symbols of his religious devotion, as in his notorious *Piss Christ* of 1987), and on the homoerotic content in the works of David Wojnarowicz and of the photographer Robert Mapplethorpe.

The disconcerting, body-like objects by Rona Pondick are less vulnerable political targets since they are not overt references to issues of sex or religion. But they draw on primal sensations that exist in the recesses of the psyche and elicit an even more profoundly disquieting effect. The *Little Bathers* [fig. 15.4] comprises dream-like transformations of fetishized human mouths, and the viewer cannot distance him or herself from an uncomfortable, simultaneously physical and psychic identification with them.

Kiki Smith's work also centers on the human body but in a more visceral manner (as opposed to the imagistic transformations of Rona Pondick's work). Like David Wojnarowicz, a close friend and sometime collaborator, Smith has an intense involvement with the most intimate functions and internal parts of the human body. In the mid eighties, Smith's sculpture included a row of glass water cooler jars etched with the names of different bodily fluids (urine, tears, sweat, milk, oil, mucus, saliva, blood, vomit, semen, puss, diarrhea). Another piece consisted of eight jars of blood. She cast a stomach in glass, rendered a heart in plaster and silver leaf, cast bronzes of a male and a female *Uro-Genital System*, and made an iron cast of a digestive system from the mouth to the anus that looks oddly like an old radiator. In the nineties she turned instead to the whole body, often rendered in fragile paper or in muslin and wax—a sense of materials influenced by the modest materials of Richard Tuttle (who had been a studio assistant to her father, the minimalist sculptor Tony Smith), and by Eva Hesse's organic use of latex, Fiberglass, and rubber. In *The Sitter* of 1992 [fig. 15.5], Smith sliced into the back to reveal an internal cross section of raw tissue. Her work helped reinvigorate the tradition of figural sculpture in the nineties.

15.4 Rona Pondick, *Little Bathers* (detail), 1990–1. Wax, plastic and rubber teeth, 3½ × 3 × 4in (8.9 × 7.6 × 70.2cm) each (500 pieces), dimensions variable.
Collection, Marc and Livia Straus. Photograph by Jennifer Kotter, courtesy Jose Freire Fine Art, New York.

15.5 Kiki Smith, *The Sitter*, 1992. Wax, pigment, papier mâché, 28 × 36 × 24in (71.1 × 91.4 × 61cm).
Collection, Emily Fisher Landau, New York. Photograph courtesy Fawbush Gallery, New York.

Transgressing Body Boundaries

Much of the work that came to attention in the nineties attempted, in one way or another, to transgress the personal boundaries of the viewer. Ann Hamilton conceived her work to be experienced through the body senses rather than mediated through language and imagery. In Kabakov's "total installations" the viewer is wholly absorbed into a self-contained fantasy space. Maurizio Cattelan's installation *Novecento* (1997) exploits the startling effect of a real taxidermed horse [fig. 15.6] hanging from the ceiling to undermine the viewer's sense of aesthetic distance. His installation for the 1999 Venice Biennale consisted of a stone room filled with dirt and in the middle were two human hands palm to palm. The hands were clearly alive—they sometimes moved—so the viewer knew that a human was buried underneath the dirt. This evoked both an intense claustrophobia and at the same time a visual experience of an elegantly minimal form.

The Los Angeles-based artist, Mike Kelley, appropriated pop culture into performances, drawings, and sculpture in ways that crassly violated social and ideological taboos. In *Estral Star I* (1989) [fig. 15.7], the title puns on *astral* and *estrus* (the term for animals in heat), imposing a crudely inappropriate sexual reference onto two sock monkeys—cuddly stuffed animals for children—refocusing our attention on the red, lip-like representation of the female genitalia on these toys. In Kelley's 1990 *Nostalgic Depiction of the Innocence of Childhood*, a nude couple seem to have sexual relations with huge, furry toys, and smear themselves with what looks like fecal matter; the performance medium makes the same underlying subject-matter as in *Estral Star I* even more

15.6 Maurizio Cattelan, *Novecento (Nineteenth Century)*, 1997. Taxidermed horse, 6ft 7in × 8ft 10½in × 2ft 3½in (200 × 270 × 70cm).
Castello di Rivoli–Museo d'Arte Contemporaneo, Rivoli-Torino. Gift of the Sustaining Friends of the Castello di Rivoli.

15.7 Mike Kelley, *Estral Star I,* 1989. Sewn sock monkeys, 31½ x 12 x 6½ in (80 x 30.5 x 16.5 cm).
Courtesy the artist.

unsettling. Kelley's artistic practice is based in conceptual art and he jumps readily from one medium or style to another to suit the character of the underlying idea.

Kelley's performances have precedence in the highly sexualized, messy performance work of Paul McCarthy, another Los Angeles artist, who began performing in the seventies. Barbara Smith (a fellow performance artist) recounted McCarthy's 1974 *Hot Dog* [fig. 15.8] as beginning with his stripping to his underwear and shaving his body. Then he: "stuffs his penis into a hotdog bun and tapes it on, then smears his ass with mustard. . . drinking ketchup and stuffing his mouth with hot dogs. . . . Binding his head with gauze and adding more hot dogs, he finally tapes his bulging mouth closed. . . . He stands alone struggling with himself, trying to prevent his own retching . . ."[3]

The sculptural medium of the French artist Orlan is her own face, which she subjected to repeated plastic surgery, sculpting it with a quite unnatural topography and videotaping the surgeries for exhibition. Matthew Barney began using sophisticated prosthetics and make-up in the early nineties to create the peculiarly beautiful, part human creatures in his films. His actors are all quite emphatically sexual and yet ambiguously gendered; their coloring is simplified but also expressionistically exaggerated. His scripts are sequential without teleology and even in the medium itself Barney creates open-ended ambiguities of category between opera, dance, drama, installation,

15.8 Paul McCarthy, *Hot Dog,* 1974. Still from performance, Oddfellows Temple, Pasadena, California. Mayonnaise, ketchup, hot dogs, hot dog buns, mustard, utensils, gauze, tables, chairs, dishes.
Photograph by Spandau Parks.

painting, sculpture, and art cinema. Barney graduated from Yale College in 1989 and by 1991 he had a one-man show at the Barbara Gladstone Gallery in Soho. In that show he used mountaineering gear to climb the walls and ceiling of the gallery, nude but festooned with tackle and bundles of steel climbing spikes. After the performance a video of the event played in the gallery, showing him crossing the ceiling like a fly and extruding shiny pellets from his rectum. The piece also included a refrigerated room, like a meat locker, maintaining chilled petroleum jelly sculptures of what seemed like mutated gym equipment. The overt sexuality, the visceral transgression of bodily process in pressing the pearls out of his anus created a simultaneously riveting prurience and repulsion. He quickly moved onto films, which had high production values from the start as though both in emulation and perversion of Hollywood. There have been five films in Barney's *CREMASTER* series; he himself performs in them [fig. 15.9]; and each still is composed like a painting in brilliant color.

15.9 Matthew Barney, CREMASTER 4: The Loughton Candidate, 1994. Color photo, plastic frame, 12 × 14in (30.5 x 35.5cm). Courtesy Barbara Gladstone. Photograph by Peter Strietmann, © Matthew Barney, 1994.

The Academy of the Avant Garde

Gnaw of 1992 by Janine Antoni is another intensely physical piece that garnered attention in the nineties. The artist spent a month and a half both incorporating and destroying (figuratively and literally) two minimalist cubes. One cube was made of lard and the other of chocolate; the technique was to chew them bite by bite and then spit them out to make lipstick (from the lard) and packaging (for chocolates out of the chocolate). In *Loving Care*, another art action of 1992, she painted the floor of a gallery using her long hair as a brush, slowly painting the people out of the space. Just as *Gnaw* took up the feminization of the minimalist cube from Eva Hesse and others of her generation, *Loving Care* (a play on the socially feminized role of caretaking and on the brand name of a woman's hair dye)

simultaneously restated Klein's *anthropométries*, as though from the point of view of the self-abnegating female models that he used as "living brushes," and ironically transformed the phallic power of the abstract expressionist brush stroke into a feminine labor.

It is both a virtue and a vice of the canny graduate school training of younger artists in the nineties that works such as these so intelligently engage in a reinterpretation of recent art history. It makes such work instantly assimilable into the reigning discourse on art. But its long-term impact may also be limited by the narrow perimeters of academic discourse. In the eighties and nineties the overheated interest in "what's hot" meant that the memory of the art world became shorter and shorter.

Cultural Identity

In a series of plates that Carrie Mae Weems included in her 1991–92 *Untitled (Sea Islands Series)*, she inscribed across the top in bold type "Went Looking for Africa" and below it on each plate she lettered a different experience on this psychic journey, as in: "and found it tightly woven in a woman's hair." This series involved her examination of the culture, the language, the visual forms of the people on the Gullah (derived from "Angola" = "golla" = "Gulla") Islands off the coast of Georgia and South Carolina, seeking her own cultural ancestry as an

Afro-American. Race is unavoidable in America; it is part of identity. In some nineties work by Carrie Mae Weems, she, as well as Robert Colescott and Kara Walker, all pushed the racial stereotypes to extremes to deal openly with how they affect identity. "It took me quite some time," Kara Walker said, "before I realized . . . that the shadows (oh here we go) of the past, the deriding names and titles, in fiction and in fact, are continually informing, no, more like de-forming and re-forming who we think we are—who I think I am."[4]

**15.10 Carrie Mae
Weems,** *Untitled (Playing
Cards)* from the *Kitchen Table
Series,* 1990. Silver print,
28¼ × 28¼in
(71.7 × 71.7cm).
Courtesy P.P.O.W., New York.

In the *Kitchen Table Series* of 1990, Weems focused on the intimacy of events around the kitchen table as the locus of fundamental reflections on the private desires and circumstances of life. The sequence of photographs is the story of a black woman (accompanied by a text of reflections) and in *Untitled (Playing Cards)* [fig. 15.10], for example, she sits at the table looking, analytically, at the man seated across from her. A photograph of Malcolm X, preaching with raised hand, is on the wall behind her, flanked by personal snapshots that reveal other parts of her sense of who she is—standards against which to measure this man. They are drinking and eating peanuts as they play a game of cards that is more a game about a human relationship.

For the mainland Chinese artist, Cai Guo-Qiang, who emigrated in 1995 to New York after a decade in Japan, it is important to integrate his Chinese cultural identity into the new cross-cultural context of the contemporary art world. He often works with explosives in the landscape [fig. 15.11], modulating the shape and speed of the

explosions in relation to the history, geography, and social conditions of the site; the scale, he imagines, is such that any life in the cosmos should be able to see it. Cai evokes the cosmic law of balance—Yin and Yang (creation and destruction)—in the momentary eternity of the explosion and uses principles of acupuncture and the ancient Chinese art of feng shui to reorient the energy of the elements in a place—their *Qi,* the life force—into better harmony with the totality of nature.

Asian perspectives became more visible generally in the increasingly global art world of the nineties with a number of interesting exhibitions of contemporary artists from India, Korea, Thailand, Indonesia, the Philippines, and elsewhere touring Europe and the United States. China, in particular, emerged with several strong new painters and installation and performance artists, such as Wang Xingwei, Zhou Tie Hai, Chen shun-Chu, Jui-Chung Yao (from Taiwan), Ma Liuming, and Zhang Huan. Zhang (in his performance piece *To Raise the Water Level in a Fish Pond* [fig. 15.12]) invited people who had lost their jobs in a

New Tendencies of the Nineties

15.11 Cai Guo-Qiang, *The Century with Mushroom Clouds—Projects for the 20th Century,* 1996. Event at Nevada Nuclear Test Site.

Photograph by Hiro Ihara, courtesy of the artist.

15.12 (below) **Zhang Huan,** *To Raise the Water Level in a Fish Pond,* August 15, 1997. Performance documentation (middle distance detail), Nanmofang Fishpond, Beijing. C-print on Fuji archival, 60 × 90in (152 × 228cm).

Courtesy Max Protetch Gallery. Photograph by Robyn Beck.

recent ruthless modernization of Chinese industry to stand in a pond, raising the level of the water—a poetic assertion of their social presence.

Kerry James Marshall's painting, *Our Town* (1995) [fig. 15.13], also concerns cultural identity but he approaches the subject as a history painter (a virtually lost genre). Marshall depicts the American dream with nice suburban houses, kids playing, and the family dog running alongside. The mother, in an apron, waves from in front of the house and across the street is a grassy park with bluebirds and

15.13 Kerry James Marshall, *Our Town*, 1995. Acrylic and collage on canvas, 8ft 4in × 12ft (2.54 × 3.657m).
Courtesy Jack Shainman Gallery, New York.

lush trees. The bluebirds with ribbons and the rays of the sunrise deliberately go too far; they seem as though they were lifted from a Disney cartoon for children and suggest the semiotic complexity of this work with symbolically laden references to different ways of painting from the cartoon animation to abstract expressionism.

The perfection of the sanitized Walt Disney touch (in the cartoon-style lettering, the bluebirds, and ribbons) is an ironic note, since relatively few black people have ever experienced this suburban utopia; there are also collaged squares on top of the surface (set near the edges) to remind us that this is only a painting, an illusion, after all. The references to abstract expressionist brushwork in the painterly white gestures and drips also cut to semantics; indeed the little girl's imaginings, her dream of the ideal childhood (in the bubble) are crossed out by these white gestures.

Marshall was born in Birmingham, Alabama in 1955 and lived there through the climax of the Civil Rights Movement in 1963 when Dr. Martin Luther King Jr. was arrested for demonstrating against segregated lunch counters and public restrooms and wrote his famous "Letter From a Birmingham Jail." It was the Birmingham police chief, Eugene "Bull" Connor, who set police dogs and fire hoses against peaceful demonstrators that spring, and it was in Birmingham, after Dr. King negotiated a desegregation plan with city officials, that his hotel was bombed, followed by the bombing of the 16th Street Baptist Church, in which four children died. These events provided the impetus behind the next series of major paintings by Marshall, his *Souvenirs* [fig. 15.14] in which the artist eulogized great black artists, musicians, and writers as well as heroes of the Civil Rights Movement—especially Dr. Martin Luther King Jr., John F. and Robert Kennedy. In the paintings in this series he used glitter, as gold leaf was used in medieval religious paintings but also in a tradition of high-affect decorative traits in Afro-American aesthetics, and he transforms the dignified black women in these stable middle-class interiors into angels with wings, tending the rituals of mourning the loss of these great figures and of the momentum of the movement itself.

15.14 Kerry James Marshall, *Souvenir III,* 1998. Acrylic with glitter on unstretched canvas banner, 9 × 13ft (2.74 × 3.96m).
San Francisco Museum of Modern Art. Courtesy Jack Shainman Gallery, New York.

New Uses of the Camera

The traditional medium for social issues has, of course, long been photography. But with computer programs to alter photographs, the presumption of objectivity in photography is increasingly questioned. Richter took up this issue seeking to reinstate the "truth" of painting as early as the 1960s and in recent works by Sigmar Polke abstract painting has acquired the visual effects of photography, paradoxically emulating its claim on "reality" in the realm of the explicitly constructed mode of abstraction [fig. 15.15]. In the meantime photography has moved closer to the fictions of painting. The photographer Jeff Wall described his large, computer-altered, backlight images [fig. 15.16] as existing "in the gray area between the theatrical and the real."[5]

At the same time there has been a flood of new work with both the still camera and with video. The most successful work in video, which has perhaps an even stronger claim on our objectivity, has transformed this mechanical recording device into a tool for everything that it intrinsically is not, as in the work of Pippilotti Rist, Tony Oursler, or Bill Viola where video is used to insinuate time, sound, and kinetics into contemplative subjects which were conceived more like painting, or as in sculptural objects like Gary Hill's *Inasmuch As It Is Always Already Taking Place* [fig.

15.15 Sigmar Polke, *Untitled,* 1998–9. Mixed media on paper, 39⅞ × 26⅞in (101.2 × 68.2cm).
Courtesy Knoedler Gallery, New York.

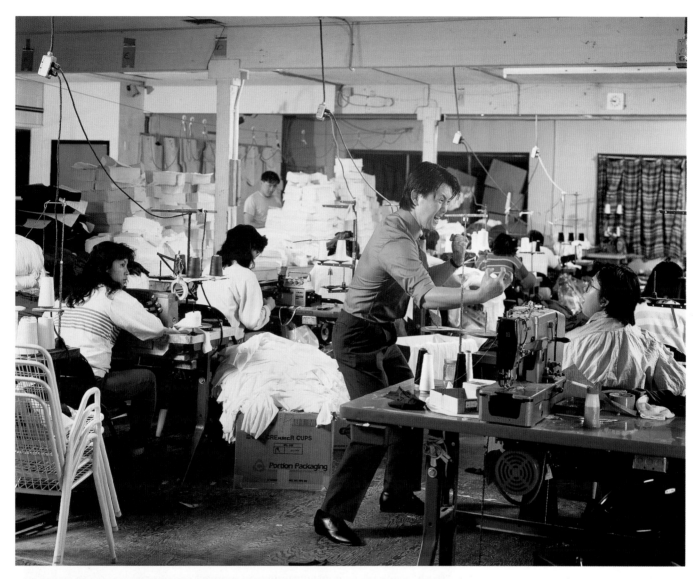

15.16 (above) **Jeff Wall,** *Outburst,* 1989.
Transparency in lightbox, 7ft 6⅛in χ 10ft 2⅞in
(229 × 312cm).
Courtesy Marian Goodman Gallery, New York.

15.17 (left) **Gary Hill,** *Inasmuch As It Is
Always Already Taking Place,* 1990. Sixteen-
channel video/sound installation, sixteen
½ × 21in (1.27 × 53.34cm) black and white
TV tubes positioned in horizontal inset in wall,
edition of 2 and 1 artist's proof.
Photograph courtesy Donald Young Gallery, Chicago.

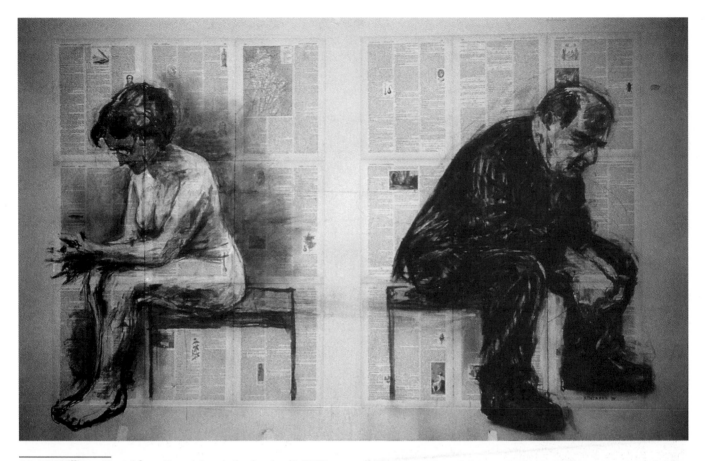

15.18 William Kentridge, *Seated Couple (back to back),* 1998.
Drawing, 42½ × 75¼in (108 × 191.1cm).
Courtesy Marian Goodman Gallery, New York.

15.17] where he divided the near motionless human body into sixteen segmented parts, each played on video to give a disconcerting life-like quality through the exploitation of sound, slight movement, and generally the "truth" value of television. One of the most mesmerizing new uses of video has been the work of William Kentridge, who appropriates the time and kinetic aspects of video into drawing. Kentridge makes film animation with beautiful charcoal drawings that appear and then seem to mutate before your eyes on the video screen [fig. 15.18]. The subject is the violent landscape of South Africa under apartheid; the constant mutation is an act of erasure.

Art as Controversy

Some artists have veered off entirely into a language of pure construction without maintaining claims to "truth." The New York sculptor John Newman, for example, drew on the language of new technology to three-dimensionalize geometric schema into almost cartoon-like organisms come to life; his objects seem disconcertingly real and unreal at the same time, as in sophisticated computer imaging [fig. 15.19]. But others seemed to use their work as a catalyst for public controversy almost apart from the aesthetic issues of the work itself.

In particular, a splashy new generation of British sculptors came to the fore in the nineties with a body of public art that galvanized debate on issues which diverged entirely from the aesthetic character of the works themselves. "Truth," if relevant at all, arose from the conversation around the work rather than from what was represented in it or even directed by it. Damien Hirst's installations were the most notorious among the sculptures by these artists for his peculiar blend of the presence of uncomfortably visceral materials (as in Beuys) and his cynical exploitation of media sensation and appropriated aesthetic precedents (as in Koons).

In the celebrated "Freeze" show, held in the area of the London Docklands in 1988, Hirst exhibited a 14-foot-long dead shark, suspended in a tank of formaldehyde. He also sliced real cows, sheep, and pigs in various ways and showcased them in preservative, too [fig. 15.20]. The pig has a title that alludes to a children's rhyme, *This Little Piggy Went to Market, This Little Piggy Went Home,* escalating the shock value still more. Marc Quinn presented a portrait

bust of himself in frozen blood (his own), and Rachel Whiteread cast the empty space of an entire room from a Victorian house in plaster and titled it *Ghost*.

If the technical concept of Whiteread's castings derived from Nauman's *A Cast of the Space Under My Chair* (1965–68), her escalation in number and scale added a new twist. In 1993, Whiteread constructed her most ambitious and best-known work, *House* [fig. 15.21], which involved casting an entire house—the last remnant of a torn-down block of Victorian row houses in East London—in concrete. The myriad details of the house left in the cast impression elicited contemplation of the former life in the house, and that was another set of issues completely from Nauman's. In addition, *House* was set in a public situation, appropriating the methods of a Christo project and like a Christo project, the object was beautiful in itself. But it differs from Christo in that the public debate it triggered took place largely after

15.19 (left) **John Newman,** *Tourniquet (Bone of Contention)*, 1991–2. Gauze, steel cable, steel plate, and epoxy, 87 × 50 × 19in (221 × 127 × 48.2cm).
Collection of the artist, photograph by Pelka/Noble.

15.20 (below) **Damien Hirst,** *This Little Piggy Went to Market, This Little Piggy Went Home*, 1996. Steel, GRP composites, glass, pig, formaldehyde solution, electric motor, 2 tanks, each 47 × 47 × 23½in (120 × 120 × 60cm).
Courtesy Saatchi Gallery, London.

15.21 Rachel Whiteread, *House,*
completed October 23, 1993 and
destroyed January 1994.
Poured concrete.
The 1993 Artangel/Beck's Commission. Grove
Road, East London. Courtesy Artangel, London.

the fact, rather than as part of the process, placing the emphasis on the object rather than on the dialectic.

Whiteread completed the casting of *House* on October 25, 1993 and then the press started in on the piece; on November 23 Whiteread was awarded the prestigious Turner Prize and, on the same day, the local council voted, in a tie that had to be broken by the chair, for the immediate demolition of the project. As James Lingwood, one of the project organizers said, that was "an incendiary combination,"[6] and heated debate in the press followed. But the debate was part of the intent. As one commentator remarked, they chose a "site where her project would fuse all the loose wires of potential catastrophe. *House*, seen from across the field, was a giant plug, feeding current into the madness of the city. Grove Road had the lot: a terrace house

with three exploitable sides (and a sitting tenant), a hyperactive local politico, anarchist squatters, post-Situationist rock stars looking for the grand gesture, and wild-eyed psychogeographers prophesying war."[7] *House* was torn down in January of 1994.

If Whiteread's first works sprung from the same sensationalist tendencies as Hirst's, she seems to have learned from her own work the potential of a deeper expression. In the details of *House* are the record of a human situation, the lives lived in that space left as palimpsests in the cast. In the Holocaust memorial she then conceived for Vienna, she cast a block from the space left behind the books on the shelves of a library; in this casting, the absence of the books implied in the impression of their ends provides a poignant memorial.

Fashion

Another interesting new development in the nineties has been the heightened engagement of several artists with aspects of fashion. Vanessa Beecroft, for example, has, on the one hand, been making paintings (influenced stylistically by fashion design drawings) in which the human image seems so ephemeral as if to dissipate into thin air and, on the other hand, organizing startling performances of nude and semi-nude fashion models in public spaces. In *Show* [fig. 15.22], a 1998 performance in the ground floor rotunda of the Guggenheim Museum in New York (with plate glass windows on Fifth Avenue), formations of more than a dozen nude or bikini-clad models stood on display. The models did not acknowledge the audience or perform in any noticeable routine except by standing in a triangular formation with the apex at the front. The occasional nude among the larger number in black underwear and the self-determined, casual movement in the stance of the figures as against the rigorous grid of the positioning both seem to suggest a lack of closure in the definition of the work—that is, elements which randomize its structure at every level. The overt sexuality also belies the disinterested expression of the models. In several respects, these performances point the viewer to the explicit and yet denied sexuality of mass marketing and indeed the strangely depersonalized commodification of sexuality in contemporary culture.

The work of Karen Kilimnik also involves an investigation of the worlds of fashion, marketing, and teenage fantasy. In her crayon and pastel drawing, *Nineteen Children of France* [fig. 15.23], for example, Kilimnik rendered a daydreaming adolescent girl with long, dark eyelashes in the slight style of a fashion sketch. The girl is surrounded by a swan insignia, such as an adolescent might draw, and fragmentary notes: "Nineteen children of France were born in this chamber" in the upper left; "MGM, Metro Goldwyn Mayer, Warner Brothers, Douglas Fairbanks Jr., Lillian Gish, Valentino" are listed to the right; and below (with incorrect orthography) "Sèvres porcelain, Baccarat." In the lower half of the sheet is another young girl, draped in a baroque swath of fabric and holding a lamb beside the inscription: "Cloe Sévigny, Sèvres, age 22, photograph by Guy Auroch Paris/the controversial indie kids/what added to her fame:/novelist Jay McInerey's proclaiming her/the new It girl./On exercise: 'I tried yoga, which Woody/showed me how to do. It felt great./But I only kept it up for about/three or four nights.' Why she's really/not an It girl after all: 'Right now/I'm wearing my pajamas at/3 o'clock and helping my mother put up Christmas wreaths.'/Hilary Sterne," and below: "Waterford."

The composition of the Kilimnik drawing is casual, as diaristic in its distribution of elements as in its inscriptions. Everything borders on clichés of an adolescent girl's reveries and doodles, on the appropriated gossip and borrowed romance of kitsch. Yet there is also the radical suggestion of a democratization of art in this, in the notion of awkward drawing, untutored composition, naive romanticism, as if to say any experience is valid, everyone is an artist. The open-ended trajectories set in the brief allusions to vintage Hollywood, fancy porcelain, the

15.22 Vanessa Beecroft,
Show, April 1998. Live performance at the Guggenheim Museum, New York.

Courtesy Deitch Projects. Photograph by Mario Sorrenti. © Vanessa Beecroft, 2000.

momentary popularity of the "It" girl are provocatively polyvalent in a post-modern sense.

The New York and Tokyo based Japanese artist Mariko Mori is a fashion school graduate and started, in the early nineties, using the techniques of fashion costuming, make-up, and photography to create a total, self-contained fantasy world around herself in installations, documented in photographs. In *Play With Me* [fig. 15.24] of 1994, Mori (a former fashion model) dressed herself like a sexy cyborg out of a science fiction film—long ponytails of light blue hair, hard-shell articulation of erotic body parts in metallic blue plastic, silver plastic gloves and dress—and stood outside a

15.23 (left) **Karen Kilimnik,** *Nineteen Children of France,* 1998. Crayon and pastel on paper, 34 × 26in (86.36 × 66cm). Courtesy 303 Gallery, New York.

15.24 (below) **Mariko Mori,** *Play With Me,* 1994. Fuji supergloss (duraflex) print, wood, pewter frame, edition of 3, 12 × 10 × 3ft (3.66 × 3.05 × 0.91m). Courtesy Deitch Projects, New York.

15.25 Mariko Mori, *Burning Desire*, 1997–8. Glass with photo interlayer, 5 panels, 10ft × 20ft × ⅞in (3.04 × 6.1 × 0.02m) overall. Courtesy Deitch Projects, New York.

Tokyo toy store; the suggestive title has a double meaning, connecting her to the robotic toys inside but also to the fantasy of her sexual availability in a utopia of pure, unemotional sexuality. In *Subway*, also of 1994, she stood in a Tokyo subway car dressed in a silver metallic costume with a headset and microphone and push-buttons on the forearm, as though she just landed from outer space. In both works she entered a public space, transformed by costume, to explore different constructed identities (like Cindy Sherman); "when you wear clothes," she said, "you become a personality, you become the clothes."[8] But also as with Cindy Sherman's works the viewer can continually create new stories to explain the images, giving them a peculiarly postmodern open-endedness.

Whereas *Subway* (measuring roughly 2 by 3½ feet) retains the character of performance documentation, the 10 by 12 foot *Play With Me* achieves a kind of cinematic reality with its panoramic scale. Unlike the costumes of Cindy Sherman, however, the costumes in both of these works do not simply create an actor in an imagined life drama, but they suggest the morphing of the human figure into a futuristic blend of human and machine. In Mori's work of 1995, the shift in scale is accompanied by experiments in 3-D effects, sound, and computer manipulation. The 1995 *Empty Dream* is an epic 24-foot-wide, photo environment of a real public swimming place, constructed inside a building to look like a beach; it is a recreation facility that actually exists in Japan. But here the artist has manipulated the photograph to insert herself in a blue plastic mermaid costume in several locations within the scene. The self-replication, the high-tech manipulation of the images, the strangeness of the real

simulacra of nature create a post-modern multivalency to the images, simultaneously connecting them to the hypervisuality of contemporary culture, to computer animation, to advertising, to nature, to the fantastic, and to the emerging technological and philosophical debate around the synthetic generation of human beings through biotechnology.

Dominic Molon has pointed out a shift in Mori's work in 1996 and 1997, from what he called the "alluring but vapid vixens,"[9] the sensual worship of celebrity and fashion to a cosmic spirituality, inspired by the fusion of Western pop culture and aesthetics with Buddhism. In these works, Mori moved into an even more dazzling high-tech virtuosity with 3-D virtual reality videos, accompanied by mesmerizingly cinematic photographs on a grand scale. In the 20-foot-wide *Burning Desire* of 1997–8 [fig. 15.25], Mori appears as an inspirational Buddhist deity levitating in Lotus position over the earth; the image simultaneously recalls Glinda floating down in her bubble in *The Wizard of Oz*. She also replicates herself as four divine, flaming apparitions in attendance around the haloed goddess. The work not only crosses cultural boundaries (from Oz to Nirvana) but transcends human body boundaries into a futuristic virtuality that blends reality with paradise. This is not a science fiction dystopia of futuristic apocalypse but the blissful emptiness to which Buddhists aspire, blended into the sublime, plastic superficiality of contemporary culture.

Slippage: Pop Culture and Romantic Nature

Mariko Mori's passion for the visual energy of high-tech effects, for the brassiness of popular entertainment and the dislocated reality of artificial settings is shared by many artists of her generation. Fred Tomaselli's 1998 *Bug Blast* [fig. 15.1] is an eye-poppingly gorgeous hybrid of nature and artifice, op art, advertising, the Los Angeles punk rock scene in which he came of age in the seventies and early eighties, blended in a simulated mind-altering high. Tomaselli grew up in Los Angeles, a mile from Disneyland, and remembers watching Tinkerbell fly off the mountain in Fantasy Land at night before he went to bed.[10] There was no affinity to art in his household; his aesthetic was fed on custom van painting, head shop designs, psychedelic posters, and theme parks.

Nevertheless, the young Tomaselli took notice, like any rebellious adolescent, of how angry his mother would become reading in the newspaper about the outrageous body works of Chris Burden in the seventies, and this piqued his interest in contemporary art. A high school classmate's mother took him to see several exhibitions in Los Angeles, among them the winter 1972–3 Bruce Nauman retrospective at the County Museum, which made him realize that "art" could be about anything! Until that point, his idea of art had consisted of reproductions of "Salvador Dali and Michelangelo"; here, suddenly, he saw a "wicked, bohemian, irrational, pathological" set of feelings and ideas in an art museum, and in his mind he compared the show to Disneyland.[11] He also encountered a James Turrell light projection [see page 307] about this time in a Venice gallery, while out skateboarding with some friends, and he thought it was really stupid until he walked up to put his hand on the box in the corner and discovered to his astonishment that it wasn't there. Reference to the artificiality of theme parks, to these experiences that make you do a double-take (jumping from one perceptual frame of reference to another in the same object), and the sense that you could make art about anything you wanted all persevere in Tomaselli's work.

Tomaselli went on to study painting in college near Los Angeles and in 1985 he moved to New York. His work of the late eighties consisted primarily of installations with a pointed artificiality: he made a piece in which he simulated waves by turning a fan on a plastic sheet and a field of styrofoam cups, tethered to the floor with string so they would move in the patterns created by the air currents; and a work called *Cubic Sky* (1986–8) in which a light bulb inside a cube with holes in it projected stars around his New York studio. These works refer back to the amusement parks in the way they immerse and absorb the viewer totally in the obviously artificial reality of a world that is both self-contained and completely dislocated from the reality of daily life. Most of these works involve kinetic elements and lighting.

Tomaselli recounted the experience of taking a hike for the first time in the mountains with friends some years ago and coming across a beautiful waterfall; he couldn't believe it was real and felt as though he should look for the pumps—it was a shocking realization to find that reality was more dislocating conceptually than the artificial. It is a point of reference that is increasingly common to people today and although Tomaselli is a painter now, not a sculptor or an installation artist, he still deals with this same perceptual slippage between reality and artifice in his work.

In 1997 and 1998, Tomaselli made a series of collages that look, at first glance, just like the pages of a field guide to birds. But when you scrutinize them more closely you see that the colorful patchwork on the birds is not made up of feathers, but of zippers, fabric, and stitching; he cut the forms from the sportswear in *Land's End* catalogues and reassembled them on pages from Perrin's *Illustrated Encyclopedia of Birds*. He titled the first of these collages *Land's End* and then began using the family names on the

15.26 Fred Tomaselli, *Families Vireonidae*, 1998. Collage on paper, 11 × 8½in (28 × 21.6cm).
Private collection.

pages of the bird book as "ready made" titles, as in *Families Vireonidae* [fig. 15.26] of 1998. This destabilized form—which flips back and forth perceptually between the snaps and pockets in the clothing to the convincing representation of the birds—is a brilliant example of the unhinged language of postmodern form.

In *Bug Blast*, the composition explodes out of the center, swirling in rings like a hypnotic mandala. He made it out of real pills, psychoactive plants, cutout pictures of butterflies, and an assortment of real bugs set in a deep plastic resin—a technique that recalls the kitsch hobbyist's "decoupage." The patterns and colors vibrate with optical intensity and at first seem to be painted. Then you come closer and realize they are real objects imbedded in the surface. The marijuana leaves and the pills can suddenly shift context and become a star-filled night sky; this instability shifts the viewer back and forth from a romantic immersion in nature—as profound as the Hudson River School or the paintings of Casper David Friedrich—to a world of cultural simulacra (as in the cutout pictures of bugs).

Another young artist working in the Williamsburg section of Brooklyn, Roxy Paine, was, by 1990, widely respected by his peers for a complex body of work that included (most famously) a group of remarkable machines, the movements of which crossed over into a disconcertingly human realm of gestures. "Tweeking the Human," the title of a 1991 exhibition he organized with another artist in a tiny storefront gallery, captures something of the unsettling poetry of these mechanical sculptures.[12]

But since 1995 he has also produced an astonishing group of artificial gardens, technically remarkable in their verisimilitude as well as in the unsettling ways in which they encroach on our psychic space. *Crop*, completed in April 1998, a 6 by 8 foot patch of waist-high opium poppies standing on a plot of artificial earth [fig. 15.27], seems at first to be disconnected from the machines. But its conceptually precise (if non-linear) underlying logic is aesthetically continuous with them. In *Crop*, we recognize Paine's predilection to classify in his systematic visual catalogue the

15.27 Roxy Paine, *Crop*, 1997–8. Epoxy, PVC, steel, wood, PETG, lacquer, oil paint, earth, 58 × 96 × 72in (147.3 × 243.8 × 182.8cm).

Private Collection. Courtesy Ronald Feldman Fine Art, New York. Photograph by John Lamka.

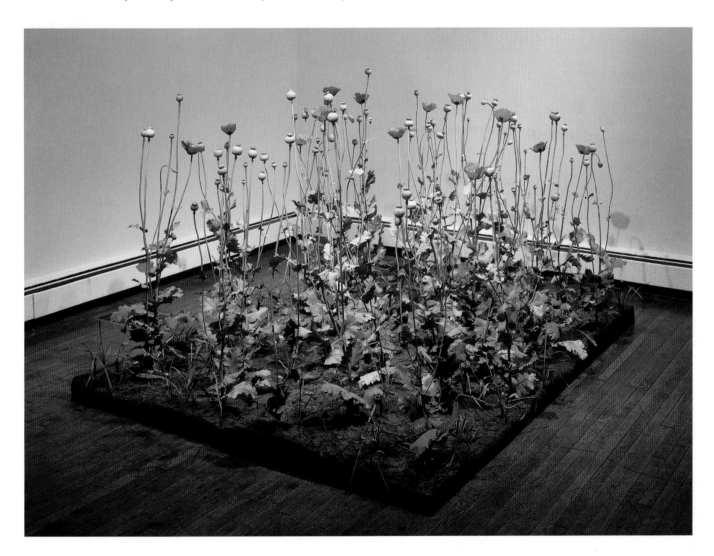

New Tendencies of the Nineties

various stages of the poppy's growth—from young buds, to the blooming flowers, to the razor-slit seed pods oozing opium. Moreover, his title, *Crop*, makes clear that he intends to extend the work as a metaphor into the potential of the plants as narcotics, with all of the attendant social and economic implications. Paine has compared this overlay of opposing yet complementary impulses in his own work—cataloguing and metaphor—to Pieter Brueghel's allegory of *The Blind Leading the Blind* in which Brueghel visually catalogues the various causes of blindness known to the sixteenth century, while simultaneously using his theme as a metaphor for human frailty: "the blind leading the blind."[13]

Paine's *SCUMAK (Auto Sculpture Maker)* of 1998 [fig. 15.28], is a remarkable machine that makes "expressively" modeled polyethyline sculptures according to directions from a computer. A laptop mounted on the wall next to a circuit box directs the extrusion of a molten polyethylene stream onto a conveyor belt for a precisely determined time, at a precisely determined rate, specified in the program which is created individually for each sculpture. After a

designated cooling time, the belt advances and the machine makes another sculpture. But these teasingly generic objects cannot be replicated even by this precise apparatus since the forces of chaos in nature continually act on the process. This finely engineered and beautifully fabricated apparatus introduces an uneasy ambiguity between human being and machine, laying bare the process of making a sculpture, as though it were a mechanical act (which here it is). Yet the beauty of the machine and the eccentricity of the results are also a paean to the romantic. Paine positions both his gardens and his machines at a fluid interface of man, nature, and science; they take the viewer to an intuitive experience of the liminal place at which scientists have arrived as they

15.28 Roxy Paine, *SCUMAK (Auto Sculpture Maker),* 1998. Stainless steel, polyethyline, extruder, cooling system, teflon, and electronics, 13ft 7in × 6ft 10in × 4ft 8in (4.14 × 2.08 × 1.42m) overall.

Private Collection. Courtesy Ronald Feldman Fine Art, New York. Photograph by John Lamka.

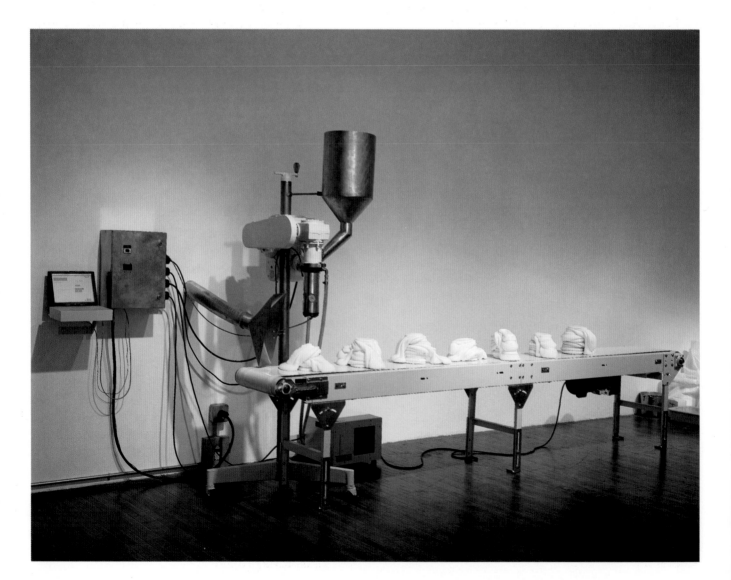

begin to redesign the human gene and connect living neurons with silicon chips.

In both *Crop* and *SCUMAK*, Paine explores a concept he has gleaned from his avid interest in science. In *Crop*, Paine has superimposed the life cycle of the plant from genesis to disintegration on the peculiar exploitation of it by humans, which in turn leads to individual and perhaps unexpected acts that ultimately coalesce into a system: the global drug culture. *Crop* hovers, like the new sciences of complexity theory, on the boundary between the tendency toward disorder, dissolution, and decay (set out in the second law of thermodynamics) and the recognition that simultaneously, systems that exhibit an inexorable tendency toward spontaneous self-organization exist at all levels of phenomena. The creative edge of new science today has shifted its focus from the Cartesian analysis of the fundamental units of matter—from molecules, atoms, nuclei, and quarks—to the observation that simple rules in physics, for example, can generate an interplay of forces which fundamentally and unpredictably differs from a simple sum of the parts.[14] Complexity is the science of how the individual pieces spontaneously fit together.

M. Mitchell Waldrop, in his book *Complexity, The Emerging Science at the Edge of Order and Chaos* (to which Paine refers), observes that after mapping and analyzing the components and mechanisms of the cell, science now is also asking how "several quadrillion such molecules organize themselves into an entity that moves, that responds, that reproduces, that is alive," or how individual acts of buying and selling by millions of individuals coalesce into an economy, or how "the genes in a developing embryo organize themselves in one way to make a liver cell and in another way to make a muscle cell."[15] In *Crop*, Paine brings you to the genetic moment in this dynamically unfolding system of events. *SCUMAK* also has this suggestion of the onset of complexity with all of the independent sculptures which, in their resemblance to one another, begin to describe a spontaneous tendency toward order on a different level.

The sculptures from Paine's machine contrast the immediacy of experience with the intensely depersonalizing commodification of an artist's work by the marketplace where it acquires a manufactured quality with a trademark style and is "normalized" by its reproduction and distribution. For Paine, it is in art making (which he considers "inherently absurd") that the vestiges of our romantic selves survive in this increasingly standardized, "streamlined," and "efficient" corporate culture.[16]

At this boundary of chaos and control where machines replicate the human act of gestural sculpture, and humans replicate nature, where instantaneous shifts occur destabilizing our sense of reality and artificiality, both Paine and Tomaselli have fashioned profoundly romantic vocabularies that sustain the experience of being human.

Postmodern Conceptualism

Much of the new work of the nineties was based on a conceptual model in which the artist readily shifted back and forth from one medium to another seeking the most appropriate form in which to express a particular idea. The idea, in turn, often derived from a structural concept or regime rather than following a more traditional formal development. The German artist Martin Kippenberger, for example, was at one moment creating painterly canvases and the next constructing a full-scale subway entrance to nowhere. The Los Angeles artist Charles Ray parked a full-scale fire truck—constructed like a toy with its equipment painted on it—in front of the Whitney Museum in New York during the 1993 Biennial exhibition; in 1986 he made *Ink Box*, a Plexiglas cube filled with ink right to the top so that it has the appearance of a solid minimalist cube; *Oh Charley, Charley, Charley . . .* of 1992 consists of eight lifelike nude sculptures of himself engaged in every possible form of sexual act. Ray's works all play on stereotypes and fixed ideas in a cynical critique of the surface of events, revealing a pervasive underlying neurosis in the culture and developing from perceptions of the cultural landscape around him rather than from a driving engagement with form.

The French artist Gilles Barbier is also known for installations which critique social norms with a sarcastic wit and frequently involve multiple sculptural surrogates of himself (something Kippenberger also did), but at the core of Barbier's work are his "dictionary pages," an ongoing project of defining his own identity in relation to the highly traditional culture of France, by systematically copying (from start to finish) the Larousse Dictionary of 1956 (the year of his birth). The Larousse has a centrality in French culture for which there is no parallel elsewhere. Once a year, the forty members of the prestigious Académie Française (founded by Cardinal Richelieu in 1635 to create a French dictionary) meets under a dome across the river from the Louvre to decide which new words may be admitted officially into the French language, and the Larousse is the definitive reflection of these deliberations. Barbier copies the dictionary by hand, page by page [fig. 16.1] going all the way across from left to right, and when he arrives at an illustration he copies that freehand too and then goes on until he fills a 7 by 7 foot sheet of paper. He then stops to read what he has done and makes "errata" sheets to emend miscopied or omitted text and illustrations, often adding notes of explanation like "I just wasn't paying attention."

Constructing the Postmodern Self

Barbier's dictionary pages might be seen as an attempt to bound and master the totality of the language of the self; his handwritten pages have an almost bodily physicality, like a skin. The paintings of Christian Schumann present a deliberately *unbounded* experience. In a painting like *Flatbush* (1998) [fig. 15.29], Schumann decenters the identity of the artist and of the subject by equating everything on the level of the sign; on the flat screen of images he juxtaposes all different kinds of styles and content, from the academic portrait head at the top center to cartoon images, lettering, disjointed fragments of text, narrative vignettes, scientific diagrams, and even shifts in verbal language (as in the passages of French). The work defines itself as open-ended. But it is not without precedent.

Underlying the radical postmodernism of Schumann is the complex overlay of images in the work of artists from the late seventies like Gary Panter and David Salle see figs. 14.27 and 14.26] and the deeper simultaneous interpenetration of content in the works of Alice Aycock and Elizabeth Murray. What makes Schumann's work new is that he has assimilated this complexity into the even script of visual data flow.

In the meantime, the corporate conformity of nineties culture and the expansion of consumerism and marketing have left less and less mental space for a cohesive sense of self. In an article on the artist Jimmie Durham [fig. 15.30], who is part Cherokee Indian, Richard Shiff took

15.29 Christian Schumann, *Flatbush*, 1998. Acrylic and mixed media on canvas, 7ft 3in × 9ft (2.21 × 2.74m).
Courtesy Postmasters Gallery, New York.

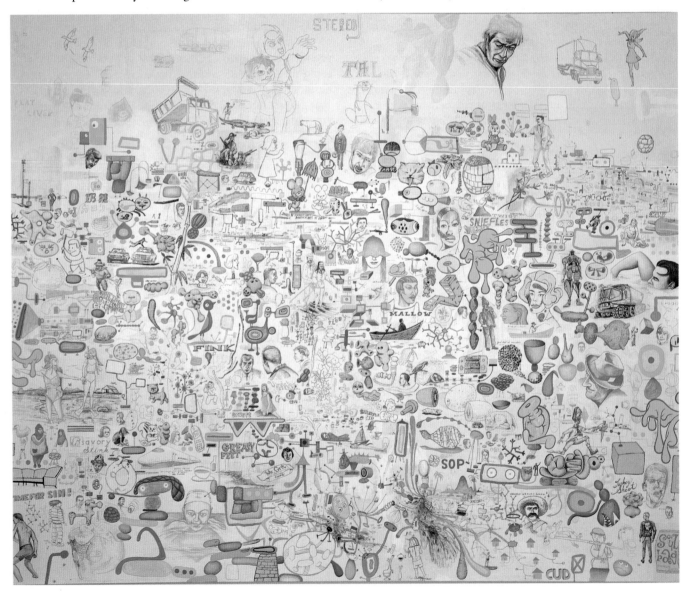

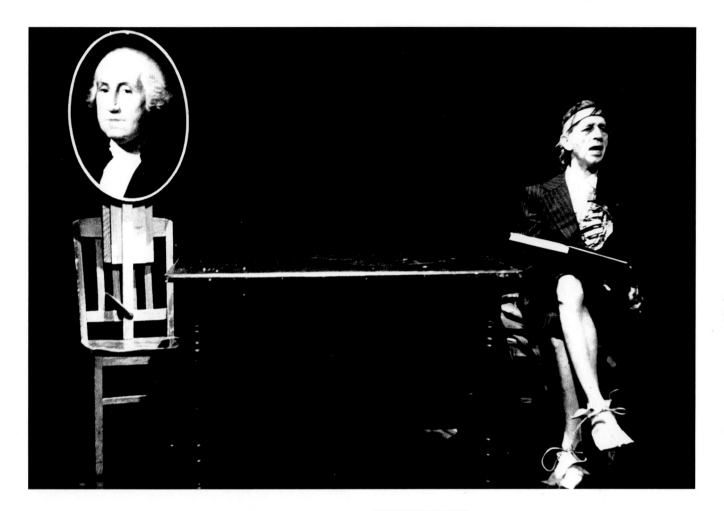

15.30 Jimmie Durham, *Crazy for Life*, performance, 1990. Dance
Theater Workshop, New York City.
Courtesy Nicole Klagsbrun Gallery, New York.

up the issue of how mainstream culture "colonizes" the
autonomous individuality of the Native American artist
with stereotypes to which the artist is compelled to
respond.[17] Durham's work centers on a postmodern
dislocation of reductive logics that classify experience or—
more to the point—individuals. To be labeled "Native
American" is to wipe out all intellectual and expressive
independence in favor of a racial classification. Durham
engages in a kind of self-empowerment through the
invention of a "trickster," inventing false "Native American"
tradition, fictions of autobiography, and in general refusing
to accept fixed identity; in some works he includes
Cherokee texts, but withholds untranslatable passages; in
others he will appropriate skulls to tease the viewer's
expectation of a "Native American" primitive tradition that
isn't there as a way of subverting any attempt at closure in
defining the work or the artist. The paradigm fits us all at the
turn of the new century as culture becomes more and more
pervasively homogenized by the frightening expansion
of huge multinational corporations and ever more impersonal
government bureaucracies that have increasingly substituted
"selections" for "choices" in our daily lives.

It is still true that "art is long and life is short" as the old
adage goes, but historical memory in the nineties became
shorter than ever and "what's hot" has an increasing

tendency to eclipse the long-term trajectories of major
artists like Aycock and Murray, both of whom have
continued to develop in depth and complexity and address
the new demands on the definition of individual identity.
Aycock built an entire oeuvre of public commissions in
the nineties that enlarged the narrative layerings of her
sculpture of the seventies and eighties to redefine the role of
personal reverie in large-scale public sculpture; Murray
continued to expand the defining perimeters of painting
both physically (as she moved toward relief sculpture in her
painting) and conceptually (by finding a monumental
language for the experience of daily life).

The use of the Internet for communicating, shopping,
transferring data (including images and video), and
"surfing" a virtually limitless sea of news and information
without time, distances, or boundaries went from zero to
nearly universal over the decade of the nineties, and its
effect on consciousness is perhaps the biggest new issue at
the end of the century. Ik-Joon Kang, a South Korean artist,
created an installation in 1994 called *Throw Everything*

waterfront in the summer of 1993, was a sensory overcharge of several hundred people showing up to do installations, performances, play in neighborhood bands, or just have a few drinks and shed all their inhibitions in the style of the "raves" of the nineties. On the other hand, Fisher also began making digital art that had no fixed materiality; instead it had the flavor of contemporary Cyberpunk fiction, as in William Gibson's 1984 novel *Neuromancer* where humans fuse with computers and communicate digitally. Fisher wrote utopian "social programs" on the computer [fig. 15.31], which he instructs his viewers to "absorb into memory" as templates for a new social (dis)order. Through community-based cultural enterprises and consumer technology, he aspired to reclaim the production of culture from the mass marketers and return it to each of us, one person at a time.

That sense of individuality, the example of the uniqueness of one person's vision of the simple elements of everyday life, is an inspiring affirmation of existence. This is part of what makes a collage like Tim Spelios's 1998 *Under the BQE* [fig. 15.32] so relevant. Spelios's eye for form takes note of the slightest scrap of crumpled paper, a

15.32 Tim Spelios, *Under the BQE*, 1998. Cut-and-pasted photographs on board, 80 × 60in (203.2 × 152.4cm). Edition of 3. Courtesy the artist.

15.31 Ebon Fisher, *Social Program for Humans: Linkage with Distressed Human*, initiated in Brooklyn, 1992. Photographic print of computer-generated image, a behavioral inducement, to be disseminated via fax, modem, computer disk, hardcopy, slide projection, or video display.

Together and Add; the title itself summed up the sense of the overwhelming quantity and complexity of information. One response was the atomization of people into smaller and more local subgroups both in physical geography and simultaneously by self-selection, if globally, on the Web.

The artist Ebon Fisher inhabited the close-knit artists' neighborhood that existed in Williamsburg, Brooklyn at the start of the nineties. His work involved the interface of media, technology, and industry with the human environment of a small community and with the individual. He was thrilled by the many possibilities of global communication in combination with the intimacy of the small artists' communities. "The web," he said, "has created the new Vienna."[18]

On the one hand, Fisher focused on the immediacy of body experience and on community-based culture, organizing massive participatory art events in the neighborhood; "Organism," for example, held in an abandoned mustard seed factory near the Brooklyn

15.33 Gabriel Orozco, *Island Within an Island (Isla en la Isla),*
1993. Cibachrome, 12⅞ × 18⅝in (32.70 × 47.3cm). Edition of 5.
Courtesy Marian Goodman Gallery, New York.

styrofoam container, a repair in the pavement that he finds under the Brooklyn–Queens Expressway by his studio, and he fits it into a personal grid, an assertion of individuality as expressed in a way of seeing. The Mexican artist Gabriel Orozco has become one of the most celebrated recent practitioners of this kind of intimacy, using found objects and making photographs that capture a definable vision. It is that identifiably personal way of seeing that matters in *Island Within an Island (Isla en la Isla)* of 1993 [fig. 15.33], for example. Here Orozco poetically compares the distant view of the skyscrapers of Wall Street on the island of Manhattan with the washed-up boards and trash leaned against a concrete parking barricade in a lot by the lower west side docks. The trash in the foreground sits like an island in a puddle, a microcosm of the skyline, and yet this modest image engages a larger debate on the validity of marginalized perspectives that is at the heart of the multicultural and global sense of humanity on which the next century will rely. Jimmie Durham remarked that "We seem to want to approach everything with the knowledge of it already . . . I want to jumble up the expectations."[19] This, of course, is not an exclusively postmodern idea. It is—and perhaps always has been—the function of art to take us to the margins of contemporary experience, to try on what seems far-fetched, peculiar, different, and new so as to explore what may be on the verge of becoming essential to know.

16

TO SAY THE THINGS
THAT ARE ONE'S OWN

More than a thousand years ago a Chinese critic named Chang Yen-yüan lamented that "contemporary paintings are chaotic and meaningless."[1] In the year of Kandinsky's first abstract paintings and the most experimental moment of Picasso's cubism, a Munich critic brought out a book called *The Death of Art* in which he complained that "art is dying of the masses and of materialism . . . for the first time we have entered a period without direction, without an artistic style, without a young revolutionary generation."[2]

The most important contemporary art has perhaps always been difficult to recognize and understand. It requires hard work from the serious viewer. It baffles people, makes them uncomfortable and angry, it seems perpetually defeated by the overwhelming ills of every historical epoch, and it isn't even "politically correct." But it does offer a unique kind of truth, embodying an individual's struggle to come to terms with his or her inner thoughts and identity in relation to the constantly changing facts of existence in the world.

If we can imagine ourselves into the experience of the artist, suspend our point of view for the moment and attempt to assume the artist's frame of mind, we can understand and feel that truth and we can use it to understand ourselves and our world. "Look at any inspired painting," Philip Guston once told a reporter for *Time* magazine. "It's like a gong sounding; it puts you in a state of reverberation."[3]

For all sincere artists, their art is an evolving perspective on events, and it is who they are. "I realized that I had things in my head not like what I had been taught," Georgia O'Keeffe wrote to her friend Anita Pollitzer, "not like what I had seen—shapes and ideas so familiar to me that it hadn't occurred to me to put them down. I decided to stop painting, to put away everything I had done, and to start to say the things that were my own."[4]

Over the past thirty years, many critics have felt that the avant-garde has reached the end of the road because "the protest of the historical *avant-garde* against art as an institution is accepted as *art*"[5] now, eradicating its posture of opposition and defining it out of existence. Others have worried that the power of corporate culture has finally silenced dissent. But as Freud pointed out in *Civilization and its Discontents*,[6] a permanent tension exists between the individual and society and the alienation that this tension engenders perpetuates an avant-garde as the expression of an enduring human need. Art contributes to the ideals and models of thinking about important issues in a culture. We need to look beyond market influences and beyond the intellectual fashions of academia to see this spiritual dimension, because artists enter their ideas into the world, not just into books and art history classes.

16.1 Gilles Barbier, *De "Coordonnée" à "Cristallisation,"* 1995.
Dictionary page with errata sheet. Ink and gouache on paper,
84¾ χ 84¾in (215 χ 215cm) and 25 χ 19⅝in (65 χ 50cm).

Private collection, California. Photo courtesy Galerie Georges-Philippe and Nathalie Vallois.

BIBLIOGRAPHY

General Guidelines

This bibliography is intended to give readers a place to start in finding further information about the many artists and issues discussed in this book. The list includes only a few standard books on each topic, some landmark essays that are not in the anthologies cited here, and every now and again something eccentric that takes up an aspect of an artist or issue from an unusual and interesting point of view. Many excellent books have been left out in order to keep the list short enough to read over a school year for a student who wants a balanced overview, and it defers to the bibliographies in the more specialized books cited for more detailed listings on particular topics. Essays in the anthologies listed are not cited individually; entries appear once where they first seem relevant and are not repeated later even though they may also relate to issues or artists covered in later chapters. The reader is also encouraged to consult the *Art Index to Periodical Literature* (or the *Art Abstracts* database), which lists articles in the art magazines by subject and author, as well as *Art Bibliographies Modern* (available in electronic form) for books, articles, and catalogs.

Some Background Reading

Adams, Henry. *Thomas Hart Benton: An American Original.* New York: Alfred A. Knopf, 1989.
Brown, Milton. *American Painting from the Armory Show to the Depression.* Princeton: Princeton University Press, 1955.
Corn, Wanda. *Grant Wood: The Regionalist Vision.* New Haven and London: Yale University Press, 1983.
Hurlburt, Laurance P. *The Mexican Muralists in the United States.* Albuquerque: University of New Mexico Press, 1989.
O'Connor, Francis V., ed. *Art for the Millions.* Boston: New York Graphic Society, 1973.
Sims, Lowery Stokes. *Stuart Davis: American Painter.* New York: Metropolitan Museum of Art and Harry N. Abrams, 1991.
Tashjian, Dikran. *William Carlos Williams and the American Scene: 1920–1940.* New York: Whitney Museum of American Art, 1978.

Anthologies of Criticism and Interviews

Foster, Hal, ed. *The Anti-Aesthetic: Essays on Postmodern Culture.* Port Townsend, Wash.: Bay Press, 1983.
Greenberg, Clement. *Art and Culture.* Boston: Beacon Press, 1961.
Greenberg, Clement. *The Collected Essays and Criticism,* vol. 1: *Perceptions and Judgements, 1939–1944,* Chicago, 1986.
Greenberg, Clement. *The Collected Essays and Criticism,* vol. 2: *Arrogant Purpose, 1945–1949,* Chicago, 1986.
Harrison, Charles and Paul Wood. *Art in Theory: 1900–1990.* Oxford: Blackwell Publishers, 1992.
Hertz, Richard, ed. *Theories of Contemporary Art.* Englewood Cliffs, N.J.: Prentice Hall, 1985.
Johnson, Ellen. *American Artists on Art.* New York: Harper & Row, 1982 [interviews].
Kuh, Katherine. *The Artist's Voice: Talks with Seventeen Artists.* New York and Evanston, Ill.: Harper & Row, 1962 [interviews].
Lippard, Lucy. *Changing: Essays in Art Criticism.* New York: E. P. Dutton, 1971.

Rosenberg, Harold. *De-Definition of Art.* New York: Collier Books, 1972.
Rosenberg, Harold. *The Anxious Object, Art Today and its Audience.* New York: Horizon Press, 1966.
Rosenberg, Harold. *The Tradition of the New.* New York: Horizon Press, 1959.
Steinberg, Leo. *Other Criteria: Confrontations with Twentieth-Century Art.* London, Oxford, New York: Oxford University Press, 1972.

Chapter 1

Different Directions in Recent Critical and Cultural Theory

Arato, Andrew and Eike Gebhardt, eds. *The Essential Frankfurt School Reader.* New York: Continuum, 1982.
Bal, Mieke and Norman Bryson. "Views and Overviews: Semiotics and Art History." *Art Bulletin,* vol. 73, no. 2, June 1991: 174–208.
Barthes, Roland. *Image-Music-Text.* Trans. Stephen Heath. New York: Hill & Wang, 1977.
Barthes, Roland. *The Pleasure of the Text.* Trans. Richard Miller. Garden City, N.Y.: Doubleday, 1972.
Baudrillard, Jean. *Jean Baudrillard: Selected Writings.* Ed. Mark Poster. Stanford: Stanford University Press, 1988.
Benjamin, Walter. *Illuminations.* Trans. Harry Zohn. New York: Harcourt, Brace and World, 1968.
Bryson, Norman. *Vision and Painting.* New Haven: Yale University Press, 1983.
Bürger, Peter. *Theory of the Avant-Garde.* Trans. Michael Shaw. Minneapolis: University of Minnesota Press, 1984.
DeGeorge, Richard and Fernande, eds. *The Structuralists from Marx to Lévi-Strauss.* Garden City, N.Y.: Doubleday, 1972.
Deleuze, Gilles and Félix Guattari. *Anti-Oedipus: Capitalism and Schizophrenia.* Trans. Robert Hurley, Mark Seem, and Helen R. Lane, with a preface by Michel Foucault. Minneapolis: University of Minnesota Press, 1983.
Derrida, Jacques. *Of Grammatology.* Trans. Gayatri Chakravorty Spivak. Baltimore and London: Johns Hopkins University Press, 1974.
Eagleton, Terry. *Literary Theory.* Minneapolis: University of Minnesota Press, 1983.
Ellmann, Richard and Charles Feidelson, Jr., eds. *The Modern Tradition.* New York: Oxford University Press, 1965.
Frascina, Francis and Charles Harrison, eds. *Modern Art and Modernism: A Critical Anthology.* New York: Harper & Row, 1982.
Gans, Herbert J. *Popular Culture and High Culture.* New York: Basic Books, 1974.
Gouma-Peterson, Thalia and Patricia Mathews. "The Feminist Critique of Art History." *Art Bulletin,* vol. 69, no. 3, September 1987: 326–57.
Harari, Josue V., ed. *Textual Strategies.* Ithaca, N.Y.: Cornell University Press, 1979.
Heidegger, Martin. *Poetry, Language, Thought.* Trans. Albert Hofstadter. New York: Harper & Row, 1975.
Huyssen, Andreas. *After the Great Divide.* Bloomington: Indiana University Press, 1986.
Jameson, Fredric. *The Political Unconscious.* Ithaca, N.Y.: Cornell University Press, 1981.
Jauss, Hans Robert. *Toward an Aesthetic of Reception.* Trans. Timothy Bahti. Minneapolis: University of Minnesota Press, 1982.
Krauss, Rosalind E. *The Originality of the Avant-Garde and the other Modernist Myths.* Cambridge, Mass. and London: MIT Press, 1986.
Lyotard, Jean-François. *The Postmodern Condition: A

Report on Knowledge.* Trans. Geoff Bennington and Brian Massumi. Minneapolis: University of Minnesota Press, 1984.
Marcks, E. and I. de Courtivron, eds. *New French Feminisms.* New York: Schocken, 1981.
Marcuse, Herbert. *Eros and Civilization.* Boston: Beacon Press, 1966.
Marx, Karl. *Grundrisse: Foundations of the Critique of Political Economy.* Trans. Martin Nicolaus. New York: International Publishers, 1970.
Morris, Robert. "Words and Images in Modernism and Postmodernism." *Critical Inquiry* 15, winter 1989: 337–47.
Norris, Christopher. *Deconstruction: Theory and Practice.* London: Methuen, 1982.
Ortega y Gasset, José. *The Dehumanization of Art and Other Writings on Art and Culture.* New York: Doubleday, 1948.
Poggioli, Renato. *The Theory of The Avant Garde.* New York: Harper & Row, 1968.
Pollock, Griselda. *Vision and Difference.* London: Routledge, 1988.
Sontag, Susan. *Against Interpretation.* New York: Dell, 1966.

Chapter 2

Altshuler, Bruce. *Isamu Noguchi.* New York: Abbeville, 1994.
Ashton, Dore. *The New York School.* New York: Viking, 1973.
Auping, Michael. *Abstract Expressionism: The Critical Developments.* Buffalo: Albright-Knox Art Gallery; New York: Harry N. Abrams, 1987.
Carmean, E. A., Jr., and Eliza Rathbone. *American Art at Mid-Century: The Subjects of the Artist.* Washington, D.C.: National Gallery of Art, 1978.
Conwill, Kinshasha Holman, Jacques Leenhardt, Giulio V. Blanc, Julia P. Herzberg, and Lowery Stokes Sims. *Wifredo Lam and his Contemporaries 1938–1952.* New York: Studio Museum in Harlem, 1992.
Doty, Robert and Diane Waldman. *Adolph Gottlieb.* New York: Whitney Museum of American Art, Solomon R. Guggenheim Museum, and Praeger, 1968.
Friedman, Martin. *Noguchi's Imaginary Landscapes.* Minneapolis: Walker Art Center, 1978.
Gaugh, Harry F. *The Vital Gesture: Franz Kline.* Cincinnati: Cincinnati Art Museum; New York: Abbeville, 1985.
Gordon, John. *Franz Kline: 1910–1962,* exhibition catalog. New York: Whitney Museum of American Art, 1968.
Graham, John D. *System and Dialectics of Art.* New York: Delphic Studios, 1937.
Guggenheim, Peggy. *Out of this Century: Informal Memoirs of Peggy Guggenheim.* New York: Dial Press, 1964; and *Confessions of an Art Addict.* New York: Macmillan, 1960; republished together as *Peggy Guggenheim, Out of this Century.* New York: Universal Books, 1979.
Guilbaut, Serge. *How New York Stole the Idea of Modern Art.* Chicago: University of Chicago Press, 1983.
Hobbs, Robert C. *Lee Krasner.* New York: Abbeville, 1993.
O'Neill, John P. *Clyfford Still.* New York: Metropolitan Museum of Art, 1979.
Polcari, Stephen. *Abstract Expressionism and the Modern Experience.* Cambridge and New York: Cambridge University Press, 1991.
Rosenberg, Harold. *Discovering the Present.* Chicago: University of Chicago Press, 1973.
Rosenblum, Robert. *Modern Painting and the*

Northern Romantic Tradition: Friedrich to Rothko. New York: Harper & Row, 1975.

Sandler, Irving. *The Triumph of American Painting: A History of Abstract Expressionism.* New York and Washington: Praeger, 1970.

Tuchman, Maurice, ed. *New York School—The First Generation Painting of the 1940s and 1950s.* Los Angeles: Los Angeles County Museum of Art, 1965.

Chapter 3

Alexander Calder

Calder, Alexander. *Calder: an Autobiography with Pictures.* New York: Pantheon Press, 1977.

Lipman, Jean. *Calder's Universe.* New York: Whitney Museum of American Art and Viking, 1976.

Marchesseau, Daniel. *The Intimate World of Alexander Calder.* New York: Harry N. Abrams, 1989.

Marter, Joan M. *Alexander Calder.* Cambridge and New York: Cambridge University Press, 1991.

Hans Hofmann

Goodman, Cynthia. *Hans Hofmann.* New York: Abbeville, 1986.

Hofmann, Hans. *Search for the Real and Other Essays.* Cambridge, Mass.: MIT Press, 1967.

Hunter, Sam. *Hans Hofmann.* New York: Harry N. Abrams, 1964.

Seitz, William C. *Hans Hofmann.* New York: The Museum of Modern Art, 1963.

Arshile Gorky

Jordan, Jim and Robert Goldwater. *The Paintings of Arshile Gorky: A Critical Catalogue.* New York: New York University Press, 1982.

Levy, Julien. *Arshile Gorky.* New York: Harry N. Abrams, 1966.

Rand, Harry, *Arshile Gorky. The Implications of Symbols.* Montclair, N.J.: Allenheld and Schram, 1980 (reprinted Berkeley: University of California Press, 1991).

Rosenberg, Harold. *Arshile Gorky: The Man, the Time, the Idea.* New York: Sheep Meadow Press/Flying Point Press, 1962.

Schwabacher, Ethel. *Arshile Gorky.* New York: Whitney Museum of American Art, 1951.

Waldman, Diane. *Arshile Gorky: A Retrospective.* New York: Solomon R. Guggenheim Museum and Harry N. Abrams, 1981.

Robert Motherwell

Arnason, H. Harvard and Dore Ashton. *Robert Motherwell.* New York: Harry N. Abrams, 1982.

Carmean, E. A., Jr. *The Collages of Robert Motherwell.* Houston: Museum of Fine Arts, 1973.

Fineberg, Jonathan. "Death and Maternal Love: Psychological Speculations on Robert Motherwell's Art." *Artforum,* September 1978: 52–7.

O'Hara, Frank. *Robert Motherwell.* New York: The Museum of Modern Art, 1965.

Terenzio, Stephanie and Dorothy C. Belknap. *The Prints of Robert Motherwell: A Catalogue Raisonné 1943–1984.* New York: Hudson Hills Press, 1984.

Willem de Kooning

Cummings, Paul, Jörn Merkert, and Claire Stoullig. *Willem de Kooning: Drawings, Paintings, Sculpture.* New York: Whitney Museum of American Art and W. W. Norton and Company, 1983.

Gaugh, Harry F. *Willem de Kooning.* New York: Abbeville, 1983.

Hess, Thomas B. *Willem de Kooning.* New York: The Museum of Modern Art, 1968.

Rosenberg, Harold. *Willem de Kooning.* New York: Harry N. Abrams, 1973.

Chapter 4

Jackson Pollock

Frank, Elizabeth. *Jackson Pollock.* New York: Abbeville, 1983.

Friedman, B. H. *Energy Made Visible.* New York: McGraw-Hill, 1972.

Landau, Ellen G. *Jackson Pollock.* New York: Harry N. Abrams, 1989.

O'Connor, Valentine and Victor Thaw. *Jackson Pollock: A Catalogue Raisonné of Paintings, Drawings, and Other Works,* 4 vols. New Haven and London: Yale University Press, 1978.

O'Hara, Frank. *Jackson Pollock.* New York: Braziller, 1959.

Rose, Bernice. *Jackson Pollock: Works on Paper.* New York: The Museum of Modern Art, 1970.

Rushing, Jackson W. "Ritual and Myth: Native American Culture and Abstract Expressionism." In Maurice Tuchman and Judi Freeman, eds. *The Spiritual In Art: Abstract Painting 1890–1985.* Los Angeles: Los Angeles County Museum of Art; New York: Abbeville, 1986: 285ff.

Barnett Newman

Hess, Thomas. *Barnett Newman.* New York: The Museum of Modern Art, 1971.

Newman, Barnett. *Selected Writings and Interviews.* Ed. John P. O'Neill with an introduction by Richard Shiff. Berkeley and Los Angeles: University of California Press, 1992.

Richardson, Brenda. *Barnett Newman: The Complete Drawings 1944–1969.* Baltimore: Baltimore Museum of Art, 1979.

Rosenberg, Harold. *Barnett Newman.* New York: Harry N. Abrams, 1978.

Mark Rothko

Ashton, Dore. *About Rothko.* New York: Oxford University Press, 1983.

Breslin, James E. B. *Mark Rothko: A Biography.* Chicago: University of Chicago Press, 1993.

Chave, Anna C. *Mark Rothko: Subjects in Abstraction.* New Haven and London: Yale University Press, 1989.

Clearwater, Bonnie. *Mark Rothko Works on Paper.* New York: Hudson Hills, 1984.

Waldman, Diane. *Mark Rothko, 1903–1970: A Retrospective,* exhibition catalog. New York: Solomon R. Guggenheim Museum, 1978.

David Smith and the Sculpture of the New York School

Fry, Edward F. and Miranda McClintic. *David Smith: Painter, Sculptor, Draughtsman.* Washington, D.C.: Hirshhorn Museum and Sculpture Garden, Smithsonian Institution; New York: Braziller, 1982.

Gray, Cleve, ed. *David Smith by David Smith.* New York: Holt, Rinehart, & Winston, 1968.

McCoy, Garnett, ed. *David Smith.* New York: Praeger, 1973.

Phillips, Lisa. *The Third Dimension.* New York: Whitney Museum of American Art, 1984.

Wilkin, Karen. *David Smith.* New York: Abbeville, 1984.

Chapter 5

Jean Dubuffet and Postwar Paris

Dubuffet, Jean. *Prospectus et tous écrits suivants,* 2 vols. Paris: Gallimard, 1967.

Glimcher, Mildred. *Jean Dubuffet: Towards An Alternative Reality.* New York: Abbeville, 1987.

Loreau, Max. *Catalogue des travaux de Jean Dubuffet,* 35 vols. Paris: Jean-Jacques Pouvert; Geneva: Weber; Paris: Editions de Minuit, 1964–86.

Morris, Frances. *Paris Post War: Art and Existentialism 1945–55.* London: Tate Gallery, 1993.

Rowell, Margit. *Jean Dubuffet: A Retrospective.* New York: Solomon R. Guggenheim Museum, 1973.

Selz, Peter. *The Work of Jean Dubuffet.* New York: The Museum of Modern Art, 1962.

Viatte, Germain and Sara Wilson. *Aftermath: France 1945–54, New Images of Man.* London: Barbican Art Gallery, 1982.

The Existentialist Figuration of Alberto Giacometti

Fletcher, Valerie J., Reinhold Hohl, Silvio Berthoud. *Alberto Giacometti, 1901–1966.* Washington, D.C.: Hirshhorn Museum and Sculpture Garden, Smithsonian Institution, 1988.

Hohl, Reinhold. *Alberto Giacometti: A Retrospective Exhibition.* New York: Solomon R. Guggenheim Museum, 1974.

Lord, James. *A Giacometti Portrait.* New York: The Museum of Modern Art, 1965.

Selz, Peter. *Alberto Giacometti.* New York: The Museum of Modern Art, 1965.

Francis Bacon

Ades, Dawn and Andrew Forge. *Francis Bacon.* New York: Harry N. Abrams, 1980.

Alley, Ronald and John Rothenstein. *Francis Bacon.* London: Thames & Hudson, 1964.

Davies, Hugh and Sally Yard. *Francis Bacon.* New York: Abbeville 1986.

Russell, John. *Francis Bacon.* Greenwich Conn.: New York Graphic Society, 1971.

Sylvester, David. *Francis Bacon Interviewed.* New York: Pantheon, 1975.

Chapter 6

Purified Abstraction

Bastian, Heiner. *Cy Twombly: Catalogue Raisonné of the Paintings, 1950–1960,* vol. 1. Munich: Schirmer and Mosel, 1992.

Bastian, Heiner. *Cy Twombly: Catalogue Raisonné of the Paintings, 1961–1965,* vol. 2. Munich: Schirmer and Mosel, 1993.

Beeren, Wim, Nicholas Serota, et al. *Fontana.* London: Whitechapel Art Gallery, 1988.

Bois, Yve-Alain. "Fontana's Base Materialism." *Art in America,* April 1989: 238–497.

Borja-Villel, Manuel J. *Fundació Antoni Tàpies.* Barcelona: Fundació Antoni Tàpies, 1990.

Braun, Emily, ed. *Italian Art in the 20th Century: Painting and Sculpture 1900–1988.* Munich: Prestel Verlag; London: Royal Academy of Arts, 1989.

Carmean, E. A., Jr. *The Great Decade of American Abstraction: 1960–1970.* Houston: Museum of Fine Arts, 1974.

Dimitrijevic, Nina. "Meanwhile in the Real World." *Flash Art,* May 1987: 44–9 [Fontana].

Elderfield, John. *Morris Louis.* New York: The Museum of Modern Art; Boston: Little, Brown, 1986.

Reinhardt, Ad. *Art as Art: The Selected Writings of Ad Reinhardt.* Edited by Barbara Rose. New York: Viking (The Documents of Twentieth Century Art), 1975.

Rose, Barbara. *Frankenthaler.* New York: Harry N. Abrams, 1970.

Sandler, Irving. *The New York School: The Painters and Sculptors of the Fifties.* New York: Harper & Row, 1978.

Seitz, William. *The Responsive Eye.* New York: The Museum of Modern Art, 1965.

Szeeman, Harold, Demosthenes Davettas, Roberta Smith, and Cy Twombly. *Cy Twombly: Paintings, Works on Paper, Sculpture.* London: Whitechapel Art Gallery; Munich: Prestel Verlag, 1987.

"New Images of Man" in Europe and America

Albright, Thomas. *Art in the San Francisco Bay Area 1945–1980.* Berkeley and Los Angeles: University of California Press, 1985.

Bibliography

Alechinsky, Pierre. *Paintings and Writings.* Pittsburgh: Museum of Art, Carnegie Institute, 1978.

Alechinsky, Pierre and Michael Gibson. *Pierre Alechinsky: Margin and Center.* New York: Solomon R. Guggenheim Museum, 1987.

Atkins, Guy. *I Jorn in Scandinavia, 1930–1953.* London: Lund Humphries, 1968.

Atkins, Guy. *II Asger Jorn. The Crucial Years 1954–1964.* London: Lund Humphries; Paris: Yves Rivière—Arts et Métiers Graphiques, 1977.

Atkins, Guy. *III Asger Jorn: The Final Years 1965–1973.* London: Lund Humphries; Copenhagen: Borgens Forlag, 1980.

Beattie, Ann. *Alex Katz.* New York: Harry N. Abrams, 1987.

Cobra 1948–1951, complete facsimile edition. Paris: Éditions Jean-Michel Place, 1980.

Elderfield, John. *Richard Diebenkorn.* New York: The Museum of Modern Art, 1991.

Hughes, Robert. *Lucian Freud: Paintings.* New York: Thames & Hudson, 1987.

Lambert, Jean-Clarence. *Cobra.* New York: Abbeville, 1984.

Schimmel, Paul and Judith Stein. *The Figurative Fifties: New York Figurative Expressionism.* Newport Beach, Calif.: Newport Harbor Art Museum, 1988.

Selz, Peter. *New Images of Man.* New York: The Museum of Modern Art, 1959.

Chapter 7

"A Coney Island of the Mind": The Beats, John Cage

Burroughs, William S. *Naked Lunch.* New York: Grove Press, 1959.

Cage, John. *Silence.* Cambridge, Mass.: MIT Press, 1966.

Duberman, Martin. *Black Mountain: An Exploration in Community.* New York: E. P. Dutton, 1972.

Ferlinghetti, Lawrence. *A Coney Island of the Mind.* Norfolk, Conn.: New Directions, 1955.

Ginsberg, Allen. *Howl and Other Poems.* San Francisco: City Lights Books, 1956.

Harris, Mary Emma. *The Arts at Black Mountain College.* Cambridge, Mass.: MIT Press, 1987.

McLuhan, Marshall. *The Mechanical Bride, Folklore of the Industrial Man.* New York: Vanguard Press, 1951.

Tomkins, Calvin. *The Bride and the Bachelors.* New York: Viking, 1968.

Robert Rauschenberg

Ashton, Dore. *Rauschenberg: XXXIV Drawings for Dante's Inferno.* New York: Harry Abrams, 1964.

Feinstein, Roni. *Robert Rauschenberg: The Silkscreen Paintings, 1962–64.* New York: Whitney Museum of American Art; Boston, Toronto, London: Little, Brown, 1990.

Hopps, Walter. *Robert Rauschenberg, The Early 1950s.* Houston: Fine Art Press, 1991.

Hopps, Walter, *Robert Rauschenberg.* Washington, D.C.: National Collection of Fine Arts, 1977.

Rose, Barbara. *An Interview with Robert Rauschenberg.* New York: Vintage, 1987.

Saltz, Jerry. "Notes on a Drawing." *Arts Magazine,* November, 1988: 19–22.

Seckler, Dorothy Gees. "The Artist Speaks: Robert Rauschenberg." *Art in America 54,* May/June 1966: 73–84.

Stuckey, Charles F. "Reading Rauschenberg." *Art in America 65,* March/April 1977: 74–84.

Tomkins, Calvin. *Off the Wall: Robert Rauschenberg and the Art World of Our Time.* Garden City, N.Y.: Doubleday, 1980.

Appropriating the Real: Junk Sculpture and Happenings

Friedman, Martin and Graham W. J. Beal. *George Segal: Sculptures.* Minneapolis: Walker Art Center, 1978.

Gordon, John. *Jim Dine.* New York: Whitney Museum of American Art, 1970.

Haskell, Barbara. *Blam! The Explosion of Pop, Minimalism, and Performance 1958–1964.* New York: Whitney Museum of American Art, 1984.

Kaprow, Allan. "The Legacy of Jackson Pollock." *Artnews 57,* no. 4, October 1958: 24–6, 55–7.

Kirby, Michael. *Happenings: An Illustrated Anthology.* New York: E. P. Dutton, 1965.

Kostelanetz, Richard. *The Theatre of Mixed Means: An Introduction to Happenings, Kinetic Environments, and Other Mixed Media Performances.* New York: Dial Press, 1968.

Levin, Kim. *Lucas Samaras.* New York: Harry N. Abrams, 1975.

Monte, James K. *Mark di Suvero.* New York: Whitney Museum of American Art, 1976.

Sandler, Irving. *American Art of the 1960s.* New York: Harper & Row, 1988.

Seitz, William C. *The Art of Assemblage,* exhibition catalog. New York: The Museum of Modern Art, 1961.

Shapiro, David. *Jim Dine.* New York: Harry N. Abrams, 1981.

Stein, Judith E., John Ashbery, and Janet K. Cutler. *Red Grooms, A Retrospective, 1956–84.* Philadelphia: Pennsylvania Academy of the Fine Arts, 1985.

Waldman, Diane. *John Chamberlain.* New York: Solomon R. Guggenheim Museum, 1971.

Claes Oldenburg

Baro, Gene. *Claes Oldenburg: Drawings and Prints.* London and New York: Chelsea House, 1969.

Friedman, Martin. *Oldenburg: Six Themes.* Minneapolis: Walker Art Center, 1975.

Johnson, Ellen H. *Claes Oldenburg.* Harmondsworth, Middlesex, England: Penguin Books, 1971.

Oldenburg, Claes. *Proposals for Monuments and Buildings 1965–9.* Chicago: Big Table Publishing Co., 1969.

Oldenburg, Claes. *Notes in Hand.* New York: E. P. Dutton, 1971.

Oldenburg, Claes and Emmet Williams. *Store Days.* New York: Something Else Press, 1967.

Rose, Barbara. *Claes Oldenburg.* New York: The Museum of Modern Art, 1969.

van Bruggen, Coosje. *Claes Oldenburg: Mouse Museum/Ray Gun Wing.* Köln: Museum Ludwig, 1979.

van Bruggen, Coosje and Claes Oldenburg. *Claes Oldenburg: Drawings, Watercolors and Prints.* Stockholm: Moderna Museet, 1977.

Jasper Johns

Bernstein, Roberta. *Jasper Johns' Paintings and Sculptures 1954–1974: "The Changing Focus of the Eye".* Ann Arbor, Mich.: UMI Research Press, 1985.

Castleman, Riva. *Jasper Johns: a Print Retrospective.* New York: The Museum of Modern Art, 1986.

Crichton, Michael. *Jasper Johns.* New York: Whitney Museum of American Art, 1977.

Cuno, James, ed. *Foirades/Fizzles: Echo and Allusion in the Art of Jasper Johns.* Los Angeles: Grunewald Center for the Graphic Arts, Wight Art Gallery, University of California, 1987.

Field, Richard S. *Jasper Johns: Prints 1960–1970.* New York: Praeger; Philadelphia: Philadelphia Museum of Art, 1970.

Field, Richard S. *Jasper Johns, Prints 1970–1977.* Middletown, Conn.: Wesleyan University, 1978.

Francis, Richard. *Jasper Johns.* New York: Abbeville, 1984.

Geelhaar, Christian. *Jasper Johns: Working Proofs.* London: Petersburg Press, 1980.

Rosenthal, Mark. *Jasper Johns: Work Since 1974.* Philadelphia: Philadelphia Museum of Art, 1988.

Rosenthal, Nan and Ruth E. Fine. *The Drawings of Jasper Johns.* Washington, D.C.: National Gallery of Art, 1990.

Shapiro, David. *Jasper Johns Drawings 1954–1984.* New York: Harry N. Abrams, 1984.

Chapter 8

Nouveau Réalisme

Bodet, Aude, Sylvain Lecombre, et al. *1960: Les Nouveaux Réalistes.* Paris: Musée d'Art Moderne de la Ville de Paris, 1986.

McEvilley, Thomas et al. *Yves Klein 1928–1962: A Retrospective.* Houston: Institute for the Arts, Rice University, 1982.

Pontus Hulten, K. G. *Jean Tinguely: Méta.* Boston: New York Graphic Society, 1975.

Restany, Pierre. *Yves Klein.* New York: Harry N. Abrams, 1982.

Joseph Beuys

Joachimides, Christos and Norman Rosenthal. *Zeitgeist, Internationale Kunstaustellung.* Berlin: Martin Gropius Bau, 1982; New York: Braziller, 1983.

Joachimides, Christos, Norman Rosenthal, and Wieland Schmied, eds. *German Art in the 20th Century.* London: Royal Academy of Arts; Munich: Prestel Verlag, 1986.

Serota, Nick. *Joseph Beuys: The Secret Block for a Secret Person in Ireland,* exhibition catalog. Oxford: Museum of Modern Art, 1974.

Sharp, Willoughby. "An Interview with Joseph Beuys." *Artforum 8,* December 1969: 40ff.

Tisdall, Caroline. *Joseph Beuys.* New York: Solomon R. Guggenheim Museum, 1979.

British Pop: From the Independent Group to David Hockney

Banham, Rayner. *The New Brutalism. Ethic or Aesthetic.* New York: Reinhold Publishing, 1966.

Friedman, Martin, ed. *Hockney Paints the Stage.* Minneapolis: Walker Art Center; New York: Abbeville, 1983.

Leffingwell, Edward et al. *Modern Dreams: The Rise and Fall of Pop.* New York: The Institute for Contemporary Art; Cambridge, Mass.: MIT Press, 1988.

Livingstone, Marco. *David Hockney.* New York: Thames & Hudson, 1988.

Massey, Anne. "The Independent Group: Towards a Redefinition." *Burlington Magazine 129,* no. 1009, April 1987: 232–42.

Russell, John and Susie Gablik. *Pop Art Redefined.* London: Thames & Hudson, 1969.

Russell, John. *Richard Hamilton.* New York: Solomon R. Guggenheim Museum, 1973.

Spencer, Robin. *Eduardo Paolozzi: Recurring Themes.* New York: Rizzoli, 1984.

Tuchman, Maurice and Stephanie Barron. *David Hockney: A Retrospective,* exhibition catalog. Los Angeles: Los Angeles County Museum of Art, 1988.

Chapter 9

The Electronic Consciousness and New York Pop

Alloway, Lawrence. *American Pop Art.* New York: Collier Books, 1974.

Armstrong, Richard. *Artschwager, Richard.* New York: Whitney Museum of American Art, 1988.

Battcock, Gregory, ed. *The New Art.* New York: E. P. Dutton, 1966.

De Salvo, Donna and Paul Schimmel. *Hand-Painted Pop: American Art in Transition 1955–62.* Los Angeles: Museum of Contemporary Art, Los Angeles; New York: Rizzoli, 1992.

Livingstone, Marco. *Pop Art: A Continuing History.* New York: Harry N. Abrams, 1990.

McLuhan, Marshall. *Understanding Media: The Extension of Man.* New York: McGraw-Hill, 1965.

Venturi, Robert. *Complexity and Contradiction in Architecture.* New York: The Museum of Modern Art, 1966.

Andy Warhol
Crone, Rainer. *Andy Warhol.* New York: Praeger, 1970.
De Salvo, Donna M. *"Success is a job in New York . . .": The Early Art and Business of Andy Warhol.* New York: Grey Art Gallery and Study Center, New York University, 1989.
McShine, Kynaston, ed. *Andy Warhol: A Retrospective.* New York: The Museum of Modern Art, 1989.
Ratcliff, Carter. *Andy Warhol.* New York: Abbeville, 1983.
Warhol, Andy. *The Philosophy of Andy Warhol (From A to B and Back Again).* New York: Harcourt, Brace, Jovanovich, 1975.
Warhol, Andy and Pat Hackett. *Popism: The Warhol 60s.* New York: Harcourt, Brace, Jovanovich, 1980.

Roy Lichtenstein
Alloway, Lawrence. *Roy Lichtenstein.* New York: Abbeville, 1983.
Rose, Bernice. *The Drawings of Roy Lichtenstein.* New York: The Museum of Modern Art, 1987.
Waldman, Diane. *Roy Lichtenstein.* New York: Solomon R. Guggenheim Museum, 1993.

James Rosenquist
Goldman, Judith. *James Rosenquist.* Denver: Denver Art Museum; New York: Viking, 1985.
Goldman, Judith. *James Rosenquist: The Early Pictures 1961–1964.* New York: Gagosian Gallery and Rizzoli, 1992.

H. C. Westermann, Peter Saul, and the Hairy Who
Adrian, Dennis and Richard Born. *The Chicago Imagist Print: Ten Artists' Works, 1958–1987, A Catalogue Raisonné.* Chicago: Smart Gallery, University of Chicago, 1987.
Adrian, Dennis et al. *Who Chicago? An Exhibition of Contemporary Imagists.* Sunderland, England: Sunderland Arts Centre, 1980.
Adrian, Dennis. *Karl Wirsum.* Champaign, Ill.,: Krannert Art Museum, University of Illinois, 1991.
Barrette, Bill, ed. *Letters from H. C. Westermann.* New York: Timken, 1988.
Benezra, Neal. *Ed Paschke.* Chicago: Art Institute of Chicago, 1990.
Cameron, Dan. *Karl Wirsum: A Retrospective.* Chicago: Phyllis Kind Gallery, 1986.
Cameron, Dan. *Peter Saul: Political Paintings 1965–1971.* New York: Allan Frumkin Gallery, 1991.
Halstead, Whitney. *Jim Nutt.* Chicago: Museum of Contemporary Art, 1974.
Halstead, Whitney and Dennis Adrian. *Made in Chicago.* Washington, D.C.: National Collection of Fine Arts, Smithsonian Institution; Chicago: Museum of Contemporary Art, 1974.
Haskell, Barbara. *H. C. Westermann.* New York: Whitney Museum of American Art, 1978.
Lawrence, Sidney. *Roger Brown.* Washington, D.C.: Hirshhorn Museum and Sculpture Garden, Smithsonian Institution, 1987.
Saul, Peter. *Peter Saul.* De Kalb, Ill.: Swen Parson Gallery, Northern Illinois University, 1980.
Saul, Peter. *Peter Saul: New Paintings and Works On Paper.* New York: Allan Frumkin Gallery, 1988 [letters to Allan Frumkin].
Schulze, Franz. *Fantastic Images: Chicago Art Since 1945.* Chicago: Follet, 1972.
Storr, Robert. *Peter Saul.* Aspen, Colo.: Aspen Art Museum, 1989.

West Coast Pop
Auping, Michael, Robert J. Bertholf, and Michael Palmer. *Jess: A Grand Collage 1951–1993.* Buffalo, New York: Albright-Knox Art Gallery, 1993.
Ayers, Anne. *L. A. Pop in the Sixties.* Newport Beach, Calif.: Newport Harbor Museum, 1989.
Beal, Graham W. J. and John Perrault. *Wiley Territory.* Minneapolis: Walker Art Center, 1979.
Plagens, Peter. *Sunshine Muse: Contemporary Art on the West Coast.* New York: Praeger, 1974.
Richardson, Brenda. *Wizdumb: William T. Wiley.* Berkeley: University Art Museum, 1971.
Tuchman, Maurice. *Edward Keinholz.* Los Angeles: Los Angeles County Museum of Art, 1966.
Weschler, Lawrence et al. *Edward and Nancy Reddin Kienholz: Human Scale.* San Francisco: San Francisco Museum of Modern Art, 1984.

Robert Arneson
Adrian, Dennis. "Robert Arneson's Feats of Clay." *Art in America,* September 1974: 80–3.
Benezra, Neal. *Robert Arneson: A Retrospective.* Des Moines, Iowa: Des Moines Art Center, 1985.
Kuspit, Donald B. "Arneson's Outrage." *Art in America,* May 1985: 134–9.
Marshall, Richard and Suzanne Foley. *Ceramic Sculpture: Six Artists.* New York: Whitney Museum of American Art, 1981.

Chapter 10

Back to First Principles—Minimal Art
Barris, Roann. "Peter Eisenman and the Erosion of Truth." *20/1 Art and Culture,* vol. 1, no. 2, spring 1990: 20–37.
Battcock, Gregory, ed. *Minimal Art.* New York: E. P. Dutton, 1968.
Berger, Maurice. *Labyrinths: Robert Morris, Minimalism, and the 1960s.* New York: Harper & Row, 1989.
Bourdon, David. *Carl Andre.* Austin, Tex.: Laguna Gloria Art Museum, 1978.
Brown, Julia, ed. *Occluded Front: James Turrell.* Los Angeles: Museum of Contemporary Art, 1985.
Chave, Anna. "Minimalism and the Rhetoric of Power." *Arts Magazine,* 64, January 1990: 44–63.
Compton, Michael and David Sylvester. *Robert Morris.* London: Tate Gallery, 1971.
Develing, Enno. *Carl Andre.* The Hague: Gemeentemuseum, 1969.
Haskell, Barbara. *Donald Judd.* New York: Whitney Museum of American Art, 1988.
Irwin, Robert. *Robert Irwin.* New York: Whitney Museum of American Art, 1977.
Judd, Donald. *Complete Writings 1959–75.* Halifax: The Press of the Nova Scotia College of Art and Design; New York: New York University Press, 1975.
Koschalek, Richard, et al. *Robert Irwin.* Los Angeles: Museum of Contemporary Art, 1993.
Reynolds, Jock. *Sol LeWitt: Twenty-five Years of Wall Drawings, 1968–1993.* Andover, Mass.: Addison Gallery of American Art, Phillips Academy; Seattle and London: University of Washington Press, 1994.
Richardson, Brenda. *Frank Stella: The Black Paintings.* Baltimore: Baltimore Museum of Art, 1976.
Rubin, William S. *Frank Stella.* New York: The Museum of Modern Art, 1970.
Shearer, Linda. *Brice Marden.* New York: Solomon R. Guggenheim Museum, 1975.
Tucker, Marcia. *Robert Morris.* New York: Whitney Museum of American Art, 1970.
Wagstaff, Samuel, Jr. "Talking to Tony Smith." *Artforum,* December 1966: 14–19.
Waldman, Diane. *Carl Andre.* New York: Solomon R. Guggenheim Museum, 1970.
Weschler, Lawrence. *Seeing is Forgetting the Name of the Thing One Sees . . . Robert Irwin.* Berkeley and Los Angeles: University of California Press, 1982.

Eva Hesse and Investigations of Materials and Process
Armstrong, Richard and Richard Marshall. *The New Sculpture 1965–75.* New York: Whitney Museum of American Art, 1990.
Barrette, Bill. *Eva Hesse: Sculpture.* New York: Timken, 1988.
Lippard, Lucy R. *Eva Hesse.* New York: New York University Press, 1976.
Nemser, Cindy. "An Interview with Eva Hesse." *Artforum,* May 1970: 63.
Nemser, Cindy. "Eva Hesse: Her Life." *Feminist Art Journal,* vol. 2, no. 1, winter 1973: 13–14.
Pincus-Witten, Robert and Linda Shearer. *Eva Hesse: A Memorial Exhibition,* exhibition catalog. New York: Solomon R. Guggenheim Museum, 1972.
Wye, Deborah. *Louise Bourgeois.* New York: The Museum of Modern Art, 1983.

Bruce Nauman and Richard Serra
Adriani, Götz, Hans Albert Peters, and Clara Weyergraf, eds. *Richard Serra: Works 1966–77.* Baden-Baden, Germany: Kunsthalle; Tübingen, Germany: Kunsthalle, 1978.
Benezra, Neal. *Affinities and Intuitions: The Gerald S. Elliott Collection of Contemporary Art.* Chicago: Art Institute of Chicago; New York: Abbeville, 1990.
Krauss, Rosalind. *Richard Serra/Sculpture.* New York: The Museum of Modern Art, 1986.
Richardson, Brenda. *Bruce Nauman: Neons.* Baltimore: Baltimore Museum of Art, 1982.
Simon, Joan, Neal Benezra, and Kathy Halbreich. *Bruce Nauman.* Minneapolis: Walker Art Center, 1994.
van Bruggen, Coosje. *Bruce Nauman.* New York: Rizzoli, 1987.
Weyergraf, Clara, ed. *Richard Serra: Interviews, Etc. 1970–1980.* Yonkers, N.Y.: Hudson River Museum, 1980.

Artists Working in the Landscape
Beardsley, John. *Earthworks and Beyond.* 2d ed. New York: Abbeville, 1989.
Burnham, Jack. *Great Western Salt Works.* New York: Braziller, 1974.
Hobbs, Robert. *Robert Smithson: Sculpture.* Ithaca, N.Y.: Cornell University Press, 1981.
Insley, Will. "Seriocomic Sp(i)eleology: Robert Smithson's Architecture of Existence." *Arts,* May 1978: 98–101.
Joosten, Ellen and Feliix Zdenek. *Michael Heizer,* exhibition catalog. Essen, Germany: Museum Folkwang, 1979.
Smithson, Robert. *The Writings of Robert Smithson.* Ed. Nancy Holt. New York: New York University Press, 1979.
Tsai, Eugenie. *Robert Smithson Unearthed: Drawings, Collages, Writings.* New York: Columbia University Press, 1991.

***Arte Povera,* and a Persevering Rapport with Nature in Europe**
[See Auping, in Benezra, *Affinities and Intuitions.*]
Braun, Emily, ed. *Italian Art in the 20th Century: Painting and Sculpture 1900–1988.* Munich: Prestel Verlag; London: Royal Academy of Arts, 1989.
Celant, Germano. *Arte Povera.* New York: Praeger, 1969.
Celant, Germano. *Mario Merz.* New York: Solomon R. Guggenheim Museum, 1989.
Celant, Germano. *Michelangelo Pistoletto.* New York: Rizzoli, 1989.
Krane, Susan. *Mario Merz: Paintings and Constructions.* Buffalo: Albright-Knox Art Gallery, 1984.

Chapter 11

Re-Radicalizing the Avant-Garde
Armstrong, Elizabeth and Joan Rothfuss. *In The Spirit of Fluxus.* Minneapolis: Walker Art Center, 1993.
Battcock, Gregory, ed. *Idea Art.* New York: E. P. Dutton, 1973.
Battcock, Gregory, ed. *New Artists Video.* New York: E. P. Dutton, 1978.

Bibliography

Battcock, Gregory and Robert Nickas, eds. *The Art of Performance: A Critical Anthology.* New York: E. P. Dutton, 1984.

Debord, Guy. *The Society of the Spectacle.* Revised English ed. Detroit: Black and Red, 1983.

Goldberg, RoseLee. *Performance: Live Art 1909 to the Present.* New York: Harry N. Abrams, 1979.

Hall, Doug and Sally Jo Fifer. *Illuminating Video: An Essential Guide to Video Art.* New York: Aperture Foundation, 1990.

Hanhardt, John G. *Nam June Paik.* New York: Whitney Museum of American Art, 1982.

Harrison, Helen Mayer and Newton. *The Lagoon Cycle.* Ithaca, N.Y.: Herbert F. Johnson Museum of Art, Cornell University, 1985.

Horvitz, Robert Joseph. "Nature As Artifact: Alan Sonfist." *Artforum,* November 1973: 32–5.

Kardon, Janet. *Laurie Anderson: Works From 1969 to 1983.* Philadelphia: Institute of Contemporary Art, University of Pennsylvania, 1983.

Lippard, Lucy R. *Six Years: the dematerialization of the art object from 1966 to 1972: . . .* New York: Praeger, 1973.

Meyer, Ursula. *Conceptual Art.* New York: E. P. Dutton, 1972.

Out of Actions: Between Performance and the Object, 1948–1979. Los Angeles: The Museum of Contemporary Art, and London: Thames and Hudson, 1998.

Richardson, Brenda. *Gilbert and George.* Baltimore: Baltimore Museum of Art, 1984.

Stooss, Toni and Thomas Kellein. *Nam June Paik: Video Time—Video Space.* New York: Harry N. Abrams, 1993.

Christo

Bourdon, David. *Christo.* New York: Harry N. Abrams, 1970.

Christo. *Christo: Valley Curtain.* New York: Harry N. Abrams, 1973.

Christo. *Christo: The Pont Neuf, Wrapped.* New York: Harry N. Abrams, 1990.

Fineberg, Jonathan. "Theatre of the Real: Thoughts on Christo." *Art in America,* December 1979: 92–9.

Fineberg, Jonathan. "Meaning and Being in Christo's *Surrounded Islands.*" In Christo. *Christo: Surrounded Islands.* New York: Harry N. Abrams, 1986.

Spies, Werner. *Christo: Surrounded Islands.* New York: Harry N. Abrams, 1984.

Spies, Werner. *The Running Fence—Christo.* New York: Harry N. Abrams, 1977.

Postmodernism

Brett, Guy et alia. *Hélio Oiticica,* exhibition catalog. Minneapolis, Minn.: Walker Art Center, 1992/3.

Caldwell, John. *Sigmar Polke.* San Francisco: San Francisco Museum of Modern Art, 1990.

Lygia Clark, exhibition catalog. Barcelona: Fundació Antoni Tàpies, 1997.

Dietrich, Dorothea. "Gerhard Richter: An Interview." *The Print Collector's Newsletter,* vol. 16, September/October 1985: 128–32.

Goldwater, Marge et al. *Marcel Broodthaers.* Minneapolis, Minn.: Walker Art Center and New York: Rizzoli, 1989.

Harten, Jürgen. *Gerhard Richter Bilder: Paintings 1962–1985.* Catalogue raisonné of the paintings. Düsseldorf, Germany: Städtische Kunsthalle and DuMont Verlag, 1986.

Linker, Kate. *Vito Acconci.* New York: Rizzoli, 1994.

Moure, Gloria et al. *Ana Mendieta,* exhibition catalog. Santiago de Compostela: Centro Galego de Arte Contemporáneo, and Barcelona: Ediciones Polígrafa, 1996.

Rainbird, Sean. *Gerhard Richter.* London: Tate Gallery, 1991.

Richter, Gerhard. *The Daily Practice of Painting: Writings 1962–1993,* edited by Hans-Ulrich Obrist. Cambridge, Mass.: MIT Press, 1995.

Gerhard Richter, exhibition catalog. London: Tate Gallery, 1991.

Storr, Robert, "Polke's Mind Tattoos," *Art in America,* December 1992: 71.

Tucker, Marcia, ed. *John Baldessari.* New York: New Museum of Contemporary Art, 1981.

van Bruggen, Coosje. *John Baldessari.* New York: Rizzoli, 1990.

Chapter 12

A New Pluralism

Beardsley, John, Jane Livingston, and Octavio Paz. *Hispanic Art in the United States.* New York: Abbeville, 1987.

Bird, Jon, Jo Anna Isaak, and Sylvère Lotringer. *Nancy Spero.* London: Phaidon Press, 1996.

Fox, Howard N. *A Primal Spirit: Ten Contemporary Japanese Sculptors.* Los Angeles: Los Angeles County Museum of Art, 1990.

Goldman, Shifra M. and Luis Camnitzer, eds. Special issue on "Latin American Art." *The Art Journal,* winter 1992.

Halbreich, Kathy, Thomas Sokolowski, Shinji Kohmoto, and Fumio Nanjo, *Against Nature: Japanese Art in the Eighties.* New York: Grey Art Gallery, University of New York; Cambridge, Mass.: MIT List Visual Arts Center; Tokyo: Japan Foundation, 1989.

Halbreich, Kathy. *Culture and Commentary: An Eighties Perspective.* Washington, D.C.: Hirshhorn Museum and Sculpture Garden, Smithsonian Institution, 1990.

Jacob, Mary Jane. *Ana Mendieta: The "Silueta" Series, 1973–1980.* New York: Galerie Lelong, 1991.

Lippard, Lucy R. *Mixed Blessings: New Art in a Multicultural America.* New York: Pantheon, 1990.

Lyons, Lisa and Kim Levin. *Wegman's World.* Minneapolis: Walker Art Center, 1982.

Michael Blackwood Films. *14 Americans: Directions of the 1970s,* 1980 [Vito Acconci, Laurie Anderson, Alice Aycock, Chuck Close, Elizabeth Murray, Nancy Graves, Gordon Matta-Clark, Mary Miss, Scott Burton, Joel Shapiro].

Neff, John et al. *Charles Simonds.* Chicago: Museum of Contemporary Art, 1981.

Nettles, Bea. *Breaking the Rules: A Photo Media Cookbook.* 3d ed. Urbana, Ill.: Inky Press, 1992.

Nochlin, Linda. "Why Have There Been No Great Women Artists?" *Artnews* 69, January 1971: 22–39, 67–71.

Powell, Rick. *The Blues Aesthetic: Black Culture and Modernism.* Washington, D.C.: Washington Project for the Arts, 1989.

Robins, Corinne. *The Pluralist Era: American Art, 1968–81.* New York: Harper & Row, 1984.

Rosen, Randy and Catherine C. Brawer, eds. *Making Their Mark.* New York: Abbeville, 1989.

Rushing, W. Jackson and Kay Walking Stick, eds. Special issue on "Recent Native American Art." *The Art Journal,* fall 1992.

Sondheim, Alan. *Individuals: Post-Movement Art in America.* New York: E. P. Dutton, 1977.

Varnedoe, Kirk. *Duane Hanson.* New York: Harry N. Abrams, 1985.

Vogel, Susan. *Africa Explores: 20th Century African Art.* New York: The Center For African Art; Munich: Prestel Verlag, 1991.

Romare Bearden

Conwill, Kinshasha Holman, Mary Schmidt Campbell, and Sharon F. Patton, *Memory and Metaphor: The Art of Romare Bearden 1940–1987.* New York: Oxford University Press and the Studio Museum in Harlem, 1991.

Washington, M. Bunch. *The Art of Romare Bearden: The Prevalence of Ritual.* New York: Harry N. Abrams, 1972.

Alice Aycock

Fineberg, Jonathan. *Complex Visions: Sculpture and Drawings by Alice Aycock.* Mountainville, N.Y.: Storm King Art Center, 1990.

Fry, Edward. *Alice Aycock: Projects 1979–1981.*

Tampa, Fla.: University of South Florida College of Fine Arts and Art Galleries, 1981.

Poirier, Maurice. "The Ghost in the Machine." *Artnews* 85, October 1986: 78–85.

Tsai, Eugenie. "A Tale of (At Least) Two Cities: Alice Aycock's *Large Scale Dis/Integration of Microelectric Memories (A Newly Revised Shantytown).*" *Arts* 56, June 1982: 134–41.

Philip Guston's Late Style

Arnason, H. Harvard. *Philip Guston.* New York: Solomon R. Guggenheim Museum, 1962.

Ashton, Dore. *Yes, But . . ., A Critical Study of Philip Guston.* New York: Viking, 1976.

Hopkins, Henry. *Philip Guston.* San Francisco: San Francisco Museum of Modern Art; New York: Braziller, 1980.

Hunter, Sam, Harold Rosenberg, and Philip Guston. *Philip Guston: Recent Paintings and Drawings.* New York: Jewish Museum, 1966.

Mayer, Musa. *Night Studio: A Memoir of Philip Guston by His Daughter.* New York: Viking-Penguin, 1988.

Storr, Robert. *Philip Guston.* New York: Abbeville, 1986.

Chapter 13

New Expressionist Painting in Europe

[Benezra. *Affinities and Intuitions.*]

Auping, Michael. *Francesco Clemente.* Sarasota, Fla.: John and Mabel Ringling Museum of Art, 1985.

Bromfield, David. *Indentities: A Critical Study of the Work of Mike Parr, 1970–1990.* Nedlands, Western Australia: University of Western Australia Press, 1991.

Cowart, Jack. *Expressions: New Art from Germany.* St. Louis: Saint Louis Art Museum; Munich: Prestel Verlag, 1983.

Crone, Rainer and Georgia Marsh. *An Interview with Francesco Clemente.* New York: Vintage, 1987.

Fineberg, Jonathan and Daniel Thomas. *An Australian Accent.* New York: P.S.1, 1984.

Gallwitz, Klaus, ed. *Georg Baselitz.* Venice: German Pavilion, Biennale di Venezia, 1980.

Garrels, Gary. *Photography in Contemporary German Art: 1960 to the Present.* Minneapolis: Walker Art Center, 1992.

Grisebach, Lucius, ed. *A. R. Penck.* Berlin: Nationalgalerie; Munich: Prestel Verlag, 1988.

Immendorff, Jörg. *Here and Now: To Do What Has to Be Done [Hier und Jetzt: Das tun, was zu tun ist].* Köln and New York: Gebr. König, 1973; republished in *Immendorff's Handbuch der Akademie für Adler.* Köln: Walter König, 1989.

Jörg Immendorff's "The Rake's Progress," exhibition catalog. London: Barbican Art Gallery, 1995.

Joachimides, Christos M., Norman Rosenthal, and Nicholas Serota. *A New Spirit in Painting.* London: Royal Academy of Arts, 1981.

Kort, Pamela. *Jörg Immendorff: Early Works and Lidl.* New York: Gallery Michael Werner, 1991.

Kort, Pamela. *Jörg Immendorff: I wanted to Be an Artist 1971–1974.* New York: Gallery Michael Werner, 1992.

Krens, Thomas, Michael Govin, Joseph Thompson, eds. *Refigured Painting: The German Image 1960–88.* New York: Solomon R. Guggenheim Museum; Munich: Prestel Verlag, 1988.

Percy, Ann and Raymond Foye. *Francesco Clemente: Three Worlds.* Philadelphia: Philadelphia Museum of Art; New York: Rizzoli, 1990.

Politi, Giancarlo. "Francesco Clemente." *Flash Art* 117, April/May 1984: 12–21.

Ratcliff, Carter. *Komar and Melamid.* New York: Abbeville, 1989.

Rosenthal, Mark. *Anselm Kiefer.* Philadelphia: Philadelphia Museum of Art; Chicago: Art Institute of Chicago; Munich: Prestel Verlag, 1987.

Ross, David. *Between Spring and Summer: Soviet Conceptual Art in the Era of Late Communism.* Boston: Institute of Contemporary Art; Tacoma, Wash.: Tacoma Art Museum; Cambridge, Mass. and London: MIT Press, 1990.

Wallach, Amei. *Ilya Kabakov: The Man Who Never Threw Anything Away.* New York: Harry N. Abrams, 1996.

Yau, John. *A. R. Penck.* New York: Harry N. Abrams, 1993.

Zweite, Armin. *Anselm Kiefer: The High Priestess.* New York: Harry N. Abrams; London: Anthony d'Offay Gallery, 1989.

Jennifer Bartlett, Susan Rothenberg: New Imagist Painting and Sculpture

Goldwater, Marge, Roberta Smith, Calvin Tomkins. *Jennifer Bartlett.* Minneapolis: Walker Art Center; New York: Abbeville, 1985.

Marshall, Richard. *New Image Painting.* New York: Whitney Museum of American Art, 1978.

Marshall, Richard and Roberta Smith. *Joel Shapiro.* New York: Whitney Museum of American Art, 1982.

Rathbone, Eliza. *Susan Rothenberg.* Washington, D.C.: Phillips Collection, 1985.

Rifkin, Ned. *Robert Moskowitz.* Washington, D.C.: Hirshhorn Museum and Sculpture Garden, Smithsonian Institution, 1989.

Rosenthal, Mark. *Neil Jenney.* Berkeley: University Art Museum, 1981.

Simon, Joan. *Susan Rothenberg.* New York: Harry N. Abrams, 1991.

Stearns, Robert. *Robert Wilson: From a Theatre of Images.* Cincinnati: Cincinnati Arts Center, 1980.

Elizabeth Murray

Graze, Sue, Kathy Halbreich, and Roberta Smith. *Elizabeth Murray: Paintings and Drawings,* exhibition catalog. Dallas: Dallas Museum of Art; Cambridge, Mass.: MIT Committee on the Visual Arts, 1987.

King, Elaine A. *Elizabeth Murray Drawings 1980–1986.* Pittsburgh: Carnegie Mellon University Art Gallery, 1986.

Simon, Joan. "Mixing Metaphors: Elizabeth Murray." *Art in America,* April 1984: 140–7.

Chapter 14

A Fresh Look at Abstraction

Benezra, Neal. *Martin Puryear.* Chicago: Art Institute of Chicago; London and New York: Thames & Hudson, 1991.

Phillips, Lisa. *Terry Winters.* New York: Whitney Museum of American Art, 1991.

Schimmel, Paul et al. *Tony Cragg: Sculpture 1975–1990.* Newport Beach, Calif.: Newport Harbor Art Museum, 1990; London and New York: Thames & Hudson, 1991.

American Neo-Expressionism

Baker, Elizabeth C., ed. "Special Issue: Expressionism I." *Art in America,* December 1982.

Baker, Elizabeth C., ed. "Special Issue: Expressionism II." *Art in America,* January 1983.

Blinderman, Barry. *David Wojnarowicz: Tongues of Flame.* Normal, Ill.: University Galleries, Illinois State University, 1990.

Blinderman, Barry. *Keith Haring: Future Primeval.* Normal, Ill.: University Galleries, Illinois State University; New York: Abbeville, 1990.

Cooper, Martha and Henry Chalfant. *Subway Art.* New York: Holt, Rinehart, & Winston, 1984.

Deitcher, David. "Ideas and Emotions." *Artforum,* May 1989: 122–7 [Wojnarowicz].

Fox, Howard N. *Robert Longo.* Los Angeles: Los Angeles County Museum of Art; New York: Rizzoli, 1989.

Fry, Edward F. *Robert Morris: Works of the Eighties.* Newport Beach, Calif.: Newport Harbor Art Museum, 1986.

Godfrey, Tony. *The New Image: Painting in the 1980s.* New York: Abbeville, 1986.

Gruen, John. *Keith Haring: The Authorized Biography.* Englewood Cliffs, N.J.: Prentice Hall, 1991.

Hooks, Bell. "Altars of Sacrifice: Remembering Basquiat." *Art in America,* June 1993: 68–75, 117.

Kardon, Janet. *The East Village Scene.* Philadelphia: Institute of Contemporary Art, University of Pennsylvania, 1984.

Kuspit, Donald and Erich Fischl. *An Interview with Erich Fischl.* New York: Vintage, 1987.

Marshall, Richard, ed. *Jean-Michel Basquiat.* New York: Whitney Museum of American Art and Harry N. Abrams, 1992.

McEvilley, Thomas and Lisa Phillips. *Julian Schnabel: Paintings 1975–1987.* London: Whitechapel Art Gallery; New York: Whitney Museum of American Art, 1987.

Pincus-Witten, Robert, Jeffrey Deitch, and David Shapiro. *Keith Haring.* New York: Tony Shafrazi Gallery, 1982.

Plous, Phyllis and Mary Looker. *Neo York: Report on a Phenomenon.* Santa Barbara: University Art Museum, 1984.

Prat, Jean-Louis and Richard Marshall. *Jean-Michel Basquiat.* Paris: Galerie Enrico Navarra, 1996.

Robinson, Walter and Carlo McCormick, "Report from the East Village: Slouching Toward Avenue D." *Art in America,* summer 1984: 134–61.

Rose, Matthew. "David Wojnarowicz: An Interview." *Arts,* May 1988: 60–5.

Rosenthal, Mark and Richard Marshall. *Jonathan Borofsky.* Philadelphia: Philadelphia Museum of Art; New York: Whitney Museum of American Art, 1984.

Saltz, Jerry. *Beyond Boundaries.* New York: Alfred Van der Marck Editions, 1986.

Saltz, Jerry. "Notes on a Painting: Not Going Gentle." *Arts,* February 1989: 13–14.

Schjeldahl, Peter. *Eric Fischl.* New York: Art in America and Stewart, Tabori, & Chang, 1988.

Wojnarowicz, David. *Memories That Smell Like Gasoline.* San Francisco: Artspace Books, 1992.

Wojnarowicz, David. *Close to the Knives: A Memoir of Disintegration.* New York: Vintage, 1991.

Wojnarowicz, David. "Spiral." *Artforum,* March 1992: 100.

Post-Modern Installation

Blurring the Boundaries: Installation Art 1969–1996, exhibition catalog. San Diego, CA.: Museum of Contemporary Art, 1997.

De Oliveira, Nicolas, Nicola Oxley, and Michael Perry. *Installation Art.* Washington, D.C.: Smithsonian Institution Press, 1994.

Finkelpearl, Tom. *David Hammons: Rousing the Rubble.* New York: Institute for Contemporary Art; Cambridge, Mass.: MIT Press, 1991.

Gumpert, Lynn and Mary Jane Jacob. *Christian Boltanski: Lessons of Darkness.* Chicago: Museum of Contemporary Art; Los Angeles: Museum of Contemporary Art; New York: New Museum of Contemporary Art, 1988.

Marmer, Nancy. "Boltanski: The Uses of Contradiction." *Art in America,* October 1989: 168–81, 233–5.

Rogers, Sarah J. *The Body and the Object: Ann Hamilton 1984–1996,* exhibition catalog. Columbus, Ohio: Wexner Center for the Arts, Ohio State University, 1996.

Appropriation

Boswell, Peter et al. *Public Address: Krzysztof Wodiczko.* Minneapolis: Walker Art Center, 1992.

Garrels, Gary, ed. *Amerika: Tim Rollins and K.O.S.* New York: Dia Art Foundation, 1989.

Heiferman, Marvin and Lisa Phillips. *Image World: Art and Media Culture.* New York: Whitney Museum of American Art, 1989.

Kardon, Janet. *David Salle.* Philadelphia: Institute of Contemporary Art, 1986.

Olander, William. "Material World." *Art in America,* January 1989: 122–9, 167.

Phillips, Lisa. *David Salle.* New York: Whitney Museum of American Art, 1987.

Phillips, Lisa. *Richard Prince.* New York: Whitney Museum of American Art, 1992.

Politi, Giancarlo. "Luxury and Desire: An Interview with Jeff Koons." *Flash Art,* February/March 1987: 71–6.

Rian, Jeffrey. "Social Science Fiction: An Interview with Richard Prince." *Art in America,* March 1987: 86–95, cover.

Schjeldahl, Peter. *An Interview with David Salle.* New York: Vintage, 1987.

Schjeldahl, Peter and Lisa Phillips. *Cindy Sherman.* New York: Whitney Museum of American Art, 1987.

Chapter 15

Deitch, Jeffrey. *Post Human.* Lausanne: FAE Musée d'Art Contemporain, 1992.

Fineberg, Jonathan. *Roxy Paine,* exhibition catalog. Chicago: Terra Museum of American Art, and Giverny, France: Musée d'art americain, 1998.

Fineberg, Jonathan, ed. *Out of Town: The Williamsburg Paradigm.* Champaign, Ill.: Krannert Art Museum, 1993.

Flood, Richard, et al. *Robert Gober: Sculpture + Drawing,* exhibition catalog. Minneapolis, Minn.: Walker Art Center, 1999.

Goldstein, Ann and Mary Jane Jacob. *A Forest of Signs: Art in the Crisis of Representation.* Los Angeles: Museum of Contemporary Art, 1989; Cambridge, Mass.: MIT Press, 1989.

Inside Out: New Chinese Art, exhibition catalog. San Francisco: Museum of Modern Art, and New York: Asia Society Galleries, 1998.

Kirsch, Andrea and Susan Fisher Sterling. *Carrie Mae Weems,* exhibition catalog. Washington, D.C.: National Museum of Women in the Arts, 1993.

Lingwood, James, ed. *House.* London: Phaidon Press, 1995.

Mariko Mori, exhibition catalog. Chicago: Museum of Contemporary Art, 1998.

Mulvey, Laura, Dirk Snauwaert, and Mark Alice Durant. *Jimmie Durham.* London: Phaidon Press, 1995.

Posner, Helaine. *Kiki Smith.* Boston: Bulfinch Press, Little, Brown and Co., 1998.

Rugoff, Ralph, Kristine Stiles, Giacinto Di Pietrantonio. *Paul McCarthy.* London: Phaidon Press, 1996.

Sensation: Young British Artists from the Saatchi Collection, exhibition catalog. London: Royal Academy of Arts, 1997.

Shiff, Richard. "The Necessity of Jimmie Durham's Jokes." *The Art Journal,* fall 1992: 74–80.

Sussman, Elizabeth. *Mike Kelley: Catholic Tastes,* exhibition catalog. New York: Harry N. Abrams and Whitney Museum of American Art, 1993.

Tucker, Marcia. *The Decade Show: Frameworks of Identity in the 1980s.* New York: New Museum of Contemporary Art, Museum of Contemporary Hispanic Art, and Studio Museum in Harlem, 1990.

Weems, Carrie Mae. *In These Islands, South Carolina and Georgia,* exhibition catalog. Tuscaloosa, Alabama: Sarah Moody Gallery of Art, University of Alabama, 1994.

Carrie Mae Weems, exhibition catalog. Philadelphia: The Fabric Workshop, 1994.

NOTES

Chapter 1

1. William Wordsworth, preface to *Lyrical Ballads*, 1802, in Stephan Gill, ed., *William Wordsworth*, The Oxford Authors Edition (Oxford and New York: Oxford University Press, 1984), 606.
2. Willem de Kooning, "Content is a Glimpse," excerpts from an interview with David Sylvester broadcast on the BBC, December 3, 1960; published as a transcript in *Location*, vol. 1, no. 1 (spring 1963); reprinted in Thomas B. Hess, *William de Kooning*, exhibition catalog, The Museum of Modern Art (Greenwich, Conn.: New York Graphic Society, 1968), 150. Cézanne also used this term; see for example John Rewald, *Post-Impressionism*, The Museum of Modern Art (Boston: New York Graphic Society, 1978), 454; quoted from Octave Mirbeau in Mirbeau et al., *Cézanne* (Paris: unpaginated, 1914), 9. See also Richard Shiff, *Cézanne and the End of Impressionism* (Chicago: University of Chicago Press, 1984), in which the author discusses the meaning and context of this phrase at considerable length.
3. See Alfred North Whitehead, *Adventures of Ideas* (New York: The New American Library, A Mentor Book, 1955), 247.
4. See Sarah Faunce and Linda Nochlin, *Courbet Reconsidered* (Brooklyn, N.Y.: Brooklyn Museum, 1988), 84.
5. Gustave Courbet, *Le Précurseur d'Anvers*, Antwerp, August 22, 1861; cited in Gerstle Mack, *Gustave Courbet* (New York: Alfred A. Knopf, 1951), 89.
6. Gustave Flaubert, "Style as Absolute," 1852, cited in Richard Ellmann and Charles Feidelson, Jr., eds., *The Modern Tradition* (New York: Oxford University Press, 1965), 126.
7. Clive Bell, "The Aesthetic Hypothesis," 1914, reprinted in Francis Frascina and Charles Harrison, eds., *Modern Art and Modernism: A Critical Anthology* (New York: Harper & Row, 1982), 69.
8. Clement Greenberg, "Avant-Garde and Kitsch," 1939, reprinted in *Art and Culture* (Boston: Beacon Press, 1961), 5–6. See also Clement Greenberg, "Modernist Painting," *Arts Yearbook* 4 (1961), 109–16.
9. See Peter Bürger, *Theory of the Avant-Garde*, trans. Michael Shaw, *Theory of Literature*, vol. 4 (Minneapolis: University of Minnesota Press, 1984); Jürgen Habermas, "Modernity—An Incomplete Project," in Hal Foster, ed., *The Anti-Aesthetic: Essays on Postmodern Culture* (Port Townsend, Wash.: Bay Press, 1983); and Renato Poggioli, *The Theory of the Avant-Garde*, trans. Gerald Fitzgerald (Cambridge, Mass.: Harvard University Press, 1968).
10. For example, see Baudrillard, "Simulacra and Simulations," trans. Paul Foss, Paul Patton, and Philip Beitchman, in Mark Poster, ed., *Jean Baudrillard: Selected Writings* (Stanford: Stanford University Press, 1988), 166–184.
11. Hal Foster, "The Crux of Minimalism," in Howard Singerman, ed., *Individuals: A Selected History of Contemporary Art 1945–1986*, exhibition catalog, Museum of Contemporary Art (Los Angeles: Museum of Contemporary Art; New York: Abbeville Press, 1986), 176.
12. Harold Rosenberg, *The Tradition of the New* (New York: Horizon Press, 1959).
13. Claude Lévi-Strauss, *The Savage Mind* (London: Weidenfeld & Nicolson, 1966), 16–36.
14. Charles Baudelaire, "The Salon of 1859," in *Art in Paris, 1845–1862: Salons and other Exhibitions*, trans. and ed. Jonathan Mayne (London and New York: Phaidon, 1965), 156.
15. Barnett Newman, 1967; cited in Harold Rosenberg, *Barnett Newman* (New York, N.Y.: Harry N. Abrams, 1978), 28.
16. Martin Heidegger, "The Origin of the Work of Art," 1935–6 (revised 1950), in *Poetry, Language, Thought*, trans. Albert Hofstadter (New York: Harper & Row, 1975), 57.
17. To be persuasive you need force, from a Marxist point of view, or persuasion, according to Max Weber.
18. See Gramsci's discussion of "hegemony" in Antonio Gramsci, *The Prison Notebooks*, with an introduction by Joseph A. Buttigieg, ed. (New York: Columbia University Press, 1991).

Chapter 2

1. André Breton, *Manifeste du surréalisme* (Paris: Editions du Safittaie, 1924); cited in William S. Rubin, *Dada and Surrealist Art* (New York: Harry N. Abrams, 1968), 121.
2. Harold Rosenberg, in conversation with Jonathan Fineberg in 1976.
3. Diego Rivera, *My Art, My Life*, ed. Gladys March (New York: Citadel Press, 1960), 124; cited in Linda Downes, "Introduction" in *Diego Rivera: A Retrospective*, Founders Society, Detroit Institute of Arts (New York: W. W. Norton and Company, 1986), 19.
4. See articles by Jacinta Quirarte, "The Coatlicue in Modern Mexican Painting," *Research Center for the Arts Review 5* (April 1982), and Betty Ann Brown, "The Past Idealized: Diego Rivera's Use of Pre-Columbian Imagery," *Diego Rivera: A Retrospective*, 1986.
5. Ernest Hemingway, *A Farewell to Arms* (New York: Charles Scribner's Sons, 1957), 30, 233.
6. William Carlos Williams, "XXI The Red Wheelbarrow," in "Spring and All," *The Collected Earlier Poems of William Carlos Williams* (New York: New Directions Publishing, 1966), 277.
7. George Biddle, letter to President Franklin Roosevelt, May 9, 1933; reprinted in William F. McDonald, *Federal Relief Administration and the Arts* (Columbus, Ohio: Ohio State University, 1969); cited in Dore Ashton: *The New York School* (New York: Viking, 1973), 46.
8. Thomas B. Hess, *Barnett Newman* (New York: Walker & Co., 1969); cited in Ashton, *The New York School*, 44.
9. Lee Krasner recalled seeing the collection there in an interview with Gail Levin. See Gail Levin, *Miró, Kandinsky, and the Genesis of Abstract Expressionism: The Formative Years*, exhibition catalog (Ithaca: The Herbert F. Johnson Museum of Art, Cornell University; and New York: Whitney Museum of American Art, 1978), 27.
10. Joseph Cornell, letter to Alfred Barr, November 13, 1936, Archives of The Museum of Modern Art; cited in Dawn Ades, "The Transcendental Surrealism of Joseph Cornell," Kynaston McShine, ed., *Joseph Cornell*, exhibition catalog (New York: The Museum of Modern Art, 1980), 19.
11. Robert M. Coates, "The Art Galleries," *New Yorker* 22, no. 7 (March 30, 1946): 83.
12. Crane Brinton, "Romanticism," in Paul Edwards, ed., *The Encyclopedia of Philosophy*, vol. 7 (New York: Macmillan and Free Press, 1967), 206. See also Nina Athanassoglou-Kallmyer, "Romanticism: Breaking the Canon," *The Art Journal* (summer 1993): 18.
13. Harold Rosenberg, in conversation with Jonathan Fineberg in 1977–8.
14. Harold Rosenberg, "The Herd of Independent Minds," *Commentary*, 1948, in *Discovering the Present* (Chicago: University of Chicago Press, 1973), 19.
15. Harold Rosenberg, "The American Action Painters," *Artnews* (1952); in *Tradition of the New* (New York: Horizon Press, 1959).
16. Ann Eden Gibson, *Abstract Expressionism: Other Politics* (New Haven and London: Yale University Press, 1997), ix.
17. Jean-Paul Sartre, *Action* (December 29, 1944). "En un mot, l'homme doit créer sa propre essence; c'est en se jetant dans le monde, en y souffrant, en y luttant, qu'il se définit peu à peu . . ."
18. Søren Kierkegaard, "Two Notes About The 'Individual,' " in *The Point of View Etc.*, trans. Walter Lowrie (London and New York: Oxford University Press, 1939), 130–1.
19. Friedrich Nietzsche, "Schopenhauer as Educator," 1874; in Friedrich Nietzsche, *Untimely Meditations*, trans. R. J. Hollingdale (Cambridge and New York: Cambridge University Press, 1983), 129.
20. See Martin Heidegger, *Being and Time*, trans. John Macquarrie and Edward Robinson (New York: Harper & Row, 1962).
21. Harold Rosenberg, "Introduction to Six American Artists," *Possibilities* (New York: Wittenborn Schultz, 1947), 75.
22. Robert Motherwell, "Symposium: What Abstract Art Means to Me," *Bulletin of The Museum of Modern Art 18*, no. 3 (spring 1951): 12.
23. Cited in Ashton, *The New York School*, 34.
24. Robert Motherwell, in conversation with Jonathan Fineberg, January 15, 1979, Greenwich, Conn.
25. Mark Rothko, introduction to the catalog of the Clyfford Still exhibition at the Art of This Century Gallery, New York, February 12–March 2, 1946, unpaginated; cited in Irving Sandler, *The Triumph of American Painting* (New York: Praeger, 1970), 67.
26. Clyfford Still, from diary notes of February 11, 1956; cited in *Clyfford Still*, exhibition catalog, San Francisco Museum of Art, (San Francisco: San Francisco Museum of Modern Art, 1976), 122.
27. Letter of June 7, 1943 by Mark Rothko and Adolph Gottlieb [with the unacknowledged help of Barnett Newman] in Edward Alden Jewell, "The Realm of Art: A New Platform and Other Matters: 'Globalism' Pops into View," *New York Times*, June 13, 1943, x9. Cited in Diane Waldman, *Mark Rothko, 1903–1970: A Retrospective* (New York: Harry N. Abrams, 1978), 39.
28. Elaine de Kooning, *Franz Kline Memorial Exhibition* (Washington, D.C.: Washington Gallery of Modern Art, 1962), 14; cited in Sandler, *The Triumph of American Painting*, 249.
29. Clement Greenberg, "A New Installation at the Metropolitan Museum of Art, and a Review of the Exhibition Art in Progress," *The Nation* (June 10, 1944); reprinted in Clement Greenberg, *The Collected Essays and Criticism*, vol. 1: *Perceptions and Judgements, 1939–1944* (Chicago: University of Chicago Press, 1986), 213.
30. Robert Motherwell, in conversation with Jonathan Fineberg, January 10, 1976, Greenwich, Conn.
31. Mark Tobey, in Dorothy C. Miller, ed., *Fourteen Americans* (New York: The Museum of Modern Art, 1946), 70; cited in William C. Seitz, *Mark Tobey*, The Museum of Modern Art (Garden City, N.Y.: Doubleday, 1962), 9.

Chapter 3

1. Alexander Calder, *Calder: an Autobiography with Pictures* (New York: Pantheon Books, 1966), 196.
2. Ibid., 54–5.
3. Thomas Wolfe, *You Can't Go Home Again*, book 1 (Garden City, N.Y.: Doubleday, 1942), 273–82.
4. Calder, *Calder: an Autobiography with Pictures*, 113.
5. Ibid., 130.
6. Calder, "What Abstract Art Means to Me," *Bulletin of The Museum of Modern Art*, 1951; cited in Jean Lipman, *Calder's Universe*, exhibition catalog (New York: Whitney Museum of American Art, 1976), 1.
7. Nicholas Guppy, "Alexander Calder," *Atlantic Monthly* (December 1964); cited in Albert Elsen, "Calder on Balance," *Alexander Calder: A Retrospective Exhibition*, Museum of Contemporary Art (Chicago: Museum of Contemporary Art, 1974), 16–17, n. 28.
8. Albert Elsen, "Calder on Balance," 8.
9. Lipman, *Calder's Universe*, 262.
10. Ibid., 172.
11. Camilla Gray, *The Great Experiment: Russian Art 1863–1922* (New York: Harry N. Abrams, 1962), 147.
12. Lipman, *Calder's Universe*, 32.
13. Lipman, *Calder's Universe*, 15.
14. Elsen, "Calder on Balance," 5.
15. Lipman, *Calder's Universe*, 222.
16. Katherine Kuh, *The Artist's Voice: Talks with Seventeen Artists* (New York and Evanston, Ill.: Harper & Row, 1962), 42.
17. Stuart Davis, letter to Henry McBride, reprinted in *Creative Art 6* (February 1930): supplement, 34–5; Stuart Davis, cited in James Johnson Sweeney, *Stuart Davis* (New York: The Museum of Modern Art, 1945), 23; cited in Diane Kelder, "Stuart Davis and Modernism: An Overview," in Lowery Stokes Sims, *Stuart Davis: American Painter* (New York: Metropolitan Museum of Art and Harry N. Abrams, 1991), 26.
18. Hans Hofmann, "The Search for the *Real* in the Visual Arts," *Search for the Real and Other Essays*, ed. Sarah T. Weeks and Bartlett H. Hayes (Cambridge, Mass.: MIT Press, 1967), 40.
19. Ibid., 64.
20. Maurice Denis, "The Definition of Neo-Traditionism," *Art et critique*, Paris (August 23 and 30, 1890); in Herschel B. Chipp, *Theories of Modern Art* (Berkeley: University of California Press, 1968), 94.
21. Hofmann, *Search for the Real*, 43.
22. Clement Greenberg, *Nation 160* (April 21, 1945): 469; cited in Cynthia Goodman, *Hans Hofmann* (New York: Abbeville, 1986), 9.
23. Cited in Cynthia Goodman, *Hans Hofmann*, 49.
24. Kuh, *The Artist's Voice*, 124.
25. Hofmann, *Search for the Real*, 48.
26. Samuel M. Kootz, "Credibility of Color: Hans Hofmann," *Arts Magazine 41* (February 1967): 38; cited in Goodman, *Hans Hofmann*, 9–10.
27. Hans Hofmann, "The Color Problem in Pure Painting—Its Creative Origin," in *Hans Hofmann*, exhibition catalog (New York: Kootz Gallery, 1955), unpaginated, cited in Goodman, *Hans Hofmann*, 110–11.
28. From "Hans Hofmann on Art," *Art Journal 22* (spring 1963): 18; reprint of a speech delivered at inauguration of Hopkins Center, Dartmouth College, November 17, 1962; cited in Goodman, *Hans Hofmann*, 111.
29. Harold Rosenberg, *Arshile Gorky: The Man, the Time,*

the Idea (New York: Horizon Press, 1962), 45; the personal impressions below come chiefly from Rosenberg.

30. Ibid., 42.

31. See Nick Dante Vaccaro, "Gorky's Debt to Gaudier-Brzeska," Art Journal 23 (fall 1963): 33–4.

32. Ethel Schwabacher, Arshile Gorky, exhibition catalog, Whitney Museum of American Art (New York: Macmillan, 1957), 62.

33. Stuart Davis, "Arshile Gorky in the 1930s: A Personal Recollection," Magazine of Art 44 (February 1951); in Diane Kelder, ed., Stuart Davis (New York: Praeger, 1971), 178–9.

34. Noted in the catalog for Gorky's first group show in New York, An Exhibition of Works by 46 Painters and Sculptors Under 35 Years of Age (New York: The Museum of Modern Art, 1930); cited by Lisa Dennison Tabak in her chronology for Diane Waldman, Arshile Gorky: A Retrospective, exhibition catalog, Guggenheim Museum (New York: Harry N. Abrams, 1981), 258.

35. According to Alice Baber, "Gorky's Color," in Arshile Gorky: Drawings to Paintings, exhibition catalog (Austin Tex.: University of Texas at Austin, University Art Museum, 1975), 76. She cites Brooks Joyner, The Drawings of Arshile Gorky, exhibition catalog (College Park, Md.: University of Maryland Art Department and Art Gallery, J. Millard Tawes Fine Arts Center, 1969), 10; who is quoting Schwabacher, Arshile Gorky, but this is slightly misleading in that on page 50, Schwabacher says Gorky made use of this Uccello's work as well as a work or works by Ingres; it is not clear from her discussion if the Miracle was on Gorky's wall.

36. See Waldman, Arshile Gorky: A Retrospective, 29–31, 258–60.

37. Stuart Davis, "Arshile Gorky in the 1930s: A Personal Recollection," in Diane Kelder, ed., Stuart Davis, 178–9.

38. Marny George, quoted in Schwabacher, Arshile Gorky, 61.

39. Willem de Kooning, letter to Artnews (January 1949); cited in Schwabacher, Arshile Gorky, 8.

40. Rosenberg, Arshile Gorky: The Man, 66.

41. Julien Levy, foreword to William C. Seitz, Arshile Gorky, exhibition catalog, The Museum of Modern Art (Garden City, N.Y.: Doubleday, 1962), 7. A similar remark is cited by most of those who knew Gorky and wrote about him.

42. Sateng Avedisian, letter to Mrs. [Minna] Metzger, March 31, 1949, Whitney Museum of American Art files; cited in Harry Rand, Arshile Gorky: The Implication of Symbols (Montclair, N.J.: Allenheld & Schram, 1981), 74, n. 4.

43. Arshile Gorky, in Schwabacher, Arshile Gorky, 66.

44. André Breton, "The Eye Spring Arshile Gorky," introduction to the Arshile Gorky exhibition at the Julien Levy Gallery 1945; cited in Irving Sandler, The Triumph of American Painting (New York and Washington: Praeger, 1970), 56.

45. See Schwabacher, Arshile Gorky, 118.

46. Arshile Gorky, letter to Vartoosh, April 22, 1944, in "The Letters of Arshile Gorky," ed. and trans. Karlen Mooradian in "A Special Issue on Arshile Gorky," Ararat, vol. 12 (New York, fall 1971): 32; cited in Jim Jordan and Robert Goldwater, The Paintings of Arshile Gorky: A Critical Catalogue (New York: New York University Press, 1982), 84–5.

47. This iconography has been discussed in Rand, Gorky: Implication of Symbols, 183–4.

48. According to Julien Levy, Arshile Gorky (New York, 1966), 24.

49. Arshile Gorky, letter of September 26, 1939, in "Toward a Philosophy of Art" (selected from letters and trans. Karlen Mooradian), Arshile Gorky: Drawings to Paintings, 31.

50. Arshile Gorky, letter of January 17, 1947, in "The Letters of Arshile Gorky," ed. and trans. Karlen Mooradian in "A Special Issue on Arshile Gorky," Ararat, vol. 12 (New York, fall 1971): 39; cited in Harry Rand "Arshile Gorky Iconography" in Arshile Gorky: Drawings to Paintings, exhibition catalog, University of Texas (Austin, Tex.: University of Texas at Austin, University Art Museum, 1975), 67.

51. Arshile Gorky, letter to Vartoosh from Hamilton, Virginia, August 1943; in Arshile Gorky, a film by Charlotte Zwerin, New York, 1982.

52. Schwabacher, Arshile Gorky, 82.

53. Arshile Gorky, "My Murals for the Newark Airport: An Interpretation," in Francis V. O'Connor, ed., Art For The Millions (Greenwich, Conn.: New York Graphic Society, 1973), 72.

54. Agnes Magruder, interviewed by Courtney Sale in Arshile Gorky, a film by Charlotte Zwerin, New York, 1982.

55. Julien Levy, foreword to Seitz, Arshile Gorky, 9.

56. Harold Rosenberg reported this to Jonathan Fineberg in a conversation in 1975.

57. Robert Motherwell, in conversation with Jonathan Fineberg, January 10, 1976 in Greenwich, Conn.

58. Robert Motherwell, in conversation with Jonathan Fineberg, January 10, 1976 in Greenwich, Conn.

59. Robert Motherwell, "Preliminary Notice," (Kahnweiler, The Rise of Cubism, trans. Henry Aronson (New York: Wittenborn & Schultz, 1949), vii.

60. Robert Motherwell, catalog of an exhibition, "The School of New York," Perls Gallery, Beverly Hills, January 1951, unpaginated; cited in Sandler, The Triumph of American Painting, 202.

61. See Stephanie Terenzio and Dorothy C. Belknap, The Prints of Robert Motherwell: A Catalogue Raisonné 1943–1948 (New York: Hudson Hills Press, 1984).

62. Robert Motherwell, commentary to the illustration of Pancho Villa, Dead and Alive in H. Harvard Arneson, Robert Motherwell, 2d ed. (New York: Harry N. Abrams, 1982), 105.

63. I have discussed the specificity of this subject matter in relation to Motherwell's childhood and character in: Jonathan Fineberg, "Death and Maternal Love: Psychological Speculations on Robert Motherwell's Art," Artforum (September 1978): 52–7.

64. Robert Motherwell, in conversation with Jonathan Fineberg, January 8, 1977, Greenwich, Conn.; see Fineberg, "Death and Maternal Love," 55.

65. Robert Motherwell, in conversation with E. A. Carmean, August 17, 1977; cited in American Art at Mid-Century: Subjects of the Artist (Washington, D.C.: National Gallery of Art, 1978), 98.

66. Robert Motherwell, "Robert Motherwell: a conversation at lunch," An Exhibition of the Works of Robert Motherwell, January 10–28, 1963, to accompany the First Louise Linder Eastman Memorial Lecture, January 14, 1963. Northampton, Mass., 1963, unpaginated.

67. Robert Motherwell, in conversation with Jonathan Fineberg, January 10, 1976, Greenwich, Conn.; see Jonathan Fineberg, "Death and Maternal Love," 55.

68. Robert Motherwell, commentary to the illustration of In Plato's Cave in Arneson, Robert Motherwell, 180.

69. Willem de Kooning, "Content is a Glimpse," excerpts from an interview with David Sylvester broadcast on the BBC, December 3, 1960; published as a transcript in Location, vol. 1, no. 1 (spring 1963); reprinted in Thomas B. Hess, Willem de Kooning, exhibition catalog, The Museum of Modern Art (Greenwich, Conn.: New York Graphic Society, 1968), 148.

70. See, for example, Edwin Denby, "Willem de Kooning," Dancers, Buildings, and People in the Streets (New York: Horizon Press, 1965), 269–70, or the account by Elaine de Kooning in Hess, Willem de Kooning, 22.

71. Hess, Willem de Kooning, 24.

72. Willem de Kooning, interviewed by Courtney Sale, in a film by Charlotte Zwerin, de Kooning on de Kooning, New York, 1980.

73. Harold Rosenberg, "Interview with Willem de Kooning," Artnews (September 1972), reprinted in Harold Rosenberg, Willem de Kooning (New York: Harry N. Abrams, 1973), 47.

74. Judith Wolfe, Willem de Kooning: Works From 1951–1981, exhibition catalog, Guild Hall Museum (East Hampton, N.Y.: Guild Hall Museum, 1981), 7.

75. Harold Rosenberg, "Interview with Willem de Kooning," Artnews (September 1972), reprinted in Rosenberg, Willem de Kooning, 51.

76. Willem de Kooning, cited in Hess, Willem de Kooning, 16.

77. Willem de Kooning, "What Abstract Art Means to Me," Bulletin of The Museum of Modern Art 18, no. 3 (spring 1951), 7. Reprinted in Hess, Willem de Kooning, 145.

78. Recounted by Harold Rosenberg, in conversation with Jonathan Fineberg, 1976. Rosenberg also refers to the episode in Rosenberg, Arshile Gorky, 68.

79. Willem de Kooning, "Content is a Glimpse," excerpts from an interview with David Sylvester broadcast on the BBC, December 3, 1960; published as a transcript in Location, vol. 1, no. 1 (spring 1963); reprinted in Hess, Willem de Kooning, 147.

80. Sally Yard, personal interview with Thomas Hess, December 5, 1977; cited in Sally Yard, Willem de Kooning: the first twenty-six years in New York (New York: Garland, 1985), 210, n. 121.

81. Willem de Kooning, interviewed by Courtney Sale, in a film by Charlotte Zwerin, de Kooning on de Kooning, New York, 1980.

82. Hess, Willem de Kooning, 47.

83. Willem de Kooning in James T. Valliere, interview with Willem de Kooning "de Kooning on Pollock," Partisan Review (fall 1967): 604; cited in Yard, Willem de Kooning: the first, 151.

84. Willem de Kooning quoted in Hess, Willem de Kooning, 78.

85. Harold Rosenberg, "Interview with Willem de Kooning," Artnews (September 1972), reprinted in Rosenberg, Willem de Kooning, 43.

86. Willem de Kooning, "Content is a Glimpse," excerpts from an interview with David Sylvester broadcast on the BBC, December 3, 1960; published as a transcript in Location, vol. 1, no. 1 (spring 1963); reprinted in Hess, Willem de Kooning, 148.

87. Willem de Kooning, interviewed by Courtney Sale, in a film by Charlotte Zwerin, de Kooning on de Kooning, New York, 1980.

88. Willem de Kooning, "Content is a Glimpse," excerpts from an interview with David Sylvester broadcast on the BBC, December 3, 1960; published as a transcript in Location, vol. 1, no. 1 (spring 1963); reprinted in Hess, Willem de Kooning, 149.

89. De Kooning ranked it as one of the three most important shows for him, along with the 1927 Dudensing Gallery show of Matisse and the 1939 Picasso retrospective at the Museum of Modern Art. Interview with the artist by Sally Yard on August 14, 1976; cited in Yard, Willem de Kooning: the first, 14.

90. Interview with Elaine de Kooning by Sally Yard, August 5, 1979; cited in Yard, Willem de Kooning: the first, 181.

91. Hess, Willem de Kooning, 73.

92. Interview with Judith Wolfe on April 24, 1981; cited in Wolfe, Willem de Kooning: Works From 1951–1981, 8.

93. Willem de Kooning, "Content is a Glimpse," excerpts from an interview with David Sylvester broadcast on the BBC, December 3, 1960; published as a transcript in Location, vol. 1, no. 1 (spring 1963); reprinted in Hess, Willem de Kooning, 148–9.

94. Selden Rodman, Conversations with Artists (New York: Devin-Adair, 1957), 102.

95. Harold Rosenberg, "Interview with Willem de Kooning," Artnews (September 1972), 58; reprinted in Rosenberg, Willem de Kooning, 48–9.

96. Harold Rosenberg, "Interview with Willem de Kooning," Artnews (September 1972), reprinted in Rosenberg, Willem de Kooning, 43.

97. Willem de Kooning, in an unpublished paper read in a Friday evening meeting on February 18, 1949, at "Subjects of the Artist: A New Art School"; cited in Hess, Willem de Kooning, 15.

98. William Seitz asserted that abstract expressionism as a whole did not distinguish between representation and abstraction. See William C. Seitz, Abstract Expressionist Painting in America: An Introduction Based on the Work and Thought of Six Key Figures, Ph.D. diss., Princeton University, 1955, 286–7.

99. Willem de Kooning, "Content is a Glimpse," excerpts from an interview with David Sylvester broadcast on the BBC, December 3, 1960; published as a transcript in Location, vol. 1, no. 1 (spring 1963); reprinted in Hess, Willem de Kooning, 149.

100. Hess, Willem de Kooning, 25.

101. Harold Rosenberg, cited in Hess, Willem de Kooning, 74.

102. Hess, Willem de Kooning, 74.

103. Rodman, Conversations with Artists, 104.

104. Hess, Willem de Kooning, 77–8.

105. Willem de Kooning, "Content is a Glimpse," excerpts from an interview with David Sylvester broadcast on the BBC, December 3, 1960; published as a transcript in Location, vol. 1, no. 1 (spring 1963); reprinted in Hess, Willem de Kooning, 149.

106. Willem de Kooning, interview with Judith Wolfe, April 14, 1981; cited in Wolfe, Willem de Kooning: Works from 1951–1981, 14.

107. Willem de Kooning, interviewed by Courtney Sale, in a film by Charlotte Zwerin, de Kooning on de Kooning, New York, 1980.

Chapter 4

1. Willem de Kooning, in Rudi Blesh, Modern Art USA: Man, Rebellion, Conquest, 1900–1956 (New York: Alfred A. Knopf, 1956), 253.

2. Lee Krasner, "An Interview with Lee Krasner Pollock by B. H. Friedman," Jackson Pollock: Black and White, exhibition catalog (New York: Marlborough Gallery, 1969), 8.

3. B. H. Friedman, Energy Made Visible (New York: McGraw-Hill, 1972), 7.

4. See Stephen Polcari, "Jackson Pollock and Thomas Hart Benton," Arts (March 1979), 120–4.

5. John D. Graham, "Primitive Art and Picasso," Magazine of Art 30, no. 4 (April 1937): 237–8; cited in Irving Sandler, The Triumph of American Painting (New York: Praeger, 1970), 106.

6. Friedman, Energy Made Visible, 62.

7. Jackson Pollock, radio interview with William Wright, taped 1950, in Francis V. O'Connor "Documentary Chronology" in Francis Valentine O'Connor and Eugene Victor Thaw, Jackson Pollock: A Catalogue Raisonné of Paintings, Drawings, and Other Works, vol. 4 (New Haven: Yale University Press, 1978), 249–50.

8. John D. Graham, "Primitive Art and Picasso," Magazine

514

Notes

of Art 30, no. 4 (April 1937): 237–8; cited in Sandler, The Triumph of American Painting, 106.

9. See William S. Rubin, "Pollock as Jungian Illustrator: The Limits of Psychological Criticism," Part I, Art in America (November 1979): 104–23; Part II, Art in America (December 1979): 72–91. The most extensive treatment of Jungian themes in Pollock's work is Elizabeth Langhorne, A Jungian Interpretation of Jackson Pollock's Art Through 1946, Ph.D. diss., University of Pennsylvania, 1977.

10. See W. Jackson Rushing, "Ritual and Myth: Native American Culture and Abstract Expressionism," in Maurice Tuchman and Judi Freeman, eds., The Spiritual In Art: Abstract Painting 1890–1985, Los Angeles County Museum of Art (New York: Abbeville, 1986), 285ff.

11. Jackson Pollock, interviewed in Art and Architecture (February 1944); cited in Elizabeth Frank, Jackson Pollock, 1st edition (New York: Abbeville, 1983), 55.

12. Jackson Rushing makes this assertion in Rushing, "Ritual and Myth," 285ff.

13. See Stephen Polcari, Abstract Expressionism and the Modern Experience (Cambridge and New York: Cambridge University Press, 1991), 248.

14. Interview with Lee Krasner by Courtney Sale in a film Jackson Pollock: Portrait by Charlotte Zwerin, New York, 1984.

15. Friedman, Jackson Pollock, 65.

16. Jackson Pollock, in Friedman, Jackson Pollock, 176.

17. Christopher B. Crosman and Nancy E. Miller, "Speaking of Tomlin," interview with James Brooks and Ibram Lassaw, Art Journal 39/2 (winter 1979/80): 114.

18. Ibid., 114.

19. Jackson Pollock, "Unframed Space," New Yorker, August 5, 1950, 16.

20. Wassily Kandinsky, "Text Artista: Autobiography by Wassily Kandinsky," in In Memory of Wassily Kandinsky, exhibition catalog (New York: Museum of Non-Objective Painting, 1945), 59.

21. Jackson Pollock, "My Painting," Possibilities 1: An Occasional Review (winter 1947/8), in the series Problems of Contemporary Art, no. 4 (New York: Wittenborn, Schultz, 1947): 79.

22. Harold Rosenberg, "The American Action Painters," Artnews, vol. 51, no. 5 (September 1952); reprinted in Rosenberg's anthology of essays, The Tradition of the New (New York: Horizon Press, 1959).

23. See Jean-Paul Sartre, Being and Nothingness, trans. Hazel Barnes (New York: Pocket Books, 1956), 50.

24. Jackson Pollock, radio interview with William Wright, taped 1950, in Francis V. O'Connor "Documentary Chronology" in O'Connor and Thaw, Jackson Pollock: A Catalogue Raisonné, 251.

25. Lee Krasner, quoted in Francine Du Plessix and Cleve Gray, "Who Was Jackson Pollock?" Art in America (May/June 1967): 48–59; cited in Friedman, Jackson Pollock, 88.

26. "Is Jackson Pollock the Greatest Living Painter in the United States?" Life (August 8, 1949): 41–5.

27. "The Wild Ones," Time Magazine (February 20, 1956): 70–5.

28. Richard Shiff, "Introduction," in John P. O'Neill, ed., Barnett Newman: Selected Writings and Interviews (Berkeley and Los Angeles: University of California Press, 1992), xiv–xv.

29. Barnett Newman, "The New Sense of Fate," 1945, in Thomas Hess, Barnett Newman, exhibition catalog (New York: The Museum of Modern Art, 1971), 41.

30. Barnett Newman, "The Ideographic Picture," catalog foreword, Betty Parsons Gallery, New York, 1947, cited in Harold Rosenberg, Barnett Newman (New York: Harry N. Abrams, 1978), 30.

31. Barnett Newman, "The Sublime is Now," The Tiger's Eye, no. 6 (December 1948): 51–3; cited in Sandler, Triumph of American Painting, 149.

32. Barnett Newman, quoted in A. J. Liebling, "Two Aesthetes Offer Selves as Candidates to Provide Own Ticket for Intellectuals," New York World Telegram (November 4, 1933); cited in Hess, Barnett Newman, 25.

33. Cited in Hess, Barnett Newman, 7–9.

34. Zohar (Book of Splendor), an early sacred book of Cabbalists, cited in Hess, Barnett Newman, 56.

35. Robert Motherwell, an interview with Max Kozloff, Artforum 4, no. 1 (September 1965): 37; cited in Sandler, Triumph of American Painting, 156.

36. Barnett Newman, 1967; cited in Rosenberg, Barnett Newman, 27–8.

37. According to Hess, Barnett Newman, 58.

38. Ibid., 58.

39. See John P. O'Neill, ed., Barnett Newman: Selected Writings and Interviews (Berkeley and Los Angeles: University of California Press, 1992), 216ff.

40. Cited in Hess, Barnett Newman, 71.

41. Ibid., 73.

42. Newman himself commented on this; cited in Hess, Barnett Newman, 93.

43. Barnett Newman, "Statement," in Barnett Newman: The Stations of the Cross, lema sabachthani, prepared by Lawrence Alloway (New York: Solomon R. Guggenheim Foundation, 1966), 9.

44. As suggested in Hess, Barnett Newman, 98.

45. Barnett Newman, "The Ideographic Picture," foreword to an exhibition catalog, Betty Parsons Gallery, New York, 1947; cited in Sandler, Triumph of American Painting, 187.

46. Dore Ashton, "Art: Lecture by Mark Rothko," New York Times (notes by Ashton from a lecture delivered by Rothko at the Pratt Institute), October 31, 1958, 26.

47. Dore Ashton, About Rothko (New York: Oxford University Press, 1983), 20.

48. Ibid., preface.

49. Robert Motherwell, in conversation with Jonathan Fineberg, January 15, 1979, Greenwich, Conn.

50. William Rubin, "Mark Rothko 1903–70," New York Times (March 8, 1970), 21–2.

51. Ashton, About Rothko, 51.

52. Mrs. John de Menil, Address made at the opening of the Rothko Chapel in Houston, February 27, 1971, mimeograph distributed at the chapel.

53. See Stephen Polcari, "The Intellectual Roots of Abstract Expressionism: Mark Rothko," Arts (September 1979): 124.

54. See the discussion of Rothko's relation to these events in Ashton, About Rothko.

55. John Fischer, "The Easy Chair: Mark Rothko: portrait of the artist as an angry man," Harper's, vol. 241, no. 1442 (July 1970): 17.

56. Mark Rothko, "The Portrait and the Modern Artist," in Art in New York, a program on WYNC, New York, copy of broadcast, October 13, 1943, pp. 1, 2, 3; cited in Maurice Tuchman, New York School: The First Generation (Greenwich, Conn.: New York Graphic Society, 1971), 139.

57. Mark Rothko, in Sidney Janis, Abstract and Surrealist Art in America (New York: Reynal & Hitchcock, 1944), 118.

58. Letter of June 7, 1943 by Mark Rothko and Adolph Gottlieb [with the unacknowledged help of Barnett Newman] in Edward Alden Jewell, "The Realm of Art: A New Platform and Other Matters: 'Globalism' Pops into View," New York Times (June 13, 1943), x9. Cited in Diane Waldman, Mark Rothko, 1903–1970: A Retrospective (New York: Harry N. Abrams, 1978), 39.

59. Letter of June 7, 1943 by Mark Rothko and Adolph Gottlieb [with the unacknowledged help of Barnett Newman] in Edward Alden Jewell, "The Realm of Art: A New Platform and Other Matters: 'Globalism' Pops into View," New York Times (June 13, 1943), x9. Cited in Diane Waldman, Mark Rothko, 1903–1970: A Retrospective (New York: Harry N. Abrams, 1978), 39.

60. Dore Ashton, The New York School (New York: Viking, 1973), 98.

61. Mark Rothko, "Personal Statement," in A Painting Prophecy—1950, exhibition catalog for a group show, David Porter Gallery, Washington, D.C., 1945. Cited in Waldman, Mark Rothko, 48–9.

62. "The Passing Shows: Mark Rothko," Artnews 43 (January 15, 1945): 27.

63. According to Ernest Briggs (a student of Rothko's in the late forties), Barbara Shikler, interview with Ernest Briggs, July 12 and October 21, 1982, transcript on file at the Archives of American Art, Smithsonian Institution, Washington, D.C.; cited in Bonnie Clearwater, Mark Rothko: Works on Paper (New York: Hudson Hill Press, Mark Rothko Foundation, American Federation of the Arts, Viking Penguin, 1984), 33–4.

64. In letters written by Still to Betty Parsons; cited by Ashton, About Rothko, 103.

65. Ashton, About Rothko, 112.

66. Mark Rothko, "Statement on his Attitude in Painting," The Tiger's Eye, vol. 1, no. 9 (October 1949): 114.

67. Letter of June 7, 1943 by Mark Rothko and Adolph Gottlieb [with the unacknowledged help of Barnett Newman] in Edward Alden Jewell, "The Realm of Art: A New Platform and Other Matters: 'Globalism' Pops into View," New York Times (June 13, 1943), x9. Cited in Waldman, Mark Rothko, 1903–1970: A Retrospective, 39.

68. Mark Rothko, some notes on art education in an unpublished notebook of the late thirties, collection of the George C. Carson family; cited in Clearwater, Mark Rothko: Works on Paper, 36.

69. Anna Chave, Mark Rothko Subjects, exhibition catalog, High Museum of Art, Atlanta, October 15–February 26, 1983, 21. She discusses the idea that Rothko intended the color blocks as disguised figures, entombment and pietà scenes in this catalog and in her Yale doctoral dissertation of 1981, published as Anna C. Chave, Mark Rothko: Subjects in Abstraction (New Haven and London: Yale University Press, 1989).

70. Dore Ashton, "Art: Lecture by Rothko," New York Times (October 31, 1958), 26; cited in Clearwater, Mark Rothko: Works on Paper, 28.

71. Mark Rothko, "The Romantics Were Prompted," Possibilities 1, 84.

72. Ibid.

73. Cited in Ashton, About Rothko, 154.

74. Mark Rothko, statement delivered from the floor at a symposium of The Museum of Modern Art in New York, published in "A Symposium on How to Combine Architecture, Painting and Sculpture," Interiors, vol. 110, no. 10 (May 1951): 104.

75. Mark Rothko, in Selden Rodman, Conversations with Artists (New York: Devin-Adair, 1957), 93–4.

76. Mrs. John de Menil, Address, unpaginated.

77. William Seitz asserted that abstract expressionism as a whole did not distinguish between representation and abstraction. See William C. Seitz, Abstract Expressionist Painting in America: An Introduction Based on the Work and Thought of Six Key Figures, Ph.D. diss., Princeton University, 1955, 274–5; and Ashton, About Rothko. Both discuss Nietzsche as an important influence on Rothko.

78. Friedrich Nietzsche, The Birth of Tragedy, trans. Francis Golffing (Garden City, N.Y.: Doubleday, Anchor Books edition, 1956), 19.

79. Mark Rothko, in Dorothy Sieberling, "Mark Rothko," Life (November 16, 1959): 82; cited in Chave, Mark Rothko: Subjects in Abstraction, 25.

80. Mark Rothko, "The Romantics Were Prompted," 84.

81. David Smith, "Who is the artist? How does he act?" Everyday Art Quarterly, Walker Art Center, no. 23 (1952). Cited in Jane Harrison Cone, David Smith, exhibition catalog (Cambridge, Mass.: Fogg Art Museum, 1966), 99.

82. David Smith, "Who is the artist? How does he act?" Everyday Art Quarterly, Walker Art Center, no. 23 (1952). Cited in Cone, David Smith, 99.

83. Smith file, reel 2, frame 578, 1950–4; in Archives of American Art, Smithsonian Institution, Washington, D.C. Cited in Cleve Gray, ed., David Smith by David Smith (New York: Holt, Rinehart, & Winston, 1968), 130.

84. David Smith, a paper delivered in The New Sculpture, a symposium held at The Museum of Modern Art, New York, February 21, 1952; cited in Garnett McCoy, ed., David Smith (New York: Praeger, 1973), 84.

85. Art in America, no. 1 (1966); cited in Gray, David Smith by David Smith, 16.

86. Robert Motherwell, in conversation with Jonathan Fineberg, January 15, 1979, Greenwich, Conn.

87. David Smith, "Economic Support of Art in America Today," speech delivered at the American Federation of Arts conference in Corning, New York, October 30, 1953; McCoy, David Smith, 107–8.

88. David Smith, "The New Sculpture," symposium held at The Museum of Modern Art, February 21, 1952; cited in McCoy, David Smith, 82.

89. Maude Riley, "Sewer Pipe Sculpture," Cue (March 16, 1940). Cited in Stanley E. Marcus, David Smith: The Sculptor and His Work (Ithaca, N.Y.: Cornell University, 1983), 51.

90. "Screw Ball Art," Time 35, no. 17 (April 22, 1940), 70. Cited in Marcus, David Smith: The Sculptor and His Work, 51.

91. David Smith, "On Abstract Art," February 15, 1940, lecture to Local 60 of the United American Artists, New York; cited in McCoy, David Smith, 40.

92. David Smith, c. 1940; cited in McCoy, David Smith, 22.

93. Clement Greenberg, "American Sculpture of Our Time—Group Show," Nation 156, no. 4 (January 23, 1943), 140–1. Cited in Marcus, David Smith: The Sculptor and His Work, 63.

94. David Smith elaborated on this several times, beginning with a speech delivered at Skidmore College on February 17, 1947. Cited in Rosalind E. Krauss, The Sculpture of David Smith: A Catalogue Raisonné (New York: Garland Publishers, 1977), 39.

95. David Smith, speech delivered on WNYC radio, New York, December 30, 1952; in Smith file, reel 4, frame 363, in Archives of American Art, Smithsonian Institution, Washington, D.C. Cited in Marcus, David Smith: The Sculptor and His Work, 117.

96. David Smith, interview with Katherine Kuh, in Katherine Kuh, The Artist's Voice (New York: Harper & Row, 1960), 229.

97. David Smith, notebook from the early fifties; cited in McCoy, David Smith, 25.

98. Smith was quite familiar with them at least since 1948, when a reproduction of Giacometti's 1947 Man Pointing was featured in The Tiger's Eye along with a work and two poems by Smith. See "The Ides of Art, 14 Sculptors Write," The Tiger's Eye (June 1948): 72ff.

99. David Smith, "Perception and Reality," a speech given at Williams College, December 17, 1951. Cited in McCoy, David Smith, 78.

100. According to Robert Motherwell (in conversation with the author on January 15, 1979, Greenwich, Conn.) Clement Greenberg destroyed them. However, Garnett McCoy (in a telephone conversation with the author

February 1, 1989) recounted that he also found a pile of such photographs—perhaps the same ones or another stack—a short time later and that Ira Lowe (another of the executors) was there at the time and took the pictures away with him.

101. See for example Karen Wilkin, *David Smith* (New York: Abbeville, 1984), 99.

102. David Smith, *New York Herald Tribune* forum in April 1950. Smith file, Archives of American Art, Smithsonian Institution, Washington, D.C.; cited in Gray, *David Smith by David Smith*, 132.

103. Smith file, reel 4, frame 695–730, in Archives of American Art, Smithsonian Institution, Washington, D.C.; cited in Gray, *David Smith by David Smith*, 132.

104. David Smith, "Report on Voltri," notes written after 1963; in McCoy, *David Smith*, 162.

105. David Smith, sketchbook 36, 1952, Smith file, reel 3, frame 174, in Archives of American Art, Smithsonian Institution, Washington, D.C.; cited in Marcus, *David Smith: The Sculptor and His Work*, 172.

106. Smith file, reel 4, frame 484–6, 1952–9; in Archives of American Art, Smithsonian Institution, Washington, D.C. Cited in Gray, *David Smith by David Smith*, 60.

107. David Smith, "The Language Is Image," *Arts and Architecture* (February 1952); in Cone, *David Smith*, 96.

108. David Smith, "Aesthetics, the Artist, and the Audience," speech delivered at Deerfield, Massachusetts, September 24, 1952; in McCoy, *David Smith*, 107.

Chapter 5

1. Friedrich Wilhelm Nietzsche, "Schopenhauer as Educator," cited in Walter Kaufmann, *Existentialism from Dostoyevsky to Sartre* (New York: World Publishing Co., 1956), 104.

2. Bataille defines "l'informe" in his *Dictionaire*, Documents, I, no. 7 (Paris, 1929). *See* also the discussion in Rosalind Krauss, *The Originality of The Avant-Garde and Other Materialist Myths* (Cambridge and London: MIT, 1985), 63–4. Subsequently, Krauss and Bois curated an exhibition with a book based loosely on Bataille's idea of "l'informe"—Yves-Alain Bois and Rosalind E. Krauss, *Formless: A User's Guide* (New York: Zone Books, 1997)—but they took the position that anything implying an attack on binary thought was an example of "l'informe" (thus taking in nearly all advanced art of the twentieth century), but this has little to do with the narrower use of the term by Bataille or Dubuffet's interest in the concept. For an excellent brief discussion of this period and issue, *see* Sarah Wilson, "Paris Post-War: In Search of the Absolute," in Frances Morris, ed., *Paris Post-War: Art and Existentialism* (London: Tate Gallery, 1993), 25–52.

3. Jean Dubuffet, *Prospectus aux amateurs de tout genre* (Paris: Gallimard, 1946), 17; cited in Peter Selz, *The Work of Jean Dubuffet* (Garden City, N.Y.: Doubleday; and New York: The Museum of Modern Art, 1962), 10.

4. Jean Dubuffet, *Anti-Cultural Positions*, originally delivered as a lecture in English at the Arts Club of Chicago, December 20, 1951; this version adapted from Dubuffet's French text by Joachim Neugroschel in Mildred Glimcher, *Jean Dubuffet: Towards An Alternative Reality* (New York: Pace Publications, Abbeville, 1987), 127.

5. Jean Dubuffet, "Memoir on the Development of My Work from 1952," trans. Louise Varèse; in Selz, *The Work of Jean Dubuffet*, 97–102.

6. Jean Dubuffet, "Memoir on the Development of My Work from 1952," trans. Louise Varèse; in Selz, *The Work of Jean Dubuffet*, 102.

7. Jean Dubuffet, "Apercevoir," in *Prospectus et tous écrits suivants*, vol. 2 (Paris: Gallimard, 1967), 62; trans. Margit Rowell in Margit Rowell, "Jean Dubuffet: An Art on the Margins of Culture," *Jean Dubuffet: A Retrospective* (New York: Solomon R. Guggenheim Museum, 1973), 15.

8. Marcel Duchamp, interviewed by James Johnson Sweeney in "Eleven Europeans in America," *Bulletin of The Museum of Modern Art* 13, nos. 4–5 (New York, 1946): 19–21; cited in Herschel B. Chipp, *Theories of Modern Art* (Berkeley and Los Angeles: University of California Press, 1968), 394.

9. André Breton, *Les Pas perdus*, Editions de la Nouvelle Revue Française, Paris (1924): 174; trans. Margit Rowell in Rowell, "Jean Dubuffet: An Art on the Margins of Culture," *Jean Dubuffet: A Retrospective*, 20.

10. Jean Dubuffet, *Anti-Cultural Positions*, originally delivered as a lecture in English at the Arts Club of Chicago, December 20, 1951; this version adapted from Dubuffet's French text by Joachim Neugroschel in Glimcher, *Jean Dubuffet: Towards An Alternative Reality*, 131.

11. Jean Dubuffet, "Honneur aux valeurs sauvages," in *Catalogue des travaux de Jean Dubuffet*, Max Loreau, fascicule 6, *Corps de dames* (Paris and Lausanne: Jean-Jacques Pauvert, 1965), 109; cited in Reinhold Heller, " 'A Swan Only Sings at the Moment it Disappears': Jean Dubuffet and Art at the Edge of Non-Art," in *Jean Dubuffet:*

Forty Years of His Art, exhibition catalog (Chicago: Smart Gallery, University of Chicago, 1984), 24.

12. Jean Dubuffet, "Landscaped Tables, Landscapes of the Mind, Stones of Philosophy," catalog introduction, trans. the artist and Marcel Duchamp, Pierre Matisse Gallery (New York, 1952); cited in Selz, *The Work of Jean Dubuffet*, 63.

13. Ibid., 66.

14. André Breton, "Seconde manifeste du Surréalisme" (1929) in André Breton, *Manifestes du surréalisme* (Paris: Jean-Jacques Pauvert, 1962), 154; trans. Margit Rowell in Rowell, "Jean Dubuffet: An Art on the Margins of Culture," *Jean Dubuffet: A Retrospective*, 19.

15. Jean Dubuffet, *Note pour les fins-lettrés (Note for the well read)*, in *Prospectus et tous écrits suivants* (Paris: Gallimard, 1967); trans. Joachim Neugroschel in Glimcher, *Jean Dubuffet: Towards An Alternative Reality*, 8.

16. Hans Prinzhorn, *Artistry of the Mentally Ill (Bildnerei der Geisteskranken)*, trans. Eric von Brockdorff (New York: Springer-Verlag, 1972), 13.

17. Ibid., 216.

18. Jean Dubuffet, "Landscaped Tables, Landscapes of the Mind, Stones of Philosophy," catalog introduction, trans. the artist and Marcel Duchamp, Pierre Matisse Gallery, New York, 1952; cited in Selz, *The Work of Jean Dubuffet*, 71.

19. Jean Dubuffet, "Empreintes," in *Les Lettres Nouvelles* 5, 48 (Paris, April 1957): 507–27; trans. Lucy R. Lippard, in Chipp, *Theories of Modern Art*, 613.

20. Glimcher, *Jean Dubuffet: Towards An Alternative Reality*, 15.

21. Jean Dubuffet, letter to Arnold Glimcher, September 15, 1969; cited in Rowell, "Jean Dubuffet: An Art on the Margins of Culture," *Jean Dubuffet: A Retrospective*, 26.

22. Jean Dubuffet in Max Loreau, *Catalogue des travaux de Jean Dubuffet*, vol. 25, *Arbres, Murs, Architectures* (Lausanne, 1974): xvi; cited in Andreas Franzke, *Dubuffet* (New York: Harry N. Abrams, 1981), 159.

23. Jean Dubuffet, "Closerie Falbala and the Cabinet Logologique," preface to an exhibition catalog of 1978; trans. Joachim Neugroschel in Glimcher, *Jean Dubuffet: Towards An Alternative Reality*, 249.

24. Jean Dubuffet, letter to Arnold Glimcher, April 19, 1985; trans. Joachim Neugroschel, in Glimcher, *Jean Dubuffet: Towards An Alternative Reality*, 301.

25. Alberto Giacometti, letter to Pierre Matisse, 1947; first published in *Exhibition of Sculptures, Paintings, Drawings* (New York: Pierre Matisse Gallery, 1948); cited in *Alberto Giacometti*, exhibition catalog, The Museum of Modern Art (Garden City, N.Y.: Doubleday, 1965), 16.

26. Alberto Giacometti, "Palais de 4 heures," *Minotaure*, 3–4 (Paris, December 1933), 46.

27. Alberto Giacometti, letter to Pierre Matisse, 1947; first published in *Exhibition of Sculptures, Paintings, Drawings* (New York: Pierre Matisse Gallery, 1948); cited in *Alberto Giacometti*, 42–4.

28. Reinhold Hohl, "Form and Vision: The Work of Alberto Giacometti," in *Alberto Giacometti: A Retrospective Exhibition*, Solomon R. Guggenheim Museum (New York: Praeger, 1974), 23.

29. Alberto Giacometti, letter to Pierre Matisse, 1947; first published in *Exhibition of Sculptures, Paintings, Drawings* (New York: Pierre Matisse Gallery, 1948); cited in *Alberto Giacometti*, 28.

30. Alberto Giacometti, cited in James Lord, *A Giacometti Portrait* (Garden City, N.Y.: Doubleday, 1965), 10, 11.

31. Ibid., 23.

32. Ibid., 8.

33. Hohl, "Form and Vision: The Work of Alberto Giacometti," in *Alberto Giacometti: A Retrospective Exhibition*, 24.

34. Alberto Giacometti, cited in Lord, *A Giacometti Portrait*, 26.

35. Francis Bacon, October 1962, in David Sylvester, *Interviews with Francis Bacon* (London: Thames & Hudson, 1975), 26–8.

36. Francis Bacon, October 1973, ibid., 100.

37. Francis Bacon, cited in John Russell, *Francis Bacon* (Greenwich, Conn.: New York Graphic Society, 1971), 20.

38. Letter from Bacon, January 9, 1959, in Ronald Alley and John Rothenstein, *Francis Bacon* (New York: Viking, 1964), 35.

39. Aeschylus, *The Eumenides*, line 252, as translated in a book well known to Bacon: W. B. Stanford, *Aeschylus in his Style: A Study in Language and Personality* (Dublin: The University Press, 1942); cited in Dawn Ades, "Web of Images," in Dawn Ades and Andrew Forge, *Francis Bacon* (London: Tate Gallery in association with Thames & Hudson, 1985), 17.

40. Francis Bacon, October 1962, Sylvester, *Interviews with Francis Bacon*, 11.

41. Francis Bacon, October 1962, ibid., 23.

42. Francis Bacon, May 1966, ibid., 48.

43. He had seen the work only in reproduction, according to Alley and Rothenstein, *Francis Bacon*, 13. He kept the film

still from *Potemkin* in his studio; Francis Bacon, May 1966, in Sylvester, *Interviews with Francis Bacon*, 34.

44. Francis Bacon, December 1971, Sylvester, *Interviews with Francis Bacon*, 72.

45. Francis Bacon, in Andrew Carnduff Ritchie, ed., *The New Decade: 22 European Painters and Sculptors*, exhibition catalog (New York: The Museum of Modern Art, 1955), 63; cited in Hugh Davies and Sally Yard, *Francis Bacon* (New York: Abbeville, 1986), 109.

46. Francis Bacon, May 1966, in Sylvester, *Interviews with Francis Bacon*, 30–2.

47. Francis Bacon, April 3, 1973, interviewed by Hugh Davies; in Davies and Yard, *Francis Bacon*, 106–7, n. 83.

48. Francis Bacon, October 1962, in Sylvester, *Interviews with Francis Bacon*, 12.

49. Francis Bacon, May 1966, ibid., 56.

50. Francis Bacon, October 1973, ibid., 92.

51. Francis Bacon, May 1966, ibid., 56.

Chapter 6

1. Antoni Tàpies, *Memória Personal* (Barcelona: Editorial Crítica, 1977), 184; cited in Manuel J. Borja-Villel, *Fundació Antoni Tàpies* (Barcelona: Fundació Antoni Tàpies, 1990), 32.

2. Lucio Fontana, *Manifesto Blanco*, Buenos Aires, 1946; cited in Yve-Alain Bois, "Fontana's Base Materialism," *Art in America* (April 1989): 244. The manifesto is anthologized as "The White Manifesto" in Charles Harrison and Paul Wood, eds., *Art in Theory: 1900–1990* (Oxford: Blackwell Publishers, 1992).

3. Cited in Harold Rosenberg, *Barnett Newman* (New York: Harry N. Abrams, 1978), 27–9.

4. Elaine de Kooning, "Subject: What, How or Who?" *Artnews* (April 1955); cited in Irving Sandler, *The New York School: The Painters and Sculptors of the Fifties* (New York: Harper & Row, 1978), 55.

5. Friedel Dzubas, statement, in Irving Sandler, "Is There a New Academy?" Part II, *Artnews* (September 1959): 37.

6. Clement Greenberg, " 'American Type' Painting," *Partisan Review* (spring); reprinted in Clement Greenberg, *Art and Culture* (Boston: Beacon Press, 1967), 208.

7. Barbara Rose, in William C. Seitz, moderator, *Art Criticism in the Sixties*, A Symposium of The Poses Institute of Fine Arts, Brandeis University (New York: October House, 1967), unpaginated.

8. William S. Rubin, "Younger American Painters," *Art International* 1 (1960): 20; cited in Irving Sandler, *American Art of the 1960s* (New York: Harper & Row, 1988), 17.

9. Clement Greenberg, "Modernist Painting," *Arts Yearbook* no. 4 (1961); reprinted in Gregory Battcock, ed., *The New Art* (New York: E. P. Dutton, 1966), 101–2.

10. Sandler, *American Art of the 1960s*, 118.

11. Kenworth Moffett, "Pop Art: Two Views," *Artnews* (May 1974): 31; cited in Sandler, *American Art of the 1960s*, 127, n. 60.

12. Michael Fried, in William C. Seitz, moderator, *Art Criticism in the Sixties*, unpaginated.

13. Michael Fried, "Modernist Painting and Formalist Criticism," *The American Scholar* (autumn 1964): 648; cited in Sandler, *American Art of the 1960s*, 50.

14. Rosalind Krauss, "A View of Modernism," *Artforum* (September 1972): 49–50; cited in Sandler, *American Art of the 1960s*, 48.

15. Sandler, *American Art of the 1960s*, 128, n. 61.

16. He was publicly taken to task for this by many historians and critics. For example, see Rosalind Krauss, "Changing the Work of David Smith," *Art in America* (September/October 1974): 31–4.

17. Diane Upright Headley, *Morris Louis: The Mature Paintings 1954–1962*, Ph.D. diss., University of Michigan, 1976, 50, n. 78; cited in Sandler, *American Art of the 1960s*, 140, n. 4.

18. Michael Fried, "Some Notes on Morris Louis," *Arts Magazine* (November 1963): 25; cited in Sandler, *American Art of the 1960s*, 29.

19. Michael Fried, "New York Letter," *Art International* (May 25, 1963): 69; cited in Sandler, *American Art of the 1960s*, 30.

20. Harold Rosenberg, conversation with the author in 1977. The quotation by itself later appeared in Rosenberg, *Barnett Newman*, 21.

21. Constant, cited in Jean-Clarence Lambert, *Cobra* (New York: Abbeville, 1984), 82.

22. Pierre Alechinsky, cited in Lambert, *Cobra*, 183.

23. Pierre Alechinsky, "Abstraction faite," *Cobra* 10; cited in Lambert, *Cobra*, 186.

24. Lucian Freud, quoted in Lawrence Gowing, *Lucian Freud* (London: Thames & Hudson, 1982), 190–1.

25. Robert Hughes, *Lucian Freud: Paintings* (New York: Thames & Hudson, 1987), 7.

26. Elaine de Kooning, "Subject: What, How or Who?" *Artnews* (April 1955): 26 and 27 respectively; cited in

516

Notes

Irving Sandler, *The New York School: The Painters and Sculptors of the Fifties* (New York: Harper & Row, 1978), 96.

27. He saw the work of the abstract expressionists but he never actually met Pollock or de Kooning, according to Mme. Armande Trentinian (Director of the Fondation Dubuffet, in an interview with Jonathan Fineberg, October 1987); his interests lay more with surrealists like Tanguy, whom he did meet and with whom he became friendly.

28. Leon Golub, Bloomington, Indiana, March 1959; cited in Peter Selz, *New Images of Man*, exhibition catalog. The Museum of Modern Art (Garden City, N.Y.: Doubleday, 1959), 76.

29. An idea frequently repeated by Rauschenberg, see for example G. R. Swenson, "Rauschenberg Paints a Picture," *Artnews* (April 1963): 46.

Chapter 7

1. Allen Ginsberg, *Howl and Other Poems* (San Francisco: City Lights Pocket Bookshop, 1956), 9, 14.
2. Lawrence Ferlinghetti, "Dog," in Lawrence Ferlinghetti, *A Coney Island of the Mind* (New York: New Directions, 1955), 67–8.
3. Harold Rosenberg, "The Herd of Independent Minds," *Commentary* (September 1948); reprinted in Harold Rosenberg, *Discovering the Present* (Chicago: University of Chicago Press, 1973), 28.
4. Marshall McLuhan, *The Mechanical Bride, Folklore of the Industrial Man* (New York: Vanguard Press, 1951), v.
5. Ibid., 3.
6. Ferlinghetti, *A Coney Island of the Mind*, 1955.
7. Cited in many places; see for example Jill Johnston, "Tracking the Shadow," *Art in America* (October 1987): 135.
8. John Cage, an address to the convention of the Music Teachers National Association in Chicago, 1957; reprinted in *Silence* (Cambridge, Mass.: MIT Press, 1966), 10.
9. John Cage, cited in Harvey Stein, *Artists Observed* (New York: Harry N. Abrams, 1986), 93.
10. Merce Cunningham, *Dance in America*, transcript of a program for WNET/13, New York, 1978, 2–3; cited by Melissa Harris in a senior art history thesis on the Merce Cunningham Dance Company written under the direction of Jonathan Fineberg at Yale University, April 1982.
11. Martin Duberman, *Black Mountain: An Exploration in Community* (New York: E. P. Dutton, 1972), 277.
12. Ibid., 278.
13. Ibid., 352–4.
14. John Cage, quoted in Calvin Tomkins, *The Bride and the Bachelors* (New York: Viking, 1965), 75.
15. See Shinichiro Osaki, "Body and Place: Action in Postwar Art in Japan," in Paul Schimmel, ed., *Out of Actions: between Performance and the Object, 1949–1979* (Los Angeles: The Museum of Contemporary Art; and London: Thames & Hudson, 1988).
16. See Paul Schimmel, "Leap Into the Void: Performance and the Object," in Paul Schimmel, ed., *Out of Actions: between Performance and the Object, 1949–1979* (Los Angeles: The Museum of Contemporary Art; and London: Thames & Hudson, 1998), 24.
17. Ray Falk, "Japanese Innovators," *New York Times*, December 8, 1957, section 2, 24.
18. According to Allan Kaprow, *Assemblage, Environments, and Happenings* (New York: Harry N. Abrams, 1966), 212.
19. William S. Burroughs, *Naked Lunch* (New York: Grove Press, 1959), 221.
20. Robert Rauschenberg, interviewed in Barbara Rose, *An Interview with Robert Rauschenberg* (New York: Elizabeth Avedon Editions, Vintage, 1987), 72.
21. Ibid., 53.
22. Some art historians have attempted to "read" these objects in Rauschenberg's work as a systematic iconography. Kenneth Bendiner, for example, argued in 1982 that *Canyon* of 1959 was a homoerotic reinterpretation of Rembrandt's *Ganymede* and in an article of 1977 Charles Stuckey turned all the images in *Rebus* of 1955 into words through free association and then attempted to "read" them like a sentence. Lisa Wainwright has successfully followed specific trains of association through sequences of permutations. See Kenneth Bendiner, "Robert Rauschenberg's 'Canyon,' " *Arts Magazine* (June 1982): 57–9; Charles F. Stuckey, "Reading Rauschenberg," *Art in America* (March/April 1977): 82–3; Lisa Susan Wainwright, *Reading Junk: Thematic Imagery in the Art of Robert Rauschenberg from 1952 to 1964*, unpublished doctoral dissertation, University of Illinois at Urbana-Champaign, 1993. Two other provocative essays on the meaning of the imagery in Rauschenberg's work are: Roger Cranshaw and Adrian Lewis, "Re-Reading Rauschenberg," *Artscribe*, no. 29 (London, June 1981): 44–51; and Graham Smith, "Robert

Rauschenberg's 'Odalisque,' " *Wallraff-Richartz Jahrbuch*, 44 (Köln, 1983): 375–82.
23. Dorothy Gees Seckler, "The Artist Speaks: Robert Rauschenberg," *Art in America* (May/June 1966): 81.
24. See Lisa Susan Wainwright, *Reading Junk: Thematic Imagery in the Art of Robert Rauschenberg from 1952 to 1964*.
25. Cited in Duberman, *Black Mountain*, 346.
26. Seckler, "The Artist Speaks: Robert Rauschenberg," 76.
27. Calvin Tomkins, *Off the Wall: Robert Rauschenberg and the Art World of Our Time* (Garden City, N.Y.: Doubleday, 1980), 72.
28. Robert Rauschenberg, quoted in Andrew Forge, *Rauschenberg* (New York: Harry N. Abrams, 1972), 10.
29. Robert Rauschenberg, interviewed in Rose, *An Interview with Robert Rauschenberg*, 50.
30. Seckler, "The Artist Speaks: Robert Rauschenberg," 76.
31. Robert Rauschenberg, statement, in Dorothy C. Miller, ed., *Sixteen Americans*, exhibition catalog, The Museum of Modern Art (Garden City, N.Y.: Doubleday, 1959), 58.
32. John Cage, an address to the convention of the Music Teachers National Association in Chicago, 1957; reprinted in *Silence*, 12.
33. Robert Rauschenberg, in an interview with Dorothy Seckler, December 21, 1965, transcript from the Archives of American Art, cited in Lisa Susan Wainwright, *Reading Junk: Thematic Imagery in the Art of Robert Rauschenberg from 1952 to 1964*, 16.
34. Michael Newman, "Rauschenberg Re-evaluated," *Art Monthly* (London, June 1981): 9.
35. Robert Rauschenberg, interviewed in Rose, *An Interview with Robert Rauschenberg*, 96.
36. Robert Rauschenberg, cited in G. R. Swenson, "Rauschenberg Paints a Picture," *Artnews* (April 1963): 46.
37. Robert Rauschenberg, in Jeanne Siegel, *Artwords: Discourse on the 60s and 70s* (Ann Arbor, Mich.: UMI Research Press, 1985), 155.
38. According to Ileana Sonnabend, who was married to Leo Castelli at the time and later became Rauschenberg's dealer in her own gallery. Ileana Sonnabend, conversation with the author, September 8, 1988.
39. See Dore Ashton, *Rauschenberg: XXXIV Drawings for Dante's Inferno* (New York: Harry N. Abrams, 1964); and Jerry Saltz, "Notes on a Drawing," *Arts Magazine* (November 1988): 19–22.
40. Robert Rauschenberg, talking about *Broadcast* of 1959, in Swenson, "Rauschenberg Paints a Picture," 45.
41. Tomkins, *The Bride and the Bachelors*, 204, 232.
42. Robert Rauschenberg, interviewed in Rose, *An Interview with Robert Rauschenberg*, 85.
43. Robert Rauschenberg, in Robert Hughes, *The Shock of the New* (New York: Alfred A. Knopf, 1981), 345; cited in Mary Lynn Kotz, *Robert Rauschenberg: Art and Life* (New York: Harry N. Abrams, 1990), 99.
44. Robert Rauschenberg, interviewed in Rose, *An Interview with Robert Rauschenberg*, 74.
45. Robert Rauschenberg, cited in Swenson, "Rauschenberg Paints a Picture," 67.
46. Robert Hughes, "The Most Living Artist," *Time* (November 29, 1976), 54.
47. John Cage, an address to the convention of the Music Teachers National Association in Chicago, 1957; reprinted in *Silence*, 12.
48. Richard Stankiewicz, remarks made on a panel at "The Club," on March 25, 1955 as recorded by Irving Sandler; cited in Irving Sandler, *The New York School: The Painters and Sculptors of the Fifties* (New York: Harper & Row, 1978), 147.
49. For a fuller discussion of the term see William C. Seitz, *The Art of Assemblage*, exhibition catalog, The Museum of Modern Art (Garden City, N.Y.: Doubleday, 1961), 93, 150, n. 5.
50. John Cage, an address to the convention of the Music Teachers National Association in Chicago, 1957; reprinted in *Silence*, 12.
51. Allan Kaprow, "The Legacy of Jackson Pollock," *Artnews* (October 1958): 26.
52. Ibid., 56–7.
53. Michael Kirby and Richard Schechner, "An Interview with John Cage," *Tulane Drama Review*, 10 (winter 1965), 55; cited in Sandler, *The New York School*, 13, n. 37.
54. Allan Kaprow, cited in Michael Kirby, *Happenings: An Illustrated Anthology* (New York: E. P. Dutton, 1965), 48.
55. Allan Kaprow, "'Happenings' in the New York Scene," *Artnews* (May 1961): 59.
56. Claes Oldenburg, transcript from a panel entitled "New Uses of the Human Image in Painting," Judson Gallery, December 2, 1959, Judson Memorial Church Archives, N.Y.; cited in Barbara Haskell, *Blam! The Explosion of Pop, Minimalism, and Performance 1958–1964*, exhibition catalog, Whitney Museum of American Art (New York: W. W. Norton and Co., 1984), 27.
57. Haskell, *Blam! The Explosion of Pop*, 27.

58. Jim Dine, in Kirby, *Happenings: An Illustrated Anthology*, 188.
59. Claes Oldenburg as cited in Tomkins, *Off the Wall*, 154.
60. Haskell, *Blam! The Explosion of Pop*, 64.
61. As reported by Haskell, *Blam! The Explosion of Pop*, 53.
62. Robert Watts, cited in René Block, "Fluxus and Fluxism in Berlin 1964–1976," in Kynaston McShine, ed., *Berlinart 1961–1987* (New York: Museum of Modern Art; Munich: Prestel Verlag, 1987), 66.
63. George Segal, in Henry Geldzahler, "An Interview with George Segal," *Artforum* (November 1964): 26.
64. Jim Dine, in John Green, "All Right Jim Dine, Talk!" *World Journal Tribune, Sunday Magazine*, November 20, 1966, 34.
65. Claes Oldenburg, notebook entry of 1961; cited in Barbara Rose, *Claes Oldenburg*, exhibition catalog, The Museum of Modern Art (Greenwich, Conn.: New York Graphic Society, 1970), 48.
66. Claes Oldenburg; cited in Rose, *Claes Oldenburg*, 30.
67. Claes Oldenburg, notebook entry, December 1–7, 1960; cited in Claes Oldenburg and Emmet Williams, *Store Days* (New York: Something Else Press, 1967), 65.
68. Claes Oldenburg, notebook entry, 1960; cited in Rose, *Claes Oldenburg*, 62.
69. Claes Oldenburg, notebook entry, 1962; ibid., 192.
70. Claes Oldenburg, ibid., 154.
71. Claes Oldenburg, notebook entry, 1960; ibid., 189.
72. Claes Oldenburg, ibid., 46.
73. Claes Oldenburg, ibid., 31.
74. Claes Oldenburg, ibid., 31.
75. Claes Oldenburg, "Extracts from the Studio Notes (1962–64)," *Artforum* (January 1966): 33; cited in Ellen H. Johnson, *Claes Oldenburg*, Penguin New Art 4 (Baltimore, 1971), 20.
76. Claes Oldenburg, notebook entry; in Oldenburg and Williams, *Store Days*, 60.
77. Claes Oldenburg, notebook entry, New York, 1961; cited in Coosje van Bruggen, *Claes Oldenburg: Mouse Museum/Ray Gun Wing* (Köln: Museum Ludwig, 1979), 16.
78. Claes Oldenburg, cited in Rose, *Claes Oldenburg*, 69.
79. Claes Oldenburg, summer 1963; ibid., 92.
80. Claes Oldenburg, notebook entry, 1966; ibid., 189.
81. Claes Oldenburg, "America: War & Sex, Etc.," *Arts Magazine* (summer 1967): 36.
82. Claes Oldenburg, notebooks; in Oldenburg and Williams, *Store Days*, 62.
83. Claes Oldenburg; cited in Martin Friedman, *Oldenburg: Six Themes*, exhibition catalog (Minneapolis: Walker Arts Center, 1975), 14.
84. Claes Oldenburg interview with Paul Carroll, August 22, 1968; in Claes Oldenburg, *Proposals for Monuments and Buildings 1965–9* (Chicago: Big Table Publishing Co., 1969), 14.
85. Claes Oldenburg, quoted in the *St. Paul Pioneer Press*, May 18, 1974, 6; reproduced in *Claes Oldenburg: Log May 1974–August 1976* (Stuttgart and New York: Presslog, 1976), unpaginated.
86. The "scripts" for this and other Oldenburg performances were published in Claes Oldenburg, *Raw Notes* (Halifax, N.S.: Press of the Nova Scotia College of Art and Design; distributed in U.S. by Jaap Rietman, 1973).
87. Marshall McLuhan, *Understanding Media: The Extension of Man* (New York: McGraw-Hill, 1965), 7.
88. John Ciardi, *How Does a Poem Mean?* 2d ed. (first published in 1959) (Boston: Houghton Mifflin, 1975), 6.
89. In particular see Joan Carpenter, "The Infra-Iconography of Jasper Johns," *Art Journal*, 36/3 (spring 1977): 221–7.
90. Jasper Johns in Walter Hopps, "An Interview with Jasper Johns," *Artforum* (March 1965): 33.
91. Jasper Johns interviewed by Leo Steinberg in Leo Steinberg, "Jasper Johns: the First Seven Years of His Art," 1962; in *Other Criteria* (New York: Oxford University Press, 1972), 32.
92. David Sylvester, "Interview," in *Jasper Johns: Drawings* (London: Arts Council of Great Britain, 1974), 19.
93. Jasper Johns, cited in "His Heart Belongs to Dada," *Time*, 73 (May 4, 1959): 58.
94. Michael Crichton, *Jasper Johns* (New York: Harry N. Abrams, 1977), 66, n. 18.
95. Tatyana Grosman, cited in Crichton, *Jasper Johns*, 19.
96. Jasper Johns, in Crichton, *Jasper Johns*, 27.
97. Jasper Johns in Vivian Raynor, "Jasper Johns: 'I have attempted to develop my thinking in such a way that the work I've done is not me,' " *Artnews* (March 1973): 22.
98. Entry of April 3, 1970 in unpublished journal by Roberta Bernstein, cited in Roberta Bernstein, *Jasper Johns' Paintings and Sculptures 1954–1974: "The Changing Focus of the Eye"* (Ann Arbor, Mich.: UMI Research Press, 1985), 21.
99. Jasper Johns, cited in Crichton, *Jasper Johns*, 46.
100. Jasper Johns in Hopps, "An Interview with Jasper Johns," 36.
101. Jasper Johns, in G. R. Swenson, "What is Pop Art? Part

II: Jasper Johns," *Artnews*, 62, no. 10 (February 1964): 66.

102. Richard S. Field, *Jasper Johns: Prints 1970–1977*, exhibition catalog (Middletown, Conn.: Wesleyan University, 1978), 33, n. 14.

103. René Magritte, "Les Mots et les images," 1929, cited in Suzi Gablik, *Magritte* (Greenwich, Conn.: New York Graphic Society, 1970), 138–40.

104. Ludwig Wittgenstein, *Philosophical Investigations*, trans. G. E. M. Anscombe (Oxford, 1953), 19e, no. 38; cited in Bernstein, *Jasper Johns' Paintings and Sculptures 1954–1974: "The Changing Focus of the Eye"*, 94.

105. Ludwig Wittgenstein, *The Blue and Brown Books* (Oxford, 1958), 39; cited in Bernstein, *Jasper Johns' Paintings and Sculptures 1954–1974: "The Changing Focus of the Eye"*, 94.

106. Sylvester, "Interview," in *Jasper Johns: Drawings*, 16–17.

107. Bernstein, *Jasper Johns' Paintings and Sculptures 1954–1974: "The Changing Focus of the Eye"*, 108.

108. Roger Cranshaw and Adrian Lewis, "Re-Reading Rauschenberg," *Artscribe*, no. 29 (London, June 1981): 49; they cite Johns as quoted in Brian O'Doherty, *American Masters* (New York: Random House, 1973), 202.

109. Hart Crane, "Cape Hatteras," cited in Alan R. Solomon, "Jasper Johns," *Jasper Johns*, exhibition catalog, Jewish Museum (New York, 1964), 16.

110. Philip Horton, *Hart Crane: The Life of an American Poet* (New York: Viking, 1957), 302; cited in Bernstein, *Jasper Johns' Paintings and Sculptures 1954–1974: "The Changing Focus of the Eye"*, 109.

111. Crichton, *Jasper Johns*, 50.

112. Jasper Johns, in John Coplans, "Fragments According to Johns, An Interview with Jasper Johns," *Print Collector's Newsletter*, vol. 3, no. 2 (May/June 1972): 29–32; cited in Field, *Jasper Johns: Prints 1970–1977*, 35, n. 27.

113. Jasper Johns, statement, in Dorothy C. Miller, ed., *Sixteen Americans*, exhibition catalog, The Museum of Modern Art (Garden City, N.Y.: Doubleday, 1959), 22.

114. Sylvester, "Interview," in *Jasper Johns: Drawings*, 9.

115. "Interview with Jasper Johns," in Christian Geelhaar, *Jasper Johns: Working Proofs* (London: Petersburg Press, 1980), 39.

116. Sylvester, "Interview," in *Jasper Johns: Drawings*, 13–14.

117. Marcel Duchamp, *The Bride Stripped Bare By Her Bachelors, Even*, a typographic version by Richard Hamilton of Marcel Duchamp's *Green Box*, trans. George H. Hamilton, New York, 1960; cited by Johns in a review of this book: Jasper Johns, "Duchamp's *Green Box*," *Scrap I*, New York (December 23, 1960): 4.

118. Peter Fuller, "Jasper Johns Interviewed: II," *Art Monthly*, no. 19, London (September 1978): 7; cited in Mark Rosenthal, *Jasper Johns: Work Since 1974*, exhibition catalog (Philadelphia: Philadelphia Museum of Art, 1988), 60.

119. Judith Goldman, *Jasper Johns: The Seasons*, exhibition catalog (New York: Leo Castelli Gallery, 1987), unpaginated.

120. Cited in Jill Johnston, "Tracking the Shadow," *Art in America* (October 1987): 135.

121. Jasper Johns, letter to the author, September 20, 1994.

122. Sylvester, "Interview," in *Jasper Johns: Drawings*, 14.

Chapter 8

1. This is discussed in careful detail in Thomas McEvilley, "Yves Klein: Conquistador of the Void," *Yves Klein 1928–1962: A Retrospective* (Houston: Institute for the Arts, Rice University; New York: Arts Publisher, 1982); and in his "Yves Klein and Rosicrucianism," in the same catalog.

2. Yves Klein, cited in McEvilley, "Yves Klein: Conquistador of the Void," 48.

3. Pierre Restany, *Yves Klein*, trans. John Shepley (New York: Harry N. Abrams, 1982), 22.

4. Yves Klein, cited in Restany, *Yves Klein*, 47.

5. Restany, *Yves Klein*, 49.

6. McEvilley, "Yves Klein: Conquistador of the Void," 50.

7. Nan Rosenthal, "Assisted Levitation: The Art of Yves Klein," *Yves Klein 1928–1962: A Retrospective* (Houston: Institute for the Arts, Rice University; New York: Arts Publisher, 1982), 119.

8. Yves Klein, "Truth Becomes Reality," trans. Thomas McEvilley, in *Yves Klein 1928–1962: A Retrospective* (Houston: Institute for the Arts, Rice University; New York: Arts Publisher, 1982), 229–30.

9. Yves Klein, cited in Restany, *Yves Klein*, 90.

10. Rotraut Klein-Moquay, cited in McEvilley, "Yves Klein: Conquistador of the Void," 62.

11. Jean Tinguely, cited in McEvilley, "Yves Klein: Conquistador of the Void," 48.

12. Ibid., 27.

13. Calvin Tomkins, *The Bride and the Bachelors* (New York: Viking Press, 1965), 173.

14. Ibid., 180.

15. Marcel Duchamp, cited in Tomkins, *The Bride and the Bachelors*, 15.

16. Joseph Beuys, cited in Caroline Tisdall, *Joseph Beuys*, exhibition catalog (New York: Solomon R. Guggenheim Museum, 1979), 21.

17. See John Anthony Thwaites, "The Ambiguity of Joseph Beuys," *Art and Artists*, vol. 6, no. 7, issue 67 (November 1971): 22; and Willoughby Sharp, "An Interview with Joseph Beuys," *Artforum* 8 (December 1969): 43.

18. Joseph Beuys, cited in Tisdall, *Joseph Beuys*, 17.

19. Joseph Beuys, in Nick Serota, *Joseph Beuys: The Secret Block for a Secret Person in Ireland*, exhibition catalog (Oxford: The Museum of Modern Art, 1974), unpaginated.

20. Joseph Beuys, cited in John Russell, "The Shaman as Artist," *New York Times Magazine* (October 28, 1979), 95.

21. Joseph Beuys, cited in Tisdall, *Joseph Beuys*, 18.

22. Ibid., 7.

23. Joseph Beuys, cited in John Russell, "The Shaman as Artist," 103.

24. Beuys as a practitioner of the occult and in particular his connection with Steiner has been explored at length (if not sympathetically) in J. F. Moffitt, *Occultism in Avant-Garde Art: The Case of Joseph Beuys* (Ann Arbor, Mich.: UMI Research Press, 1988).

25. Joseph Beuys, in George Jappe, "Joseph Beuys soll gehen. Soll er?" *FAZ* (November 28, 1969); cited in Irene Von Zahn, "By Way of Introduction," in *Some artists, for example Joseph Beuys*, exhibition catalog (Riverside: University of California, 1975), unpaginated.

26. Joseph Beuys, cited in Tisdall, *Joseph Beuys*, 94–5.

27. Ibid., 7.

28. Ibid., 10.

29. Reyner Banham, *The New Brutalism* (New York, 1966).

30. Lawrence Alloway, "The Long Front of Culture," *Cambridge Opinion*, 17, 1959, in John Russell and Suzi Gablik, *Pop Art Redefined* (London, 1969): 41.

31. Reyner Banham, "Vehicles of Desire," *Art*, no. 1 (September 1955): 3; cited in *Modern Dreams: The Rise and Fall of Pop*, exhibition catalog (New York: The Institute for Contemporary Art, 1988), 66.

32. Alison and Peter Smithson, "But Today We Collect Ads," *Ark*, no. 18 (November 1956); reprinted in *Modern Dreams*, 57.

33. Commentary by Richard Hamilton, in *Richard Hamilton*, exhibition catalog (New York: Solomon R. Guggenheim Museum, 1973), 24.

34. Richard Hamilton, note from 1956, cited in *Richard Hamilton*, 24.

35. See Simon Frith and Howard Horne, *Art into Pop*, London, 1987).

36. David Hockney, cited in Marco Livingstone, *David Hockney* (New York: Thames & Hudson, 1988), 40.

37. David Hockney, in Nikos Stangos, ed., *David Hockney by David Hockney* (New York: Harry N. Abrams, 1977), 61.

38. David Hockney, in Stangos, *David Hockney by David Hockney*, 93.

39. David Hockney, quoted in Lawrence Weschler, *Cameraworks: David Hockney* (New York: Alfred A. Knopf, 1984), 11.

40. Gert Schiff, "A Moving Focus: Hockney's Dialogue With Picasso," in *David Hockney: A Retrospective*, exhibition catalog (Los Angeles: Los Angeles County Museum of Art, 1988).

Chapter 9

1. William L. O'Neill, *Coming Apart: An Informal History of America in the 1960s* (Chicago: Quadrangle Books, 1977), and in Sandler, *American Art of the 1960s* (New York: Harper & Row), 81.

2. Claude Lévi-Strauss, "The Structural Study of Myth," in *Structural Anthropology* (New York: Basic Books, 1963), 217. This is also at the heart of Lévi-Strauss's critique of Sartre; see Claude Lévi-Strauss, *The Savage Mind* (London: Weidenfeld & Nicolson, 1966), 253ff.

3. Allan Kaprow, "Should the Artist Become a Man of the World?" *Artnews*, vol. 63 (October 1964): 34.

4. John Carlin and Sheena Wagstaff, "Beyond the Pleasure Principle: Comic Quotation in Contemporary American Painting," *The Comic Art Show*, exhibition catalog, Whitney Museum of American Art (New York: Fantagraphics Books, 1983), 55.

5. Tom Wesselmann, in G. R. Swenson, "What is Pop Art? Part II: Jasper Johns," *Artnews*, vol. 62, no. 10 (February 1964): 41.

6. *Time*, vol. 80 (October 12, 1962): 85; cited in Sidra Stich, *Made in USA*, exhibition catalog, University Art Museum, University of California (Berkeley and Los Angeles: University of California Press, 1987), 89.

7. Adam Gopnik, "The Art World: The Innocent," *New Yorker* (April 10, 1989): 109.

8. Andy Warhol in *Andy Warhol* exhibition catalog (Stockholm: Moderna Museet, 1968), unpaginated.

9. According to Benjamin Buchloh, "Andy Warhol's One-Dimensional Art: 1956–1966," in Kynaston McShine, ed., *Andy Warhol: A Retrospective*, exhibition catalog (New York: The Museum of Modern Art, 1989), 39.

10. According to Warhol, in Barry Blinderman, "Modern Myths: An Interview With Andy Warhol," *Arts Magazine*, vol. 56 (October 1981): 145; cited in Marco Livingstone, "Do It Yourself: Notes On Warhol's Techniques," in McShine, *Andy Warhol*, 66.

11. Andy Warhol and Pat Hackett, *Popism: The Warhol 60s* (New York: Harcourt Brace Jovanovich, 1980), 7.

12. Cited in ibid., 16.

13. Ibid., 7.

14. Andy Warhol, *The Philosophy of Andy Warhol* (New York: Harcourt Brace Jovanovich, 1975), 100–1.

15. Kynaston McShine, "Introduction," in McShine, *Andy Warhol*, 14–15.

16. Irving Blum gave an engaging account in Laura de Coppet and Alan Jones, *The Art Dealers* (New York: Potter; distributed by Crown, 1984), 150–8.

17. Isabel Eberstadt, in Jean Stein, ed. with George Plimpton, *Edie: An American Biography* (New York: Alfred A. Knopf, 1982), 208.

18. Andy Warhol, in Gene Swenson, "What Is Pop Art?" Part I, *Artnews*, vol. 62 (November 1963): 26.

19. Warhol, *Andy Warhol*, unpaginated.

20. Warhol, *Philosophy of Andy Warhol*, 7.

21. Warhol and Hackett, *Popism*, 50.

22. Warhol, *Andy Warhol*, unpaginated.

23. Henry Geldzahler, in Stein, *Edie*, 201.

24. Warhol and Hackett, *Popism*, 133.

25. Emile de Antonio, in Stein, *Edie*, 239.

26. Henry Geldzahler, in Patrick S. Smith, *Warhol: Conversations About The Artist* (Ann Arbor, Mich.: UMI Research Press, 1988), 185.

27. Calvin Tomkins, *Off the Wall: Robert Rauschenberg and the Art World of Our Time* (Garden City, N.Y.: Doubleday, 1980), 261.

28. Warhol and Hackett, *Popism*, 110.

29. Warhol, *Philosophy of Andy Warhol*, 92.

30. Tomkins, *Off the Wall*, 260–1.

31. Warhol and Hackett, *Popism*, 24.

32. Brigid Polk, *Time* (October 17, 1969): 48.

33. Andy Warhol, in Phyllis Tuchman, "Pop!: Interviews with George Segal, Andy Warhol, Roy Lichtenstein, James Rosenquist, and Robert Indiana," *Artnews*, vol. 73 (May 1974): 26. See also Livingstone, "Do It Yourself," 77, n. 9; and Warhol and Hackett, *Popism*, 248, in which Warhol explains that his assistant's remark was a deliberately outrageous joke.

34. See Trevor Fairbrother, "Warhol Meets Sargent at Whitney," *Arts Magazine*, vol. 61 (February 1987): 71, n. 12.

35. Warhol, *Philosophy of Andy Warhol*, 91.

36. Warhol, *Andy Warhol*, unpaginated.

37. Warhol, *Philosophy of Andy Warhol*, 146.

38. Warhol, *Andy Warhol*, exhibition catalog, Kunsthaus (Zurich, 1978): 106.

39. Roy Lichtenstein, in Bruce Glaser, "Oldenburg, Lichtenstein, Warhol: A Discussion," *Artforum* (February 1966): 22.

40. Roy Lichtenstein, in Lawrence Alloway, *Roy Lichtenstein* (New York: Abbeville, 1983), 105–6.

41. Roy Lichtenstein, in Swenson, "What is Pop Art?" Part I, 62.

42. Roy Lichtenstein, in Diane Waldman, *Roy Lichtenstein* (New York: Chelsea House, 1971), 25.

43. Roy Lichtenstein, in Alloway, *Roy Lichtenstein*, 106.

44. Roy Lichtenstein, in Swenson, "What is Pop Art?" Part I, 63.

45. Roy Lichtenstein, in Glaser, "Oldenburg, Lichtenstein, Warhol: A Discussion," 23.

46. James Rosenquist, in Judith Goldman, *James Rosenquist* (Denver: Denver Art Museum; New York: Viking Penguin, 1985), 13.

47. James Rosenquist, in G. R. Swenson, "What is Pop Art?" Part II, *Artnews*, vol. 62 (February 1964): 63.

48. James Rosenquist, in G. R. Swenson, "The new American 'Sign Painters,'" *Artnews*, vol. 61 (September 1962): 61.

49. James Rosenquist, in Goldman, *James Rosenquist*, 16.

50. Ibid., 27–8.

51. Ibid., 35.

52. James Rosenquist, cited in John Rublowsky, *Pop Art* (New York: Basic Books, 1965), 93.

53. James Rosenquist, "Art: Pop: Bing Bang Landscapes," *Time*, vol. 28 (May 1965): 80; cited in Sandler, *American Art of the 1960s*, 162.

54. See David McCarthy, "H. C. Westermann's *Brinksmanship*," *American Art*, vol. 10, no. 3 (fall 1996), 50–69.

55. H. C. Westermann, letter to Tom Armstrong, May 3,

Notes

1978; in Bill Barrette, ed., *Letters from H. C. Westermann* (New York: Timken, 1988), 163.

56. Peter Saul, letter to Allan Frumkin, Mill Valley, California, 1972; in *Peter Saul: New Paintings and Works On Paper* (New York: Allan Frumkin Gallery, 1988), unpaginated.

57. Ibid., unpaginated.

58. Ibid., unpaginated.

59. Peter Saul, letter to Allan Frumkin, Mill Valley, California, 1967; cited in *Peter Saul: New Paintings and Works On Paper*, unpaginated.

60. Peter Saul, letter to Allan Frumkin, Mill Valley, California, 1966; in *Peter Saul: New Paintings and Works On Paper*, unpaginated.

61. Peter Saul, letter to Allan Frumkin, Mill Valley, California, 1972; in *Peter Saul: New Paintings and Works On Paper*, unpaginated.

62. Whitney Halstead, "Made in Chicago," in *Made In Chicago*, exhibition catalog (Washington, D.C.: National Collection of Fine Arts, Smithsonian Institution, 1974), 14.

63. Roger Brown, in Sidney Lawrence, *Roger Brown*, exhibition catalog (Washington, D.C.: Hirshhorn Museum and Sculpture Garden, Smithsonian Institution, 1987), 93.

64. See Robert George Reisner, "The Parlance of Hip," in *The Jazz Titans* (Garden City, N.Y.: Doubleday, 1960), 156.

65. Jess, cited in Michael Auping, *Jess: Paste-Ups (and Assemblies) 1951–1983*, exhibition catalog (Sarasota, Fla.: John and Mabel Ringling Museum of Art, 1983), 10; cited in Stich, *Made in U.S.A.*, 147.

66. Peter Voulkos, cited in Thomas Albright, *Art in the San Francisco Bay Area 1945–1980* (Berkeley and Los Angeles: University of California Press, 1985), 135.

67. William Wiley, in Albright, *Art in the San Francisco Bay Area 1945–1980*, 119.

68. John Donne, *Devotions upon Emergent Occasions* [1624], no. 17.

69. See Graham W. J. Beal, "The Beginner's Mind," in Graham W. J. Beal and John Perrault, *Wiley Territory*, exhibition catalog (Minneapolis: Walker Art Center, 1979), 25ff.

70. Stuart Morgan, "The Hard Way," in James Lingwood, et al., *Vija Celmins: Works 1964–1996* (London: Institute of Contemporary Arts, 1996), 77.

71. Robert Arneson, in Chiori Santiago, "Portrait of Bob," in *The Museum of California*, vol. 10, no. 4 (January/February 1987): 6.

72. Robert Arneson, transcript of a tape-recorded conversation with Maddie Jones, 1978, Archives of American Art, unpaginated; cited in Neal Benezra, *Robert Arneson: A Retrospective* exhibition catalog (Des Moines: Des Moines Art Center, 1985), 23.

73. Robert Arneson, telephone conversation with Jonathan Fineberg, June 27, 1990.

74. Robert Arneson, transcript of a tape-recorded conversation with Maddie Jones, 1978, Archives of American Art, 44–6; cited in Robert C. Hobbs, "Robert Arneson: Critic of Vanguard Extremism," *Arts Magazine* (November 1978): 89.

75. Robert Arneson, telephone conversation with Jonathan Fineberg, June 27, 1990.

76. Robert Arneson, conversation with Jonathan Fineberg at Yale University, February 3, 1981.

77. Robert Arneson, quoted in Cecile N. McCann, "About Arneson, Art and Ceramics," *Artweek* (October 26, 1974): 1; cited in Benezra, *Robert Arneson: A Retrospective*, 93, n. 30.

78. This and the following remarks come from a telephone conversation between Jonathan Fineberg and the artist on June 27, 1990, in response to the sources for the work put forward in Dennis Adrian, "Robert Arneson's Feats of Clay," *Art in America* (September 1974): 81.

79. See Benezra, *Robert Arneson: A Retrospective*, 53, 56.

80. As in the Roman *pasquinade*. See Irving Lavin, "Bernini and the Art of Social Satire," *History of European Ideas*, vol. 4, no. 4 (Oxford and New York: Pergamon, 1983), 365–420; reprinted with corrections from Irving Lavin et al., *Drawings by Gianlorenzo Bernini from the Museum der bildenden Künste, Leipzig*, exhibition catalog (Princeton: Art Museum, Princeton University, 1981).

81. Robert Arneson, telephone conversation with Jonathan Fineberg, June 27, 1990.

82. Donald B. Kuspit, "Arneson's Outrage," *Art in America* (May 1985): 135.

Chapter 10

1. Barbara Rose, "ABC Art," *Art in America* (October/November, 1965): 58.

2. Donald Judd, "Specific Objects," *Arts Yearbook 8* (1965): 74–82; reprinted in Donald Judd, *Complete Writings 1959–75* (Halifax: The Press of the Nova Scotia College of Art and Design; New York: New York University Press, 1975), 181–9. Robert Morris's term "unitary forms" conveyed roughly the same idea; see Robert Morris,

"Notes on Sculpture," Part I, *Artforum* (February 1966); reprinted in Gregory Battcock, ed., *Minimal Art* (New York: E. P. Dutton, 1968), 228.

3. Lucy R. Lippard, "New York Letter: Recent Sculpture as Escape," *Art International* (February 20, 1966): 50.

4. Hal Foster, "The Crux of Minimalism," in Howard Singerman, ed., *Individuals: A Selected History of Contemporary Art 1945–1986*, exhibition catalog (Los Angeles: Museum of Contemporary Art, 1986), 174. See also Anna Chave, "Minimalism and the Rhetoric of Power," *Arts Magazine* (January 1990): 56.

5. Donald Judd, "Kenneth Noland," *Arts Magazine* (September 1963); reprinted in Judd, *Complete Writings 1959–75*, 93.

6. Morris, "Notes on Sculpture," Part I; reprinted in Battcock, *Minimal Art*, 224.

7. Clement Greenberg, "Recentness of Sculpture," in Maurice Tuchman, ed., *American Sculpture of the Sixties*, exhibition catalog (Los Angeles: Los Angeles County Museum of Art, 1967), 25.

8. Michael Fried, "Art and Objecthood," *Artforum* (summer 1967): 20.

9. Ad Reinhardt, "Art-as-Art," *Art International* (December 20, 1962); cited in Dorothy C. Miller, *Americans 1963*, exhibition catalog (New York: The Museum of Modern Art, 1963), 82.

10. Ad Reinhardt, "Twelve Rules for a New Academy," *Artnews* (May 1957): 38; excerpted in Dorothy C. Miller, *Americans 1963*, exhibition catalog (New York: The Museum of Modern Art, 1963), 83.

11. According to Irving Sandler, *American Art of the 1960s* (New York: Harper & Row, 1988), 21.

12. Frank Stella, in William S. Rubin, *Frank Stella*, exhibition catalog (New York: The Museum of Modern Art, 1970), 12.

13. Carl Andre, "Frank Stella," in Dorothy C. Miller, *Sixteen Americans*, exhibition catalog (New York: The Museum of Modern Art, 1959), 76.

14. Brenda Richardson, *Frank Stella: The Black Paintings*, exhibition catalog (Baltimore: Baltimore Museum of Art, 1976), 3–4.

15. Michael Fried, "Frank Stella," *Towards a New Abstraction*, exhibition catalog (New York: Jewish Museum, 1963), 28; and Michael Fried, "New York Letter," *Art International* (April 25, 1964): 59.

16. Walter Darby Bannard,, "Present-Day Art and Ready-Made Styles," *Artforum* (December 1966): 30; cited in Sandler, *American Art of the 1960s*, 19.

17. Frank Stella, quoted in Bruce Glaser (interviewer) and Lucy R. Lippard (editor), "Questions to Stella and Judd," *Artnews* (September 1966): 59–9; reprinted in Battcock, *Minimal Art*, 158.

18. See Chapter 9, note 8.

19. Barbara Haskell, *Donald Judd*, exhibition catalog (New York: Whitney Museum of American Art, 1988), 21.

20. Donald Judd, "In the Galleries: Frank Stella," *Arts Magazine* (September 1962); reprinted in Judd, *Complete Writings 1959–1975*, 57.

21. Donald Judd, in John Caplans, "An Interview with Don Judd," *Artforum* (June 1971): 49.

22. Donald Judd, in Caplans, "An Interview with Don Judd," 40.

23. Tony Smith, cited in Morris, "Notes on Sculpture," Part II; reprinted in Battcock, *Minimal Art*, 228, 230.

24. Carl Andre, in Phyllis Tuchman, "An Interview with Carl Andre," *Artforum* (June 1970): 61.

25. Carl Andre, informal discussion with Jonathan Fineberg's students at Yale University in 1981.

26. Don Flavin, ". . . in daylight or cool white: an autobiographical sketch," *Artforum* (December 1965): 24.

27. For a detailed discussion of the dependence on Duchamp see Maurice Berger, *Labyrinths: Robert Morris, Minimalism, and the 1960s* (New York: Harper & Row, 1989).

28. Morris, "Notes on Sculpture," Part I; reprinted in Battcock, *Minimal Art*, 226.

29. Jonathan Fineberg, "Robert Morris Looking Back: An Interview," *Arts Magazine* (September 1980): 111, 114. See also Robert Morris, "Anti-Form," *Artforum* (April 1968): 33–5.

30. Sol LeWitt, "Paragraphs on Conceptual Art," *Artforum* (summer 1967): 80.

31. Ibid., 80.

32. For a more thorough discussion of minimalism and critical theory see Roann Barris, "Peter Eisenman and the Erosion of Truth," *20/1 Art and Culture*, vol. 1, no. 2 (spring 1990): 20–37; and Robert Morris, "Words and Images in Modernism and Postmodernism," *Critical Inquiry* 15 (winter 1989): 337–47.

33. Robert Morris, "Notes Toward a Model," from *Robert Irwin*, exhibition catalog (New York: Whitney Museum of American Art, 1977), 30.

34. Robert Irwin, cited in Jan Butterfield, "Robert Irwin: On the Periphery of Knowing," *Arts Magazine* (February 1976): 74.

35. James Turrell, in Josef Helfenstein, "First Light and Catso White," in *James Turrell; First Light*, exhibition catalog (Bern: Kunstmuseum, 1991), 11.

36. James Turrell, "Interview with James Turrell," in Julia Brown, ed., *Occluded Front: James Turrell*, exhibition catalog (Los Angeles: Museum of Contemporary Art, 1985), 41.

37. James Turrell, statement to Julia Brown, 1985, cited in Josef Helfenstein, "First Light and Catso White," in *James Turrell; First Light*, 14.

38. Ellsworth Kelly, in Harvey Stein, *Artists Observed* (New York, 1986), 46.

39. Robert Ryman, cited in Nancy Grimes, "White Magic," *Artnews* (summer 1986): 87.

40. Lynn Gumpert, Ned Rifkin, Marcia Tucker, *Early Work: Lynda Benglis/Joan Brown/Luis Jimenez/Gary Stephan*, exhibition catalog (New York: New Museum, 1982), 8.

41. Eva Hesse, cited in Lucy R. Lippard, *Eva Hesse* (New York: New York University Press, 1976), 24–5.

42. Tom Doyle confirmed that Hesse was impressed with Uecker and Beuys in Lucy R. Lippard, *Eva Hesse*, 33.

43. As noted in Bill Barrette, *Eva Hesse Sculpture, Catalogue Raisonné* (New York: Timken Publishers, 1989), 62.

44. Eva Hesse, in Cindy Nemser, "An Interview with Eva Hesse," *Artforum* (May 1970): 59.

45. Eva Hesse, a sheet of pencil notes from her last year, in Linda Shearer, "Eva Hesse: Last Works," in Robert Pincus-Witten and Linda Shearer, *Eva Hesse: A Memorial Exhibition*, exhibition catalog (New York: Solomon R. Guggenheim Museum, 1972), unpaginated.

46. Bill Barrette pointed out that she even titled her one-person show at the Fischbach Gallery in November 1968: "Eva Hesse: Chain Polymers." See Barrette, *Eva Hesse Sculpture, Catalogue Raisonné*, 15.

47. Barrette, *Eva Hesse Sculpture, Catalogue Raisonné*, 218.

48. Barrette, *Eva Hesse Sculpture, Catalogue Raisonné*, 14; Lippard, *Eva Hesse*, 115, 210.

49. Eva Hesse, in Nemser, "An Interview with Eva Hesse," 60.

50. Ibid., 63.

51. Bruce Nauman, in Willoughby Sharp, "Nauman Interview," *Arts Magazine*, vol. 44, no. 5 (March 1970): 26.

52. Bruce Nauman, in Jane Livingston and Marcia Tucker, *Bruce Nauman: Works From 1965 to 1972*, exhibition catalog (Los Angeles: Los Angeles County Museum of Art, 1973), 10.

53. Bruce Nauman, in Sharp, "Nauman Interview," 27.

54. Brenda Richardson, *Bruce Nauman: Neons*, exhibition catalog (Baltimore: Baltimore Museum of Art, 1982), 15.

55. Bruce Nauman, in Sharp, "Nauman Interview," 25, n. 5.

56. Robert Arneson, in conversation with Jonathan Fineberg, Benicia, California, February 19, 1989.

57. Bruce Nauman, cited in Richardson, *Bruce Nauman: Neons*, 20.

58. Richard Serra, "Document: 'Spin Out '72–'73 for Bob Smithson,' " *Avalanche* (summer/fall 1973), reprinted in Clara Weyergraf, ed., *Richard Serra: Interviews, Etc. 1970–1980* (Yonkers, N.Y.: The Hudson River Museum, 1980), 36.

59. First published in Grégoire Müller, *The New Avant-Garde: Issues for the Art of the Seventies* (New York: Praeger, 1972); reprinted in Weyergraf, *Richard Serra: Interviews, Etc. 1970–1980*, 9–11.

60. Richard Serra, "Play it Again, Sam," *Arts Magazine* (February 1970); reprinted in Weyergraf, *Richard Serra: Interviews, Etc. 1970–1980*, 18.

61. Richard Serra, "Extended Notes from Sight Point Road," in *Richard Serra: Recent Sculpture in Europe 1977–1985* (Bochum, Germany: Galerie m, 1985), 12; cited in Douglas Crimp, "Serra's Public Sculpture: Redefining Site Specificity," in Rosalind Krauss, *Richard Serra/Sculpture*, exhibition catalog (New York: The Museum of Modern Art, 1986), 47.

62. Heizer's term. Telephone conversation with Jonathan Fineberg, October 18, 1993.

63. Michael Heizer in a brochure for Galerie H, Graz, 1977, unpaginated; cited in Sandler, *American Art of the 1960s*, 333.

64. Michael Heizer, "The Art of Michael Heizer," *Artforum* (December 1969): 34; cited in John Beardsley, *Probing The Earth: Contemporary Land Projects*, exhibition catalog (Washington, D.C.: Hirshhorn Museum, Smithsonian Institution, 1978), 10.

65. Conversation between Jonathan Fineberg and John Weber in October 1982.

66. Robert Hobbs, *Robert Smithson: Sculpture* (Ithaca, N.Y.: Cornell University Press, 1981), 1.

67. Robert Smithson, "Entropy and the New Monuments," *Artforum* (June 1966): 26–31; reprinted in Nancy Holt, ed., *The Writings of Robert Smithson* (New York: New York University Press, 1979), 9–18.

68. Robert Smithson, "Towards the Development of an Air

Terminal Site," *Artforum* (summer 1967): 40; reprinted in Holt, *The Writings of Robert Smithson,* 46.
69. Tony Smith, in Samuel Wagstaff, Jr., "Talking With Tony Smith," *Artforum* (December 1966): 19; reprinted in Battcock, *Minimal Art,* 386.
70. Robert Smithson, in "The Symposium," *Earth Art,* exhibition catalog (Ithaca, N.Y.: Andrew Dickson White Museum of Art, Cornell University, 1970), unpaginated.
71. Robert Smithson, "The Spiral Jetty," in Gyorgy Kepes, ed., *Arts of the Environment* (New York: George Braziller, 1972), 231, n. 1; reprinted in Holt, *The Writings of Robert Smithson,* 115, n. 1.
72. As discussed by Hobbs, *Robert Smithson: Sculpture,* 30.
73. Eugenie Tsai, "The Sci-Fi Connection: The IG, J. G. Ballard, and Robert Smithson," in *Modern Dreams: The Rise and Fall of Pop,* exhibition catalog (New York: The Institute for Contemporary Art, 1988), 71–6.
74. Robert Smithson, "The Spiral Jetty," in Holt, *The Writings of Robert Smithson,* 111; cited in John Beardsley, *Earthworks and Beyond* (New York: Abbeville, 1984), 22.
75. Ibid., 22.
76. Robert Smithson, "The Spiral Jetty," in Holt, *The Writings of Robert Smithson,* 111.
77. Robert Smithson, "A Sedimentation of the Mind: Earth Projects," *Artforum* (September 1968): 50; reprinted in Holt, *The Writings of Robert Smithson,* 82; cited in Beardsley, *Probing The Earth: Contemporary Land Projects,* 85.
78. Michael Heizer, "The Art of Michael Heizer," *Artforum* (December 1969): 37.
79. They included Giovanni Anselmo, Alighiero Boetti, Luciano Fabro, Jannis Kounellis, Mario Merz, Giulio Paolini, Giuseppe Penone, Michelangelo Pistoletto, and Gilberto Zorio.
80. Jannis Kounellis, in Kathan Brown, *Italians and American Italians* (Oakland: Crown Point Press, 1988), unpaginated, cited in Michael Auping, "Primitive Decorum: Of Style, Nature, and the Self in Recent Italian Art," in Neal Benezra, *Affinities and Intuitions: The Gerald S. Elliott Collection of Contemporary Art,* exhibition catalog (Chicago: Art Institute of Chicago, 1990), 163.
81. Mario Merz, in Germano Celant, "The Organic Flow of Art," *Mario Merz,* exhibition catalog (New York: Solomon R. Guggenheim Museum, 1989), 15.
82. Mario Merz, in Richard Koshalek, "Interview With Mario Merz," in *Mario Merz,* exhibition brochure (Minneapolis: Walker Art Center, 1972), 3; cited in Celant, "The Organic Flow of Art," 29.
83. Mario Merz, in Susan Krane, *Mario Merz: Paintings and Constructions,* exhibition catalog (Buffalo: Albright-Knox Art Gallery, 1984), 6.
84. Mario Merz, in Jean Christophe Ammann and Suzanne Pagé, "Entretien avec Mario Merz," in *Mario Merz* exhibition catalog (Paris: ARC/Musée d'Art Moderne de la Ville de Paris; Basel: Kunsthalle, 1981), cited in Celant, "The Organic Flow of Art," 35.

Chapter 11

1. Douglas Heubler, statement in Seth Sieglaub, *January 5–31, 1969,* exhibition catalog (New York: published by the author, 1969); in Lucy R. Lippard, *Six Years: the dematerialization of the art object from 1966 to 1972: . . .* (New York: Praeger, 1973), 74.
2. Jan Dibbets, in Ursula Meyer, *Conceptual Art* (New York: E. P. Dutton, 1972), 121.
3. Lucy R. Lippard and John Chandler, "The Dematerialization of Art," *Art International* (February 1969): 31–6; and Lippard, *Six Years: the dematerialization of the art object from 1966 to 1972: . . .*
4. Sol LeWitt, "Paragraphs on Conceptual Art," *Artforum* (June 1967), 83.
5. Cited in Lippard, *Six Years: the dematerialization of the art object from 1966 to 1972: . . . ,* 179.
6. For one discussion of this change, see Robert Morris, "Words and Images in Modernism and Postmodernism," *Critical Inquiry* 15 (Winter 1989): 337–47. An emblematic example is Joseph Kosuth, "Art After Philosophy," *Studio International,* part one (October 1969): 134–7; part two (November 1969): 160–1; part three (December 1969): 212-13; reprinted in Gregory Battcock, ed., Idea Art (New York: E. P. Dutton, 1973).
7. Joseph Kosuth, "Art After Philosophy," *Studio International* (October 1969): 135.
8. Lawrence Weiner, in "Art Without Space," a symposium on WBAI-FM, New York, November 2, 1969, moderated by Seth Sieglaub with Lawrence Weiner, Robert Barry, Douglas Heubler, and Joseph Kosuth; cited in Lippard, *Six Years: the dematerialization of the art object from 1966 to 1972: . . . ,* 130.

9. Piero Manzoni, "Libera dimensione," *Azimuth,* 2 (January 1960); cited in Giuliano Briganti, "Cultural Provocation: Italian Art of the Early Sixties," in Emily Braun, ed., *Italian Art in the 20th Century: Painting and Sculpture 1900–1988* (Munich: Prestel Verlag; London: Royal Academy of Arts, 1989), 302.
10. Harold Rosenberg, *The De-Definition of Art* (New York: Macmillan, 1973).
11. Brenda Richardson, *Gilbert and George,* exhibition catalog (Baltimore: Baltimore Museum of Art, 1984), 12.
12. Helen Mayer Harrison and Newton Harrison, in Michel de Certeau, "Pay Attention: To Make Art," in Helen Mayer Harrison and Newton Harrison, *The Lagoon Cycle,* exhibition catalog (Ithaca, N.Y.: Herbert F. Johnson Museum of Art, Cornell University, 1985), 19.
13. The quotations from Vito Acconci in this and the next three paragraphs come from a conversation with students at the Pierson College Master's Residence, Yale University, January 25, 1982.
14. Adrian Piper, in Lucy R. Lippard, "Catalysis: An Interview With Adrian Piper," in *From The Center: Feminist Essays on Women's Art* (New York: Dutton, 1976), 167.
15. See Mary Jane Jacob, *Ana Mendieta: The "Silueta" Series 1973–1980* (New York: Galerie Lelong, 1991) and Gloria Moure et al., *Ana Mendieta,* exhibition catalog (Santiago de Compostela: Centro Galego de Arte Contemporánea and Barcelona: Ediciones Polígrafa, 1996).
16. Ana Mendieta in John Perreault, "Earth and Fire: Mendieta's Body of Work," in *Ana Mendieta: A Retrospective* (New York: New Museum of Contemporary Art, 1987), 10.
17. Amilcar de Castro, Ferreira Gullar, Franz Weissmann, Lygia Clark, Lygia Pape, Reynaldo Jardim, and Theon Spanudis, "Neo-concretist Manifesto," Rio de Janeiro, March 1959; reprinted in *October 69* (summer 1994): 93.
18. Lygia Clark, *Trailings,* 1964; reprinted in *October 69* (summer 1994): 99. See also *Lygia Clark,* exhibition catalog (Barcelona: Fundació Antoni Tàpies, 1997).
19. Lygia Clark, *Concerning the Instant,* 1965; reprinted in *October 69* (summer 1994): 100.
20. Hélio Oiticica, "Tropicália, March 4, 1967, in Guy Brett et al., *Hélio Oiticica,* exhibition catalog (Minneapolis: Walker Art Center, 1992/3), 124.
21. Hélio Oiticica, "Tropicália, March 4, 1967, in Guy Brett et al., *Hélio Oiticica,* exhibition catalog (Minneapolis: Walker Art Center, 1992/3), 124.
22. RoseLee Goldberg, "Performance: The Golden Years," in Gregory Battcock and Robert Nickas, eds., *The Art of Performance: A Critical Anthology* (New York: E. P. Dutton, 1984), 87.
23. Janet Kardon, *Laurie Anderson: Works from 1969 to 1983,* exhibition catalog (Philadelphia: Institute of Contemporary Art, University of Pennsylvania, 1983), 25.
24. Michel Serres and Craig Owens in: Craig Owens, "Sex and Language: In Between," in Kardon, *Laurie Anderson: Works From 1969 to 1983,* 53.
25. Nam June Paik, cited in Douglas Davis, "Electronic Wallpaper," *Newsweek* (August 24, 1970): 54.
26. Daniel Buren, "Is Teaching Art Necessary?" June 1968, unpaginated; cited in Lippard, *Six Years: the dematerialization of the art object from 1966 to 1972: . . . ,* 53.
27. There is a full account of the episode in Jack Burnham, "Hans Haacke's Cancelled Show at the Guggenheim," *Artforum* (June 1971): 67–71.
28. Marcel Broodthaers, quoted in *Piero Manzoni,* exhibition catalog (Brussels: Galerie des Beaux-Arts, 1987); cited in Michael Compton, "In Praise of the Subject," in Marge Goldwater et al., *Marcel Broodthaers* (Minneapolis: Walker Art Center; and New York: Rizzoli, 1989), 21.
29. See Christopher Phillips, "Homage to a Phantom Avant-Garde: The Situationist International," *Art in America* (October 1989), 182–91, 239; and *Arts Magazine* (January 1989), which contains four articles on situationism by Edward Bail, Bill Brown, Myriam D. Maayan, and Kristine Stiles.
30. Guy Debord, *The Society of the Spectacle,* 1967 (New York: Zone Books, 1995), 12.
31. Guy Debord, *The Society of the Spectacle,* 1967 (New York: Zone Books, 1995), 13.
32. Guy Debord, *The Society of the Spectacle,* 1967 (New York: Zone Books, 1995), 16.
33. Jean Dubuffet, "Rough Draft for a Popular Lecture on Painting," 1945, trans. Joachim Neugroschel in Mildred Glimcher, *Jean Dubuffet: Towards An Alternative Reality* (New York: Pace Publications, Abbeville, 1987), 46.
34. Willem de Kooning, "What Abstract Art Means to Me," *Bulletin of The Museum of Modern Art* 18, no. 3 (spring 1951): 7; reprinted in Thomas B. Hess, *Willem de Kooning* (New York: The Museum of Modern Art, 1968), 145–6.
35. Yves Klein, cited in Pierre Restany, *Yves Klein* (New York: Harry N. Abrams, 1982), 8.

36. Joseph Beuys in Willoughby Sharp, "An Interview with Joseph Beuys," *Artforum* (November 1969); cited in Lippard, *Six Years: the dematerialization of the art object from 1966 to 1972: . . . ,* 121.
37. President Dwight David Eisenhower, "Farewell Radio and Television Address to the American People," January 17, 1961, in Robert L. Branyan and Lawrence H. Larsen, eds., *The Eisenhower Administration 1953–1961,* vol. 2 (New York, 1971): 1375.
38. Christo, in an interview with Jonathan Fineberg at the University of Illinois at Urbana-Champaign, 1977; cited in Fineberg, "Theatre of the Real: Thoughts on Christo," *Art in America* (December 1979): 96.
39. Christo, unpublished interview with Jonathan Fineberg at the University of Illinois at Urbana-Champaign, 1977.
40. Christo, in an interview with Jonathan Fineberg at the University of Illinois at Urbana-Champaign, 1977; cited in Fineberg, "Theatre of the Real: Thoughts on Christo," 97.
41. Ibid., 98.
42. Robert Arneson, in conversation with Jonathan Fineberg, 1981.
43. Christo, in conversation with Jonathan Fineberg, 1983; cited in "Meaning and Being in Christo's *Surrounded Islands,*" in *Christo: Surrounded Islands* (New York: Harry N. Abrams, 1986), 27.
44. See Charng Jiunn Lee, *Watering, That's My Life: The Symbolism and Self-Imaging of Marcel Duchamp,* unpublished doctoral dissertation, University of Illinois at Urbana-Champaign, 1993. Dr. Lee has shown that Duchamp's entire *oeuvre* after 1912 centered on the practice of Ch'an Buddhist and Taoist philosophy. Although the many artists influenced by Duchamp's work over the course of the twentieth century appear to have had no inkling of this (with the possible exception of John Cage) they did recognize that his use of a discourse among real objects to provoke enigmatic, conceptual experiences was his characteristic mode of interacting with the viewer.
45. Neil Postman, *Amusing Ourselves to Death: Public Discourse in the Age of Show Business* (New York: Penguin Books, 1986), 99–100, 110; cited in Marvin Heiferman, "Everywhere, All the Time, for Everybody," in Marvin Heiferman and Lisa Phillips, *Image World: Art and Media Culture,* exhibition catalog (New York: Whitney Museum of American Art, 1989), 27. See also Erik Barnouw, *Tube of Plenty: The Evolution of American Television* (New York: Oxford University Press, 1975), 114.
46. Robert Storr, "Polke's Mind Tattoos," *Art in America* (December 1992): 71. Wim Beeren, "On the 'Werkgruppe', three paintings by Sigmar Polke in the collection of the Boymans-van Beuningen Museum," in *Sigmar Polke,* exhibition catalog (Rotterdam: Museum Boymans-van Beuningen, 1983; Bonn: Städtisches Kunstmuseum, 1984), 16, referred to the relationship of the preprinted images to the ones created by the artists as "hallucinatory." John Caldwell went still further, proposing a literal reading of *Alice in Wonderland* as referring to watching TV sports on a drug high, in John Caldwell, "Sigmar Polke," in *Sigmar Polke,* exhibition catalog (San Francisco: San Francisco Museum of Modern Art, 1991), 11.
47. See Grandville, *Un Autre Monde* (Paris: H. Fournier, 1844); cited in Gary Garrels, "Mrs Autumn and Her Two Daughters," in Sigmar Polke (Amsterdam: Stedelijk Museum, 1992), 68.
48. Gerhard Richter, "Notes 1966," in Gerhard Richter, *The Daily Practice of Painting: Writings 1962–1993,* ed. Hans-Ulrich Obrist (Cambridge, Mass.: MIT Press, 1995), 58.
49. Gerhard Richter, "Notes 1964–1965," in Gerhard Richter, *The Daily Practice of Painting: Writings 1962–1993,* ed. Hans-Ulrich Obrist (Cambridge, Mass.: MIT Press, 1995), 35.
50. Gerhard Richter, "Notes 1964–1965," in Gerhard Richter, *The Daily Practice of Painting: Writings 1962–1993,* ed. Hans-Ulrich Obrist (Cambridge, Mass.: MIT Press, 1995), 35.
51. Gerhard Richter, interview with Benjamin H. D. Buchloh, 1986, in Gerhard Richter, *The Daily Practice of Painting: Writings 1962–1993,* ed. Hans-Ulrich Obrist (Cambridge, Mass.: MIT Press, 1995), 160.
52. Gerhard Richter, letter to E. de Wilde, February 23, 1975, in *Gerhard Richter,* exhibition catalog (London: Tate Gallery, 1991), 112.
53. Gerhard Richter, interview with Rolf Shoen, 1972, in Gerhard Richter, *The Daily Practice of Painting: Writings 1962–1993,* ed. Hans-Ulrich Obrist (Cambridge, Mass.: MIT Press, 1995), 72–73.
54. Rainald Schumacher, "Gerhard Richter," *Flash Art,* no. 199 (March–April 1998): 86–7.
55. Gerhard Richter, Documenta 7, 1982; cited in *Gerhard Richter,* exhibition catalog (London: Tate Gallery, 1991), 112–113.
56. John Baldessari, cited in Coosje van Bruggen, *John Baldessari* (New York: Rizzoli, 1990), 19.
57. Van Bruggen, *John Baldessari,* 35.

Chapter 12

1. Robert Motherwell, quoted in Grace Glueck, "Motherwell, at 61, Puts 'Eternal' Quality Into Art," *New York Times* (February 3, 1976), 33.
2. Calvin Tomkins, "The Art Scene," *New Yorker* (May 19, 1980): 134–6.
3. Barbara Rose, *American Painting: The Eighties*, exhibition catalog (New York: Grey Art Gallery, New York University, 1980).
4. Rafael Ferrer, in Kim Levin, "Rafael Ferrer: In The Torrid Zone," in *Rafael Ferrer: Impassioned Rhythms*, exhibition catalog (Austin, Tex.: Laguna Gloria Art Museum, 1982), 12.
5. See Robert Farris Thompson, "Betye & Renee, Priestesses of Chance and Medicine," in *The Migrations of Meaning: A Source Book*, exhibition catalog (New York: INTAR Gallery, 1992), 19–31.
6. Romare Bearden, in Charles Childs, "Bearden: Identification and Identity," *Artnews* 63 (October 1964): 24, 54, 61; cited in Sharon F. Patton, "Memory and Metaphor: The Art of Romare Bearden," in Kinshasha Holman Conwill, Mary Schmidt Campbell, and Sharon F. Patton, *Memory and Metaphor: The Art of Romare Bearden 1940–1987* (New York: Oxford University Press and the Studio Museum in Harlem, 1991), 38.
7. Willem de Kooning, "What Abstract Art Means to Me," *Bulletin of The Museum of Modern Art* 18, no. 3 (spring 1951); cited in Harold Rosenberg, *Willem de Kooning* (New York: Harry N. Abrams, 1973), 146.
8. Nancy Spero, in *Jon Bird, Jo Anna Isaak, and Sylvère Lotringer* (London: Phaidon Press, 1996), 12.
9. Carolee Schneeman, in Bruce McPherson, ed., *Carolee Schneeman, More than Meat Joy; Complete Performance Works and Selected Writings, 1963–1979* (New Paltz, New York: Documentext, 1979), 52; cited in Kristine Stiles, "Uncorrupted Joy: International Art Actions," in Paul Schimmel, ed., *Out of Actions: Between Performance and the Object, 1949–1979* (Los Angeles: The Museum of Contemporary Art; and London: Thames & Hudson, 1998), 297.
10. Carolee Schneeman, in Bruce McPherson, ed., *Carolee Schneeman: More Than Meat Joy: Complete Performance Works and Selected Writings, 1963–1978* (New Paltz, New York: Documentext, 1979), 239–40; cited in Norma Broude and Mary D. Garrard, *The Power of Feminist Art* (New York: Harry N. Abrams, 1994), 162–3.
11. Anne Middleton Wagner, *Three Artists (Three Women): Modernism and the Art of Hesse, Krasner, and O'Keeffe* (Berkeley, Los Angeles, London: University of California Press, 1996), 20.
12. Richard Estes, quoted in Harvey Stein, *Artists Observed* (New York: Harry N. Abrams, 1986), 273.
13. Audrey Flack, *Audrey Flack On Painting* (New York: Harry N. Abrams, 1981), 84.
14. Richard Haas et al., "The Exuviae of Visions: Architecture as a Subject for Art," *Perspecta: The Yale Architectural Journal* 18 (1982): 95.
15. See Martin Filler, "The Writing on the Wall: Richard Haas and the Art of Architecture," in *Richard Haas: Architectural Projects 1974–1988*, exhibition catalog (New York: Brooke Alexander; Chicago: Rhona Hoffman Gallery, 1988), 5.
16. Jackie Ferrara, in conversation with Jonathan Fineberg, October 4, 1986.
17. Jackie Ferrara, letter to Jonathan Fineberg of October 27, 1993.
18. See "Interview," in Mika Koike, Motoi Masaki, Makoto Murata, eds., *Tadashi Kawamata* (Tokyo: Gendaikikakushitsu Publishing, 1987), 37.
19. Mary Miss, in Deborah Nevins, "An Interview with Mary Miss," *The Princeton Journal: Thematic Studies in Architecture* 2 (1985): 99.
20. As stated by the artist in *14 Americans: Directions of the 1970s* (New York: Michael Blackwood, 1980).
21. See Charles Simonds, "Microcosm to Macrocosm/Fantasy World to Real World," *Artforum* (February 1974): 36–9.
22. Ibid., 38.
23. Gordon Matta-Clark, interview with Donald Wall, "Gordon Matta-Clark's Building Dissections," *Arts Magazine*, 50 (May 1976): 79.
24. Gordon Matta-Clark, in Joan Simon, "Gordon Matta-Clark 1943–1978," *Art in America* (November/December 1978): 13.
25. Gordon Matta-Clark, cited in Mary Jane Jacob, "Introduction and Acknowledgements," *Gordon Matta-Clarke: A Retrospective*, exhibition catalog (Chicago: Museum of Contemporary Art, 1985), 8.
26. Ibid., 8.
27. Susan Rothenberg, cited in Joan Simon, "Interviews," *Gordon Matta-Clarke: A Retrospective*, exhibition catalog (Chicago: Museum of Contemporary Art, 1985), 73.

28. Romare Bearden, in M. Bunch Washington, *The Art of Romare Bearden: The Prevalence of Ritual* (New York: Harry N. Abrams, 1972), 9.
29. Patton, "Memory and Metaphor: The Art of Romare Bearden." See also Mary Schmidt Campbell, "Romare Bearden: A Creative Mythology," Ph.D. diss. (New York: Syracuse University, 1982), 50–3.
30. Patton, "Memory and Metaphor: The Art of Romare Bearden," 22.
31. Romare Bearden, in Patton, "Memory and Metaphor: The Art of Romare Bearden," 40.
32. Ibid., 39.
33. Ibid., 38.
34. Romare Bearden, in Mary Schmidt Campbell, "History and the Art of Romare Bearden," in Kinshasha Holman Conwill, Mary Schmidt Campbell, and Sharon F. Patton, *Memory and Metaphor: The Art of Romare Bearden 1940–1987* (New York: Oxford University Press and the Studio Museum in Harlem, 1991), 9.
35. Alice Aycock, "Alice Aycock, Reflections on Her Work, An Interview with Jonathan Fineberg," in *Complex Visions: Sculpture and Drawings by Alice Aycock*, exhibition catalog (Mountainville, N.Y.: Storm King Art Center, 1990), 16–17.
36. Alice Aycock, "Conversation Between Alice Aycock, Tilman Osterwold and Andreas Vowinckel," *Alice Aycock: Retrospective der Projekte und Ideen 1972–1983, Installation und Zeichnungen*, exhibition catalog (Stuttgart: Württembergischer Kunstverein, 1983), unpaginated.
37. Alice Aycock, "Work 1972–74," in Alan Sondheim, ed., *Individuals: Post-Movement in Art in America* (New York: E. P. Dutton, 1977), 106.
38. She talks about such experiences in: Alice Aycock, *Project entitled "The Beginnings of a Complex . . ."* (New York: Lapp Princess Press and Printed Matter, 1977), unpaginated.
39. Alice Aycock, lecture to students at Yale University, 1981.
40. Alice Aycock, in Margaret Sheffield, "Mystery Under Construction," *Artforum* (September 1977): 63.
41. Alice Aycock, "Alice Aycock, Reflections on Her Work, An Interview with Jonathan Fineberg," 13.
42. Ibid., 13.
43. Alice Aycock, "Conversation Between Alice Aycock, Tilman Osterwold and Andreas Vowinckel," unpaginated.
44. Alice Aycock, "Alice Aycock, Reflections on Her Work, An Interview with Jonathan Fineberg," 13.
45. Ibid., 30–2.
46. Ibid., 9.
47. Lecture at the Cooper Union, March 1974. Cited in Dore Ashton, *Yes, but . . ., A Critical Study of Philip Guston* (New York: Viking, 1976), 1.
48. Harold Rosenberg, "Liberation from Detachment: Philip Guston," *The De-Definition of Art* (New York: Collier Books, 1973), 132–40.
49. Philip Guston, letter of October 1974 to Dore Ashton; cited in Musa Mayer, *Night Studio: A Memoir of Philip Guston by His Daughter* (New York: Viking Penguin, 1988), 104.
50. Ashton, *Yes, but . . ., A Critical Study of Philip Guston*, 87.
51. Peter Schjeldahl, "Philip Guston," in *Art of Our Time: The Saatchi Collection*, vol. 3 (New York: Rizzoli, 1985), 12–13.
52. Mercedes Matter, interview with Musa Mayer, 1987; cited in Mayer, *Night Studio*, 65–6.
53. Philip Guston, cited in Ashton, *Yes, but . . ., A Critical Study of Philip Guston*, 74.
54. Philip Guston, in *Philip Guston: A Life Lived*, a 16 mm. film (Michael Blackwood Films: New York, 1982).
55. Philip Guston, "Philip Guston's Object: A Dialogue with Harold Rosenberg," *Philip Guston: Recent Paintings and Drawings*, exhibition catalog (New York: The Jewish Museum, 1966), unpaginated.
56. Philip Guston, in William Berkson, "Dialogue with Philip Guston, November 1, 1964," *Art and Literature: An International Review* 7 (winter 1965): 66; cited in Robert Storr, *Philip Guston* (New York: Abbeville, 1986), 43.
57. Philip Guston, cited in Ashton, *Yes, but . . ., A Critical Study of Philip Guston*, 154; a more complete version of the statement is reprinted in Magdalena Dabrowski, *The Drawings of Philip Guston*, exhibition catalog (New York: The Museum of Modern Art, 1988), 29.
58. Ashton, *Yes, but . . ., A Critical Study of Philip Guston*, 156.
59. "Philip Guston Talking," a lecture given by Philip Guston at the University of Minnesota in March 1978, edited by Renée McKee in *Philip Guston: Paintings 1969–80*, exhibition catalog (London: Whitechapel Art Gallery, 1982), 52.
60. Philip Guston, in *Philip Guston: A Life Lived* (New York: Michael Blackwood Films, 1982).
61. "Philip Guston Talking," a lecture given by Philip Guston at the University of Minnesota in March 1978, edited by Renée McKee in *Philip Guston: Paintings 1969–80*, 52

62. Philip Guston in *Philip Guston: A Life Lived* (New York: Michael Blackwood Films, 1982).
63. He made reference to this in "Philip Guston's Object: A Dialogue with Harold Rosenberg," unpaginated. For a discussion of the *golem* see Gerschom G. Scholem, *The Kabbalah and Its Symbolism* (New York: Schocken Books, 1969), 158–204; and Jorge Luis Borges, *Seven Nights* (New York: New Directions Books, 1980), 95–106; cited in Robert Storr, *Philip Guston*, 60.
64. Philip Guston, in *Philip Guston: A Life Lived* (New York: Michael Blackwood Films, 1982).
65. Philip Guston; cited in Ashton, *Yes, but . . ., A Critical Study of Philip Guston*, 177.
66. Ross Feld, "Philip Guston: an essay," in *Philip Guston*, exhibition catalog (New York: San Francisco Museum of Modern Art and George Braziller, 1980), 29; also cited in Mayer, *Night Studio*, 182.

Chapter 13

1. Pamela Kort, *Jörg Immendorff: Early Works and Lidl*, exhibition catalog (New York: Gallery Michael Werner, 1991), unpaginated.
2. Jörg Immendorff, *Here and Now: To Do What Has to Be Done (Hier und Jetzt: Das tun, was zu tun ist)* (Köln and New York: Gebr. König, 1973), republished in *Immendorff's Handbuch der Akademie für Adler* (Köln: Walter König, 1989).
3. Trans. from Pamela Kort, *Jörg Immendorff: I Wanted to Be an Artist 1971–1974* (New York: Gallery Michael Werner, 1991), unpaginated.
4. See Jörg Immendorff, in Siegfried Gohr and Pamela Kort, "Interview with Jörg Immendorff," May 1994, *Jörg Immendorff The Rake's Progress*, exhibition catalog (London: Barbican Art Gallery, 1995), 119.
5. See Thomas McEvilley, "The Work of 'Georg Baselitz'?," *Georg Baselitz: The Women of Dresden*, exhibition catalog (New York: Pace Gallery, 1990), 10; and Mariette Josephus Jitta, "Drawings: A. R. Penck," *Tekeningen: A. R. Penck* (The Hague: Gemeentemuseum, 1988), 180.
6. Donald Kuspit, "Flak From The 'Radicals': The Case Against Current German Painting," in Jack Cowart, *Expressions: New Art from Germany*, exhibition catalog (St. Louis: Saint Louis Art Museum and Munich: Prestel Verlag, 1983).
7. Siegfried Gohr, "The Difficulties of German Painting with Its Own Tradition," in Cowart, *Expressions: New Art from Germany*, 35.
8. Anselm Kiefer, quoted in Axel Hecht, "Macht der Mythen," *Art: Das Kunstmagazin*, Wiesbaden (March 1984): 33; cited in Mark Rosenthal, *Anselm Kiefer*, exhibition catalog (Philadelphia: Philadelphia Museum of Art; Chicago: Art Institute of Chicago; Munich: Prestel Verlag, 1987), 26.
9. Anselm Kiefer, interview with Mark Rosenthal in April 1986; cited in Rosenthal, *Anselm Kiefer*, 95.
10. Francesco Clemente, in Giancarlo Politi, "Francesco Clemente," *Flash Art* 117 (April/May 1984): 17; cited in Michael Auping, "Primitive Decorum: Of Style, Nature, and the Self in Recent Italian Art," in Neal Benezra, *Affinities and Intuitions: The Gerald S. Elliott Collection of Contemporary Art*, exhibition catalog (Chicago: Art Institute of Chicago, 1990), 164.
11. Francesco Clemente, in Donald Kuspit, "Clemente Explores Clemente," *Contemporanea*, vol. 2, no. 7 (October 1989): 40; cited in Raymond Foye, "Madras," in Ann Percy and Raymond Foye, *Francesco Clemente: Three Worlds*, exhibition catalog (Philadelphia: Philadelphia Museum of Art; New York: Rizzoli, 1990), 51.
12. Michael Auping, tape-recorded conversation with Clemente, May 11 and 12, 1984; cited in Michael Auping, "Fragments," *Francesco Clemente*, exhibition catalog (Sarasota, Wash.: John and Mabel Ringling Museum of Art, 1985), 18.
13. Kathy Halbreich, *Culture and Commentary: An Eighties Perspective*, exhibition catalog (Washington, D.C.: Hirshhorn Museum, Smithsonian Institution, 1990), 38.
14. See Rainer Crone and Georgia Marsh, *An Interview with Francesco Clemente* (New York: Vintage, 1987).
15. Ibid., 42.
16. Ilya Kabakov, in Katrina F. C. Cary, "Ilya Kabakov: Profile of a Soviet Unofficial Artist," *Art and Auction* (February 1987): 86–7; cited in Robert Storr, *Dislocations*, exhibition catalog (New York: The Museum of Modern Art, 1991), 22.
17. Ilya Kabakov, in Claudia Jolles, "Interview with Erik Bulatov and Ilya Kabakov, Moscow, July 1987," in Erik Bulatov (London: 1989), 40–41; cited in Amei Wallach, *Ilya Kabakov: The Man Who Never Threw Anything Away* (New York: Harry N. Abrams, 1996), 56.
18. Ilya Kabakov, *Five Albums* (Helsinki: Museet för Nutidskonst, The Museum of Contemporary Art, 1994; and Oslo: Museet for Samtidskunst, National Museum of Contemporary Art, 1995), 33.

19. Ilya Kabakov, "Installations," in Wallach, op. cit., 178.
20. Ilya Kabakov, *Ten Characters*, text accompanying an installation at Ronald Feldman Fine Art, New York, 1988; cited in David Ross, ed., *Between Spring and Summer: Soviet Conceptual Art in the Era of Late Communism* (Boston: Institute of Contemporary Art; Tacoma, Wash.: Tacoma Art Museum; Cambridge, Mass. and London: MIT Press, 1990), 25–7.
21. Ilya Kabakov, conversation with the author, Champaign, Illinois, September 17, 1998. See also Ilya Kabakov, in "Boris Groys and Ilya Kabakov: A Dialogue on Installation," *Das Leben der Fliegen/Life of Flies*, 258–70; in Wallach, 77.
22. Ilya Kabakov, *The Palace of Projects*, exhibition catalog (Madrid: Museo Nacional Centro de Arte Reina Sofía, 1998), 1.
23. According to Calvin Tomkins, "Profiles: Getting Everything In," *New Yorker* (April 15, 1985): 55; reprinted in Marge Goldwater, Roberta Smith, Calvin Tomkins, *Jennifer Bartlett*, exhibition catalog (Minneapolis: Walker Art Center; New York: Abbeville, 1985).
24. As pointed out in Marge Goldwater, "Jennifer Bartlett: On Land and At Sea," Goldwater, Smith, and Tomkins, *Jennifer Bartlett*, 75, n. 3.
25. Michael Hurson, "Thurman Buzzard—An Essay on Fiction," *Artists' Architecture: Scenes and Conversations* (London: Institute of Contemporary Art, 1983), 69.
26. Michael Hurson, in conversation with Jonathan Fineberg about the "New Image Painting" show, Chicago, September 1979.
27. Neil Jenney, in Richard Marshall, *New Image Painting*, exhibition catalog (New York: Whitney Museum of American Art, 1978), 38.
28. Neil Jenney, unpublished transcript of a symposium held at the Brooklyn Museum, 1974; cited in Mark Rosenthal, *Neil Jenney: Paintings and Sculpture 1967–1980*, exhibition catalog (Berkeley: University Art Museum, 1981), 47.
29. See Linda Shearer, "An Interview with Robert Moskowitz," in Ned Rifkin, *Robert Moskowitz*, exhibition catalog (Washington, D.C.: Hirshhorn Museum and Sculpture Garden, Smithsonian Institution), 51.
30. Susan Rothenberg, in conversation with Jonathan Fineberg in her studio, New York, April 11, 1986.
31. Susan Rothenberg, in conversation with Jonathan Fineberg in her studio, New York, April 11, 1986.
32. This is the way Susan Rothenberg explained the work in a conversation with Jonathan Fineberg in her studio, New York, April 11, 1986.
33. Joan Simon, *Susan Rothenberg* (New York: Harry N. Abrams, 1991), 33.
34. Ibid., 24.
35. The details of Rothenberg's personal life come from Simon, *Susan Rothenberg*, unless otherwise noted.
36. Susan Rothenberg, Simon, *Susan Rothenberg*, 79.
37. Ibid., 88.
38. Joel Shapiro, tape-recorded interview with Richard Marshall, May 3 and 6, 1982, in Richard Marshall and Roberta Smith, *Joel Shapiro*, exhibition catalog (New York: Whitney Museum of American Art, 1982), 96.
39. Alice Aycock, in conversation with Jonathan Fineberg in her studio, July 9, 1992.
40. Elizabeth Murray, in Deborah Solomon, "Celebrating Paint," *New York Times Magazine* (March 31, 1991), 40.
41. Elizabeth Murray, in Kay Larson, "One From the Heart," *New York Magazine* (February 10, 1986), 43.
42. Elizabeth Murray, quoted in Roberta Smith, "Motion Pictures," in Kathy Halbreich and Sue Graze, *Elizabeth Murray: Paintings and Drawings* (New York: Harry N. Abrams, 1987), 13.
43. Ibid., 122.
44. Elizabeth Murray, in *14 Americans: Directions of the 1970s* (New York: Michael Blackwood Films, 1980).
45. Elizabeth Murray, in Halbreich and Graze, *Elizabeth Murray: Paintings and Drawings*, 44.
46. Ibid., 42.
47. Elizabeth Murray, in Richard Marshall, *50 New York Artists* (San Francisco: Chronicle Books, 1986), 82.
48. Elizabeth Murray, in Halbreich and Graze, *Elizabeth Murray: Paintings and Drawings*, 127.
49. Elizabeth Murray, in Paul Gardner, "Elizabeth Murray Shapes Up," *Artnews*, vol. 83 (September 1984): 55.
50. Elizabeth Murray, in Halbreich and Graze, *Elizabeth Murray: Paintings and Drawings*, 130.
51. Elizabeth Murray, from conversations with Richard Armstrong, excerpted in the brochure for the exhibition *Elizabeth Murray: Paintings and Drawings* (New York: Whitney Museum of American Art, 1988).
52. Elizabeth Murray, in Halbreich and Graze, *Elizabeth Murray: Paintings and Drawings*, 118.
53. Elizabeth Murray, in Deborah Solomon, "Celebrating Paint," 46.

Chapter 14

1. Lisa Phillips, "The Self Similar," in Lisa Phillips, *Terry Winters* (New York: Whitney Museum of American Art, 1991), 17.
2. Tony Cragg, cited in *Tony Cragg* (London: Tate Gallery, 1989), 11–12.
3. Julian Schnabel, cited in Jeanne Siegal, "Julian Schnabel," *Arts Magazine* (June 1983): 15.
4. Julian Schnabel, "Writings," November 21, 1985; in Thomas McEvilley and Lisa Phillips, *Julian Schnabel: Paintings 1975–1987*, exhibition catalog (London: Whitechapel Art Gallery; New York: Whitney Museum of American Art, 1987), 104.
5. See, for example, Robert Hughes, "Careerism and Hype Amidst the Image Haze," *Time* (June 17, 1985): 81.
6. Elizabeth Murray, quoted in Roberta Smith, "Research and Development, Analysis and Transformation," in Jerry Salz, *Beyond Boundaries* (New York: Alfred Van der Marck Editions, 1986), xiii; cited in Lisa Phillips, "Blind Date with History," McEvilley and Phillips, *Julian Schnabel: Paintings 1975–1987*, 99.
7. Julian Schnabel, "Writings," July 11, 1986; in McEvilley and Phillips, *Julian Schnabel: Paintings 1975–1987*, 104.
8. Julian Schnabel, conversation with Jonathan Fineberg and a few of Fineberg's Yale University students in Schnabel's studio, New York, fall 1981.
9. Julian Schnabel, "Writings," from the Madrid notebooks, 1978; in McEvilley and Phillips, *Julian Schnabel: Paintings 1975–1987*, 104.
10. Eric Fischl, in Donald Kuspit and Erich Rischl, "An Interview with Erich Fischl," in *Fischl* (New York: Vintage, 1987), 62.
11. Eric Fischl, in Nancy Grimes, "Eric Fischl's Naked Truths," *Artnews* (September 1986): 72.
12. Robert Colescott, in conversation with Jonathan Fineberg, Champaign, Illinois, February 17, 1992.
13. Jonathan Borofsky, in Joan Simon, "An Interview with Jonathan Borofsky," *Art in America* 69 (November 1981): 157–64.
14. Jonathan Borofsky, in Kathy Halbriech, *Jonathan Borofsky: An Installation*, exhibition brochure (Cambridge, Mass.: MIT Press, 1980); cited in Mark Rosenthal, "Jonathan Borofsky's Modes of Working," Mark Rosenthal and Richard Marshall, *Jonathan Borofsky*, exhibition catalog (Philadelphia: Philadelphia Museum of Art; New York: Whitney Museum of American Art, 1984), 14.
15. Jonathan Borofsky, note to the illustrations, in Rosenthal and Marshal, *Jonathan Borofsky*, 106.
16. John Carlin, "Bombing History: Graffiti and Art of the Eighties," unpublished paper read at the meeting of the College Art Association in Boston in 1987.
17. Claes Oldenburg, quoted in the *New York Times*, 1984; cited by John Carlin, "Bombing History: Graffiti and Art of the Eighties," unpublished paper read at the meeting of the College Art Association in Boston in 1987.
18. Barry Blinderman, "Close Encounters with the Third Mind," in Barry Blinderman, *Keith Haring: Future Primeval*, exhibition catalog (Normal, Ill.: University Galleries, Illinois State University, 1990), 18.
19. Ibid., 16.
20. William S. Burroughs, *Naked Lunch* (New York, 1959), 221.
21. See Richard Marshall, "Repelling Ghosts," in Richard Marshall, *Jean-Michel Basquiat*, exhibition catalog (New York: Whitney Museum of American Art and Harry N. Abrams, 1992), 16. Also see the detailed chronology at the back of the catalog.
22. "Le silence éternel de ces espaces infinis m'effraie." Blaise Pascal, *Pensées* (1670), 206.
23. Robert Farris Thompson, "Royalty, Heroism, and the Streets: The Art of Jean-Michel Basquiat," in Richard Marshall, *Jean-Michel Basquiat*, 32.
24. bell hooks, "Altars of Sacrifice: Re-Membering Basquiat," *Art in America* (June 1993), 72.
25. Henry Geldzahler, "Art: From Subways to Soho, Jean-Michel Basquiat," *Interview*, 13 (January 1983): 46; cited in Robert Farris Thompson, "Royalty, Heroism, and the Streets: The Art of Jean-Michel Basquiat," in Richard Marshall, *Jean-Michel Basquiat*, 32.
26. Robert Farris Thompson, "Activating Heaven: The Incantatory Art of Jean-Michel Basquiat," in *Jean-Michel Basquiat*, exhibition catalog (New York: Mary Boone and Michael Werner Gallery, 1985), unpaginated.
27. Jean-Michel Basquiat, in Robert Farris Thompson, "Royalty, Heroism, and the Streets: The Art of Jean-Michel Basquiat," in Richard Marshall, *Jean-Michel Basquiat*, 32.
28. See David Wojnarowicz, *Memories That Smell Like Gasoline* (San Francisco: Artspace Books, 1992) and David Wojnarowicz, *Close to the Knives: A Memoir of Disintegration* (New York: Vintage, 1991).
29. David Wojnarowicz, in Barry Blinderman, "The

30. Compression of Time: An Interview with David Wojnarowicz," in Barry Blinderman, ed., *David Wojnarowicz: Tongues of Flame*, exhibition catalog (Normal, Ill.: University Galleries, Illinois State University, 1990), 49.
30. David Wojnarowicz, in Lucy R. Lippard, "Out of the Safety Zone," *Art in America* 78 (December 1990): 134.
31. See Walter Robinson and Carlo McCormick, "Report from the East Village: Slouching Toward Avenue D," *Art in America* (summer 1984): 160.
32. David Wojnarowicz, in Matthew Rose, "David Wojnarowicz: An Interview," *Arts Magazine* 62 (May 1988): 62.
33. David Wojnarowicz, in conversation with Jonathan Fineberg in Wojnarowicz's studio, November 13, 1987.
34. David Wojnarowicz, *Close to the Knives: A Memoir of Disintegration*, 114.
35. Christian Boltanski, interview with Jacques Clayssen, *Identité/Identifications*, exhibition catalog (Bordeaux: Centre d'Arts Plastiques Contemporains, 1976), 24; cited in Nancy Marmer, "Boltanski: The Uses of Contradiction," *Art in America* (October 1989): 175.
36. Christian Boltanski, interview with Béatrice Parent, in Christian Boltanski, *Dernières Années*, exhibition catalog (Paris: Musée d'Art Moderne de la Ville de Paris, 1998).
37. David Hammons, interviewed by Kellie Jones, *Real Life*, no. 16 (autumn 1986): 8; in Tom Finkelpearl, *David Hammons: Rousing the Rubble* (New York: Institute for Contemporary Art; Cambridge, Mass.: MIT Press, 1991), 28.
38. Ibid., 34.
39. Ann Hamilton, "A Conversation with Ann Hamilton," interview by Hugh Davies and Lynda Forsha, in *Ann Hamilton* (San Diego: San Diego Museum of Contemporary Art, 1991): 66.
40. Ann Hamilton, "Ann Hamilton: Temporal Crossroads," interview by Joan Simon, in *Art Press* (December 1995): 24.
41. Ann Hamilton, cited in Dave Hickey, "In the Shelter of the Word: Ann Hamilton's tropos," in *Ann Hamilton, Tropos* (New York: Dia Center for the Arts, 1995): 141.
42. Ann Hamilton, "A Conversation with Ann Hamilton," interview by Hugh Davies and Lynda Forsha, in *Ann Hamilton* (San Diego: San Diego Museum of Contemporary Art, 1991): 61.
43. Ann Hamilton, lecture at the University of Illinois at Urbana-Champaign, September 1997.
44. Ann Hamilton, "A Conversation with Ann Hamilton," interview by Hugh Davies and Lynda Forsha, in *Ann Hamilton* (San Diego: San Diego Museum of Contemporary Art, 1991): 64.
45. Ann Hamilton, conversation with the author, Columbus, Ohio, December 18, 1998.
46. Ann Hamilton, in Neville Wakefield, "Between Words and Things," in *Ann Hamilton* (Liverpool, England: Tate Gallery Publishing, 1994), 16.
47. Roland Barthes, "The Death of the Author," in *Image-Music-Text*, trans. Stephen Heath (New York: Hill & Wang, 1977), 143, 146. Previously published as "La mort de l'auteur," *Mantéia*, 5, 1968.
48. Roland Barthes, "The Death of the Author," in *Image-Music-Text*, trans. Stephen Heath (New York: Hill & Wang, 1977), 142–3, 146–7. Previously published as "La mort de l'auteur," *Mantéia* 5, 1968.
49. John Carlin, *Pop Apocalypse*, exhibition brochure (New York: Gracie Mansion Gallery, 1988), unpaginated.
50. Thomas Lawson, "Last Exit: Painting," *Artforum* (October 1981): 42.
51. Peter Schjeldahl, "An Interview With David Salle," in *Salle* (New York: Vintage, 1987), 48.
52. David Salle, in Richard Marshall, *50 New York Artists* (San Francisco: Chronicle Books, 1986), 96.
53. Lisa Phillips, "His Equivocal Touch in the Vicinity of History," in Janet Kardon, *David Salle* (Philadelphia: Institute of Contemporary Art, 1986), 12.
54. See Jonathan Fineberg, " 'A long time ago in a galaxy far, far away . . . ,' " in Jonathan Fineberg, ed., *Out of Town: The Williamsburg Paradigm* (Champaign, Ill.: Krannert Art Museum, 1993), unpaginated.
55. Richard Prince, letter to Craig Owens, 1982; cited in Lisa Phillips, "People Keep Asking: An Introduction," Lisa Phillips, *Richard Prince* (New York: Whitney Museum of American Art, 1992), 33. For an interesting autobiographical account see J. G. Ballard's interview with Prince, published in *Punch* magazine as "Extraordinary," September 1967, revised from Ballard's notes by Prince and published in *ZG*, reprinted in: Vicente Todolí, *Spiritual America: Richard Prince* (Valencia, Spain: Instituto Valenciano de Arte Moderno, 1989).
56. Richard Prince, in Jeffrey Rian, "An Interview with Richard Prince," *Art in America* (March 1987): 90.
57. Ibid., 94.
58. Jean-François Lyotard, "Introduction," *The Postmodern Condition: A Report on Knowledge* (1970), trans. Geoff

Notes

Bennington and Brian Massumi (Minneapolis: University of Minnesota Press, 1984): xxiv.

59. Cindy Sherman, in Marshall, *50 New York Artists*, 109.

60. Cindy Sherman, in "Cindy Sherman," *American Photographer* (September, 1983): 73; cited in I. Michael Danoff, "Afterword: Guises and Revelations," Peter Schjeldahl and I. Michael Danoff, *Cindy Sherman* (New York: Pantheon, 1984): 196.

61. Cindy Sherman, interview with Lisbet Nelson, "Q & A: Cindy Sherman," *American Photographer* (September 1983): 77; cited in Lisa Phillips, "Cindy Sherman's Cindy Shermans," in *Cindy Sherman*, exhibition catalog (New York: Whitney Museum of American Art, 1987): 14.

62. Haim Steinbach, in Gary Garrels, *New Sculpture: Robert Gober, Jeff Koons, Haim Steinbach* (Chicago: The Renaissance Society at the University of Chicago, 1986), unpaginated.

63. Haim Steinbach, in Peter Nagy, moderator, "From Criticism to Complicity," *Flash Art* 129 (summer 1986): 46, n. 1.

64. See Roberta Smith, "Rituals of Consumption," *Art in America* (May 1988): 164–71.

65. Jeff Koons, in Alan Jones, "Jeff Koons, 'Et qui libre,' " *Galleries Magazine* (November 1986): 94.

66. Jeff Koons, in Giancarlo Politi, "Luxury and Desire: An Interview with Jeff Koons," *Flash Art* (February/March 1987): 71.

67. Ibid., 72.

68. Tim Rollins, cited in William Olander, "Material World," *Art in America* (October 1989): 124.

69. Tim Rollins, quoted in Suzi Gablik, "Report from New York: The Graffiti Question," *Art in America* 70 (October 1982): 37.

70. See Ben H. Bagdikian, *The Media Monopoly* (Boston: Beacon Press, 1987): 4; cited in Marvin Heiferman, "Everywhere, All the Time, for Everybody," in Marvin Heiferman and Lisa Phillips, *Image World: Art and Media Culture*, exhibition catalog (New York: Whitney Museum of American Art, 1989), 32.

71. See Randy Rosen and Catherine C. Brawer, eds., *Making Their Mark* (New York: Abbeville, 1989).

72. Krzysztof Wodiczko (with Douglas Crimp, Rosalyn Deutsche, and Ewa Lajer-Burcharth), "Conversation with Krzysztof Wodiczko," *October* 38 (winter 1986): 39; cited in Peter Boswell, "Krzysztof Wodiczko: Art and the Public Domain," *Public Address: Krzysztof Wodiczko* (Minneapolis: Walker Art Center, 1992), 13.

73. Peter Boswell has also cited the Situationist International as an important source. See Guy Debord, *The Society of the Spectacle*, revised English edition (Detroit: Black and Red, 1983), unpaginated; Jonathan Crary, "Spectacle, Attention, Counter-Memory," *October* 50 (fall 1989), 97–106; and Ken Knabb, ed., *Situationist International Anthology* (Berkeley: Bureau of Public Secrets, 1981); all cited in Boswell, "Krzysztof Wodiczko: Art and the Public Domain," 19.

74. Krzysztof Wodiczko, in *Krzysztof Wodiczko: WORKS*, exhibition brochure (Washington, D.C.: Hirshhorn Museum and Sculpture Garden, Smithsonian Institution, 1988), unpaginated; cited in Boswell, "Krzysztof Wodiczko: Art and the Public Domain," 19.

Chapter 15

1. Robert Gober, in Richard Flood and Robert Gober, "Interview 2 (January 15, 1993)," in Richard Flood, et al., *Robert Gober: Sculpture + Drawing*, exhibition catalog (Minneapolis: Walker Art Center, 1999), 126.

2. C. Carr, "Rehearsals for Zero Hour: Performance in the Eighties," *The Decade Show: Frameworks of Identity in the 1980s*, exhibition catalog (New York: New Museum of Contemporary Art, 1990), 204.

3. Barbara Smith in Ralph Rugoff, "Survey," Ralph Rugoff, Kristine Stiles, Giacinto Di Pietrantonio, *Paul McCarthy* (London: Phaidon Press, 1996), 43.

4. Kara Walker, "Interview with Sydney Jenkins, 1995," cited in Jo Anna Isaak, *Looking Forward Looking Black* (Geneva, N.Y.: Hobart and William Smith Colleges Press, 1999), 6.

5. Jeff Wall, in Vicki Goldberg, "Photos That Lie— and Tell the Truth," *The New York Times*, "Arts and Leisure" (March 16, 1997): 34.

6. James Lingwood, "Introduction," James Lingwood, ed., *House* (London: Phaidon Press, 1995), 7.

7. Iain Sinclair, "The House In The Park: A Psychogeographical Response," in James Lingwood, ed., *House* (London: Phaidon Press, 1995), 18.

8. Mariko Mori, "We've Got Twenty-Five Years," interview with Dike Blair, *Purple Prose* (summer 1995): 100; cited in Dominic Molon, "Countdown to Ecstasy," Mariko Mori, exhibition catalog (Chicago: Museum of Contemporary Art, 1998), 3.

9. Dominic Molon, "Countdown to Ecstasy," Mariko Mori,

exhibition catalog (Chicago: Museum of Contemporary Art, 1998), 7.

10. Fred Tomaselli, January 30, 1999 conversation with the author in Tomaselli's Williamsburg studio.

11. Fred Tomaselli, telephone conversation with the author, October 8, 1999.

12. Roxy Paine and Kit Blake, "Tweeking the Human," in "Brand Name Damages" and "Minor Injury" galleries, Williamsburg, Brooklyn, 1991.

13. Phone conversation with the author, April 8, 1998. A color reproduction of Brueghel's painting *The Blind Leading the Blind* can be found in Janson, H. W. and Janson, Anthony F., *History of Art*, 5th edition, revised (New York: Harry N. Abrams, 1997), 544. It can also be found in the 4th edition of Janson's *History of Art* on page 544, and in black and white in the 3rd edition, on page 495.

14. Conversation with Gordon Baym, Department of Physics, University of Illinois at Urbana-Champaign.

15. M. Mitchell Waldrop, *Complexity: The Emerging Science at the Edge of Order and Chaos* (New York: Simon and Schuster, 1992), 16, 11.

16. When "the artist formerly known as Prince" (as we are now required to call him) had his very name legally taken away by lawyers at Warner Brothers Records as the price of his contractual freedom, the resulting dislocation of his identity (into a kind of cold void that your computer might call a file with no label) is a form of disconnectedness in which we can all feel a resonance.

17. See Richard Shiff, "The Necessity of Jimmie Durham's Jokes," *The Art Journal* (Fall 1992): 74–80.

18. Ebon Fisher, telephone conversation with the author, fall 1998.

19. Jimmie Durham, "Covert Operations: Excerpts from a Discussion between Jimmie Durham and Michael Taussig with Miwon Kwon and Helen Molesworth," 1993; in Laura Mulvey, Dirk Snauwaert, and Mark Alice Durant, *Jimmie Durham* (London: Phaidon Press, 1995), 119.

Chapter 16

1. Chang Yen-yüan, c. 847, *Li-tai-ming-hua-chi*, 1/6; see William Acker, *Some T'ang and Pre-T'ang Texts on Chinese Painting* (Leiden: E. J. Brill, 1954), 149.

2. Victor Aubertin, *Die Kunst Stirbt* (Munich, 1911); cited in Klaus Lankheit, ed., *Blue Rider Almanac* (New York: Viking, 1974), 11.

3. Philip Guston, *Time* (January 7, 1952); cited in Musa Mayer, *Night Studio: A Memoir of Philip Guston by His Daughter* (New York: Viking Penguin, 1988), 63, and in Dore Ashton, *Yes, but..., A Critical Study of Philip Guston* (New York: Viking, 1976), 105.

4. Georgia O'Keeffe, writing to Anita Pollitzer from South Carolina in the teens, cited in Doris Bry, *Georgia O'Keeffe: Some Memories of Drawings* (Albuquerque: University of New Mexico Press, 1988), unpaginated.

5. Peter Bürger, *Theory of the Avant-Garde*, trans. Michael Shaw, *Theory of Literature*, vol. 4 (Minneapolis: University of Minnesota Press, 1984), 53.

6. Sigmund Freud, *Civilization and its Discontents* (London: Hogarth Press, 1930).

INDEX

Index

Index

Index